Fall 2017

CARCERAL
FANTASIES

||||||||||||||

FILM AND CULTURE

JOHN BELTON, EDITOR

FILM AND CULTURE
A series of Columbia University Press
EDITED BY JOHN BELTON

For the list of titles in this series, see page 441.

CARCERAL FANTASIES

Cinema and Prison in Early Twentieth-Century America

ALISON GRIFFITHS

Columbia University Press

NEW YORK

Columbia University Press
Publishers Since 1893
New York Chichester, West Sussex
cup.columbia.edu
Copyright © 2016 Columbia University Press

Library of Congress Cataloging-in-Publication Data
Names: Griffiths, Alison, 1963– author.
Title: Carceral fantasies : cinema and prison in early twentieth-century
 America / Alison Griffiths.
Description: New York : Columbia University Press, 2016. | Series: Film
 and culture | Includes bibliographical references and index. | Includes
 filmography.
Identifiers: LCCN 2015048081 | ISBN 9780231161060 (cloth : alk. paper)
Subjects: LCSH: Prisoners—Recreation—United States. | Prisoners—
 United States—Social conditions. | Motion picture audiences—United
 States. | Prison films—History and criticism. | Imprisonment in motion
 pictures.
Classification: LCC HV8860 .G85 2016 | DDC 365/.668—dc23
LC record available at http://lccn.loc.gov/2015048081

Columbia University Press books are printed on permanent and durable
acid-free paper.

Printed in the United States of America

c 10 9 8 7 6 5 4 3 2 1

Cover/jacket: Noah Arlow

Parts of *Carceral Fantasies* were previously published in earlier form:

"The Carceral Aesthetic: Seeing Prison on Film During the Early Cinema
 Period," *Early Popular Visual Culture* 12, no. 2 (August 2014): 174–98.
"Tableaux Mort: Execution, Cinema, and Galvanistic Fantasies," *Republics
 of Letters: A Journal of Knowledge, Politics, and the Arts* 3, no. 3
 (April 29, 2014), http://arcade.stanford.edu/rofl_issue/volume-3-issue-3.
"A Portal to the Outside World: Motion Pictures Arrive in the Penitentiary,"
 Film History 25, no. 4 (Fall 2013): 1–35.
"Bound By Cinematic Chains: Early Cinema and Prisons, 1900–1915."
 In André Gaudreault, Bicolas Dulac, and Santiago Hidalgo, eds.,
 A Companion to Early Cinema (Oxford: Wiley, 2012), 420–40.

For Evan, Charlie, and Soren

While society in the United States gives the example of the most extended liberty, the prisons of the same country offer the spectacle of the most complete despotism.

<small>GUSTAVE DE BEAUMONT AND ALEXIS DE TOCQUEVILLE, 1833</small>

Contents

Figures

CHAPTER THREE

Acknowledgments

Carceral Fantasies is a product of my sustained interest in crossing disciplinary borders to explore filmmaking and film exhibition in unexpected contexts (anthropology in my first book and museums and spaces of immersion in my second). Walter Mignolo's idea of "border thinking,"[1] in the sense of both giving voice to subaltern people and working across fields, infuses this book. The border is a fitting figure both for the book's straddling of film and penal studies as well as for the architecture of prison walls and razor wire fences, cell blocks and recreation yards, and cell windows and barred doors. *Carceral Fantasies* recognizes the real people whose lives are posthumously touched, individuals whose incarceration and death by capital punishment left families crippled with grief and economic hardship, including the entry in Sing Sing's record of executions listing the names of the six child survivors of Ferraro Giovanbatista, sent to the electric chair on March 20, 1919. These somber artifacts are tempered with shards of hope from the same institution, as when inmates sat down to a Thanksgiving dinner and watched motion pictures at Sing Sing in 1914. Similarly, the long hours I spent cloistered conducting archival research in the institutional and personal records of early twentieth-century prisons provided a stark contrast with the unforgettable time I spent among contemporary inmates and staff at Sing Sing.

Support for *Carceral Fantasies* came from a NEH Summer Stipend, several grants from the Research Foundation of PSC-CUNY, and summer research and reassigned time from the Weissman School of Arts and Sciences at Baruch College, CUNY. I am especially grateful to the school's former dean, Jeff Peck, who championed this project from the outset. The book benefited greatly from the thoughtful responses I received at a number of conferences,

lectures, and symposia, including "Women in the Silent Screen" in Bologna, Italy; the "Power of Display" at the University of Chicago; "Europe on Display" at McGill University; the Berkeley Film Seminar; the "Ecologies of Seeing" Nomadikon conference at the College of Saint Rose, Albany; the 2012 SOCINE (Brazilian Society for Cinema Studies) conference in Sao Paulo; the Domitor conference in Bristol, UK; the Film, Theory, and Visual Culture Seminar at Vanderbilt University; the Scottish Graduate School for Social Science Summer School at the University of Edinburgh; and a talk at Rensselaer Polytechnic Institute in Troy, New York.

I am grateful to Stephen Bottomore, Tom Gunning, Maggie Hennefeld, Laura Horak, and Gregory Waller for generously sharing material relating to early prison film screenings and press coverage. Professor Ellen Belcher, head of Special Collections, Lloyd Sealy Library, John Jay College of Criminal Justice, and research librarian Tania Colmant-Donabedian helped me navigate the Lewis E. Lawes Collection; Professor Belcher also recommended other scholarly sources at an early stage of the research. The following archivists assisted me in identifying materials and making efficient use of my time: Bill Gorman at the New York State Archive, Albany; Elif Rongen-Kaynakci at the EYE Film Institute, Netherlands; Jennifer Tobias at Museum of Modern Art; Jenny Romero and Faye Thompson at the Margaret Herrick Library, Academy of Motion Picture Arts and Sciences; Brett Service at the Warner Bros. Archive; and archivists at the British Film Institute, the Library of Congress Division of Motion Picture and Recorded Sound and Rare Manuscript Room, Special Collections at Syracuse University Library, the New York Public Library, the Archival Film Collections of the Swedish Film Institute, the National Library of Sweden, Division of Audiovisual Media, and the Newman Library at Baruch College. I am especially grateful to prison historian and activist Scott Christianson, whose encyclopedic knowledge of the subject and experience working with key individuals in New York State corrections brought vital perspectives to this book.

The following individuals are owed thanks for logistical, intellectual, and emotional support: Charles Acland, Richard Baxtrom, David Birdsell, Robin Blass, Ralph Blumenthal, Hatty Booyah-Kashannie, Constance Classen, Nicholas Friendly, Sara Friendly, André Gaudreault, Jill Boulet-Gercourt, Philippe Boulet-Gercourt, David Gilfillan, Sue Gilfillan, Michael Goodman, Tamar Gordon, Frances Green, Lee Grieveson, Beth Griffiths, Jim Griffiths, Nigel Griffiths, Anna Grimshaw, Tom Gunning, Mick Harris, Caitlin

McGrath, Caryn Medved, Charles Musser, Eve Moros-Ortega, Shaun O'Brien, Kathleen O'Heron, Jana O'Keefe Bazzoni, Mary O'Neill, Fiona Rees, Phillip Roberts, Matthew Solomon, Shelley Stamp, Dan Streible, Lara Tatara, Victoria Trevor, Haidee Wasson, Kristen Whissell, and Johannes Wiebus. I want to thank Linda Foglia, former assistant public information officer at New York State Department of Corrections and Community Supervision, Sing Sing Correctional Facility superintendent Michael Capra, and Lesley Malin, deputy superintendent, Sing Sing Correctional Facility for granting interviews and allowing me to visit the prison on several occasions. Andre Jenkins, a founding member of the inmate-organized Forgotten Voices group at Sing Sing, shared with me what it is like to watch visual media while incarcerated. I could not have finished this book in a timely manner without the help of my research assistant, Agnese Gangadeen, who came on board at the point I became interim dean of the Weissman School of Arts and Sciences at Baruch in June 2015. Agnese filled in gaps in primary research, worked on the large number of images, and copyedited chapters, all while expecting her first child. I am truly grateful for and impressed by her research skills, competence, and professionalism.

I am extremely fortunate to have had William Boddy respond enthusiastically to the idea of this book (he knew from the start that this was a long-haul project). I am humbled to have him by my side, nourishing my intellect and soul as partner and colleague. I want to give a shout-out to my children, Evan, Charlie, and Soren, for their patience when conversations frequently veered toward prisons and film. Charlie was my research assistant in several archives in Los Angeles and also helped with manuscript preparation. I had the great pleasure of working with Jennifer Crewe at Columbia University Press for a third time and I am delighted she oversaw the book to its completion despite her new responsibilities as president and director of the press.

CARCERAL
FANTASIES
|||||||||||||

Introduction

The criminal, in the sense that we so often use the word, is just as imaginary as the equator.

THOMAS MOTT OSBORNE, former Sing Sing Prison warden and reformer, 1915[1]

Carceral Fantasies is about how motion pictures and the penitentiary in the United States came into contact, both figuratively and literally, in the first two decades of the twentieth century. Expansive in scope, the book examines the earliest cinematic representations of prison and punishment (mostly pre-1915) and, more intriguingly, how motion pictures were shown to both male and female prisoners and gained a foothold in American prisons between 1909 and 1922. Why the double objective, why not just one of these methodologically distinct approaches? Prison is a paradox: unknown to the vast majority and yet resolutely imagined through popular culture, what I call the *carceral imaginary*.[2] Cinema plays a key role in this paradox: affording audiences virtual access to the penitentiary through prison films and, more recently, TV shows, while giving prisoners an opportunity to sample the outside world—if only vicariously—through organized screenings, recreation yard television, and, in some facilities, in-cell television. Exploring the penitentiary not merely as a cinematic subject but as an exhibition venue, *Carceral Fantasies* makes the case that any study of film reception in prison has first to acknowledge where our ideas about this institution and its inhabitants come from. *Carceral Fantasies* is methodologically ambidextrous, then, not through choice but through necessity, using textual analysis, cultural and penal history, and the effect of incarceration on the senses to sift through archival material. If we are to even come close to understanding the rich, fascinating, yet all too elusive relationship between cinema and prison, we must acknowledge the fact that no single method can do all this work. Responding to David Garland's call in *Punishment and Modern Society* for a nuanced, multidimensional interpretative approach to understanding our puzzling relationship to punishment,

1

Carceral Fantasies privileges neither text nor institution but argues the need for both.[3]

How do we know of punishment, prison, and inmates? Tales of punishment, incarceration, torture, and especially execution have enthralled audiences since time immemorial; as Caleb Smith argues, "prison is not only a material structure . . . but also a set of images and narrative patterns."[4] Even witnessing actual executions was within the realm of the possible up until the dawn of the twentieth century, as death penalties were carried out in public. A rich, macabre visual culture evolved around spectacularized executions, images of barbaric deaths recorded in medieval artworks, woodcuts, paintings, drawings, photographs, lithographs, and motion pictures. *Carceral Fantasies* begins with an analysis of how the invention of cinema responded to the longue durée that is visualized executions, not by constructing a genealogy of execution on film, but by homing in on a method of execution that came of age with cinema: electrocution. Both are exemplars of technological modernity, affiliated with Thomas Alva Edison, early cinema's doyen, and shaped by shared histories of popular and scientific display.[5] Without Edison's expert testimony in the legal appeal of William Kemmler,[6] a case that established electrocution as a replacement for hanging in New York State and made Kemmler the test case for this new method of execution in 1890, the electric chair might have remained a blueprint and not one of the deadliest killing machines in U.S. prison history. Edison is doubly implicated as filmmaker and historical agent behind the establishment of the apparatus that took the lives of death row inmates.

Edison's role in the history of electrocution adds immeasurably to our understanding of one of the earliest and most famous prison films, *The Execution of Czolgosz, with Panorama of Auburn Prison* (1901).[7] The film has three main use values: to transcend press accounts of Czolgosz's execution through imaginary access to the death chamber; to put to rest lingering concerns about the brutality of electrocution by supporting the mistaken notion that not only had electrocution been perfected since Kemmler's death, but it was as clean and simple as turning on a lightbulb; and third, to assuage Edison's pivotal role in the legalization of electrocution, since this film showed it working flawlessly. On many levels, *The Execution of Czolgosz* is a recursive film, a throwback to public executions and other "plebeian sports" that roused the passions. As a writer for the *Philanthropist* noted in 1812: "To see five of their fellow creatures hanged, was as good as a horse-race, a boxing-matching

[*sic*], or a bull-baiting. . . . It is a spectacle which cannot soften one heart, but may harden many."[8] Like other public rituals, electrocution drew meaning from performance-based cultures such as the freak show, scientific and popular experiments with electricity, and the Phantasmagoria, as well as civic ceremonies, the latter underscored most powerfully in the legally mandated witnesses, the others in the site of the body as a locus of spectacle.

But *Carceral Fantasies* also explores how a carceral imaginary was constructed in some of the earliest films—actualities, fiction, and dramatic reconstructions—featuring prisoners.[9] Early cinema was embedded within a mediated landscape of prison imagery at the turn of the last century, one that included stereocards, postcards, newspapers, magazine illustrations, and vaudeville skits. Cinema was one representational site among many shaping public attitudes toward prison, alternately pandering to the "most voyeuristic and punitive emotions of the audience" and urging us to root for the prisoner pitted against merciless authority."[10] The mass media, as Rebecca McLennan argues in *The Crisis of Imprisonment*, quickly became a "coauthor in the penal drama" of incarceration, ensuring that notorious prisons such as New York's Sing Sing stayed in the headlines, especially when famous criminals were executed, riots erupted, or inmates staged escapes.[11] According to penal scholar Nicole Hahn Rafter, prison films are mostly concerned with "oppression, transgression, and the restoration of the natural order of justice," although even relatively mundane goings-on at the prison claimed the imagination of a public eager for any tidbits about penitential life.[12] The same-sex sociality of incarceration creates ample narrative possibilities for stories of male or female friendship and bonding, homoerotic desire, and the cult of hypermasculinity, prison stories that frequently foreground displays of the body or violence (or both).

Convicts have a long lineage or history as cinematic subjects. Prisons, as Jan Alber reminds us, found an expressive outlet in the novels of Charles Dickens—Amy Dorrit's brother Tip returns repeatedly to debtors' prison in *Little Dorrit* (1855–1857)—and Dickens himself could claim familiarity with the institution through his father's incarceration, which forced the younger Dickens to leave school early and work in a factory.[13] Garbed in comic-looking black and white stripes, prisoners function as "reliable signs of embodied discipline," examples of what Juliet Ash calls "sartorial punishment," clothes as "signifiers of the power of political systems to bodily punish miscreants."[14] Depicting prisoners performing some version of hard labor or marching the

lockstep, an awkward, shuffling walk in which the convict's head is turned to one side as he holds the waist of the man in front, prison motion pictures sated a desire to peer inside one of society's most notorious institutions.[15]

Prison's Challenge to Ideas of Film Spectatorship

Interest among film historians in how cinema was experienced in nontheatrical spaces has grown exponentially in the last ten years; as film historian Haidee Wasson argued in *Cinema Journal* in 2009, "Endorsing the idea that there is a singular knowable entity called 'the cinema' that was uniformly operationalized across all social and historical contexts is an error we are reminded of daily in our contemporary and ever-changing technological environment."[16] And while our understanding of cinema's role as a regulatory device has been significantly advanced by film scholars such as Lee Grieveson in *Policing Cinema*, William Uricchio and Roberta Pearson in *Reframing Culture*, Haidee Wasson in *Museum Movies*, Richard Abel in *Americanizing the Movies*, and Peter DeCherney in *Hollywood and the Culture Elite*, no one has turned the spotlight on early film spectatorship in prison, and the several books on cinema and prison have been concerned exclusively with representations of prisoners in films (predominantly from the sound era) and been encyclopedic rather than focused, including Bruce Crowther's *Captured on Film* and Nicole Rafter's *Shots in the Mirror: Crime Films and Society*. Likewise, Yvonne Jewkes's UK case study, *Captive Audiences: Media, Masculinity and Power in Prisons*, Paul Mason's *Captured by the Media: Prison Discourse in Popular Culture*, and Peter Caster's *Prisons, Race, and Masculinity*, while making important interventions, are neither interested in the finely grained historical experience of prison cinema exhibition nor concerned with representations of prisoners in the popular imaginary before WWII.

With prisons, cinema entered an environment in some ways similar to other spaces of social reform, education, and coercion where early film screenings occurred, including schools, museums, churches, boys' and girls' clubs, the YMCA, military bases, and insane asylums.[17] There is consanguinity across these spaces in their appropriation of cinema, especially during the early cinema period before the regularization of the economics and social practices of exhibition was accomplished. Film exhibition in prison exemplifies the idea of intermediality, combining older technologies and screen practices, including lantern slide lectures, musical concerts, and vaudeville perfor-

mances with motion pictures. Such diverse programming was not unique to the penitentiary, but was a feature across other nontheatrical venues of the period. The prison warden, asylum superintendent, or military commander often acted as film programmer and censor, and a member of the audience's institutional population typically supplied piano or other musical accompaniment during screenings. Prisons seldom boasted a dedicated space for film exhibition (screenings were almost always held in chapels that doubled as auditoriums), and the prison lacked the extratextual signifying elements of cinema lobbies, film posters, barkers, and ticket booths that were part of civilian moviegoing. The examination of cinema in the prison complicates received models of early cinema's transformation from a storefront nickelodeon to an ideologically sanctioned middlebrow entertainment. Likewise, the persistence within prison screenings of older exhibition forms, including the magic lantern show, vaudeville program, concert performance, and public lecture, along with the distinct setting of a prison administration employing the new medium in service of a larger regime of surveillance and discipline, demand a rethinking of the social *and* sensory experience of cinema in nontheatrical venues.

The challenge of reconstructing the historical experience of cinema, never an easy undertaking, is in some ways surprisingly less daunting in the case of prison (at least during its first decades), since we have detailed records of screenings from prisoner newspapers, identifying when, where, and with whom inmates watched motion pictures. Rather than view cinema as an unprecedented new media form in the prison, I argue that one evocation of the cinematic experience—the sensation of staring at the rectangle of light on a blank cell wall, which becomes a proxy screen—helped lay the ground for the arrival of motion pictures behind bars. Somewhat paradoxically, one could argue that prisoners were sensorially primed for cinema long before it made its (relatively) late appearance in U.S. penitentiaries between 1909 and 1914. And while cinema brought the outside world in, it also turned the prison inside out, as a result of the location shooting within prisons that took place with increased regularity.

Carceral Fantasies fills a striking gap in our understanding of cinema's usefulness in progressive penal reform and illuminates the little-known story of Hollywood's relationship to prisons, which included studios supplying films free of charge in exchange for location shooting.[18] Not only did Vitagraph, Fox, Metro, and Paramount loan hundreds of films for Sing Sing screenings, but

Warner Bros. conducted inmate test screenings throughout the 1920s and 1930s and, in 1933, Harry M. Warner personally financed the construction of the three-thousand-seat prison gymnasium in memory of Jack Warner's son Lewis, with the expressed hope that in addition to giving the inmates recreation, it would also "build their character." While New York City may be considered the center of the early American motion picture industry, with thousands of storefront theaters serving a new popular audience, thirty miles up the Hudson River, in the small town of Ossining, New York, a separate system of film exhibition culture was taking shape within the infamous Sing Sing Prison. A parallel cinema existed at Sing Sing, where men who had come of age with cinema outside the prison sat side by side with those whose first encounter with the medium occurred behind bars. At the same time, inmates often watched the same comedy or dramatic releases that their free brethren saw beyond the prison walls. The historical experience of prison filmgoing is less the tale of a unique medium than the story of a specific disjunct alignment between the civilian and captive experiences of cinema. In less than a year, a vibrant fan community would emerge within Sing Sing, with films regularly reviewed in the "On the Screen at Sing Sing" column of the prisoner newspaper, *The Star of Hope. Carceral Fantasies* also connects the emergence of cinema in prisons to the larger project of nation building, evidenced both in discussions of cinema's potential as an agent of acculturation for the immigrant prisoner population by inmates writing in *The Star*, and in Sing Sing warden Lewis E. Lawes's involvement in the American Boy Scout movement.

Film exhibition in prison serves both as a disciplinary agent—related to Michel Foucault's idea of punishment shifting from a violent public spectacle to an "economy of suspended rights" in the penitentiary—and as a great equalizer, giving prisoners a modicum of the cultural capital shared by family and friends outside.[19] Moreover, as agents of surveillance, the prison guards are doubly implicated in the film screening, watching the watchers of cinema while also partaking of the viewing experience. Rather than assume that the protocols of civilian film exhibition were completely absent in the penitentiary, *Carceral Fantasies* looks for points of convergence and divergence, suggesting that anthropologist Anne Laura Stoler's argument that the space of rupture in the ethnographic archive, located in the "disjuncture between prescription and practice, between state mandates and the maneuvers people made in response to them, between normative rules and how people actually lived their lives," can be applied to the penal context.[20] How might organized en-

tertainment have created opportunities for all manner of disjunctions, spatially with regards to film exhibition and psychically in terms of cinema's role as a palliative against the ills of incarceration? And might these disjunctions give us special access to new ways of thinking about both the nature of incarceration and what it means to attend the cinema? My hunch is that it does.

Carceral Topoi

Carceral Fantasies is organized into three parts: "The Carceral Imaginary," "The Carceral Spectator," and "The Carceral Reformer." Chapter 1 explores the nature of the carceral imaginary within the context of early execution films, galvanism and the electrical wonder show, and the Phantasmagoria. Thomas Edison's famous *The Execution of Czolgosz, with Panorama of Auburn Prison* (1901) is the chapter's theoretical vortex, a phantasmic film that lied about electrocution in order to trigger a case of collective amnesia for contemporaneous audiences who, eleven years after William Kemmler's botched electrocution at Auburn, had conveniently forgotten about this grisly method of capital punishment. I use the contested cultural meanings of electricity and capital punishment as suggested in *The Execution of Czolgosz* to discern how electrocution is represented in examples as diverse as an episode of Harry Houdini's *Master Mystery* series (Grossman and King, 1919), a fictional reconstruction of Ruth Snyder's 1928 electrocution in *Picture Snatcher* (Lloyd Bacon, 1933), and *The Green Mile* (Frank Darabont, 1999). These films satisfy a psychic impulse to witness punishment and incarceration, a subject taken up in greater depth in the next chapter.

Chapter 2 examines how actuality, reconstruction, and fictional films representing prisons and prisoners made before cinema's transitional era constructed a carceral imaginary that was indebted to precinematic visions of imprisonment while at the same time established new rules about visualizing incarceration. Prison life can be represented, but it is rarely experienced by elite commentators, and its form has been reduced to a predictable repertoire of images: prison stripes or jumpsuits, bars and wire fences, aimless bodies moving in an exercise yard or assembled in mess halls. Beyond enumerating the kinds of visual tropes used in prison dramas to signify the imprisonment, this chapter examines conventional and subversive narrative spaces carved out for prison dramas and considers whether films made prior to the transitional era open up alternative ways of theorizing carcerality. Given that most

people's perceptions of prison came from popular cinema, how do these films rise to the challenge of representing prison with any degree of accuracy, and are there any films that disrupt commonly held beliefs about life behind bars?

Part 2 of the book, "The Carceral Spectator," begins with chapter 3, "Screens and the Senses in Prison," an analysis of how film exhibition in prisons across the United States and United Kingdom was covered in the popular press, trade publications, magazines, and prisoner-written books and articles, and how incarceration's recalibration of space and time affected the senses in curiously protocinematic ways. These accounts reveal a great deal about the distinctive nature of nontheatrical film exhibition in cinema's earliest decades and the special journalistic attention that the prison as exhibition venue attracted. I examine the introduction of prison libraries, illustrated lectures, and vaudeville shows; the popular press's imagining of film spectatorship in prison as a social experiment akin to avant-garde filmmaker Stan Brakhage's idea of the "untutored eye"; film as a portal to the outside word; and the cell and prison chapel as overdetermined, metaphorical spaces of projection.

Chapter 4 explores how cinema stood on the shoulders of a longer history of prison entertainments at Sing Sing, considering how the reform efforts and wardenships of Thomas Mott Osborne (1914–1915) and Lewis E. Lawes (1920–1941), along with the Mutual Welfare League (MWL), a self-governing prisoner organization, transformed the prison into a vibrant space of nightly filmgoing by the late 1910s. With a brief overview of how libraries, education, concerts, and other live entertainment paved the way for motion pictures, the chapter considers the unique conditions of possibility for showing film in Sing Sing. Issues addressed include how film obtained a foothold, jibed with other reformist and recreational agendas, and created new habits of being; why Hollywood executives curried favor with Warden Lawes; and cinema's role in inculcating ideas of modern citizenry (a clarion call in the U.S. penological discourse). The chapter also turns to the role played by early radio broadcasting in the prison, since radio headsets installed in Sing Sing's cells in the late 1920s brought in the outside world and served as a strategic ally for Warden Lawes, whose fireside chat radio programs were piped directly into the cells on Sunday evenings.

The book's final section, "The Carceral Reformer," examines penal reform and the growing number of purpose-built women's reformatories constructed in the United States in the context of a brief cycle of prison reform films made

between 1917 and 1919. In light of Angela Davis's argument about the aston-ishing growth of women's prisons in the early 2000s in the United States, chapter 5 plumbs the history of women's incarceration and early twentieth-century media, not only to shed light on the uses of sanctioned entertainment in the women's prison but also to give voice to female inmates, to excavate what literary scholar Nancy Bentley calls the "sediments of gendered experience."[21] Building on the work of feminist scholars such as Antonia Lant, Shelley Stamp, Vicki Callahan, Jennifer Bean, and Diane Negra, this study redirects the conversation on women's experiences of cinema to an unlikely but impor-tant location: the women's prison.[22] Chapter 5 examines two key questions: how women incarcerated in prisons and reformatories at the turn of the last century first encountered modern media such as magic lantern slides, phono-graphs, and motion pictures and why film exhibition began later in the women's prison than in male institutions. For example, at the New York State Prison for Women in Auburn, women were never shown film in the 1910s, while male inmates over the wall in the men's facility started watching mo-tion pictures in 1914, with Auburn becoming the first prison in the state to start showing film. And yet on some occasions when films were shown to women in prison, they took place in coed screenings, as at Connecticut State Prison in the early 1920s.

Chapter 6 examines how penal reformers appropriated cinema for their cause, addressing not only the moral rehabilitation of individual prisoners but changes in institutional policy. Paying specific attention to films made by prison reformers like Katherine Russell Bleecker, who in 1915 shot footage at three of New York State's biggest penal institutions (Auburn, Sing Sing, and Great Meadow), the chapter explores where these films circulated (in prisons and outside), what publicity they generated, and, in cases where the films no longer survive, what evidence of their impact (if any) on prison con-ditions might survive. But the chapter expands the optic of prison reform films to an analysis of commercially made films from the late 1910s and 1920s whose narratives and object lessons were hailed by the press as powerful pro-paganda for reformist measures, as powerful in effecting change as films made specifically for that purpose, or even more powerful.

The book's conclusion fast-forwards to the contemporary period, with brief discussion of several prison museums and contemporary media use in Sing Sing Prison, the subject of chapter 4. The prison museum is a fascinating simulacrum, a semiotic frenzy that is haunting and, by public reputation,

often haunted. Visitors manifestly seem to love imagining what it must be like to be incarcerated, and in many ways prisons have always functioned as de facto museums, given the large number of gawkers allowed to tour facilities from the eighteenth through the early twentieth centuries. Prison museums with relics of executions and punishment such as an electric chair, hanging scaffold, or whipping post are especially popular. Meanwhile, a world of prisoner-produced artwork, theater, photography, filmmaking, and writing, a vital topic too vast to more than suggest in this book, promises contrapuntal insights, offering men and women a voice to express their feelings, thoughts, and identities.[23] The conclusion also addresses some features of contemporary media use at Sing Sing Prison, an attempt less to construct an exhaustive history of media use in prisons than to offer a snapshot of some recent changes, including the introduction of in-cell television. Impossible as it might be to claim to grasp the experience of incarceration, *Carceral Fantasies* recognizes the powerful role of the imagination in this project, encompassing both fantasies of escape and freedom enacted by inmates, and fantasies of punishment and despair conjured up by popular culture.

PART ONE

THE CARCERAL IMAGINARY

Chapter One

Tableaux Mort

EXECUTION, CINEMA, AND
CARCERAL FANTASIES

> Ghoulish or not, the public is always present at an execution. It
> is present as a juridical fiction, but as more than a fiction, as an
> authorizing audience unseeing and unseen, but present
> nonetheless.
> AUSTIN SARAT, *When the State Kills*[1]

are we?

Why are we fascinated by images of punishment, or, more extremely, the
extinction of life, and how has popular visual culture throughout the ages
catered to this lurid curiosity?[2] No different from the "If it bleeds, it leads"
imperative of contemporary news, where stories of murders, accidents, fires,
and human suffering drive ratings, execution films were made for the very
same reason that waxworks of serial killers, gruesome murders, and elec-
trocutions were included in chamber-of-horrors exhibits and dime muse-
ums. Our sensibilities may be offended by both the filmic execution and the
waxwork simulacrum, but it is often hard to avert one's gaze. As Roald Dahl
describes it in *The Witches* when the young boy first sees the unmasked
witches, "There are times when something is so frightening you become
mesmerized by it and can't look away."[3] This chapter works with the prem-
ises that prisoners and the optic of execution constitute primal exemplars of
Dahl's can't-look-away-ness and that popular culture, along with science and
the news industry, have ensured a steady stream of gruesome images of
state-mandated murders and fictive representations of prisoners condemned
to die, including stereocards of lynched bodies and even a phonograph re-
cording of a lynching.[4]

Historical accounts of cinematic representations of capital punishment and
imprisonment often begin with Thomas A. Edison's *The Execution of Czol-
gosz, with Panorama of Auburn Prison*, a four-shot motion picture made in
1901 that cuts from a panorama of the exterior of Auburn Prison in upstate

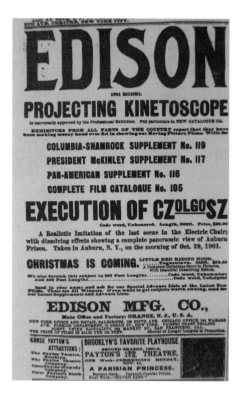

Fig. 1.1 Advertisement for Edison's
Execution of Czolgosz. New York Clipper,
November 16, 1901

New York to a dramatic reenactment of anarchist Leon Czolgosz's electrocution, a reenactment that a *Clipper* announcement boasted was "faithfully carried out from the description of an eye witness" (fig. 1.1).[5] An unemployed machinist and son of Polish immigrants, Czolgosz shot President William McKinley on September 6, 1901, in the Temple of Music at the Pan-American Exposition in Buffalo, New York (fig. 1.2).

The subject of intense public interest, Czolgosz was electrocuted with three jolts of 1,800 volts at Auburn Prison on October 29, 1901, just forty-five days after McKinley's death. Following an autopsy, sulfuric acid was poured into Czolgosz's coffin and his body buried in quicklime to hasten decomposition.[6] Czolgosz's personal possessions and clothes were also burned, to ensure that no one profited from nefarious access to the body or possessions. The *New York World* reported that a "museum keeper in a large city telegraphed an offer of $5,000 for either the body or the garments of the murderer."[7]

I use *The Execution of Czolgosz* and several other execution films in this chapter as a critical vantage point from which to better understand our fas-

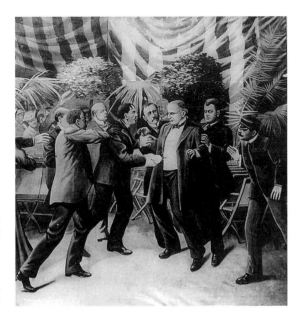

Fig. 1.2 Drawing by T. Dart Walker depicting the assassination of President William McKinley by Leon Czolgosz at Pan-American Exposition reception on September 6, 1901. http://www.loc .gov/pictures/item/96521677/

cination with representing execution and punishment on film. There is an epistephilic longing in the execution film not just to see life extinguished but also to penetrate the walls of the penitentiary and show what goes on in its darkest corner: the death chamber. Punishment and the visual are ineluctably bound, as Austin Sarat argues in *When the State Kills*.[8] As the twentieth century's most common method of execution in the United States—over four thousand people died in the electric chair between 1890 and 1966, and New York State topped the chart with 695 executions—electrocution is by no means an anachronistic artifact from an earlier era. And while cameras have been banned—if not always successfully—from the execution chamber, journalist-witnesses speak of the trauma of the experience, as they did at the first electrocution at Auburn Prison in 1890.[9] And let us not forget that execution can engage the senses in powerful ways, generating disturbing sounds, smells, and emotions.[10]

The execution film derives meaning as the "ceremonial of punishment," Michel Foucault's term for all manner of staged public punishments and macabre visual spectacles that exploited the idea of the uncanny, of being copresent with the dead, including the waxwork exhibit, the electrical wonder show (demonstrations inspired by galvanistic experiments with electricity),[11] and the Phantasmagoria. Derived from the Greek *phantasma*, meaning "ghost," and *agoreuo*, "I speak" (the calling up or summoning of ghosts), the

semblance of truth, likelihood (handwritten margin note)

Phantasmagoria was an eighteenth- and nineteenth-century entertainment in which ghostly apparitions were made to appear using the magic lantern, smoke, and mirrors.[12]

In this regard, *The Execution of Czolgosz* joins many other titles, including *The Execution of Mary, Queen of Scots* (Edison, 1895), *An Execution by Hanging* (American Mutoscope and Biograph, 1898), *Execution of a Spy* (Biograph, 1900), *Histoire d'un crime* (Ferdinand Zecca, 1901), *The Executioner* (Pathé Frères, 1901), *A Career of Crime* (American Mutoscope and Biograph, 1900), *Electrocuting an Elephant* (Edwin S. Porter and James B. Smith, 1903),[13] *Au bagne* (Scenes of a convict life) (Pathé, 1905), *A Reprieve from the Scaffold* (AM&B, 1905), *The Caillaux Case* (Richard Stanton, 1918), episode seven of Harry Houdini's *The Master Mystery* (Harry Grossman and Burton L. King, 1919), *Picture Snatcher* (Lloyd Bacon, 1933), and *The Green Mile* (Frank Darabont, 1999), to name just a few films that have transported audiences to the space of execution for over a century.[14] Not all these films are set exclusively in the prison, but they all represent the apparatus of capital punishment. With varying degrees of verisimilitude, the early execution film animates scenes from the headlines, responding to what Harry Marvin, vice president of the Biograph Company, described as the public's demand for film companies to "gather the news in a pictorial way and disseminate it at once."[15]

My goal in this chapter is to situate *The Execution of Czolgosz* and other execution films within a rich array of precinematic entertainments, as well as discuss *Czolgosz's* legacy in three other films featuring the electric chair that tell distinct stories about the device's fraught status within the American popular imagination and cinematic lexicon: Harry Houdini's *The Master Mystery*, *Picture Snatcher*, and *The Green Mile*. I begin with some of the earliest execution films mentioned above, tracing the depiction of execution from the scaffold dance (public hangings) to the Chamber of Horrors waxwork, before reevaluating *Czolgosz* in the context of the Phantasmagoria, the electrical wonder show, and the historical record of electrocution's effect on the body, an account occluded—or suppressed—in Edison's film. Experiments to revivify a dead human body or make parts of it seemingly spring to life serve as an important backdrop for our understanding of films representing electrocution and for audience members witnessing electrocution in the 1890s. This long history of electrical display, executions, and cinema's role as a state witness helps us better grasp prison and punishment's indelible hold on our imagination.

Public Execution and Mary, Queen of Scots

> Sir, executions are intended to draw spectators. If they do not
> draw spectators they don't answer their purpose.
> Dr. Samuel Johnson, 1783[16]

In 1901, the *Star of Hope*, a prison magazine published at Sing Sing Prison, thirty miles outside New York City, but featuring contributions from the state's main penitentiaries, ran a cover story entitled "Reformed by a Picture." The article was a morality tale told by an inmate of Clinton Prison about a friend and former Sing Sing prisoner who reformed after seeing *The Execution of Mary, Queen of Scots* (fig. 1.3), made in 1895, on a temporary screen in an open-air screening in Columbus, Ohio:

> Small things have changed the course of many of our lives, and, by some mysterious power influenced us for good and evil. A kinetoscope is an innocent looking piece of machinery and one would hardly credit it with the reformation of the crook, but it did. One of its pictures, projected upon a square of canvas in the city of Columbus, Ohio . . . was the means by which a notorious crook was made to realize his position. . . . It was as thorough a conversion as I have ever witnessed. That little picture accomplished more in five minutes than all of his term in prison did, or could ever accomplish, if he was incarcerated for the remainder of his natural life.[17]

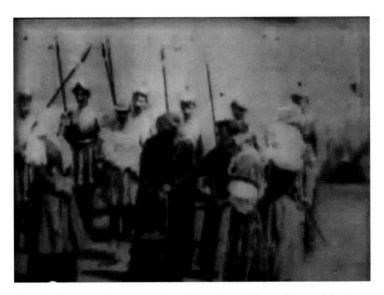

Fig. 1.3 Frame enlargement from *Execution of Mary, Queen of Scots*
(Edison, 1895).

The prisoner's elaborate account of the screening is fascinating not only for the prescient way in which it foregrounds cinema's role as a moral reformer, but for the inmate's extraordinary recall of the minute details of this execution film. Despite misremembering its length at five minutes instead of an elliptical twenty seconds, the description compensates for the fact that few of the *Star of Hope*'s inmate readers would have ever seen motion pictures let alone this film. The painstaking detail is also a writerly move designed to underscore the emotion of the public execution.[18] The decapitation at the end of *Mary, Queen of Scots*, an early example of stop-camera photography, left both men deeply moved: "The execution was done so quickly that it rendered me speechless. Turning to my friend, I saw his face was pale, and if his life depended upon it he could not of [sic] spoken one word. When he recovered from the shock he turned to me and said: 'That was meant for me, and I'm going to heed the warning.'"[19] Combining the shock factor of the early cinema of attractions with the literal shock of seeing Queen Mary's head suddenly roll to the ground, *Mary, Queen of Scots* delivered a gut-wrenching reminder of the irreversibility of execution.

Although a reconstruction, the film was the closest thing to attending an actual execution that these two men had ever witnessed, and the visceral effect of seeing the queen's head tumbling to the ground in an infant communication medium must have been disconcerting to say the least. Historical fact takes a backseat to the idea of execution as fast and precise in this film, since records indicate that it took several attempts to sever the queen's head (death by chopping block was tricky, as it demanded considerable skill and experience on the part of the executioner). The film's title announces its status as a historical reenactment, and even though spectators may have winced and been oblivious to the dummy substitution trick, even today's spectators often demand a second viewing in order to confirm what it is they (think) they have seen.

This parable about *The Execution of Mary, Queen of Scots*' reformative power adumbrates cinema's role within an optic of execution that long predates motion pictures (woodcuts published in broadsides and photographs satisfied an audience's desire for images of public execution long before motion pictures).[20] Such filmic spectacles also created a unique spectatorial entry point for those inmates on death row who faced the prospect of electrocution. Incarcerated at a prison where executions were part of the grisly cycle of men exhausting the appeals process and being scheduled to die, this film hit a raw nerve as a reminder of the fate awaiting those on death row. Accord-

ing to the inmate's account, the reformed criminal gave away a roll of bills to a female beggar and her children and turned his back on crime, becoming a respected citizen.[21]

Pathé's *The Executioner* (1901) (fig. 1.4) brings the audience a lot closer to a beheading than *Mary, Queen of Scots.* The film opens with a priest staring dispassionately at the camera as an executioner prances around the set and begins swinging his axe in eager anticipation once the prisoner is led into the execution chamber. A small platform with a wooden chest on top becomes a makeshift chopping block, and after some stage business involving the executioner tearing off his cloak in swashbuckler style, a second priest leads the prisoner to the block while a third stands frame right looking on. The effect of the head being severed from the body with one swipe of the axe is sophisticated, especially the substitution shot revealing the beheaded prisoner's body sliding slowly off the block. The severed head—which shares an uncanny resemblance to the executioner—is held up in front of the camera before being placed on a platter, an explicit nod to the performative imperative of public executions.

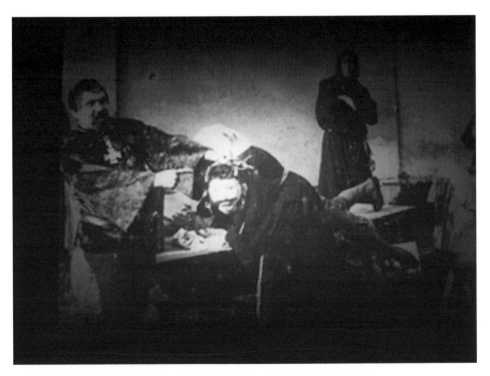

Fig. 1.4 Frame enlargement from *The Executioner* (Pathé Frères, 1901).

Save for the hands of the priest, which spring up in shock at the moment of the beheading, this film is a virtual prototype of execution as entertainment, with the executioner becoming a poster child for what André Gaudreault calls early cinema's internal monstrator, a magician demonstrator.[22]

In 1898, American Mutoscope and Biograph (AM&B) cameraman Arthur Marvin filmed the hanging death of an African American at the county jail in Jacksonville, Florida. Catering to what Miriam Hansen characterized as the sadistic impulses of early cinema audiences,[23] *An Execution by Hanging* is "probably the only moving picture that was ever made of a genuine hanging scene," and it breaks the action down into four brief phases: the man mounts the gallows, an executioner places the noose around his neck and adjusts his black cap, the trap is triggered, and the body shoots "through the air, and hang[s] quivering at the end of a rope."[24] *An Execution by Hanging*[25] occupies a unique place in the history of filmed executions; a throwback to the scaffold dance of the eighteenth and nineteenth centuries, where if you were close enough to the scaffold you witnessed death, the film is eerily contemporary, a nod to the smartphone's ability to capture the live and the immediate, as when an Iraqi soldier used his mobile phone to shoot an unauthorized video of Saddam Hussein's hanging on December 30, 2006.[26] The desire to represent the moment of death in execution is virtually as old as the practice of execution itself.

Execution films like these are an outgrowth of the woodcuts, broadsides, sketches, and literature depicting public executions that were sold to crowds wanting a souvenir of the event, crowds that often swelled into the tens of thousands.[27] Even last-word statements were sold as broadsides on the roads thronged with people after a hanging. Public executions were overdetermined by social conventions, rituals governing representations of the state, so much so that "the manner in which sentences were executed was at least as important as the content of the sentences."[28] The more notorious the murderer, highwayman, or burglar, wrote the authors of *The Criminal Prisons of London and Scenes of Prison Life* in 1862, the larger the crowds "of the most respected citizens . . . wending their way from all parts of the city toward the fatal tree."[29] Removing executions from the public view did nothing to stem a morbid fascination; indeed, one could argue it heightened the voyeurism, since it was now no longer possible to "see for yourself." Public executions not only drew crowds but were spectacles where witnessing became less about actually being able to see the scaffold than about

Fig. 1.5 Albumen print of interior of Tombs Prison, Manhattan, from Robert N. Dennis's collection of stereoscopic views, New York Public Library. Wikimedia Commons, http://commons.wikimedia.org/wiki/File:Interior_of_Tombs,_from_Robert_N._Dennis_collection_of_stereoscopic_views_2.jpg

being part of the event. At the Tombs Prison in Manhattan in the late nineteenth century (fig. 1.5), New Yorkers clung to the chimneys and railings of surrounding buildings to catch a glimpse of the condemned about to be hanged. And if fear of falling impeded those eager for an eyewitness view, the Chamber of Horrors on the lower level of the Eden Musée on Manhattan's Twenty-Third Street served up a cavalcade of execution tableaux in its basement, including wax blood gushing from the "'headless, writhing corpse' of an executed Moroccan criminal, a lynched American horse thief dangling from a tree limb, and a terrified French prisoner witnessing the grisly work of the guillotine."[30]

Waxworks conventionalized representations of violent crime scenes, the clammy, milky hue of the flesh and the smell of the molded bodies concocting a multisensory experience.[31] Execution waxworks transmogrified the assaulted physical senses into contemplative or spiritual ones that justified the act of witnessing and drove home the object lesson that serious crime met with serious consequences; as Kathleen Kendrick explains, "By reproducing the gory effects of contemporary crimes, the Chamber of Horrors offered another form of access to the shared body of information generated by mass media accounts."[32] The walls occluding visual access to executions were no barrier

for the tabloid press and waxwork proprietors who repackaged executions and crime scenes for bloodthirsty audiences.

The Legacy of *Czolgosz*

Unlike contemporary audiences, who have no historical memory of how, when, and where electrocution was first used as a legal method of capital punishment in the United States, audiences viewing *The Execution of Czolgosz* in 1901, just eleven years after the first U.S. electrocution, would probably have had *some* recollection of the earlier public controversy over this method of capital punishment. How public opinion—at least as represented in the press—went from sharing the sentiment of Dr. George Shrady, who, upon seeing the first electrocution in 1890, declared, "I want never again to witness anything like that," to nonchalantly watching *Czolgosz* is curious indeed.[33] With electrocutions continuing unabated from 1890 to 1901, the public might have become inured to its brutalizing effects on the body, many people believing that it was more humane and modern than hanging, despite countless stories of botched executions, usually stemming from faulty equipment and miscalculations of the amount of current to be applied.[34]

The retributive impulse of including Czolgosz's name in the eponymous film afforded it a specificity and currency that linked it to the illustrated-newspaper function of early cinema (this was not *any* electrocution but one of a presidential assassin). Mary Anne Doane argues that the meanings of *The Execution of Czolgosz* are contingent on external spectator knowledge, although I contend that the film's vexed status as simultaneously a reenactment, reportage, and snuff film, coupled with the fact that the film could be purchased and shown without the opening panorama, means that *Czolgosz* could stand in for *any* prisoner's death by electrocution, imbuing the film with an instructional quality, a moving textbook illustration of a nonsensational, bloodless homicide.[35] Notwithstanding this degree of textual openness, *Czolgosz* is a "narrative of national catharsis," constructing audience members as "eyewitnesses for the state" and promising closure for the nation in the wake of the assassination of President McKinley.[36] But the film's sanitized depiction of state killing also intervened in a longer debate over the use of the electric chair in the United States[37] and justified Edison's role in the establishment of electrocution, a topic he avoided in interviews in later years.[38] The film is phantasmic for the simple reason that it constructs an idealized

version of what death by electrocution should, but rarely did, look like, vivi-fying the fantasy of the "quick, clean death that supporters of the electric chair had long promoted, while omitting the gruesome details that marked real electrocutions" (fig. 1.6).[39] The thirteen seconds of electrical charge de-livered in bouts of six, five, and two seconds (in reality, the current was kept on for sixty seconds), the swift stethoscope examination by two doctors that confirms death, and the warden-demonstrator at frame left who brings an end to the proceedings by turning toward the camera and speaking, all serve to transform death by electrocution into a creepy display of magic, with the final declaration of death the equivalent of the prestige. The look at the camera is also a nod to the self-fashioning and performative underpin-ning of eighteenth-century scientific demonstrators, whose social status shored up the validity of the experiments *and* the experimenter.[40]

Because *The Execution of Czolgosz* was made in the aftermath of public executions, whose heyday in the United States was 1776–1865, it was just one other way of sating a desire for visual information about this notorious electrocution, and, as Charles Musser observes, Edison was even prepared to pay two thousand dollars for footage of Czolgosz entering the death cham-ber, but when the authorities refused, he made do with the panoramas.[41] A wax effigy of Czolgosz was placed in the Eden Musée's Chamber of Horrors

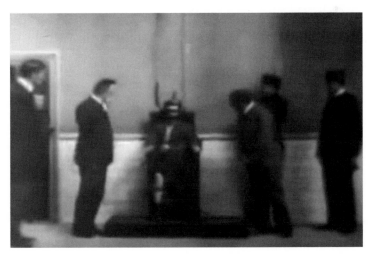

Fig. 1.6 Frame enlargement from *Execution of Czolgosz, with Panorama of Auburn Prison* (Edison, 1901).

electric chair, an object first exhibited at the museum in 1898 in an installation that told the story of the killing and dismemberment of William Guldensuppe in 1897 and the subsequent electrocution of one of his assassins. And even though photographs and artists' sketches of the electric chair had circulated in popular culture since 1889, the waxwork gave audiences an opportunity to savor an image that was too fleeting in the Edison film and lacking in gory realism in the sketches, lithographs, and photographs. *Czolgosz* thus complicates historian of execution Louis P. Masur's argument about the "shift from public, external, physical forms of punishment to private, internal, psychological modes of discipline," insofar as prison authorities clung to the idea of execution as civic ritual, no doubt a way of balancing the ignominious spectacle with capital punishment policy.[42]

The Execution of Czolgosz was not the first reconstructed electrocution film. In 1900, AM&B made *A Career of Crime*, a five-part film that shows a criminal's exploits culminating in his electrocution, ostensibly at Sing Sing Prison.[43] This is fast-track electrocution, the entire process taking an elliptical twenty seconds or so; the mise-en-scène, with a large brick wall signifying an old-fashioned prison, a priest standing immediately to the left of the condemned man, evokes the scaffold rather than the so-called modern electrocution death chamber. Priests were never allowed to stand next to someone being electrocuted—people were kept well away from the body because of the heat—evidence of either artistic license or ignorance on the part of the filmmaker. The man also does not wear a mask, though it was standard to do so, at least in New York State. Like the hangman's hood, the black leather cap dispelled all hopes of de-ritualizing electrocution, as the body of the condemned became monstrous and anonymous through donning the mask. Our reaction to the electrocution is cued by the embodied response of the priest, who not only removes his hat (as does a guard standing next to him) but drops to the ground in shock at witnessing death. This film delivered an unambiguous teleological object lesson: go over to the dark side of crime and be prepared to die in the electric chair. More disconcerting, however, is the fact that this man has not committed murder but larceny, and, in the spirit of what would go on to become California's three strikes and you're out law, is killed for failing to reform.

Reassessing *Czolgosz*: The Kemmler Case and the Electrical Wonder Show

> I think that the killing of a human being is an act of foolish barbarity. It is childish—unworthy of a developed intelligence.
> THOMAS EDISON on capital punishment, 1888[44]

> It was impossible to imagine a more revolting exhibition.
> *BUFFALO EXPRESS*, August 8, 1890, describing Kemmler electrocution[45]

Coming as it did at the height of technological innovation at the end of the nineteenth century, electrocution as represented in *A Career in Crime* and *The Execution of Czolgosz* must have seemed both uncannily familiar (the *New York Herald* reported that the prototype electric chair resembled an "ordinary barber's chair," adding that there was "nothing uncomfortable about the chair save the death current which goes with it") and utterly terrifying, a cautionary tale about how the state now dispensed with its criminals.[46]

Prison visitors waited to sit in the electric chair, to sate a perverse curiosity about what it must have felt like to be so close to death and yet have the ability to walk away, as New York State's second electrocutioner, Robert G. Elliot, recalled in his memoir: "The electric chair seemed to hold a horrible fascination for everybody, including women; and all invariably wanted to be shown the death chamber. Once inside, most of them were not satisfied until they had sat in the forbidding instrument."[47]

Czolgosz's chair might well have been a table if the Medico-Legal Society proposal of having the condemned lie horizontally on an electric table covered with rubber cloth had been adopted; it was thought a chair would afford more dignity to the condemned, since "strapped to a table, he would be utterly helpless, resembling a bit too closely an experimental animal strapped to a laboratory table for vivisection."[48] A contributor to the *Medico-Legal Journal* proposed using a small room, "something like a sentry box or watchman's hut" with a metal-lined floor and electrodes descending like a showerhead, a space that shares a strong affinity with the box used by magicians to reveal parts of the (almost always) female cut-in-half body.[49] In 1883, five years before the first legalized electrocution in 1888, an invention of a Mr. H. B. Sheridan (of the Sheridan Electric Company), who had created an "improved

device for executing criminals condemned to death," was described in an *Electrical World* article entitled "Device for the Execution of Criminals."[50]

On August 6, 1890, less than two years after Edison began to electrocute animals in his New Jersey laboratory, William Kemmler, an inmate at New York's Auburn Prison, became the first human victim of state-sanctioned electrocution in the United States (fig. 1.7). During Kemmler's legal appeal of his death sentence, financed by Westinghouse at a cost exceeding $100,000, a corporate move to prevent alternating current (AC) that Westinghouse produced from being associated with death by electrocution, Edison assumed the role of expert witness, testifying about alternating current electricity's effectiveness as an agent of death. Edison's motivation for getting involved was driven by a similar desire to have his direct current (DC) free from association with electrocution. Edison's "curt and unequivocal" testimony, coupled with the 1888 New York State Death Penalty Commission's belief that "none can be regarded as a higher authority," made Edison a pivotal figure in the passage of the Electrical Execution Act.[51]

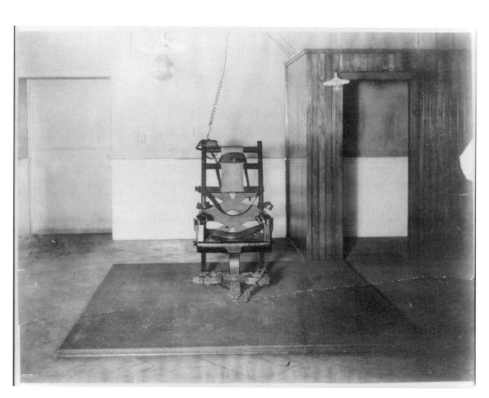

Fig. 1.7 Electric chair used to execute William Kemmler, 1890. Wikimedia Commons, http://commons.wikimedia.org/wiki/File:Electric_chair.jpg

In contrast to the relatively swift demise of the twenty-four dogs (procured by local boys for twenty-five cents apiece), six calves, and two horses that had been electrocuted in Edison's laboratory in New Jersey, Kemmler's execution was a botched, gruesome disaster, "an awful spectacle and sacrifice to whims and theories of a coterie of cranks and politicians," in the words of a *New York World* journalist who titled his story "A Roasting of Human Flesh in Prison— Strong Men Sickened and Turned from the Sight."[52] Despite such headlines as "Far Worse than Hanging," hostile international press coverage of the fiasco (the *Times* of London's suggested that a more effective method of ex- ecution would have been to hit Kemmler with an axe), and the *New York Times* denouncing it as a "disgrace to civilization,"[53] Kemmler's death did not result in the repeal of the Electrical Execution Act.[54] Instead, Edison blamed the botched job on misplacement of the electrodes and questioned whether the full charge had been applied for the appropriate amount of time.[55] Elec- trocutions continued unabated, and in the ensuing decade up to 1900, fifty individuals in New York State died in the electric chair.[56] And lest any states were leery of replacing other methods of capital punishment with the electric chair, *The Electrocution of Czolgosz* assuaged any lingering doubts.

Electricity's History in Science and Popular Culture

A history of electricity's role in the multitude of devices and places where it could be found, "in batteries and machines, in lecture theaters and exhibi- tion halls, in Cornish mines and Italian volcanoes," brings important pers- pectives to our understanding of *The Execution of Czolgosz*, especially the idea of electricity as a multisensory phenomenon that quite literally could touch spectators.[57] A poem entitled "Dynamo-Electric Dangers" that ap- peared in an 1883 issue of *The Operator and Electrical World* served as a cautionary tale to those wandering amid dynamo-electric machines and other devices at the 1883 London Exhibition of Electrical Science and Art (fig. 1.8). The illustration shows a clownish dandy with hair on end, eyes bulging, and mouth agape who has stepped on a live wire and was only rescued when a friend moved his legs and broke the circuit; squiggly lines representing electricity twist from his hands and feet, and his fingers are extended clawlike.[58]

Accounts of death from accidental electrocution along with stories of people surviving electric shocks appeared with regularity in the pages of *Electrical World*, alongside discussions of the effect of electrical light on the occurrence

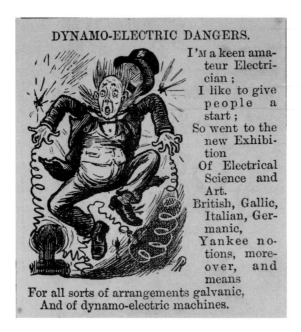

Fig. 1.8 Illustration accompanying poem showing clownish dandy stepping on a live wire at the 1883 London Exhibition of Electrical Science and Art. "Dynamo-Electric Dangers," 1

of freckles, the telephone as an aid to flirting, and electrical toys, marionettes, and women (whose bodies could hold a charge). Whether causing the legs of dead frogs to move in experiments conducted by Italian physician Luigi Galvani in 1791 (fig. 1.9) or allowing an electric eel to stun its prey twice daily at feeding time for the amusement of the spectators at the Adelaide Gallery in London in the 1830s, galvanism was an important part of a culture of display, a popular wonder that drew a crowd, if not as large a crowd as attended public executions.[59]

And yet, as Craig Brandon argues, "Most laypeople, even at the turn of the [twentieth] century, did not have the slightest idea what electricity was, how it was produced or what made it perform its miracles. All they knew for sure was that it was the power of the lightning bolt, the very weapon of Zeus and Thor, that had somehow been harnessed by brilliant scientists like Edison."[60]

Almost a century before the first electrocution, physicians discovered that the appearance of death was a far from reliable indicator of someone's corporeal demise, and even today, determining death from the cessation of pulse and respiration can be difficult, since they are not unequivocal signs of morbidity; indeed, creatures that appear dead can be revived if air is forced into their lungs, as was the case when a suffocated dog was revived in 1755 and a drowned man shocked back to life with electricity in 1775.[61] Italian scientist

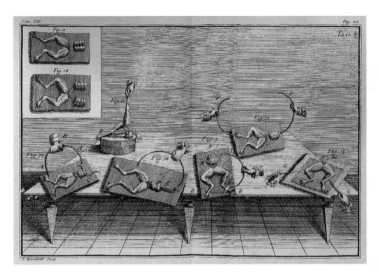

Fig. 1.9 Experiment with frog legs by Luigi Galvani from *De viribus electricitatis . . . in motu musculari commentaries* (1791). Wikimedia Commons, http://commons.wikimedia.org/wiki/File:Esperimenti_con _rane_-_Galvani.jpg

Giovanni Aldini, nephew of physicist and philosopher Galvani, conducted experiments to test the effectiveness of electricity as a method of resuscitation following asphyxiation, and in 1803 he procured the body of a freshly executed criminal to further his research: "When the poles were touched to the jaw and ear, the face quivered and the left eye opened, while a shock from the ear to rectum produced a reaction so strong as 'almost to give an appearance of reanimation'"[62] (fig. 1.10).

This attempt to bring back the dead, satirized in this cartoon from 1836 showing Francis Blair rising from the dead (fig. 1.11), is a devilish reversal of the path of electrocution, which permanently rids society of the criminal as opposed to bringing one back to life (the question of what Galvani would have done with his revivified criminal is unanswered).

Rumors abounded, too, that doctors in the rooms adjoining the death chamber were eager to experiment with electricity to see if an electrocuted man could be brought back to life. And anxiety about whether a person's heart might suddenly start beating again following an electrocution led some to speculate that the reason that autopsies were done immediately following electrocutions (death row inmates complained about the sound of the saw) was to prevent this feared phenomenon.

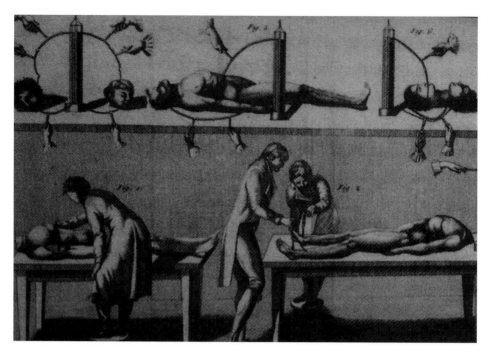

Fig. 1.10 Doctors conducting experiments on newly executed criminals. Illustration from galvanism essay by Giovanni Aldini (1762–1834). Wikimedia Commons, http://commons .wikimedia.org/wiki/File:Experiments_with_cadavers_and_severed_heads_Essai_th_orique _et_exp_rimental_sur_le_galvanisme_1804.jpg

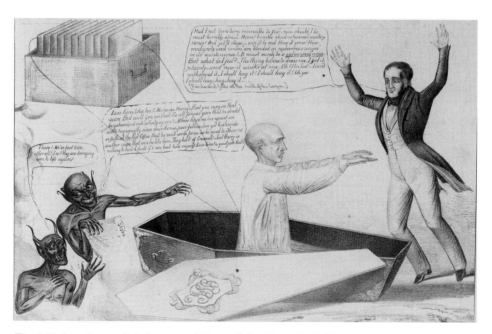

Fig. 1.11 American political cartoon lithograph by Henry R. Robinson showing Jacksonian newspaper editor Francis Blair rising from a coffin following a shock from a galvanic battery. Courtesy Library of Congress, Prints and Photographic Division. Wikimedia Commons, http://commons.wikimedia.org/wiki/File:A_Galvanised_Corpse.jpg

Electrocution was not the first way electricity had been associated with criminals in popular culture. Mary Shelley drew inspiration from galvanism in her 1818 novel, *Frankenstein; or, the Modern Prometheus*, in which a monster is constructed from remains looted from charnel houses—in the words of Victor Frankenstein, "the dissecting room and slaughter house furnished many of my materials."[63] Galvanic resurrection is important to our understanding of electrocution, for it reminds us of electricity's long-standing association with restoring life as well as permanently extinguishing it, a dualism vividly illustrated in Shelley's gothic novel. In James Whale's 1932 film, *Bride of Frankenstein*, when Henry Frankenstein utters the words "But this isn't science, it's more like black magic," and when the monster, later in the film, says, "I love dead. Hate living," we are vividly reminded of the neo-Satanic undercurrent in all things galvanistic. If electricity could bring bodies back to life, it was natural to question how efficient it would be as a state-sanctioned method of execution, and when we place this in the context of a late nineteenth-century fear about being buried alive, public (and professional) concerns about the reliability of electricity as a method of capital punishment were not without justification.[64]

Showmen used electricity to heighten the drama of and audience participation in shows, sometimes quite literally, as in Johann Samuel Halle's 1784 necromancy show, which gave the audience mild electric shocks from "wires hidden under the floor and connected to an electrical machine."[65] Halle housed his modified magic lantern in a wooden box resembling a coffin. The idea was playfully evoked in an 1883 *Electrical World* essay entitled "Electrical Marionettes," in which it was suggested that electrodes fastened to the arms of chairs in an auditorium could galvanize the audience by shocking people's funny bones so that when an actor told a joke, "the audience could thus be made not only to . . . [get] it, but to explode in simultaneous cachinnation."[66] Fast-forward to 1959, and we see a similar technique employed during Hollywood cinema's product differentiation era (think widescreen and Smell-O-Vision). The movie *The Tingler* (William Castle) employed a system called Percepto, in which every seat was wired with an electric buzzer that would cause the spectator to "tingle" under the ruse that the projector had suddenly broken and the monster was loose in the auditorium. Vincent Price addressed the audience from the darkened screen.[67]

Christoph Asendorf argues that part of the fascination with electricity arose out of the "closely related analogy to erotic attraction (or repulsion),

characterized as tension between the sexes."[68] Electra, a carnival performer and modern incarnation of eighteenth-century experiments conducted by the German physicist Georg Bose, who with his "electrica attractio" charged pretty women wearing insulated shoes with electricity, literally embodied this tension: "The cavaliers from whom they demanded a kiss received a strong electric shock."[69] *Carnival*, derived from the Latin *carnem levare*, means the "putting away or removal of flesh," an apt descriptor of the gruesome work of the electric chair in the prison, and, for author Raymond Bradbury, signifying "the madness of life itself, as well as death, which looms large in the metaphor of the carnival."[70] A carnival-like atmosphere prevailed outside Sing Sing Prison on execution day (electrocutions began at the prison in 1891), a throwback to the scaffold dance and 1890s European fairground culture, which, as Vanessa Toulmin argues, "has a long history of embracing new forms of technological innovations or innovations in exhibiting practices" and presented a wide range of new attractions, including "steam-powered roundabouts in 1861, ghost shows in the 1870s, and X-ray photography and the cinematograph in 1896."[71]

Sing Sing had long been a major tourist attraction, with virtually an open-door policy in the late nineteenth century; for example, from May to December 1899, more than 5,100 people visited the prison, one prisoner noting that "visitors galore pass through its various departments daily."[72] Sing Sing warden Thomas Mott Osborne permitted 250 celebrity tourists to traipse through the prison on a single day in 1914, including the evangelist Billy Sunday, bare-knuckle fighter John L. Sullivan, and presidential candidate Jennings Bryan, and under Lewis E. Lawes's wardenship at Sing Sing in the early 1920s, as many as 3,000 visited in a single year.[73] It is not clear whether their tour included the death house, but one would be surprised if it did not. An archivist at the Ossining Historical Society told me that he still gets letters from individuals asking to "borrow" the electric chair; the original Sing Sing chair is housed in an upstate correctional facility and may or may not be displayed at the proposed, but stalled for fiscal reasons, Museum of Sing Sing in Ossining.

Although there was nothing to see outside Sing Sing Prison's walls on execution day, being in close proximity offered a vicarious pleasure, akin perhaps to the experience of standing outside a freak show or ghost train at the traveling fair and getting shivers without ever stepping inside. On days with multiple executions, Sing Sing Prison officials devised a color-coded system

of flags for the assembled press and onlookers to signal when each man had died in the electric chair (a black flag was hung outside Swansea Prison in the United Kingdom immediately after a hanging). And for those not legally mandated to witness the execution or events preceding it newspapers filled in the missing information, covering the trial, conviction, and execution in a sensational manner.[74] Lawes, along with the Westchester County Committee for the Removal of Sing Sing Prison, explicitly recognized the carnivalesque in electrocution and began campaigning in the 1920s for the "removal of the electric chair and the horrors attached to it."[75]

Electrocutions in prisons were initially huge news, even more so when the criminal was a celebrity like Czolgosz. The day of Czolgosz's execution, Edwin S. Porter and James White tried to gain entry to Auburn Prison near Buffalo but were denied access and had to settle for footage of the prison façade (fig. 1.12), which, Kristen Whissel argues, aligns "audiences with a point of view similar to the one available to the tourists who arrived at the prison on the railway line visible within the frame."[76] Given that Auburn Prison ranked second to Niagara Falls as a tourist attraction in the nineteenth century, the

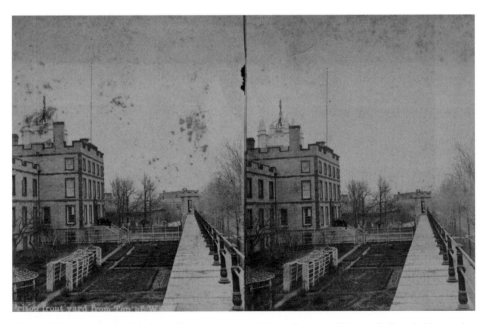

Fig. 1.12 Stereograph of Auburn Prison front yard from the top of the wall, Trowbridge and Jennings, 1865. Wikimedia Commons, http://commons.wikimedia.org/wiki/File:Prison_front _yard_from_top_of_wall,_by_Trowbridge_%26_Jennings.jpg

opening thirty-five-second panorama of the prison that gradually reveals more of the penitentiary, including the unmistakable castle-like façade of the administrative building, would have been recognizable for American audiences.[77]

Even the cut to a second, more portentous high-angle pan of the prison draws us in closer to the events that are about to be re-created. The dissolve from the prison building to its interior is significant, not only linking, as Musser argues, "outside and inside, but actuality and reenactment, description and narrative, a moving and static camera."[78] There was something phantasmagoric about the prison building itself, Osborne comparing its effect to that of a vague unease that stole upon him, almost as if the "sorrows of the thousands who [had] lived beneath the dome had left their traces upon its walls."[79] Prison has long been home to things ghostly and supernatural, in no small measure due to its lineage in the Gothic imaginary.

Czolgosz and the Phantasmagoria

Another way of making sense of *The Execution of Czolgosz*'s roots in popular entertainment is to consider its relationship to the Phantasmagoria (fig. 1.13).

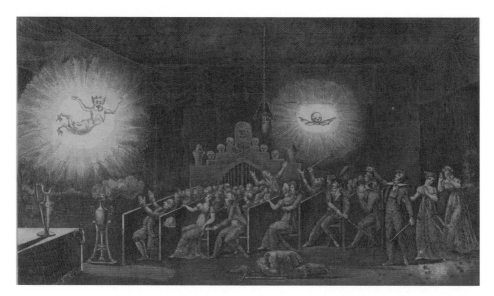

Fig. 1.13 Etienne Gaspard Robertson's Phantasmagoria in an old Capuchin chapel in rue des Champs, Cours des Capucines, France, 1797. Wikimedia Commons, http://upload.wikimedia .org/wikipedia/commons/4/48/1797_Robertson_phantasmagoria_CapuchineChapel _RueDesChamps_Paris.png

The Phantasmagoria gave audiences the scary sensation of being present with the dead—something actually experienced by witnesses of electrocution, if only until they were required to exit the execution chamber—through the appearance of ghostly apparitions that were sometimes projected onto a curtain of smoke rather than a traditional textile screen, providing an overall effect of bloodcurdling necromancy; as Tom Gunning argues, "It exploited associations between projected images and specters of the dead—linkages that seem to have existed since the origin of lantern projections."[80] American horror of the 1950s took a leaf out of the Phantasmagoria's book of spine-chilling effects and used exploitation gimmicks such as the "Emergo 'process,'" which consisted of little more than a twelve-foot skeleton flying over the audience on a wire. *Thirteen Ghosts* (William Castle, 1960) similarly paid homage to the Phantasmagoria through use of a 3-D glasses spin-off technology known as "Illusion-O," which enabled audiences wearing special glasses to see infrared ghostly superimpositions.[81]

Terry Castle's characterization of the Phantasmagoria as trenchantly ambiguous, mediating "oddly between rational and irrational imperatives [and carrying] powerful atavistic associations with magic and the supernatural," seems an equally apt description of *The Execution of Czolgosz*.[82] More intriguingly, Castle's analysis of how the Phantasmagoria's semantic grounding in the occult has shifted over time, from, in her words, "something external and public . . . to something wholly internal or subjective: the phantasmatic imagery of the mind," raises the question of whether those few witnesses of an actual electrocution and even those who watched *Czolgosz* with living memory of Kemmler's electrocution experienced something akin to a Phantasmagoria of the mind in the days, weeks, and months following an execution.[83] And lest we forget, inmates through the ages have evoked the Phantasmagoria to explain the mind-body transmogrification of solitary confinement; even celebrated prison warden and reformer Osborne found himself slipping into a "world of phantasmagoria and being engulfed in an ocean of chaotic sights and sounds."[84]

Our first encounter with the prison at the beginning of *The Execution of Czolgosz* has something of a phantasmagorical feel, as a fast-moving train comes between the camera and the prison and thwarts our ability to see the penitentiary (the empty passenger car directly in front of the prison had delivered the viewing party to Auburn, a nod to the film spectator's status as vicarious witness of this reconstructed electrocution). The prison exterior is

eerily void of life and yet we know that what is about to go on inside the building involves the taking of life in a thoroughly macabre fashion. For Auburn's inmates, the train was a powerful auditory sign, a way of telling the time of day and a reminder that just across the street was a fast, if unreachable, way out of the prison, the Auburn railway station. For the film's spectators, Auburn Prison could be mistaken for a factory, another industrial complex that regulated and disciplined working-class and immigrant bodies, and the prison's status as a tourist attraction gave the train another layer of signification.

Following the film's two opening pans, our first glimpse inside Auburn Prison reveals Czolgosz standing with both arms against the bars of his cell door and an expanse of large-brick wall occupying the rest of the frame. This is among the earliest cinematic images of a penitentiary, albeit a reconstructed one, and it is ironic that it is an image of a man with minutes left to live. As the four guards approach the cell, Czolgosz steps out of the way, disappearing into the darkness for a few seconds before being retrieved by a guard and marched across the frame. Following another dissolve into the death chamber, the same set but now with white tile halfway up the wall, Czolgosz is solemnly led to the electric chair and quickly strapped in (his lower right leg is bared so that electrodes can be applied). The Edison catalog described the rest of the film as follows: "The current is turned on at a signal from the Warden and the assassin heaves heavily *as though the straps would break*. He drops prone after the current is turned off."[85] Edison knew that the movement of Czolgosz's body when the current was applied would serve as the film's denouement, and this reference to the electrocuted body breaking its bonds not only introduces narrative suspense when none is needed, but underscores the association of electricity with monstrous power—or, rather, the body becoming monstrous. Promotional hyperbole notwithstanding, the copy about the straining body against the leather straps was no exaggeration, since we find an almost identical description of electrocution's effects on the body in an account of attending an electrocution written by Sing Sing warden Lawes:

> The body of what a moment ago was a living human being *leaps forward as if to break its bonds*. A thin, wisp of smoke curls slowly up from under the head and there is a faint odor of burning flesh. The hands turn red, then white, and the cords of the neck stand out like steel bands. . . . The drone increases in vol-

ume, the body is still straining at the straps. The hands grip the arms of the chair in an ever-tightening grasp. The raucous droning continues. Now there is a general subsidence and the body relaxes. One of the men, apparently a physician, approaches the inert body, applies his stethoscope, shakes his head, and steps back. The droning is heard again and simultaneously the body assumes rigidity . . . and tries to burst its bonds. Again a subsidence, another examination. . . . A voice is heard . . . "warden, I pronounce this man dead."[86]

The forward and backward movement of the prisoner's body as the current is applied has a corollary in the Phantasmagoria, a sensation Gunning calls a "contradictory sense of emergence from the screen toward the viewer that is evoked and then disavowed."[87] There are also galvanistic echoes in Lawes's multisensory description of the leaping, straining, and gripping body in this unidentified electrocution. Verbs such as "leap" and "burst" assign agency to the condemned, as his body's involuntary movements are interpreted as an attempt to escape. Despite being strapped into the chair, the body of the condemned moves, sometimes quite violently (the "unseemly struggles and contortions" of executions were indeed noted by the Medico-Legal Society), pitching forward toward the spectator and up and down in the chair as the current was raised and lowered.[88] The movement was often far more dramatic than that seen in *The Execution of Czolgosz*; for example, in 1893, the action of a man's legs contracting during his electrocution at Auburn Prison was so violent that the front legs of the electric chair ripped from the ground, propelling him face forward into the audience.

Death also created unique sounds in the prison, including the sputtering drone from the turbine powering the electric chair (especially audible to inmates in solitary confinement at Auburn Prison), and the condemned man's body pushing against the restraining leather straps during an execution was followed within hours, after the body had cooled down, by the shriek of drills and saws, signaling the start of the autopsy of the executed inmate in an adjoining room—referred to as the "Ice House" by inmates.[89] The freak show performer provides another frame of reference, where discourses of otherness, liminality, and a breakdown of binary oppositions governing part versus whole, animal versus human, and shock versus pity evoke complex spectatorial responses. The nomenclature surrounding the electric chair, referred to as "Big Yellow Mama" in Alabama, "Old Sparky" in Texas and Florida, and more generically as the "hot squat," strengthens not only the lingering

sideshow[90] ethos of the electric chair but its uniquely American identity.[91] Movement, sound, repetition, and electrocution's grisly impact on the hands, neck, and head of the body must have made the pronouncement of death a moment of release for those suffering through witnessing.

Even more troubling than the visual and aural experience of electrocution was its olfactory effect (New York State executioner Elliot would routinely switch on a ventilating fan at the end of every electrocution to rid the room of smoke and odor).[92] Traditionally relegated to a lower position on the sensory hierarchy, smell was nonetheless considered by Italian Dominican philosopher and theologian Thomas Aquinas to be a spiritual and instructive sense, serving in spiritual people to differentiate good from evil and, in the words of olfaction scholar Susan Ashbrook Harvey, "acutely effective in conveying divine presence or absence, demonic activity, or moral condition."[93] The experience of electrocution as smell, a sense often associated with the act of discernment since smells are often invisible, makes it that much more disagreeable and serves as a metonym for both the prison, often a site of bad smells, and decomposition.[94] And whereas prior to the nineteenth century newspapers provided only terse accounts of executions because they were open to the public, once hangings were restricted, penny press newspaper editors stepped in, printing descriptions of hanging victims' bodies convulsing, twitching, defecating, and urinating; faces turning purple; and throats gurgling.

Electrocution always threatens to be more than the senses can bear, transforming the freakish occurrence of being struck by lightning into a perverse inversion of nature's mysterious energy force. In the Phantasmagoria and early twentieth-century electrocution, technology was doing the devil's or, in the case of electrocution, the state's work. Despite concerted efforts at the actual electrocution to "minimize the opportunity for notoriety or sensationalism on the part of the prisoner as well to insure that *his taking off* should be effected in an orderly and dignified manner," execution is by definition a sensational and traumatic event to behold, something disavowed in the *Philadelphia Medical Journal*'s reference to Czolgosz's "taking off," as if he were leaving a dinner party early rather than being killed. If advocates for electrocution were looking for a nonspectacular substitute for hanging (a key factor in New York State's rationale for selecting electricity over more reliable, though messier, methods such as a firing squad or guillotine), they were unsuccessful in their choice of electricity.[95] The ceremony surrounding executions thus served as an act of self-validation, providing a veneer of dignity

for an event that was otherwise inglorious. The attending rituals had all the trappings of high drama: sets; protagonists and antagonists; ensemble players including doctors, legally appointed officials, guards, and witnesses; a dramatic buildup and a predictable narrative arc; last-word monologues; and finally, the long-awaited (or dreaded) denouement that, depending on a technical hitch or miscalculation, may or may not go according to plan.[96]

Harry Houdini, *Picture Snatcher*, and *The Green Mile*: The Electric Chair on Screen

> I am ready to ride that thunderbolt boys.
> Sing Sing Inmate No. 77681 before being electrocuted[97]

In 1910, Harry Houdini paid $6.70 to Hubert's Museum in New York City to acquire the electric chair used to execute William Kemmler.[98] Citing "sentimental reasons" and plans to use the electric chair in his stage show, Houdini kept the chair in his home, and according to biographer Harold Kellock, "his wife was never able to get this gruesome and unlovely relic out of the house. Whenever she had it quietly removed to the cellar, Houdini missed it and had it brought upstairs again."[99] Houdini used an electric chair (most likely the one he owned) in the cliffhanger ending of episode seven of the fifteen-episode *Master Mystery* serial (1919) (fig. 1.14), where in the role of Department of Justice undercover agent Quentin Locke, he must escape before the current is turned on and before he is attacked by a giant robot, the mysterious Automaton Q.[100]

The last-minute escape from the electric chair is unremarkable, and the image of Houdini struggling to free himself from the restraining straps is a far cry from the more typical cinematic image of the stoic death row inmate. The straps do not look especially tight, Houdini does not wear the leather mask, and on a scale of difficulty, it has none of the tension of Houdini's famous underwater or aerial stunts. The economic benefits of staging an escape within a fictional narrative—shot on a sound stage, Houdini is not in any real danger—rather than an elaborate location stunt where if something goes wrong the magician might die, lessens the corporeal impact of both the chair and Houdini's escape.[101]

Perceived, as Kellock argues, as a "symbol of elusiveness and illusion," Houdini's escapology, even as represented in this *Master Mystery* episode, was

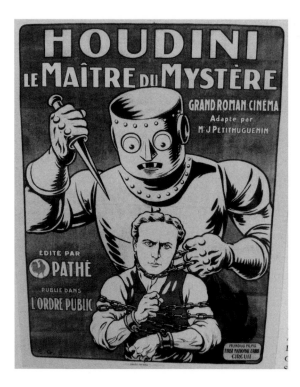

Fig. 1.14 Pathé poster for
The Master Mystery series starring
Houdini, 1919.

nonetheless contained by a discourse of exceptionalism, which lessened any actual threat he might have posed to systems of incarceration. The verb *to Houdinize*, which was first included in the *New Standard Dictionary* in 1920, riffing off the more street version of "doing a Houdini," points to the slippage between the man and his act; in other words, to become like Houdini is to perform an act of escape.[102] This blurring of the fiction of Houdini's prison escapes—he was never imprisoned by law and was always a free man—and the fact of his walking into these institutions and doing what no other man could do is visible, as Matthew Solomon argues, in Houdini's refusal to make a "clear distinction between fiction and nonfiction in both his act and the discourse surrounding his fiction films of the 1910s and 1920s."[103]

Houdini's talent and the electric chair's terror are neutralized by cinema, and even though Houdini reached a far larger audience via the globally distributed films (and escaped the grind of live stunts and the stage), the melodramatic demands of the serial overshadowed the prowess of the stunts (which were often the result of cinematic effects). Also, just like cinema, the

electric chair was bound up in complex ways with issues of race, national identity, and Americanism. Not only were African Americans disproportionately put to death compared to whites, but the foreign born were also more likely to receive the death sentence.[104] As the quintessentially assimilated body (Houdini exemplified the American Dream), Houdini threw into sharp relief notions of the good versus bad Eastern European immigrant and how the electric chair, as a modern solution to the "barbarity" of hanging, would expurgate from the social body those who transgressed. The fact that the electric chair can be added to the list of both spectacular and more prosaic objects from which Houdini escapes is testimony to electrocution's more settled place within the American imaginary by the late 1910s. Houdini's escape from an electric chair is thus not only a testament to the ubiquity of the electric chair as a potent icon in the early twentieth-century American imaginary, but also a fascinating reversal of the narrative of *The Execution of Czolgosz.*

Houdini's career was irrevocably shaped by prison; as an immigrant outsider, he identified with prisoners, also becoming close friends with Lawes (Houdini's widow, Beatrice, donated thirty books from Houdini's library to Lawes after her husband's death), and on Christmas Eve 1924, he performed at the prison, escaping from a hangman's noose and from a packing case that convicts had nailed him into.[105] As a finale, he "produced personal spirit messages from notorious departed inmates at Sing Sing and from Ben Franklin and performed diverse 'spirit' manifestations."[106] Audiences went wild when Houdini unmoored the semantic fixity of other methods of incarceration such as handcuffs and straitjackets; escaping from objects of oppression was a snub to the authorities even if they, too, were cooperative agents who were never overly concerned about Houdini inspiring a legion of prison breakers. As Fred Nadis argues, "In identifying himself with lock pickers, jail breakers, and other thieves, Houdini took on the aura of the heroic antihero appropriate to the age of the muckrakers."[107]

Presenting his own body as a "natural spectacle," Houdini performed in a bathing suit, loincloth, or, in prison escapes and private demonstrations, nude.[108] A story about his escape from the infamous Bridewell Prison in the United Kingdom in 1904 takes the idea of him being the prisoner from hell almost literally by including an account of a prisoner who suddenly encountered him naked and thought he was the devil (fig. 1.15):

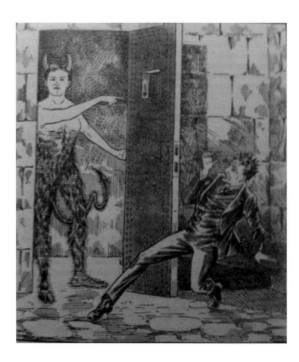

Fig. 1.15 Houdini as "prisoner from hell," cartoon, 1904. Rare Book and Special Collections Division, Library of Congress

> Running along the corridor, he opened the doors of other cells, which he had thought were all empty. When he reached No. 14 and flung open the door, he confronted a prisoner. "I don't know which one of us was more surprised," said Houdini to an *Express* representative. "Here I was, standing absolutely nude before a terrified miserable object. Poor fellow! What shock it was for him. He was an Irishman just recovering from a drunken bout. 'Arrah!' he said, when he recovered; 'I though it was the devil.'"[109]

The image of the prisoner mistaking Houdini for the devil taps into the long-standing trope of incarceration as an earthly purgation, a metaphor that medievalist Gerhard Geltner argues can be traced to the late medieval period and that was made famous by Samuel Coleridge in his poem "The Devil's Thoughts."[110] Houdini not only gets mistaken for a supernatural being but also in so doing creates near anarchy. Neither a prisoner nor a guard, Houdini cavorts around the institution like a devilish imp, a trickster who can usurp the rule of the law but always in the name of fun. Yet again, we find traces of the Phantasmagoria.

The legacy of the electric chair in *The Execution of Czolgosz* and *The Master Mystery* has survived in two distinct tendencies in twentieth-century cinema. In the version indebted to *Czolgosz* (though disavowing that film's

relentless frontality), the pre-Code (era prior to strict censorship guidelines of the 1934 Motion Picture Production Code) film *Picture Snatcher* (Lloyd Bacon), from 1933, reenacts the death of convicted murderess Ruth Snyder, known in the press at the time as "Ruthless Ruth," who plotted to kill her husband with her lover, Henry Judd Gray, after she had persuaded him to take out a life insurance policy (her crime was the inspiration for James M. Cain's novel *Double Indemnity*, which was brought to the screen by Billy Wilder in 1944). Cameras had been successfully kept out of the death chamber until the infamous execution of Ruth Snyder on January 12, 1928 (a woman had not been executed at the prison since 1899), when *Chicago Tribune* photographer Tom Howard was hired by the *New York Daily News* and finagled a way to join other journalists in the death chamber and take a photograph with a hidden camera.[111] Seated in the front row of witnesses with a miniature camera strapped to his left ankle and a shutter release concealed in his jacket pocket, Howard lifted up his pant leg and secretly took a photograph of Snyder in the throes of electrocution.[112] Snyder's straining body appeared on the front page of the *New York Daily News* under the headline "DEAD!"

James Cagney plays the fast-talking, sardonic ex-con Danny Kean in *Picture Snatcher* (fig. 1.16), a stereotype of the ruthless journalist that Hollywood milked for its box-office appeal to working-class and immigrant audiences.[113] Egged on by his editor's plea that he would "give a thousand dollars and my right eye for a flash of that woman in the chair," Cagney persuades Sing Sing Prison guard Captain Pat Nolan to grant him access and take the heat if anything goes wrong, and he joins a half dozen or so other press men and witnesses in the death chamber.

Our experience of electrocution in *Picture Snatcher* is mediated entirely by the journalists, some of whom are dreading the prospect of watching an electrocution: "I'd rather take a beating than do this," says one; others appear nonchalant: "These things don't phase me at all." By denying the audience a visual representation of the electric chair and the condemned woman, the director, Lloyd Bacon, re-creates the brutality of electrocution through a set that is a facsimile of Sing Sing's actual death chamber and the reaction shots of the journalists (fig. 1.17).

The image of the witnesses slowly entering the room and removing their hats as if they are entering a place of worship, followed by a pan of their faces as the camera moves slowly down the pews to the front row where Cagney is seated, foreshadows exactly how we are going to experience electrocution

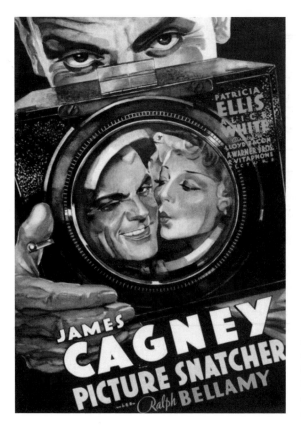

Fig. 1.16 Poster for *Picture Snatcher* (Lloyd Bacon, 1933) starring James Cagney. Wikimedia Commons, http://upload.wikimedia .org/wikipedia/en/a/a2/Picture _Snatcher_FilmPoster.jpeg

(one of the men vomits shortly after taking his seat). Following a quick cut-away to Captain Nolan declaring that he is going to "sit this one out," we cut back to a medium-long shot of the death chamber and a prison officer walking over to pull the lever. Refusing to show us the chair, let alone the condemned, the point of view never waivers; we see neither a reverse angle from the perspective of the female convict nor a journalist point-of-view shot. Staying at an oblique angle to the witnesses, the intensity of the scene is heightened by the auditory intrusion of footsteps and heavy chains, a sound occurring over close-ups of Cagney's hand on the shutter cord and his pant leg lifting slowly up to expose the camera. It is to the embodied reactions of the journalists, however, who seem to undergo a collective shudder as their bodies mirror the contortions of the executed, that we return for the final shot of the scene.

This has been a harrowing experience even for journalists who have seen it all before. One cannot, it seems, become inured to the horrors of witness-

Fig. 1.17 Sing Sing's death chamber and electric chair. Witnesses sat in pews. Ossining Historical Society

ing an electrocution, especially when a woman ends up in the chair. Once safely back at the newspaper, Cagney's verbal description of what he saw in the death chamber does not jibe with our memory of his physical appearance at the prison; speaking in rapid-fire street slang, Cagney fills in the missing visuals like a braggadocio: "There it was, right under my nose, the hot seat. They pop her into the chair, put a hood over her head, and strap her in. One guy gives the offee [*sic*], the other one throws in the works, and the dame fries." In most respects, the representation of electrocution in *Picture Snatcher* is nothing like that in *The Execution of Czolgosz*; in the former, reaction shots carry the burden of representation, the spectator's imagination forced to fill in the missing visuals, our gaze that of a witness, a disembodied, omniscient presence. Michael Moore chose a similar strategy when representing the carnage of 9/11 in his documentary *Fahrenheit 9/11*, opting for a blank screen and audio of the impact before cutting to slow-motion reaction shots of people crying and staring in total disbelief at the horror of what is unfolding around

them. Moore never shows the planes hitting the Twin Towers, only debris falling from the sky, which takes on a tragic beauty since it resembles a winter snowfall or spring cherry blossoms floating to the ground.

The second tendency in the representation of electrocution on film is more indebted to electricity's use in the wonder show and Houdini's melodramatic imagining of the electric chair and can be found in films such as *The Green Mile* (1999), an adaptation of Stephen King's serialized novel of the same name. The film fits squarely within the prison film genre, which for over a century of cinema has entertained audiences with stories of escape, inmate culture, wrongful convictions, reform, religious conversion, and capital punishment. *The Green Mile*'s representation of race, incarceration, and death row in the fictitious Louisiana Cold Mountain State Penitentiary in 1935 divided critics, and many scholarly readings coalesced around its problematic representation of blackness, hypermasculinity, and a white supremacist imagination.[114] Tania Modleski accused the film of constructing "offensive racial stereotypes," while Linda Williams situated it in the "mainstream of the negrophilic Tom tradition," stretching our credulity of white beneficence in the Jim Crow South; ethnic and minority press reviews read the film as a "counter-memory of past race and ethnic oppression."[115]

Pivotal to the narrative, if not the main character, is John Coffey, a seven-foot-tall African American man who has been wrongfully imprisoned for the death of a young girl and who is discovered to have supernatural powers of healing. Meek, infantilized, and echoing the traditional Uncle Tom figure, Coffey is an example of what Christopher John Farley calls MAAFs (Magical African American Friends), a symptom of Hollywood screenwriters' ignorance of the experience of blackness.[116] Set during the peak of executions in the United States, *The Green Mile*'s representation of three electrocutions, each one of which is very difficult to watch, even within the psychic safety of a fictional story, can hardly be accused of exaggerating the frequency and relative normalcy of electrocution, especially in the Deep South. The film is essentially one long flashback by former chief prison guard Paul Edgecomb (played by Tom Hanks), who narrates the story from a retirement home set in the present. Constructed as a "memory project" by the film's protagonist, the film was also viewed through the lens of slavery, with some reviewers arguing that Coffey could be seen as a "historically authentic representation of black experience during Jim Crow," especially those wrongly convicted of murder and lacking adequate legal representation.[117]

What makes *The Green Mile* especially interesting for our purposes is that cinema and electrocution are conjoined in reflexive, somewhat surreal ways in this film. On the eve of Coffey's execution, when asked by Edgecomb if there is anything he would like, Coffey replies, "Ain't never seen me a flicker show." The close-up of Coffey's face cuts immediately to a shot of the back of his head as he watches Fred Astaire and Ginger Rogers singing "Heaven, I'm in Heaven" from the "Cheek to Cheek" sequence in Mark Sandrich's 1935 *Top Hat* (fig. 1.18).

The death chamber has been transformed into an improvised motion picture theater, the screen set up in the location usually reserved for the electric chair (fig. 1.19). Coffey, in a reverse angle of where he will sit during his execution, takes a seat in the area reserved for witnesses. The projector beam not only backlights Coffey but shores up his mystical, "Suffering Servant" identity and foreshadows the "negative sublimity of the Passion" when he is electrocuted the following day (his initials, J. C., support this idea)[118] (fig. 1.20).

The image of the inmate temporarily released from the psychic burden of incarceration also refers to the sequence in Preston Sturges's *Sullivan's Travels* (1941) in which prisoners watch a film in a Southern black church. And given that cinema and electrocution coexisted in prisons in spaces that looked

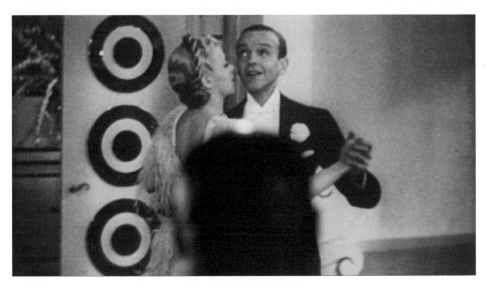

Fig. 1.18 Frame enlargement from *The Green Mile* (Frank Darabont, 1999) in which inmate John Coffey watches the film *Top Hat* in the prison's death chamber.

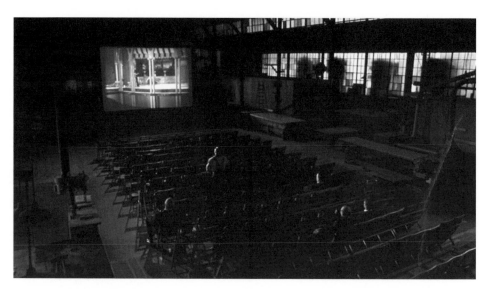

Fig. 1.19 Frame enlargement from *The Green Mile* (Frank Darabont, 1999) showing the death chamber transformed into a movie theater.

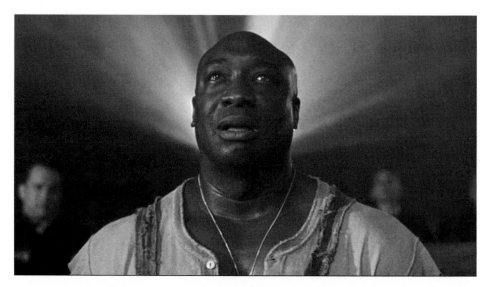

Fig. 1.20 Frame enlargement from *The Green Mile* (Frank Darabont, 1999) showing Coffey transformed into a messianic figure by the backlit beam of the film projector.

strangely similar (spectators sat on pews facing the front of a room in both the chapel, which doubled as the place where most prisoners first watched films, and the death chamber at Sing Sing), they circled around similar ideas of the uncanny, liminality, and the grotesque.

The use of media by death row inmates predates cinema and can be seen in the employment of phonograph records to calm inmates' nerves as they counted down the hours to their electrocution, thus the informal naming of the death house as the "Dance Hall."[119] The sudden silencing of the music in the death house was an ominous sign, a signal that the end was indeed nigh for the convicted prisoner seated in the electric chair behind the little green door.[120] The night before Jacob Oppenheimer, called the "Human Tiger" by the press, was executed at Folsom Prison in California, he requested that the song "Somebody Else Is Getting It, Right Where the Chicken Got the Axe" be played continuously for two hours on the prison phonograph.[121] And at Sing Sing in the 1920s, motion pictures were shown to twenty-three inmates on death row, a sheet doubling as a screen hung down one side of the cells (a repeat screening was offered to the men on the other side).[122] According to Ralph Blumenthal, Hollywood actor, Thomas Meighan donated the screen, and the men were shown two comedies, one of which was an unreleased Buster Keaton feature. Lawes said the screening was planned to take the death row inmates' minds off an upcoming execution.[123]

Coffey's execution takes place during an electrical storm, which suggests both nature's wrath at the killing of an innocent who has supernatural powers of healing and also the ungodliness of electrocution, which in this scene is near apocalyptic.[124] Devices sanctioned and, in the case of motion pictures, invented by Edison are aligned in *The Green Mile*, reminding us of electrocution's and cinema's histories in the traveling showman's arsenal of popular gimmicks. Indeed, as peripatetic devices, early cinema and electric chairs could become mobile deliverers of spectacle. Mississippi's newly adopted electric chair in the early 1940s was "trundled from county to county on the back of a truck," and, in miniaturized form, the electric chair was a macabre toy, which, in the case of the three-inch version owned by John Blackburn, former warden of Louisiana's Angola Prison, delivered a small electric shock whenever it was touched.[125] Like Blackburn, who would roar with laughter when an unsuspecting visitor received a shock, Edison also saw humor in electricity's ability to surprise, using it to play pranks with an induction coil in his days as a peripatetic telegrapher. And when Edison entertained the idea

of opening a "Scientific Toy Company," one of the devices he hoped to sell was a "Magneto-elec-Shocking-Machine" that, like the electric chair, would shock those who had the misfortune to come into contact with it.[126]

The disciplinary function of electricity did not originate with the electric chair. Ohio State Penitentiary began using powerful jolts from an induction coil to punish inmates in 1878, applying electrodes to the skin of the convict that made him "yell sometimes, *as if he were* badly hurt," according to the *New York Sun*.[127] The fact that the induction coil could deliver a punishment in an expedited fashion created a logic for electrocution, which, as Edison wrote, was "a good idea" because it would be so "lightning quick that the criminal can't suffer much."[128] And the qualifier "as if he were badly hurt" suggests a "bark that is louder than its bite" attitude toward inmate pain from the electric shock.[129] Although timid in comparison to how electricity's power would be harnessed in electrocution, the idea of using electricity to discipline prisoners, including with the "Tucker telephone," which sent shocks through an inmate's genitals, led to the development of electroshock weapon technology (popularly known as the Taser), an incapacitating weapon that interferes with superficial muscle function and causes a terrifying shock and frequently pain in those subjected to it.[130]

Accommodating Electrocution: Concluding Thoughts

> If a fellow shoots straight, we send him to the chair. If he shoots and hits the shoulder, he gets five years, and then we let him go home and practice up on his marksmanship.
> Lewis E. Lawes, 1931[131]

Despite garnering significant publicity for the prison, Sing Sing's annual theatrical show, put on entirely by members of the prisoners' Mutual Welfare League, was always trumped by the attention associated with a scheduled electrocution, which brought the media out in droves and provided a different kind of "wonder show" for an assembled audience of state-mandated witnesses and journalists. When it came to scheduling, however, the theatrical show took precedence over an electrocution, as evidenced by the two-hour delay of the execution of Peter A. Seiler and George Ricci in December 1927 to accommodate the revival of Gershwin's 1924 hit *Sweet Little Devil*[132] and the postponement of the December 1932 execution of Charles Markowitz and Joseph Brown from the traditional Thursday night slot to 12:30 A.M. Saturday, immediately following the final performance of Sing Sing's annual re-

view.[133] The show was pivotal in projecting an image of reform at work, in which convicted men showed off their artistic skills and raised money for the Mutual Welfare League benevolence fund. Electrocution, however, closed down the possibility of reform, and for this reason was always bracketed off from the penitentiary's potential as a regenerative force.

By the time electricity had been fully integrated into American homes in the 1920s (albeit with approximately one thousand deaths from electric shock annually), picture palaces dominated big-city filmgoing and cinema had won the respectability battle.[134] One thousand or so electrocutions were carried out annually in the United States in the 1920s.[135] Electrocution using alternating current was the industry standard around the country from 1890 until the 1980s, when it was largely replaced by lethal injection.[136] The public outcry following Kemmler's execution was by then a distant memory. And perhaps many had forgotten just how pivotal a role Edison had played in the establishment and acceptance of electrocution (when asked how quickly electricity could kill a man, Edison replied, "In the ten-thousandth part of a second"). In the words of an 1890 *New York Times* reporter, "It was Edison's testimony more than any other factor that led the courts to rule that the electric chair was neither cruel nor inhuman."[137]

Edison's *Execution of Czolgosz* was responding to a public fascination with electrocution that was at its highest between 1890 and 1905, with hundreds of individuals writing letters to prison wardens either volunteering to pull the lever or asking for permission to attend as witnesses. According to New York State executioner Elliot, who replaced John Hulbert as New York State's executioner in 1926 (he also worked in a similar capacity for neighboring states), multiple executions increased the requests from would-be witnesses, with one applicant declaring, "The more there are, the better the show."[138]

For Elliot, attending motion pictures served a therapeutic function before a scheduled execution: "The feature [in Charlestown, Massachusetts,] was a light, sparkling comedy, and helped me to forget the task which lay ahead of me," Elliot recalled in his memoir.[139] Having seen firsthand the reactions of thousands of witnesses to electrocutions, Elliot could speak with authority on the topic of spectator response: "I have seen them turn pale, tremble, or gag as they watched life depart from a human being. I have seen them stare off into space; cover their eyes with their hands . . . fidget nervously with some piece of clothing. I have heard them groan feebly or cry out. . . . Some try and peek into or enter the autopsy room after it is all over. Officers have actually

had to order a few to leave . . . so insistent were they on remaining."[140] We see some of those reactions among the journalists depicted in *Picture Snatcher*.

The closest most people would come to these sensations is the movies, where horror, albeit of a fictive kind, might scare and sometimes traumatize those purchasing the experience. And while the outcome of an electrocution is known, how it plays out generates an element of narrative suspense—as it did in hanging—a factor that nudges electrocution even further into the realm of the cinematic.[141] Kemmler, who "dreaded the long drop and thought he'd rather be shocked to death," was transformed into a macabre circus act on the morning of his electrocution, and Edison tapped into this sadistic horror in both *The Execution of Czolgosz* and *Electrocuting an Elephant*, a film in which a circus elephant is electrocuted in front of crowds at Luna Park.[142] Houdini's name can be added to the ranks of countless actors who sat in electric chairs in filmed renditions of electrocutions; some inmates have also come perilously close to taking their seat before a last-minute reprieve arrived. And the world of fiction and drama documentary is the only legal space for the representation of execution, given that U.S. law, holding that the news media have no First Amendment right to televise executions, still bans cameras from recording them.[143]

The Execution of Czolgosz might have been doubly fascinating for European audiences, as here was a film that marked the United States as distinct from Europe in its use of electrocution. And while most Europeans were broadly united in their horrific reaction to Kemmler's electrocution, doubtless there were others who wished that the method could have been exported to European soil (the last hanging in the United Kingdom took place in 1964, the year before it was banned). In defining the American experience, the sum of the electric chair's parts exceeded the whole: here was a putatively modern killing machine linked to the wizard of Menlo Park, offered as less bloody than the guillotine and more precise than hanging, although neither of these claims proved true. The death chamber represented in *Czolgosz* was not a hermetically sealed space untainted by popular culture or rituals appropriated from scientific and pseudoscientific practices but a nexus of influences where the precinematic came head to head with one of the twentieth century's most brutal inventions. *Czolgosz* also offered a virtual view of electrocution to women, who were excluded from the death chamber; despite countless requests from female journalists and laywomen, women were only allowed in if they were about to be electrocuted or accompanying the condemned as a fe-

male guard. In 1899, Martha Place became the first woman executed, for blinding and strangling her stepdaughter.[144]

By creating what might be considered a textbook electrocution, and one that can be infinitely repeated via the cinematic loop, Edison used Czolgosz's electrocution to expunge the historical record and possibly expurgate any lingering guilt he might have had about his role in the legalization of death by electrocution in New York State. Edison's cinematic faux eyewitness testimony supports the efficacy and legality of this form of capital punishment. Witnessing electrocution's effect on the body—albeit acted rather than real—*Czolgosz*'s spectators, like the spectators of all electrocution films, shared a curious historical legacy with spectators of electrical wonder shows, the Chamber of Horrors waxwork, the Phantasmagoria, and salon-based scientific experiments, displays involving electricity that swept Europe in the 1740s, such as the Venus Electrification, whose kisses threw sparks at spectators, and countless experiments at London's Royal Society.[145]

The electric chair takes center stage in the sexually charged 1946 Ray Bradbury short story "The Electrocution" featuring the famous circus performer Electra. The story was inspired by Bradbury's childhood memory of Mr. Electrico, a sideshow performer caped in black velvet and seated in an electric chair. When a switch was thrown, "he quivered in the surge of raw electricity, his face burning like white phosphor as the current sizzled his frail body." Bradbury recalled as a spectator "standing there with balls of fire tufting my earlobes and frying my lashes."[146] In "The Electrocution," Electra, a married woman who falls in love with a man obsessed with her performance, replaces Mr. Electrico. Out on a walk after an evening's show, the performer runs into him and after a passionate kiss declares, "Darling! You're much more dangerous than that electric chair!" Her performance in the electric chair the following evening reaches orgasmic proportions: "The power stirred her faster and faster. The electric chair felt soft and warm; it melted. . . . Somebody, out there in the ecstatic regions of dark, touched the offered blade. She knew who it was, she could imagine his eyes there, his lips parted as the current jumped into him and out again. He was pressed against the rope hard, hard against the rope."[147]

Edison was doing nothing new when he decided to combine the actual location of Czolgosz's execution with re-created footage. The British crime reconstruction film *Arrest of Goudie* (1901), made by the Mitchell and Kenyon Company and exhibited by Ralph Pringle, also used actual locations but in

this instance re-created the crime exactly where it had taken place and included the arrest of gambling-fraud victim Thomas Peterson Goudie, who was accused of embezzlement. Like *The Execution of Czolgosz*, the *Arrest of Goudie* was also timely, released, remarkably, only two days after Goudie's arrest, and it also drew, as Toulmin has argued, on a Victorian fascination with crime reports and the waxwork. Unlike *Czolgosz*, however, the film leveraged meaning from the local-interest film—a specialty of the Mitchell and Kenyon Company—and reenacted the event of the *arrest* rather than the event of the *execution*.[148]

Execution films have contributed to a carceral imagination about what goes on in the darkest recesses of the penitentiary. And while none of the films, save the no-longer-extant *An Execution by Hanging* (1898), shows an actual execution, they are part of a death penalty film genre comprising documentaries about wrongful incarceration, such as *Fourteen Days in May* (Paul Hamann, 1988), *The Thin Blue Line* (Errol Morris, 1988), and *The Trials of Darryl Hunt* (Ricki Stern and Anne Sundberg, 2006); and fictional films, such as *Angels with Dirty Faces* (Michael Curtiz, 1938), *In Cold Blood* (Richard Brooks, 1967), *Executioner's Song* (Lawrence Schiller, 1982), *Dead Man Walking* (Tim Robbins, 1995), and *Monster's Ball* (Marc Forster, 2001). Watching a film like *The Execution of Czolgosz* today, we are reminded of the fact that as incarceration activist and feminist theorist Angela Davis argues, prisons have remained "one of the most important features of our image environment," causing us to take their very existence for granted.[149] There is nothing "everyday" about an execution, however, as testified by the reaction of *Czolgosz*'s twenty-first-century spectators, some of whom, like their historical predecessors, are not quite sure (especially if they have no knowledge of early cinema) if what they are witnessing is real. But *Czolgosz* defies easy explanation, even as an example of what the Biograph Company called "News Happenings."[150] It might have afforded us virtual access to the penitentiary's death chamber, but it also laid bare the "trace of 'torture' in the modern mechanisms of criminal justice," the paradox of the noncorporal penal system.[151] *Czolgosz*'s legacy is not simply that of cinema's role as illustrated newspaper or of the cruel and unusual punishment that is electrocution but a fascination with the magic that is electricity and its ability to give and take away life.

Prison on Screen

THE CARCERAL AESTHETIC

> The motion pictures are not filling the jails, but the jails are
> filling the motion pictures.
> *Kinematograph and Lantern Weekly*, 1912[1]

> The prison is one of the most important features of our image
> environment.
> ANGELA Y. DAVIS, *Are Prisons Obsolete?*[2]

Prisons and prisoners are sites of imaginary projection, catalysts for think-
ing the unthinkable—spending one's life, or a portion of one's life, behind bars.
Isolated in the penitentiary from the public gaze, prisoners are transformed,
as John Bender argues, into "subjects, characters, objects of imaginative
projection."[3] Long enshrined within American visual culture, representations
of life in prison normalized definitions of criminality that prison literary
theorist Auli Ek argues "structure and legitimize the logic of imprison-
ment."[4] But what are some of these images? Writing at the height of the
nickelodeon boom in 1909, Charles Edward Russell listed "the close-cropped
head, the broad stripes, the lock-step march, the silent groups, and the ball
and chain" as the essential visual tropes making up our "mental picture" of
what he called "the half-world of the condemned."[5]

Cinematic representations of imprisonment are obviously not alone in sup-
plying information about prison, competing with other carceral knowledge
systems ranging from the "anonymous exactitude of statistics as accounted
by historians, sociologists, and U.S. Department of Justice" to the policy and
academic research published in annual proceedings of national prison groups
such as the National Prison Association, the American Prison Association,
and the American Correctional Association. And let us not forget theoretical
discourse on prisons, most notably the work of Foucault, which, while useful
in documenting the United States' fraught history of incarceration, can

nevertheless result in a myopic vision or, as prison theorist Peter Caster argues, "shine so brightly" on the cultural functions of prisons as they are projected on page, screen, and stage as to "obscure the representations themselves."[6]

This chapter examines how actuality, reconstruction, and fictional films representing prisons and prisoners[7] made before cinema's transitional era fueled a carceral imaginary that, while not deviating radically from visual tropes predating cinema, nevertheless gave expression to new ways of telling stories about convicts that took advantage of cinema's modes of signification. I explore how cinema contributes to our understanding of imprisonment in both predictable and sometimes surprising ways, and how it constructs key aspects of penality that are missing in the knowledge systems listed above. Prison life is essentialized into a series of apotropaic signs in early cinema: striped uniforms, bars, chains, cells, recreation yards, lockstep marching (fig. 2.1), chain gangs, warden's offices, and surrounding countryside.

Even becoming a prisoner effects something of a performative quality, the convict, in Gresham M. Sykes words, urged to "'play it cool,' to control all affect in a hard, silent stoicism which finds its apotheosis in the legendary figure of the cowboy or the gangster."[8] Seeing an image of an actual prisoner, one immediately wants the backstory: What is she or he serving time for—

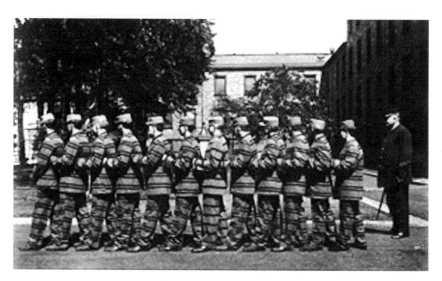

Fig. 2.1 Prisoners performing the lockstep. Wikimedia Commons, https://commons.wikimedia.org/wiki/File:Auburn_lockstep.gif

something serious such as murder, or something less heinous such as larceny or a drug offense? Who are these individuals, where did they come from, and what circumstances got them into prison in the first place? In the case of prisoner of war films, it is fairly obvious why the person is incarcerated; but in films of unknown offenders whose public punishments were recorded for the camera, or convicts housed in penitentiaries, we have to imagine what kind of crime a body or face has committed. Reenactments and fictional films complicate matters further through imaginative topoi that blur boundaries between fact and fiction. Fictional prison films tap into stock themes that make for edge-of-your-seat drama: rebellion against injustice, questions of control and its effect on the psyche and masculinity, and the gap between appearance and reality.[9] In fact, prison film heroes are more often than not constructed as idealized types, wronged individuals who invite our identification and speak to the rebelliousness in all of us; as journalist Theodore Waters noted in 1906, the audience is almost always on the side of the escaped convict, even when that individual has committed a serious crime.[10]

My goal is to contextualize early prison films within the broader visual lexicon of prison representation from the Middle Ages, before considering how this nascent genre constructed a carceral imaginary that, while drawing upon precinematic visual tropes, nevertheless gave expression to new, occasionally anarchic ways of telling stories about convicts that took advantage of cinema's more expansive modes of signification and spatiotemporal transmutations. This was especially true in the trick film, a virtual handmaiden for fantasies of escape and transgression. Content and form were sometimes merged in these films, as deviant behavior was expressed through the deviance of special effects. My investigation is shaped by two questions: first, how early films about prisons reinforced yet paradoxically questioned aspects of penality that are missing in official carceral knowledge systems and even Foucault's theory of panopticism;[11] and second, how early prison films, unburdened by cinema's institutional mode of representation and Hollywood-code censorship, evoked something akin to prison "structures of feeling," through scenes of corporal punishment, spatial and temporal recalibration, and bodily mutation.[12] Could the relative freedom of early cinema's emerging style between the years of 1895 and 1913 have created metaphors for understanding the experience of prison? Might the elliptical quality of early actualities or the grotesque metamorphoses in the early trick films come closer than conventional narrative films from the later studio era to evoking what it might feel

like to live behind bars? I begin with a brief detour into the deep historical past of medieval visual culture as a vital source of carceral iconography before addressing several films made about prison life before 1909.

Prison Bars and Chains: Seeing Incarceration in Medieval Art

We can trace the carceral aesthetic to religious art from the Middle Ages, as images of prisoners and imprisonment appeared in a range of public and private media, including stained glass windows, woodcuts, altarpieces, and books of hours (personal prayer books). According to medievalist Megan Cassidy-Welch, Saint Leonard of Limoges served as the "patron" saint of prisoners and Saint Barbara of Nicomedia, incarcerated at the hands of her father, is frequently represented either within, alongside, or holding a prison tower (the act of holding one's space of incarceration, intriguing to be sure, suggests other connections between medieval visual culture and the early trick film, where laws of verisimilitude are often abandoned). According to Cassidy-Welch, "Not only was the prison important in the individual vitae of various saintly individuals . . . but experiences of imprisonment and the space of the prison itself could also be represented for wider didactic and devotional purposes in the visual culture surrounding saints' cults."[13] *Symbols* of incarceration, such as chains, were as important signifiers of imprisonment as *spaces* of confinement; for example, in a thirteenth-century clerestory window from Chartres Cathedral, Saint Peter is seen wearing a chain on his foot despite being released from prison, and in a 1500 altarpiece depicting Saint Leonard and Saint Barbara, Saint Leonard holds a heavy-looking chain with a lock.[14]

Ideas of incarceration within the medieval religious imagination were inexorably tied to "salvific discourses" and played a crucial role in narrating the specific experiences of saints through stained glass, altarpieces, or smaller objects such as books of hours. Rules governing the iconography of imprisonment were established during this period; prison towers were referred to as *cells*, with containment and deprivation visualized via barred windows and specific representations of the body. As is common in most medieval art, similitude is less important than the *idea* of the experience; Saint Peter is often shown enclosed within the initial "N" (for *nunc*, meaning "present"), doubly confined by the space of imprisonment *and* the ornate manuscript letter located on the border of the page. Incarceration is also rendered metonymically, as in images of Saint Barbara in which she is shown either holding the

prison tower in her arms, or, in the 1480 *Legenda aurea*, standing with her hand lightly touching the roof. Enshrining a belief that imprisonment exceeds the corporeal and is as much a state of mind, this imagery underscores divine intervention and the possibility of escape from imprisonment, a theme that reverberates in the early cinema trick film.

The image of a face separated from the onlooker by bars is a recurring trope in art and cinematic constructions of incarceration. Shown with clasped hands, looking out through the upper section of his barred window at four oblivious guards walking past his cell, Saint Peter gazes out at that which escapes him, appearing to be either deep in thought or, as Cassidy-Welch argues, attempting to petition the guards. The four bars crossing Saint Peter's body signify incarceration, since without them any notion of captivity is lost. We see a similar, if fleeting, first impression of presidential assassin Leon Czolgosz behind the barred door of his cell in Auburn Prison in Edison's 1901 reconstruction, *The Execution of Czolgosz, with Panorama of Auburn Prison*. One important difference in the current era, however, is the fact that a prisoner would never be represented looking out from his cell door directly into the free world, since for security reasons, most modern penitentiaries have neither exterior windows in cells nor doors that lead outside, although each cell in Eastern State Penitentiary in Philadelphia had two doors, one of which led to a private mini exercise yard for each prisoner.[15] Notwithstanding these differences in prison architecture, the image of an individual standing behind bars is a powerful inscription of detention, and one that registers immediately with a viewer.

In *Stained Glass Window with Scenes from the Life of Saint Vincent*, one of a pair of windows devoted to Saint Vincent of Saragossa made between 1245 and 1247 for the Lady Chapel at the monastery of Saint-Germain-des-Prés in Paris, there is a scene showing Saint Vincent in prison as well as one of him being tortured by fire, with his head and torso depicted in a tower-like structure built upon an arch (fig. 2.2). The saint's head is tilted to one side and both arms are lifted defensively against his body, his gaze downward, signifying prayer, submission, or resignation. This image proposes several attributes of imprisonment: it is an embodied experience, worsened by acts of torture such as the fire used by Saint Vincent's torturers; it takes place in designated spaces, a tower in this instance, separated from domestic space and discursively linked to military exploits; and it requires a comportment of self, in this case, gestures of humility or fear, such as an averted gaze. Although not shown in the Saint Vincent stained glass, chains were the great levelers in medieval

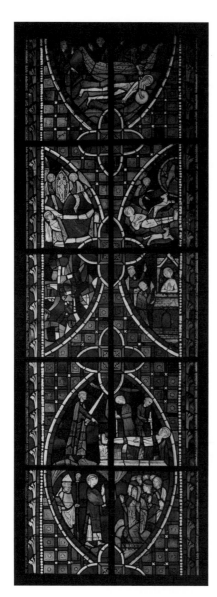

Fig. 2.2 Stained Glass Window with Scenes from the Life of Saint Vincent, 1245–1247, for the Lady Chapel at the monastery of Saint-Germain-des-Prés in Paris. Wikimedia Commons, https://commons.wikimedia.org/wiki/File:French_-_Stained_Glass_Window_with_Scenes_from_the_Life_of_Saint_Vincent_-_Walters_4665,_4666,_4667,_4668_-_View_A.jpg

culture, isomorphic with captivity and punishment and issued to captives from all social ranks, whether they were kept in a tower or a dungeon.[16] A prisoner is chained to a wall in the 1903 American Mutoscope and Biograph film *A Convict's Punishment*, the cell coded as a punitive rather than a rehabilitative space, closer in design to a medieval dungeon, with chains and other objects of torture, than the modern reformatory.

Fig. 2.3 Frame enlargement from *A Convict's Punishment* (AM&B, 1903).

The film is organized around four pieces of action: guards enter the cell (fig. 2.3), the prisoner resists arrest and his shirt is ripped, he is chained to the wall, and he is whipped. *A Convict's Punishment* is close in form to the reconstruction of the queen's beheading in *The Execution of Mary, Queen of Scots* (Alfred Clark, 1895 (see fig. 1.3). In both films, social control is enacted through corporal punishment. Structured around punitive optic, the film re-enacts the visual excesses of the scaffold dance, transforming the cell into a parallel public sphere where the film spectator is a virtual witness. While prisons are often represented as porous institutions in early cinema and subject at any moment to escape attempts, in reality medieval prisons were far more permeable than the modern penitentiary is, as the medieval prison's walls operated as "breathing membranes, not hermetic seals," according to medievalist Guy Geltner.[17] Medieval prisons were also located in the centers of settlements, allowing for far greater interaction with civic society than the geographically and socially isolated contemporary super-max prison. *A Convict's Punishment* serves as an object lesson for potential criminals who presume that physical beatings are a thing of the past; the cell as a monastic space

where isolation triggers introspection and eventually reform is eschewed in this film, as the prisoner's disorderly behavior is seen as grounds enough for a harsh beating. The film is also reactionary, abandoning the idea of imprisonment as rehabilitation for a custodial model in which corporal punishment is part and parcel of serving a sentence. Traces of the progressive prison reform movement are nowhere to be seen in *A Convict's Punishment*, the film deviating little from old-school methods of corporal punishment, a way of doing business in prison that mollified anticoddlers, reassuring audiences that incarceration had changed little since medieval times.

Light and the Carceral Aesthetic

Light was in high demand in prison. Describing a visit to Ohio State Penitentiary, journalist Charles Edward Russell called the cells constructed in the 1834 building "black caves." He said, "At noon barely so much light enters the corridor that one may see one's way about. No light enters the cells . . . and the dining hall is wonderfully dark, with no ventilation to speak of, and reeking of unpleasant odors." The prisoners were entombed in spaces where sunlight had not penetrated for seventy-five years.[18] Candlelight was rationed by the governing authorities of the Dutch Stadt Huys in Amsterdam and English City Hall, which both served as prisons; a new candle was allowed every two days and could be burned until eight o'clock during winter and nine o'clock in summer.[19] Prison administrators recognized the salutary effect of light on an inmate's disposition; Sing Sing warden Addison Johnson knew from experience that a cell with natural light encourages in the prisoner "better deportment and character than when he is confined in a dark and gloomy space where it is impossible for him to read or occupy his time."[20]

Light radiating into a prison cell from a barred window is an iconic image of incarceration used by artists, set designers, and art directors to signify the world outside the prison, religious conversion (seeing the light), and hope. A simple yet classic representation of light in the prison cell can be seen in the enigmatic depiction of a cell from the Surrey House of Correction, Wandsworth, United Kingdom, circa 1860, that shows an inmate staring out toward light coming from a barred window.[21]

Standing with his back to the viewer, hands grasping the handle of a device known as the "crank," a hard-labor machine used in English prisons to counter the supposed deleterious effects of idleness, the imprisoned man faces a square of light splashing a radiant highlight on the furthermost wall

(fig. 2.4).[22] The effort expended on the crank pits labor (or some perverse version of it) against recreation; an open book lies on the table opposite the man, suggesting that reform must involve the mind as well as the body. With its prominently displayed list of prison rules, water closet, hand basin, gaslight, and what appears to be a rolled-up hammock on the floor, the cell contains virtually all of life's necessities (save food and companionship) that a man can expect while imprisoned. The location of the prison door on the left positions us less as Peeping Tom than as invited guest, where the photographer stood to take the picture upon which this lithograph is based. But our presence in the room also triggers an imaginary discourse, a glimpse into the prisoner's interiority: While grinding away on the crank for hours on end and staring at the light coming in through the barred window, who knows what fantasies and fancies of flight (and dread) might have raced through his mind as his muscles began to ache and the sunlight streaming through the window eventually faded? This access bespeaks the omniscient authority of Jeremy Bentham's Panopticon designs of 1787–1791 (if not the actual architecture);

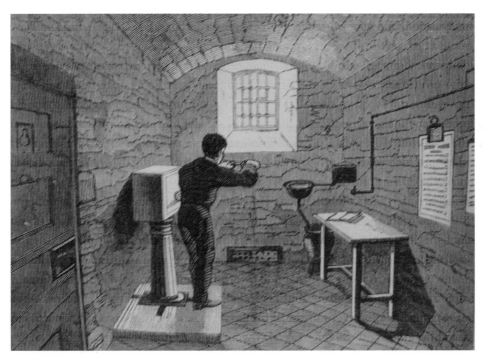

Fig. 2.4 Inmate operating the crank, an exercise device used in the cell, Surrey House of Correction, Wandsworth, London, ca. 1860. Illustration from Mayhew and Binny, *Criminal Prisons of London*

as John Bender writes, "Bentham fused narratively structured reformative confinement with the principle of supervision: an imaginative projection in the subject's consciousness of the jailer's eye watching."[23] The *Times* of London came out against the use of the crank in 1853, calling its employment "cruel and oppressive . . . and so utterly without result to the public."[24]

Light as a crucial part of the architectonics of reformation and a trigger for salvific conversion can be seen in prisons from the Middle Ages, initially part of churches, and institutionalized in the Gothic architecture of Eastern State Penitentiary in Philadelphia, a prison known as Cherry Hill, which opened in 1829 (fig. 2.5). Designed by British architect John Haviland, who was influenced by British prison buildings' radial design, Eastern State Penitentiary was the crucible for the "separate system" or the "Pennsylvania System," a disciplinary regime in which isolation from other prisoners was a central tenet of the reform.[25] Haviland selected the "hub-and-spoke" form of the prison to promote "*watching, convenience, economy* and *ventilation*."[26] Each cell had plumbing, central heating, a high arched ceiling, a skylight representing the "Eye of God," and a tiny door into a miniature, private exercise yard (food was passed in through a small portal in the wall). The individual cells' arched ceilings resembled medieval cloisters, and the thick walls and

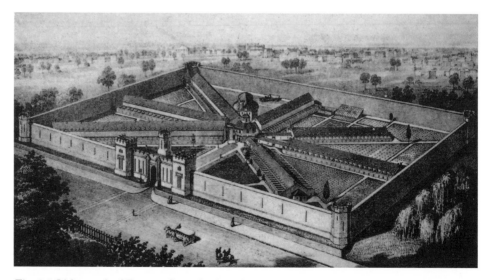

Fig. 2.5 Lithograph of Eastern State Penitentiary, 1855. Wikimedia Commons, http://commons.wikimedia.org/wiki/Category:Eastern_State_Penitentiary#/media/File:Eastern_State_Penitentiary_aerial_crop.jpg

double doors (a metal and a wooden door separated the prisoner from the church-like hallway) meant that inmates housed in adjacent cells were never allowed out at the same time. Hermetically sealed in his cell-like crypt, the prisoner had little else to do than to contemplate his crime and, if the silent method succeeded, reform; God, as represented in the skylight, was there not only to "watch over" the inmate, but also to guide him from the dark toward the light.[27]

By the time Eastern State opened in 1829, state law specified that hard labor should be included in confinement, although only after a period of several days' confinement, the idea being that work, like books and other recreation, was considered a privilege rather than a right, as specified in the first annual report: "When a convict first arrives, he is placed in a cell and left alone, without work and without any book [at Wormwood Scrubs Prison in London, inmates spent a probationary period of nine months in cellular isolation]. *His mind can only operate on itself.*"[28]

Images of Eastern State showing the reformative power of light were hugely influential in the formation of the carceral aesthetic and have continued to define how we see and idealize imprisonment, as seen in an illustration accompanying Sing Sing warden Lewis E. Lawes's 1931 *New York Times Magazine* essay "The Mind of the Man in Prison" in which a wide rectangle of light partially illuminating one half of a man's face shines through a prison cell window into an empty space (fig. 2.6). Read metaphorically, prison is a world of nothingness, where the only part of the body not shrouded in darkness is the head. Rather than gazing up at the light, the man stares directly ahead, his chin resting lightly on his clenched fist. This image strips incarceration down to a few elemental signs: light, dark, bars, and a body. Light's diurnal patterns in the cell (the constant movement of shadows depending on the time of year and day) give way to a much longer temporal arc in the first half of the caption: "With the Passing of the Years There Will Come the Moment of Regret and Hope," suggesting that time as well as seeing the light aids rehabilitation. We see virtually identical artwork in two other *New York Times Magazine* articles written by Lawes between March 1930 and October 1931. In "A Warden Speaks for Convicts," a prisoner's hands are clenched into tight fists around metal bars that complicate the meanings of the "Mind of the Man" illustration (fig. 2.7). The large hands and knuckles, symbolizing pent-up aggression and frustration, are in stark contrast to the supportive fist seen in the first image. And even though the

Fig. 2.6 Illustration accompanying Lewis E. Lawes's article "The Mind of the Man in Prison," *New York Times Magazine*, April 19, 1931.

Fig. 2.7 Illustration accompanying Lewis E. Lawes's article "A Warden Speaks for Convicts," *New York Times Magazine*, March 16, 1930.

prisoner gazes out at a meandering river or road, the angular shape of his head makes him a slightly less noble figure than the "Mind of the Man" prisoner. However, the caption, "Toward Social Justice," sublimates the image's possible pejorative connotations, putting the onus on the viewer to share Warden Lawes's views on more enlightened prison methods; in other words, we are asked to take that same (albeit meandering) forward path of social progressivism.

Barred windows are shown as part of a matrix of diagonal lines (fig. 2.8) in the third article written by Lawes for *New York Times Magazine*, entitled "What a Prison Should Be." Huge, floor-to-ceiling barred windows provide the backdrop to a half dozen or so inmates in striped uniform working at industrial machines. Hunched over their workstations with their backs to the light, the prisoners' bodies are horizontal versions of the windows, the uniforms, like the bars, preventing them from escaping. The expressionist style of the image perfectly befits the dystopian vision of inmates barely looking up from their manufacturing work. In the second image accompanying this article, the constructivist aesthetic of the industrial workshop gives way to

what a title [handwritten margin note]

Fig. 2.8 Illustration accompanying Lewis E. Lawes's article "What a Prison Should Be," *New York Times Magazine,* October 18, 1931.

Fig. 2.9 Illustration accompanying Lawes, "What a Prison Should Be."

an arched doorway with an open barred gate that is similar to the window in the workshop image. Five men walk out of the prison gate down a straight country road, the man in the immediate foreground wearing a hat that nullifies his prisoner identity (fig. 2.9).

The shift in the location of prisons from urban centers to rural locations is represented in many images of incarceration and is an accurate reflection of the growth of the prison-industrial complex and its role in rural economies (in contradistinction to medieval prisons, which were always located in urban centers).[29] An intriguing representation of incarceration from the inside out is the masthead of Sing Sing Prison's inmate-published newspaper, the *Star of Hope*, from 1899 (fig. 2.10).

The *Star*'s masthead shows the high walls of the prison and the observation tower looking north toward the village of Ossining. We see the railway tracks (which still run through the prison grounds on the left), along with the Hudson River and a country road shared by walkers, horseback riders, and a horse-drawn buggy. Several houses can be seen in the vista, possibly a farm in the upper right-hand corner, and three cottages along the dirt road in the center of the image. Were it not for the guard's lookout tower, which provides a 360-degree panorama of the prison and the surrounding area, and the decorative border, in which a prisoner with his back to the viewer sits on a cot in his cell on the far right, this bucolic scene could be virtually anywhere.

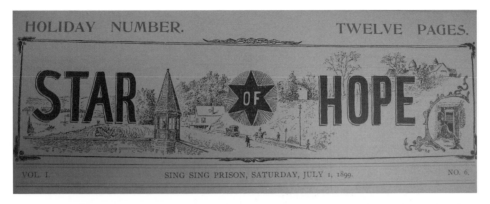

Fig. 2.10 Masthead of Sing Sing Prison's inmate-published newspaper, *Star of Hope* (1899).

There is a cinematic quality to the cell vignette that resembles a matte-shot superimposition from the early cinema period. The image of a world immediately beyond Sing Sing is an aspirational one; it is also an image of a world on the go, albeit a premodern world (we see a train, sailboat, horse and cart, horse and rider, and pedestrian), a painful reminder of the prisoner's suspended mobility. The vine encircling the cell is a gentle reminder of the prisoner's isolation and restores a modicum of dignity to the incarcerated. The framed image of the cell suggests yet another way of using light to access prisoner interiority, echoed perhaps in the image of the solitary man, who appears to have stopped in his tracks and is staring back at the prison. Could this man be our inmate upon release, or is the scene we are looking at a poetics of wish fulfillment for a still-entrapped prisoner? The connotative meanings of a star, radiating brightly and linked to celebrity, magic, astronomy, Christianity, and the great unknown are also leveraged in this semiotically rich masthead. Direct cinema documentarian Frederick Wiseman exploited the iconicity of the inmate staring out of the cell window at several points in his controversial film *Titicut Follies* (1967): first, when the sex offender interviewed in the second scene of the film is taken, naked, to his cell and the camera, in a long take, looks through the prison door peep-hole at him standing, staring out the barred windows, his shaved head and ears appearing in profile. And again, when Jim, the former Pittsfield middle school math teacher who is taunted repeatedly about his "dirty room," alternates between stomping rhythmically on the floor, banging his hands on the window bars, staring out the window, and, most unsettlingly, returning the camera's gaze.

Fig. 2.11 "The Higher Life" feature logo. *SOH* 3, no. 1 (April 20, 1901)

Another place in the *Star of Hope* where light is used symbolically as a metacomment on incarceration is in the column entitled "The Higher Life" (fig. 2.11), about religious services at the various prisons.[30] Like the masthead, the image is not some imaginary elsewhere but a view of either the eastern or western bank of the Hudson River from Sing Sing Prison (the white structure under the balloon's basket could be Sing Sing, in which case we are looking east across the Hudson). Five or so sailboats and a barge can be seen on the river along with a giant sunset (or possibly sunrise). Taking up approximately a quarter of the vertical space on the left of the image is a hot-air balloon with a bald man, who might be wearing a striped uniform, leaning far out of the basket. The hot-air balloon serves as a metaphor for the idea of "Higher Life," since, like God, the inmate in the basket looks down from a high vantage point and stares at his reflection in the water. While this graphic for the column "The Higher Life" denotes religious services in prison, its connotative meanings include escape or possibly even suicide.

An illustration accompanying an article on Sing Sing's role as a laboratory for the study of crime and criminals from a 1930 issue of the *Ithaca Journal-News* shows the ubiquitous rays of light penetrating the bars of the prison cell, but in this instance the words "Scientific Studies" appear in large print in the middle of the rays.[31] The inmate's body on the left of the image is bathed in light as he grips the bars of his cell. A caption identifies Sing Sing as "largely an institution for the study of crime and criminals," and under-

neath there is a photograph of the prison's new clinic and hospital building. Light in the image carries the usual connotative meanings of freedom and divine intervention, although the words "Scientific Studies" complicate our interpretation of the beam of light, suggesting that salvation comes through neither escape nor religious belief but science. Social science promises to shed "light" on criminal behavior, and the man's gesture implies that this is something desirable. Unethical medical experiments such as the Tuskegee syphilis project, in which male prisoners were infected with syphilis so scientists could study the disease's progression, spring to mind when looking at this image. The light engulfing the convict's body also has connotative ties to the prison searchlight (although the beam is much larger in this illustration); light control in general is another way of maintaining discipline, a powerful tool in the panoptic regime of regulation.

A very different beam of light can be found in an image in the *Star-Bulletin*'s (formerly the *Star of Hope*) 1918 motion picture column in which an elderly man with clown or tramplike features holds a small projector in his hands next to a basket filled with unspooling celluloid (fig. 2.12). Handwritten inside the beam of light are the words "Pictures Seen on Sing Sing's Movie Screen." Clown, hobo, and projectionist are transubstantiated in this image, each capable of making people laugh or feel uncomfortable. Prisons drew upon the professional experience or electrical skills of their inmate population to project films, but with the clothes this man is wearing he is coded more as a hobo than a resident of a large penitentiary.[32] The tramp identity is an obvious play on the itinerant motion picture exhibitor, and the unspooling film from the open canister reinforces the improvised nature

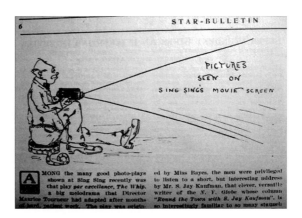

Fig. 2.12 "Pictures Seen on Sing Sing's Movie Screen."

of motion pictures in the penitentiary. Light occupied the central space in the Venn diagram that conjoined the penitentiary with motion pictures: vital in both experiences, light delivered fantasy, warmth, and escape, and it has endured as a potent elemental sign of the carceral condition.

Clothes That Hurt: Prison Stripes and Other Uniforms

We can also trace the visual lexicon of the carceral aesthetic in the depiction of prison uniforms, clothes that physically and psychologically hurt. Ill fitting and made of scratchy wool or prickly fibers, unwashed, and minimally customizable, prison clothing is how we identify convict peoples. A striped uniform and bars are all that are needed to signify incarceration, a point not lost on African American silent-era filmmaker Oscar Micheaux, as can be seen in his depiction of the Reverend Isaiah T. Jenkins (played by Paul Robeson) and Yellow-Curley Hinds in prison with a single medium shot of them dressed in prison stripes behind bars (fig. 2.13). From the powerful race melodrama *Body and Soul* (1925), the elliptical shot is a visual hieroglyph of the apparatus of incarceration that cues us to fill in the missing backstory.

Fig. 2.13 Frame enlargement from *Body and Soul* (Oscar Micheaux, 1925) showing the corrupt Reverend Isaiah T. Jenkins and jailmate Yellow-Curley Hinds in an elliptical flashback.

Some of the earliest convict uniforms resembled those worn by medieval court jesters and were designed to prevent escape and mark a prisoner as risible or pitiful in the eyes of the public; as clothing historian Juliet Ash argues, prison clothing provided the guards with "constant visible knowledge about the prisoner's behavior and identity."[33] Uniforms worn by inmates in Gloucester Prison in the nineteenth century resembled the bright blue-and-yellow alternating panels worn in the fourteenth century by the condemned, who were paraded on their way to a hanging in a "striped coat and white shoes, [their] head covered by a hood or a fool's cap."[34]

Prison is an intensely corporeal experience, and clothing heightened the sensation of discomfort. Masking prisoners with hoods or caps was not just a curious custom from the Middle Ages, but an integral part of nineteenth-century prison reform, as seen in Eastern State Penitentiary, where inmates were required to wear hoods that impeded their "topographical knowledge" of the prison or of fellow inmates.[35] Modeled on Eastern State's silent system, Pentonville Prison in London also required its male prisoners to wear a peaked cap pulled down over their faces to mask identity[36] (fig. 2.14).

With his right hand placed on his hip, the prisoner strikes a cocky pose, countering the uniform's disciplinary power, if only momentarily (his eyes peeking out from the otherwise concealed body hint at the possibility that the prisoner sees a lot more of us than we do of him, a potential blow to panopticism's visual reign). There is also a slightly hostile or threatening quality to the engraving, a kind of "What are you looking at?" feeling that potentially challenges the imputed power relations of the prisoner as subject-to-be-looked-at. Henry Mayhew and John Binny were unnerved by the "hasty stolen glance" with which inmates wearing masks at the Surrey House of Correction in Wandsworth looked at them, describing their appearance as "curious and sinister."[37] Like other subject peoples, inmates sometimes resented having their photograph taken: a group of Sing Sing prisoners scheduled for transfer to Auburn reacted angrily to the press when they attempted to take their pictures in 1914, picking up rocks and throwing them at the photographers, venting their anger no doubt on being moved from Sing Sing, a much preferred facility due to its ease of access for visitors.[38]

Prison stripes were first introduced in the United States in the early nineteenth century (by the 1850s in the United Kingdom). The uniforms contributed to an optic of surveillance and theatricality that defined a great deal of the prisoners' ritualized lives; even the nails in the soles of prison boots and shoes were hammered in an arrow shape that provided indexical

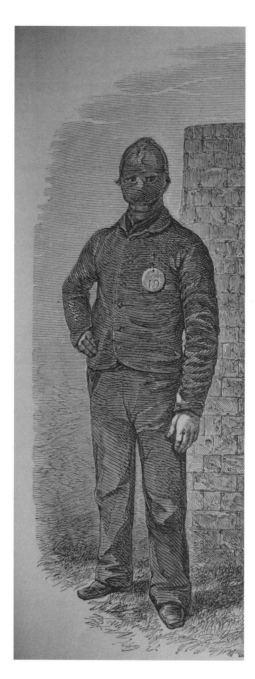

Fig. 2.14 Peaked cap pulled down to cover face, worn by inmate from Pentonville Prison, London, ca. 1860. Illustration from Henry and Binny, *Criminal Prisons of London*

proof that government property had passed this way, especially useful when prisoners were on the run.[39] Until its abolition in favor of work-wear grays in 1899,[40] which made prisoners appear little different from working men living on the outside, the New York State prison uniform of broad arrows or zebra stripes, indicating whether the prisoner was a first, second, or third termer via the number of stripes, confirmed, as Ash argues, "not only that the clothing was the property of the prison authorities—and thus the Government— but also that the convict's body was similarly owned."[41] According to Sing Sing warden Addison Johnson, the shift in policy had a corporeal effect on the prisoners and a psychic impact on guards: "Those who formerly had slouchy gaits and shuffling feet gave place to a careful and quick step . . . [and] it must be confessed that I conceived for them, individually and as a class, a broader and better sentiment than has heretofore possessed me."[42] Cornelius V. Collins, New York State superintendent of prisons, believed that the very atmosphere of the state's prisons benefited from the banishment of stripes, making it closer in guise to a garrison than a prison.[43]

We cannot talk about striped prison uniforms without delving deeper into the iconicity of the black-and-white stripe, specifically the choice of black, which John Harvey, in *The Story of Black*, argues is the most problematic of (non)colors, ambiguous and associated with extremes that are "opposite and absolute."[44] The meanings of black have not been constant, as Harvey explains: "The history of this color is like the record of an invasion. Black used to mark, mainly the terrifying realms that lay outside human life but over time we have brought black close to us: we have searched it out within our bodies and even within our souls."[45] The black-and-white prison stripe, while an inexorable sign of carcerality, is also a comic trompe l'oeil—is the zebra a white animal with black stripes or the opposite? Prisoners garbed in striped convict uniforms leverage some of the same discursive meanings of black-and-white stripes as does the zebra, an animal that inscribes notions of the unlikely and the mildly risible.

Prisoner-of-War Films

> It is not solitude that plagues the prisoner but life *en masse*.
> GRESHAM M. SYKES, *Society of Captives*, 1958[46]

When not shown in monastic solitude contemplating past actions, the prisoner is often represented en masse, in motion, parading, marching the lockstep,

working, or, less frequently, engaged in physical activity in the exercise yard. Like all propaganda, the prisoner-of-war film speaks to the enemy as well as to the victorious, transmuting the iconography of the jingoistic military parade into a walk of shame, not unlike the criminal "perp walk," although audience responses to prisoners are contingent on when, where, and to whom the film is shown. Prisoner-of-war films are overdetermined texts, since the geopolitical context of a specific war, the actions of soldiers fighting it, and "war crimes" committed by either side make comparing the POW to the domestic incarcerated somewhat difficult.[47] This is illustrated in *Captain Dreyfus* (aka *Alfred Dreyfus During His Daily Outing in the Courtyard of the Jail*) (Biograph, 1899), a film shot sub rosa by a French cameraman working for Biograph from the rooftop near the prison in Rennes, France, where Dreyfus was being held on charges of treason. Known as the Dreyfus affair, the young French-Jewish artillery officer was accused in 1894 of communicating French military secrets to the German Embassy in Paris.[48] The film marked the occasion of a retrial in the ensuing political and judicial scandal after Dreyfus had already served five years of a life imprisonment sentence on Devil's Island in French Guiana (retried in 1899, he was found guilty with extenuating circumstances and then, in 1905, declared innocent and released).[49] In a sense, *Captain Dreyfus* anticipates the need for good visuals in contemporary cable news gathering and the heightened public fascination in the scandal that warranted taking some risks and obtaining the footage.

Many of these films are structured by the same organizational and visual logic as other actualities, but in the case of prisoners of war and political prisoners, there is a currency to the film, what Charles Musser calls "the newspaper function" of early cinema. The Spanish-American War brought us some of the earliest images of prisoners of war, including AM&B's *Admiral Cervera and Officers of the Spanish Fleet Leaving the* St. Louis, shot in July–August of 1898.[50] Evincing a jingoistic visuality, the Wargraph (promotional term used by early film manufacturers) used cinema to proclaim victory and parade the enemy before the camera. Like the contemporary perp walk, the paraded prisoner of war reassured the domestic audience of sovereign power; it gave a face to the enemy, in this instance a high-ranking individual and officers who endured the humiliation of being escorted from their ship. The extant frame enlargements of *Admiral Cervera and Officers of the Spanish Fleet*, showing the *St. Louis* berthed and small groups of officers standing on three different levels in the ship, construct a much different image of a pris-

oner, since the admiral and officers' naval whites mitigate the pejorative connotations of capture by the enemy.

Edison's *Boers Bringing in British Prisoners* is a reenactment shot by James White in the Orange Mountains in New Jersey in April 1900 that shows a "mixed Company of Gordon Highlanders, Irish Fusilliers and English lancers" prisoners, led by a troop of Boer cavalry. The film opens with an extreme long shot of the troops moving slowly toward the camera from frame right to left, ending in a medium shot in which a military official waves at the camera. According to the Edison catalog, "The expression of their faces show who is the victor, and who the vanquished. You can read in the dust and smoke-begrimed countenances of the prisoners, the story of their stubborn resistance to superior numbers before they surrender: while the Boers give expression to their feelings, by cheering and waving their hats in triumph as they pass by." The camera-as-faux-witness conceit of this reenactment invites spectators to imagine that its representation on film is a visual corollary of what such a parade of prisoners of war might have looked like. The film answers the classic "what if cinema were there" question with a reenactment of the victors showing off their conquest.

WWI created unprecedented opportunities to cinematically document the (often unwanted) spoils of war and newsreels of POW concentration camps as well as prisoners being transported to military prisons. The newspaper function of early cinema, in which actualities documented important public occasions, transformed into the standardized newsreel.[51] POW films, such as Pathé's Animated Gazette and Topical Budget series, manifest an observational quality as the camera scans the environment, pausing on points of interest that may or may not show prisoners. Movement is a complex signifier in early POW films. Evoking the iconography of the military parade, the POW film displays little of the celebratory feel of men marching triumphantly off to war. Instead, the images show beleaguered individuals moving under military direction or lining up for provisions. The POWs are viewed as bodies in transit, as in the 1916 Topical Budget film *German Prisoners Embark on a French Transport*, which shows prisoners "disembark[ing] from a small steamer on to a jetty from which they immediately mount a gangway up the side of a transport ship."[52] More often than not, prisoners are represented as human cargo that cannot stay at the point of capture. For example, in *Austrian Prisoners in a Concentration Camp* (Italy, 1916), prisoners are seen at a makeshift open-air mass before being taken to the interior of Italy. The return gaze

is an unavoidable by-product of the POW film, a gesture that can be as fleeting as eye contact or as stylized as tipping one's cap at the camera. Some POW film descriptions refer to the angry stares of captives at the camera; with titles such as *Captured at Neuve Chapelle: German Prisoners Arrival in England*, from Pathé's Animated Gazette, these films turn the trafficking of military collateral into patriotic talking points, charting the progress of war and giving a face to the enemy that has either surrendered or been captured.[53]

The Penal Body in Motion

Prisoners were paraded before the camera in noncombative contexts as well. Indeed, with their built-in movement, the lockstep and military-style marching were logical choices for early cinematographers, since they showcased the medium's kineticism. Early examples of prisoners paraded for the camera include *The Lock-Step* (fig. 2.15), *Male Prisoners Marching to Dinner* (fig. 2.16), and *Female Prisoners: Detroit House of Corrections* (fig. 2.17), all from 1899. The motivation for making *The Lock-Step* was bound up with the fetish value

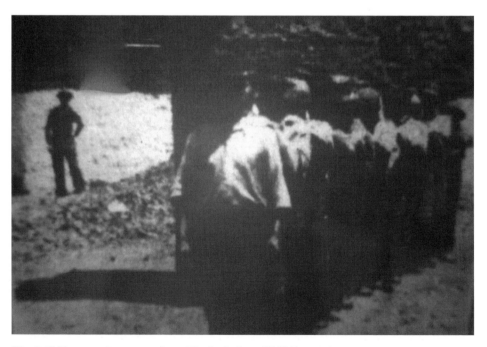

Fig. 2.15 Frame enlargement from *The Lock-Step* (AM&B, 1899).

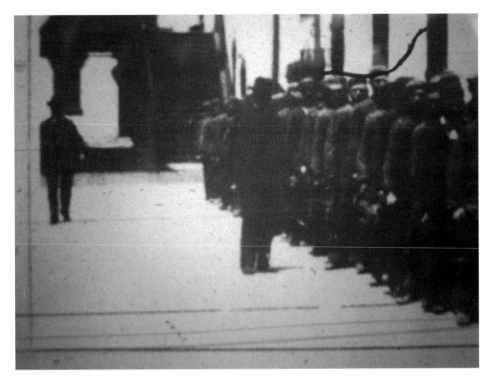

Fig. 2.16 Frame enlargement from *Male Prisoners Marching to Dinner* (AM&B, 1899).

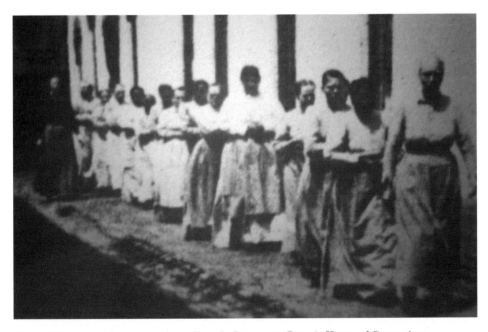

Fig. 2.17 Frame enlargement from *Female Prisoners: Detroit House of Corrections* (AM&B, 1899).

of seeing convicts embody principles of penal control and submission through military-style marching. Ironically, 1899 was also the year that Sing Sing Prison, following the recommendation of the New York State Prison Commission, abolished lockstepping (for first-grade men, inmates who could perform skilled labor, lockstepping was abolished in 1897), and Auburn Prison followed suit in 1901.[54] This was therefore one of the last opportunities to record (as opposed to re-creating via staging) a punitive practice that was on the verge of extinction, making *The Lock-Step* the penal equivalent of salvage ethnography. A 1900 *Star of Hope* Thanksgiving cover included the banning of the lockstep as one of seven things the inmates at Sing Sing were thankful for (fig. 2.18); below the caption, "[We are thankful] that this has been abolished," we see four inmates (two white and two black) in prison stripes performing the lockstep.

The derogatory representation of the black prisoners—with exaggerated features and one of them staring menacingly toward the reader—implies that the prisoners are thankful not only for the abolishment of the lockstep but for no longer having to walk so closely to prisoners from different ethnic

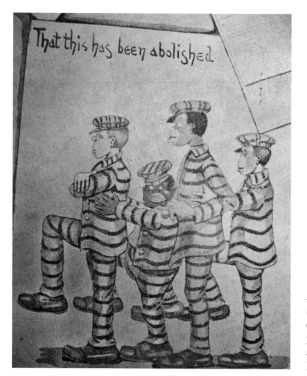

Fig. 2.18 Thanksgiving cover of *Star of Hope* illustrating recent changes in Sing Sing Prison policy for which the inmates are thankful, 1900. New York Public Library

groups. Connecting the legacy of the lockstep to discourses of race and imprisonment, the cartoon does more than mock a recently abolished punitive practice.

The Lock-Step was shot in either a dirt prison yard or prison labor camp—piles of earth can be seen in the background against a whitewashed wall. A vertical pole, probably about a foot in circumference, is located in the center of the frame, around which male prisoners, dressed not in prison stripes but dark pants and white shirts, with some wearing hats, enter from upper frame left, march around the pole at the back of the frame, and then turn right to move toward the camera, ending up in a medium long shot. Each prisoner's left hand rests on the shoulder of the man in front, and a guard walks about five feet ahead of the group as their movement sweeps from the back of the frame toward the camera. As befits the year of production, there is no camera movement and the convention of having a subject walk diagonally across the frame toward the camera, a trope seen in countless newsreels, is strictly followed. The parade would become a staple feature of the iconography of the newsreel, to the chagrin of English film critic Robert Herring, who in 1938 said, "Life as seen by 'the eyes and ears of the world' is a series of parades—mannequin, military, monarch."[55] An individual assumed to be a guard, dressed in black and standing apart from the locksteppers, directs a blistering stare at the camera in the film's closing moments, as if to say "You got all you need" or "I told you so." The look can also be read as the relinquishing of power from the camera to a prison representative who will take over the job of surveillance once the cameraman has left the prison. The look definitely punctuates the film and is complicated by the fact that the marching inmates also gaze down slightly on the camera as they pass by.

Male Prisoners Marching to Dinner, shot in the Detroit House of Correction's interior courtyard, features about thirty-five men standing along the edge of a building before entering the mess hall for dinner. Two prison employees stand to the left of the inmates, one in the midground frame left, the other immediately next to the men in the center of the frame. Grouped tightly together, most of the inmates cock their heads slightly in order to see the camera, and while it is hard to decipher individual faces, there is an unsettling quality to seeing so many convicts staring at the camera, not because of their status as prisoners (although we should not disregard this) but because of the return gaze's de facto triggering of a certain angst on the part of the onlooker, awareness perhaps, as Calvyn Pryluck argues, that the issue of a "society's

right to know and the individual's right to be free of humiliation, shame, and "indignity" is often fraught.[56] The prisoners are examples of social control at work, yet in these early films they are constructed as attractions no different from other early cinema subjects such as the Brooklyn Bridge, firefighter parades, or other symbols of civic pride. *Male Prisoners Marching to Dinner* has additional relevance for New York State audiences, since 1899 was also the year the New York State Commission on Prisons ([NYSCP] now the New York State Commission of Correction) explicitly recommended marching (to replace the banned lockstep), "two by two in military formation, with heads held high and no bodily contact between them," for movement between cells, mess halls, classrooms, and workshops. Aside from its obvious regulatory function, prison administrators argued that such marching would mitigate the feminizing effects of imprisonment-enforced idleness, tending instead to "manly appearance and deportment."[57]

The film *Female Prisoners: Detroit House of Corrections* gave the thrill of seeing prisoners an added twist, since here were women who had been imprisoned most likely for socially deviant crimes such as prostitution, drunkenness, petty larceny, or vagrancy.[58] Structurally and figuratively, *Female Prisoners* is virtually identical to *Male Prisoners Marching to Dinner*, save for the fact that the women do not appear to be dressed in a regulation uniform, but in clothes associated with the working class: plain blouses, utilitarian long skirts, and aprons. It is only when we notice a female guard dressed all in black at the rear of the frame that the symbolic differences in attire become apparent. Unlike the men, who are in tight formation, there is more space between the women and their bodies appear less regimented as they walk diagonally across the frame toward the right-hand corner. Except for the woman at the front, all the women clasp or hold their hands, and toward the end of the film the women stop and all fold their arms across their bodies in a gesture that, if not exactly defiant, reinforces a view of these women as not to be messed with.

One woman who lived up to this reputation was Mary May Rogers, the last woman legally executed in Vermont, who murdered her husband so she could pursue a relationship with her lover Morris Knapp. Rogers inspired three prison- or execution-related reenactment films made by AM&B in 1905 (Frank A. Dobson shot all of the films on a New York City rooftop). The first in the trilogy, *A Reprieve from the Scaffold*, was made in response to the December 9, 1904, resolution of the Vermont House and Senate investigation

into Rogers's physical and mental health at the time of the murder; had it been passed by both houses, the resolution would have commuted Rogers's sentence to life imprisonment.[59] The brief, single-shot film shows a gallows set with two men standing facing the camera and a priest. Rogers is led up to the scaffold, a noose placed around her neck, and a black hood slipped over her head. With seconds to spare, a man rushes in holding a letter in his left hand; the hood is removed from the head of the actress playing Rogers and she is led away from the scaffold looking, not surprisingly, somewhat dazed and traumatized.

The second film, *Reading the Death Sentence*, dramatized the unsuccessful outcome of the appeal heard by the U.S. Supreme Court in November 1905 and the signing of Rogers's death warrant by Governor Charles J. Bell one week before her execution. The film shows a man with a letter in his hand descending a staircase and walking to a bank of cells; a guard opens one of the cells; a woman appears in the doorway; and another man who has entered the frame reads the letter. The only emotion betrayed by Rogers is when she bows her head in resignation and is escorted from the cell. The last film, *Execution by Hanging* (aka *Execution of a Murderess*), opens with three prison officials nervously awaiting Rogers's entry; the dangling noose and large brick walls bespeak the prison location, and barely a few seconds go by before Rogers is brought in (each arm held by a guard), followed by a priest holding a Bible. To mitigate immodesty, the prisoner's black dress is tied around her ankles and a hood placed over her head. The films ends at the moment she would have dropped through the trap door.

Mary's cinematic death occurred six days before her actual death on December 8 (*A Reprieve from the Scaffold* and *Execution by Hanging* were both filmed on December 2). AM&B went on something of a crime film spree in December 1905, getting maximum use out of their rooftop prison set by filming *A Break for Freedom* and *The Impossible Convicts* on the same day they shot *Reading the Death Sentence*. These fictional crime films are testimony to this genre's natural migration from the dime novel, penny press, and vaudeville skit to cinema, and the absence of contemporaneous knowledge about Mary May Rogers transforms the reenactment trilogy into sensational scaffold-dance porn. For poor and immigrant working classes frequenting motion pictures, the likelihood of having had a brush with crime, being imprisoned, or having a family member or friend spend time inside was significantly greater than for spectators who watched these films in more respectable venues. And yet the serialized quality of these films, the historical

equivalent of today's news feeds, and public fascination with high-profile criminal cases, doubly so when the accused is a woman, made them popular with both working-class and more well-do-to audiences.

Prison in Early Narrative Films

In France, Pathé saw the appeal of crime as the backdrop for a class-uplift morality story when it released *Au bagne* (Scenes of convict life, 1905), about a convict's incarceration and escape, and *Le bagne des gosses* (Children's reformatory), which also features an escape, and is a composite of previous Pathé releases in the genre.[60] *Au bagne* constructs a series of tableaux in which a new admission to a penal colony instigates a riot, escapes through the barred window of the dungeon, is captured trying to escape, executed by firing squad, and ignominiously dumped at sea. The film is constructed as a straightforward escape-pursuit-capture narrative, delivering a predictable object lesson that breaking prison rules can lead to execution. The modular-ized structure of *Au bagne* suggests that the carceral aesthetic was easily readable as a sign by 1905, so readable in fact that each tableau of *Au bagne* inscribes a vision of carcerality that brought new certainties about life behind bars. The film builds on established iconographical tropes on the nature of imprisonment and its attendant rituals, such as the riot and es-cape. But the devil lies in the details in this film, as I would argue that it is interesting not so much for its construction of a carceral aesthetic and lay-ing down of some of the rules for the imaginary representation of prison, but for its striking lack of sentimentality.

The opening shot of the film establishes the penal colony location by show-ing an armed guard in military uniform walking from the courtyard of a painted prison backdrop into the prison office (an intertitle announces the space as "The Office"); the austere Gothic-style arched doorway and window flanked with heavy bricks and vertical bars remind us that prison's space is an active agent in the disciplinary process, although it is only when we see two male prisoners wearing loose white shirts and hats with large numbers on the front carrying a ball and chain while fettered that we know with cer-tainty that we are in prison. Titled "The Fettering," the second scene takes place in a space that is a cross between a barber's shop and blacksmith's work-shop, although the Gothic arches and fan-shaped barred windows complicate the overall design aesthetic: fetters are being applied to a prisoner's legs at the same time as we see another prisoner having his head shaved (fig. 2.19),

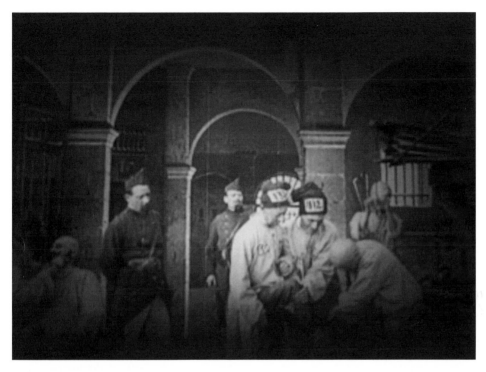

Fig. 2.19 Frame enlargement from scene entitled "The Fettering," *Au bagne* (Scenes of convict life) (Pathé Frères, 1905).

a powerful symbol of the loss of "liberty and personal autonomy" and degradation within Western culture.[61]

These scenes establish fairly early in the history of the prison film that the process of *becoming* a prisoner (shown in each half of this tableau) is about embodying ideals of incarceration through altered physical appearance, amply shown in this scene. There is a fetishistic quality to seeing the effects of imprisonment on the body, a desire sated in the third scene of *Au bagne*, entitled "Hard Labor," which shows about half a dozen inmates carrying heavy supplies onto a cargo ship. The embodied punishment theme carries over into the fourth scene, "The Scourging," which shows a shirtless prisoner with a shaved head (another iconic referent) being brought into a cell, forced to lie down on a low platform with head and feet restrained by guards, and brutally whipped by an overzealous prisoner (paint or dye on the end of the scourging whip leaves convincing-looking bloody streaks on the man's back, a special effect used in countless scourging scenes since the Mystery Cycle plays of the Middle Ages). That the corporal punishment is enacted by another

prisoner rather than a guard reminds us of how easily alliances can form across power lines (the phenomenon of the trusty) within prison's brutalizing universe.

A dispute between a prisoner and a guard in a high-walled exercise yard leads to a riot in the next scene. The Gothic arch and barred gate from which the prisoners enter figuratively connects the early twentieth-century prison with its medieval counterpart, an association reinforced by the drawbridge. Unbeknown to the guard, the prisoner has a metal file (lifted no doubt from the earlier fettering) that he hides behind a loose brick, and has been busily filing through one of the bars in the dungeon window. The prisoner's escape through the barred window triggers the film's most sophisticated camera work, including a reverse-angle shot of the man climbing out, camera tilting as he climbs down the side of the prison wall, using gaps in the bricks as toe-holds, and a tilt up to the dungeon window, where we see a guard on the balcony next to a cannon that he fires to trigger the alarm. Our prisoner's taste of freedom is short lived, however, as two boats with prison guards quickly converge on our escaped convict and he is captured. The final two scenes of *Au bagne* include little extraneous material, showing the prisoner being executed by firing squad in the presence of about a dozen internal prisoner-witnesses, and, in the final scene, titled "The Immersion," buried at sea by a half dozen inmates who carry the body on a stretcher along a cause-way. With no ceremony, the inmates and guards scurry away and, with the camera still rolling, we are left to think about what we have just witnessed before the film suddenly ends.

Au bagne's modular structure and predominant tableaux mise-en-scène make it the cinematic equivalent of a lantern slide show or series of stereo-cards on prison life. If lacking the illusionism of actual prison location shooting—a trademark of prison films from the 1910s onward—the location does have a real world referent, the French penal colony of Devil's Island State Penitentiary. *Au bagne*'s Gothic-inspired prison architecture, especially its arched gateway with an eighty-foot-high bell tower, iron portcullis, and two square towers,[62] incorporates expressionist elements into the mise-en-scène, such as the sharp objects jutting out of the top of the prison wall, the flying buttresses in the fettering scene, and iconography of chains and double bars on the cell windows.

Recycling what Richard Abel calls the "comforting, patriarchally inflected myth of 'natural' redemption," *Au bagne*'s sequel, *Le bagne de gosses*, makes

the prisoner a doubly sympathetic figure: a child guilty of nothing more hei-
nous than stealing a loaf of bread after his mother dies in abject poverty.[63]
Sentenced to hard labor in a congregant prison camp, the boy manages to
escape but is hotly pursued by the guards. An intriguing and touching mo-
ment in the ensuing chase occurs when the boy hides in a dog kennel, a shot
preceded by a 180-degree rule break that shows the boy eating the dog's food
from the rear of the kennel as it looks on through the kennel opening. While
this image generates a chuckle, its darker elements resonate with the film's
transpositions: boys treated like men in labor camps, and children behaving
like animals—images mitigated, however, by the film's happy ending, in which
the boy is rescued by an upper-middle-class male benefactor and shown one
year later in fancy clothes, fully assimilated into bourgeois culture.

Three types of punishment are represented in *Le bagne des gosses*: chain-
gang conscript labor (boys digging), restricted movement (boys kneeling or
standing with outstretched arms), and repetitive motion (boys running around
in small circles).[64] Regulating the body by making it work, remain still, or move
suggests the creative (and darkly comic) lengths penal authorities go to in order
to discipline young offenders. When taken to his prison cell, our protagonist
has a vision of his dead mother, a narrative device thoroughly in keeping both
with the Victorian fascination with ghosts and with prison reformers' theories
of the retributive power of solitude. The cell is transformed into a phantasma-
gorical space of reflection that only ends when a guard enters and slips the boy
a piece of bread, which, as a potent symbol of Christian redemption, ironically
refers to what landed the boy in prison in the first place.[65]

Cell walls are similarly overdetermined signs in prison films. They con-
fine but also offer limited opportunity for agency through windows (portals
of escape) and customization, such as marking off time on a calendar or
hanging pictures and photographs, and, in the minds of reformers, they
trigger reflection and penance. English prison reformer Jonas Hanway, in
his volume of published letters, *Distributive Justice and Mercy* (1781), saw,
as Caleb Smith argues, a corollary between "prison architecture and the ar-
chitecture of the mind," the idea that by staring at the blank prison walls the
inmate would "discover the true resemblance of [his] mind, as it were a mir-
ror."[66] The idea of the prison wall as a reflective surface goes back at least to
the Middle Ages, when prisoners were encouraged to embark on pilgrimages
of the mind, as seen in the 1499 German book *Aigenschafft, die ain pilgir an
ijm haben sol* (The desirable traits of a pilgrim). Prison overseers in the

Middle Ages even released troublesome inmates on the pretext that they were embarking on a pilgrimage, although in truth it was to get rid of them. The idea of a pilgrimage of the mind and the detailed steps outlined in the text to assist the prisoner in its successful completion suggest that corporeal entombment was no impediment for a spiritual journey.[67] Christopher Hale compares the cell to a camera obscura, reflecting the "glass and transparency of the Inspection House" upon its walls. But as *Le bagne de gosses* suggests, the prisoner's imagination can usurp the fantasy of complete control by priming the walls of the cell for projecting images lifted from the prisoner's very own subjectivity.[68] A parable of the deleterious effects of poverty and single parenthood and a depiction of the failure of the penitentiary to either reform or contain its inmates, the film is a rich metacomment on the punitive practices of early-twentieth-century prisons and the redemptive value of class uplift, which saves the boy from a presumed life of petty crime and recidivism.

The trope of a cell wall as a metaphorical blank screen, but one that triggers a mental breakdown rather than a transcendental mystical experience, is brilliantly explored in *Il due machinisti* (The two machinists) (Cines, 1913), a film about a train engineer wrongly imprisoned for causing a train accident at the depot. Alone in his cell, the man paces frantically, gesticulating wildly, at one point walking toward the camera with wide, manic eyes and hands tightly clenched into fists. The source of his anger is soon revealed, as he imagines seeing the purportedly injured engineer drinking and laughing with friends in a bar. The man reacts violently to this hallucination in a display of histrionic acting, even turning his back to the audience and becoming an internal spectator to his own mind's eye, which taunts him to the point of near hysteria (fig. 2.20). If the prison cell's white walls were designed to trigger a reflective penance, in *Il due machinisti* the response is one of rage as the result of an overactive imagination.

There are a lot of escapes in films set in prisons during the early cinema period, a perfect handmaiden for the chase, a staple of early narrative cinema.[69] When combined with crime, the chase was a riveting (if predictable) narrative formula, sometimes comedic, as when mishaps occurred along the way, and almost always bringing closure through capture. One of the simplest versions of the prison escape film is AM&B's *A Break for Freedom* (1905), which drives home the object lesson that prisoners are inherently violent and opportunistic. The film shows a prison guard descending stairs carrying food on a tray. Prisoners' striped arms poke through the barred

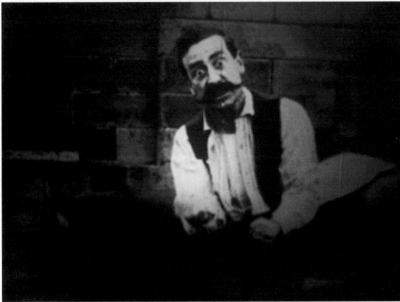

Fig. 2.20 Frame enlargements from *Il due machinisti* (Cines, 1913). Courtesy Library of Congress

cells, and, as the guard puts down the tray to unlock the third cell and walks away, one of the prisoners jumps him, grabs his gun, shoots him, and unlocks the remaining cells. The film ends when another guard comes down the stairs just as the men are about to escape; he, too, is shot as the convicts ascend the stairs. *A Break for Freedom* shares the modularized structure of a great many early films, hinting at a temporal before and after, which would fill the audience in on missing narrative information. That a scene of violent escape resulting in two homicides appealed to popular film audiences suggests the enduring ambivalence toward the figure of the incarcerated, and the word *freedom* in the film's title subtly justifies the prisoner's actions, although the gun violence might have complicated any straightforward identification with the escapees. The film strays little from the stereotypical belief in prison as a space of dramatic conflict, mythologizing the inept prison guard and the tenacious, violent felon.

Filming prison escapes on location during the early cinema period occasionally became newsworthy, especially when members of the public mistook the image of an actor dressed in regulation prison stripes being pursued by guards on location for a real escape. In 1907 the *Washington Post* reported the account of a New York film company shooting a prison escape chase scene that drew the attention of an armed police officer oblivious to the context: "It was only due to the proverbial poor marksmanship that the pictures were procured without the 'convict being killed.'"[70] *Escape from Sing Sing* (Vitagraph, 1905) also included a dramatic chase, even more dramatic when we consider that it was staged on the roof of Vitagraph's New York City Nassau Street office building and in Bronx Park (now the site of the Bronx Zoo and Botanical Garden).[71] A narrative spin-off of a contemporaneous theatrical melodrama and a 1903 AM&B film with the same title, the making of *Escape from Sing Sing* was the subject of a long essay by Theodore Waters in the January 1906 issue of *Cosmopolitan* that strove to demystify the craft of filmmaking and explain the audience's increasing demand for story films and verisimilitude.[72] The film was innovative for several reasons, most notably, as Richard Kozarski points out, for shooting the rooftop prison escape scenes with two cameras rather than the single style favored by directors such as D. W. Griffith.

Escape from Sing Sing pushed the envelope in other ways, too, most memorably for its violence, "nearly all of [it] directed against police, innocent bystanders, and even a small child." Indeed, Kozarski argues, "the constant beatings, robberies, and episodes of 'pumping lead' . . . seem to prefigure the

violent narrative of a first-person short video game."[73] Waters played the role of one of the convicts escaping from Sing Sing in the film, clad in stripes and a witness to the violent assault on the warden that led to freedom (later in the film a guard is beaten into "feigned insensibility").[74] According to Waters, on the rooftop prison set, "the cells had neither fronts nor sides, but that fact did not appear on the moving picture . . . [and] the arrangement could be adapted to make a jail courtyard scene," eliminating the need to shoot on location. Waters even got into his role as a convict: "Slowly, stealthily, as convicts might, we raised the iron cover and with the machine recording every moment, every expression, we crept along the roof and peered over the edge."[75] The cell's minimalism was conducive to economic set design and construction in the fledgling motion picture industry—Waters even commented on how the cells were quickly transformed between shoots—and any industrial-looking rooftop could easily have doubled up as Sing Sing's roof. After the rooftop scenes, the convicts were photographed in Bronx Park, where they shot at pursuing guards, ambushed a picnicking family, held up a car by firing guns at its occupants, and became embroiled in a shoot-out with the guards, before finally arriving at the home of the ringleader. During the final shoot-out with the three escaped convicts, a stray bullet kills the ringleader's young daughter, leading her grief-stricken father, the only prisoner still alive, to surrender. Despite the trail of carnage, when the keeper finally enters the cottage and realizes the convict's daughter is dead, he respectfully waves his men back and "gently lay[s] a hand upon [the prisoner's] shoulder."[76] The melodramatic ending confirms Walters's theory of the ideological pull of the "bad guy/escaped convict," the fact that the prison keeper (and by extension the audience) can look sympathetically upon a prisoner whose escape and flight from the authorities was not without the loss of innocent life, including his own daughter. *Escape from Sing Sing* illustrates Austin Sarat's idea of the "politics of sentimental identification," the fact that cinema has long wrestled with the "question of whether criminals can and should be accorded the status of victims."[77]

Another early prison film that explores this question is *When Prison Bars and Fetters Are Useless* (Pathé Frères, 1909), a trick film that represents prison as a highly permeable space and the prisoner's body as equally mutable.[78] Permeability, defined as something "having pores or openings that permit liquids or gases to pass through," is a structuring principle of prison bars and windows that allow air to circulate and body parts to protrude. Since

the title *When Prison Bars and Fetters Are Useless* is a spoiler, narrative plea-
sure derives not from *whether* but from *how* our protagonist will overcome
incarceration. The film's opening shot is virtually identical to that of *Au
bagne*, except it takes place in a wood-paneled warden's office rather than a
space adjacent to the penal colony's interior courtyard. We know it is a prison
rather than a police station because the words "Prison Regulation" appear on
a small whiteboard on the wall. Looking dapper, if a bit shifty, in a pinstriped
suit, striped tie, and cloth cap, a prisoner is dragged into the warden's office
and searched by two guards who remove stolen watches and jewelry. After
being processed he is led handcuffed to his cell, where his feet are shackled,
and, still wearing his pinstriped suit, whose narrow stripes gently mock the
prison uniform, he is left to his own devices. Somewhat unexpectedly, the
film's next shot is a close-up of the prisoner's hands, with his fingers pointing
toward the camera (fig. 2.21). We see chains looped twice around each wrist
and around his neck. Using stop-motion, his fingers morph into a lump of

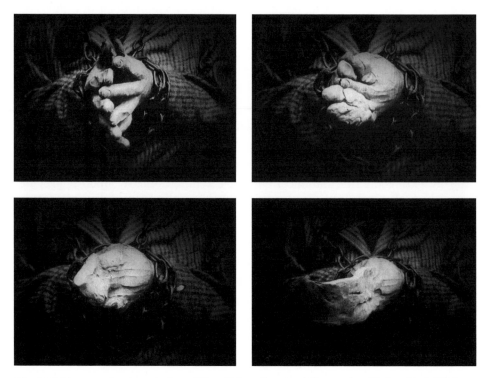

Fig. 2.21 Frame enlargements from *When Prison Bars and Fetters Are Useless* (Pathé Frères,
1909) showing hands transformed to clay.

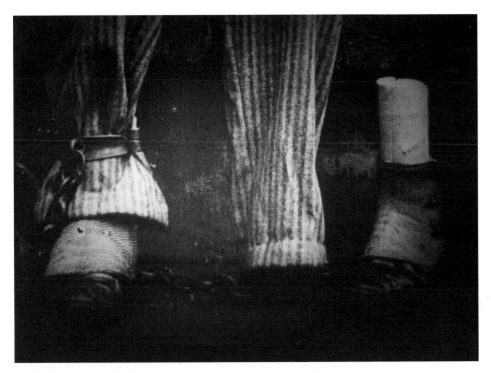

Fig. 2.22 Frame enlargement from *When Prison Bars and Fetters Are Useless* (Pathé Frères, 1909) showing foot detached from the body to expedite escape from fetters.

clay, which then transforms into an elongated, finlike object that draws in toward the prisoner's body, slips behind the chains, and quickly releases his arms. A similar unfettering occurs with the man's feet. Following a close-up of each lower leg and shoe, each foot twists 360 degrees, detaches from the body, and moves to the side of the pants leg, thus freeing the man's legs from the shackles (fig. 2.22). Taking more drastic and final measures, the guards place the prisoner inside a sack, tie a rope around his body, and dump the trunk at sea (another macabre link to *Au bagne*), implying that when prison bars and fetters are useless, the only solution is death by drowning.

The second half of the film is one long chase sequence, in which objects anthropomorphize, morph, disassemble, and reassemble: a bicycle frame becomes a whole bike, a policeman cut in half in a collision with the bicycle is glued back together by a billboard man, and when two policemen are tossed out the window as folded pieces of paper, they are unfolded by a tramp and

return to human form. *When Prison Bars* ends with the prisoner slithering, like an unfurled fireman's hose, back into the warden's office (inadvertently, one assumes), becoming human again only to make a speedy exit.[79]

When Prison Bars is indebted to the visual logic of the trick film, a popular early cinema genre that used physical metamorphosis, motion animation, editing, and other special effects. The film also exemplifies early cinema's intermediality, since Harry Houdini's prison escapology immediately comes to mind. When we factor in Houdini's frequent performances in penitentiaries—convicts nailed him into a packing case at Sing Sing during one show—we see that *When Prison Bars* extends the skill of prison escapology to ordinary felons, but in this instance replaces bodily contortion with metamorphosis.[80] Houdini's nonchalance after a prison break—his biographer Harold Kellock once described how he "walked jauntily out of the stoutest jail door in a few minutes' time, fully clothed and looking as if the whole affair had cost him no particular exertion"—is also suggested in *When Prison Bars* when the inmate smokes a cigarette immediately after escaping from his handcuffs and fetters (a wink perhaps to the bodily release from a postcoital cigarette).[81] Governed by the same suspension of physical laws as magic is, the trick film takes cinema's already slippery ontological status as absent presence and magnifies it into a moment of anarchic plenitude.[82] Films with criminal themes are dreams come true for makers of early trick films. The prison as location is rife with all manner of possibilities for tricks, and, as in *Escape from Sing Sing*, the trick film leveraged spectators' ambivalent, if not sympathetic, predisposition toward prisoners. The plasticity of the prisoner's body can be read as a metaphor for the cinematic medium in the transitional era, what Maggie Hennefeld calls a "rhetoric of metamorphosis—of ushering figures spontaneously from one form to the next," in which tricks perform their own "historiographic meta-narratives."[83]

The convict's body not only escapes human form in *When Prison Bars*, but also becomes superhuman, able to change shape, survive in water, and ride a bicycle in the sky. Escape as a visual rhetoric is all about defying borders. The borders between spatial units that hold prisoners captive are not only heavily policed but also governed by complex rituals enacted upon the body, including the search of visitors' bodies and possessions upon entry and the innumerable security checks of inmates and visitors alike. Moreover, the prison as a porous space, as discussed above, also suggests the anarchic, surrealist quality of some of the early prison trick films. Bumbling guards

and cops, ineffective restraints, and a felon who can literally work wonders with his body are a magnificent snub to law and order in *When Prison Bars*. The fact that the convict ends up back in the same cell, only this time to ditch his captors/pursuers and escape once again to freedom, leaves few in doubt as to whose side we should be on while watching. The film therefore pits the rationality of the criminal justice system—arrest, conviction, incarceration—against the irrationality of the convict's mutable body; the carceral logic of rehabilitation is not simply turned on its head but flatly denied.

The conceit of the incarcerated body performing feats of magic is found in many places beyond the early trick film. Contemporary prison researchers Edward Zamble and Frank J. Porporino observe that inmates often construct scenarios in which mind and body are temporarily divorced. One participant in their 1988 prison study reported, "Sometimes I imagine that my mind could go to sleep for a year or two, while my body stayed here. When I'd awake nothing would be different, maybe nobody would even notice."[84] In this scenario, however, the mind goes dormant, while the escape trick films' ingenuity evokes a mind capable of thinking one step ahead of the pursuing authorities.

Prison as an anarchic and surreal space is showcased in the trick comedy *The Impossible Convicts*, directed by Billy Bitzer in 1905. The film opens with a guard marching backward down a flight of stairs, followed by four convicts, all wearing prison stripes, who also hop backward, into their open cells (fig. 2.23). Other guards enter and walk backward down the stairs, including a guard carrying a food tray who is suddenly attacked by one of the prisoners, who grabs the guard's keys and releases his fellow inmates. The prisoners run facing forward up the stairs but, upon seeing another guard, they reverse direction, and jump backward into their cells. The guard whose keys were stolen suddenly revives, and, when joined by another guard, he walks backward into one of the cells. The convicts repeat this backward-and-forward motion, hopping into and out of their cells like demented rabbits. They are even joined by the guards, who mimic the prisoners' repetitive movements into and out of their cells. The film ends abruptly with one of the prisoners making one last-ditch attempt to escape by wrestling with a guard at the top of the stairs.

The narrative simplicity of *The Impossible Convicts*, featuring prisoners attempting to escape, is overdetermined by the visual logic of repetitive motion, temporal reversal, and time-warped bodies malfunctioning. As one

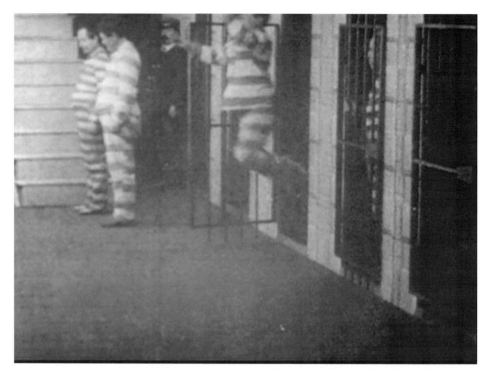

Fig. 2.23 Frame enlargement from *The Impossible Convicts* (Biograph, 1905).

of early cinema's foremost special effects, reverse motion was easy to accomplish (reversing the film in the projector) and delivered a dose of unadulterated and often surprising pleasure to spectators who saw divers jumping out of the water, walls reassembled, and dismembered victims of traffic accidents rendered whole. Reverse motion in *The Impossible Convicts* offers a metaphor for the psychological recalibration of time in prison (there is documented evidence of prisoners perceiving time differently while incarcerated).[85] It also suggests the coexistence of mind-numbing routine, such as the multiple daily head counts when inmates return to their cells, and the grotesque physical fact of incarceration itself. Returning to a space for no reason other than to be counted is on one level a waste of time (although vital for maintaining security), a point underscored by its depiction in reverse, with prisoners and guards bizarrely hopping into and out of the cells. More to the point, the film's title implies that it is the prisoners, rather than the guards, who exercise the most control over their bodies. The word *impossible* in the title, defined in one sense as "incapable of having existence," thus points not only

to the convicts' difficult behavior but to reverse motion, and on a more abstract level, incarceration itself.[86]

As the semantic glue binding several early prison films, impossibility is never far from either the visual grammar of escapes (prisoners removing bars from their windows) or the syntagmatic chains of cause and effect. In *The Escaped Lunatic* (Wallace McCutcheon, 1904) impossibility defines the prisoner's delusional state, since he imagines he is none other than the Emperor Napoleon. Although technically confined in a mental asylum rather than a penitentiary, his cell is virtually identical to that of a prison, with barred windows and Spartan furnishings. The guards wear white suits and hats, however, rather than the more typical military-style uniform worn by corrections officers, flagging the fact that this is an institution for the mentally ill. The film begins with a fight with the keepers over the terrible food; they beat the inmate unconscious, and when he wakes up, he uses the leg of his table to smash through the window and escape, thus triggering the long chase, during which he encounters obstacles such as roofs, water, and hills. The film ends virtually where it began, with the escaped patient jumping through the window of a prison cell, putting on his Napoleon hat and sitting down at the table to read the paper. The madcap chase in *The Escaped Lunatic* is replayed in *The Escaped Convict*, made the same year, and, barring a few plot differences, it adheres closely to the circular structure of the escape-capture-return model. *The Escaped Convict* reinforces the visual carceral logic of the prison uniform as a moniker of captivity; climbing into the bedroom window of a vicar's house, the prisoner steals the civilian's clothes, thus shedding his convict identity. Resorting to wearing the prisoner's clothes in order to pursue the burglar, the vicar is wrongly arrested, and soon after the prisoner is discovered hiding behind a haystack. The film ends with both men at the police station. As in *The Escaped Lunatic*, a dispute, violent in both cases (an escaping prisoner is shot, presumed dead, at the start of *The Escaped Convict*), precedes each escape, leading to a protracted chase and the restoration of order. Neither film engenders sympathy for the prisoner, its novelty value residing squarely in the coupling of the chase, an industry staple around 1903, and the prison setting. Cinema's drive for narrative closure and moral conservatism echoes societal norms about the capture and punishment of offenders: we expect rules about the proper outcome to be observed in both.

The Good Prisoner: Melodrama and Redemption

D. W. Griffith's *The Modern Prodigal* (Biograph, 1910) is a morality tale about redemption and the deleterious effect of the city on a country lad. The film opens with the young man kissing his mother good-bye as she gently strokes his head. The intertitle, "The return in the raiment of sin," cuts to the film's second shot, which shows the same man garbed in prison stripes, running across the frame with the penitentiary he has escaped from visible in the background. Fleeing to his mother's house, the son's body language bespeaks the shame of having to confess to his mother what has happened since he left for the city. In oversized histrionic gestures, the man falls to his knees in front of the chair where his mother had earlier sat, and, searching for her substitute (since she is nowhere to be seen), he hugs a tree before collapsing in tears on the ground. The film's overt sentimentality, melodrama, and symbolism (at one point he resorts to eating corn husks in the pigsty) evince Griffith's small-town-pastoralism values. The remainder of the film follows the fugitive chase formula, with the prisoner evading pursuing guards by sticking close to the banks of a river and, at one point, diving under the water and hiding in a semi-submerged box. Later, the prisoner becomes aware of three boys splashing in the water, one of which begins to drown. The prisoner jumps into the fast-moving river to rescue the boy not long before his father shows up; though indebted to the fugitive for saving his son's life, the father nevertheless escorts the prisoner back to his farm at gunpoint, leaving his wife to ensure the convict does not escape while he prepares the buggy. When the wife drops her guard by falling asleep, the prisoner flees with civilian clothes, once again returning to his mother's farm. This time she is there, her response presaged by the inter-title "My son was dead and is alive again. He was lost and is found," which cuts to the final image, of him being greeted with open arms by his mother. He is redeemed through saving the boy's life, for being a mother's boy, and for pre-sumably turning his back on the city, an antimodern modern prodigal. Griffith goes beyond leveraging sympathy for an escaped convict in very general terms to employing the full force of melodrama to deliver the object lesson. Not only is the man a cherished son, but he also acts heroically, and, rather than return to the iniquitous city, he comes home to his mother. The sins of the original crime are thus expurgated by the selfless act of jumping into the river to save a life.

Life followed art, although with a different outcome, at Sing Sing Prison in 1927, when inmates in the recreation yard saw three young boys slide from

their boat into the water not far from the banks of the Hudson River. Hearing the boys' cries and realizing that they could not swim, several prisoners begged the guards on duty to allow them to jump into the water and save the boys, but the guards refused, fearing that if they unlocked the gates the men would escape. The ensuing tragedy (all three boys drowned) was widely reported in the news media, and Warden Lewis E. Lawes publicly expressed dismay at the guards' rigid interpretation of their duties.[87] The ethical logic of a feared escape under the ruse of being a Good Samaritan plays out in reverse in *The Modern Prodigal*, where the fugitive gives up his freedom to save a young life. Redeemed, the fugitive's family, rather than the state, can now assume the role of rehabilitating the man, as he has escaped not only the penitentiary but also the corrupting influence of the metropolis and modernity.

Griffith also explores the theme of sacrifice in *A Convict's Sacrifice*, a 1909 prison melodrama with a more complex narrative than *The Modern Prodigal*. The film begins with the long-sought-after moment of release, when the prisoner (played by James Kirkwood) is returned his civilian clothes. Our first impressions of prison from this shot are unfavorable; the discharged prisoner is angry, directing a hostile stare at one of the guards, and the convict's instant replacement by a man awaiting processing constructs the prison as a well-oiled machine, churning out the unrehabilitated, who most likely will return sooner or later. Forced to beg food from other laborers, the released man is next seen digging trenches at a construction site, although another worker takes pity on him and shares a lunch brought by his daughter. He gets into a fight with a coworker whom he accidentally kills, and winds up back in jail, back in prison stripes, and back in a cell, where we find him curled up on the floor in a fetal position. The cell bespeaks the medieval carceral aesthetic discussed above: a brick wall of unevenly sized, roughly hewn stone; a small window opening with a wooden cover; a ring attached to the wall for restraining the body; and a metal cot with ill-fitting sheet and pillow. Recovering slightly, the man sits on the edge of the bed as three guards enter the space. We next see the prisoner fettered and marching the lockstep in a chain gang with four other inmates. Griffith painstakingly shows how each inmate has to be unlocked from the fetters before commencing work, using this carceral routine to build suspense and imbue his film with authenticity. Seeing an opportunity for escape, the prisoner dramatically lunges at the camera, running out of the frame in the direction of the audience (fig. 2.24). This is an amazing shot, bold, visceral, and perfectly

Fig. 2.24 Frame enlargement from *A Convict's Sacrifice* (Griffith, 1909).

embodying the volatility of the unfettering; the mise-en-scène, consisting of a chaotic jumble of twisted, striped bodies, dust, and giant rocks, adds to the drama.

The drama mounts as the guards pursue the fleeing prisoner, an action cuing the obligatory chase sequence. Stealing civilian clothes from a scarecrow, the man reenters the frame and, in a dramatic gesture, tosses his prison uniform violently to the ground, cursing at it in the process (fig. 2.25).

Recognized from a fugitive poster, the convict fights off two men and ends up hiding out in the home of his friend from the construction site, whose sick daughter needs medicine the family cannot afford. He tries to persuade the friend to turn him in for the reward money so the daughter can be saved, and, just as guards enter the house, the prisoner takes the reward notice out of his pocket, writes on it, and gives it to his friend. Rather than return to prison for a third time, however, the prisoner suddenly makes a break for it but is shot in the back and killed (fig. 2.26). The film ends with the poignant

Fig. 2.25 Frame enlargement from *A Convict's Sacrifice* (Griffith, 1909).

Fig. 2.26 Frame enlargement from *A Convict's Sacrifice* (Griffith, 1909).

tableau of his friend's wife and two girls standing around his body and placing flowers on his chest.

Like most of Biograph's one-reel melodramas, *A Convict's Sacrifice* hews closely to Griffith's code of moral redemption, a point not lost on the *Moving Picture World* reviewer who felt the film got across the message that "a man is a man, whether clad in the stripes of a convict or in a dress suit. . . . In this picture the Biograph people have emphasized this point forcibly. . . . And when the lesson is taught by a convict it becomes all the more impressive and convincing."[88] Griffith delivers the film's melodramatic punch line in the last two scenes, when a father's inability to provide medicine for his sick daughter triggers the eponymous sacrifice. One scene in particular marks this film as memorable in the history of prison representation: the dramatic escape from the penal colony. Griffith takes pains not just to represent an amalgam of penal practices (the lockstep, fettering with ball and chain, a prison labor camp under the watchful eye of an armed guard), but to introduce "layers of characters building up an encompassing environment" that includes a line of convicts marching the lockstep in the right background and another line entering from the right and "moving at a diagonal toward the foreground, where they begin hammering rocks."[89]

Biograph's *A Famous Escape* (Wallace McCutcheon, 1908), a prison film set during the Civil War, and featuring D. W. Griffith playing one of the prisoners, represents escape not as a high-stakes dash for freedom in full view of the armed guards, but as a calculated group effort, involving the laborious task of digging a tunnel out of the cell. The film is about a soldier's and husband's capture and imprisonment in a military facility where, along with four other captives, an escape is planned. The film's most ingenious shot is of the men digging quietly underground as a guard patrols above. They make their escape but are soon discovered missing, which culminates in a deadly shootout between pursuing guards and an African American man who tries to help them get away. Only two of the soldiers (including the man bidding his wife and children farewell in the opening scene) make it home, where they are reunited with their families. Bookending the film with sentimentalized representations of the rural American family and images of patriotism (a little girl waves an American flag in opening and closing scenes), McCutcheon widens the optic of prison escape to include Civil War soldiers, whom we obviously view differently from other felons, although not that differently, since both groups are represented as victims. The military prison looks little different from any other prison: there is the obligatory medieval-looking brick

wall with metal ring; the guards are clothed in military uniforms; and the prisoners are in bedraggled versions of their uniforms rather than prison stripes.

"Lulled into Lassitude": Final Thoughts on the Prison Film[90]

> Show me an American who looks like Uncle Sam or an Englishman who looks like John Bull and I will grant the possibility of finding a man who looks like the so-called typical born criminal.
> LEWIS E. LAWES, *New York Times Book Review*, 1928[91]

In the Tombs, AM&B's 1906 film set in the Manhattan Detention Complex at 125 White Street in the notorious Five Points downtown neighborhood, renowned for its street gangs and vice, is a wonderful example of cinema's polysemous representation of incarceration during the early cinema period. It contains virtually everything we would expect to see in a prison: a cell, a barred door, a dark interior space, guards, and visitors. Two women are shown in the film: the first, dressed in black, is most likely the inmate's wife; the second is coded as his mistress or even a prostitute. Women visit men a lot in prison movies (even to this day, women visit men far more often than men visit women, since men move on quickly and find replacements for their incarcerated others), so this film must have resonated with female spectators who possibly identified with the two women who dutifully show up to visit their man. Responding somberly to the first woman, whose hand he shakes through the bars just before she departs in tears, the prisoner is elated to see the second woman, dressed in a white gown with matching gloves and a straw hat. The guard crosses his arms nonchalantly when she races in, body language suggesting that at the Tombs this is par for the course. Desiring a more intimate encounter with the second woman, the prisoner bribes the guard to open the cell door so he can step outside and passionately kiss her. Prison is thus the setting for a romantic tryst, the woman in white quite possibly the cause of the man's imprisonment. So smitten is the prisoner by this woman that the guard has a hard time dragging the man back into the cell, but eventually succeeds in separating the couple. *In the Tombs'* brevity and simplicity belie a more complex metacomment on imprisonment; first, it codes prison as a place of corruption; second, it privileges a voyeuristic gaze, heightened by the Tombs' reputation as a scandalous, vice-ridden jail; and third, its

representation of an illicit encounter reminds us that prison is a place where sexual behavior is always covert, unsanctioned (unless the prison permits conjugal, aka "family," visits), and brief.

The early cinema prison film constructed a speculative gaze about penitential life, as an image of a prisoner wearing a striped uniform told only half the story. Cinema told enough of a story, however, to make the prison film a safe commercial bet, since the prison break, chase, and capture formula fit perfectly with Hollywood's emerging classical style. Actualities were promoted as a series of sensational moving vignettes, as seen in an ad for *Life in a Western Penitentiary* (Citagraph, 1914) from *Moving Picture World*, which likened the film to a walk through the midway at a world's fair: "See the place, 645 Convicts in real life, the Prison Records, Bertillon System, Snake Hole Dungeon, Life Termers, Ball and Chain Men, Cells of Death Watch, Cell Houses, Condemned Prisoners, Death Trap and Black Cap, Convict Burial, Prison Grave Yard, *everything boiling with intense interest*, a true moral lesson but not overlooking the drawing power."[92] Prison gave ordinary people, who were not privileged either via politics or celebrity, virtual access to the space of corrections.[93] Melodramatic story lines, scenes of corporal punishment, histrionic acting, and, in some instances, the eschewal of verisimilitude make it difficult to generalize what these films meant for either historical or contemporary audiences.

Several of the films discussed in this chapter remind us of prison's permeability and liminality.[94] These films locate prisoners on the borders between captivity and liberty, a space we all technically reside in until circumstance or a lapse in judgment changes everything. Prison interiors were conventionalized during the early cinema period, influenced by a custodial (medieval) architectonics that spawned a Gothic romanticism that was especially influential for nineteenth-century writers, whose classic tales of imprisonment and escape "deepened and enlarged the basic prison metaphor and its associated paradoxes."[95] The cell's prescriptive iconography is a metaphor for a highly regimented and homogeneous existence, and yet prisoners, like all human beings, are highly adaptable, as Zamble and Porporino argue in their study of the various coping mechanisms utilized by Canadian prisoners.[96]

We become proxy viewers to carcerality and acts of corporal punishment in these films, technologies of correction that read as anachronistic, although they were likely still practiced in many U.S. prisons. And if these films share a blind spot, it is a total disregard for reform measures such as prisoner edu-

cation or recreation.[97] In many respects, these films are anachronistic, hyperbolic lightning sketches of an imagined carceral life in which inmates are hell-bent on escaping, inciting riots, or breaking prison rules. They project audience fantasies about what life inside must be like, as well as serving as prescient reminders of the approaching end of penal progressivism. Did inmates enjoy seeing prison- or crime-themed films? There is scant discussion of this topic, although when questioned on it, Warden Lawes of Sing Sing noted that prisoners liked crime films, "but only to a limited extent," and found stereotypical representations of a hoodlum, with a "twisted nose, large ears, and wear[ing] a cap tightly pulled over his head" amusing to say the least. Lawes also acknowledged that it was "impossible to state with any degree of accuracy to what extent such pictures check the tendencies of prisoners to commit crime."[98]

The stylistic range of films examined in this chapter coalesces around three ideas: that reform is achieved through moral fortitude rather than prison; that prison is a place of violence; and that prison takes a psychic toll on the individual, especially in solitary confinement. Touring Eastern State Penitentiary in 1842, Charles Dickens was shocked to the core by the inhumanity of the separate system and the way in which it ground away at selfhood: "I hold this slow and daily tampering with the mysteries of the brain to be immeasurably worse than any torture of the body; and because its ghastly signs and tokens are not so palpable to the eye and sense of touch as scars upon the flesh; because its wounds are not upon the surface, and it extorts few cries that human ears can hear; therefore I the more denounce it, as a secret punishment which slumbering humanity is not roused up to stay."[99]

Two of the most commonly articulated criticisms of prison life, its numbing routine and constancy, are at odds with cinema's narrative drive. These films construct prison either as a series of caught glimpses of the incarcerated (as in the early actualities of marching prisoners, the chain gang, or prisoners waiting to enter a mess hall) or as action-filled dramas that get the iconography more or less right, but have a harder time moving beyond the surface details and melodramatic escapes. And yet, as I have argued, early cinema's trick films and special effects function as highly suggestive entry points into inmate subjectivity, even speaking to the violence never far from the surface in the prison-industrial complex. Unlike canonical prison films from the golden era of prison films, the 1920s and 1930s, such as *The Big House* (George W. Hill, 1930), *The Criminal Code* (Howard Hawkes, 1931),

I Am a Fugitive from a Chain Gang (Mervyn LeRoy, 1932), and *20,000 Years in Sing Sing* (Michael Curtiz, 1933), which coalesce around the theme of the wrongly convicted, innocent man, films from the early cinema period have no prevailing ideological agenda (other than to situate audiences on the side of little guy rather than authority), making it impossible to group them into taxonomical categories.[100]

The grim realities of prison are only hinted at in these films, and suffering is suggested through the iconography of walls, chains, and bars. Slop buckets, poorly ventilated cells, vermin, and overcrowding are present by omission only, but the evocation of human suffering is pervasive. The olfactory and auditory landscapes of prison are occluded, and while the arrival of sound in Hollywood would address the latter, the smell of prison could only ever be hinted at through reaction shots and abject imagery. When asked in a 2003 BBC radio interview what was missing in media representations of prisons, British poet and playwright Benjamin Zepheniah said, "The smell of the place. . . . We used to slop out . . . you've got the smell of four to six people's urine, the smell of masturbation, in one little room."[101]

Seeing incarceration is an oxymoron—how can such a psychological experience be represented through a visual register? The prison film engenders an ambiguous response in viewers, triggering both contempt and fascination. Janus-faced, we are punisher and punished, weighing up a prison film's success and appeal like any other entertainment. In her analysis of Vincent van Gogh's *La ronde des prisonniers* (The exercise yard, or The convict prison) (1890), based on an engraving of Gustave Doré's sketch of prisoners exercising at Newgate Prison in London and painted by Van Gogh while he was a patient at the asylum in Saint-Rémy, Claire Valier finds psychoanalysis, especially the theories of Melanie Klein, useful in exploring our subjective investments in viewing acts of punishment.[102] The son of a civil engineer, Gustave Doré was a celebrated graphic artist in his native France. He first visited London in 1868 and compared the prisoners circling in the exercise yard at Newgate Prison (fig. 2.27) to a "chain of portraits" and a "moving coil" of individuals identified by their occupations and crimes, their faces helping narrate their helpless plight and damnation.[103]

Van Gogh's "The Exercise Yard" depicts forty or so male prisoners walking in a tight circle in a space reminiscent of a medieval fortress (there is one arched window on the rear wall and three on the right-hand one); two of the men—the only prisoner not wearing a hat, and the man directly behind

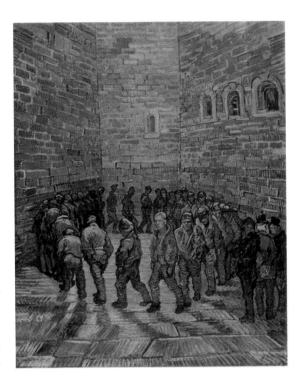

Fig. 2.27 Vincent van Gogh's *La ronde des prisonniers* (The exercise yard, or The convict prison) (1890), based on an engraving of Gustave Doré's sketch of prisoners exercising at London's Newgate Prison. Wikimedia Commons, https://commons.wikimedia.org /wiki/File:Van_Gogh_10.jpg

him—turn to look toward the viewer, a man presumed by most critics to represent Van Gogh himself. The prisoners' return gaze breaks the circuitous monotony of the exercise, but more significantly, it imputes coresponsibility for the punishment to the viewer. Images such as *La ronde des prisonniers* as well as the countless motion pictures made since cinema's emergence have not just supported popular images of incarceration but been responsible for their creation (we are, after all, the taxpayers who fund prisons). We are surrogates for the state that incarcerates, and the prisoner returning our gaze reminds us that witnessing is never just about seeing, but is bound up with questions of power, access, accountability, pleasure, and guilt.[104]

Analogous to a journey into the world of the ethnographic other, virtual encounters with prisoners enshrine what Auli Ek calls the "'low'—in terms of social, moral, and sexual deviance—morphed and fetishized through the narrative focus on dirt, bodily functions, violence, and sexual perversion."[105] Yet few of these themes could be graphically represented in films regulated by emerging industrial norms and discursive regimes policing cinema and culture at the dawn of the twentieth century.[106] Early prison films are enigmas

in many respects, conforming only partially to the "prison film as morality play" thesis.[107] They institutionalize the iconography of the carceral aesthetic while simultaneously offering bizarre, oneiric encounters with a prison system that few, at the turn of the twentieth century, imagined would transform into the industrialized complex of mass incarceration that it has become. Even though we see emerging typologies of the wrongly convicted or sympathetic prisoner, benevolent warden, and corrupt guards in some of these films (D. W. Griffith's 1909 *A Convict's Sacrifice* is one example), the trick films analyzed here are more effective at evoking prison's discombobulating effect, its structures of feeling, if you will, than are the classic prison films of the 1920s and 1930s that single out individuals who prevail over the system rather than the nameless masses who people the penitentiaries.

The penitentiary has remained an enduring, if paradoxically elusive, image in Western visual practice. As literary theorist John Bender argues, "The very nature of the penitentiary as a representation of a representation works to explain both its practical failure and its ideological persistence."[108] While we might be cocreators of this mythical image of the prison, picturing ourselves "at once as the objects of supervision and as impartial spectators enforcing reformation of character on the isolated other," I would wager we are also resisters, border dwellers who can never quite decide on which side of the law we reside. "Punishment puzzles us," in part because a period of relative penological optimism in the twentieth century in prison history has "given way to a persistent skepticism about the rationality and efficacy of modern penal institutions."[109]

These films offer us vital clues as to why we adore and abhor confinement and punishment, watching, as prison film theorist Mike Nellis argues, in a state of "tense bewildered neutrality, identifying one moment, repelled at the next."[110] Cinema's utility as a governing, disciplinary apparatus that reinforces normative values about how society deals with its miscreants is definitely on show here, but with several important caveats: there is a barely concealed libidinous desire in many of these films, one that can be traced to sensational images of punishment predating cinema discussed in the previous chapter. Thomas Hardy was troubled (and, it would seem, aroused) when he saw convicted murderer Elizabeth Martha Brown executed outside Dorchester Jail: "What a fine figure she showed against the sky, as she hung in the misty rain, and how the tight, black, silk gown set off her shape as she wheeled half round and back."[111] Even though a cloth had been placed over

Brown's face, as it began to rain "her features came through it," an image he described as "extraordinary" and could never get out of his mind for the rest of his life (Tess's hanging in *Tess of the d'Urbervilles* re-creates the scene). Like a photograph developing in sensitized chemicals, Brown's image also evokes the death mask, although it is hard not to read her rain-drenched face as a symbolic snub to the authorities that tried to conceal her (or afford her some modesty) in her final moments on earth. Brown's humanity seems to bleed to the surface of the cloth, a point not lost on Hardy. Early prison films also access these traces of humanity, in eclectic, oft-forgotten films that weren't shy about rewriting aesthetic and ideological rules. As Sergei Eisenstein wrote, "People must . . . feel their humanity, they must be human, become human"—a narrative drive in a great many prison films made at the height of the genre's popularity in the 1930s and 1940s but eschewed in the superhuman powers of the convict in the prison trick film.[112]

humanity

PART TWO

THE CARCERAL SPECTATOR

Chapter Three

Screens and the Senses in Prison

From the Oldest lifer to the latest arrival, they sat in the dark
hall of the prison . . . and enjoyed a bill [that] comprised the
very best films and vaudeville numbers.
Hartford Courant, 1914[1]

We reorient our attention away from films representing prisons and inmates
to how the nascent industry found a home in U.S. penitentiaries in this
chapter. Prison films tell/imagine only one small part of what it is like to be
incarcerated; examining the experience of watching films *in* prison, it turns
out, does an even better job of taking us into the world of the prisoner than
films do. While we may think we know something of the nature of filmgoing
in prisons from Hollywood films showing convicts mesmerized by the screen,
exposed to dangers such as fires from flammable nitrate, or taking advan-
tage of distracted guards to stage a riot,[2] there is little understanding of how
film gained a foothold, meshed with existing reform initiatives, or supported
new efforts at rehabilitating and Americanizing the largely immigrant in-
mate population in New York State prisons.[3]

Drawing upon the fields of penology, film history, and critical prison stud-
ies, I begin with a brief examination of reform efforts preceding and coexist-
ing with cinema and a discussion of how film, as a space and time machine
par excellence, was affected by new understandings of what it meant to live
in a radically circumscribed space and under the watch of carefully controlled
institutional time. Next I explore popular culture's fascination with the
screening of motion pictures in prison, including the way in which the exten-
sive press coverage at the turn of the last century constructed moviegoing in
prison as a novelty and a progressive social experiment. Indeed, the fascina-
tion with prison cinema stems in part from its hypervisualization *in* cinema.
The bulk of the chapter is concerned with constructing a portrait of what it

113

was like to be a film spectator while incarcerated, exploring whether a culture of filmgoing in prison, in which, as Haidee Wasson and Charles Acland argue, cinema was required "to do something in particular," in other words, become useful, was ultimately more similar than dissimilar to filmgoing on the outside.[4]

Paving a Way for Motion Pictures: Lectures, Concerts, and Vaudeville in Prison

Lectures and musical concerts were initially held in prisons on special occasions, usually holidays, as a treat or reward for prisoners. Lectures were also given both in prison schools as part of formal education and to the larger inmate population. At Elmira Reformatory in eastern New York State, lectures, along with examinations and private readings, were thought to "sharpen the intellect instead of dull[ing] the mind by suppressing opinion or failing to encourage its freest expression."[5] An unprecedented number of lectures and performances were delivered in Auburn Prison near Syracuse in December 1914 and January 1915, nightly from December 21 to 24, and then again on December 26 before resuming for three nights, January 11–13. The lectures covered such topics as Rudyard Kipling, wireless, leather tanning—in which Mr. Emmerson "took his audience on a trip with him through tanners, cutting, binding and bottoming, showing each process and lots of leathers" during the talk—and a travelogue on Christmas Eve richly illustrated from the lecturer's forty-two trips across the Atlantic. "For an hour we *lived and moved and had our being in a veritable kaleidoscope* of changing light and color," wrote the reviewer in the *Star of Hope*.[6] It is tempting to brush off the armchair travel reference in this review as a clichéd, certainly conventionalized by this point in the mid-1910s, response to illustrated lectures (the lecturer identified himself as the son of a railroad man rather than a "literary man or author"). And yet the phrase "had *our being* in a veritable kaleidoscope of changing light and color" suggests an embodied, subliminal response that went beyond what the average lay audience might have felt at that time, especially given how old-fashioned a lantern slide show might have felt in 1914. The reference to living and moving for the duration of the lecture also makes palpable its antithesis, the utterly predictable, mind-numbing daily grind of the prison. When we factor in the popularity of travel books among prison readers from the turn of the twentieth century to 1930—a piece in the *Balti-

Fig. 3.1 Inmates attending performance in the auditorium at New York's Elmira Reformatory, ca. 1920. New York State Archives, Albany

more Sun from 1930 noted that "even more enjoyed [than detective stories] are the travel stories. They globe trot through Africa, China, South America and the Arctic by way of the printed page"—then it is easy to see why travelogues were so popular as lecture topics.[7] Prisons also screened travelogues and industrials to their army of "armchair Columbuses"; from the relative comfort of the new auditorium at Elmira (fig. 3.1), "many journeys are taken by land and sea to the far corners of the earth," noted Dr. Frank L. Christian, superintendent of Elmira Reformatory, in 1930.[8]

Anticoddler Charles Dudley Warner was skeptical about lectures, this so-called rose-water treatment (he referred to lectures as a "sort of treatment"): "Holidays, occasional fine dinners, concerts, lectures, flowers—we are going ridiculously far in this direction unless we add a radical something to this sort of treatment that will touch the man and tend to change his nature and inclination."[9] Sheriff William H. Jackson also railed against what he called

"sentimental methods of crime prevention now in vogue" (baseball leagues and motion pictures) found in large prisons: "What is permissible in Atlanta or Sing Sing is not good practice in Denton," he said.[10]

Lewis E. Lawes, Sing Sing's celebrated warden, pinned high hopes on the reformative power of lectures, aligning them with other institutional efforts to "encourage the 'man behind bars' to develop and retain normal reactions, and to dissipate, as far as is humanely possible . . . the oppressiveness of prison life."[11] Lawes instituted Sing Sing's lecture series in the 1920s to "make up the deficiency in entertainments when the prison was divided by the new cell block" (those in the old cell block had access to more organized events to get them out of their cramped cells, described by Charles Edward Russell in 1909 as a "frightful place, very dark, damp, and to the senses pungently suggestive of long and odorous occupation").[12] Clergymen, educators, scientists, and military officers were among those invited to speak. Prison authorities also used recreation to stave off depression and to keep the men as healthy and productive as possible since, if confined in their cells, they would only be at risk for the rampant tuberculosis, pneumonia, and syphilis.[13]

Musical performances, such as concerts and vaudeville, also broke the monotony and were viewed as essential components of a modern, progressive penology. Music was felt to have special reformative powers. As put by Lawes, "Music brings something more than the deliberate meaning. Music brings to each man what he needs most, and it gives him something personal to build on."[14] Like prison lectures, concerts were organized by charitable groups such as the Ladies Auxiliary of the Society for the Aid of Jewish Prisoners, who brought in Mrs. Nathan Grad to perform at Sing Sing in spring 1900. The following year, the Auburn City Minstrels and the Ossining Banjo Club performed for prisoners at Auburn Prison at Thanksgiving, when phonograph recordings and pianoforte followed a meal in which chicken (a culinary treat) was served. The minstrels repeated the show over the wall in New York State Prison for Women on December 5, 1901, for the women inmates who were entertained for two hours with an opening juggling act, "songs, jokes, [and] dancing," including a "genuine coon song, 'I'm Goin' To Live Anyhow Until I Die.'"[15] Groups, such as the Pennsylvania Chautauqua Society, also organized musical concerts for the men. As the chapel space at Sing Sing was deemed inadequate for "an aggregation of Italian music of exceptional

ability" given in 1914, the mess hall was used since it was "the only place in the prison in which all the inmates could be assembled at the same time."[16] Substituting the mess hall for the chapel (which could only hold about 1,200 men) was probably done to mitigate the need for a repeat performance, and the timing of the concert immediately after dinner also made the mess hall a logical space to entertain the men.[17] Prisoner musicians were just as likely to perform in concerts as invited groups; for example, on September 12, 1912, inmate number 64791 coordinated an open-air concert at Sing Sing in which "sweet, harmonious and entrancing" strains of music that "sent gloom and melancholy . . . scurrying down into the lanes of oblivion" brought "smiles of satisfaction" to all those fortunate enough to be within earshot ("scurrying" is a curious verb choice, suggesting that dark thoughts are akin to the rodent life of the prison, forever present, sometimes visible, and always scampering out of sight).[18]

A vaudeville show at Auburn Prison in December 1914 featured nine acts, including pyrotechnics, contortionists, violinists, and musical sketches, rounded off with "nine full reels" of motion pictures and "the latest and best in the way of up-to-the-minute kinetics."[19] A half day of "wholesome fun" was organized at Clinton Prison in upstate New York in January 1901 consisting of "jig dancing; clog-dancing; tumbling; club-swinging; monologue; dialogue; mandolin solos; vocal solos; glee club; Dutchmen with their Bologna; Hibernians with their brogue; Africans with their color and their song; character actors and the barroom scene with its humor and pathos."[20] A vaudeville show in February 1915 featured ten acts separated by an intermission and an overture played by the Mutual Welfare League orchestra (fig. 3.2).

Several things can be gleaned about the role of libraries, lectures, concerts, and vaudeville in not just paving the way for cinema, but making life more tolerable for the prisoners (and probably the authorities) and transforming the prison into a hybridized, carnivalesque space where laughter, merriment (though never of the bacchanalian kind), and different kinds of shared memories could be forged. These leisure activities did several things for the inmate population: they made them compliant, literate, and in some instances a little bit more American, although it is just as likely that travelogue lectures about a prisoner's homeland triggered a strong feeling of nostalgia and cultural identity.[21] Christian, superintendent of Elmira, summed it up best

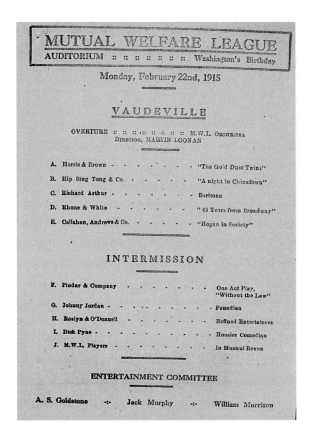

Fig. 3.2 Vaudeville lineup, Auburn Prison, New York, 1915. New York State Archives, Albany

when he wrote about the purpose of recreation in the late 1920s: "Through its many diversified activities . . . [it] has contributed to the gratification of the individual's desires, the development of group consciousness and the acquisition of proficiency in cultural and masculine accomplishments."[22]

More practically though, recreation was a means to an end insofar as it created compliant subjects and, in the case of physical sports, an outlet for pent-up frustration and energy. At Elmira, inmates played varsity sports against outside teams, and an "honor inmate" system that included a "social hour" during which boys played chess, bridge, and checkers and chatted, fostering fair play, bringing the boys into contact with so-called normal boys, and encouraging good sportsmanship.[23] Recreation piqued the imagination, maybe even releasing endorphins into the body, triggering memories, thoughts, feelings, and perhaps a sense of hope.

Space, "Air Castles," and the Sensory Landscape of Prison

> You've got nothing in prison without memory. . . . Without
> memory you'd become institutionalized, an automaton.
> BRITISH INMATE GEORGE, ca. late 1990s[24]

Prison wreaks havoc on the senses, trapping the body in a constricted, in-
hospitable world where agency, dignity, and vivacity are in short supply. The
same senses are engaged in prison as in the free world, but as a disciplinary
space governed by paternalistic ideals and structures of surveillance, the
prison acts upon the human sensorium in distinctive and unforgiving ways.
At the turn of the last century, and continuing into the present, life in prison
was experienced as a series of oppositions that either numbed the senses or
extremely heightened them to subtle changes: the dark, tiny, claustrophobic
space of the single-occupancy cells that at Sing Sing were 7 feet long, 3.4 feet
wide, and 6.7 feet high (fig. 3.3); the expansive prison chapel or exercise yard;
the misery of weekends locked up in cells where time seemed to stand still

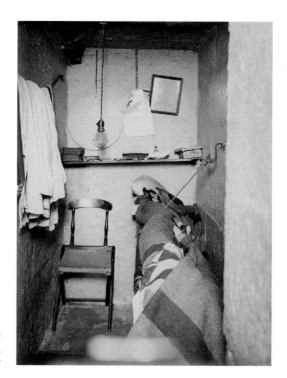

Fig. 3.3 Sing Sing cell, ca. 1900.
Wikimedia Commons, http://commons
.wikimedia.org/wiki/File:Sing_
Sing_(prison)_-_cell.jpg

compared to the too-brief visits by loved ones; and the dirty, noisy workshop, where hands grew coarse weaving baskets, stood in contrast to the daylight and fresh air of the yard. Even death could be sensed behind bars, a blind witness to electrocution once giving to Warden Lawes a "fair description of what happened, saying he was able to 'sense' what was going on."[25]

Whether maintaining security in the cell blocks, regulating access to the recreation yard, establishing a prison library or classroom, or resignifying the space of the chapel into a concert hall or motion picture theater, controlling space and people's behavior in it was paramount in prison. In *The Production of Space*, Henri Lefebvre argues that space "implies, contains and dissimulates social relationships," a point of huge significance for incarcerated subjects, whose world was so attenuated that the social became inscribed in the spatial in markedly significant ways.[26] Given that access to space was highly circumscribed in prison (outdoor space being the most prized), cinema's disregard for the fixities of time and space must have either rubbed salt in the wound of imprisonment or had the opposite effect, bringing virtual freedom, dare I say escapism, for the duration of the picture.

Long before motion pictures were screened for inmates, prisoners overcame their spatial limitations by using their imaginations to elude the drudgery and tedium of confinement, what one inmate in 1899 referred to as building "air castles," a psychic process that resonates metaphorically with cinema. According to Auburn inmate number 25551, "It is when we build 'air castles' with the eyes shut that our mental vision is clearest. . . . Distance is overcome so easily that thought may be one moment in America, the next in Europe. . . . We may cross the wildest mountain passes, span the broadest deserts. . . . What a wonderful journey, how cheap, how enjoyable, how free. . . . And all this journey can be mentally made in a single hour."[27] Reminiscent of the promotional hype of early cinema travelogues, the reference to Europe in this air-castles exercise acknowledges both the large immigrant makeup of the incarcerated population (which by the early 1900s stood at roughly 40 percent) and the kind of mental activity undertaken by inmates who spent an inordinate amount of time in their cells.[28] Mentally constructing air castles was a way of bringing the large and expansive into the small and confined, as the French philosopher Gaston Bachelard argues in his discussion of the miniature in *The Poetics of Space*: "How many times poet-painters, in their prisons, have broken through walls, by way of a tunnel! How many times, as they painted their dreams, they have escaped through a crack in the wall! And to get out of prison all means are good ones. If need be, mere absurdity

can be a source of freedom."[29] Gendering the imagination, Kierkegaard compares the relative quiet of the daytime mind, like a "diligent maid who sits quietly all day at her work," to a force that upon the fall of darkness becomes more active, more dangerous even, and "can speak so prettily for me that I just have to look at it even if it isn't always landscapes or flowers or pastoral idylls she paints."[30] The idea of air castles is significant, therefore, not only for clawing back agency on behalf of the prisoners but for better understanding how they tried to stay sane using techniques that share an affinity with Kierkegaard's theories of mental circumvention. Existentialist thought could even be used to explain the discrete pleasure of the motion picture: "Amusement . . . will lift those who see it out of themselves, out of their surroundings, which for one reason or another may be irksome, or depressing, and *place them, temporarily, at least in an imaginary world where things seem to go right*, and where discouragements and disappointments are apparently alike unknown," editorialized the *Moving Picture World* in 1909.[31] An Auburn inmate writing in 1916 easily recognized the elliptical, cinematic quality of memories, titling his poem "Memory's Motion Picture Show":

> Within my prison cell I lay; the sun was sinking low;
> Fond memory brought me pictures of the happy long ago
> I saw myself again a boy, with other lads at play . . .
> Just then to view there came the brook, where I once loved to roam
> In memory's motion picture show of dear old home, sweet home
> Another reel and then I saw beneath a summer's sky,
> A mother in the doorway as she kissed her boy good-bye.[32]

Memory as a motion picture triggered the exact opposite reaction for another Auburn inmate, who described "lonely vigil with his memories," "hideous ghosts from long ago," and each moving scene a black record or a "flitting picture upon the screen."[33]

Jack London's 1915 novel *The Jacket*, published under the title *The Star Rover* in the United States, is an extraordinary take on the air-castle theme. In it, convicted murderer and former professor of agronomics Darrell Standing is strapped so tightly into a straitjacket as punishment for abusing the guards at San Quentin that he loses all sensation in his body and hallucinates time and space travel, akin to the Hindu concept of the transmigration of the soul. Standing's out-of-body experiences, in which he journeys back to his previous incarnations, function as a metaphor for cinema's capacity to dissolve spatial and temporal barriers—the book opens with the line "All my

life I have had awareness of other times and places"—and in chapter eleven, when Standing feels that his expanding brain has moved outside his skull, he recalls, "Time and space, in so far as they were the stuff of consciousness, underwent an enormous extension. Thus, without opening my eyes to verify, I knew that the walls of my very narrow cell had receded until it was like a vast audience-chamber."[34] London's powerful narration, especially the bone-shuddering evocation of San Quentin's solitary confinement unit, makes even the metapsychosis scenes "seem very real to the reader."[35]

But even without access to artificial or natural light, as in some solitary confinement (special housing units [SHU]), prisoners have projected images on the backs of their eyelids as former Alcatraz prisoner Leon "Whitey" Thompson did when serving time in "The Hole" at Alcatraz in the early 1950s. The audio guide given to all tourists visiting Alcatraz includes Thompson's voice as a narrator; when the tour reaches the solitary confinement cells, Thompson tells the visitors how to start building air castles: "Close your eyes and seal it off, seal your eyes off wit' [*sic*] your hand. With a little concentration, you can see a light . . . and pretty soon, that light'll get brighter, and you've gotta concentrate on this. And after a while, not a short while, this takes time and practice, but pretty soon, you can almost put your own TV there, and you can visualize, you can see things, and you can go on trips. And this is what I did."[36]

Music permeating from neighboring cells was another way to trigger air castles. Permission to play a musical instrument in the cell was considered a milestone for men "whose minds tire of reading and walking from one end of the cell to the other, and staring blankly at whitewashed walls, who wish to drown the dark thought that cross[es] their unhappy minds, and who wish to be spared from insanity and worse." Unlike the concert performances, music coming from the cells had an ethereal quality to it, since it was often hard to know exactly where it was coming from, and men playing other instruments would often join in. Auburn inmate number 26336 had this to say about the sounds he heard: "As I write these lines, from the Gallery below comes a sweet, faint murmur of music, played softly on a guitar. The melody is taken up by a violin and harmony added by a banjo, played by a man on the Gallery above. The music swells—nothing is heard except these sounds that seem to come from heaven."[37] A bugle sound was also used at Sing Sing to call the men in from the recreation yard and baseball field to the prison chapel, an efficient way to garner attention and reminiscent of the bugle's use in mili-

tary taps.[38] Even the more prosaic sounds that made up the auditory carceral landscape, the "occasional cough, the sound of a stealthy football, the jar of some iron door or the clank of a distant bolt or bar," were amplified in the prison setting.[39]

This was an era of "unprecedented amplification," according to historian John M. Picker, "alive with the screech and roar of the railway and the clang of industry, with the babble, bustle, and music of city streets, and with the crackle and squawk of acoustic vibrations on wires and wax."[40] No surprise, then, that the auditory faculties of Sing Sing prisoners, who stemmed mostly from New York City, were especially heightened as a result of possessing an ear practiced in the acoustic vibrancy of urban life, an era of "close listening . . . an auscultative age" hastened by the invention of the stethoscope in 1816.[41]

Sounds in the prison cell could very well have been a stimulus for air castles; the sounds of keys, slop buckets, metal doors, a train whistle, the nighttime tapping of pipes as a medium for telegraphic communication, and the human voice were all amplified, creating a kaleidoscope of sounds that rarely changed.[42] Outside of the cell, organized concerts and community singing were designed to lift spirits and alleviate boredom; during inclement weather, the inmate population was frequently "turned into the auditorium where they are allowed to participate in a period of community singing. These sings cheer up the group, encourages them to forget their troubles and influences them into a buoyant spirit which is conducive to resocialization."[43]

Incarcerated individuals experienced time as well as sound and space differently when incarcerated; rather than using time, or preferably taking time, inmates tended to "pass through" time, existing, not unlike the phenomenon of motion pictures, in an eternal present tense.[44] The temporally governed life of an inmate locked in his or her cell at precisely the same time every day took on something of the quality of sidereal time, a time-keeping method used by astronomers to identify the optimum position for pointing a telescope at the sky.[45] Osborne referred to sidereal time in October 1912, when, under the pseudonym Tom Brown, he was imprisoned in solitary confinement as part of a weeklong stay at Auburn Prison to investigate inmate conditions (fig. 3.4). According to Osborne's biographer, Rudolph Chamberlain, "Sidereal time marked the interim as a single day, but experience had made it an era."[46] Admitting that "usually [I am] very good at guessing time, but in this place I am utterly unable to make an accurate calculation," Osborne noted

Fig. 3.4 Prison reformer Thomas Mott Osborne appearing as Tom Brown for undercover weeklong stay to determine prison conditions at Auburn Prison, New York, 1912. OFP

that his ability to *gauge* the time of day underwent a bizarre shift, as ordinary sensory stimuli were replaced by a void that paradoxically made the senses extraordinarily sensitive to subtle changes in the environment, such as the sound of approaching footsteps.[47] Osborne referred to prison as "this hideous, imbecile, soul-destroying system," and on the morning he was released, compared the experience to that of life being drained from his body: "I have a feeling as if nothing were alive, as if I were a gray, uneasy ghost visiting a city of the dead. The only thing suggestive of life seems to be the sound of my heavy shoes upon the stone pavement."[48]

The sidereal time of astronomers' stargazing also evokes the viewing of motion pictures in prisons, which likewise ran by the clock (most often Sunday afternoons), was consumed as units of time (i.e., reel lengths), and provided a vantage point from which to gaze at a distant space and time. Of course, the fixed length of the prison sentence, the idea of doing time, makes plain the redefinition of time within the penitentiary. Time in the prison is

experienced as something to be marked off, reduced if released early on parole, and either done hard or done easily (the very young and very old inmate populations tend to do easier time while those entering in their prime suffer the most).[49] Bodies were governed in prison (and arguably in the factory or school) through restrictive spatial and temporal logics; as prison theorist Caleb Smith argues, "The captive in the penitentiary is violently arrested in time, painfully fixated upon the past while the years creep by."[50]

Reading and writing poetry were other ways prisoners built air castles. Both were a serious business behind bars, especially poetry writing, an activity "not . . . solely for the purpose of whiling away the dreary moments of leisure when the thoughts try to find utterance in some way, nor to calm the mind only, but because the composer knows it is his moral duty." Writing poetry was considered a vigorous mental workout, an activity that could nourish and strengthen the moral compass and impact the entire body, as an anonymous contributor to the *Star of Hope* explained in 1900: poetry was capable of "stimulating and strengthening the . . . mind, thereby reacting upon his body, weakened from long and close confinement in prison, making him stronger, wiser, and better."[51] More so than books or lectures, composing and reading poetry would trigger a mental release, regenerating not only the mind but also the entire body. Poems were regularly submitted to the *Star*; for example, during the magazine's first year, 388 poems of various genres and styles of verse were submitted, constituting 11,958 lines of poetry. Reflecting upon all aspects of the incarcerated self, these poems were composed in the smallest of prison spaces, the cell, where the mind was arguably the most active.

Reading in the cell was somewhat similar to reading in another confined space where people increasingly found themselves in the second half of the nineteenth century: the railway car, a space inculcating new patterns of Victorian readership and social mores. While there are obvious differences across these spaces, both produced captive subjects that turned to reading to while away the time, avoid having to talk to people, and create *some*-time out of what would otherwise be a *non*-time, before arriving at a destination or getting out on parole. Of course, this does not factor in the experience of travel as novelty, the journey culminating in a new locale, or the excitement of moving through space at speed. And while the subject of the railway and cinema has generated considerable scholarship, cinema was literally conjoined with trains in 1909, via a plan by an Italian engineer to install moving picture screens in railway cars. Touted as a "powerful advertising scheme," the

traveler would "see on a screen in the car the different views, buildings, monuments, art treasures, etc. of the different countries they were passing through . . . [and] the different local industries."[52] An announcement for an American version appeared in the trade press two years later, although this version offered a prototype of today's electronic train indicator, in which lantern slides with the latest train information would be displayed on the platform. Train depots were also considered potentially profitable parallel spaces of entertainment along with moving pictures on trains.[53]

If the railway car and prison cell are ultimately more dissimilar than similar, they nevertheless invite speculation about how they functioned as spaces of nontraditional media consumption. In similar ways to the books, journals, newspapers, poems, and magazines consumed in the cell and train car, motion pictures punctured the boredom and introduced a new routine: going to the movies in a carceral setting. It is hardly surprising, then, that when films first began appearing in prisons, journalists jumped on the novelty value bandwagon of film being shown to audiences that were not trapped in the Marxist sense, but literally confined. This imbued much of the coverage of motion picture use in prisons with a pseudo social scientific feel, as if the journalists were reporting on an experiment in which the prison was the laboratory and cinema the research variable.

Film in the Prison Chapel: Virtual and Real Escape

> When you're up in the chapel, conduct yourselves like men not kids.
> Lewis E. Lawes, Sing Sing warden, 1932[54]

Virtually all prisoners in the United States watched motion pictures in the chapel and still do in modern correctional facilities. Despite its sanctified status, the prison chapel is historically one of the more risky spaces in the institution where breaches of conduct were routine and men and women could break prison rules. Under the "separate system" introduced in the United Kingdom in the mid-nineteenth century, which purportedly prohibited prisoners from speaking to one another through a doctrine of strict separation that was policed (if never completely enforced) via surveillance and uniforms (men and women wore bizarre headgear to curtail vision [fig. 3.5]), Pentonville Prison's chapel in London had four hundred distinct stalls (also known as "sittings") (fig. 3.6) "so arranged that the officers on duty . . . may have each

man under their surveillance." The chapel pews were modified through the addition of partial screens to ostensibly prevent prisoners from either seeing or communicating with one another and to assist the officers on duty with the task of surveillance.[55]

The prison chapel had long been a space where certain rules about the strict separation of gender could be modified, if not entirely eschewed. For example, at the Surrey House of Correction, Wandsworth, London, male and female prisoners sat in the same space but were separated by a high wooden partition and overseen by guards of both sexes seated around the back and sides of the pulpit. Elevated seats constructed in the center of the chapel—positioned at different levels to indicate rank—were taken up by the governor, deputy governor, chaplain, and clerk, who had a commanding view of both men and women on either side.[56] The higher your status, the more you could see, a privilege that came with the burden of having to act on what you saw—disciplining rule breakers—as opposed to hewing to the adage "Out of sight, out of mind."

The "separate system" was largely a failure. As the authors of an 1862 prison survey pointed out, the screens in the chapel did little to curb deviancy,

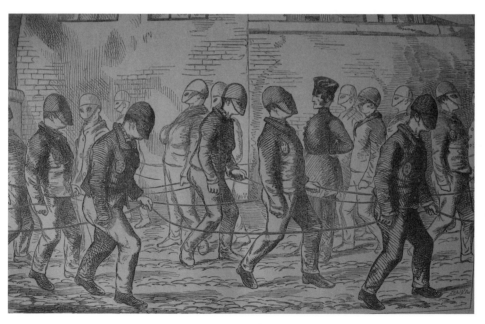

Fig. 3.5 Inmates wearing peaked caps while exercising at Pentonville Prison. Illustration from Mayhew and Binny, *Criminal Prisons of London*

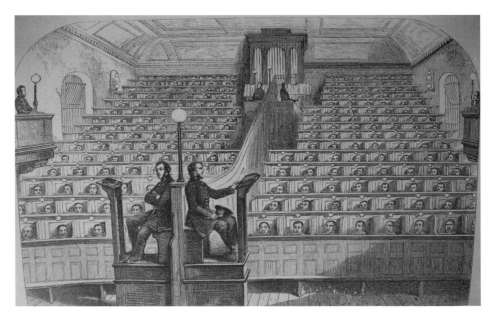

Fig. 3.6 Chapel, Pentonville Prison, showing dividers between seats and guards seated on high chairs for optimal, though never foolproof, observation. Illustration from Mayhew and Binny, *Criminal Prisons of London*

as chapel attendance "may be termed the golden period of the day to most of them; for it is here, by holding their books to their faces and pretending to read with the chaplain, that they can carry on the most uninterrupted conversation."[57] If we can learn anything from the historical record about prisoner behavior in chapels, it is that these spaces simply increased the likelihood of infractions of prison rules such as passing contraband around, plotting, or, more seriously, executing an escape. And while a great deal could be said about how the social experience of cinema was affected by the chapel as an exhibition site within a larger penal context, and the extent to which film screenings occasioned unsanctioned behavior, any pronouncements on the irony of showing (potentially sacrilegious) popular amusement must be tempered by the fact that the chapel has always been a highly adaptable space.[58] Moreover, when chapels are integrated into larger institutional structures such as airports or hospitals, their meaning is shaped not only by their informing context but also by the motivation for attending.

Thinking through some of these qualifiers can suggest how prisoners might have made sense of watching film in the chapel, where habits of displaying respect and proper decorum might, at least in the mind of the prison

authorities, if not in actuality, have been automatically transferred from the religious to the secular context. The chapel's cultural meaning changed when the projector was turned on and Christian redemption replaced the moral conservatism of "soft" reform. As an institution embedded within an institution, the prison chapel was a highly adaptable space (fig. 3.7); put simply, it occasioned an opportunity for two types of escape: literal escape under the cloak of darkness and loud laughter, and figurative escape via cinema's imaginary signification. Not only did it physically change when motion pictures were shown (a temporary screen was installed in most instances), but the space bespoke the soft reform associated with organized religion. Prison administrators' dependence on the chapel's ability to do double duty as a place of worship and concert hall did not always go down well with chaplains; lobbying for a separate recreation space, Auburn Prison chaplain William E. Cashin complained in 1914 that: "The fact that the Chapel is one day used for theatrical performances and the next for religious services is not conducive to promote a feeling of reverence or to excite devotion."[59] And yet, penal reform and religious reform were coarticulated in the prison chapel, one leveraging meaning from the other. Christian-themed motion pictures, a

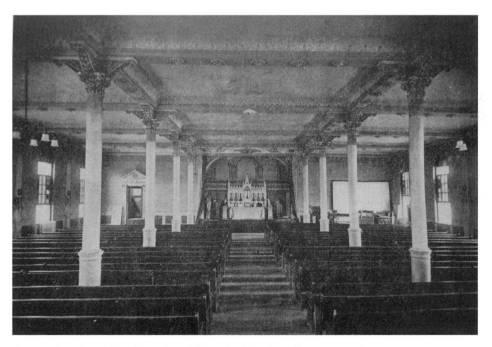

Fig. 3.7 Interior of Sing Sing chapel from the *Sing Sing Revue* souvenir program, 1926. Courtesy LLP-JJC

genre favored by many prison authorities, performed extension work on behalf of the church, although some critics wondered whether audiences outside the prison, accustomed to seeing commercial motion pictures, would tolerate the typically slow pace of religious pictures.

Motion pictures shown in prison chapels meant quite distinct things for younger convicts with recent memory of attending as free men and those whose first and only encounter was behind bars.[60] In both the civilian church and the prison chapel, the idea of motion pictures as entertainment was over-determined by the need for it to be useful, in the case of the prison, useful not just in the sense of saving souls or helping to fund new roofs, but *really* use-ful, controlling large numbers of volatile men whose passions may be roused by what they saw on the screen or viewed in the darkened room, such as getting even with a fellow inmate, doing something illegal, or staging an escape.[61] While fights or scuffles were probably too common or minor to be documented in the historical record, there are occasional references to pris-oners exploiting the physical conditions needed to project film for personal gain. For example, at Leavenworth Federal Prison in Kansas City, Kansas, prisoners working as clerks in the warden's office created false invoices from which friends on the outside received fraudulent payment; various signa-tures were forged "by use of the projection light of the prison's motion pic-ture machine to make a genuine signature show through another paper, on which he had traced the desired signature."[62] This kind of tenacity under-scores just how much more than ordinary cinema film was in the prison.

A combination of darkened space, distracted guards—whose uniforms were virtually identical to those of the ushers in motion picture palaces (fig. 3.8)—unhappy about working on Sunday afternoons, and loud laughter cre-ated conditions for escape attempts, which thirty-seven prisoners confined at Lincoln Heights Police Station in Los Angeles made use of in June 1922.[63] Crowded into the jail dining room with four hundred other inmates for a motion picture show, the ad hoc screening provided the perfect distraction for the men to sneak out one by one: "In the cover of the laughs one prisoner slipped through one of the barred windows, and alighted gently upon the soft ground below. . . . The operator cranked off reel after reel of the comedy film, and with every laugh a prisoner executed a perfect Houdini through the window of the jail dining room until thirty-six others had followed the lead taken by the first."[64]

Four naval prisoners in Portsmouth, Connecticut, similarly escaped from a bimonthly film screening at their facility in July 1924, the fugitives sneak-

Fig. 3.8 Prison guard and motion picture theater usher wearing virtually identical uniforms, ca. 1910. (Left image) Wikimedia Commons, https://commons.wikimedia.org/wiki/Category :Thomas_Mott_Osborne#/media/File:Sing_Sing_%28prison%29_with_warden.jpg; (Right image) *MPW*

ing out of the hall "and down the stairs under cover of the semi-darkness during the show."[65] And while there is no evidence that escapes during film were frequent enough to curtail film screenings altogether, it is amazing to think of something as simple as laughter serving as the perfect ruse for a crafty piece of escapology. The pressure on prison guards to remain vigilant during screenings must have been intense, since the temptation to relax and enjoy the screening rather than "watch the watchers" was surely exploited by some prisoners. A 1928 article from the *Atlanta Constitution* reporting the results of a prison guard questionnaire distributed by the newspaper states that between 1923 and 1928, thirty-three guards were killed on the job and eighty-nine so badly injured that they required extended hospital stays.

Motion pictures were singled out as an example of "new privileges" that "have increased the guard's work and have made necessary a more intense, more nerve-wracking vigilance." As one of the guards reported in the questionnaire, "In prison, danger comes from the most unexpected quarter, and always with suddenness."[66] Here was another example of "useful cinema," though not as the prison authorities intended, as it refutes theories of cinema spectatorship portraying audiences as transfixed and absorbed by the screen. As observational studies have repeatedly shown, audiences engage in all manner of licit and illicit practices when ostensibly watching a movie, including finding means to escape the exhibition space.

The escape of prisoners during screenings paled in comparison to full-scale riots. For example, a Thanksgiving riot in Folsom Prison, near Sacramento, California, in 1927 claimed the lives of seven men (two guards and five prisoners; twenty-two other inmates and staff members were also injured). According to the *Boston Daily Globe*, "The first intimation of a flare-up in the prison came after the convicts were all seated for a motion picture show in the cell house. The seven or eight convicts moved quickly toward Ray Singleton, the assistant turnkey . . . surrounded him and hustled him to the hospital."[67] Singleton was then stabbed (and died of his injuries) before gunshot fire broke out between guards and prisoners. Riots in prisons played a key role in film censorship in prison; for example, the Ohio State Penitentiary riot—called the "night of the holocaust" by the news media—which claimed the lives of 318 men, was the stated reason for banning *The Big House* (George W. Hill, 1930), not only from the prison, but from the entire (traumatized) state;[68] the film's damning portrayal of overcrowding and its condemnation of prison administration were considered too inflammatory and close to what had occurred at Ohio State Penitentiary. According to the *Baltimore Sun*, "For several days after the fire the prisoners practically controlled the situation within the walls in [a] manner somewhat to that depicted in the movie."[69] It was a fairly routine practice to lock the doors of the space where motion pictures were being shown (as occurred at Folsom before the riot), a practice with devastating consequences when a fire broke out. When a convict projectionist let the flaming head of a match drop into an open film container in the mess hall at Texas State Prison Farm No. 2 in 1928, the flames soon engulfed the improvised theater. The pressure of the men's bodies heaving against the locked door to flee the flames made it impossible to open; as a consequence, two men were killed, eight left seriously burned and unlikely to survive, and dozens injured.[70]

Given that prisons and insane asylums existed as microcommunities insofar as they had chapels, gymnasia, schools, shops, hospitals, and morgues, there is a fascinating consanguinity across the spaces. Cinema was something of a homegrown affair in both: the prison warden or asylum superintendent acted as censor-programmer, and inmates supplied the piano accompaniment, quite convincingly, it seemed: "He reminded me of the boys who play in the 'movie' shows, for he had the stool pulled half way between the middle of the piano and the left end, and his feet stuck out slantingly to the pedals," remarked *New York Tribune* journalist Lewis Wood when he came across a rehearsal at Sing Sing during his three-day stay at the prison.[71] And if the description of a 1909 screening in the chapel at Longview Asylum, Ohio, is in any way typical, "there was no giggling, no jostling, the aristocratic usher was conspicuous by absence, and all took their seats without disturbance."[72] Of course the historical record proves this was not always the case, a point vividly illustrated in Vittorio De Sica's 1946 neorealist masterpiece *Shoeshine* when a screening for male adolescents ends with flames engulfing the screen and the projector.

"For the Amusement of the Shutins": Carceral Spectatorship as a Social Experiment[73]

> How many people overlook the fact, or are ignorant of it, that
> the moving picture has many other important uses besides
> that of amusing us.
> *Moving Picture World*, 1910[74]

Motion pictures presented unprecedented opportunities for social scientists to pry into the leisure habits of a burgeoning middle class as well as lower-class audiences. A 1907 editorial from the *Moving Picture World* waxed lyrical about the unprecedented opportunity presented by cinema for digging deeper into the human condition:

> There is no form of amusement where human nature can be studied at closer range, or to better advantage, than at one of the many motion picture theaters, which have become a part of our national entertainment system within the past decade. For when you desire to study human nature, you must find human beings at their leisure, and when they are relaxed in their seats and watching the flitting film they are ideal subjects for study. . . . The millionaire and the clerk, the laborer and the capitalist, side by side and both find equal enjoyment in the pictures.[75]

The poor are even compared to the incarcerated in W. Stephen Bush's 1908 "Who Goes to the Moving Pictures?"; like the recently professionalized anthropologist, Bush is fascinated by the poor's somatic response to cinema. Says Bush, "To me there is nothing more interesting than watching the faces and the actions of the audience in an electric theater in what are called the poorer sections of the city."[76] There is one striking difference, however, in the way cinema is characterized in the trade press discourse and how it is characterized in prisoner publications such as Sing Sing's *Star of Hope*. Cinema was frequently promoted as a form of "brain rest" in the trades, an idea proposed by Dr. Willis Cummings in the May 1909 issue of *Moving Picture World*, while in prison motion pictures were a retreat from the mind-numbing sameness and homogeneity. But even Cummings's idea of brain rest is something of a misnomer; as an antidote for mental fatigue and exhaustion, audiences would be cured by cinema's physiological sensations, "the exhilarating effect of the moving story on the screen . . . made a new man of us. We have felt better, clearer headed and far less fatigued for this refreshing change," said Cummings.[77] Dr. Cummings viewed motion pictures as similar to chess, a curative for neurasthenia, a nineteenth-century psychopathological term for a medical condition characterized by symptoms of fatigue, anxiety, and headaches. Moving pictures achieved the same effect as chess but in opposite ways, by overstimulating the brain as opposed to intensely focusing it.[78]

The curative powers of cinema were nowhere more enthusiastically taken up than with the mentally ill. In an era when promoting cinema's utility was par for the course—one could easily play fill-in-the-blank with the phrase "Cinema as a . . ."—with hyperbolic titles like "Motion Pictures as a Cure for Insanity," accounts of cinema having a "soothing effect upon the minds of insane persons . . . [and] in many cases of mild insanity [being] cured by the same means" appeared regularly in the trade press and quality press.[79] These accounts continued well into the 1920s and were endorsed by such prominent figures as former Sing Sing warden and head of the Department of Criminology of the New York School of Social Work, Dr. George W. Kirchwey, who argued that cinema served as a palliative for both institutionalized and general audiences, furnishing "an outlet for adventure and for allowing the mind to relax." It appeared that in carceral institutions, cinema created docile subjects that were less likely to brood and were, in Kirchwey's words, put in a mental condition that was "helpful in restoring health."[80]

This idea of cinema as a magical elixir was nothing new, however. We have only to look at the popularity of lantern shows in mid-nineteenth-century asylums to see how pervasive this discourse was. Because of photography's indexicality, precision, and sharpness, Dr. Thomas Story Kirkbride, neurologist-director of the Pennsylvania Hospital for the Insane, believed that rational thought would be restored by the slide shows, allowing patients, in historian Emily Godbey's words, "to see—and think—in a clear and rational manner." Being part of an audience helped resocialize patients, heightening the "therapeutic effectiveness" of the show.[81] The screenings were also designed to be aspirational, in the sense that visible differences between the sane and the insane would be blurred and, in Godbey's words, "patients would aspire to the caregivers' and guests' level of functioning."[82] But at the same time as the patients are infantilized and constructed as naïve spectators who mistake the image for reality (often along gender lines), they are praised for being exemplary viewers, a point vividly illustrated in this quote: "Silence was maintained almost unbroken throughout the performance, though a picture of a negro chasing a chicken caused loud chuckles, a few 'aa ha's' in the section of seats occupied by the colored men. Keen interest was manifested in the pictures and when a party of women in a cart, which was whirled across the screen waved their hands to the audience, a whole row of the female patients waved back."[83] If most psychiatrists knew in their heart of hearts that cures were far from likely, they nevertheless adopted motion pictures for some of the same reasons prison authorities did: to amuse and control the inmate population. And the *Moving Picture World* had few problems with this since the amusement rationale did "not in any way depreciate the commercial opportunities for exploitation of films in asylums. On the contrary . . . the pictures have come to be the most important means of amusing . . . patients that they have been able to provide."[84] The therapeutic effect of motion pictures extended well beyond people excluded from mainstream society; in the words of Dr. Henry S. Atkins of Missouri State Hospital for the Insane in Saint Louis, "There can be no doubt that dormant faculties in asylums or in schools can be brought to healthy activity by a judicious use of the moving pictures."[85] Sensory deprivation, while the most extreme in a solitary cell in an asylum or prison, was also a problem in the classroom, where minds dulled by a droning teacher's voice or boring assignment would crave external stimulation.

A great deal of the coverage of motion picture screening in prisons read like pop psychoanalysis. A recurring trope in this press coverage is the

poignant image of the pristine spectator first encountering cinema and the depicted marvels of modernity while locked up, a beguiling (if enigmatic) figure for journalists and an unlikely version of avant-garde filmmaker Stan Brakhage's "untutored eye."[86] At Joliet Prison in Illinois in 1912, for example, a lifer told Warden E. J. Murphy, "I didn't know their wuz [*sic*] such things," referring both to the cinematic apparatus and to the racing car, airplane, and submarine depicted on the screen.[87] When a lifer at Charlestown State Prison in Boston celebrated his birthday in prison for the fiftieth time (he was sentenced in 1875), he credited motion pictures with teaching him about such modern wonders as the electric car, elevator, and automobile: "By watching the prison movie he has gained an idea of the way things are," wrote the *Los Angeles Times* journalist.[88] The lifer at Joliet, for example, described prison time transformed by the experience of watching motion pictures, since these were not ordinary minutes but "deliriously happy" ones, "thirty minutes of freedom" during which "glimpses of various bits of science, which many of the men had never seen, flashes of European scenery, American skyscrapers, and other strange things whirled before the child-like audience."[89] Cinema was doubly hailed as a benevolent force in these accounts, bringing a ray of light (literally) into the lives of the inmates and reminding readers of cinema's unsurpassed capacity for virtual travel. Not surprisingly, the prisoner-audience was often infantilized in a manner consistent with the othering of so-called vulnerable groups such as women, children, and people of color.

Indeed, the theme of the first-time moviegoer behind bars was ubiquitous. In 1913, the *Atlanta Constitution* ran an excerpt from the prisoner publication *Good Words*, written by a prisoner-reporter who sat between two lifers experiencing cinema for the first time in a federal prison (former sailors, one had been inside since 1880, the other since 1897). "Why, it's just like you was lookin' at folks!" said one of the men. That cinema's belated appearance behind bars attracted the interest of journalists should come as no surprise. To this day, how prison authorities negotiate what parts of the modern world prisoners have access to is newsworthy, as seen in a 2011 *New York Times* article about the large number of letters written by inmates to the editors of men's magazines (coined "jail mail").[90] The sense of glee in these accounts seems premised upon both the idea of incongruity—the films versus their reception context—and the idea that the venue might alter the perceptual experience of cinema, that prisoners might in fact see something differently when they stared at the screen by dint of their incarceration. Incarceration constructed

a mental scrim through which the outside world was viewed. Native peoples living in remote parts of the world were similar to prisoners in this respect. Lewis E. Lawes recognized this connection between prisoners and indigenous peoples when he scrapbooked an article about an Inuit hunter freaking out when he first watched a film in the Faroe Islands: "His companions overpowered him and lashed him to his berth in the steamer Tjaldur," reported the *New York Times*. Prisoners and ethnographic peoples oblivious to modernity in the first third of the twentieth century were linked through discourses of otherness; their behavior made the headlines, fueling a racist, infantilizing discourse that Robert Flaherty exploited when he showed Inuit hunter Allakarialak identifying the gramophone record by biting it in *Nanook of the North* in 1922.[91]

Prisoners who had never witnessed motion pictures by the early 1910s shared an unlikely affinity with a radically different demographic group, one that eschewed cinema for its lower-class connotations: "There are thousands of people, especially in the better walks of life who have never put foot across the threshold of a moving picture theater, and have no immediate intention of doing so, for the one reason that they feel ashamed to be seen pushing their way through the entrance of some untidy looking theater."[92] Prisoners, native peoples, and the upper middle class were thus the last holdouts of non–motion picture attendees in early twentieth-century America and, arguably, the world.

Another feature of prison film spectatorship that made it interesting for journalists was the homosocial makeup of the audience (excepting a small number of prisons housing women that organized coed screenings, such as in Craiginches Prison in Aberdeen, Scotland, which showed a bioscope exhibit to male and female prisoners in 1909),[93] a phenomenon that undoubtedly shaped the meanings of the heterosexual dramas projected on the screen and the rituals attending motion picture exhibitions, which, outside of prison, men often attended with their wives or girlfriends (although younger men probably went mostly with peers as they do today). And while access to images of women greatly increased when commercial releases started appearing in prisons by the mid-1910s, we should not forget that cinema complemented rather than replaced other entertainments in prisons that had routinely included women, such as Mrs. Field's Bible class at Sing Sing, which began in 1890. Cinema functioned as a panacea, however, normalizing heterosexual behavior seen on the screen and, in the minds of prison administrators, curbing homosexual desire.

In an environment defined by constant surveillance, cinema provided a temporary cloak of anonymity for prisoners (as it did for the worker who slipped into the nickelodeon or picture palace to escape for a while), an opportunity to disappear for a short period of time into the darkened space of the chapel. This was precisely how a journalist invited to the 1927 Christmas film screening at Connecticut State Prison described it: the prisoner, eyes "intent on the screen as darkness settled over the audience . . . [was] hid[den] from view for the next two hours."[94] A 1927 *Photoplay* magazine illustration drawn by Norman Anthony perfectly demonstrates this idea (fig. 3.9). The inmate audience, two dozen or so Caucasian men with hunched shoulders and sunken cheeks, stares intently at a baseball game on the screen as if they have been drugged or mesmerized. To the left of the screen is a barred gate, which, like the screen itself, also has light radiating from it. Light is connotatively linked to freedom and escape in both the projector beam and the backlit barred prison door. The prison stripes perfectly befit the uniformity of the gaze and possibly the boredom of the baseball game as the batter waits for the next pitch. The caption, "On Parole," underscores motion pictures'

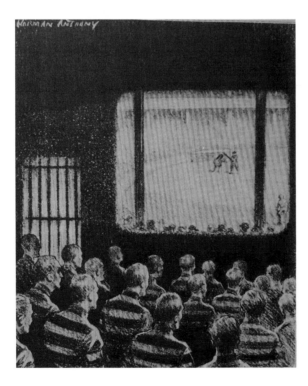

Fig. 3.9 "On Parole," *Photoplay,* May 1927, 66. Illustration by Norman Anthony

promise of virtual escape for the inmate audience. Cinema in prison is a metaphor for the promise of parole, a vision of what that parole might look like once they got outside.[95] And yet, the impassive faces and zombielike demeanor also suggest that the inmates have undergone what Caleb Smith calls a form of "civic death . . . stripped down and dehumanized," forced to live out this death before being resurrected and released.[96]

Film Finally Arrives: Earliest Motion Picture Usage in American Prisons

> The motion pictures are not filling the jails, but the jails are
> filling with motion pictures.
> *Kinematograph and Lantern Weekly*, July 11, 1912[97]

The earliest account I have found of film being shown in a U.S. prison is from a fall 1907 edition of the *Washington Post*, which described the aftermath of moving pictures exhibited at Western Penitentiary in Pittsburgh, Pennsylvania.[98] With the provocative title "Convicts Hiss Chaplain," the article described the increased security measures put into place in the prison chapel as an antiriot precaution after the motion pictures that had previously been shown on Sunday afternoons were replaced by hymn singing. The reason for the suspension of screenings was described as follows: "More than a month ago permission was given by the penitentiary authorities for the exhibition of some so-called religious pictures in a moving-picture machine in the chapel. The operator got hold of the wrong films and treated the convicts to some pictures of bathing resorts for girls. That ended the motion picture."[99]

How the bathing films ended up at Western Penitentiary is anyone's guess. Prisoners with outside contacts in the industry were sometimes responsible for getting hold of films (as prisoner number 1841, known inside Great Meadow Prison as "Priscilla," did in 1914 when he procured films from the proprietor of a moving picture theater on East Seventy-Ninth Street in New York City). And the convicts themselves sometimes raised money to rent motion pictures, as inmates at Oregon State Penitentiary did in 1912.[100] A more plausible explanation is that the operator thought this was a perfect opportunity to give the men a much-deserved visual treat and deliberately substituted the bathing girls reels. Indiana State Prison followed the same route as Western Penitentiary, exhibiting religious moving pictures in the chapel starting in 1911. The projector was operated by convicted wife-murderer

William E. Hileshaw, and according to Warden E. J. Fogarty, the subjects were to be "religious in character, with an occasional comic film that is clean and bright."[101]

We can glean several things about the nature of filmgoing in the prison from this account of the reel switches at Western Penitentiary: the venue (a chapel); the time (Sunday afternoon); the level of official supervision of the content of the films shown (which allowed mild stag films to be substituted deliberately or inadvertently for religious films); and concern over the short- and long-term impact of cinema on prisoner morality and discipline. Programmed in a similar fashion to a children's Sunday school meeting, the exhibition of religious films to prisoners in the prison chapel (the logical space to accommodate large groups with minimum disruption) can be viewed as a safe foray into motion pictures for the institution. While some exhibition practices are similar across prisons, schools, churches, museums, and clubs, there was something unique about going to the movies behind bars. One of the most obvious features was the fact that attendance at prison screenings, like those in schools, was (most likely) coercive rather than elective (inmates at Sing Sing later in the 1910s had the option of remaining in their cells), unless an inmate was too sick to go to a screening and was in the prison hospital.

Despite being inseparable from the larger disciplinary apparatus, filmgoing was egalitarian and free (which particularly annoyed the anticoddlers who opposed the prison reform movement of the time), and it united the prisoner community around a shared experience, doubtless spawning conversations about the films. At Indiana State Prison in 1911, films were shown immediately after military drills,[102] the prison authorities regimenting and disciplining the incarcerated body before exposing it to cinema, almost as a way of inoculating the prisoner against the potential deleterious effect of film or using it as a reward after the ordeal of the drills.[103] Both drills and cinemagoing relieved the dull routine of convict life and, in theory, kept the prisoners in compliance with prison regulations. One would imagine, however, that cinema was nowhere near as effective as military drills, and the risk of raucous or dangerous behavior under the conditions necessary for cinema must have served as a deterrent to the introduction of motion pictures in some prisons.

Motion pictures were almost always initially shown in penitentiaries around one of the federal holidays, at Christmas, Thanksgiving, or the Fourth of July. At the United States Penitentiary in Leavenworth, Kansas, six thousand feet of film were shown for the first time the day after Christmas

1910; Warden Robert W. McClaughry booked the films via local exhibitor C. F. Mensing, and Big Jim McQuade, a new vocalist at the Leavenworth Casino theater, sang songs.[104] The film screening was labeled an experiment and justified as follows: "The intention is to show pictures of the educational type, with the idea of bringing the prisoners in touch with the outside world. Many of the men have no knowledge of what is taking place outside the prison walls. Motion pictures will show them this."[105] The same films were shown to inmates at the Kansas State Penitentiary under the supervision of Warden J. K. Codding, a strong advocate for motion pictures in prisons. This account of two prison screenings from the *Nickelodeon* also makes reference to the fall 1910 meeting of the International Prison Congress in Washington, DC, where the idea of motion pictures being used in conjunction with Bible study "was advanced and met with approval by many of the delegates." "Since then," we are told, "it has been considered by many penitentiaries over the country."[106]

Starting in 1909, the motion picture trade press and newspapers began routinely posting notices about prisons starting to show film.[107] Indeed, such was the newsworthiness of motion pictures in prisons that reporters even covered stories of prisoners *refusing* to attend screenings[108] (fig. 3.10). The *Bioscope* reported in 1909 that the Board of Prison Managers in Columbus, Ohio, had purchased a "moving picture outfit" so the convicts at Ohio State Penitentiary could be entertained every few weeks; justifying the expense, the prison governor said it would "give the men some idea of what is going on in the outside world, and will present new ideas to the great majority of the convicts who have been in the prison for many years."[109] Paying for the film rental from an amusement fund at Oregon State Penitentiary, Superintendent C. W. James proposed a plan whereby films would circulate through a number of state institutions, including mental asylums, industrial schools, and schools for the deaf. Films, interspersed with numbers performed by the convicts, were shown at the penitentiary for the first time on the Fourth of July, 1911.[110]

Frankfort Penitentiary, Kentucky, began Sunday afternoon screenings in the prison chapel in winter 1912, claiming that "the morals of the men may be improved by showing them the proper kind of pictures."[111] San Quentin Prison outside San Francisco began weekly film screenings in June 1913: "From their toil in the jute mill and the stone quarry, the men serving time will troop once a week into the large dining room of the prison, where films depicting scenes of life that goes on outside the high gray walls that shut them

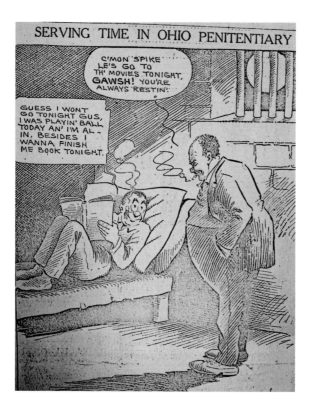

Fig. 3.10 Cartoon of filmgoing, Ohio State Penitentiary. OFP

in will be unreeled."[112] We learn from a December 31, 1914, notice in the *San Francisco Chronicle* where at least some of the films shown in San Quentin came from; the entire week's bill showing at the Loew's Empress Theater was transported to the prison. Vaudeville acts were also integrated into the bill. The inmates "can be sure that they will, for a couple of hours at least, forget the unpleasantness of their surroundings and enjoy some of the innocent hilarity with which most of the outside world is imbued at this time of year."[113] The generosity of local exhibitors was another way motion pictures found their way into prisons; for example, Eastern Feature Film provided titles free of charge for the 829 inmates at the state prison in Charlestown, Boston, in 1920, whereas the "local office of a well-known film company" donated the eleven-reel *Over the Hills* as a courtesy to the federal prison in Atlanta.[114] The proprietor of the Thompson Square Theatre, Charlestown, Boston, also generously lent films to the state prison at Thanksgiving in 1922.[115] By the late 1920s, a navy film exchange had been established in New York that served the "scouting fleet, control force, stations, hospitals, prisons in the

eastern US, special squadron forces in Europe and navy and marine stations in the West Indies."[116]

Prisons felt the need to justify showing motion pictures, not only fiscally in terms of the purchase of the apparatus (films were mostly donated or loaned), but within an institutionally sanctioned rationale of prisoner reform. Film screenings promised to provide men with information about the outside world, necessary, it was felt, for their eventual release.[117] Cinema was also used as a litmus test to gauge prisoners' normal range of human reactions, an idea latent in this review of a screening at Connecticut State Prison: "In the comedy pictures, they ably proved that they had not lost their sense of humor and roared at the funny actions of Charlie Chaplin and other comedians."[118] The "everyman down on his luck" feel of some descriptions of prisoners assembled for motion pictures behind bars was exploited by Universal Studios in 1915, when the company decided to include prisoners housed at the federal prison in Atlanta in the competition to name their about-to-be-released "modern life drama." A $50 award went to the winner, the prison authorities allowing a special mail dispensation so the inmates could submit their entries.[119] First National Pictures offered a $100 cash prize for the best review written by Sing Sing prisoners in 1925 of *The Beautiful City*, starring Richard Barthelmess; to ensure that all prisoners had an opportunity to view the film—save those on death row and denied privileges—the film was screened without the usual accompaniment by convict musicians.[120]

Not Quite or More than Cinema?

On some level, seeing films in prison was nothing like the social experience of "going to the movies." Prisoners had little agency regarding what films to watch, when, and with whom. And yet the films they watched were often identical to those shown in commercial nickelodeons, a nod to the conventional conceit of filmgoing as a universal humanizer. The chapel as an exhibition venue and the emotional effect upon prisoners of the most banal commercial film subjects are poignantly represented in Preston Sturges's 1941 film *Sullivan's Travels* in a scene depicting Southern chain-gang convicts brought to an African American church to watch motion pictures. The effect of incarceration on the mind and body is palpable in the shot of the inmates' feet shuffling into the chapel, and the hero's question to his fellow inmate-spectator—"Am I laughing?"—suggests that incarceration has transmogrified

a prisoner's senses so much so that the response of laughter is no longer registered cognitively, but only physically.

But the laughter in response to the depicted Disney cartoon is maniacal, becoming increasingly hysterical (fig. 3.11), as Kathleen Moran and Michael Rogin argue in their analysis of the film.[121] African Americans and convicts not only share the improvised motion picture theater experience but are linked as disenfranchised subjects, the prisoners' chains a powerful visual evocation of slavery and the leased system where convict chain gangs worked in conditions similar to slavery. As Davis argues, "The appalling treatment to which convicts were subjected under the lease system recapitulated and further extended the regimes of slavery."[122]

Despite its unique setting, prison filmgoing shared some cultural associations with theatrical moviegoing. Discourses of benevolence, education, and moral and civic reform dominated many nontheatrical contexts,[123] and they combined with the prison's unique institutional context and the proclivities of individual wardens. There is no clear-cut separation among reformist

Fig. 3.11 Frame enlargement from *Sullivan's Travels* (Preston Sturges, 1941) showing inmates laughing at the motion picture.

claims for cinema in prison, in other nontheatrical venues, and in public cinemas in the silent film era. Film spectatorship as a social laboratory where human behavior could be closely studied was apparent to some degree in both the prison and the outside world, although it was magnified in the penitentiary as a result of the significant number of naïve (first-time) film spectators. For many on the outside, there was something seductively voyeuristic about the idea of trapped men watching motion pictures while serving time. In alignment with institutionalized rationales of uplift and reform, prison officials favored films with unambiguous moral messages and broadly drawn heroes and villains. A report describing films shown for the second time at Connecticut State Prison in July 1915 reassured readers that "[the prisoners] were with the hero all of the time in all of the pictures and loudly applauded when he finally bested the villain in the play and won the hand of the maiden fair."[124]

Cinema in prison created a new type of social space that was different from its concomitant version on the outside. While it was public insofar as guests were sometimes present at screenings, it did not conform to other ideas of the public. As a motion picture venue, Sing Sing was neither fully public nor private, representing a space where ideas of the public were inflected by carcerality. Yet Sing Sing's status as a nonpublic sphere was compromised because it occupied a very prominent place in the public imaginary, hypervisualized and never far from the headlines as a result of scandals, investigations, and cases of notorious criminals. And if, as Miriam Hansen argues, quoting Alexander Kluge, cinema constituted not only a new public sphere, but a sphere composed of the "interaction between the films on the screen and the 'film in the head of the spectator,' then what kind of film unfolded in the minds of spectators divorced from the actual public sphere?"[125] What must it feel like to watch films that packaged virtual tourism and escapism when you literally could not escape? This question was the driving force behind much of the press fascination with motion pictures in prisons; cinema was a portal into the world of the ethnographic other *and* a salve for imprisoned others at home.

Cinema in the prison cleaved relationships between prisoners and administrators, prisoners and guards, prisoners and family, and prisoners and prisoners. It gave inmates something to talk about with family members, serving as an icebreaker in tense situations. At minimum, it was something they shared in common. One father serving time in a British prison in the late 1990s kept abreast of how the local soccer team was doing in order to

have something to talk about with his young son during visits.[126] Some would argue it restored a semblance of humanity to men locked up like caged animals, since going to the movies in prison brought a measure of normalcy to what was a far from normal existence. Showing motion pictures to incarcerated men came with a slew of attendant risks: riots, fires, and escapes were not just feared but occurred under the watch (or not) of the guards, who also put themselves at risk when hundreds of men assembled—greatly outnumbering the guards—to watch movies.

One could argue, then, that the perceived deleterious effects of cinema as an immoral agent are turned on their head in the case of the prison, since of all the groups that *should* have been protected from the "immoralizing" influences of film, surely criminals were at the top of the list. Logically speaking, however, as de facto "immoral" subjects, prisoners may have been perceived as immune to cinema's pejorative effect since they were already damaged goods. Even though films with a strong reformist agenda were generally preferred for screening by prison authorities over crime films with a weaker moral compass, the commercial fare playing at the local movie theater was as likely to be shown to inmates in the prison chapel as educational subjects were, complicating any simplistic account of cinema fulfilling a purely reformist function.

To say that the experience of cinema in prison was complicated is a gross understatement. Configured schematically, jailhouse cinema would represent a Venn diagram, with aspects of the experience overlapping with the use of film in other nontheatrical venues such as schools, museums, army bases, YMCA houses, and boys' and girls' clubs, and other aspects overlapping with experiences in traditional theatrical sites of filmgoing. When cinema emerged in the late 1890s, it was a technology of the imagination as well as a scientific tool, simultaneously providing new images of prison life while participating in a long tradition of representing incarceration. When Edgar Allan Poe began his 1842 prison story "The Pit and the Pendulum" (fig. 3.12) by writing that he felt as if his senses were leaving him, he tapped into a common conceptualization of the inmate's corporeal transmogrification.[127]

And yet if the sensory deprivation of prison life was thought to lead both to a sensory deadening and to a heightening of the inmate's senses, then the introduction of the complex stimuli of illustrated lectures, concerts, lantern slides, and motion pictures into the prison suggests the complexity of the questions around cinema's role in the institution. For prisoners, cinema represented much more than mere entertainment; that rectangle of light so

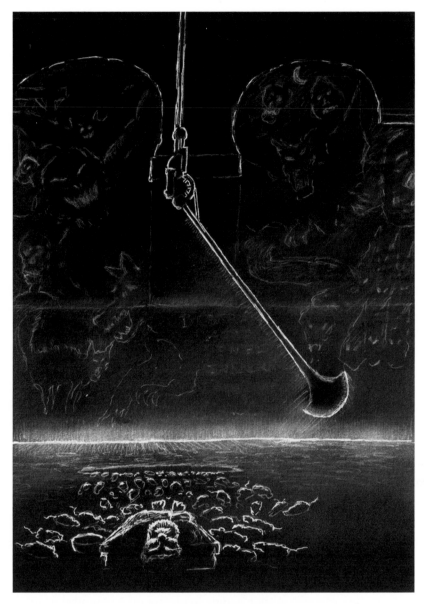

Fig. 3.12 Illustration from Edgar Allen Poe's "The Pit and the Pendulum" of prisoner bound and staring at viewer. Image by Harry Clark, 1919

ubiquitous in prison movies became animated with images of hope, a future, an elsewhere, and an elsewhen beyond the prison bars. Transmogrification opens up a way of moving beyond the simple binary of sensory deprivation versus overstimulation, opening up a third space, where biopolitical governance coexists with inmate projection and imagination.[128]

That rectangle of light also became familiar, enshrined in prison routines that now included filmgoing. In fact cinema became such an institutionalized part of the carceral experience by the early 1920s that inmate audiences might have ranked among the nation's most frequent film goers, since they may have attended film screenings more often than the free citizenry. Cinema continued to be a portal to the outside world, but with the spate of prison movies made in the 1920s and 1930s, lay audiences might be as likely to be gazing in at representations of the penitentiary as inmates were gazing out at a world beyond their reach.

As institution, practice, experience, ritual, and disciplinary tool, early cinema was an exceedingly slippery signifier in the prison: for conservative social commentators, it was a potent example of the untoward coddling of prisoners, whereas for penal reformers film had the potential to uplift, reward, and inculcate American values. Writing in the *Star of Hope* in 1916, Great Meadow prisoner number 1964 addressed the utility of cinema as perceived by the outside world, prison authorities, and inmates: "To the world at large motion picture shows in prison have meant little more than the pampering of prisoners. Even the metropolitan papers . . . have complained at times that the honest man has to shed a nickel to see a 'movie' while a 'con' saw a two dollar feature for free."[129] Prisoner number 1964 also recognized the role of film in "amusing the prisoners, of helping to keep them contented without turning them out in the air and sunshine." Preoccupying the prisoner the most, however, was cinema's potential to instill American values among immigrant inmates: "A son of Italy enters the prison to pay for a statutory offense that is no crime in his land where women mature at an early age. The day after he enters, by using film, we can begin his education in Americanism. His education does not wait on the tediously acquired alphabet. . . . In six months he has learned more from the pictures than he could have learned from books in a sixteen-year sentence."[130] In a manner reminiscent of cinema's trumpeting by the industry, trade press, and progressives, the prisoner-author homes in on cinema's potential as an Americanizing force (while taking a mild swipe at the injustice of statutory laws). For Great Meadow prisoner number 1964, cinema is front and center in the reform process, the spectator "at the mercy of the mind which created the film." Moreover, via films that he calls "blessed messengers of discontent," defined as narratives with hard-luck characters who serve as negative role models, "you are in a position to make over your man, to inculcate in him,

awaken in him, the mightiest of all forces, right desire, whose fruit is always CHARACTER."[131]

But how closely did cinema in prison replicate the social, cultural, and psychological experience of cinema as a mature, standardized, industrialized product, which it was on the verge of becoming in the early to mid-1910s? In terms of the ritualized aspects of filmgoing, there are several points of convergence and divergence, convergence insofar as the film text was the same as the one shown theatrically but divergence with respect to pretty much everything else. And while we may never know what watching films in prison was like during the early cinema period, it is possible to construct a hierarchy of institutional use value, with the maintenance of compliant subjects somewhere near the top. The manner in which cinema was experienced differently in the penitentiary versus a motion picture theater or in nontheatrical venues such as churches, museums, or clubhouses thus depends on a range of social and psychological issues, a point that encourages us to think beyond the theatrical model of film spectatorship as the only true experience of cinema.

The habitus of filmgoing in prison, while a popular trope in countless Hollywood films showing prisoners gathered to watch films, is as complex as this sociological term itself, developed by Marcel Mauss and Pierre Bourdieu.[132] The habitus of filmgoing in prison can only be understood through a triangulated approach that locates moving pictures within a tradition of precinematic entertainments and considers what the inmates were actually watching and how these films were reviewed or referenced in prisoner publications such as the *Star of Hope* as well as in serious and popular journalism. It also requires searching for the fissures and cracks in all of these "sanctioned" accounts of film exhibition to find traces of the *experience*. When we refer to the escapism of cinema and speculate about what must have been going through the minds of the Sing Sing population when they watched Houdini perform his famous escape tricks or screen his movies, we are once again asked to rethink how spectatorship is resignified by the space of the prison. Inmate spectators were as complex and unknowable as the public film audience; they had taste preferences that were equally variegated, and they did not all "love the movies" just because cinema was a break from their mind-numbing routine. Even when it possesses a diversionary quality, motion picture viewing behind bars is by no means isomorphic with the film-going experience of a free man or woman.

Ironically, in the modern prison, the din from constantly blaring televisions and radios drives some inmates crazy, since not only is peace and quiet hard to obtain, but, as Stateville, Illinois, prisoner Sam Guttierez puts it, "the noise from competing radios and TV's in neighboring cells, particularly the rock and country music stations turned on full blast," is something he just cannot get used to.[133] Radios and television (but very limited Internet use) help distract and placate; they also bring the outside world into the prison, giving it a veneer of normalcy, as suggested by the fact that Britain's HM Prison Service prisoner handbook has an image of a portable television on a small table in a cell on the Web page, an icon of reassurance, to be sure.[134] At the same time, popular culture and the movies have always been symbols of normalcy for the prison population, generating countless conversations in the exercise yard, workshop, and cell.

"It was all the same and yet oh so different" would be how I would characterize inmates' accounts of watching film in the prison, the same frames flickering through the projector at the same speed as in the theaters but in a unique space and context that most of us will never experience. As historians of early cinema, we can learn a great deal about filmgoing at the margins by turning to peripheral, nontheatrical institutions such as prisons to do justice to the subtleties and vagaries of film spectatorship; film on the inside still counts as filmgoing, even if the destination is steps away from where you reside.

Chapter Four

"The Great Unseen Audience"

SING SING PRISON
AND MOTION PICTURES

Watch the play of expressions on our faces when the machine is in action, and if we do not convince you that we are grateful nothing else would.
Sing Sing prisoner discussing film, 1915[1]

While New York City, along with Chicago, may be considered one of the key hubs of the early American motion picture industry, with hundreds of storefront theaters serving a new popular audience, thirty miles up the Hudson River, in the small town of Ossining, New York, a separate system of film exhibition culture was taking shape within the infamous Sing Sing Prison (fig. 4.1).

Built by prison labor in 1828 to replace Newgate Prison in New York City, it was at the time the largest prison structure in the United States, designed on the congregant/silent system and crafted from stone hewed from the surrounding area that served as an effective fire deterrent but was terrible at staving off damp.[2] Its name, derived from a term in the language of a local Native American tribe, "Sint Sinks," was a variation on an older term, "Ossine Ossine," meaning "stone upon stone."[3] The fact that in 1914 one could sit in the Sing Sing chapel, built in 1830,[4] and watch the same theatrical film comedy or popular melodrama currently playing before Manhattan audiences, perhaps seated next to a lifer who may have never seen motion pictures before, underscores how the experience and historical meaning of film viewing are profoundly shaped by the exhibition context.[5] From an examination of the archival record, it is clear that Sing Sing was a vibrant space of popular entertainment beyond cinema, including boxing, football (with its famous "Black Sheep" football team),[6] and vaudeville acts (Houdini, a personal friend of Lewis E. Lawes, both performed and screened his *Master Mystery* film series

151

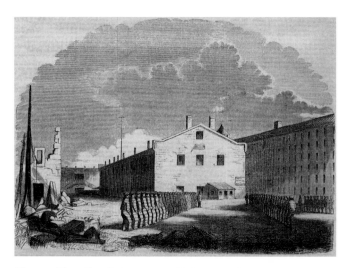

Fig. 4.1 Sing Sing Prison, 1855. Wikimedia Commons,
http://commons.wikimedia.org/wiki/File:Sing_Sing_prison,
_near_New_York,_in_1855.jpg

there).[7] Motion picture companies, including Vitagraph, Fox, Metro, and Para-mount, loaned hundreds of films to the prison and were thanked in Sing Sing's Annual Show Program (fig. 4.2).

Cinemagoing was integrated into the complex daily routines of this public institution—routines governed by the need to control large numbers of incarcerated men and built upon a long history of precinematic entertain-ment, such as lectures, concerts, performances, and sports. Sing Sing's in-mate population spent the bulk of the day either laboring outside, as seen in this stereograph (fig. 4.3), or in workshops manufacturing shoes, brooms, baskets, mats, or underwear, stopping work at 4 P.M. for an hour of recreation (playing ball games, etc.) before supper was served in the mess hall. Follow-ing a return to the cell for a head count, which usually lasted approximately ten minutes, prisoners could choose whether to go to the assembly hall or chapel for entertainment or a lecture, and could go in either the first or second shift (the space was too small to accommodate everyone at once).[8]

This chapter considers what we can learn about prison spectatorship by focusing exclusively on Sing Sing, a prison whose size, infamy, and status as one of the oldest penitentiaries in the nation would have given its policies re-garding film national exposure. And while it was not the first prison to show film in New York State or the United States, it is safe to say that what was going on at Sing Sing was by no means atypical and certainly coincident with

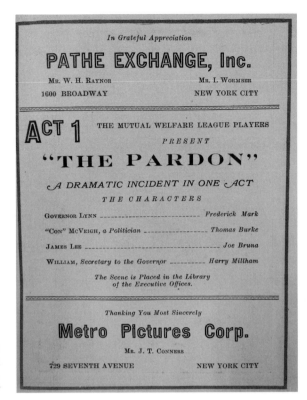

Fig. 4.2 Program for *The Pardon* performed at Sing Sing with Pathé and Metro Pictures Corp. thanked, ca. 1920s. OFP

Fig. 4.3 Sing Sing prisoner working outside old cell block, 1885. Wikimedia Commons, http://upload.wikimedia.org/wikipedia/commons/0/00/State_Prison%2C_at_Sing_Sing%2C_New_York.jpg

film policies at other New York State prisons including Auburn, Clinton, and Great Meadow.[9] I will consider the following questions: How did cinema at Sing Sing confirm or undermine disciplinary or penal authority, and what determinative weight should be placed on the prison as exhibition venue? How did film in prison comport with precinematic entertainments already in place? What was the rationale for showing film inside prisons? Who chose what the prisoners viewed, and how and where did the films fit into the institution's disciplinary apparatus? Did cinema help build community within the prison, and what kinds of habitus did prison spectatorship engender? And, finally, what can this case study on motion pictures and prisons tell us about the nature of cinema spectatorship as a whole, when so many of filmgoing's public protocols were either modified or eschewed in the prison?

Experiencing cinema under the veil of punishment is hardly commonplace, and while we cannot fully grasp the intersubjective complexities of groups of men and women viewing film under the watchful eye of guards who are themselves de facto spectators, or sometimes watching *without* guards present, as occurred in Auburn and Sing Sing during the earliest weekly screenings, this chapter can at least consider the history of nontheatrical cinema in the unlikeliest of venues.[10] This chapter paints a nuanced portrait of prison filmgoing and fan culture, reading the experience as much against the grain as with it, borrowing anthropologist Ann Laura Stoler's metaphor of the historical watermark to recapture the experiences of inmates watching film in prison.[11] While traces of what cinema inside was like, for either a guard or an inmate, can sometimes be found in the archive, and of course is retrievable to some extent in contemporary instances of inmates attending film screenings while incarcerated, the historical experience, especially when the motion picture industry was still nascent, is a bit like a watermark, permanently inscribed but not immediately obvious. Reconstructing what cinema was like in prison—which films were viewed, where they came from, and how cinema fit into the institution's disciplinary apparatus—is an exercise that involves imagining that "what might be [is] as important as knowing what *was*."[12] Ironically, it might be easier to trace patterns of spectatorship in prison than in the context of commercial exhibition, since many of the locations (if not the delivery platforms) of cinema's use in carceral settings have virtually stayed the same over the past one hundred years.[13] The story of cinema's emergence at Sing Sing can thus be reconstructed by examining the inauguration of the library, lectures, and educational programs at Sing Sing; the publica-

tion of the *Star of Hope*; cinema's usefulness in the war against carceral health concerns; Hollywood's relationship with Sing Sing as facilitated by Lewis E. Lawes; and finally, radio's impact on prison life, which intersects in interesting, albeit unlikely, ways with cinema.

The Prison Library, School, and Organized Sport: A Reform Trifecta

> If a man is to be a success in prison he must escape. He must escape from himself and the thought of his confinement. In some this manifests itself directly in plans and efforts to escape. In others some form of activity.
> SUMNER BLOSSOM, 1930[14]

> Sleeping and reading are both good ways of forgetting— especially sleeping. I trained myself to sleep sometimes as much as fifteen hours a day.
> EDWARD WISE, former Sing Sing death house inmate[15]

Books, magazines, photographs, magic lantern slides, gramophones, and motion pictures were integrated into prison life, serving to break the monotony of a sensory-curtailed existence. The conditions for showing film at Sing Sing were established long before the first projector was delivered to its chapel screening room in October 1914; however, as in many other public institutions, what allowed film to gain a foothold were precinematic initiatives that performed similar institutional functions as film, including the prison library, which opened in 1846 under the stewardship of librarian Chaplain John Luckey. In addition to the library, prisoners enjoyed (or not, as the case may be) "Sunday religious services, Bible class, [lectures by members of] the Volunteer Prisoner's League [beginning in 1896], and other uplifting influences," all of which led the way for organized sports and motion pictures.[16]

The growth of libraries in U.S. prisons in the nineteenth century was linked exponentially to increases in literacy. Prisons without libraries were singled out for criticism by prison inspectors. For example, Indiana's women's prison was deemed lacking for failing to provide a library, and in 1914, inmates of Arizona State Penitentiary submitted a petition to Congress lamenting the fact that some U.S. prisoners were denied newspapers, magazines, and even a prison library.[17] In New York State the number of prisoners who could read and write in the 1840s rose to 80 percent by the turn of the century,[18]

and at Auburn Prison, approximately three thousand magazines and trade journals were in circulation every month. "Bibliotherapy" provided "moral and intellectual reflection" and distraction that was likened to medicine by the author of the 1890s' *New York State Elmira Reformatory Annual Report*: "Know a man, his habits, his thoughts, his condition of mind, and then give him a suitable book to read as you would give a patient the proper medicine for his recovery."[19]

The prison library was enlisted in the fight against the saloon, as Secretary of Prison Commission W. F. Spalding wrote in the report of the Prison Commission for 1873 on Women: "By teaching them to read and putting interesting books in their hands, one step would be taken toward weaning them from the saloons on their release from prison."[20] The idea of reading ameliorating the gap between an idle body and mind was widespread, as a Brooklyn prison warden stated: "If we cannot give a man work to do, we try and keep his mind occupied."[21]

Chaplain John Luckey became Sing Sing's inaugural librarian in 1846 and, according to Blake McKelvey, was the first prison librarian to include books other than Bibles.[22] Modeling the library on mechanics institute libraries (since this was before public libraries became widespread), he promoted the library from the pulpit: "Friends, being legally charged with the control of the library, I have made arrangements to follow, as far as possible, the course pursued by 'out door' librarians; you are, therefore, invited, with the concurrence of your several keepers, to come and select a book, each for himself, with the same freedom and feelings of self respect that inspire those who visit . . . any other library and for the strict observance of rules (which you will find hanging in the library) I appeal solely to your magnanimity."[23] Several things marked the library off as different from its surroundings: it was modeled on the equivalent free institution, which bracketed the experience from the relentless regimentation governing life in prison; selecting books was an expression of agency, something in short supply in the prison; and, on an emotional level, the library made the prisoners feel more normal since reading was an activity that distracted the mind. In contrast to standardized rules about maintaining silence, the prison library was also a space where social intercourse was allowed, and, for Luckey, it was an opportunity to converse with prisoners about books and to engage in pastoral care (facilitated by the fact that Luckey vetted prisoner letters to family members written once every three months). The library was renovated in 1903, with more bookcases added and almost five hundred worn-out books removed; it contained the "best works

of modern thinkers, imaginative writers and historical gleaners," and was comparable to any modern library on the outside. By 1926, 24,452 magazines and books were in circulation at Sing Sing, for a prison population of 2,500 men.[24] By 1916, the Mutual Welfare League (MWL), the prisoner-governed union that started out at Sing Sing as the Golden Rule Brotherhood, had a small library of its own where inmates were free to borrow books any time they were out of their cells and not working.[25]

Access to Sing Sing's library was strictly rationed in the 1840s, with twice-annual visits permitted in 1846, compared to once or twice monthly in the 1880s, weekly in the 1890s, and daily by 1917.[26] Sing Sing inmate number 65368, writing about the library in 1917, while complimentary about the size (twelve thousand books) and management of the library, nonetheless felt that there were both "good" and "bad" ways to read books, arguing that some prisoners devoured a book a day while others read three or four a week. "Better a thousand times we read ten books right than to wade through a library or an ocean of words and forget what we have read, even before the book is laid," wrote number 65368.[27] And while it is hard to know what the men were reading, since card catalogs are no longer extant, subjects as diverse as philosophy, history, and current affairs filled the shelves along with magazines and journals.[28] Free religious publications such as *The Christian Advocate*, *The Parish Visitor*, *The War Cry*, *Sabbath Reading*, *The Weekly Witness*, *Volunteer's Gazette*, *Jewish Volks-Advocat*, and *Jewish Gazette* were also sent to Sing Sing starting in 1901.[29] Book donations were encouraged, and Luckey appealed for magnanimity since high-demand books were often unavailable and there were restrictions (and heated debates) about the appropriateness of certain titles for society's outcasts.[30] By 1897, Sing Sing prisoners were borrowing approximately one thousand books a week from their newly refurbished, ten-thousand-volume library, "'properly shelved, classified, and indexed,' with a brand new catalogue."[31]

In 1899, 47,761 books were taken out at Sing Sing, suggesting that even though few men were enrolled in prison school due to limited resources, a far larger percentage of the incarcerated community were intent on stimulating their minds through reading. Books alleviated boredom, staved off mental illness, and equipped prisoners with life skills; as described in the 1899 *Report of the Superintendent of State Prisons*, books "aided in the preservation of mental soundness . . . lifting some men to a higher plane of thinking and of feeling than they ever obtained before, and putting them in a position to enter on a free life again, better equipped to face its duties and to bear the

burdens than when they entered prison."[32] Put more simply, a book brought a sense of elsewhere and presence into a space bereft of either; as Chaplain John C. S. Weills put it in his 1899 report, "To men locked in their cells, many hours each day, a good book is a solace and a companion."[33] The idea of reading as metaphorical escape is just that, however, an idea, since not all inmates liked the sensation, as suggested by the contemporary case of Joshua Miller, who told Rachel Aviv of the *New Yorker* in 2012 that reading fiction was just too painful a "journey into the free world."[34]

In addition to the prison library, Sunday services led by public religious figures and prison reformers also helped pave the way for cinema. The last Sunday of the month was a musical or song service, a second Sunday given over to a "question time" where topics of a theological, religious, or ethical manner were discussed, and a special visitor always organized for the third Sunday.[35] One of the most frequent and popular visitors at Sing Sing was the English-born Maud Ballington Booth, also known as Little Mother, who founded the Volunteer Prison League (VPL) and made her first appearance at Sing Sing on May 24, 1896, when she was invited by Warden Omar V. Sage to conduct a chapel service.[36] Accompanied by her coworker Mrs. E. A. McAlpin, Booth "gave addresses most inspiring toward righteousness of life, and each of whom also holds, from time to time, personal interviews with a large number of men greatly to their well being."[37] From prisoner accounts of her visit, Booth mesmerized the convict population, not merely because of her gender and physical appearance (she was described as a "petite, modest-looking little woman in a shovel bonnet"): "The chapel seemed to be aflame with restlessness, appreciative of the presence again of *one* whom they have learnt to love and revere."[38]

Prisoner education in New York State, an outgrowth of the library, began in earnest at the end of the nineteenth century, although the 1899 *Report of the Superintendent of State Prisons* noted that the "education, training and reformation of the prison inmates" had been adopted and prevailed some fifteen years before this. The number of prisoners admitted to prison schools in the three main state prisons (Auburn, Sing Sing, and Clinton) was minuscule, however, in 1899, with just 72 "scholars" in Auburn, 114 in Sing Sing, and 125 in Clinton.[39] Notwithstanding these low numbers, there was a strong public commitment to libraries and education, and they were enlisted as powerful agents in the battle against mental atrophy. In 1905, under the supervision of Professor Calvin Derrick, Sing Sing's school was allocated new space in a second story, built above an industrial building. The new

quarters consisted of "four light, airy rooms, each furnished with the most modern equipment, an office for the head teacher, and a general assembly room for lectures etc. that will seat three hundred men." Inmate teachers staffed the school, and, as a result of a law in the 1910s requiring immigrants to learn to read and write in English, instruction was stepped up to a minimum of one hour every day in the classroom for non-English speakers.[40] Civilian instructors at Sing Sing taught classes with approximately thirty inmates in drawing, elementary Spanish and French, salesmanship, economics, and newspaper writing.[41]

Like the lectures and the prison school, organized sports such as the famous Black Sheep football team were enlisted in the reform battle against lethargy, mental inactivity, and physical ill health, inculcating, as E. Anthony Rotundo argues, "social, cooperative, and even submissive values," an "ascetic self-denial" for those engaged in more serious athletic training.[42] Sports helped create compliant subjects and, along with other sanctioned recreational activities, supported self-betterment: "Leisure time in prison that is regulated and supervised makes for health and clean living among the prisoners. Clean sport, such as baseball, handball, occasional 'movies,' all create and sustain interests that crowd out dejection, moping and despondency, which frequently culminate in defiance and mutiny."[43] In 1914, a boxing demonstration generated much excitement at Sing Sing (baseball, lawn tennis, medicine ball, and football [fig. 4.4] were also showcased) as inmate volunteers were sought to fight in two-minute rounds. The event was written up in a multisensory review of the match: "Now they were going fast and furious. Slam! Bang! The noise of those five ounced [sic] gloves was music to the ears of the followers of the fistic game, and it was a shame to stop . . . at the time keeper's cry of 'time,' which ended the round."[44] In June 1915, Warden Osborne organized a showcase of Broadway's dazzling talent, the group identified as the "Lambs Gambol"[45] (fig. 4.5).

A review of Sing Sing entertainment in the *American* commented on the men's exemplary behavior under the new Mutual Welfare League trusty agreement: Cartoons including *The Fatal Pie* (Rube Golderberg, 1916) and Windsor McCay's *Gertie, the Dinosaur* (Windsor McCay, 1914) were shown, making the event a vaudeville tour de force.[46] The Mutual Welfare League made access to organized entertainment such as vaudeville not only more likely but safer, since the onus fell on the shoulders of the inmates to behave in such a manner as to virtually guarantee that acts would continue to appear at Sing Sing and make the headlines in press coverage.

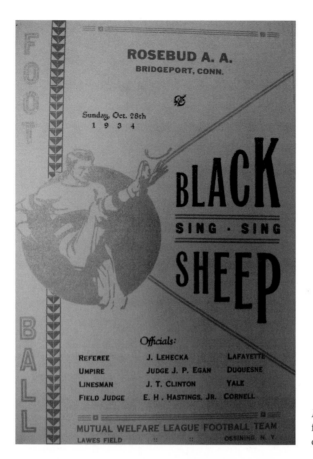

Fig. 4.4 Program for Black Sheep football team, Sing Sing Prison, ca. 1929. Courtesy LLP-JJC

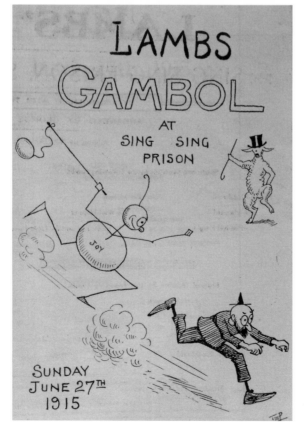

Fig. 4.5 Cover of "Lambs Gambol" program for showcase of Broadway talent at Sing Sing Prison, June 1915. Courtesy of MHL

Sing Sing's First Motion Picture Screening and Filmgoing Normalized

> And motion pictures allow them to relax amid these brief
> intimate glimpses of the world from which they have been
> isolated.
> Lewis E. Lawes, ca. 1935[47]

> The only moving-picture some men can ever see in Sing Sing
> is when the inmate moves out the front gate.
> Overheard at Sing Sing, *Star of Hope*, 1916[48]

The intermedial environment into which motion pictures emerged at Sing Sing was only one factor facilitating film's integration into the prison. Entertainment culture at the prison only took hold because of a more lenient administrative attitude toward the prisoner organization and the Mutual Welfare League (MWL). When the MWL met in the chapel on Sundays, the class associations of the entertainment ran the gamut; in Thomas Mott Osborne's words, "There was a wide variety. . . . One day a musicale, another day a scientific lecture, then a moving picture show, followed the next [Sunday] by a lecture on Napoleon."[49] This cultural shift included evening events in the chapel, a unique experience for inmates accustomed to being locked up at night.

Most of what we know about the exhibition and reception of film at Sing Sing comes from the *Star of Hope*, a Sing Sing–based prisoner magazine (fig. 4.6) published between 1899 and 1920 and distributed free to prisoners in all major New York State prisons (and available by subscription to penologists and other citizens).[50] The *Star of Hope*'s mission was "to encourage moral and intellectual improvement among its institutional constituency; to acquaint the public with our correct status; to disseminate penological information and to aid our condition morally by dispelling that prejudice which has ever been a hindrance to a fallen man's self-redemption."[51] According to penal historian Rebecca McLennan, the *Star* had four separate constituencies of readers and writers: "penal bureaucrats, convicts, wardens, and civilian penologists."[52] The *Star* was a vital force in the reform movement, publishing articles written by the inmates of the five major New York State prisons, including the State Prison for Women at Auburn, and documenting virtually every film shown in Sing Sing between 1914 and 1920, when it ceased publication after the governor declared it illegal to charge a subscription.[53]

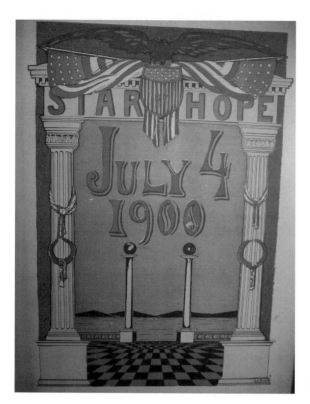

Fig. 4.6 Cover of *Star of Hope* 2 (July 4, 1900).

"Every inmate is considered a reporter and urged to contribute something to its columns," wrote the editor in the anniversary issue in 1900.[54] And while the prisoners were not free to write whatever they wanted—"much that is produced cannot be printed for one reason or another," wrote Sing Sing Chaplain S. Ernest Jones—the novelty factor of voyeuristically reading the thoughts of the incarcerated gave readers of the publication a unique window into the lives of the unfortunate.[55]

For those incarcerated in New York State penitentiaries, reading the *Star of Hope* was seen as a "salutary occupation," a "healthful stimulant in the mental activity of the contributors and, in a less degree, of all those who read the paper."[56] With a circulation of five thousand, the *Star* reported on world events, but mostly on issues of governance, prisoner rights, reform efforts, and weekly goings-on at each of the major penitentiaries. The *Star* was enjoyed equally by men and women, as inmate number 316 from the State Prison for Women at Auburn wrote in April 1901: "It is with great pleasure that I look forward to its arrival on Saturdays because I am always sure of finding

some comfort and some cheer in its pages. There are three departments which I never miss reading or studying . . . Higher Life, Open Congress, and Education."[57]

Despite its size and proximity to New York City, Sing Sing was not one of the first penitentiaries in the United States to show moving pictures. Its sister prison in the Adirondacks, Clinton, got a Power No. 6A projector (donated by the Auburn Film Company) six months earlier, in spring 1914, and started a regular Sunday film series.[58] The *Star of Hope* devoted inches of column space to motion pictures at Clinton following a Labor Day screening of *Never Again* (Edwin R. Philips, 1912), a Vitagraph two-reel comedy about a couple of hoboes who lock up two maids in a country store before being captured by the town police. The inmates eagerly anticipated the screening: "Everything comes to he who waits—providing he waits long enough. It was not so very long ago that we requested the reel man to get us another good two-reel comedy."[59]

But the inmates also got to see a film that struck a reflexive chord, *The Toll of Mammon* (Harry Handworth, 1914), shot on location at Clinton Prison and culminating in a poignant image of a consumptive prisoner, pardoned after thirty years of incarceration, walking a "well worn path to the front gate" and then out through "the small door in the big gate and into the arms of his little wife." In the words of a *Star of Hope* inmate author, "The little scene is a memorable one. Some day we all must pass through that gate to freedom and to many of us there will be no waiting wife." This walk-to-freedom scene must doubtless have affected prisoners differently. The inmate author's sarcastic comment about not having a waiting wife suggests that the fictionalized version of newly released prisoners by no means reflects every man's situation. And while the film's narrative arc suggests a benevolent criminal justice system—a man commits a crime, is captured, serves his sentence, and is finally pardoned on health grounds—this was by no means a preferred or inevitable reading. *The Toll of Mammon* could therefore be read simultaneously as a beacon of hope for the prisoners, an object lesson in good behavior for the administration, and a perverse take on Tom Gunning's idea of a "cinema of locality," films offering added pleasure through audience recognition either of themselves on the screen or familiar sights from their community.[60] Itinerant motion picture cameramen/exhibitors would occasionally shoot footage in communities and include the films in the lineup of the traveling show. For example, coverage in the *Times* of London of the opening of a new cinematograph theater by the Duchess of Portland in 1910

referred to "the majority of the audience [having] the unusual experience of witnessing their own arrival and subsequent deportment," only seventy minutes after the motion picture had been shot.[61]

Cinema arrived at Sing Sing in the wake of one of the most turbulent periods in the prison's history, when a "slew of highly politicized commissions of inquiry, grand jury indictments, civil legal proceedings, and muckraking exposés unleashed a steady torrent of stories and images of prisons, prisoners, and keepers into the public sphere."[62] The first exhibition of motion pictures at Sing Sing took place in October 1914, under the temporary wardenship of George S. Weed, who oversaw the prison from October 1 until Osborne took over on December 1 the same year. It is hard to overestimate just how excited the inmates must have been at seeing motion pictures in the prison's Y-shaped chapel, a flexible space that could either be one large room or, through folding doors, separate rooms within the chapel.

The inmates did not learn of the motion picture screening until early in the morning of Saturday, October 17, 1914, a gray, rainy day with low-lying clouds over the Hudson River. Despondent at the prospect of spending the entire day locked inside because of the inclement weather, "all disposition to complain was removed" when the men learned that a "moving picture machine had arrived at Sing Sing and a 'show' would be given in the afternoon."[63] During the inaugural screening, seven reels were projected in the chapel in two screenings (the norm at the prison given the size of the chapel, which could not accommodate the entire prison population in one sitting), consisting mostly of Kalem comedies and Mack Sennett's *What the Doctor Ordered* (1912).[64] After the final film, the projector was turned off to allow Chaplain Luckey to thank the individuals who had made the screening possible, especially Miss Ella H. Davidson of New York City, who had donated the motion picture projector along with enough films for three months' worth of weekly screenings.[65] She made a guest appearance to thunderous applause at the second screening the following Sunday.

It is tempting to read a great deal into the gendered connotations of Davidson's gift, and to have seen her walk into Sing Sing's chapel with the men cheering must surely have been a sight. If we go along with the idea of cinema as a source of comfort to these men, then Davidson was something of a "Florence Nightingale of motion pictures." Other films exhibited that day included the ironically titled *A Race with Time* (Kenean Buel, 1912), about a

station agent's daughter securing a mail contract for the railroad as well as a future husband (the railway president's son), and, last but not least, *Conway, the Kerry Dancer* (Sidney Olcott, 1912), a film featuring the Irish jig. The inmates' response was ebullient: "To say that we enjoyed the entertainment would tell only half the truth, we enjoyed it and we enjoyed the thought of the other entertainments of which it was the promise and the forerunner."[66] Not surprisingly, the editors of the *Star of Hope* trumpeted the monumentality of the occasion, hoping with all their hearts that this would be the start of something permanent. The self-governance of the MWL was publicly credited in the pages of the *Star* "for the order and fine discipline which is being maintained in the chapel," and Sunday film screenings gave the men a much-needed break from their cells, where they would otherwise have spent an inordinate amount of time over a typical weekend.[67]

Responsibility for booking lecturers, acts, and performers was shared by the elected MWL officials (the secretary of the Entertainment Committee), the warden or senior staff members, and inmates themselves, as when Elmer D. Taylor, representing the Colored Committee of Auburn Prison as chair of its entertainment committee, wrote to columnist D. Ireland Thomas asking for assistance in procuring "any entertainers from the outside world who would care to donate their time to come in and entertain these men and women."[68] And so began the tradition of showing films at Sing Sing, a ritual involving "700 or more of us sit[ting] in the chapel watching the pictures, instinct with life, that are thrown up on the screen and listening between the reels, usually six in number, to the very excellent music, both vocal and instrumental."[69] Members of the MWL's executive board also elected a sergeant at arms and deputies, who oversaw security at screenings and regulated the line-ups and marching to the mess hall.[70] Within three weeks of the inaugural screening, the *Star* had established a weekly column (the first was on November 7, 1914) reviewing the entertainments titled "At the Movies," which later became "On the Screen in Sing Sing" (fig. 4.7).

Holidays, such as Thanksgiving and Christmas, were no longer the only times of the year that special entertainment was featured. By the beginning of 1915, motion pictures were exhibited weekly, sometimes more frequently, depending on the availability of films. Sunday, February 7, 1915, was a standout day for film at Sing Sing: "Motion pictures galore claimed our attention,"

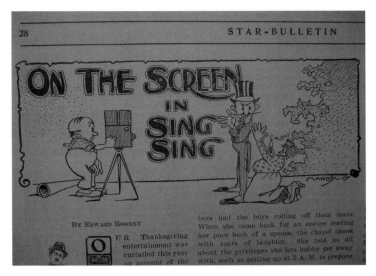

Fig. 4.7 "On the Screen in Sing Sing," masthead for *Star-Bulletin* 19, no. 8 (January 1918).

wrote the editor of the *Star of Hope*. And they were "good and there were plenty of them." The afternoon of film began with the five-reel *Winning the Futurity* (Walter Miller Feature Film, 1915), followed by the crusades drama *The Blind Queen*, introduced by Clifford P. Saum of the Reel Film Company, who promised Sing Sing's budding film fans "all the reels we might need." The Paramount comedy *The Man from Mexico* (Thomas N. Heffron, 1914), starring John Barrymore, rounded out the day, a film donated by William L. Sherry of the Feature Film Company.[71]

Several protocols of the emergent model of theatrical film exhibition were either eschewed or modified in this and subsequent screenings at Sing Sing, imbuing the experience with something of an anachronistic feel, reminiscent of early cinema's integration into vaudeville and the funfair. First, cinema's use within an intermedial environment that included pyrotechnics, contortionists, violin soloists, and lecturers, which all appeared at Sing Sing during the 1914 holiday show, was a throwback to the prenickelodeon period rather than the start of the picture palace era.[72] Second, the free admission was a negation of the commercial underpinnings of cinema (the men were charged "not a Broadway price [but] simply a decent regard for the rules by which we are all governed").[73] Third, motion pictures altered the temporal

rhythms of Sing Sing's penal culture, quite rapidly turning inmates into heavy viewers who probably watched on average far more films per week than their nonincarcerated brethren.

Films sometimes showed up unexpectedly, as on Monday, January 4, 1915, when inmates returning to the workshops from lunch were instructed to "fall in line and march to the chapel for motion pictures."[74] The first three films that afternoon were sponsored by the Industrial Betterment Committee of the National Manufacturers Association and consisted of *Workman's Lesson* (Thomas Edison, 1912), an industrial film about safety precautions in the American factory; the dramatic one-reeler *Crime of Carelessness* (James Oppenheim, 1912), which warned of the dangers posed by workplace smoking, blocked fire exits, flammable waste, and the resulting destruction of property and death or permanent disability to workers; and *The Man He Might Have Been* (William Humphrey, 1914), a morality tale about a father going against both his son's wishes and his son's teacher's recommendation to send the boy to a night industrial school.

The final film, *An American in the Making* (Carl Gregory, 1913), produced by the United States Steel Corporation's Committee of Safety, was a parable of the American dream, a fitting subject for inmates who held out hope for a redo once they were released. The film opens with a Polish man accepting an industrial sponsorship from a relative to travel to the United States and learn a trade. We trace his journey across the Atlantic, watching him gaze at the Statue of Liberty, pass through U.S. immigration, and, after a long train ride, meet his sponsor. The film's message cannot have been lost on the thousands of immigrant prisoners watching it at the start of the workweek at Sing Sing, many of whom had similarly arrived in America from Europe. If the intertitle "He Finds a Better Place than the Saloons for His Leisure Hours" was unintelligible for non-English speakers, the film's depiction of safety equipment in a steel plant and a YMCA building in Gary, Indiana, where our unskilled laborer finds a temporary home and succeeds in finding a wife and starting a family, drove home the Americanization object lesson.[75] A final intertitle noting the passing of six years marks a return to the dramatic style of the opening—except our immigrant is now a company man working for United States Steel Corporation and living in company housing, married, and playing with his young son in a snowy company playground. *An American in the Making* made several points simultaneously, targeting immigrant

prisoners with lessons about American values of hard work, corporate benevolence, and the centrality of family, while also educating prisoners about workplace safety.

Such impromptu screenings at Sing Sing were rare, however. With a goal of chasing away the "gloom that has been accumulating within the dull, gray walls of Sing Sing during the past eighty or more years," the MWL's Entertainment Committee solicited donations from exhibitors, lecturers, and performers, programming evening entertainment in the prison chapel. The *Star of Hope* not only provides us with a near-exhaustive list of the films shown at Sing Sing between 1914 and 1920 (when it ceased publication), but, in many cases, donors are thanked for the loan of films, as Vitagraph was in September 1916 for *The Man Behind the Curtain* (Cortland Van Deusen, 1916) and in December 1916 for *The Light of New York* (Van Dyke Brooke, 1916), an unintentionally reflexive crime drama in which the hero robs a wealthy banker, who dies of shock during the holdup, and is sentenced to Sing Sing, but not before almost successfully tricking the banker's daughter into marrying him. According to the *Star*, there were weeks at Sing Sing when films were shown every night, with titles coming into the prison from the Keystone, World Film, Fox, and Bluebird production companies. In November 1918, a total of 285 reels of films were shown, consisting of forty features, forty-nine comedic shorts, and twelve Pathé News and Universal Animated Weekly newsreels. The *Star* congratulated the Entertainment Committee of the MWL, noting that this was the largest amount of film ever shown in a single month at Sing Sing, a phenomenon made possible by the cooperation of several distributors who responded to the prisoners' appeals for motion pictures.[76]

Writers in the *Star of Hope* expressed appreciation to motion picture executives for "doing their bit" at Sing Sing, and for their humanitarianism in the face of the nonprofit prison screenings from which neither producer nor exhibitor received revenue. "The gratitude of the 'shut-ins' you will see radiating from every countenance here tonight," wrote a contributor to the *Star*, with thanks given to the donor of the program as well as "each of the distinguished artists whom it is our great honor and privilege to thank and applaud for this short 'bit' they are 'doing' at Sing Sing."[77] Warner Bros. certainly "did their bit"; in exchange for location shooting for *20,000 Years at Sing Sing*, Harry Warner paid for the construction of the prison's gymnasium (in memory of his son Lewis Warner and intended to provide inmates, in Warner's words, with "recreation and to build their character").[78] Jack War-

ner's authoritarianism drove employees to start referring to the studio as Sing Sing, San Quentin, and West Point.[79] Giving back to the inmate community continued well beyond the silent cinema era, with studios offering to make charitable donations to prisoner funds in exchange not only for location shooting but for the free publicity to be leveraged from showing films to a convict audience. For example, as compensation for previewing the Twentieth Century Fox film *Johnny Apollo* (Henry Hathaway, 1940) at the prison in the presence of the press and editors of college newspapers, Fox offered to "contribute substantially" to Sing Sing's Prison Welfare Fund or any other cause suggested by Warden Lawes.[80]

The Hollywood film studios' desire to use Sing Sing as a location effectively transformed the inmate population into workers for hire, employed in a version of the convict labor they performed daily in the prison workshops. The heading of the *Star of Hope* column listing films recently shown at Sing Sing formalized the thank you: "Pictures and Shows Seen at Sing Sing . . . and Our Sincerest Good Wishes Are Extended to the Motion Picture Producers Who Have Gladdened Many a Dark Hour."[81] On several occasions, Sing Sing's inmates enjoyed prereleases, such as Universal's seven-reel feature *Come Through* (Jack Conway, 1917), about a young man from a Montana mining camp who climbs to the heights of New York society as a dancer and gentleman burglar. A prisoner-reviewer in the *Star* expressed gratitude for the screening while boasting about the inmates placing their "stamp of approval on [the film] long before it was released for outside public gaze." Prisoners assumed the unlikely role of industry insiders or journalists at these screenings— connoisseur viewers who could vouch for the authenticity of an "underworld picture," although in this instance, the film was a more seemly take on the genre, as *Come Through* was "shorn of all the sordidness of the 'underworld'" since it examined the hypocrisy of those living the high rather than the low life.[82] In sum, Sing Sing's prison chapel was no second-run venue for films that had finished playing theatrically. Furthermore, Sing Sing's resident audience was often joined by members of the motion picture industry and visiting dignitaries, including New York State senators and the superintendent of prisons, who sometimes stayed for motion picture shows after spending a day inspecting the prison and dining in the warden's residence.[83]

Film programming was eclectic, ranging from Paul Rainey's famous wildlife films one night (where the jungle life was made "very real to all present") to Pathé Weekly news, vaudeville, and *Vendetta*, a dramatization of Marie

Corelli's novel of the same name, the next.[84] On January 29, 1915, cartoons parodying prison life and public perceptions of it were shown, including *What the Public Thinks We Are* (showing a man in prison stripes with a hard face) and *Are We Really Here?*[85] Two films contrasting old and new penal regimes came next: *As It Used to Be*, featuring "a gang of gray-clad zebras marching the lockstep," and *As It Is Now*. During the chorus of "It's a Long Way to Tipperary," inmates sang along to the words projected on the screen. More cartoons rounded off the evening. The following month, the Strand Theater of New York donated a $360 Simplex motion picture projector to Sing Sing, a gift secured by the chairman of the Entertainment Committee (inmate 64311) and his two associates (inmates 62886 and 63778).[86] On Lincoln's birthday in February 1915, a special meal was matched with special entertainment, including a concert by the Sitting Trio of Berlin, an illustrated lecture by Charles S. Tator on "Our Unique United States,"[87] and films shot by John Everest Williamson during the Williamson Submarine Expedition in the Bahamas, the first underwater motion pictures ever made, ingeniously titled *Thirty Leagues Under the Sea*.[88]

There is no simple way of ascertaining the impact of early motion pictures on the Sing Sing audience, of assessing prisoner subjectivity and interiority from a distance of one hundred years. One must, therefore, search for clues beyond the public remarks about the general impact of motion pictures on the plight of the imprisoned in the narrowly circulated and often marginal remarks, such as one by a contributor to the *Star of Hope* about entertainment giving a prisoner a chance to "consult his moods."[89] The idea of consulting the moods is reminiscent of Hippocrates' humors theory that linked bodily fluids to the four temperaments: sanguine, choleric, melancholic, and phlegmatic. Believing that different types of bodily fluids were responsible for these four moods, medievalists and philosophers down through the centuries have viewed the humors as important agents in shaping personality and maintaining bodily health.[90] Entertainment in the prison chapel served as a litmus test of prisoner well-being, and the *Star* urged prisoners to use these occasions to gauge their own mental health and absorb the moral object lesson, to "laugh, applaud, think, and reflect by [themselves] and grow."[91] Rhetoric about the positive benefits of entertainment not only reassured prison authorities (and the anticoddlers) that entertainment was paying off in terms of inmate cooperation and good behavior, but reminded the prisoners that this was how they should feel about the ameliorative effects of cinema, a bit

like the hero in *Sullivan's Travels* asking whether he is responding appropriately to the comic film.

Less than five months after the inaugural screening at Sing Sing, the prison boasted a vibrant film culture, becoming the number one leisure activity of 1,800 or so men. A large number of reels of film entered the prison on a weekly basis, inmates had access to homegrown film criticism in the *Star of Hope*, and film studios began shooting on location at Sing Sing, including for Maurice Tourneur's 1915 *Alias Jimmy Valentine*, which had footage of actual prison drills. The experience of watching *Alias Jimmy Valentine* at Sing Sing became an act of self-witnessing for the 1,800 inmates, as the prison's reviewer put it: "The play was full of action and the scenes were very realistic, especially those laid in Sing Sing. . . . And of the companies of men marching through the yard to the mess hall were men—scores of men—who sat in the audience viewing the pictures, and, of course, they and their comrades had no trouble identifying them."[92]

Being in prison and recognizing yourself on the screen must have been a bizarre experience, triggering an existential jolt about your dire situation. The actuality footage contained within *Alias Jimmy Valentine*—exterior shots showing the men at work in the quarry, marching to and from the shops, and recreating in the yard—elicited a mixed response from Sing Sing's inmate population. While some of the men purportedly cheered loudly when Warden Osborne appeared in the opening shot of the film, several of them are seen lowering their heads and tipping their caps to conceal their identity as they march before the camera (fig. 4.8). Resembling a "perp walk," where arrested individuals are paraded from the police precinct to a waiting car before the assembled news media, Tourneur's footage of Sing Sing prisoners doing their drills is redolent with layers of signification, especially when we factor in the film's exhibition at the prison. And yet the men's reaction to being seen on screen also generated some mirth, the quarry scene eliciting a big laugh, and jokes were "distributed all around as the men recognized each other in the line of marchers going to and from the shops."[93] We see a similar range of reactions to being imaged in a photograph, taken at the screening of *Alias Jimmy Valentine* and showing some men looking away or hiding (fig. 4.9), that appeared in *Motography*. While seeing yourself on screen in the company of fellow inmates might have lessened the embarrassment of being identified as a convicted criminal, being seen by family members, friends, or future employers was a different kettle of fish.

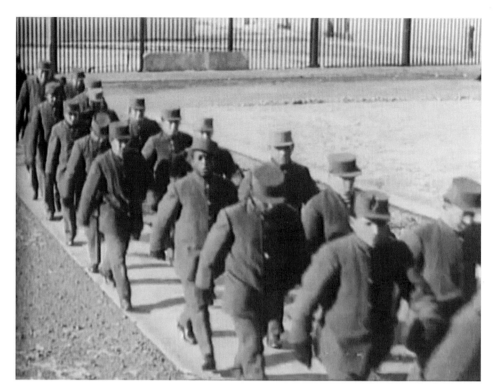

Fig. 4.8 Frame enlargement from *Alias Jimmy Valentine* (Maurice Tourneur, 1915).

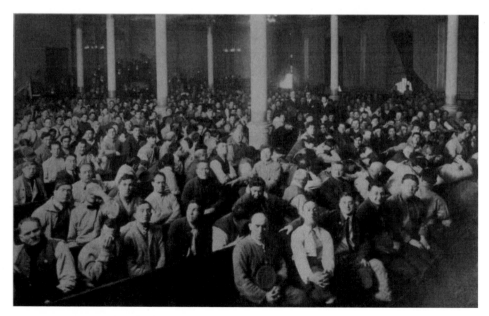

Fig. 4.9 Faces of inmates viewing *Alias Jimmy Valentine* (Maurice Tourneur, 1915) at Sing Sing Prison. *Motography*, 1915

Cinema's Role in the Prison's Health Crusade

By 1927, films were shown to certain Sing Sing inmates at 10:00 P.M. every single night of the week, as F. Raymond Daniel reported in the *New York Evening Post*: "They have movies every night but that's just to get out of the unhealthy cells. The three hundred men in the new sanitary block are not allowed to go to the show."[94] Linking film to a public health crisis at Sing Sing shaped the discourse around motion pictures as early as 1915, and while evening classes, lectures, and concerts were also a way of getting men out of their cells during the evening, it was film that needed justifying the most, shown "not only for the purpose of education and amusement, but for the larger reason of taking the men from the vile and unsanitary cells as much as possible."[95] The *New York Times* corroborated the public-health justification for showing the films, arguing that "the purpose of these prison shows is widely misunderstood." They were not, the *Times* claimed, for the purpose of amusement—"'coddling the prisoners' is the usual expression"—but had quite another purpose.[96]

The prisoners were offered the choice of staying in their damp cells and watching films every night or relocating to new, dry cells and seeing films on Tuesdays and Fridays. The *New York Times* quoted Lawes as saying that "contrary to general belief, nightly shows were given not primarily to entertain the prisoners, but rather to keep them out of the insanitary [*sic*], stone cells, most of which have been abolished."[97] Living in cells that measured seven feet long, six and a half feet wide, and six feet high (just 168 cubic feet of air, far below the minimum of 400 specified by the New York Board of Health), prisoners frequently contracted pulmonary, upper respiratory, and dermatological diseases. Cinema's role in public health at Sing Sing differentiated it further from theatrical screenings, although for poor audiences living in run-down tenements, going to the cinema was also a healthy alternative to staying at home.

Another rationale for the nightly screenings was to inhibit inmates from engaging in sex,[98] after doubling up in cells became necessary for the first time in 1859 (1,228 inmates, with cell capacity for 1,072) and the norm during the 1890s.[99] Lawes spoke frankly on the issue of homosexuality in prison in an interview with the *New York Daily News* in 1934, arguing that normalcy (by which he meant heterosexuality) could be encouraged—if never fully attained—through such entertainment as motion pictures, radio, football

teams, and brass bands. Falling short of recommending conjugal visits, Lawes definitely pointed toward the idea in his argument that "until near normal sex lives can be lived in prison, a large part of our attempt to remake [inmates] instead of merely to punish them are bound to be defeated . . . [since] the sex instinct is not killed by wars and bars; it is merely distorted, turned in on itself."[100] As a way of mitigating the effects of damp cells and preventing sexual activity, the screening of films at Sing Sing complicates the usual moral panic about cinema's corrupting influence; in the prison at least, representations of sexual activity on screen were tame compared to what went on offscreen.

Yoking one insalubrious institution (prison) with another (motion pictures) thus puts an interesting spin on the traditional moral panic over the deleterious effects of motion pictures on so-called vulnerable groups such as children, women, and the working class. And while concern about same-sex relationships had been voiced for a very long time (and was a factor in Osborne's resignation after he was accused of having sex with several prisoners in 1916), it is striking that cinema should be employed in the fight against them.[101] It is worth mentioning that Lawes also enlisted the library in the war against same-sex relationships in prisons, arguing that "he'd tried to find the answer to that [homosexual sex] in wholesome recreation, in sportsmanship on the athletic field, in talking pictures, in radio, in letter writing, in a well-ordered library, in an occasional lecture by laymen with a worthwhile message, in visits from close relatives, and, of course, in religious affiliation."[102] The likelihood of the "well-ordered library" (or any of the other recreational forms) magically sating prisoners' carnal desires is pretty slim; indeed, one could argue that these activities might have stirred rather than suppressed desire.

Notwithstanding the prison authority's goal of using cinema to (attempt to) stave off perceived sexual deviancy and ill health, cinema in Sing Sing was shaped by lots of forces and competing discourses, none of which dominate. One of the least compelling explanations of what cinema meant in the prison was its role as a panoptic device, exercising control over inmates through compliance and conformity. In light of the fact that evening screenings were not always mandatory (men had the option of remaining in their cells) and that motion pictures created opportunities for all manner of unsanctioned behavior, a Foucauldian reading of cinema's uses in the prison must be measured. But how did the prison authorities feel about prisoners watching

virtually the same lineup of films as their free brethren? And surely the endemic moral panic about the negative effects of film on so-called vulnerable groups must have applied to prisoners, or perhaps the stakes were lower because they were already on the wrong side of the law and considered beyond redemption?

The Coddling Debate

There were, of course, those who disagreed with the practice of inmate film screenings, and cinema for the incarcerated became part of the ongoing debate over coddling in the early twentieth century. Despite a 35 percent drop in crime since 1916, New York City police commissioner Richard Enright nevertheless blamed prison leniency for increases in serious crime: "They have the best food, the best treatment, medical attention of the highest order, baseball, lawn tennis, motion pictures every day, drama often and sometimes grand opera. Convicts are treated better than ninety percent of the people who have homes in this city."[103] For anticoddlers, filmgoing pampered prisoners, giving them something they did not deserve. And for those who felt that prisons should be places of unrelenting punishment, inmates playing sports, watching movies, or even listening to a band as they marched into the mess hall for meals was too much to stomach.[104]

Cinema represented the equivalent of giving prisoners their liberty, a view expressed in the facetious tone of Charles Dudley Warner's list of prison conveniences: "a library, often large and well selected; an admirably arranged hospital; a cheerful chapel, garnished with frescoes and improving texts . . . Sunday services and Sunday schools . . . a chaplain who visits the prisoners to distribute books and tracts, and converse on religious topics; [and] lectures, readings and occasional musical concerts by the best talent."[105] While most wardens flatly denied coddling, some, such as Henry A. Higgins of the Boston House of Correction, blamed "hard boiled prison methods," rather than coddling, for a crime wave in the early 1920s.[106] Wardens caught up in the coddling debate were in something of a double bind, then, as lawyer Henry Melville explained to Sing Sing's warden Lawes in 1922: "There really are a lot of people who think you ought to coddle. You'll be damned if you do and damned if you don't. Meanwhile most people will think you are doing about right but they are the kind that don't say anything."[107] Lawes also objected to what he saw as a double standard: the same people who would never dare

assume expertise in the management of schools, hospitals, power plants, garages, or morgues knew "all about how to run a prison—simple—just lock the convicts up and throw away the key."[108]

Lawes vehemently defended the screening of films at Sing Sing against charges of coddling, arguing, "If they are permitted to go to movies at night or to ball games on Saturday and Sunday it is because we believe they should receive some recreation that will place them in a better mood toward society. . . . Some people may call it coddling the prisoners but I merely consider it an essential part of my policies."[109] In the minds of some, motion pictures and sports were viewed as evidence of progressive penal policy; in the minds of others, as egregious examples of convict indulgence.[110] But Lawes dug even deeper into the complex meanings of the idea of coddling in an article published in the *New York Times* in November 1931. Tracing the term's use to the period following the opening of the first prison library in the 1840s (which led to reading in cells) and the abolishment of the lockstep and prison stripes in 1904, Lawes argued that these "so-called luxuries"—a Christmas or Thanksgiving dinner, occasional lectures, moving pictures, and radio earphones in individual cells—paradoxically "increased [the sensation of] punishment" for some prisoners, since they emphasized the fact of their imprisonment.[111]

Motion pictures were seen to coddle prisoners because they offered a temporary lifting of the psychic veil of imprisonment, and in that shared experience, for a brief hour or so, the inmates of Sing Sing were no different from their free brethren watching the same films down the road in the small town of Ossining. This shared experience continues to offend some commentators, and the coddling debate has never entirely gone away, as witnessed in our current era, when budget cuts and antipathy and indifference toward the incarcerated have worsened prison conditions for many. Whereas coddling was once presented as strategic—New York State senator William L. Love viewed coddling as a means of staving off mental illness among prisoners, especially those under twenty-one years old, who were imprisoned for petty crimes and perceived as victims of their environment[112]—it is now largely an antiquated term, although quality newspapers like the *New York Times* continue to refer to initiatives such as prisoner art, drama, and yoga programs in terms consistent with the older coddling debate.[113]

Efforts to limit the entertainment Sing Sing prisoners had access to took a bizarre turn in 1921, when a man purporting to represent the Mutual Welfare League told motion picture producers who occasionally supplied film to

Sing Sing that the MWL no longer wished to have films shown at the prison. This incident proved troubling to both MWL and prison officials, since this fake, and possibly demented, agent was also interfering in fund raising for the league, telling the production company working on the film *Miss Lulu Bett* (William C. de Mille, 1921) that the MWL wanted to cancel the show.[114] As late as 1938, prison administrators and reformers were still dealing with the age-old dichotomy of harsh punishment versus coddling; writing in *Harper's Weekly*, one reformer opined, "It is suggested that we build schools and establish libraries, promote athletics, and provide some entertainment, and when we do so—immediately the cry is raised that we are coddling the criminal and what's the world coming to."[115]

Lawes, Hollywood, and Sing Sing: A Marriage of Convenience

When Lawes took over as Sing Sing's thirty-ninth warden in January 1920, Osborne sent him a letter in which he stated, "You will not take it amiss that I do not congratulate you on becoming warden of Sing Sing. In my judgment, it is, under existing conditions, what Mr. Rattigan [NYS prison commissioner] once called it, 'an impossible job.'"[116] Born in Elmira, New York, in 1883, Lawes (fig. 4.10) began his penal career by running a youth reformatory in Orange County, New York, becoming a guard at Clinton Prison in the Adirondacks before being offered more senior positions at Auburn Prison; Elmira Reformatory in 1906;[117] Hart Island Reformatory in 1915, where he was superintendent; Massachusetts State Prison in 1918, where he was warden; and Sing Sing in 1920, where he was warden for twenty-one years.

By the 1940s, Lawes had become a nationally renowned penal expert, anti–death penalty activist, progressive, leader of the Boys' Club movement, and media celebrity.[118] As staunch critic of the death penalty, Lawes spoke frequently and fervently on the subject, laying out his opposition in his 1932 book *Twenty Thousand Years in Sing Sing*: "I am opposed to the death penalty because the evasions, the inequality of its application, the halo with which it surrounds every convicted murderer, the theatrics . . . the momentary hysteria, passion and prejudice aroused by the crime which often make it impossible to weigh the facts carefully and impersonally and, finally, the infrequency of its application—all tend to weaken our entire structure of social control."[119] Lawes published five books, two of which were turned into

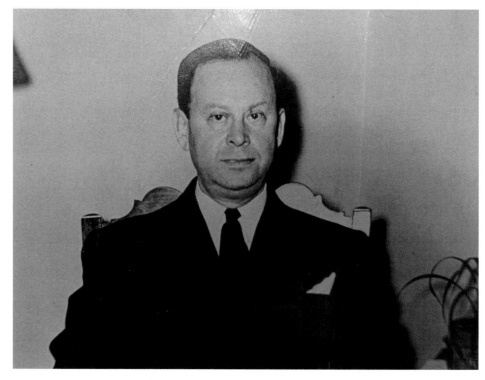

Fig. 4.10 Lewis E. Lawes, Sing Sing warden from 1920 to 1941. LLP-JJC

movies; cowrote *Chalked Out*,[120] a Broadway play; and hosted a Sunday night Fireside Chats radio program.[121] Given the countless solicitations Lawes received from magazine and newspaper editors to write articles, publicity blurbs, book reviews, and editorials and answer questions about prison conditions, his ruminations on motion pictures were obviously inflected by his reputation as a progressive prison reformer and penologist.[122] Lawes's opinion was solicited on a range of topics, including the perceived deleterious effects of crime films on young people, a question sent him by the International Penitentiary Commission in preparation for the Ninth International Penitentiary Congress, held in London in 1925. While Lawes's response was unremarkable in terms of hitting the right notes about the dangers of crime films, his reference to a "recent growth of cinematographic shows" in which the public is lured to watch "the worst criminal exploits, and other sensational and immoral representations" demonstrated that Lawes was not afraid

to stand on the side of the moral conservatives, even though his relationship with Hollywood might have posed a conflict of interest.[123]

Siding with the progressives, who blamed film for society's ills and the spike in crime, made Lawes vulnerable to charges of hypocrisy, however, since not only did the motion picture industry use Sing Sing for location shooting but two of Lawes's books had been optioned and turned into films—*Up the River* (John Ford, 1930), starring Lawes's nine-year-old daughter, Joan (Cherie) Lawes, and *20,000 Years at Sing Sing* (Michael Curtiz, 1932; the book was also a May 1932 Book of the Month Club selection). Lawes was friends with several studio heads who had much to gain from maintaining a cordial relationship with the warden of the world's most notorious prison. PR and film promotion gimmicks, such as film previews at the prison and competitions for the titling of films, were some of the other ways in which the industry co-opted the prison into its publicity machine. While there is little archival discussion of the effect motion picture shooting might have had on maintaining security at the prison, anecdotal evidence suggests that this caused great excitement among the inmates, and, for some at least, the presence of motion picture personnel on Sing Sing's grounds lent an air of glamor to the gray surroundings, shored up the institution's notoriety, and brought the long-sought-after outside world a bit closer. As compensation for previewing *Johnny Apollo*, a film about a father and son finding regeneration in prison, in the presence of the press and editors of college newspapers at Sing Sing in 1940, Twentieth Century Fox offered to contribute to Sing Sing's MWL Fund. *Angels with Dirty Faces* (Michael Curtiz, 1938), *Each Dawn I Die* (William Keighley, 1939), *and Kiss of Death* (Henry Hathaway, 1947) all used location shooting at Sing Sing, a tradition that continued well into the twentieth century with *True Believer* (Joseph Ruben, 1989), with James Woods and Robert Downey Jr.; *Hudson Hawk* (Michael Lehmann, 1991), starring Bruce Willis, James Coburn, and Andie MacDowell; and *Analyze This* (Harold Ramis, 1999), featuring Robert de Niro and Billy Crystal.

"Do they foster social adjustment or do they tend toward its disruption?" Lawes asked of motion pictures in the late 1920s. He answered his own question with a somewhat predictable glass-half-full/glass-half-empty response: "There are some splendid productions. But most moving picture producers give their public what it wants—trashy, unreal crime, or combination fairy

and filth stories."[124] Crime films posed a singular problem for Lawes and other wardens; if they delivered a powerful object lesson that crime did not pay and represented the criminal as mentally afflicted, then they could be of some value, but Lawes remained skeptical of the genre, saying, "I do not, as a rule, approve of pictures dealing with the criminal mind because they tend too much to rely on violence and excitement, instead of emphasizing the lesson they should convey—that crime does not pay."[125] Opposed to film censorship, Lawes held out hope that public opinion might sway the Hollywood screenwriter to inscribe more prosocial messages in films and tone down the glamorized violence. "Predatory criminals in luxury, rich exploiters of labor and evil designs on virtue, all are portrayed in elaborate detail. . . . I am opposed to official censorship, but I believe public opinion can, and will force a change for the better in the cinema scenario."[126] In 1929, sound films were projected at Sing Sing, a notice in the *International Review of Educational Cinematography* stating that the apparatus had been installed for the projection of films "aiming at the social re-education of the prisoners."[127]

In spring 1935, Gustavus T. Kirby, chairman of the Boys Athletic League, organized a testimonial dinner at the Waldorf Astoria in New York for Lawes recognizing thirty years of service. Invited to the dinner were such Hollywood luminaries as Will H. Hays, president of the Motion Pictures and Distributors of America, Harry M. Warner from Warner Bros., and Major Edward Bowes, vice president of MGM, who were invited to comment on Lawes's contributions to humanity as an outspoken critic of capital punishment and a prison reformer. President Franklin Roosevelt wrote a letter congratulating Lawes on his service and his fidelity, impartiality, and humanity.[128] Several of these men had good reason to be grateful to Lawes; when Harry Warner's brother Jack used Sing Sing as a location in the 1930 film *Up the River,* he wrote Lawes in 1932, personally thanking him for "the splendid cooperation given our boys who are photographing at the prison."[129] Friend and admirer Charles Chaplin, who had toured Sing Sing with Lawes in 1921, praised Lawes for his common sense and humanitarianism, half-jokingly saying, "I think it would be a mistake to release you from Sing Sing even after doing thirty years there, and if I had my way I would insist that you remain."[130]

The motion picture industry was quick to exploit the prisoners' new status as film fans, with Carl Laemmle of Universal launching a contest to find the best name for an untitled film tragedy that premiered at Sing Sing in February 1915 (the winning convict would receive $50). Six months later, the

New York Times announced the winner, convict 265's title *Life's Crucible*.[131] This publicity stunt quickly spawned imitators, including another film company offer of a prize of the same amount for the best "scenario written and submitted by any 'guest' in warden Thomas Mott Osborne's 'detention home' up the Hudson." According to the *New York Tribune*, "The winning scenario will be produced in Sing Sing before being released. Comedies, dramas or melodramas are available but 'biographies' are barred."[132]

There is little to no discussion of censorship by the prison authorities or the MWL at Sing Sing; according to Lawes, the MWL's director of entertainment was "its own censor of what was decent and presentable to the general prisoner population," and while some titles were rejected, including all of Fatty Arbuckle's films after his 1921 sex scandal (a policy in keeping with many other theaters across the country), most were screened without problem.[133] And even though the warden had veto power as the censor at large, the MWL entertainment director was in charge of "all recreation on the field and in the chapel," organizing sports, musicals, motion pictures, and "whatever social welfare work that was called to its attention by prisoners on behalf of their dependents."[134] In any event, prison censorship of films was only part of a network of constraints for Hollywood filmmakers, including a strengthened production code after 1933. Despite accusations of glamorizing criminals, especially with the rise of the 1930s gangster genre, the code's message that crime never paid was normalized within an institutional mode of representation.[135] The *Star of Hope* earlier praised what it saw as a shift toward "clean moral pictures" in June 1918, analogizing immoral pictures to a "disease . . . [that] if allowed to spread would eventually have proven fatal," although the author quickly added that a portrayal of vice was "essential in many instances."[136] Censoring crime films for inmate audiences might have seemed pointless to prison administrators in any event. Nevertheless, the *Star* was quick to defend films whose "sensual atmosphere" was deemed inappropriate, arguing that the "great moral lesson and eternal truths" driven home by a film justified any potential impropriety.[137]

In the summer of 1929, when Sing Sing's new cell block was completed, Lawes cut back the number of weekly screenings from seven to two, on Tuesday and Friday evenings, at 7:00 P.M. instead of 10:00 P.M., arguing that "two shows a week are both sufficient and reasonable. The inmates, according to keepers, prefer having their new cells and less entertainment by pictures to the old quarters and more amusement."[138] Those inmates still housed

in the old cell block could continue to attend nightly screenings, for the primary purpose, Lawes argued, of "health, as the cells are so small and unsanitary that it is important that prisoners should not be kept locked in them a minute longer than necessary."[139] By this time, a typical program consisted of two features, a newsreel, and short subjects. These films were first run, an arrangement made possible by Sing Sing's membership in the New York Film Board of Trade and with the cooperation of the Skouras brothers (who operated a film exchange) and the local theater. A profile of Sing Sing from a 1949 issue of *Corrections* magazine concisely confirmed the arrangement with the local theater: "Programs are usually the same as shown in the village of Ossining."[140]

At Clinton Prison in the Adirondacks, cinema and ball games leveled the differences between the free and the incarcerated, since the general public was permitted entry to both.[141] And in 1928, inmates at the prison in Windsor, Vermont, saw films several hours before the townspeople; a full house was instantly guaranteed at the prison, whereas it would take longer for the general public to decide whether or not it wanted to see a film during its theatrical run.[142] Films at the Windsor prison were shown in the so-called Ballroom for Inmates, a space that was also occasionally rented out to community groups. The prison was thus both part of a community and an autonomous community, with "several different factories, a power and light plant, storehouses, work buildings, barns, hospitals, kitchens, and mess halls, school, morgue etc.," according to Lawes.[143] Motion pictures bridged the differences.

Radio Introduced: Prison Walls Torn Asunder

Radio was ontologically suited to carcerality, the perfect medium for isolated individuals, serving "the sightless, the bedridden, the farmer and the deaf."[144] Lawes was an early adopter of the new medium, stating that radio "cannot be an instrument for anything but good and for that reason, if no other, every effort will be made to find its permanent place in prison life."[145] According to Ralph Blumenthal, Lawes installed a radio set in Sing Sing's chapel in July 1922, shortly before the title bout between lightweight champion Benny Leonard and Lew Taylor. However, if "luring" inmates to listen to more edifying sermons, lectures, and classical music in the chapel through the initial box-

ing match was relatively straightforward, making radio accessible to every inmate in the cells was no easy feat.[146] A commercial loop-operated receiver and two nine-tube amplifiers housing six push-pull amplifiers were purchased, and the receivers were wired in multiple series so as to prevent a total shutdown in the event of a system failure.[147]

Radio was installed in the cells of 1,800 inmates housed in Sing Sing's new cell block A (as opposed to just the chapel) in fall of 1929, and inmates used an earpiece to listen to concerts, news, sermons, and so-called bedside stories or fireside chats programming.[148] The prisoners listened to "what came over the air from the central receiving station in the prison auditorium, whether the program be to their taste or not," and if prisoners misbehaved, radio privileges could be withdrawn.[149] Radio was even piped into the death house, although on execution day, a deathly hush befell the space as the radio was shut off, and a prescient silence, save the sound of occasional voices, cloaked the space.[150] In the condemned cells, programs were amplified via loudspeakers rather than headphones, perhaps due to a concern that the wires might be used to commit suicide.[151] The MWL was responsible for installing and maintaining radio at Sing Sing, and even though inmates passively listened rather than actively tuned in, a contrast to the hypermasculinist connotations of the radio hobbyist "fishing" for distant radio stations from their homemade sets in attics and basements, listening was optional rather than mandatory.[152] The radio attachments in each cell were similar to those in "ultra-modern metropolitan" hotels, an ironic conjoining of spaces of luxury and punishment.[153] Radio's live broadcasts mobilized a sense of coevality, an experience that heightened the sensation of being "there" on the outside rather than stuck "here" on the inside. Radio offered a reprieve from too much noise or the opposite, too much quiet, and listening with the eyes shut might have provided a temporary shield against prison's sensory numbness and boredom and triggered the air castles discussed in the previous chapter. Boredom and its doppelganger monotony were silent menaces in prison, causing anguish and depression, as an unidentified *Star of Hope* contributor from Great Meadow Prison wrote in 1915: "Much of the real distress of prison life arises from the sheer monotony of the experience, and most anything in the way of diversion from the usual daily grind is welcome and enjoyed." Radio was just such a diversion, not as exciting as

some entertainment organized at Sing Sing or even motion pictures, but a diversion nonetheless.[154]

Lawes's reputation as a media celebrity and anti–death penalty proponent—he was constantly asked for radio interviews on articles or books he had written—meant that by the early 1930s he had his own NBC radio program on crime (every Wednesday), which the inmates of Sing Sing were allowed to listen to.[155] Crime was a popular subject for radio dramas and other genres and not just in the United States. In 1930, Danish radio listeners tuned into a radio program in which they became virtual jurors, hearing a gripping courtroom drama of a (fictional) poisoning case in which a diabolical criminal had covered up traces of a murder, and mailing in their verdict to the radio station. Lawes had clipped this news item and put it in his scrapbook, evidence perhaps of some interest in replicating the idea for his radio program.[156] Reporting on convicts as radio fans, Robert Eichberg wrote, "Two groups of experts on crime and criminals are listening intently to every word he [Lawes] says. The first group comprises 'the boys' at Sing Sing . . . the second group is made up of prison wardens, crime prevention officers, and the like all over the United States."[157] Lawes had a sizable listening base, and one fan, disgruntled at the editing of Lawes's program in order to cut to a music program playing Tin-Pan Alley music, complained, "It's the 'little morons' who are catered to on the air today almost all of the time."[158] Little was left to chance on tightly scheduled and sponsored radio programs. For example, on WEAF's *Vitalis Program* (men's hair product sponsor), the entire interview with Lawes from the August 30, 1939, program was scripted. The banter began with host George Jessel asking Lawes about how gangster film stars George Raft and James Cagney were "getting along up in your institution," to which Lawes replied, "These two boys are doing time at Warner Bros." Milking the gag for one more funny line, Jessel replied, but "every time I see them, they're up at your place."[159] Lawes responded with "I'd like to see every man in prison escape," followed by "I mean I'd like to see every man leave the prison when his term is finished, having escaped from any need to return to the poisonous influences which brought him there in the first place."[160]

Listening to a radio program in which their warden discussed crime, imprisonment, and reform not only reminded inmates of the celebrity status of the boss of their institution, but turned radio into a disciplinary arm of the prison.[161] Similar to the experience of seeing Sing Sing and former warden Thomas Mott Osborne on screen in *Alias Jimmy Valentine*, listening to Lawes

reinforced other reform efforts at the prison. Experienced inmate engineers operated the three-channel radio, which was also used by Lawes as a public address system and for broadcasting lectures delivered in the chapel.[162] The author of the Lowell, Massachusetts *Telegram*, wrote, "Possibly one of the reasons for the close attention paid by the prisoner to these broadcasts" was the fact that "so many of the characters in the dramatizations although unidentified by name or number, are familiar to the men in the cells."[163]

Appearing on a "Collier's Hour" program on WJZ, Lawes talked about men having breaking points, educated criminals being more dangerous than ignorant ones, and the 125,000 people incarcerated in U.S. prisons at the time (a minuscule number compared to today).[164] Interviewed in 1934 about radio use at Sing Sing for the magazine *Radio Stars*, Lawes pointed out that he did not "know of a privilege granted the inmates, aside from visits and letters, that they would be more loathe to lose," although he quickly qualified this remark by adding that most prisoners would be hard pressed to give up their daily newspaper, a case of substantive news winning out over "meager radio news reports."[165] Even before radio was commercially available, Sing Sing inmates were given a lecture on the mysteries of wireless, a talk labeled "at once the most difficult and the most interesting subject for our audience."[166] Radio was enlisted in the war against crime in other ways, including with the introduction of radio systems linking police cars to the headquarters. By 1931, over sixty cities had introduced police radio thanks to the eight wave channels set aside by the Radio Commission for state use.[167] And lest we mistakenly think that prison was only ever the recipient of broadcasting, at Elmira Reformatory in upstate New York, winter boxing matches organized in the gymnasium, as well as other activities, were broadcast live on WESG and the prison radio station; twenty-five inmates were responsible for the broadcasts, which "served as an incentive for them to develop their special talents in singing, dramatics, and music."[168] Radio listening was ultimately tied to a broader program of rehabilitation, given that the majority of incarcerated men would one day be liberated; as Lawes saw it, "Allowing inmates to keep pace with world events through broadcast and other media prevented them from deteriorating mentally and losing contact with the community to which most of them would eventually return."[169]

Cinema (and radio) at Sing Sing was useful in lots of ways, from rehabilitation to improving inmate physical and sexual health. It was noncompliant

with regard to the protocols of an industrialized model of theatrical exhibition; and it was not limited to the exhibition of motion pictures but was involved in the larger production and publicity apparatus. One could argue that the moral reform debate regarding cinema was turned on its head in the case of the prison, since of all the groups that might have been protected from the "immoral" influences of film, it was surely criminals who were at the top of the list. Even though prison authorities often favored films with a strong reformist agenda over crime films with a weaker moral compass, the ordinary commercial fare playing at the local movie theater was as likely to be projected to inmates in the prison chapel as educational subjects were, complicating any simplistic argument of cinema's reformist function. Cinema and modern prison reform were nevertheless strategic allies, and motion pictures at Sing Sing were recuperated into a rehabilitative discourse that leveraged additional credibility from the growing visual education movement. By the end of 1918, the idea of motion pictures as a force in visual instruction had become so mainstream that even the *Star of Hope* reported on government use of film in schools. Film as a panacea to all that was dull in formal education was useful for the defense of a prison audience that risked losing motion pictures at the whim of a new administration, restrictions on accepting donated films, or political pressure from anticoddlers. The prisoners were even sensitive to the role of motion pictures in modern advertising, with one inmate writing an article about it in a 1918 issue of the *Star*.[170] Film brought laughter to the penitentiary, and Lawes speculated on its psychological impact on prisoners, sometimes stating the obvious, such as inmates' preference for musical comedies whose lively tunes, dancing, and frequent injections of humor served as the "best antidote for the blues." At other times, Lawes was more sanguine, even pensive, telling one visitor after a film screening that a smiling inmate should not be confused with a happy inmate: "No man in here is happy. Their smiles simply indicate that momentarily, at least, they have forgotten their troubles."[171]

A final vision of cinema at Sing Sing relates to the ways in which film exhibition complicates traditional ideas of the public and private spheres. Sing Sing was neither truly public nor private, a liminal space where ideas of the public were overdetermined by carcerality. Sing Sing's status as a counter–public sphere was compromised by the fact that it occupied a very prominent place in the public imaginary, hypervisualized and never far from the headlines as a result of scandals, investigations, and notorious criminals.

With a self-aggrandizing, publicity-seeking warden running the show at the height of the motion picture studio system, Sing Sing and Hollywood found themselves cozying up on many occasions. Lawes had dabbled in the movie business even before stepping foot in Sing Sing, allowing 150 juvenile offenders in 1916 to become armed extras (using rifles and revolvers loaded with blanks) in *The Brand of Cowardice* (John W. Noble), a Mexican-American War drama, when he was head of a boys' reformatory in New Hampton, New York.[172] According to Blumenthal, Lawes offered the use of his reformatory boys as extras, in return asking only for "a moving-picture projector for [his] boys [since] they liked to watch pictures too. He had wanted an outfit for the farm but had been afraid to put it in the budget."[173]

Called the nation's "warden in chief" by Blumenthal, Lawes used motion pictures strategically, to further his own career and to ameliorate the effects of incarceration.[174] So when we watch Hollywood classics such as *20,000 Years at Sing Sing*, we should remember that location shooting at the prison tells only half the story. Motion pictures came to Sing Sing not only to heighten the verisimilitude of crime films but to entertain men whose lives were not that different from those of the fictional characters portrayed on the screen. Art imitated life at Sing Sing, the prisoners assuming the mantle of experts when watching crime films that might have reminded them of their own miscreant pasts, pasts many never escaped from, even when they were released on parole and experienced that long-sought-after moment they had seen represented in films like *The Toll of Mammon*.

Cinema's utility in the early twentieth-century prison was closely bound to Lawes's lifelong dedication to improving the conditions of the incarcerated. Given the length of his wardenship (twenty-one years), Lawes had the most to say about motion pictures, and his parallel career as a prison reformer, novelist, screenwriter, and frequent media contributor thickens institutional records of film use in the prison. Lawes argued that "motion pictures . . . [can] assist the more enlightened penologist in his efforts to rehabilitate the inmate. The prisoner is no longer shut in behind bars and made to feel that he never existed in another world. Now he sees the universe in action."[175] Cinema, especially newsreels, could restore a measure of dignity to the inmates, since it interpellated them into the role of citizens worthy of knowing what was going on in the world around them, rather than lost causes with a tainted past and no future. Cinema was also a psychic palliative, offering a "means of release from the mental disturbances of prolonged confinement . . .

the emotional relaxation that is nowhere more salutary than in institutional life," according to the authors of the first yearbook of the American Prison Association's Committee on Education.[176] Lawes spoke frequently and passionately about how film screenings at Sing Sing were exemplary versions of film exhibition on the outside. In an essay entitled "The Great Unseen Audience," Lawes boasted, if tongue in cheek, about the capacity house at his prison: "The manager of any moving picture house would be envious to see the turnouts to our picture show at Sing Sing."[177] The up-to-date equipment, operated by an inmate projectionist, coupled with a fresh weekly lineup of films, provided the perfect breeding ground for film fandom; as noted by the *Daily Herald* in 1937, prisoners decorated their cell walls with images of stars culled from illustrated papers.[178] Inmates became film fans just like men and women on the outside; if their souls had been partly destroyed through years of incarceration, their film memory might have been more robust, easing the transition back to civilian life. In this respect alone, cinema was a respite or palliative, soothing the sore that is incarceration.

PART THREE

THE CARCERAL REFORMER

A Different Story

RECREATION AND CINEMA IN WOMEN'S
PRISONS AND REFORMATORIES

Many a poor girl is in prison just because she had faith in the
spoutings of some empty-headed idiot with more wind than
brains.
State Prison for Women, Auburn, prisoner number 321, 1901[1]

Even though there is a dearth of historical research on how media first en-
tered the all-male penitentiary, there is even less information on the gendered
uses of entertainment as rehabilitation in women's reformatories and state
prisons.[2] Why the goings-on in male prisons when work stopped for entertain-
ment were nothing like the goings-on in women's reformatories when recre-
ation broke the monotony is the subject of this chapter.[3] And while it is rela-
tively easy to identify the record of popular press fascination with prison film
screenings in male penitentiaries, the lack of reference to screenings in
women's prisons and reformatories suggests that authorities in women's pris-
ons provided fewer opportunities for film viewing. If New York's State Prison
for Women at Auburn, where there is no record of film screenings through at
least 1920, is typical, women suffered inequity not only in sentencing poli-
cies but in their access to modern media within the prison. Given cinema's
delayed emergence in women's prisons, it is important to consider what sub-
stituted for film, what modes of recreation were borrowed from morally sanc-
tioned institutions, and how prison authorities conceived of suitable entertain-
ment for women. I begin with an analysis of the pervasive double standard
that led to gross sentencing inequities at the turn of the last century before
turning to examine the impact of the reformatory movement on the recre-
ation culture of women's prisons, using the State Prison for Women at Auburn
Prison in upstate New York as a case study, and investigating whether the
moral panic around women's entry into the public sphere had any effect on

191

when and how film was used in female spaces of incarceration. I then turn to film use at Bedford Hills Reformatory in New York State before speculating on why film was slower to emerge in women's reformatories.

Women and Incarceration: The Double Standard

> The female born criminal is, so to speak, doubly exceptional,
> first as a woman and then as a criminal. . . . As a double
> exception, then, the criminal woman is a true monster.
> CESARE LOMBROSO AND GUGLIELMO FERRERO, 1893[4]

Female criminals have always occupied a fraught place in the popular and scientific imaginaries. Underscoring the role of sexual and psychological factors in explanations of female crime, Italian sociologists Cesare Lombroso and Guglielmo Ferrero argued that the criminal type existed in 18 percent of the female population (31 percent of the male population) and identified what they claimed were physiological markers of criminality and prostitution, the latter being a separate group of criminals in Lombroso's view. His theories of female criminality infused a great deal of the discourse on women and crime in the late nineteenth and early twentieth centuries,[5] and, in addition to their obvious conceptual shortcomings and problematic research on prostitution, his work exploited age-old essentialist myths about women's purported natures, a tendency to regard women who have been punished by the state as "significantly more aberrant and far more threatening to society than their male counterparts."[6] If we follow the misogynist logic of Lombroso's construction of the female criminal as a "true monster," even noncriminal women, by dint of being "exceptional," were a little bit monstrous.

It is against this backdrop, and in part to challenge Lombroso's theories of female criminality, that a powerful group of women[7] spearheaded the reform movement in the United States in the final decades of the nineteenth century, a movement that launched the formation of the American Prison Association in 1870.[8] Between 1870 and 1935, twenty female reformatories were established in the United States, driven by the argument that women should be responsible for day-to-day reformatory management.[9] The women's reformatory strove to create what historian Nicole Hahn Rafter calls a set of "feminized penal practices" that eschewed the model of the nineteenth-century brick prison (itself fashioned on the factory or military barracks) in favor of cottage-style dwellings located around a central administrative building.[10]

The Indiana Reformatory Institution for Women and Girls, which opened in 1873, and the Massachusetts Reformatory Prison for Women in Framingham (also known as the Sherborn Reformatory), which opened in 1877, were the first purpose-built prisons for women. Indiana Reformatory was operated entirely by women.[11] The Hudson House of Refuge in Hudson, New York (1887–1904), accepted only women aged fifteen to thirty (later lowered to twenty-five) convicted of petty larceny, habitual drunkenness, and prostitution (prior to its opening, women sentenced by the state were housed either in New York City or local county jails, or sent to the state reformatory for men in Elmira, New York).[12] The word *refuge*, with its connotations of protection, escape, aid, and relief, was used in the context of women prisoners as early as 1852, when British journalists Henry Mayhew and John Binny argued that women had to be rescued through the "medium of a refuge" in order to counteract the challenges besetting them in their return to respectability upon release.[13] For some indigent women, the local prison at times indeed became a refuge from the extreme hardships of life outside the institution, a manipulation of its original punitive purpose.[14]

Women incarcerated within some male state prisons also found themselves in institutions committed to (at least) the appearance of reform.[15] The women's section of the Missouri Penitentiary, a large farm building on the banks of the Missouri River that opened in 1916, was a famed example of a farm-based, "lockless prison," with no guards and no bars. "With the exception of a wire fence that any healthy youngster could climb there is nothing keeping the prisoners in," wrote a *New York Sun* reporter in 1931.[16] California also developed an alternative model of female incarceration that made headlines. A prison built in the Tehachapi Mountains northwest of Los Angeles was compared to a "summer resort" by one newspaper, boasting of having "no grim, gray walls, no watchtowers, no heavy barred windows, cells blocks, or armed guards."[17] Endorsed by the prison commission established by progressive governor Clement Calhoun Young, the design was premised on the idea that "the best penitentiary for women is the one which looks the least like one, and which has a corrective rather than a punitive atmosphere."[18] The removal of bars from the windows was a radical step, although mostly symbolic, since women were still contained by double barbed-wire fences at the facility's perimeter, providing what Rodney D. Brandon, director of the State Department of Public Welfare, called "the illusion of freedom," which worked "wonders in the morals of the prisoners." Removing the bars deepened a woman prisoner's

visual field, allowing her "to see for some distance," which Brandon argued would "have a beneficial psychological effect."[19]

Motion pictures similarly enlarged one's visual field in prison, albeit virtually, and were credited for helping prisoners cope with the boredom, sensory deprivation, and emotional hardship of incarceration. And yet there is an interesting contrast here: women were seen to benefit from access to actual distant views from the cell windows in the "prison without bars," whereas men's visual field in prisons was severely limited by the design of prison architecture, but was metaphorically enlarged by more frequent access to motion pictures. Though I am leery of reading too much into architectural difference in male versus female prison design, there is definitely something to be said about how fields of vision are structured differently in each carceral setting. At Sherborn Reformatory, where the incarcerated went from being called "inmates" in the late nineteenth century to being called "women" by Superintendent Jessie Holder in 1911, and "students" in 1932 when nationally renowned prison reformer Miriam Van Waters took over, "inspirational vision" was added to a coterie of reform efforts involving sight. Van Waters would gather students and staff to view the night-blooming cereus plant, allowed women who had earned privileges to decorate their cells with images borrowed from a picture library, and had stained-glass windows in the chapel created by the acclaimed craftsman Charles Connick, along with murals of women "at work, play, and worship" completed by two local artists hired through the New Deal Works Project Administration.[20] We can thus talk about the reformist "vision" of the modern women's prison in terms of both its physical design, eschewing bars and providing scenic surroundings, and its mission of making bad girls good. However, the euphemistic "systems of operation" used in the "cottage style" reformatories were seen as useless on women perceived as "incorrigible" and a "detriment . . . and a hindrance to the other inmates who seek to improve themselves."[21]

The picture library at Sherborn contained "comely prints and others of distinct educational value," which could be borrowed by the women and would remain in each cell for a week before being passed on to the next cell and replaced by a new picture.[22] The idea of the cell as a decorated and constantly changing visual environment (fig. 5.1) customized by the prisoner is reminiscent of the advertising billboard or art gallery, where images are seldom permanent. The prison cell also differs from domestic space, where artwork hung on walls usually stays for a very long time, sometimes until the person dies.

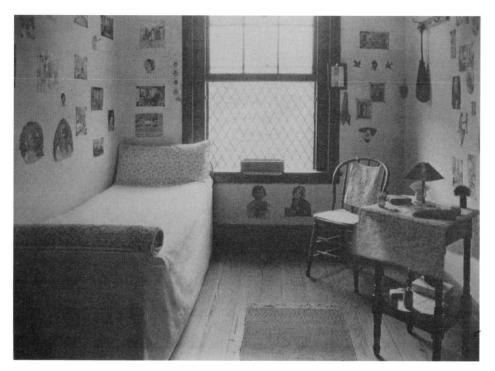

Fig. 5.1 Interior of cell for women at Massachusetts Reformatory Prison for Women, ca. 1920, showing images on walls. Photo from Freedman, *Their Sisters' Keepers*

The idea of new pictures to look at is redolent with metaphorical meaning, suggesting the changing motion picture shows at the local theater or the constantly shifting content of modern advertising: it affords the prisoner agency (the ability to choose this picture over that), allowing her to reimagine and personalize the cell (if not disavow its carcerality) by positioning, juxtaposing, and contemplating images before relinquishing them to another convict.

Giving women "comely" pictures to look at was part of the larger reform effort. These images of pastoral, religious, or domestic tableaux were designed to advance the inmate's transformation and adoption of middle-class social and gender norms, and though they shared some of the same goals as advertising in selling lifestyles and normative values, they were protocinematic as well, insofar as they anticipated the weekly change of film program. They therefore brought at least some aspects of cinema into the solitary space of the cell and could be considered nineteenth-century versions of today's digital photo frame or computer desktop wallpaper. Books from prison libraries, like Sherborn's peripatetic pictures, were also portable, and to accommodate them, pockets

were sometimes sewn onto the outside of a female prisoner's dress skirt large enough to carry a library book, which she was encouraged to read whenever she had a "moment of leisure," such as when there was insufficient work. Anticipating today's digital reading tablets or smart phones carried in pockets, purses, or backpacks, the portable book kept boredom (and potential mischief) at bay or, the opposite, was used to conceal mischief such as the passing of notes.[23]

The female inmate's cell or dormitory housing morphed into a pseudo domestic space in the reformatory, which eschewed the word *cell* for the less pejorative *small room*.[24] Sherborn also had a "recreation room," a "cheerful sunny apartment furnished with comfortable chairs, flowering plants, and a plentiful supply of games, books, and magazines"; no comparable space was offered male prisoners, whose leisure time took place in either the recreation yard or the prison chapel.[25] The women were encouraged to "amuse themselves quietly in any manner they please[d]," another clue as to the gendered natured of prison-based recreation activities.[26] Put simply, women's leisure options fit into a Victorian ideal of the parlor-sanctuary, where self-amusement and quiet acceptance of one's place in the home were normalized—the slippage across prison and domestic space is unmistakable, as housewives across the ages can attest. "Replication of the rituals of genteel society, faith in the reforming power of middle-class role models, and insistence that inmates behave like ladies" were operationalized in the nineteenth-century women's reformatory, and female convicts were encouraged to mimic—if not internalize—the proclivities and sensibilities of polite middle-class society.[27]

In the late nineteenth and early twentieth centuries, women were punished for promiscuity, saloon visiting, and behavior that would have gone virtually unnoticed in men.[28] For example, in 1928, a thirty-five-year-old Pottsville, Pennsylvania, woman spent three months in jail awaiting trial, charged with being a "common nuisance," an "offense" consisting of little more than "going about the streets with bare legs." She was eventually acquitted, and the judge noted that "we see bare legs in the chorus and at the beach and they are no nuisance there."[29] Not only were women subject to incarceration for transgressing behavioral norms—under the 1913 Mental Deficiency Act, unmarried British women receiving government assistance when pregnant or giving birth were automatically classified as "feeble minded"—but they were also demonized in psychological analyses of criminals, such as J. O. Stutsman's 1926 *Curing the Criminal*, which blamed women in the public sphere for stirring men's sexual desires: "If the man's weakness is sexual, his baser

impulses are stirred by loose women on the streets, sparsely dressed women on the beaches rivaling the goddesses of the ancients, suggestive poses and appearances on the stage, voluptuous pictures on the screen, and almost nude pictures in the magazines."[30] Failure to conform to standards of female propriety came at a steep price; as prison historian Lucia Zedner argues, "Deviance from femininity alone . . . was grounds for suspicion and condemnation . . . [and] lack of concern, or worse, systematic exploitation meant that women often endured much poorer conditions than men convicted of similar offences."[31] Penal historian Rebecca McLennan makes a similar argument, noting that whereas men would typically get three days in the dark cell (solitary confinement) for talking in the silent system or for insolence against prison authorities, women were held in dark cells "for between seven and fifteen days for the offenses of quarrelling, writing notes, insolence, and vile language."[32]

Women's recreation in prisons was tied to a long Christian tradition that dated to Justinian times, made famous in the United Kingdom by prison reformer and philanthropist Elizabeth Fry (fig. 5.2).

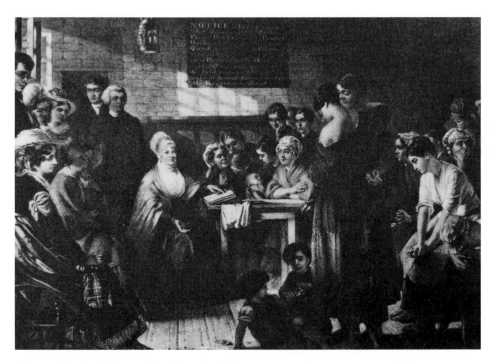

Fig. 5.2 Elizabeth Fry reading from the Bible to women prisoners on a tour of Newgate Prison, London, 1813. Religious Society of Friends in Britain

Horrified by what she saw at Newgate Prison in London, Fry formed the British Ladies' Society for Promoting the Reformation of Women Prisoners in 1817.[33] Testifying before Parliament on prison conditions,[34] Fry instituted the Brighton District Visiting Society in 1824, a volunteer organization that brought help and support to the poor. Guided by Christian principles and even inspiring Florence Nightingale, Fry provided clothing for female prisoners, organized sewing classes, and had admirers that included Queen Victoria, the king of Prussia, and British prime minister Sir Robert Peel, who supported legislation sympathetic to Fry's cause.[35] Modeled on the moral responsibility that middle- and upper-class women assumed toward servants employed in their households, the phenomenon of "Lady Visitors" domesticated prison space, and, given that released young women often ended up working as domestics, a prison visit might even lead to subsequent employment. The practice of lady visiting was institutionalized in the United Kingdom in 1901 through the formation of the National Association of Lady Visitors.[36] Early examples of visiting programs in the United States include the Ladies Committee and Visiting Committee at the Philadelphia House of Refuge, which opened with twenty-three female and sixty-eight male inmates in 1826.[37] The "judicious suggestions and assistance" offered by the Visiting Committee were seen as beneficial, "especially in the female department."[38]

The history of entertainment and reform initiatives for women offenders is thus closely bound to the reformatory potential of female visitors as role models capable of "establishing personal influence over each woman prisoner," in contrast, Zedner argues, to the "quasi-militaristic, anonymous, and strictly uniform regime imposed on men."[39] In addition to lady visitors, women's recreation in the prison yard, more often than not, consisted of sedate walks, in keeping with the health benefits attributed to ladylike strolling, although in the case of women imprisoned with infants[40] and toddlers at Brixton Prison in the 1850s, the women were subject to regulated walking rather than able to move freely. The illustration of female convicts exercising in Brixton's "airing yard" (suggesting both the idea of fresh air and the "public expression of an opinion or subject") depicts them moving along the prison's paths in pairs (the three women standing alone are guards, lacking the prisoners' white aprons) (fig. 5.3).

Another image of prison recreation from the same period yokes motherhood to the regulatory function of the prison, depicting fifteen mothers cir-

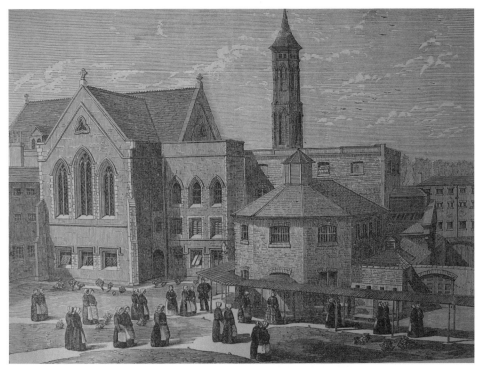

Fig. 5.3 Women exercising at Brixton Prison. Illustration from Mayhew and Binny, *Criminal Prisons of London*

cling the exercise yard of the House of Correction, Tothill Fields with their children in tow (fig. 5.4).

Female prisoners must have suffered from the stress of keeping infants and toddlers in such a confined space, let alone from the physical strain of carrying or dragging children by the arm pointlessly around in circles. Time spent outdoors may nevertheless have been infinitely preferable to being confined in dormitories or cells, and in the absence of an oral or written record of female carceral subjectivity, these images tell part of the story of what it must have felt like to undergo this experience, day in and day out.

Like their male counterparts, women convicts initially wore prison stripes, even joking about the uniform they had to wear at the State Prison for Women at Auburn in the *Star of Hope*, the New York State prisoner-published journal that began circulating within the five largest prisons in 1899 (and was available to the public by subscription); one inmate joked in 1901 that "the latest spring styles are stripes, as usual."[41] When stripes were abolished for male

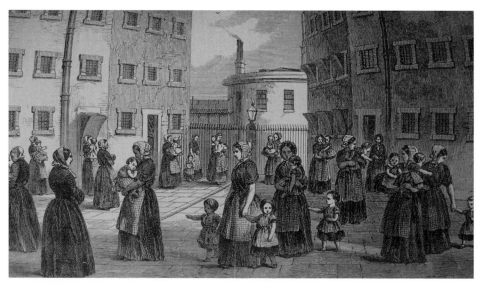

Fig. 5.4 Women in recreation yard walking in circles with their children, Tothill Fields Prison. Illustration from Mayhew and Binny, *Criminal Prisons of London*

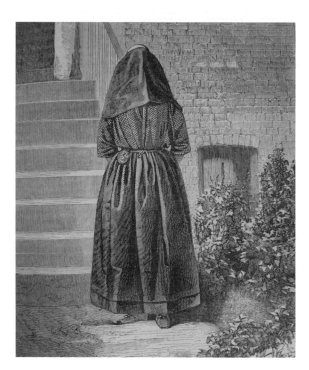

Fig. 5.5 Woman prisoner from Pentonville Prison wearing a veil designed to purportedly conceal identity under the silent system. Illustration from Mayhew and Binny, *Criminal Prisons of London*

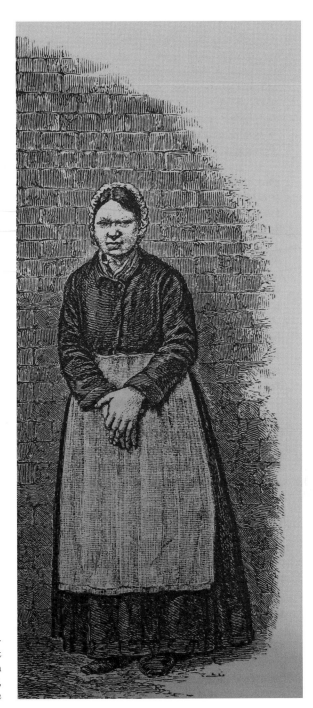

Fig. 5.6 Unveiled, unidentified woman prisoner held at Pentonville Prison. Illustration from Mayhew and Binny, *Criminal Prisons of London*

and female prisoners in 1901, they were replaced by plain, matronly cotton dresses with large aprons with white, hemstitched collars that gave a "neat appearance" and resembled domestic service attire.[42] Inmates were banned from communicating when incarcerated under the silent system enforced at the Surrey House of Correction in Wandsworth, London, a prohibition felt more keenly, it was presumed, by women who were required to wear veils made out of thin material to conceal their identities as they moved around the prison (fig. 5.5).

The complex image of the veiled prisoner, based on a photograph by Herbert Watkins, is a fitting metaphor for women's invisible place within the visual history of corrections; suggesting chastity, virtue, and the Virgin Mary, the veil usually failed at concealing identity and made it easier for women to whisper to one another since their mouths were obscured by the fabric. The image of the veiled prisoner also functions as a metonym for the logics of penology, where individuals are sentenced to a liminal existence in the prison complex. Prison uniforms, however, as Juliet Ash points out, could also be modified; for example, in order to keep up with 1860s London fashion, inmates used their bedding to improvise bustles.[43] If traces of subjectivity are harder to dis-

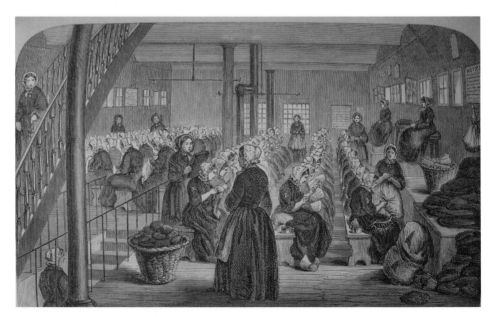

Fig. 5.7 Sewing workroom, House of Correction, Tothill Fields or Brixton. Illustration from Mayhew and Binny, *Criminal Prisons of London*

cern in faces covered up by veils, other images of women in Pentonville Prison are less enigmatic. In this lithograph of an unveiled female convict (fig. 5.6), the woman's snarled facial expression, large, clasped hands—hands roughened from endless sewing (fig. 5.7), oakum picking (retrieving tar from old rope), laundry labor, or gardening in the prison grounds—and gaze directed beyond the frame are signs of her wizened, institutionalized existence.[44]

"Not . . . So Fortunate as Our Brothers": Recreating at the State Prison for Women at Auburn

The State Prison for Women at Auburn in upstate New York (also known as the Auburn Women's Prison [AWP]) opened in 1892 under the matronship of Annie Welshe (fig. 5.8), previously head of the women's ward at Bellevue Hospital in New York City.[45] The women's prison was housed in a building immediately adjacent to the Auburn male prison, which began accepting inmates in

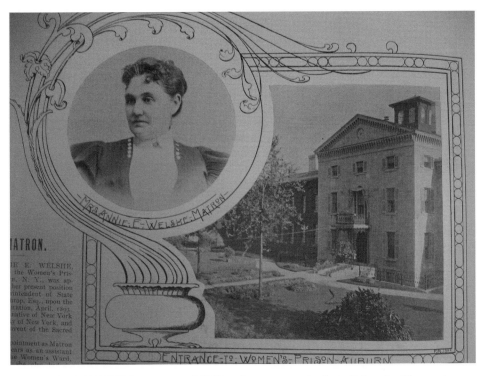

Fig. 5.8 Annie [M.] Welshe, matron of AWP, and entrance to the State Prison for Women at Auburn, New York, ca. 1892. (Initial "E" is a typographical error.) *SOH*, New York Public Library

1817. Prior to the opening of the women's prison, female inmates had been housed at Auburn from 1817 to 1872, after which point they were transferred to Mount Pleasant, a female prison annex on the grounds of Sing Sing, before returning to Auburn in 1892. When women were first convicted to Auburn, they lived in a windowless attic room, where food was delivered once daily and sexual abuse by male guards was rife.[46] The name Welshe was steeped in notoriety at Auburn Prison, since in January 1826, a young Irish immigrant named Rachel Welsh died six weeks after giving birth to a baby conceived in the prison. An autopsy revealed that Welsh had been violently whipped and impregnated by prison guard Ebenezer Cobb while kept for three months in solitary confinement.[47]

The lithograph of Welsh (fig. 5.9) does more than reconstruct her emaciated and brutalized body; it visualizes the libidinously charged, sadistic fantasy of male violence toward women. Following a public outcry, a commission was

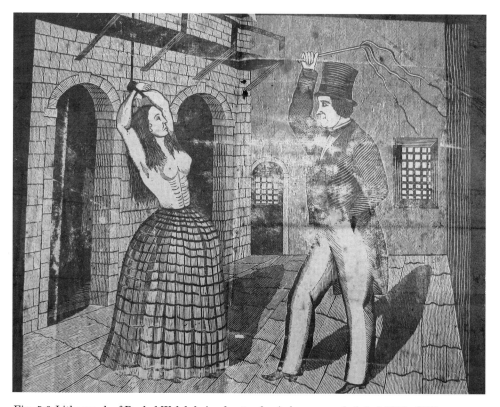

Fig. 5.9 Lithograph of Rachel Welsh being beaten by Auburn guard, dated 1838. OFP

established to investigate Welsh's death, prompting New York officials to campaign for separate facilities for female prisoners between 1828 and 1839.[48]

AWP was in operation for forty years, despite repeated efforts by the male prison authorities to acquire the space to alleviate overcrowding, only closing in 1932 when its female inmates were transferred to the Bedford Hills Reformatory in Westchester Country and the space was relinquished to the male prison, still in operation.[49] The prison coexisted with three other state women's reformatories, Albion, Hudson House of Refuge, and Bedford Hills. Of the four prisons, AWP was the one to incarcerate women convicted of more serious crimes, women of color (half the women housed there in 1913 were black), immigrants, and married or widowed women.[50] The number of women confined at Auburn hovered around one hundred at the close of the nineteenth century, half of its capacity of 260 beds.[51] The average age of the women confined in the AWP in 1899 was thirty-one, and 72 percent of the population were first offenders (of the thirty-five women admitted that year, only eight were second-timers).[52]

Like other New York State prisons, Auburn Prison was a major tourist attraction, second in popularity only to Niagara Falls, and its male and female inmates were displayed as carceral exhibits. The women became living incarnations of imaginary constructions of female criminals read about in dime novels, penny press stories, and sociological studies such as Lombroso's.[53] In August 1899, 483 sightseers traipsed through the prison, 162 more people than the 321 women imprisoned there, a number that provoked the "Women's Writes" columnist in the *Star of Hope* to ask, "Why is it that some women giggle when there is really nothing to giggle at? We refer to those who come to see the sights of the prison and giggle at things most of us would cry over."[54] The sight and sound of gawking and snickering women clearly hit a raw nerve with this prisoner, a sentiment signified in this cartoon parodying the naïve questions asked by women visitors when touring Sing Sing Prison (fig. 5.10).

Of the 170 women held at AWP in 1902, only 15 percent had committed crimes against another person, including murder, manslaughter, assault, and abduction; three-quarters of the women were Caucasian (the remainder African American); and two-thirds were from Manhattan or Brooklyn.[55] This made family visits difficult, as noted in the 1904 *Annual Report*: "The relatives of most of them are poor and the expense of a trip to Auburn to visit the prisoner is a great burden to them."[56] Auburn's distance from the inmates' homes in New York City (approximately 252 miles) as well as its close

Fig. 5.10 Cartoon of woman visitor asking warden modeled on Lewis E. Lawes about his promotion to warden. OFP

proximity to and supervision by the men's prison led the superintendent of prisons in New York State to lobby for the closure of the prison and the transfer of the women to the State Farm for Women in Valatie (132 miles from New York City), where the prisoners could be overseen entirely by women.[57] This did not materialize, however.

Female inmate labor at the AWP consisted of making mattresses, finishing blankets woven in the men's prison, caning chairs, manufacturing prison uniforms (for both male and female prisoners), and tending the flower and vegeta-

ble gardens.[58] Gardening not only substituted for organized exercise but was a means of "restoring many of them to health . . . giving them strength, and also a new occupation which they may follow outside." Those who gardened were called "farmerettes," a coveted title that the women were keen not to lose through rule breaking or bad behavior.[59] Farm work and gardening were considered the most "humanizing" of prison trades, and certainly less punitive than oakum picking. Seventy-one of the women incarcerated at AWP self-identified as either domestics or housekeepers, casting doubt on the success of sending girls out of reformatories into domestic service (for some it was a revolving door straight back to prison). The 1912 AWP *Annual Report* lamented the fact that the "only employment open to [women prisoners] is domestic service,"[60] and hoped that courses in domestic science, sewing, and dressmaking would "equip many for making a livelihood at agreeable, remunerative employment, that will leave no excuse for resorting to dishonorable means of obtaining both the necessities and some pleasure and recreation."[61]

Rates of illiteracy were higher among female than male prisoners, and the AWP organized five sessions of school every evening,[62] religious services on Sunday, and Sunday school, which gave inmates "a more thorough knowledge of Christian doctrine than they had before."[63] That the male prisoners, over the "high, thick wall, with only a wicket for passage" between the male and female prisons, did not receive Sunday school attests to the additional value attributed to Christian doctrine as an agent of gendered reform.[64] Like children, women may have been considered more pliable and responsive to religious instruction, although even the male prisons in New York State had a number of religious speakers, including Mrs. Maud Ballington Booth (aka "Little Mother") (fig. 5.11) and representatives of the Volunteer Prison League, who frequently visited Sing Sing.[65]

Visits from Little Mother and the institution of Sunday school remind us of prison's tendency to infantilize its inhabitants, a process enshrined in rituals of "public humiliation, enforced respect and deference . . . all features of childhood's helplessness in the face of a superior adult world."[66] Maternalism was a cornerstone of Miriam Van Waters's penology: "I mother this cold girl—kiss her resistant forehead—melt her into smiles," was how she described her interactions with a recalcitrant inmate, and she even introduced read-aloud sessions in which forty women sat around her listening to contemporary fiction.[67]

Fig. 5.11 Logo of the Volunteer Prison League featuring Mrs. Maud Ballington Booth ("Little Mother"). *SOH*, New York Public Library

A feature of the carceral experience that was virtually identical in both male and female prisons was the library, hailed by reformers as a healthful distraction and criticized by anticoddlers as a space of lax discipline. A modest five-hundred-book library opened at AWP in 1893; books covered in manila paper were given out to the women once a week and magazines and papers were permitted upon approval of the matron.[68] From 1899 to 1901, over three hundred books were added, and even though fiction outnumbered nonfiction, a female inmate contributor to the *Star of Hope* noted that books on history, travel, and lives of famous men and women were also popular and that the "higher tone a book has, the more eagerly it is sought for."[69] Women inmates could also read magazines such as *Harper's, Scribner's Century, Lippincott's, Strand, Munsey, Junior Munsey, Ladies Home Journal*, and *Cosmopolitan*, which were valued even more than books for depicting life on the outside. "Were it not for these means of occupying our spare time, life in prison would be a great deal worse, for nothing is so detrimental to the mind as complete idleness," wrote one female prisoner.[70] Experts and penal authorities argued that libraries produced mental relaxation, and, if the case of the women imprisoned in the Surrey House of Correction in Wandsworth, London, was in any way typical, younger women (not girls) were the most likely to appreciate books.[71] Basic literacy was taught for the primary pur-

Fig. 5.12 Logo for "Women's Writes" column. *SOH* (1899).

pose of giving inmates access to the scriptures, yet claims in annual reports by prison chaplains about the wide distribution of Bibles, prayer books, and religious and moral tracts appear unlikely, as Zedner argues, given the high levels of illiteracy among female inmates.

The *Star of Hope* offered women convicts a journalistic voice through a column entitled "Women's Writes" (fig. 5.12), a play on giving voice to the state's female prison population as well as mobilizing a discourse of suffrage.[72] The 1899 (the year the journal launched) logo for the column shows a bourgeois woman seated in a Regency chair in front of an ornate writing bureau with books on a lower shelf and threads or wires (fig. 5.13), perhaps symbolizing the column's relevance for both imprisoned and free women, stretching out toward the words "Women's Writes."[73] A photograph of the actual desk used by the editor of the "Women's Writes" column at Auburn Prison (prisoner number 196) along with one of Matron Welshe sitting at her rolltop desk appeared in the same issue of the *Star of Hope*; the empty chair is rich in connotative meaning, symbolizing both a prisoner's invisibility as well as prison policy not to include photographs of inmates in the magazine.

Women prisoners used the column to address a number of issues, most commonly the damaging effect of their relationships with men. Many of these

Fig. 5.13 Annie Welshe sitting at her rolltop desk, matron's office, State Prison for Women at Auburn. *SOH* (1899)

entries contain sediments of the gendered experience of prison, a voice of self-scrutiny, regret, and barely concealed frustration. Auburn prisoner number 253 blamed both a woman's environment and, most significantly, alcohol, for landing women in jail: "If only I went home when I wanted to; but no, they made me have another drink," she wrote, arguing that "you can wager that drink played a considerable part in their crime."[74] Auburn prisoner number 25502 was no less emphatic in her belief that a "woman had not yet been born that cannot place her finger on some one man who influenced her toward love and happiness on the one hand, or through love's betrayal made her life a vale of shame, or despair, or both."[75] For the most part, women prisoners praised the prison newspaper in similar ways as did male convicts, seeing it as a vehicle of self-improvement that provided a sense of a world beyond the prison and, as one woman put it, a "spirit of mutual helpfulness."[76]

By the late 1920s, educational offerings had expanded considerably at AWP, with women taking stenography classes in the prison school and correspondence courses in business, English, office management, food and nutrition, Spanish, real estate law, bookkeeping, and accountancy, although historically, prison authorities had viewed educating poor women with am-

bivalence at best or as irrelevant at worst.[77] However, the schoolroom in women's prisons focused as much on the pastoral care of inmates as on the eradication of illiteracy. Helen P. Stone, matron of AWP, characterized it thusly: "A constant effort is made to have a sense of freedom in the schoolroom, but with no undue liberties because of such freedom." The goal was the teaching of "lessons of ethics not found in our text books," an important clue for understanding subtle differences in the educational culture of male versus female penitentiaries.[78] Lantern slides were used to illustrate lectures, and in 1921, the large assembly room was subdivided into three rooms ("due to the system now in vogue of having small classrooms"), the center room converted into a "dark room, which will be used for visible teaching by means of a stereopticon machine." The term *visible teaching* was a nod to the growing visual education movement, appropriating the goals, if not the correct terminology, of using images to vivify ideas and pique the interest of bored minds.[79]

Close examination of the kinds of leisure activities available to female inmates versus male prisoners reveals stark inequities, including the fact that film took much longer to reach women's institutions than it did men's institutions. At AWP, women were not shown films in the 1910s or 1920s, even though they read about the motion pictures projected over the wall at Auburn Prison and in other New York State penitentiaries in the *Star of Hope*, which kept a detailed record of films shown in New York State's large male penitentiaries starting in 1913. Auburn male prisoner number 33828, describing the stupendous day of entertainment and good food enjoyed at Thanksgiving in 1914, felt a bit guilty about the lack of parity in entertainment: "I thought of our unfortunate sisters, just over the wall, in the Women's Prison and wondered if they were as well off as we."[80] The male prisoners were certainly noisy that day; released into the exercise yard at 1:30 P.M., the prison band played and "King Hilarity reigned supreme until about 4:30pm," the men trying to "get some of the pent-up noise (noise is the best words I find for it) out of [their] system." A celebration of Tom Brown's Day (to honor reformist Thomas Mott Osborne, who spent a week at Auburn in 1913 under the pseudonym and helped introduce the Mutual Welfare League at the prison) a couple of years later also generated more noise than usual, something a woman contributor to the *Star* commented on, perhaps in the hopes of gently pointing out the unfairness of recreation policies: "If noise and music is any sign, there must have been a big time. Although we women could not participate, our hearts

were none-the-less with our brothers in gray."[81] The women could vicariously share in the men's mirth through sound but not firsthand.

There is not a single reference to film being shown at the AWP in the twenty-one-year history of the *Star of Hope*. Describing an evening's entertainment in early December 1914, female prisoner number 876 wrote, "We have not been so fortunate as our brothers on the other side of the wall [who] are more up to date with their moving pictures. Still we have enjoyed our magic lantern pictures [of the life of Christ] very much."[82] For this woman, the disparity was framed in terms of access to modernity, the men's prison simply being "more up to date" (although motion pictures had been around for almost twenty years by this point). This comment suggests that the women's prison was stuck in the nineteenth century in terms of access to modern modes of mass communication. The inmate tiptoes around the unfairness of not letting women watch film yet she backtracks by praising the lantern slides of religious subjects, akin to the shows put on for Sunday school children, for fear no doubt of even these diversions being abolished should the women complain. Even films with female protagonists and themes of moral redemption like *Her Life and His* (Frederick Sullivan, 1917) never made it over the wall to the women, although as a possible consolation, or conversely to rub salt in the wound, a long narrative summary of the film appeared in the *Star-Bulletin*, which the women could freely read.[83]

The disparity in entertainment policies of the adjacent male and female prisons at Auburn is suggested in Auburn Prison's 1912 Chaplain's Report, which notes that women prisoners had access to outside entertainment on "*some* of the holidays and in the Sunday services, *from time to time*."[84] They also were taught group singing. We can glean two things from the report: the intermittent, ad hoc nature of providing female inmates with outside entertainment, in contrast to the more systematic approach to organized amusements in male prisons, and the special significance of hymn singing as a technique to inculcate Christian values.[85]

Women in the predominant single-sex prisons and reformatories made the best of the leisure activities offered them, such as the dancing lessons taught for the first time at AWP by a Miss Paulina Titus in summer 1916, accompanied by phonographic music.[86] A *Star-Bulletin* article about the 1916 Columbus Day prison entertainment also made reference to "phonograph selections . . . played and dancing enjoyed until six o'clock," after which women returned to their cells "to dress for the evening entertainment given by a number of our colored friends at Auburn [the Auburn City Minstrels]."[87] And while men at

Auburn Prison watched films such as Harry Leverage's 1916 *The Girl and the Gangster*, Auburn's female inmates were offered the more refined and uplifting experience of listening to the sisters of Saint Aloysius Convent, along with young boys and girls (it is not surprising that they were not shown the film, given its title). Children's choirs performed regularly at the AWP (including the local choir from Westminster Church of Auburn in 1911), representing the kind of wholesome entertainment and Christian message deemed appropriate for female inmates, simultaneously appealing to their maternal instincts through the presence of singing children.[88] If the response of prisoner number 914 is anything to go by, the choral performance succeeded in generating both compassion and motherly love: "Many of *us* have little children of our own. Did the scene mean that we try for their sakes to help one another while here, to become better women and a credit to those awaiting our return to that haven of rest, home? Yes."[89] This reflection on motherhood, sacrifice, and self-improvement is especially significant when we consider that the *Star of Hope*'s readership included male prisoners across New York State and even civilian subscribers. Given the overt censorship of the *Star*, it is hardly surprising that such comforting reflections made it into print, but it is interesting, nevertheless, that a live performance, rather than a lecture, religious sermon, or printed book, served as a catalyst for such thoughtful reflection on the reformative value of wholesome amusements.

Entertainment in women's prisons came from socially sanctioned institutions, including Syracuse and Auburn churches that sent representatives to visit the women in ways not dissimilar to the lady visitors from Elizabeth Fry's era. Female inmates at Auburn were housed in six wide wards "resembling a large assembly-hall" with "airy and comfortable cells" on either side. Light was in abundance and a recess with large bay windows in the middle of the corridor housed two long wooden tables where female inmates ate and socialized. With a common area immediately outside their cells, the women had significantly more freedom of movement than the men in Auburn Prison, which made it easier for them to generate their own entertainment—"each ward recreates by itself," wrote Matron M. E. Daly in 1920—putting on plays organized either by each ward or by those attending school (the matron's daughter, Mary Daly, also sang and danced with the women).[90]

Inmate-produced recreation, especially dramatics, was sanctioned in most women's prisons, suggested by frequent reference to drama and playwriting in official reports (even to this day, women prisoners are seen to favor putting on plays more than male prisoners).[91] At juvenile hall in Los Angeles in

the mid-1910s, the young women wrote and performed plays for guests, as they did at El Retiro, Miriam Van Waters's West Coast reformatory, where recreation took precedence over education and work as central tenets of a woman's rehabilitation. And while there is no mention of film being shown at El Retiro, the girls were accompanied by graduates of the institution to attend plays, films, and the circus in Los Angeles.[92]

Performances given at Auburn's male prison were sometimes repeated for the women inmates. The Auburn City Minstrels, who had entertained the men at Thanksgiving, also appeared at the AWP with "songs, jokes, [and] dancing" in a show described as "about the same." Edward Lynch opened with a juggling act, followed by a "genuine coon song," "I'm Goin' to Live Anyhow Until I Die," sung by a Mr. Hanlon, and an appearance by the Auburn Juvenile Minstrels.[93] On Labor Day 1914, "colored friends" (most likely the Auburn City Minstrels) visited the women's prison chapel, playing piano, singing, and performing the aptly titled one-act farce "The House Without Men." Ice cream, cake, and candies were then served in the mess hall before the women were allowed to return to the chapel for a "fine little dance" until 6 P.M.[94] Local choirs sometimes performed in foreign languages for the women, as the Italian Church of Auburn did in 1907.[95] Ladies from the Auburn Women's Christian Temperance[96] visited twice the same year, once in June to bring flowers and again in December with holiday treats: "On both of these occasions they were accompanied by several *friends* who provided entertainment of several hours' duration."[97] This offhand comment in the *Annual Report* suggests the improvised and informal nature of women's entertainment in prisons; women were visited in a manner similar to the deliverance of alms, an act of charity toward the less fortunate that was rooted in the apostolic age. Visitors to male penitentiaries are seldom referred to as "friends"; they are either named or identified by their profession or affiliation.

Acting Out, Frustration, and the Failure of the Reformatory Movement

> Another great need in [Bedford Hills] is the making of some provision for recreation and amusement of the inmates when they are not employed.
> Report of the Board of Managers, 1920[98]

Bedford Hills Reformatory (now called Bedford Hills Correctional Facility) opened in May 1901 on a twenty-acre site. Modeled on the cottage plan refor-

matory, it housed female inmates classified by age and behavior into one of four cottages.[99] Besides learning trades at Bedford, the women were also allowed to do "fancy work during the hours of recreation" that would "keep their fingers out of mischief," including drawing, crocheting, and embroidering "trifles for their rooms."[100] Many of Bedford's inmates were prostitutes, drug addicts, or mentally ill. In 1911, John D. Rockefeller financed a Laboratory of Social Hygiene at Bedford, and by 1916, it was organized into three separate departments, one investigating heredity and environment (run by eugenics field workers), a second conducting psychiatric studies, and a third for psychological testing.[101] In 1920, the legislature passed New York's first defective-delinquent law, which required women over the age of sixteen deemed to be "mentally defective to an extent to require supervision, control, and care" to be transferred with indefinite sentences to the Bedford Division for Mentally Defective Women.[102] Not surprisingly, when these women realized the conditions of their confinement—the reality that they would not be released at the end of their sentences—many became incensed and hard to control.[103] There were reports of "continual unrest, friction, irritability, and dissatisfaction that was as trying and unsettling for the patients themselves as for the staff," despite the provision of organized sports (basketball, volleyball, and seasonal croquet and ice skating) and "occupational training" (basketry, weaving, embroidery, knitting, painting, carpentry, etc.).

Hydrotherapy, consisting of "continuous baths, shower baths, and wet packs," was used at Bedford on so-called psychopathic delinquents (distinct from "defective delinquents," classified by authorities as intellectually challenged).[104] Troublesome inmates were shoved into baths or covered in wet packs, read to by nurses during a postdinner reading hour (later abandoned due to the friction between the women), and, if really "difficult," transferred to a hospital for the insane. There was a belief that entertainment needed to be "as simple as possible" because of the perceived instability of the inmate population. Even acting in short plays was feared to arouse strain "more than such a group of unstable individuals can stand," since it purportedly elicited a powerful emotional response.[105] Against this backdrop of fears of female inmates' unpredictable behavior and heightened emotions, and coupled with prejudices toward cinema as a working-class amusement (discussed in greater depth below), it stands to reason that the stakes involved in introducing motion pictures during the mid-1910s were just too high.

Bedford Hills did not have a suitable space for church services or entertainment, using instead a space on the second floor of the administration

building for religious services and other events. The administration lobbied repeatedly for a "two-story building for recreational and assemblage purposes . . . a common meeting place and a chapel room [for] establishing and maintaining a high morale in the Institution."[106] It was in this second-floor room that recreational activities such as community singing, folk dancing, and, after 1919, motion pictures were screened. A clue to institutional attitudes toward film at Bedford Hills is embedded in the repeated requests for additional space, especially a chapel, in the late 1910s and early 1920s. Pointing out that Bedford Hills Reformatory only had a "room used for dancing, movies etc.," representatives of the Board of Managers argued that "when there are so many feeble-minded, or partially so, this is not helpful to awakening of the spiritual life."[107] The absence of a chapel, a space where motion pictures were usually shown in male penitentiaries, meant that the perceived deleterious effects of film could not be inoculated against by the architecture and iconography of religion.

Film caused trouble on occasion at Bedford Hills. When a scheduled film screening was suddenly canceled on New Year's Day, 1920, the women staged a riot. Informed by Warden Henrietta Hoffman that they were not going to be allowed to attend a moving picture show, the women "began to scream and shout and varied this by smashing furniture and banging their iron beds up and down the floor. The din became so loud that the reserve guards and matrons were summoned."[108] Amid growing tensions and insufficient staffing at the prison, a riot broke out, reported in the following day's *New York Times*.[109] At the time of the screening, the Bedford Hills population consisted largely of recidivists (100 out of 167) with over two-thirds of the population being prostitutes with venereal disease.[110] The seven-year period before 1920 had witnessed a revolving door of four superintendents, one of whom, Helen A. Cobb, was dismissed for maltreatment of prisoners. When Superintendent Katherine Davis left in 1913 to become New York State's commissioner of corrections, the situation was dire, with overcrowding, understaffing, and 25 percent of the population labeled feebleminded; the 1913 *Annual Report* minced few words when it described how "nerves have been strained almost to the breaking point."[111]

Eighteen months after the New Year's Day riot at Bedford, the *New York Tribune* reported that cancelation of a moving picture scheduled for exhibition at the reformatory had provoked ten women to escape from the prison. The women took flight as a "protest against the administration . . . because the

usual weekly exhibition of moving pictures had been ordered omitted as too melodramatic."[112] While the censored film is not identified in the article, its depiction of a murder in the final sequences (and of eight other killings) led to it being pulled by the prison censor at such a late notice that a replacement could not be found. Superintendent Dr. Amos T. Baker's fears that screening a crime melodrama to "impressionistic and excitable girls" might invoke a serious security breach had the inverse effect of triggering such a breach *despite* the film's censorship. Defending his decision, Baker argued, "They say it was because I cut out moving pictures it has been the custom to give every Monday night but I still think it was because of resentment against transferring other inmates to the psychopathic cottage."[113] Whatever the proximate causes of the 1920 unrest, film exhibition was inevitably caught up in penal policy, censorship, and governance. The motion picture censor at Bedford is not named, but the fact that the institution had a designated film censor (or someone acting in that capacity) is interesting, since no one had that title in Sing Sing or Auburn.

By 1922, film was being shown on Monday and Tuesday evenings at Bedford Hills, the same title repeated each night to accommodate the size of the audience (the film screenings were preceded by singing lessons in the gymnasium for each group in the afternoons).[114] The Bedford Hills prisoners' angry reaction to the loss of the filmgoing privilege suggests the high stakes of the prison exhibition, evoking an earlier period of female incarceration from the 1850s and 1860s when, as Zedner points out, "women's extreme frustration with the monotonous prison regime continued to lead to dramatic outbursts of anger and destruction."[115] Running through the history of the depiction of the female prisoner is the tension between, on the one hand, the idea of women as docile subjects, amenable to moral conversion, and, on the other, their reputation as unruly subjects when provoked to anger.[116] Arthur Griffiths, deputy governor of Millbank Prison in London in the 1850s, put it this way: "They are far more persistent in their evil ways, more outrageously violent, less amenable to reason or reproof."[117] This characterization recurs in an 1854 report on women prisoners written by a medical officer: "My experience of the past year has convinced me that the female prisoners, *as a body*, do not bear imprisonment as well as the male prisoners; they get anxious, restless, more irritable in temper, and are more readily excited, and they look forward to the future with much less hope of regaining their former position in life."[118] The consensus at the time was that female inmates

presented a greater disciplinary challenge than men, premised on the myth that women could not control their violent passions, were more irrational and hysterical than their male counterparts, and were inherently unsuited to the psychological strain of incarceration and discipline. The image of the disorderly woman, a "wily, duplicitous" figure who was a "stock character in misogynist" satire that flourished in Western Europe (especially in the Netherlands) in the late seventeenth and early eighteenth centuries, was popular in catchpenny prints (illustrated broadsides) but can also be traced to carceral history.[119] Mayhew and Binny described mid-nineteenth-century London women prisoners erupting in "wild fits of passion . . . occasionally destroy[ing] the tables, windows, and bedding in their cells," concluding that not only were female prisoners "more violent and passionate than the males, but their language, at such times, is declared by all to be far more gross and disgusting than that of men in similar circumstances." According to several accounts, women were not keen on the religious books foisted upon them, and if reported for misbehavior, it was often for "destroying their books and not for insolence."[120] Women ripped pages out to send notes to friends or "ripped whole volumes to shreds in outbursts of anger."[121] Venting frustration on library books was one of several ways women expressed their rage in prison (they also tore up clothes, destroyed furniture, and cursed). Women's outbursts marked them as doubly deviant, for they were eschewing feminine norms and "breaking out," the term used to describe their unruly antics.[122] When we factor in the boredom, frustration, and mental illness that doubtless afflicted many women, it is hardly surprising that women occasionally presented challenges to prison authorities.

A powerful index of female rage in prison (albeit triggered by a response to male violence rather than the fact of incarceration) can be seen in D. W. Griffith's *Resurrection* (1909), an adaptation of Leo Tolstoy's 1899 novel *Voskraeseniye*, about a Russian prince, Dmitri Nekhlyudov, who seduces and impregnates a servant girl named Katusha Maslova (fig. 5.14). Nekhlyudov fires her after the baby is born, and their paths cross again when he sees her in the dock on trial for murder (he is a jury member). After Katusha's conviction, Dmitri visits her in prison; her flirtatious behavior quickly gives way to rage, however, once she realizes who he is, and she starts to attack him with her Bible (fig. 5.15). In a classic Griffith move that doubles as a penological and moral mnemonic, the Bible becomes an agent of reform, the passage she reads—"Jesus said unto her, I am the resurrection and the life: he

Fig. 5.14 Frame enlargement from *Resurrection* (Griffith, 1909) showing Dmitri Nekhlyudov entering Katusha's cell.

Fig. 5.15 Frame enlargement from *Resurrection* (Griffith, 1909) showing Katusha "acting out" in her prison cell.

that believes in me, though he were dead, yet shall he live"—appearing in an insert shot. Religious conversion and psychic rehabilitation are signified via a series of emblematic shots of her pointing toward heaven and reading the Bible, an act mocked by her motley crew of cell mates, who serve as grotesque caricatures of fallen women. *Resurrection* thus tells a familiar story of women's reform through religious devotion, but its depiction of female criminals as promiscuous hysterics prone to violent outbursts conforms to the stereotype of women deviants as harder to manage than men. And even though Katusha's actions are justifiable given her appalling treatment by Dmitri, the image of her violent rage panders to widespread perceptions of unruly female criminals perpetuated in prison annual reports, journalistic accounts of prison visits, and popular novels and theater.

Bedford Hills Reformatory's volatile environment became more threatening when groups of inmates, far outnumbering the guards, gathered to watch film. If the tensions at Bedford Hills played out in other female prisons enacting harsh policies of confinement informed by eugenics and theories of female pathology, it is hardly surprising that many women's prisons deemed it altogether too risky to bring film into their institutions. Moreover, as *Resurrection* attests, as an aid in the reform of fallen women, the Bible was considered a safer, if not entirely foolproof, bet than a motion picture.

Explaining Film's Late Arrival

As a working-class amusement enmeshed in urban spaces of vice and immorality, and amid anxieties about women's heightened presence in the public sphere, motion pictures entered the prison with a social reputation. The epitome of "cheap amusements," motion pictures were indistinguishable from other lowbrow pastimes, as John Collier noted when he called film a "carnival of vulgarity, suggestiveness, and violence, the fit subject for police regulation," when it broke into the mainstream around 1908.[123] However, the height of the nickelodeon period five years later coincided with the peak of concern about prostitution and other "crimes of morality" in the United States.[124] The *Birmingham Herald* was shocked in 1908 to discover that nickelodeons were "largely, almost exclusively patronized by school girls and young women."[125] Even though female deviance and criminality were seen as stemming from immorality, as Estelle Freedman argues, "exposés about

the sexual exploitation of young women, popularized in newspapers, magazines, and through dozens of vice-commission reports in American cities, provided both social-purity and prison reformers with new reasons to criticize the treatment of fallen women."[126] Moving pictures were caught up in a wider moral panic about the deleterious effects of modernity on young women (the white slavery scare magnified broader concerns about women's vulnerability in the public sphere), and the debate over whether motion picture venues were safe places for women too frequently played out in the pages of the *Moving Picture World*: "I wonder how any respectable girl can go in a moving picture show. More young girls are led astray in these places than anywhere else. The shows are a blot and a stain on the community. They are frequented mostly by degraded young men and boys, and young girls do not go there for any good purpose."[127]

Attending motion pictures was the first step toward female criminality in the minds of moral conservatives. "Nice ladies," in contrast, "knew practically nothing about moving pictures," opined Mrs. R. G. Dolose, former member of the Board of Censors, who had organized a screening for a women's club in a New York City hotel. "Most of them had never seen a moving picture before. Others thought that moving pictures were shown only in the slums among dirty people in houses with poor ventilation."[128] Motion pictures were singled out as causal factors in working-class women's downfall— "the mother and child are mainstays of the entertainment" wrote a *Moving Picture World* contributor in 1909—so showing them in prisons before the rise of the motion picture palace that mitigated film's former dubious reputation might have been out of the question.[129] Women's place within the public sphere was fraught, especially during the white slavery panic of the early 1910s, which called into question women's safety when they attended the cinema and other working-class amusements. New patterns of socializing and concerns about the cinema as a locus for dating and prostitution gave motion picture attendance an unsavory reputation, linked to sexual intermingling in which a "woman's presence was immediately and perilously eroticized."[130] If Shelley Stamp's argument that women's status as film goers "remained to be negotiated, even as late as mid decade,"[131] is correct, it suggests that superintendents of women's prisons may have had a hard time justifying cinema as a regular feature of prison entertainments in the mid- to late 1910s. Films shown with no special accommodation in a male prison, such as the six-reel antidrug film *The Terror*, shown to three hundred men in the chapel

at Tombs Prison in Manhattan in 1914, did not automatically circulate to comparable women's prisons and reformatories, though recently appointed NYC prison commissioner Bement Davies said she would "consider" screening the film at Bedford Hills following its exhibition at the Tombs.[132]

The fledgling film industry tried to mitigate the medium's unsavory reputation, including through trade press articles such as "Nickelodeon Versus Saloon," which constructed filmgoing as safer and more satisfying for the urban flaneuse: "Women whose only pleasure was to sit on the doorstep and watch the teams go by have been brought in touch with real life."[133] Mirroring the efforts of middle-class women visiting "wayward women" in prison in the hope that the inmates would aspire to more decorous behavior, women were enlisted in the bourgeoisification-of-motion-pictures movement (an industry-driven campaign to make cinemagoing respectable), as evidenced in a 1910 *Moving Picture World* quote about a distinguished woman lecturer helping brand film as respectable: "We want to see women of the refined intellectual type assisting in the uplift of the moving picture, because we think such personalities . . . would be instrumental in attracting the better classes of the community to the picture house."[134]

As a new social force, cinema triggered widespread anxieties about "its audience and the maintenance of a healthy social body." Many governmental investigations and reports into nickelodeons from 1906 to 1910 raised concerns about their attracting a potentially disorderly and criminal audience composed of the working class, immigrants, and women.[135] In the words of a *Chicago Tribune* reporter, five-cent theaters were little more than "schools of crime where murders, robberies and holdups are illustrated." Not only did the exhibition of "cheap plays" encourage wickedness, but also they "manufacture[d] criminals to the city streets."[136] As Richard Koszarski, Kathy Peiss, and Miriam Hansen have pointed out, women were avid moviegoers by the late 1920s, "a larger percentage of those who patronize moving picture entertainments" according to the *Moving Picture World*.[137] If we accept Stephen Groening's point that women were *more* likely than men to be "interested in film, to be entranced by film, and to be susceptible to any given film's messages," then the concern about importing this type of female spectatorship from the streets into the prison may have heightened the anxiety of prison superintendents, who, as middle-class women, might have had limited access to cinema during its earliest years.[138]

Given the high value attached to moral reform for female inmates (the nineteenth-century prison "mark system," for example, rewarded men for dil-

igence and productivity, while female inmates, as Zedner notes, earned marks for "good conduct, honesty, propriety, and 'moral improvement'") it is no surprise that film, with its unsavory social reputation, was viewed with some suspicion by directors of women's prisons.[139] William Healy's 1915 *The Individual Delinquent: A Textbook of Diagnosis and Prognosis for All Concerned in the Understanding of Offenders*, devoted a section to the "Influence of Pictures, Especially Moving Pictures," where the author discussed cinema's indexicality, narrative structure, and lowbrow exhibition venues. While Healy considered boys especially susceptible to cinematic corruption—"It is nearly always a boy who is affected, and the impulse started is an imitative one"— he argued that girls and women were also vulnerable to cinema's deleterious influence.[140]

Another factor behind film's delayed entry into the women's prison concerns doubts about the medium's legitimacy and efficacy as an apparatus of reform. Film never assumed the role of proxy warden in women's prisons and reformatories, a role it had assumed by the mid-1910s at male penitentiaries such as Sing Sing and Auburn. Films shown in these male prisons performed a similar ideological function to the training films shown to women workers at Western Union in the 1920s, films Groening argues taught "corporate values, moral character, and the ethics of capitalism to a population not yet assimilated to the industrial organization of work."[141] A similar process of identification, in which the viewer was called upon to exteriorize "herself in the portrayals within the film at the same time that she is internalizing the lessons of the film," might therefore have rationalized cinema's place within the male penitentiary, a justification that was not extended to women's reformatories.[142]

As a mass medium, film's commercialized and universalized mode of address conflicted with several long-running tenets of female prison reform, identified as individual treatment, personalization, and kindness in the 1873 report of the Prison Commission.[143] And even though women outside prison were target audiences for filmed melodrama, cinema, unlike concerts, live performances, and lectures, was less reliant upon contextualizing remarks by a lecturer, or framing by the exhibition context itself. Those making decisions about whether to show film in women's prisons may have felt that it might engender the *wrong* kind of identification for women convicts. Instead, the entertainment offered to women in prisons was governed by the twin logics of performance and imitation; for example, in the "exercise and entertainment" ritual carried out at the Detroit House of Correction every

Thursday night, women *enacted* the manners and customs of refined society, rather than watching them on the screen as they would in a Griffith melodrama: "The whole family dress in their neatest and best attire . . . to read aloud an hour of entertaining stories and poetry. . . . After exchange of salutations between 'young ladies' and madame the visitor, and after the reading, tea and simple refreshments are served in *form and manner as in reformed society*."[144] Here we have the simulacral performing a disciplinary function, coercing women into showing off a faux class equity they would never access. With an emphasis on "'softening' and 'civilizing'" female convicts, film might have brought too much unsavory cultural baggage and a lower expected impact in the fight against moral turpitude.[145] But what other features of the motion picture made it risky or less effective in reforming or rehabilitating incarcerated women in the pre-1920 era?

As an act of consumption, the experience of sitting down to watch a film in prison resembled that of frequenting a local nickelodeon. In both venues, films could be "troublesome," offering, as Lee Grieveson argues, "new and different ideologies of sexuality . . . seen as particularly damaging to girls and young women."[146] Moreover, film's solicitation of different forms of identification—Siegfried Kracauer's idea of the filmgoer being "poly-morphously projected in a movie theater," and cinema as a "big dark hole . . . animate with the semblance of a life that belongs to no one and consumes everyone"—reinforced larger anxieties about women's role in the public sphere.[147] Women assumed something of an absent presence in the world of labor and city streets, locatable in those spaces but, as Nancy Bentley argues, never fully assimilated in public life, evidence that the public sphere was "not an aggregation of actual spaces but a mediated path to authority and self-representation."[148]

However, some progressives in the early cinema period singled out film as markedly different from other cheap amusements, a "counterattraction" capable of moral and cultural uplift.[149] This discourse gained traction with prison reformers such as Jane Addams, women's suffrage leader, sociologist, and founder in 1889 of Chicago's Hull House (fig. 5.16), the first settlement house in the United States. Hull House included its own motion picture theater playing uplifting titles until 1907 designed to compete with the neighboring nickelodeons on Chicago's South Side, which led women, in Addams's view, to grief because they "may be induced unthinkingly to barter [their] chastity for an entrance fee."[150] While fearful of "movie mad" women milling

Fig. 5.16 Hull House, Chicago Meeting Hall, 1905. Wikimedia Commons, http://commons .wikimedia.org/wiki/File:Hull _House_Women%27s_Club _building.jpg

around motion picture theaters with questionable males,[151] Addams supported cinema's potential as an instrument of social reform, writing in the *Moving Picture World* in 1908 that it was just a matter of time before film would be used in the same way as the stereopticon to educate and entertain in schools and churches.[152]

Women filmgoers were identified in the motion picture trade press at the time as instrumental in cleaving out a culturally respectable space for cinema, allies of aspiring exhibitors who could point to the introduction of amenities such as restrooms, nurseries, and uniformed attendants that appealed especially to women.[153] As Richard Abel argues, the "moving picture increasingly became inscribed within the rhetoric of moral reform or uplift (with its imperialist notions of responsibility for 'others less fortunate')."[154] But this discourse stopped short of persuading women's prison administrators such as Matron Welshe at the AWP to include film as a recreation option for female convicts.

In the less rigidly policed environment of the female prison, film might have had less of a crucial role to play as a disciplinary agent, since in reformatories, it was the (always married) female warden, as Zedner explains, who maintained order by "setting a personal example, gaining the trust of prisoners, and instilling a sense of loyalty."[155] The failure of film to gain an early foothold at AWP might also be a result of its policy to incarcerate "older and second-term felons—women considered too far sunk in criminality to respond to reformative influences."[156] Younger felons housed at Bedford who had come of age with motion pictures were perhaps seen as more "deserving" of the most modern mass media, more susceptible to cinema's

regulatory potential, and housed in a reformatory rather than a custodial state prison.

However, when we consider the prevalence of Victorian values in a great deal of early silent cinema emphasizing chastity and moral conservatism, film's slow adoption in women's reformatories does seem somewhat surprising. Perhaps the theme of the "fallen woman" rang too close to home, or, as Leslie Fishbein contends, the sympathy afforded fallen heroines in many silent films challenged the cult of Victorian womanhood that the matrons of reformatories clung to in the hopes of effecting reform. Films that featured a male hero's rescue of the innocent heroine in physical and sexual peril gave way to narratives in the late 1910s and 1920s that "not only blurred the distinction between true women and their fallen counterparts, but actually affirmed the superiority of the fallen."[157] Given the complex interplay of interpersonal relationships at women's reformatories and the emphasis placed on the modeling of good behavior and the punishment of even the smallest infractions, the cinema of the late 1910s might have fit less comfortably in the larger disciplinary schema.

We can also find clues as to how cinema conflicted with the reform agenda of women's prisons in the legislature, such as the 1919 Kansas legal decision *State v. Heitman*, which allowed disparate sentencing laws for each sex. Drawing upon the argument that a female inmate's reform required lengthier (and often indeterminate) prison sentences than the briefer incarceration in a local jail typically served to men, the judge appropriated the mythology of women's heightened sensory predispositions to defend the gender-based sentencing policy: "Women enter spheres of sensation, perception, emotion, desire, knowledge, and experience, of an intensity and kind which men cannot know . . . the result is a feminine type radically different from the masculine type, which demands special consideration in the study and treatment of non-conformity to law."[158] Motion pictures were perceived as one among many deleterious "spheres of sensation, perception, [and] emotion" that women gained access to, and the *State v. Heitman* decision signaled a marked "retreat from Progessive's [*sic*] efforts to reinvigorate women's prisons with diversified training," a shift away from "reform in general and feminism in particular."[159]

A final reason for the delayed entry of motion pictures in women's prisons and reformatories was structural and logistical. Unlike male prisoners in New York State, who in 1913 formed the Golden Rule Brotherhood (renamed the Mutual Welfare League), a prisoner organization that boasted an entertain-

ment committee and secretary responsible for procuring the loan of films, the women at Auburn Prison formed no such organization, either because so few of them were in for long enough sentences to gain positions of authority, or because they were officially prevented from doing so. The turnover of women prisoners, which, as Groening observes, "inhibits workers' cohesion, collectivity, and solidarity," might also have been an inhibiting factor in their organizational development.[160] Women imprisoned at the nearby Adirondack Clinton Farms Prison did organize a system of self-government, possibly due to the small size or the philosophy of the farm prison, so there is *some* evidence of women collectively organizing, although not in large state facilities such as Auburn and Bedford Hills.[161]

In an all-female environment, save maintenance employees and some male guards, it may have been less likely that someone was able or willing to operate a 35 mm projector and organize reel changes during a film screening, although I have not come across any references to this being a factor.[162] If providing a self-trained in-house projectionist might have been deemed too technically challenging or risky in terms of audience safety or damage to borrowed films, a professional projectionist would have been necessary, entailing costs or, in the case of AWP, allowing a male inmate to enter the prison to operate the projector. Obtaining films to project might also have been tricky in an all-female environment, since it would have been easier for men with prior connections in the motion picture industry to reach out to distributors and exhibitors for the loan of prints than for women, who were less likely to have worked or moved within this professional milieu. In most instances, films were offered by local theater managers, film studios, and distributors free of charge to prisons such as Auburn and Sing Sing, so it is quite possible that the inmates at the Women's Prison at Auburn in 1914 might have been offered films and possibly a projector at the same time as the men, but the prison authorities withheld their approval. In any event, many of these hypothetical logistical barriers to film exhibition are moot in the case of AWP, where, on the other side of the prison wall, film was shown to male inmates. Still, the hassle of moving the projector to the women's prison or the added security risk of allowing the women prisoners to attend the male screenings may not have been inconsequential factors.

Permissible Screenings

For women housed in male penitentiaries, access to film was sometimes unrestricted, and female inmates often watched films with their male counterparts in coeducational screenings.[163] For the Fourth of July holiday in 1915 for example, 638 male and female prisoners watched moving pictures together at Connecticut State Prison, marching to the chapel in pairs, with the women taking their seats before the male prisoners.[164] The sexual tension that must have ensued from watching motion pictures in the same physical space as the opposite sex, even in a place of worship, was bound to mark these as very special occasions for the prisoners (and they were just that, taking place on Independence Day or at Thanksgiving rather than on a weekly basis). The anticipation alone of watching a film in the company of men—a memory from the outside suddenly invoked—must have generated a great deal of excitement, and while all eyes were supposedly on the screen under the watchful gaze of guards, there must have been some head turning, as any teenage memory of going to the movies will attest. A handful of women were thus regulars at Connecticut State Prison chapel entertainment. "Completely segregated from the men," the *Hartford Courant* author identified one of them as eighteen-year-old Lillian Gentile, described as once being "thoroughly bad" and now in the company of "other . . . poor, broken creatures, about whom hard things had been said in time past." With their gazes fixed upon the actors who had come to entertain them, the psychic burden of imprisonment let up slightly for the duration of the performance: "They had a chance to forget and in forgetting they seemed no different from any other audience gathered in any other hall."[165] Women staying in the Shelter for Women at Connecticut State Prison were not permitted to see the films, however, and their Christmas entertainment took the form of a reunion with former inmates who "delight to return on this day."[166]

Mixed-sex screenings for film industry professionals were the focus of a 1918 opinion essay written by George Gordon Wade for the *Star of Hope*; according to Wade, "We note with interest that women are to be invited to attend trade screenings of future releases, and feel it is a step in the right direction. A majority of the patrons of the silent drama are women, and most every photoplay depicts situations that strongly appeal to the feminine side of human nature, whereas mere man looks on *unmoved*. Scenes of tenderness, tears, and sadness, are as food to most women's hearts, and they retain memories of such scenes long after most men would have forgotten them."[167] Why,

one might ask, was the inclusion of women at trade screenings noted "with interest" by this contributor to the *Star*? Both prison film exhibitions and trade press screenings had up until this point excluded women, and notwithstanding the sentimentalized construction of an idealized female spectator, the reference to male viewers looking on "unmoved" suggests that all-male prison audiences are missing out on the affective properties of films and lack the ability to recall emotional scenes. And yet, prison audiences may arguably have more in common with female audiences than civilian male spectators, retaining memories of melodramatic scenes from films for far longer than on the outside. In an interview I recently conducted with Andre Jenkins, an inmate serving a mid- to long-term sentence at Sing Sing, he spoke openly about being moved to tears listening to a radio show about adopted twins reuniting with their birth mother: "I cried like a baby," he admitted, and without an ounce of self-consciousness.[168]

Coed prison exhibition and the idea of women attending trade screenings pale in comparison to prison reformer and administrator Miriam Van Waters's willingness to break down barriers between the outside world and the prison (before taking over as superintendent, she told the *Boston Globe* that "the goal of the modern institution must be to have institutional life approximate outside normal life as nearly as it can").[169] Not only did she reproduce aspects of noncarceral life behind bars, informing her parents in 1932 that she wanted to "bring the outside world in," but she also allowed certain "students" imprisoned at Framingham (formerly Sherborn Reformatory) to attend cinema in the community, eat at restaurants, and, through indenture, work as domestic servants while serving their sentences.[170] Ironically, it is logical to assert that this is exactly what cinema in prison might do, and yet there is no reference to film screenings at Framingham during this period.

This circles back to the challenging logistics of film exhibition in the women's prison (lacking in-house projectionists or electricians), film's suspect moral pedigree (conflicting with the morality of sanctioned leisure activities that female inmates might imitate), and the belief that film was less effective at transmitting reformist ideals for all-female audiences, the notion being that women ought to engage in more active and embodied practices of reform such as singing, sewing, and dancing, rather than passively watching film. Coupled with the simple prejudice that female inmates were less deserving of film (in accordance with the persistent construction of the irrational and recalcitrant female offender), we have several possible explanations as to why motion

pictures were neither quickly nor easily integrated into the recreational culture of women's prisons or reformatories. Operated more like a factory than a sanatorium or school, the male penitentiary contained workshops where men toiled in ways not dissimilar to those in their civilian lives; inmates re-created a version of a hypermasculine public sphere in the nightly film screenings in the prison chapel and were rewarded with entertainment after a day's hard labor in a prison workshop; no such habitus could be re-created for women whose recreation was governed by a topos of domesticity. Women inmates therefore found themselves in a catch-22 situation: with little to occupy their time, they were undeserving of organized entertainment on the same scale as men, a problem recognized in the 1919 Bedford Hills annual report: "Women are allowed too much time for killing in their rooms and conversing with one another. They could put in eight hours' work, have an hour's hard play every day, and still have time to do their own housework . . . and go to *occasional* entertainments." The operative word here, however, is "occasional."[171]

Training women for social roles as mothers and homemakers while incarcerated reinforced deep structural inequities, as Rose Giallombardo argued in *Society of Women*, an influential study of a West Virginian federal reformatory: "The reduction of women to a weak, dependent, and helpless status was brought about by more subtle means than by the gun or the high wall."[172] The idea of life behind bars as an imitation or charade of civilian existence is doubly ironic when we introduce filmgoing into the mix since both film and prison refract a version of reality.[173]

This argument is echoed in contemporary prison researchers Edward Zamble and Frank J. Porporino's suggestion that discipline and governance are easier in penitentiaries (an argument entrenched in institutionalized sexism), when inmates are able to re-create on the inside "some of the pattern of their lives on the outside."[174] Although referencing 1980s Canadian prisons, Zamble and Porporino's observation touches a raw nerve about gendered recreation in prisons, since by allowing motion pictures into male penitentiaries in the early 1910s, prison wardens were giving men a semblance of normalcy, allowing them to experience behind bars a pastime they enjoyed while free. Sadly, the same could not be said for incarcerated women, whose enjoyment of cinema as a working-class amusement was curtailed, an ironic state of affairs given the large number of women who frequented nickelodeons, often with their children. Rafter's argument that "women's reformatories were based on acceptance or the willing embrace of differential standards for

the imprisonment of women and men" goes beyond questions of sentencing and public policy to include the use of motion pictures.[175]

And lest there be any lingering doubt about the differential treatment of women in prisons,[176] a survey conducted in 1917 by Helen Worthington Rogers on legislative measures adopted by the forty-eight states to cater to so-called delinquent women revealed that "in none [of the questionnaire responses was] there any mention of recreation as a reformative agency."[177] At the same time as film was finding a foothold in male penitentiaries between 1909 and 1915, six large U.S. states established reformatories for women. An exhaustive analysis of their annual reports, internal records, and prisoner publications might reveal occasional use of film, but given that there is no mention of film screenings in women's reformatories in the mainstream media, a media obsessed with reporting on film exhibition in male penitentiaries (or in prisons with female wings), we can conclude that film use was more restricted in women's prisons and reformatories, at least until the early 1920s, than in male institutions.

The image of *Orange Is the New Black*'s Piper Kerman watching film in a twenty-first-century low-security federal prison, suggesting that incarcerated women enjoyed equal access to modern media in the twentieth and early twenty-first centuries, belies a fraught history of media discrimination in female prisons (it also belies the staggering increase in the number of women incarcerated; there were more women in prison in California by 2003 than there were in the entire country in 1970).[178] If most prison superintendents foresaw motion pictures' integration into male prison life as a relatively uncomplicated, albeit risky, decision in terms of security, the same cannot be said of women's reformatories and prisons. Prison architecture, progressive and reactionary penal discourse, and the problematic image of the female prisoner in early twentieth-century America shaped the conditions of film's emergence in women's prisons and reformatories; labeled "disgraced and dishonored" by Giallombardo, the situation of the female prisoner affected early media use, although by the time of television's routine appearance in prison, there seems to have been few differences between media use in male and female penal institutions.[179] Television's construction as a domesticating and feminized medium no doubt comported better with mid-century American expectations of what women deserved while they did their time behind bars.

Chapter Six

Cinema and
Prison Reform

And frankly, try as I would, I could not completely visualize the
viewpoint of the prisoner. No one can—unless he is a genuine
prisoner.
LEWIS WOOD, *Sing Sing from the Inside*, 1915[1]

On June 6, 1917, a riot erupted at Illinois State Penitentiary in Joliet. As re-
ported in the press, five buildings were set on fire and infantrymen assisted
guards and fire department personnel in restoring order. Reporting that "the
whole thing is somewhat of a shock to those that have followed with interest the
developments in that institution," the uprising was blamed on the "'misguided
interference of women' in efforts of prison reform."[2] The "misguided interfer-
ence" was, in fact, a national letter-writing campaign in which women wrote to
individual Joliet inmates. In response to the thrill of receiving letters, convicts
started gathering in groups to share them, "speculating on the appearance and
character of the writers" and no doubt enjoying the ensuing jollities. In an al-
ready tense carceral environment, acting warden A. L. Bowen's decision to ban
both the writing and sharing of letters triggered the prisoners' violent melt-
down. But when interviewed by a journalist, Warden Bowen expressed almost
as much outrage and frustration at the cross-generational nature of the vir-
tual and in some cases actual liaisons (when women letter writers visited
inmates) as at the riot itself, barely concealing his disgust at the idea of a
sixty-five-year-old woman from Miami traveling to Joliet to visit her twenty-
two-year-old prison pen pal; lamented Bowen, here were women the men had
never seen or heard of, "bent on curiosity [and] all clothed in the sex-exciting
garb of the day . . . parading and making a holiday for themselves in front of
the men" and writing as long as fifty-page, sometimes steamy letters.[3]

We can glean much about the gendered politics of prison reform from this
single incident: women are demonized in the reporting, constructed as med-

dling, cradle-snatching interferers whose interest in brightening the lives of the men would inevitably serve no good in the eyes of the authorities. Serving as a stark reminder of the complex and volatile meanings of incarceration, this anecdote also signals how reformers utilized communication media (letter writing among the oldest) to lobby for prisoner rights and, in some instances, to become romantically involved with them. Letter writing improved prisoner morale, supported reform efforts through incentives to "go straight," and even found a place within inmate culture at Joliet. Letters, like photographs, continue to be exchanged, archived, and treasured in prison, far more so than in the free world, where e-mail and social media have rendered personal letter writing virtually obsolete.

Prison has always been a complex signifier in American culture,[4] vilified by some for socializing youngsters to careers of crime and delinquency and celebrated by others as an effective tool to train inmates to avoid the temptations of the saloon, gambling, and petty crime upon their release.[5] Cinema's connection to "broad regulatory anxieties about . . . particular citizens and populations,"[6] briefly explored in the previous chapter, is taken up more deeply here, moving beyond regulatory discourses to examine how motion pictures were used by reformers to solicit public sympathy and humanize what were considered to be incorrigible social outcasts.

I turn first to cinema's appropriation by reformers as a muckraking tool, focusing on several examples of filmmakers gaining access to prisons. These reformers (few of whose films are extant) include Katherine Russell Bleecker, who shot footage in three New York State penitentiaries to accompany a touring exhibit on prison reform organized by the Joint Committee on Prison Reform (JCPR) in 1916. These early prison films are important precursors to subsequent and better-known prison documentaries, including Frederick Wiseman's *Titicut Follies* (1967), filmed in Bridgewater Prison for the Criminally Insane in Massachusetts. I next examine how prison reform was represented in several films made in the late 1910s: *The Honor System* (Raoul Walsh, 1917), *The Prison Without Walls* (E. Mason Hopper, 1917), and *The Right Way* (1921), directed by Sidney Olcott and written by prison reformer and former Sing Sing warden Thomas Mott Osborne. Some of these films integrated prison footage with material shot in urban locations into narratives of rehabilitation and reform. Osborne went on tour with *The Right Way*, lecturing before screenings, drumming up media interest, and seeking support from public officials and social elites sympathetic to prison

reform. I conclude by asking whether the use of cinema by early prison re-
formers helped effect changes in policies of incarceration before such reform-
ist efforts were absorbed in Hollywood's romanticized vision of the criminal
underworld and the image of the irascible yet honorable gangster of the
late 1920s.

Osborne and the Prison Reform Films of
Katherine Bleecker

Occupying a prominent role in the popular imaginary, prisons and prisoners
were by no means newcomers to the medium of motion pictures in the mid-
1910s, having been featured in early actualities and story films since cine-
ma's emergence in the mid-1890s. And while these films were initially made
for curiosity purposes rather than the promotion of the cause of prison reform,
they did double duty by drawing attention to appalling prison conditions.
Thomas Osborne (fig. 6.1), one of the nation's preeminent prison reformers in
the 1910s and the early 1920s, is a key figure in the enmeshing of motion pic-
tures and reform in New York State.[7]

Born in Auburn, New York, in 1859 into a wealthy manufacturing family
(including many politically active members), Osborne graduated from Harvard,
served two terms as mayor of Auburn, and in 1905, launched the progressive
Auburn Daily Citizen. He was selected by New York governor Charles Evans
Hughes to investigate railroad staffing levels on the state's first Public Ser-
vice Commission and, under Governor William Sulzer in 1913, was appointed
chairman of the State Prison Reform Commission. The year before becoming
Sing Sing's warden in 1914, Osborne undertook an extraordinary publicity
stunt to expose prison conditions at Auburn Prison, using the pseudonym Tom
Brown to spend one week at the prison (prison authorities were aware of the
endeavor but at his behest afforded him no special treatment). Shortly after
entering a prison system that he had previously described as "devilish, stu-
pid, brutal, and inhuman," Osborne was set to work weaving baskets and even
spent one night in solitary confinement.[8]

Osborne's stunt triggered a frenzy of media interest, with one newspaper
claiming that Warden Charles F. Rattigan (Auburn warden from 1913 to 1916)
was asked by filmmakers if they could shoot footage of "the millionaire stu-
dent of prison trying to live for a time as convicts do," arguing that huge prof-
its could be made "from [showing] how [he] looks making baskets with a

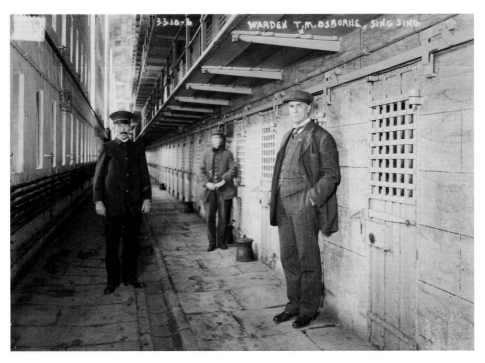

Fig. 6.1 Thomas Mott Osborne (right) with two unidentified men, Sing Sing Prison, ca. 1914, George Grantham Bain Collection, Library of Congress. Wikimedia Commons, http://upload .wikimedia.org/wikipedia/commons/6/67/Sing_Sing_%28prison%29_with_warden.jpg

crowd of long-term criminals."[9] The news value of a millionaire prison reformer slumming it behind bars garnered sensational headlines and cartoons, such as "It Makes a Difference," which shows Osborne seated next to a wizened-looking inmate in the basket-weaving workshop[10] (fig. 6.2). Osborne, whose body appears considerably less prison worn than the older man, looks down at his hands, concentrating on the task at hand (he wrote about how hard the work was in his journal) but also perhaps fearing the attention of the guard standing in the far left corner of the image. The older man's head, angled slightly toward Osborne's hands, suggests the tendering of advice on how to master basket weaving (he has woven about twice as much as Osborne), and the captions justifying each man's loss of liberty—"John Doe for the Benefit of Society" and "Thomas Mott Osborne for the Benefit of Humanity"—paint Osborne as the martyr-reformer, willing to personally suffer for the greater good of improving prison conditions. Another cartoon (fig. 6.3) shows Osborne smoking a cigar while flopped in a chair and wearing

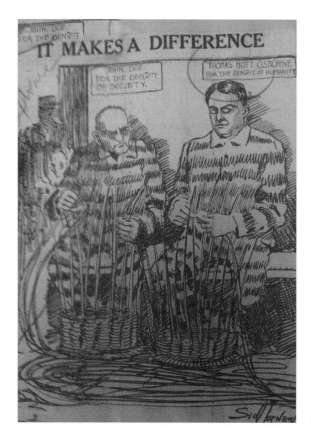

Fig. 6.2 Cartoon of Osborne in the basket-weaving prison workshop, Auburn Prison, September 1913. Courtesy OFP

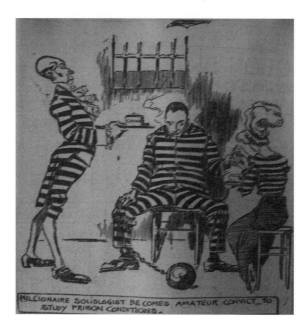

Fig. 6.3 Cartoon of Osborne as "millionaire student of prison" being coddled in his cell, September 1913. Courtesy OFP

a ball and chain, being brought caviar as he receives a manicure; mocking the authenticity of Osborne's experience, the cartoon seems to suggest an amateur English theatrical production featuring the snooty English footman and flouncy maid, with Osborne as an "amateur" at being a convict since his wealth and status mitigated any genuine suffering.[11]

The idea for inmate self-government at Auburn stemmed directly from Osborne's address to the inmate population at the end of his "incarceration," and a team of inmates quickly set to work drafting a constitution, electing officials, and crafting an oath of allegiance to the newly hatched Mutual Welfare League.[12] Osborne was catapulted to the forefront of the national prison reform movement and inundated with requests, recommendations, and commentary, his office desk piled high with mail from "sociologists, moving picture promoters, magazines, newspapers, college professors, physicians who have new methods of curing crime, convicts on the outside who are interested in his experiment, convicts in other institutions who offer advice, and countless other correspondents."[13]

The publicity continued unabated even when Osborne became warden of Sing Sing (fig. 6.4); according to Denis Brian, "There was more press coverage of penal reform during Osborne's two years at Sing Sing than at any previous time in the country's history."[14] Osborne recalled being approached by "many motion picture producers who had an idea of putting the prisons in the movies," although he admitted that the prospect "never seemed to strike me very strongly."[15] When asked about commercial cinema's representation of prison in an interview in the late 1910s, Osborne complained that "films in general . . . give a distorted view of prison life. So do books."[16] At the same time, so committed was Osborne to the role of recreation in prison reform that once, when an entertainer failed to show up at Sing Sing in February 1915, Osborne stepped in, lecturing the inmates on music, illustrated with selections on the piano.[17]

At the same time, the MWL was not without its detractors, and Osborne was criticized for failing to work harmoniously with Governor Charles S. Whitman, misjudging some of the prisoners he invested with power, and, in one journalist's words, being "altogether too theatrical," a charge echoed in another journalist's reference to the "jocular atmosphere of the . . . penal clinic for reformers."[18] Future Sing Sing warden Lewis E. Lawes offered a magnanimous assessment of Osborne: "He had the right idea. After a while the ship began to flounder. It could not be kept on an even course, and before long it found itself entirely off the beaten lane."[19] Osborne temporarily resigned as a result of an official investigation in April 1916, only to be reinstated three months later.[20]

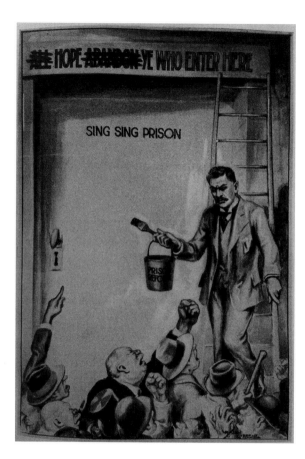

Fig. 6.4 Cartoon of Osborne painting sign with "Prison Reform" paint. *Puck* magazine, 1914

In the minds of some, the power invested in the MWL represented a challenge to prison authorities that could only be tackled through the suspension of educational and recreational activities for several months in 1916; as a later journalist was to explain, "A democratic society had suddenly developed in an institution, which is by nature a most autocratic type of community."[21]

Notwithstanding Osborne's pejorative view of prison films, in 1914 Katherine Russell Bleecker was commissioned to make films to accompany a touring exhibit organized by the Joint Committee on Prison Reform (JCPR), an organization made up of representatives from a number of prison reform initiatives in New York State. In 1916 the exhibit traveled to Buffalo, Rochester, Syracuse, and Albany, and the films were shown to inmate audiences at Auburn and Sing Sing and subsequently distributed by the Community Motion Picture Bureau. O. F. Lewis, secretary of the New York Prison Association,

writing in the *Delinquent*, called the films and the JCPR exhibit "the most novel means yet devised for driving home the facts and glaring deficiencies of parts of the prison system."[22] Overseen by Secretary of the JCPR Alexander Cleland, the exhibit was hailed as being more effective than descriptions, photographs, and lantern slides alone. Not only did the exhibit incorporate the latest techniques in modern museum and advertising display, but it attempted to construct a visceral and memorable message about the need for prison reform. Seeking professional assistance to execute the exhibit idea, the JCPR recruited the Department of Surveys and Exhibits of the Russell Sage Foundation.

The JCPR's exhibit coincided with the professionalization of commercial exhibit design and the growth of modern advertising methods, and aimed to extract the most relevant and expressive data from the voluminous information on prison conditions and present it in a coherent and accessible way. The JCPR decided against exposing corruption in prisons, preferring instead to focus on the "simple, frank depiction of conditions at Sing Sing, in county jails, and on the road with tramps and vagrants."[23] The JCPR channeled two-thirds of its annual operating budget of $12,000 toward the exhibit, including $3,000 for Bleecker's motion pictures. The exhibit included three hundred feet of panel space, divided into individual booths with a hundred three-foot-wide panels.[24] Six phonographs ran continuously, although their novelty value was offset by the "perversity of such devices [that] afforded the managers of the Exhibit an almost constant source of bother to keep running properly."[25] The panels featured two or three enlarged photographs, sparing use of charts and statistical tables, and architectural plans for a proposed modern replacement for Sing Sing Prison, the Westchester County Penitentiary, which was never built.

Visual representations of Sing Sing long predated this exhibit, with a notable slide show produced in 1912 by A. J. Clapham, who obtained forty-five photographs of the prison that showed the inmates working in the various departments and occupying their cells, as well as shots of the death chamber.[26] The slides were so popular that the Boston-based Kellman Feature Film Company purchased the rights for their exhibition. Even as the motion picture industry was on the cusp of transitioning into a fully formed entertainment modality, lantern slide shows associated with nineteenth-century screen practices could still make money if the topic was prurient, topical, or capable of piquing the public's imagination through the twin vectors of education and

sensation. A men-only lecture by Dr. E. Stagg Whitin, general secretary of the National Committee of Prisons and Prison Labor of New York, "showing the evils of the contract system in prisons" exposed similar aspects of carceral life when it was given at a YMCA meeting held at the Princess Theater in Hartford, Connecticut, in 1914.[27]

The plan to shoot motion pictures in large New York State penitentiaries had been hatched in 1914, when Superintendent of Prisons John B. Riley wrote the wardens of several male and female penitentiaries in New York State authorizing Cleland to take motion pictures "for educational purposes."[28] "I wish you would cooperate with him and take such steps as may be necessary to enable him to obtain pictures which will not only be interesting but will be instructive to the general public," Riley informed the wardens.[29] Settling on Auburn and Great Meadow Prisons out of a list of eight locations (Sing Sing was not included in the initial plan), Cleland asked Osborne to lean on Warden Rattigan and officers in Auburn Prison's Mutual Welfare League to cooperate with the film, but insisting at Auburn same time that "no prisoner ought to be in the film *without his full consent*."[30] Cleland was informed five days later by Principal Keeper Riley that he would have unrestricted access to the prison, save for "those confined in the condemned cells—as such persons are required by statute to be isolated." Wrote Riley, "I see no objection to the public having full knowledge of the prison routine and I am perfectly willing you should secure moving picture of everything and anything."[31] Cleland initially approached Horace G. Plimpton in the Motion Picture Department at Thomas Edison's studios for production estimates, but in the absence of a scenario, Plimpton said it was "quite impossible for me to give an estimate of the cost on this without having an opportunity to see the scenario. If I could have a rough draft made and sent to me, I shall be very glad to tell you what we should have to charge for the picture."[32] While I have not come across exact quotations for the production, Lewis reported in the *Delinquent* that Edison's price for shooting the film was prohibitively high.

As a matter of financial expediency Cleland did something quite radical for the time and hired Bleecker, with two years' filmmaking experience to her name, as the film's writer, camera operator, and director (fig. 6.5). Hiring a woman camera operator was virtually unprecedented, although as Alison McMahan, Shelley Stamp, and Jane Gaines have argued, women such as Alice Guy Blaché and Lois Weber were more active as directors during

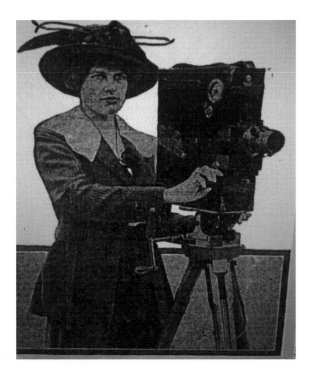

Fig. 6.5 Katherine Russell
Bleecker behind the camera.
New York Times Magazine, 1915

the early cinema period than in the 1920s and beyond.[33] Bleecker was one of
a handful of women working as camera operators in the early 1910s; so rare
were women employed behind the camera in the industry that *Photoplay*
profiled one of the few other women camera operators at the time, Francelia
Billington, who worked as an actor at the Reliance-Majestic Studio in Los
Angeles and occasionally stepped behind the camera.[34] Such was the novelty
of a woman cinematographer that the *New York Times Sunday Magazine*
profiled Bleecker in 1915; headlined "Prison Moving Pictures Taken by a
Girl," one of the accompanying illustrations shows Bleecker standing with
both hands on the camera looking serious but composed.[35]

Constructed as though it were an eyeline match of what Bleecker sees
through the viewfinder, the second illustration (fig. 6.6) depicts twelve Auburn
inmates wearing anachronistic double-striped second-term uniforms standing
in the lockstep formation with shaved heads and furrowed brows (striped uni-
forms and the lockstep were banned in 1901). Bleecker narrowed down an
initial group of one hundred convict volunteers to forty, since that was the
number of "old-time suits of striped garments" available.

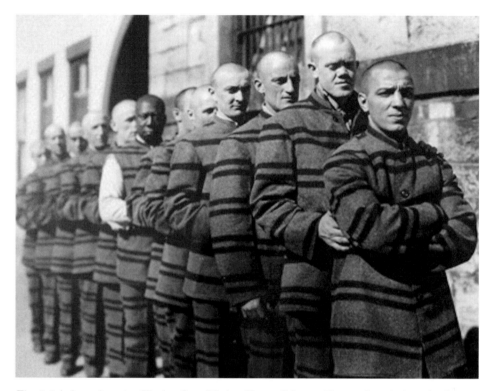

Fig. 6.6 Auburn inmates "Posing for a Motion Picture" dressed in anachronistic striped uniforms for Bleecker's film. *New York Times Magazine*, 1915

A self-taught photographer whose previous camera experience included shooting amateur dramatics performed by Newport, Rhode Island, socialites, Bleecker lived up to the image of the intrepid cinematographer in the *New York Times Magazine* article, listing prison as one of many exciting shooting locations she had encountered in her two years' experience (the others were of modes of transportation including an airplane, a tugboat, and an automobile).[36] For the inmate subjects at Sing Sing, Bleecker's presence behind the camera may have been as much of a novelty as the apparatus itself. Along with the fact that Bleecker brought "a good deal more than a commercially colored vision" to the filming, her fee apparently did not strain the modest budget for the planned exhibit (she was thanked for "bringing a spirit of co-operation to the project"). Still, the $3,000 cost of making the films was described as "tremendous" but was met by "special contributions [and] returns from non-commercial exhibitions of the pictures."[37]

Charged with re-creating scenes of antiquated punishments at Auburn Prison, where she began filming first, including floggings in which men were lifted off the ground by their arms before being whipped, Bleecker recalled a twenty-year-old man stepping forward: "I had a cardboard paddle made and gave the guard instructions to pull the victim up, then lower him gradually until his toes rested on the floor, but to appear to be holding tightly to the rope so as to keep up the illusion." In all the excitement, however, the guard forgot to lower the convict-actor, who ended up hanging by his wrists and not uttering a sound for fear he would ruin the take. Bleecker only discovered this when she approached the inmate to thank him and discovered he had fainted.[38] Bleecker also filmed the second anniversary of Osborne's own incarceration, a "Tom Brown" day gala including parades, races, music, recitations, and a late-afternoon banquet in which inmates dined on lobster salad. Not only did Auburn prisoners readily volunteer to play the role of old-regime inmates, but they also raised funds for the film, staging a minstrel show in the chapel that netted $800 to offset costs (they jokingly said that if two or three of them could be let out for a night they would return forthwith with the money). Osborne himself re-created his stay in Auburn Prison as inmate Tom Brown alongside other Auburn prisoners who played themselves in an attempt to evoke "all the horrors of the prison system before the reforms."[39] Bleecker was less enthusiastic about her experience filming at Sing Sing, describing the men as jaded and reluctant to tote her equipment and complaining that when volunteers were called forth, "they came laggingly." Blaming lax discipline and the three-by-three-by-seven-foot cells, Bleecker wrote that the men were justified in their despondency, since she found the institutional atmosphere "disheartening" and felt "dejected" most of the time she was there. Bleecker found Great Meadow a vast improvement on Sing Sing, beginning with its bucolic 1,100-acre setting. She shot footage of inmates farming, building roads, and harvesting timber, along with the weekly baseball game.[40]

Bleecker edited seven thousand feet of footage into several titles released in December 1915, including *Within Prison Walls* (the title of Osborne's book about his stay in Auburn),[41] *A Day in Sing Sing*, and *A Prison Without Walls* (featuring Great Meadow).[42] The three-reel *Day in Sing Sing* portrayed the physical conditions and industries in the first two reels and the activities of the Mutual Welfare League in the final reel. The most sensational of the three films, *Within Prison Walls*, re-created Osborne's Tom Brown experience,

something motion picture companies had been desperate to do since Osborne conducted his experiment in 1913, though never gaining permission from prison authorities or Osborne. Given the widespread national press interest in Osborne's original Tom Brown stunt, this opportunity to stage the experience for the camera guaranteed public interest in Bleecker's film, even more so in 1915, since Osborne was now warden of Sing Sing, one of the most notorious prisons in the world. Even the Great Meadow film, aptly titled *A Prison Without Walls* to contrast with Auburn Prison's *Within Prison Walls*, had the novelty value of showing how a thousand-plus-acre farm prison operated on an honor system.[43]

The JCPR exhibit opened in New York City on January 10, 1916, with a screening of Bleecker's films and a lecture by Katherine B. Davis at the Washington Irving High School in the Gramercy Park neighborhood in Manhattan. This event served as a promotional teaser for the actual exhibit installed at the nearby Russell Sage Foundation building, which donated their auditorium. A major draw of the physical exhibit was the re-creation of a Sing Sing cell: almost as amazing as "the clanging iron barred door, the old iron cots, let down from the wall, the dirty mattresses, the doubtful blankets, the bucket, and the gloomy duskiness of the interior of the cell" was the fact that the cell had been constructed by inmates (as had all the models in the exhibit).[44] After two weeks in New York City, the exhibit traveled to Buffalo under the auspices of the Erie County Branch of the Women's Department of the National Civic Federation, moving on after three days to Syracuse, then Albany, and returning to reopen in New York City in April (in each city it was modified slightly to meet the particular reform agenda of that area). The films accompanying the exhibit were credited with generating public interest (it was estimated that between 25 and 50 percent of people came because there were "pictures") and for driving home the object lesson. A note of caution was also issued, however, about the risks of the movies detracting from the exhibit, of audiences arriving early to watch the films and not paying sufficient attention to the exhibit, and of too much time being allocated to the films alongside the scheduled lecture.[45]

The prison reform movement operated alongside many other contemporary civic movements, including women's suffrage, public health, and the Red Cross disaster relief, that also used cinema to raise public awareness.[46] More to the point, Bleecker's efforts were just one example of reformers going into prisons to obtain footage: in 1914, California district attorney Captain John D. Fredericks sponsored a prison reform film shot in Folsom and San Quentin

Prisons showcasing humanitarian treatment and reformation of criminals rather than punishment. Fredericks's fictional film depicted four grades of convict life, where success at each grade would earn promotion to a higher level affording more privileges and access to skills (in the second grade inmates learned a trade, in the third they were moved to an honor camp, and in the fourth they undertook parole work, on either the highways or a farm).[47] Fredericks hoped to leverage public support for his progressive penology as part of a gubernatorial run, and use his credentials as a public prosecutor to not just show the usual "incidents in the routine of convicts, their environment and the punishment and restraint they are subjected to," but to "give the convict the chance to show his worth, to improve his condition and to be prepared to enter a trade when he is a free man."[48] That Fredericks could pitch his 1914 reform film as both distinctive and recognizable within a range of prison-themed films suggests how established film was within progressive penology. And like the New York prison exhibit, Fredericks's films were scheduled to tour major cities in Southern California, opening in Los Angeles. Reform films made under the auspices of nonprofit organizations or public officials rather than commercial production companies were unique products in the war on antiquated prisons; spearheaded by prominent individuals with political clout, such traveling road shows, as in the case of Captain Fredericks's, could double up as political campaign propaganda.

Early Commercial Reform Films

From our contemporary era of mass incarceration and punitive attitudes toward lawbreakers—according to penal historian Estelle Freedman, "the reform era of the late nineteenth and early twentieth centuries seems to have disappeared, and a new vengeance toward prisoners now pervades much of culture"—the reform discourse of the early twentieth century seems hopelessly remote.[49] This empathetic sensibility was evident in *The Honor System* (Fox Film, 1917), which supported much of the specific agenda of prison reform at the time: the abolition of flogging, bodily deprivations, lockstepping, and striped uniforms, and the establishment of a prison honor system with a measure of self-government. Based on a story by *Los Angeles Times* journalist Henry Christen Warnack and directed by Raoul Walsh, *The Honor System* interlaced documentary-style location shooting at the old Arizona State Penitentiary in Yuma with a fictional love story centered on two prison reformers. Arizona governor George W. P. Hunt gave Walsh permission to shoot in

the disused facility at Yuma using inmates from the contemporary prison in Florence as extras in scenes that were "absolutely correct in every detail," according to one critic.[50] Walsh spent a few nights in the penitentiary to imbibe the atmosphere prior to shooting, following in the footsteps of other reformers and journalists who strove to reconstruct as authentic a portrait as possible of the prison they were investigating.[51]

The Honor System told the story of Joseph Stanton, sentenced to life imprisonment for murdering a man in self-defense. Appalled at the inhumane conditions, he successfully lobbies the governor to investigate the prison and implement an honor system. Corrupt state senator Crales Harrington denounces the idea of prison reform, and when Stanton is granted a three-day leave from prison on the condition that if he fails to return the honor system will be abolished, Harrington attempts to kidnap Stanton until the deadline has passed. Escaping in the nick of time to save the honor system, Stanton exposes the senator, who winds up in jail, while Stanton is pardoned so he can marry Ethel, the warden's daughter. Walsh modeled the film's governor closely on Arizona governor Hunt, including quoting from Hunt's speeches, in the hope that the film would catalyze prison reform in Arizona.[52] According to Walsh, Hunt allowed an Arizona State Penitentiary prisoner serving a life sentence to attend the premiere at the Lyric Theatre in New York, unwittingly freeing the inmate, who reportedly escaped after the screening and headed to Canada.[53] Hunt's humanitarianism extended to offering a temporary stay of execution for death row inmates who had appeared in *The Honor System* so they could see themselves on screen before they were hanged.[54] If reform measures came too late for inmates on death row, cinema memorialized the men facing their death, adding a macabre poignancy to André Bazin's notion of cinema as an embalming technology.[55]

The Honor System received mixed reviews, criticized for pushing reform too forcefully and for its unconvincing melodrama.[56] *Exhibitors Trade Review* (*ETR*) criticized the film for being "inadequate as propaganda for prison reform [and] of doubtful dramatic worth," complaining that it had been "*encumbered*" with a "profoundly serious purpose" that failed to sway audiences.[57] For the *ETR* reviewer, the film's reformist arguments relied on brief, sentimental scenes that triggered only immediate and ephemeral interest. Similarly, the film's melodrama irked *Motography* reviewer Charles R. Condon, who criticized the reform scenes as little more than a "sanctimonious procession of sweet kindnesses . . . punctuated at proper moments with illustrations of

how a prison can perform its proper functions and be fit for human beings."[58] Reviewers faulted the dramatic slump following the melodramatic climax two-thirds of the way through the film, although the reviewer in *Wid's* praised Walsh for keeping the film from becoming "objectionably heavy as preachment." The emerging consensus was that while the film rang true in its condemnation of appalling prison conditions, it was somewhat lacking as drama.[59] The *New York Times* review from February 1917 referred to *The Honor System* as part of "the cumulative protest against the inhumanity in prison administration," and "an indictment of the prison system itself . . . not the mere abuse of it," a fair assessment of the medievalism of corporal punishment and prison conditions, although even this reviewer was aware of the inherent risks incurred in using film as a hammer (he noted, it would "probably not suffer much as propaganda because of the hair-raising melodramatics").[60]

With hallmarks of D. W. Griffith's sentimentality—what Condon called "fingerprints of Griffith . . . things that people like to see"—*The Honor System* did not shy away from reconstructing sensational images of prison degradation, such as shots of bread riddled with maggots, a prisoner whipped until he loses consciousness, and a "dark, dank [dungeon] crawling with snakes and rats."[61] But whereas melodrama's structure of feeling works in Griffith's iconic *A Drunkard's Reformation* (1909), a film that depicts the hero's self-recognition in the film's play within a play to wage a war on the saloon, critics seemed to view the use of melodramatic tropes as interfering with the seriousness of the prison reform agenda and at odds with the overall tone of the film.[62]

For the *ETR* reviewer, the contrivance of a miscarriage-of-justice plot set in an "extremely noxious prison," which goes to the "other extreme in showing what prisons should be," simply stretched credulity; put simply, the film was "not distinctive or significant as a propaganda screen."[63] Reviewer Edward Weitzel was more forgiving, arguing that a prison film had to supply "good entertainment regardless of its standing on reform."[64] Even *Motography*'s Condon, who criticized the sentimental prison scenes, concluded that *The Honor System* could effect change: "A state hiding a prison like the one shown here will lose no time in renovating and humanizing it after viewing 'The Honor System,'" opined Condon.[65] Some reviewers praised the film on both fronts, calling it the "most powerful philippic against the prison system under which prisoners are held as wild beasts rather than humans that has

ever been produced . . . [while offering] convincing, graphic and heart-moving drama." At the same time, the reviewer wondered whether a subject like prison reform should ever be turned into entertainment: "If reform propaganda of any variety whatever has a place on the screen, then assuredly this picture deserves first rank."[66] Even members of the American Prison Association invited to a prerelease screening of the film in Boston in November 1916 were divided on the film's realism; "Some asserted that the film accurately portrayed prison conditions; others said that such brutalities had not been practiced in years," stated the *New York Tribune*.[67] *The Honor System* was also shown to an audience that could best vouch for its verisimilitude, prisoners at Sing Sing. Addressing the prison audience after the screening, an MWL member praised it for striking at the "very heart of prison despotism" and throwing the "searchlight of publicity full upon the horrors which made the prison of the old type a living hell."[68]

Based on a story by Robert E. MacAlarney and screenplay by Beulah Dix, *The Prison Without Walls* (E. Mason Hopper, 1917) exposed political corruption in the fictitious Brockway Prison in California, where a group of dishonest prison employees responsible for "frequent escapes, continuous smuggling of dope and constant insubordination" discredited the prison administration and stymied efforts at reform.[69] The film begins with the governor reaching out to an old Harvard friend, Huntington Babbs, to help him identify the "Man Higher Up" within the corrupt conspiracy.[70] Babbs agrees to enter Brockway undercover as burglar Peter Conroy, and befriends safe blower "Horse" Gilligan. When prison reformer and heiress Helen Ainsworth inspects Brockway with her attorney fiancé, Norman Morris—she assists ex-convicts in securing work and has even employed an ex-shoplifter, Felice, as her maid—Babbs leads the tour, and is immediately taken with Helen, as she is with him. Upon his release, Helen hires Babbs to be her secretary and assist with prison welfare work. Unbeknown to Helen, her fiancé, Morris, is a "crook and a libertine" and leader of the prison ring grafters, paid to coordinate the attack on the reformist governor. Morris is also having an affair with Felice, who pilfers prison reform documents from Helen's desk and embezzles money from Helen's bank accounts. Babbs witnesses Morris slipping a roll of bills to the corrupt deputy warden while touring Brockway, and is convinced of Morris's pivotal role in the grafting scam. Morris's plan to assassinate Babbs is foiled, however, and with Felice threatening to reveal their affair, Morris hires Gilligan to crack Helen's safe, instructing Felice to plant explosives in Babbs's room so he is presumed guilty. When Gilligan recognizes Babbs from Brock-

way, he agrees to make good on a promise to repay Babbs after an earlier incident in the prison shoe shop, when Babbs protected Gilligan from a knife-wielding dope fiend, and furnish evidence of Morris's guilt. Helen meanwhile discovers Babbs in front of the cracked safe, assumes his guilt and shoots him in the arm, devastated at his apparent relapse, and orders him to leave the next morning. After learning that Morris plans to incriminate her, Felice produces a pistol from her handbag and shoots him. The film ends with the governor reassuring Helen and Babbs that the "Prison Without Walls" movement has been saved and the two confessing their love to each other.

The oxymoronic yet evocative title *Prison Without Walls* doubles up as the title of a prison reform pamphlet written by the fictitious character John Havens that appears in an inserted close-up in scene six of *The Prison Without Walls* (as well as the title of Katherine Bleecker's 1915 reform film). Helen envisions a day when "the fortress prison, the dark cell, [and] the strait jacket are over," replaced by the governor's dream of a system of prison farm colonies across the state.[71] Her vision takes the form of a long shot of a conventional custodial prison that resembles a fortress dissolving into an image of a convict, "sullen, hopeless, in stripes, [and] behind bars." As the man lifts his head, we detect a glimmer of hope in his face as the dissolve reveals the same man now working in a garden dressed in khakis rather than prison stripes. The vision ends with a cut to a close-up of Helen, "sad and discouraged," shaking her head before the dialogue intertitle "The prison grafters are beating us through their hold on the wardens." The vision is somewhat reminiscent of Griffith's *A Corner in Wheat* (1909), an antimonopolist parable that juxtaposes the bourgeois life of the corrupt "wheat king" with the plight of the rural and urban poor who can no longer afford to buy bread. The convicts indentured on the prison farm in Helen's vision are linked to the agricultural poor in *A Corner in Wheat* through their victimhood and disenfranchisement, but unlike the prisoners, the rural farmers are not even offered a vision of a better life.

Helen's vision economically strips the complexity of prison reform down to three simple images of a prisoner transformed by the farm colony. Her female subjectivity triggers the vision, implying that the pathos necessary to imagine better conditions for the incarcerated is gendered, or at least given expression through a female imaginary. Many female prison reformers were active in the suffrage movement, and their interest in prison conditions was often sparked by their own incarceration for suffrage activism, when they were frequently exposed to atrocious prison conditions and formed bonds with other

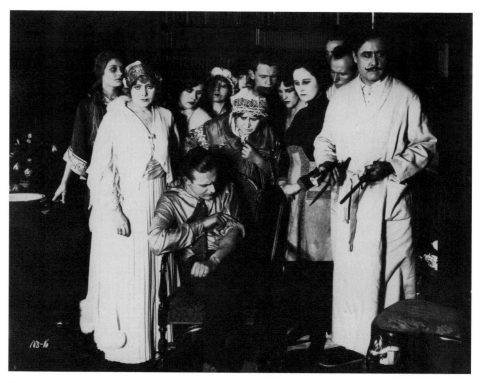

Fig. 6.7 Production still from *The Prison Without Walls* (E. Mason Hopper, 1917) showing upper-class socialites gathered around Huntington Babbs. Paramount collection, courtesy MHL

inmates.[72] Lois Weber's *The People vs. John Doe* (1916) was a powerful polemic against capital punishment, highlighting one of the major causes of the Progressive era; as Shelley Stamp argues, "More than any of Weber's Universal social-problem films, *The People vs. John Doe* features an active female protagonist leading the charge for social justice."[73] The milieu of the wealthy prison reformer can be glimpsed in surviving production stills from *The Prison Without Walls*, including this image of Helen and her society friends gathered around Babbs (whom they think has tried to rob the safe) in the manor house library (fig. 6.7).

Carcerality in *The Prison Without Walls* is signified through conventional prison iconography, including the shadows of two vertical bars descending from the top of the frame onto Babbs's left shoulder as he witnesses the liaison between Morris and the corrupt deputy warden in Brockway Prison. The monochrome inmate uniform worn by Babbs was chosen to suggest progress

at the Brockway institution, a visual cue explained in the shooting script: "Perhaps well here to show the men in a prison uniform other than the stripes, as if that were one of the reforms that Jackson had introduced." A production still from Helen's tour of Brockway shows Morris, Helen, and Babbs in front of a dark prison cell (fig. 6.8); Helen stares mournfully into the black nothingness of carceral space, her face brightly lit from the side. The effects of harsh prison conditions are metonymically read from Helen's facial expression, while Morris's partially obscured face and Babb's averted gaze suggest their respective traits of criminality and righteousness. Her visual prominence in the tableau implies that women are more powerfully moved by prison conditions. Reform as political action is triggered by reform as *reaction* to prison conditions in this image. The image also reminds us of prison's porosity, the fact that carcerality has always been visible for those with money or power to see it.

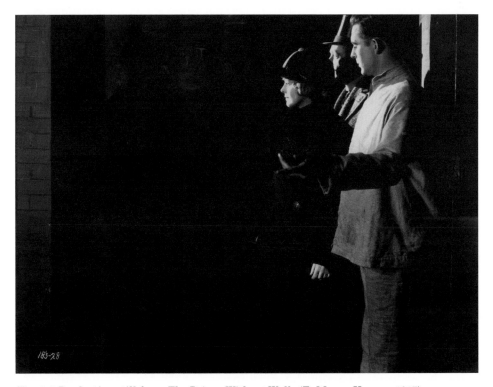

Fig. 6.8 Production still from *The Prison Without Walls* (E. Mason Hopper, 1917) showing Morris, Helen, and Babbs staring into prison darkness. Paramount collection, courtesy MHL

The Right Way: Prison Rehabilitation Through the Honor System

> The whole thing, aside from its sociological purpose, makes an extremely gripping story.
> *Variety*, 1921[74]

> There are many big, throbbing, pathetic moments in the film.
> *Billboard*, 1921[75]

The harsh prison conditions Osborne encountered when he went undercover at Auburn Prison in 1913 are re-created in *The Right Way*, a 1921 film that made every plot twist, character, and visual motif work on behalf of prison reform.[76] Organized around a tale of two boys who end up on the wrong side of the law, one a victim of a deprived home, the other rich but unable to resist a career of forgery, the film begins with the poor boy being sent to a reformatory for a minor offense. Thrust into a corrupt penal system, upon his release he sinks deeper into a criminal life and is later sentenced to a state prison characterized by the lockstep, striped uniforms, silent system, contract labor, and torture. By the time the rich boy is sentenced for forging his father's check later in the film, conditions have improved at the same prison, thanks to the changes implemented by a visionary warden (modeled on Osborne) and the efforts of the Mutual Welfare League.[77] *The Right Way* reaches a climax when a friend of the poor kid, a young man referred to as the Smiler, is wrongly convicted of murdering a stool pigeon and receives the death penalty (fig. 6.9). Although trusted members of the MWL, the rich boy and poor boy escape in order to prove the Smiler's innocence, but return to the prison too late to save him from the electric chair. The sympathetic warden paroles the two boys for their efforts, and they leave prison to join their respective sweethearts.

The Right Way cost an estimated $100,000 to make, and was shot (with a 10:1 shooting ratio) on location at Auburn, Sing Sing, and the U.S. naval prison in Portsmouth, New Hampshire, institutions with which Osborne had close ties. Osborne downplayed the ninety-minute film's reformist goals; it is "not a propaganda picture," he insisted, arguing that the "prison scenes enter the picture as part of the story instead of the story being built right into prison life."[78] Part of the film's profits were donated to Sing Sing's MWL, whose members enjoyed a private screening at the prison and were

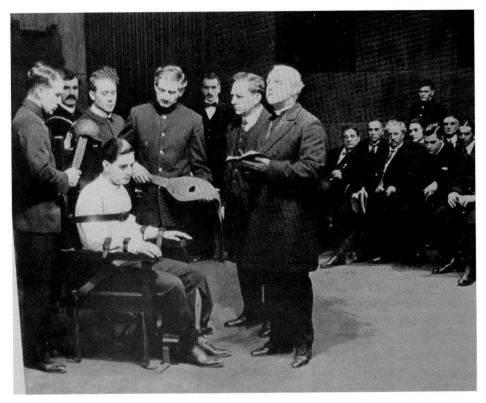

Fig. 6.9 Production still from *The Right Way* (Sidney Olcott, 1921) showing innocent boy about to be electrocuted.

offered an opportunity to give feedback ("the men just went wild over it," said Osborne).[79] Praised for its realism, "heart appeal," and "new and revealing" manner, *The Right Way* criticized capital punishment, pointed "a finger at [backward] prison methods," all while depicting some "unusual prison scenes" as a result of the location shooting.[80] Though a fictional narrative, *The Right Way* employed a documentary sensibility that traded on heightened verisimilitude, with critics describing the scenes "built up from a lot of prison events," a plot taken from "real facts, that happened, and unfortunately continue to happen," and "many of the actors [actual] prisoners."[81] The film's prologue depicts Osborne and director Sidney Olcott on the grounds of the naval prison, and two thousand prisoners were filmed outside the confines of the naval prison with no guards in sight, offering compelling evidence of the honor system at work. The principal actors in *The Right Way* had close contact with the naval convicts, attending their

theatrical shows and baseball games and sharing cigarettes; the prisoners were "tickled to death to get a chance to act" and were among a group of extras totaling about two thousand.[82]

Completed in 1919 or early 1920, the film was produced and released by the Producers Securities Exchange and advertised under various titles.[83] The film went under the title *Making Good* for a premiere at the Wieting Opera House in Syracuse, while the title *The Right Way* appeared in an advertisement (fig. 6.10) in the *Syracuse Herald* that promised "Penitentiaries Exposed," "Dope distributed among the prisoners," "The flogging of a prisoner," and "Prisoner chained to floor for 24 hours."[84]

The Right Way's exhibition pattern was a throwback to the illustrated travel lecture, popularized by Burton Holmes, Lyman Howe, and Frederick Monson. In a publicity flyer for the Allen Theatre in New York City, the "Hon. Thomas Mott Osborne" is listed as appearing at both matinee and evening screenings to discuss "his experiences as warden of Sing Sing and Auburn prisons, as well as relate some of the happenings that befell him while a prisoner in Auburn

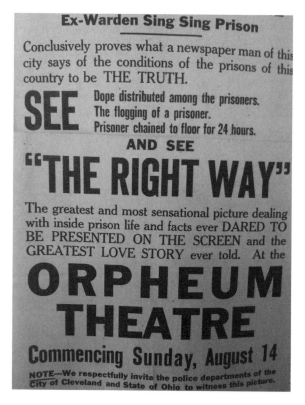

Fig. 6.10 Poster advertising *The Right Way* (Sidney Olcott, 1921) at the Orpheum Theatre, Syracuse, New York. OFP

prison."[85] Osborne conjured up some novel publicity stunts for *The Right Way*, including giveaway pocket puzzles that announced, "There is a right way and wrong way to work this puzzle. . . . Come to the [blank] Theatre the week of [blank] and see *The Right Way*. Mr. Osborne will show you how."[86] Another promotional stunt involved an aviator flying over a town or city and dropping balloons with cards announcing, "This balloon knew *The Right Way* to earth and to you," along with information about theater and show times.[87]

Anticipating the negative reaction of anticoddlers, film reviewers sympathetic to penal reform defended *The Right Way* from attacks: "The picture carried no idea that the prisoner should be pampered, only that he should receive humane treatment and be taught that when he goes out in the free world he still can be a man among men and win the respect of his fellow citizens," was typical of many reviewers' responses.[88] Other critics were more blunt, calling *The Right Way* "a kind of propaganda for the Osborne method," although the qualifier "kind" suggests the reform film's generic indeterminacy, its admixture of documentary realism and acted sequences that led the same reviewer to remark that "except for a few titles arguing for the appearance of Osborne in the picture, it might well be a 'crook play.'"[89] For this reviewer *The Right Way* exhibited many of the same generic conventions as the crime film, although *Billboard's* Marion Russell disagreed, arguing that the film "smashes all tradition in point of theme, originality, and remarkable photography."[90] *Moving Picture World* described the film as a "picture with a purpose, the purpose being to stimulate prison reform." Indeed, for some reviewers, the "showing up" of the old prison methods inevitably led to "overstressing . . . of the points Mr. Osborne wishes to bring out," including the dramatic images of a prisoner "suffering the terrific torture of thirst" as he is forced to survive on one gill of water a day, and the scene when an innocent man is electrocuted.[91]

Parsing the reformist agenda of *The Right Way*, one could argue it differs from the "crook play" in three ways: Osborne's star power as the inveterate celebrity reformer; the mix of commercial, private, and prison screenings;[92] and its status as what one critic called a "screen echo" of the reformist movement. Osborne's reputation legitimized *The Right Way*, bestowing on the film "added strength as a box office attraction," according to *Moving Picture World* critic Arthur James. The film's entertainment value meant that "no matter which side the spectator may take in his views of prison reform," it generated "sympathy for the oppressed and to the common sense of society."[93] A reviewer

for *Motion Picture News* saw the film's fictional frame as something of a Trojan horse, suggesting that the film carried just enough fiction to give it "dramatic dressing." The spirit of optimism felt by the prison community in response to the replacement of the brutal warden with a more humanitarian regime would be "caught" by the spectator, and the electrocution of an innocent inmate in the film's climax might trigger a broader moral reconsideration of the treatment of social outcasts.[94]

The film supplemented and, in some respects, replaced the prison reform pamphlet mailed to supporters' homes and distributed at conferences, world fairs, and exhibitions. Headlines lauded the film's social utility; "'The Right Way' Will Keep You Out of Jail," a reviewer opined in the *Chicago Herald,* claiming that the film delivered "a warning that will not go altogether unheard."[95] The film's opening in Syracuse "created a great deal of interest" by virtue of Auburn Prison's proximity and a voyeuristic curiosity to peek inside one of New York State's oldest prisons (even if the bulk of the film's prison footage was shot at Sing Sing). Osborne's deep ties to Auburn must have made his appearance at the screening something of a homecoming celebration.

Osborne leveraged the maximum emotional effect from reconstructing the prison environment from the pre- and postreform eras. Reform was signaled in the prisoners' bodies, including through the juxtaposition of the striped uniform, abandoned in New York State in 1901, with the later monochrome uniform. A publicity still from the rock pile scene at Portsmouth Naval Prison (fig. 6.11) appeared on the front page of the *Syracuse Herald,* depicting approximately a hundred men in prison stripes huddled together like wasps in a nest, overseen by about fifteen guards (the striped uniforms had to be specially obtained for the shoot).[96] When combined with the architectonics of carcerality, the striped uniform operationalized a discourse of reform, apparent in a *Billboard* reviewer reference to "amazingly vivid photography" showing "the narrow tiers of the prison with the barred cells and the long almost endless line of zebra-garbed outcasts marching grimly through the corridor." Fast-forward to a new era of improved conditions and the same men are dressed in dapper civilian shirts and bowties (fig. 6.12), "free from the disfiguring stripe . . . feeling no longer down trodden, with spirit crushed, but men who were paying their price to the State in a manly way."[97] The men have revoked, if not entirely shed, their carceral identities, and, given their uniforms, they now more closely resemble military recruits.

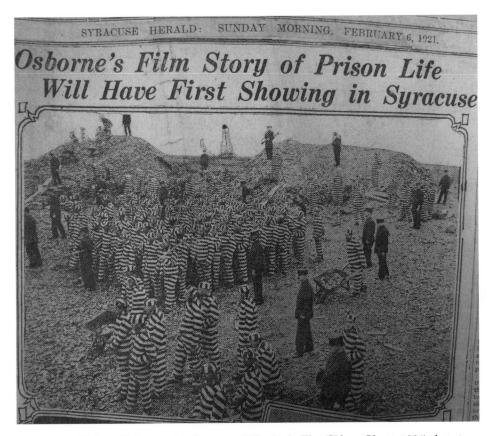

Fig. 6.11 Publicity still from rock pile scene of *The Right Way* (Sidney Olcott, 1921) shot at Portsmouth Naval Prison. *Syracuse Herald*, February 6, 1921

Publicity stills help us reconstruct several of the film's scenes, including the frequently mentioned whipping scene (fig. 6.13). In one still, the striped uniform, chains, lattice prison door, punitive guard, and homoeroticism distill prison's brutalizing effects upon the body. The guard's fingers on the prisoner's arm trigger a myriad of possible counterreadings including compassion, homoeroticism, and sadomasochism. If begging for mercy seldom halted corporal punishment, asking for salvation in the presence of a priest redeemed prisoners in the eyes of prison authorities, reformers, and society. A publicity still from *The Right Way* of the Smiler, the man falsely accused of murder, standing next to a priest holding a Bible behind the barred door of his cell (fig. 6.14) codes the cell as a penitent space where Christian rituals can be enacted and the sordid work of capital punishment sanitized through

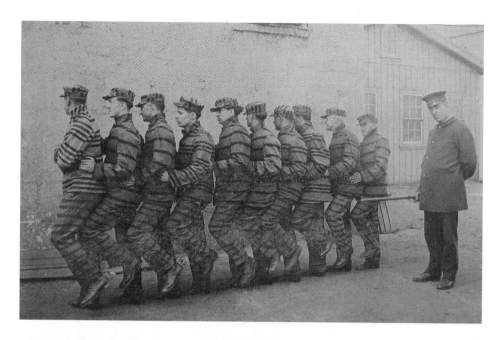

Fig. 6.12 "The Old System and the New": Men dressed in striped uniforms averting their gaze versus looking at the camera wearing civilian clothes under Osborne's reformist regime, production stills from *The Right Way* (Sidney Olcott, 1921).

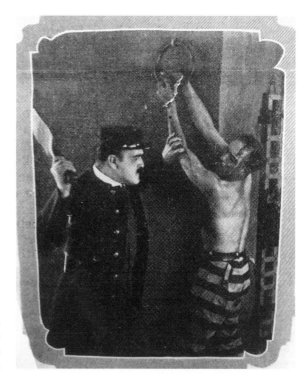

Fig. 6.13 Whipping scene from *The Right Way* (Sidney Olcott, 1921) showing carcerality's iconic trademarks.

Fig. 6.14 Publicity still showing the Smiler, falsely accused of murder, standing next to a priest in his cell, *The Right Way* (Sidney Olcott, 1921).

discourses of forgiveness, regret, and acceptance. The vertical bars slicing the condemned man's body, light shining onto his face and torso, and his upward gaze are the prison equivalent of the Christian Pietà, a tableau that needs no captioning. Scenes such as these exposed "the brutality of the present system of reform," and such was the realism of the torture that one critic reminded his readers that "the guards whose pictures were recognized . . . were not those who had taken part in the old days of stern discipline, but [guards who] volunteered to reenact the cruel scenes on a volunteer candidate."[98]

The Right Way joined a national conversation about juvenile delinquency that progressive wardens such as Lewis E. Lawes took up with gusto. Warden of Sing Sing from 1920 to 1941, Lawes was active in the Boys' Club, formed in 1860 in Hartford, Connecticut, and renamed the Boys' Club of America in 1931. The organization used character building and vocational training to mitigate the effects of urban disaffection and boredom, and with the slogan "American Youth to Save America," the club railed against the street corner and vice.[99] Lawes could have been describing the plot of *The Right Way* when he delivered a radio address in 1928 about the power of cinema, what he called one of the "greatest agencies in directing thoughts and feelings," and discussed the role environment played in shaping behavior: "[Facing] a lack of spacious playgrounds, children of the city streets take to petty gambling with dice, cards et cetera instead of socially useful games, leading them to petty thievery and sometimes, finally to the electric chair."[100]

Recuperating Cinema: The Debate Around Juvenile Delinquency

The tension between the conceptions of cinema as an agent of social reform and as a source of regulatory anxiety is inscribed in this example of cinema's contradictory place in the popular imaginary in the early 1930s.[101] In February 1931, the *New York Times* ran two articles about cinema and youth in New Jersey: The first, "Mothers May Check Children at Movies Under Shopping Plan," described the transformation of a cinema in Pompton Lakes, New Jersey, into a free daycare facility. The second, "Engelwood Club Scores Crime Films," reported efforts to tighten censorship and enact a ban on children attending movies unaccompanied by adults, the opposite of what was happening twenty miles away in Pompton Lakes (Lawes had clipped both of these

articles and pasted them into his voluminous scrapbooks).[102] The year 1930 saw the studios' introduction of the morally sanctioning Hays Code, and the culmination of a decade of concern about the insalubriousness of Hollywood. The Hays Code sanctioned prison and civic reform films, at the expense of gangster films that were seen to glorify violence; moral commentators spun a version of the hypodermic theory of media effects (strong, immediate, and direct), and journalists were only too happy to offer stories of young boys acting upon criminal impulses triggered by the viewing of a crime film.[103] For example, Judge William H. Smothers of the Atlantic City Juvenile Court called for federal censorship of motion pictures, citing a boardwalk robbery in the immediate wake of a gangster film as evidence of cinema's pernicious effects.[104]

Of course, concerns about the impact of motion pictures on young boys began much earlier, with a flurry of press coverage around 1909. With headlines such as "Higher Education the Need" (1910) about a fourteen-year-old Manhattan boy who claimed he was inspired by a fictional highwayman to commit robbery, and "Film Pictures Stir British Boys to Crime" (1912), "cheap melodramatic stories and juvenile crime" were causally linked, with a constant stream of stories about boys being moved to imitate crimes, often committed by cowboys or gentlemen burglars, filling the pages of daily newspapers of large urban areas.[105] The *Moving Picture World* fought back with "How the Picture Causes Juvenile Delinquency" in 1911, arguing that moving pictures were neither increasing delinquency nor causing crime but "revealing social conditions and call[ing] loudly for the situation to be handled wisely and well."[106] Campaigners for strict censorship of motion pictures included Kate Davis of Wilkes-Barre, Pennsylvania, president of the National Legal Regulation, who contended that if the motivation for crimes committed by juveniles could be traced to cinema, this would provide proof that unregulated motion pictures could be a "most efficient training school for criminals." Young girls were also caught under the spell of motion pictures, one gang of eight- to twelve-year-olds from Denver purportedly telling a judge that "when they did not know how to commit a crime, then went to the 'movies' and studied the films until they got the idea."[107]

The culture of the male prison as represented in early twentieth-century films paralleled many depictions of the all-male workplace, from which boy culture drew inspiration and role models. Discourses of "wildness" in both the moral panic around juvenile delinquency and descriptions of explosive prison

violence frequently compared boys to racialized others, or even a race unto themselves (Charles Dudley in *Being a Boy* referred to "the race of boys").[108] Boy culture valued competition, mastery, games, and social skills, and even though self-control and submissiveness to leadership figures and the group grew in importance, the cultures of the male workplace and the penitentiary reveal a strong correspondence. Social organizations assisted in the project of social control. In addition to the Boy Scouts, other groups such as the Sons of Daniel Boone, Woodcraft League of America,[109] and the YMCA channeled boyhood and young men's excesses into socially sanctioned activities, with the YMCA playing a pivotal role as a buffer against a city's vices for new immigrants,[110] recognizing the educational potential of motion pictures as early as 1910. The YMCA organized motion picture screenings to inculcate religious and civic principles, what Ronald Walter Greene calls a form of "pastoral exhibition."[111] These screenings followed a tradition dating to the late nineteenth century of using visual media, such as magic lantern shows, to attract city youth, who also took advantage of the organization's free meals.[112] Political support for the ameliorative effects of the boys' clubs, scouts, and YMCA continued well into the 1930s, with a report from the *American Police Review* at the end of the decade rallying community groups to keep "normal boys normal."[113]

The Legacy of the Reform Movement

The late 1910s elevated the prison reform film to a prominent place within popular culture. And though the 1920s prison movie (a generic offshoot of the gangster genre) continued to draw attention to barbaric prison conditions, the reform message of these commercial films coalesced around a cluster of tropes, including the stereotyping of prison guards as "brutal and corrupt thugs," the plight of the wrongly accused, and prison space as a dirty, rat-infested living hell. *Boston Blackie*, released in 1923, opened with a particularly gruesome sequence of inmates being tortured by the "water cross," and while its prison reform politics were unambiguous, the entertainment value was deemed only "fair" by the *Chicago Daily Tribune*.[114] One film that eschewed the wrongly accused prisoner convention is George W. Hill's *The Big House* (MGM, 1930), starring Chester Morris, Wallace Beery, and Lewis Stone, and described by the *New York News* as a "stark, mad film [that] depicted with forceful morbidity, the horrors that lurk within the four walls."[115] A mammoth prison set was constructed in Culver City, California, complete

with cell block, prison yard, mess hall, chapel, and warden's office; the art director failed to obtain either authentic locks for the cells or uniforms, since state rulings forbade the sale of these objects even for artistic projects.[116]

Reviewers were struck by the film's unsentimentality, one calling it a "magnificently savage picture of life behind bars," another referring to the "unrelenting hardship of prison life" captured powerfully through the overcrowding of cells, rotten food, and brutality of solitary confinement, and yet another commending the "high realism to many of the penitentiary scenes."[117] The attention to authentic carceral detail in *The Big House* was most likely a result of screenwriter Frances Marion's site visit to San Quentin, a suggestion Irving Thalberg made to her "before you polish the final script." Gaining permission to tour the facility from Warden James Holohan, Marion was viewed as an "object of repressed ridicule" (her words) by both inmates and guards, although she was given access to all areas of the prison, including death row, and when she met with trusties she recalled training her ear so it could become "attuned to their vernacular."[118]

In the opening sequence of the film, we are interpellated into the role of new intake as we follow Kent Marlowe being processed into a prison designed for 1,800 inmates but overflowing with 3,000 men (fig. 6.15).[119] Sharing a cell with "Machine Gun" Butch and Morgan (fig. 6.16), the more sympathetic of the two, Kent gets embroiled in a planned prison breakout, and his cellmate Morgan falls in love with a photograph of Kent's sister Anne. However, in exchange for a promise of freedom, Kent informs the warden of the pending jailbreak and during the ensuing riot, the warden, Kent, and Butch are all killed, leaving Morgan pardoned and free to marry his sweetheart.

The Big House sent shockwaves through prison administrators at the time and was banned from most penitentiaries in fear of copycat uprisings (there was a major riot at Auburn Prison in 1928 and in several Midwestern prisons prior to the film's release). And while one female reviewer predicted the film would be a huge success with men, she feared that female film fans might find *The Big House* a bit "too frigid."[120] Vetting the film, Lawes found it "raw but not likely to incite violence," and attended the opening at the Astor Theater in New York.[121] Warner Bros. convinced Lawes not just to endorse *The Big House* but also to smooth the film's passage with the censor by writing a telegram of support in which he touted the film's ability to "impress upon youthful minds that prison is a fine place to keep out of."[122] Some reformers felt that the film's gritty realism and lack of sentimentality might serve as a

Fig. 6.15 Frame enlargement of reconstructed cell block set from *The Big House* (George W. Hill, 1930) showing Kent Marlowe being led to his cell assignment.

Fig. 6.16 Frame enlargement from *The Big House* (George W. Hill, 1930) showing Marlowe entering the overcrowded cell.

soft deterrent, nipping criminal proclivities in the bud, although by 1930, the horrors of prison were such a constant that young male viewers were seen to be immune to the effects.[123]

The reform agendas of *The Honor System* and *The Right Way* seem quaint and naïve compared to *The Big House*, where the inmates are guilty of the crimes they have committed and prisoner discontent leaves few untouched. Hill used an affective soundscape to re-create the claustrophobia of Butch's entry into solitary confinement—over a shot of a deserted corridor we hear men's voices call out to one another, cry, and curse—and the gray monotony and overcrowding of carceral space are re-created via the flat lighting and cramped mise-en-scène.[124] If *The Honor System* and *The Right Way* leveraged excitement about cinema's power as a "new social force," what *Moving Picture World* as early as 1908 called "an instrument whose power can only be realized when social workers [or, in this case, prison reformers] begin to use it," *The Big House* was no less committed to revealing the human scab of suffering that is the penitentiary.[125] *The Big House* delivered a searing indictment of the prison system without offering solutions; in the absence of sympathetic, wronged individuals, carcerality itself comes under attack. A 1937 study guide for use with educational screenings of *The Big House* showed how handily the film could generate discussion around reform: "Do prisons as a rule succeed in reforming criminals?" led inevitably to the broader sociological question about whether, in the fight against crime, the government should increase spending on law enforcement, prisoner rehabilitation, or social security benefits.[126]

Reform was about effecting change at both the macrolevel of penal policy and the microlevel of individual stories of rehabilitation, a balance that reform films of the late 1910s struggled to maintain. Moreover, the extent to which motion pictures in the hands of reformers actually accomplished much with regard to prison policy is debatable; according to Rebecca M. McLennan, between 1896 and 1919, prisons were as much reformed by "convicts, guards, wardens, labor organizers, manufacturers, workingmen, and political leaders as by these so-called reformers."[127] The Joliet letter-writing scandal with which I opened this chapter illustrates more than the phenomenon of jail mail pen pals, which continues to this day as an anachronistic reminder of the materiality of prison life, where in the absence of Internet access and social media, the letter as object from the outside world takes on added significance. It speaks to the ever-fraught nature of incarceration in the cultural imaginary,

the way in which prison, like other total institutions, strips what Erving Goffman calls an inmate's "presenting culture" ("a way of life and a round of activities taken for granted"), triggering the mortification of self and a series of "abasements, degradations, [and] humiliations."[128] Reformers and directors were striving to make prison less a total institution than a transparent, more porous place, bringing cameras behind prison walls, recommending alternatives to the custodial mode, such as the farm prison, and riding a wave of modern Enlightenment-era public concerns about the rights of the politically disenfranchised. Beyond lobbying for the abolition of brutal punishment and implementing an honor system, some progressives compared reform to an "atmosphere" that should vitalize an entire administration and pervade the institution. Writing about the Massachusetts Reformatory at the turn of the last century, progressive Joseph F. Scott argued that "the moment a prisoner comes in to the prison he should be compelled to breathe the atmosphere; it should be impossible for him to get away from it anywhere, or at any time, while he remains a prisoner; in his cell, in his school, or at his work, he should be as nearly as possible shut up to it."[129]

Cinema was an imperfect moral agent, but a powerful cultural force nevertheless, and prison reform films were conscripted as a "screen echo of the recent agitation on prison reform."[130] As an art form with mass appeal, cinema was plastic enough to be molded to the needs of prison exhibits and reformers trying their hand as screenwriters or directors. Whether these films exacted policy changes or simply kept the conversation going about the desperate need for systemic change is less important than the convergence of penal discourse and popular entertainment. This alignment marshaled a kind of "cognitive cognition" where cinema and prison reform could be mutually informing (prison stories sold movie tickets, after all) through collaboration (the industry required access to prisons for location shooting or ethnographic detail).[131] But even though cinema functioned as a mobilizing agent for the prison reform movement, the moral conservatism of its increasingly institutionalized mode of representation rendered pathos the only tangible emotional response to draconian prison conditions and a racist criminal justice system.

Conclusion

THE PRISON MUSEUM AND
MEDIA USE IN THE
CONTEMPORARY PRISON

Imprisonment has long been analogized as a living death, connecting it to the Phantasmagoria in unexpected ways. The peaked caps with two holes for the eyes worn by inmates at Pentonville Prison in the nineteenth century (designed to prevent recognition between or interaction with fellow inmates) gave prisoners what social reformers and journalists Henry Mayhew and John Binny described as a "*half-spectral* look," the eyes resembling "phosphoric lights shining through the sockets of a skull . . . [giv]ing one the notion of a *spirit* peeping out behind it."[1] Incarceration as living death is a leitmotif in historical accounts of incarceration: "It was as if one were in a vast grave-yard, the silence is so oppressive" was how one Auburn inmate described sitting down to eat in the mess hall in 1915, and at a Thanksgiving dinner no less.[2] Prison's transmogrification of its inhabitants evokes Maxim Gorky's well-known reaction to seeing the Lumière brothers' moving picture demonstration in Paris, when he analogized the experience of watching ghostly figures on the screen to being in the "kingdom of the dead."[3]

Carceral Fantasies has approached the question of modern media's relationship to prisons through an expansive optic that encompasses how cinema represented prisons on public screens and how film screens found their way into prisons. The surreal meeting point of these trajectories, the overlapping center of a Venn diagram, is the experience prisoners have of watching themselves on screen, as many of them did, especially at Sing Sing Prison, where location shooting and the use of prisoners as extras might provoke a jolt of self-recognition, as in the premiere of *Alias Jimmy Valentine* (Maurice Tourneur, 1915) at Sing Sing. The public's perennial fascination with prisons defies full explanation, although this book has explored media's

entry into penal institutions as one vantage point from which to make sense of this phenomenon.

More than any other visual media, motion pictures helped construct an enduring carceral imaginary, pitting the penitent inmate against the free subject outside the prison's gates. Whether presented as a "wretched creature who needs the healing embrace of a benevolent authority" or as a threat to be feared and locked away, inmate protagonists of the classical Hollywood cinema nevertheless most frequently rehearsed the narrative of redemption through penitence, a trope increasingly marginalized under the current "tough on crime" ideology and resulting prison-industrial complex described by civil rights activist Angela Y. Davis.[4] We learn about prison from popular culture with first-time convicts freely admitting that their perceptions of what to expect when entering prison has been predominantly shaped by what they have seen on television and in movies.[5] "We do not respond to the televised situation as we would to a real situation, but we respond to the *concept* of the real situation," argues Joshua Meyrowitz, an obvious yet salient point for this investigation.[6]

Prisons today also provide their own source of images, through surveillance cameras that add an interesting layer to Foucault's panoptic visuality. The cell block cameras put the guards *and* inmates under the watch of surveillance and can document abuses—if turned over to investigating authorities—in ways similar to the cellphone videos of police brutality against unarmed black people. But even surveillance videos cannot capture the horror that goes on inside some prisons, as Missouri Penitentiary inmate Louis Watkins reported following a cell block raid in 1996: "I've never seen anything like that in the movies," he told the Associated Press, proof that Hollywood exists as a fantastical yardstick by which to measure actual prison conditions.[7] I want to conclude by briefly analyzing two sites where popular culture encounters incarceration: the prison museum and the contemporary use of media in Sing Sing Prison. What has changed and what has remained the same in the hundred years separating film's first appearance and the writing of this book?

Prison Museums: Carceral History Turned Commodity

I have visited several prison museums over the course of researching this book, including the Alcatraz Federal Penitentiary in San Francisco (1934–1963) and Eastern State Penitentiary in Philadelphia (1829–1971), and, in

England, Dartmoor Prison (1809–) and Bodmin Jail (1779–1927).[8] The spectator's immersion in the authentic physical spaces of incarceration separates the prison museum from the purpose-built exhibition space, and, with the exception of the Dartmoor museum, which is housed in a former milking parlor adjacent to the still-operating prison, each museum features empty cells and cells that have been staged to represent a prisoner's habitation at a specific historical moment, the penal equivalent of a museum period room sans the resignification.

The retail store is an important part of the museum experience, and the prison museum is no exception, although at Alcatraz, exiting via the gift shop (fig. C.1) is impossible (visitors on the island may instead purchase items from a string of vending carts), since the museum's main retail store is located at Fisherman's Wharf, the Disneyfied tourist mecca at the other end of the ferry ride that attracts thousands wishing to dine, shop, and see the famous seals lolling in the harbor. With a façade that echoes the white structure and water tower of the actual prison, the shop is a benign double of it, assuring visitors

Fig. C.1 Alcatraz gift shop exterior, Fisherman's Wharf, San Francisco. Author collection

Fig. C.2 Alcatraz gift shop's prison-themed inventory, Fisherman's Wharf, San Francisco. Author collection

that they don't have to travel to Alcatraz Island to pick up some prison-themed merchandise. On the left as you enter is a life-size mannequin of one of Alcatraz's most famous inmates, Al Capone, dressed in a black pinstriped suit, red-and-gray patterned tie, and gray fedora. While his clothing is not for sale, the black-and-white striped sweatpants, T-shirt, and hoodie on the mannequin immediately next to him are (fig. C.2), along with fanny packs, baby onesies, headbands, socks, and no end of other prison-themed merchandise. Capone's mannequin embodies the look of the 1930s mafia boss, impeccably dressed but shifty-looking; the mannequin, with chiseled Aryan features, selling the contemporary prison garb looks more like an Austrian fashionista than a typical American convict, a reminder of the cultural influence prison uniforms have had on fashion, most significantly the dropped-waist "sagging" look, which derives from the no-belt policy of penitentiaries.[9]

Fig. C.3 Alcatraz prison uniform distribution center, Fisherman's Wharf, San Francisco. Author collection

The most evocative image in the gift shop, however, is the row upon row of stacked striped shirts, a disquieting reversal of the punitive logic of the inmate processing center where ill-fitting, previously owned, and frequently stained uniforms are distributed to the new intake. In contrast to the contemporary prison shop display, the actual uniform distribution center at Alcatraz looked more like the depleted stock of a retail store after a big sale (fig. C.3).

Retailing's commercial imperative parodies the prison-industrial economy at Alcatraz's store, since anyone can buy a piece of prison memorabilia in an exchange that turns Alcatraz into a clichéd emblem of incarceration in the form of a purchasable, displayable sign at the consumer's whim. As a manifestation of commercial culture, the Alcatraz museum is no different from prison-themed movies or reality shows: in both, prison's realities are transmuted to commercial ends. This encounter with incarceration's consumerist doppelganger is in stark contrast to the dilapidated state and eerie stillness of the abandoned prison, whose brick walls, mottled with green fungus, rusted metal, and peeling paint, are shaped by a different informing narrative.

Putting the gift shop on the mainland not only boosts profits but buffers visitors from the sensory dislocation of *feeling* Alcatraz's history versus *buying* a piece of prison kitsch. Alcatraz prison as cultural signifier encompasses thirty-two films set in the institution between 1937 and 2002, including *Alcatraz Island* (William C. McGann, 1937); *Birdman of Alcatraz* (John Frankenheimer, 1962), featuring amateur inmate-ornithologist Robert Stroud; the irresistibly titled *Escape from Alcatraz* (Don Siegel, 1979); and the more recent *The Rock* (Michael Bay, 1996), *Half Past Dead* (Don Michael Paul, 2002), and *Half Past Dead 2* (Art Comacho, 2007).[10]

Dartmoor Prison (fig. C.4) adopts a different approach to commodifying the prison experience, offering books on the prison's history, postcards of the original buildings and surrounding landscape, and, most memorably, an assortment of garden ornaments painted by Dartmoor's inmates (fig. C.5). Like the rows of striped T-shirts at Alcatraz, the owls, foxes, snarling black dogs, and see-, hear-, and speak-no-evil squirrels trigger a surfeit of meaning and a measure of aura (the peeling paint and dank surroundings where the objects are displayed also add to the pathos): they bear traces of their makers' bodies and hands, and the simple knowledge that they were painted by men sent to prison for all manner of crimes imbues them with a grotesque fetish value, an indexical trace of carcerality itself. The garden ornaments, for me at least, were more powerful as artifacts of imprisonment than many of the more predictable prison objects on display in the museum; actual prisoners' hands had worked on these already-disquieting garden objects, prisoners that may now have been released, died since the objects were made, or are serving very long sentences.

Fig. C.4 Exterior of Dartmoor Prison, UK. Author collection

Fig. C.5 Painted garden ornaments for sale in Dartmoor Prison, UK, gift shop. Author collection

A similar incongruity can be found in the unlikely iconography of the photographic backdrops in prisoner waiting rooms, a subject Alyse Emdur powerfully explores in her 2013 book *Prison Landscapes*. Many prison interview rooms allow inmates to take photographs alone or with family members against a number of themed backdrops, some of them painted by inmates (cultural theorist Nicole Fleetwood argues that the photograph is as much an opportunity for physical contact permitted in the act of posing as it is about the image).[11] In the introduction to an interview with Emdur on Venue .com, we are told that the subject matter ranges from "picturesque waterfalls to urban streetscapes and from ski resorts to medieval castles," and that the large-format paintings serve twin functions: "For the authorities, they help restrict photography of sensitive prison facilities; for the prisoners and their families, they are an escapist fiction, constructing an alternate reality for later display on fridge doors and mantelpieces."[12]

Prison museums appropriate the hyperillusionism and in situ aesthetics of the museum period room and life group diorama to narrate and sensorially

Fig. C.6 Al Capone's cell, Eastern State Penitentiary, Philadelphia. Author collection

evoke incarceration's history, like Eastern State Penitentiary's reconstruction of Al Capone's former large, corner cell, including the original furniture and rugs (fig. C.6). Alcatraz offers various versions of the period room approach, with some cells bare and others housing artifacts such as board games for solo play, headphone jacks for radio listening, books, personal hygiene items, and a few items of clothing.

Bodmin Jail (fig. C.7), advertising itself as an "all weather, family attraction," is the most adventurous in transforming cells into theatrical tableaux.[13] Within several cells inmates' crimes are reconstructed, imaginatively transporting the visitor out of the cell to the scene of the crime. Mannequins, props, and captions describe the crime and punishment of the individuals (almost all were hanged), such as Elizabeth Commins (fig. C.8), age twenty-two, who, impregnated by a servant, delivered her baby in a cowshed and killed it by striking its head against the wall. Natural light and green- and red-filtered artificial light spectacularize the grisly crime scene, although the relatively low-tech mannequins, made by one of the employees at Bodmin,

Fig. C.7 Exterior of Bodmin
Jail, UK. Author collection

Fig. C.8 Cell reconstructing
inmate Elizabeth Commins's
crime, Bodmin Jail, UK.
Author collection

share a closer affinity with the funfair ghost ride than the hypermimeticism of Madame Tussaud's waxworks.

Bodmin Jail also creates vivid tableaux of prison punishments, including flogging, and visitors in search of the uncanny can pay seventy-five pounds ($115) for an overnight ghost walk through the institution followed by a 7 A.M. breakfast. Hosted by Mark Rablin, an "experienced and professional Psychic medium and energy therapist," visitors participate in group workshops in the main civil and naval prison, hoping to leave scared stiff—if they last through the cold, damp night—and with a better understanding of the paranormal. The prison ghost walk follows in a long tradition of monetizing the prison's spectral reputation (profits from the ghost walk pay for ongoing prison restoration). In 1947, the 99 Club opened for visitors at Bodmin Jail, serving lunch and dinner with a buffet and cocktail bar, advertised as "the clink with a drink." Visitors could round off the night dancing in the famous Old Chapel. Prison as a themed amusement space for the wealthy is featured in Michael Moore's documentary *Roger and Me* (1989), when Flint, Michigan's well-off are invited to spend the night dressed in period costumes at a brand new prison.

Bodmin Jail suggests prison's ambivalent place in the Western cultural imaginary, a place to be shocked and moved to tears; in its juxtaposition of desolate, weed-filled, abandoned cell blocks with amusement park–like reconstructions of lurid crime scenes, Bodmin Jail's continuing appeal is grounded in the same impulses that piqued audience interest in early prison films. Like museums of cultural and natural history, where theatrical dioramas compensate for the absence of historical actors, prison museums construct auto-ethnographies of their carceral mechanisms and notorious events and prisoners. Eastern State Penitentiary's museum has supplemented the traditional architectural relic and house-of-horrors features of the prison museum with a deployment of the site as an exhibition venue for artist video and photography engaging with contemporary corrections policy and the entire criminal justice system.[14] Prison museums, especially those located adjacent to working prisons, cannot resignify the past through a radically new carceral episteme, since in some instances, conditions are far worse today than they were one hundred years ago, with the three-strikes sentencing policy, enacted in California, only gradually being revoked.

Contemporary Media in Prison

Toward the end of the second episode of the Netflix drama *Orange Is the New Black* (Netflix, 2013), an adaptation of Piper Kerman's memoir of the fourteen months she spent in a low-security federal correctional institution in Danbury, Connecticut, for drug trafficking, Piper sits stone faced in an improvised movie theater at the fictional Litchfield Correctional Facility in upstate New York, surrounded by fellow inmates cracking up at the physical comedy on the screen.[15] Not sure at first why Piper does not laugh, we soon realize that as a new inmate, she has neither the government-approved radio tuned to the channel broadcasting the audio track nor the earbuds necessary to listen, a situation resolved when the inmate sitting next to her shares one of her buds. An homage to the infamous Southern chapel film-screening scene in Preston Sturges's *Sullivan's Travels* (1941), when imprisoned Hollywood director John Lloyd Sullivan initially stares stone faced at the Disney cartoon before starting to laugh, this scene from *Orange Is the New Black* is simultaneously a commentary about how media are consumed differently behind bars, cinema's ability to alleviate some of the pain of captivity, if only momentarily, and inmate solidarity. Like Piper, Sullivan is a fish out of water in the 1940s Southern chapel: both are Caucasian, well educated, upper middle class, and surrounded by people who, for the most part, are none of the above. As M. Lamar, artist and brother of transgender *Orange* actress Laverne Cox (who plays transgender inmate Sophia Burset) sarcastically observed at a 2014 Baruch College appearance with his sister, Piper has been "thrown into the black jungle" of incarceration, to be eaten alive by the natives, mostly black and Hispanic working-class women.

Film is the great leveler in both these examples, and in Piper's case,[16] it is a missing earbud rather than a delayed emotional response that prevents her from enjoying the film. In the federal women's prison, the protocol for viewing is similar to airline travel, where passengers either are given or supply their own earbuds, although there is no choice of what to watch when the institution is the programmer. In prison, where viewers are isolated via sound yet gathered as a collective, the paradoxical experience of film makes supervision easier, since it would be harder for corrections officers to police the space if women's whispers and covert actions were masked by a loud soundtrack.

Popular culture has always crossed over from the civilian world into the prison, in the form of books, magazine and newspaper subscriptions,[17] film screenings, radio (inmates at Greenhaven Prison, New York, even operated their own station), and television.[18] Until April 2014, television sets at Sing Sing were restricted to the recreation yard, mess halls, and Building 7 (Honor Housing Building [HHB]) (in their cells, inmates listen to radio stations selected by the Inmate Liaison Committee). The television sets in the recreation yard are housed in what appear to be giant wooden birdhouses with doors (visible in the distance through the razor-wire fencing), located along the perimeter of the fence with bleacher seating in front of them (fig. C.9). Each television is turned to a different channel aimed at a specific genre or ethnic group (channel selection is controlled by staff and, according to one guard I spoke to, inmate gang leaders);[19] inmates know which channel will be on each set and can make a viewing decision accordingly.

The model of viewing inscribed in this setup is curious, to be sure, the antithesis of contemporary models of individualized streaming or downloadable content and distinct from that of 1950s television, when viewers watched

Fig. C.9 TV sets in recreation yard, Sing Sing Correctional Facility, Ossining, New York. Courtesy Lesley Malin, Department of Corrections and Community Supervision

a small number of channels on a single set. This collective, perambulatory television viewing suggests the contemporary use of screens in public places like the drive-in cinema, rock concert, or athletic event, though in the striking setting of razor-wire fencing. Televisions in prisons—at Sing Sing, the sets receive forty-one over-the-air channels—are used as regulatory agents, ways of lowering violence by keeping inmates in their cells, and, through the threat of removal, they play a role, if only small, in quelling fights between prisoners. Certainly fights around which channel to watch are eliminated when inmates are able to view programs in isolation; large amounts of television viewing not only consume time but, as Yvonne Jewkes argues, provide "a means of disengaging from the inmate culture and keeping away from potential trouble."[20] In facilities without in-cell television, consumption is public whether the prisoner likes it or not, just one of the main ways in which the separation of public and private space is violated in prison.[21]

I interviewed Andre Jenkins, a Sing Sing prisoner serving twenty-two years for robbery and a founding member of the advocacy group Forgotten Voices, about the place of television at Sing Sing.[22] Jenkins received his bachelor's while at Sing Sing in May 2014 and is now enrolled in a master's program[23] through Hudson Link,[24] a nonprofit providing higher education, life skills, and reentry support to incarcerated men and women.[25] He described the HHB at Sing Sing as "one of the most liberal [prison] spaces you could live in," where large flat-screen TVs are positioned near the ceiling; Jenkins described the setup as reminiscent of the fictional prison series *Oz* (HBO, 1997–2003).[26] Inmates in the HHB are granted more time outside of their cells (from 6:00 A.M. to 11:30 P.M., compared to 7:00 A.M.–9:15 P.M. in the regular population), and television viewing is structured around a different set of rituals, with the programming on the TV set on the main recreation floor moving from lunchtime game shows like *The Price Is Right* and *Who Wants to Be a Millionaire* to *The Chew*, a food program; an afternoon movie; news between 4:00 and 6:00 P.M.; *Jeopardy*; and finally an evening movie. Game shows are popular for their interactivity and for keeping prisoners abreast of consumer shifts; with 95 percent of inmates released at some point, their value to advertisers as future consumers, albeit with little current income and market access, should not be ignored. Just as a previous generation of inmates incarcerated in the early twentieth century often learned via prison motion picture screenings about changes in the urban landscape, technology, advertising, and entertainment, so too has a contemporary generation of prisoners locked

up for more than fifteen years come to know of the Internet and social media via film and television.

Though inmates have had access to radio sets in their cells since the late 1920s, individual use of television sets has taken much longer to arrive.[27] Starting in April 2014, inmates were allowed to purchase a $147 in-cell thirteen-inch, flat-screen television equipped with headphones. Over a third of the 2014 prison population of 1,550 purchased a TV within the first month (over six hundred sets), far more than the prison administration predicted (initially the TV came with a basic cable package, but with the expectation of additional sports and movie channels).[28] Not surprisingly, TV's arrival in the cells at Sing Sing has engendered some ambivalent reactions from both prisoners and administrators. Jenkins felt that television could end up being both a blessing and a curse: "A television is like a friend, your best friend . . . [but] for me . . . who's achieving academic goals, a television is a distraction. . . . But I bought it anyway, just so when I'm locked in my cell, if I choose to watch something that the masses don't want to watch, I can watch it."[29] In-cell television came at a price beyond that of the initial outlay for the set; in exchange for the sets, inmates agreed to a reduction in the number of mailed packages they could receive.[30]

Logistically speaking, filmgoing at Sing Sing has changed little since cinema was introduced into the facility in 1914. The auditorium is transformed into an ad hoc motion picture theater, inmates no longer rely on the benevolence of exhibitors donating film but watch titles obtained either through the prison's Netflix account or the prison's three-hundred-title DVD library (inmates also fund-raise for special screenings, asking for $1 donations).[31] The Inmate Liaison Committee consults with recreation staff on movie choices, with new Netflix releases, assuming the subject matter is not wildly inappropriate,[32] usually being screened in the auditorium.

Cell blocks take turns attending the films, with a maximum of twice a week, in groups of approximately four hundred inmates. However, several violent incidents during screenings in 2010—an ever-present threat afforded by the darkened chapel (fig. C.10)—provoked a new policy of keeping the house lights up and mandating an empty seat between inmates. For Jenkins, the compromised lighting was a painful reminder of how a film should be viewed in a proper movie theater: "You can manage but it's not as nice as it was. . . . The movie's a strain. . . . When you're in the movie theater in society, it's pitch black . . . you can actually get lost in the movie. You're going to the movie to

Fig. C.10 Chapel, Sing Sing Correctional Facility, Ossining, New York. Courtesy Lesley Malin, Department of Corrections and Community Supervision

be entertained. You're not thinking about somebody coming over your shoulder; you've got your popcorn, your soda, and you watch."

"It's like knowing there's a pit bull behind you," said Sing Sing superintendent Michael Capra of the threat of violence during chapel film screenings, a point seconded by Jenkins, who said he preferred to watch movies on the flat screen in the HHB, where on the weekends he can stay up until 2:00 A.M. watching a film rather than suffer the anxieties associated with chapel screenings (although, at six feet eight inches tall and three hundred pounds, Jenkins admitted he had little to fear). He nonetheless expressed frustration at the chapel knife attacks; in his words, "It was an unspoken rule you do not act up during movie time. This is where, you know this was like, it's truce right now, whatever you're doing it's a truce." Jenkins was also acutely aware of the system of privilege governing all forms of recreation at Sing Sing, privileges that could be revoked by prison authorities if security was compromised.

A century after its introduction, film at Sing Sing is no longer trumpeted as a reformative tool. The earlier sentiments of wrongfully convicted former

lifer Louis Victor Eytinge, who in 1923 became an outspoken public advocate of the motion picture in prisons by arguing that film ameliorated many of the ills of incarceration, now seem quaint at best: "Motion pictures are the greatest present force in the prisons of this country for the moral uplift, education and enlightenment of convicts. They do more to bring about the regeneration of men and women who have gone wrong than any other agency. *They are a beacon of hope to humans in despair.* They helped me a lot and were largely instrumental in changing my perspective."[33] Just as there is some truth in Eytinge's comment about film ameliorating some of the mental discomfort of incarceration, new rituals governing television consumption will undoubtedly emerge once the in-cell cable system is fully operational. Both Jenkins and Superintendent Capra worried that inmates might become the carceral equivalents of "couch potatoes." "Your cell is your house and now your house has a TV in it," quipped Capra on the shift in TV access policy. When asked what he thought it must be like to consume media behind bars, he replied matter-of-factly that "it's an escape. You're not here anymore. You get to escape just like you would from a hard day at work."[34] Collapsing the situation of the worker with that of the inmate, both of whom use TV to escape hardship and regimentation, Capra mapped out TV as a management tool, information channel, and positive role model; chapel services and events going on in the prison auditorium could be streamed live to cell-bound inmates, although Capra recognized that staffing and security concerns might take some time to sort out. To be sure, those inmates who feared for their personal safety in the setting of collective viewing might be able to relax while watching TV and watch exactly what they want in their own cells. One English prison inmate interviewed as part of a study on media access in prison was only too aware of television's soporific effect, saying that in-cell television had usurped books and radio; television failed to trigger "air castles," psychic flights of fancy. Instead, it was "just more immediate, more *there*," and less able to transport the prisoner from the cell.[35]

"An Affront on Our Common Humanity": Closing Thoughts

The early twentieth-century discourses of prison reform addressed in this book seem quaint and anachronistic, and after decades of mandatory sentencing laws and major reductions in federal and state support for higher educa-

tion in prison, until recently the United States seemed to have gone back to an era before the penal reform movement of a century ago. Lately, however, the nation has seen growing resistance to the reigning "tough on crime" policies born in the 1960s, including President Barack Obama's summer 2015 announcement of a limited pilot program to reinstate Pell educational grants for some inmates.[36]

The rise of the Black Lives Matter movement in the summer of 2015 brought issues of criminal justice and prison reform back into the national political spotlight. Falling crime rates, public skepticism about an interminable "war on drugs," and growing fiscal pressures at the state level brought new resistance to the regime of mass incarceration that costs the United States $80 billion annually to keep 2.2 million people incarcerated. In early 2016, President Obama announced a ban on solitary confinement for juveniles in federal prisons, and outlawed its use on low-level infractions. Noting that solitary confinement could lead to "devastating, lasting psychological consequences," Obama cited evidence that restricting the use of solitary confinement would result in a reduction of assaults on staff and an increase in prisoners' entering rehabilitation programs.[37] Obama's moves came in the wake of news coverage of prisoner abuse at New York City's notorious Rikers Island, including the tragic case of sixteen-year-old Kalief Browder, who spent nearly two years in solitary confinement and suffered horrific violence at the hands of guards and fellow inmates. Administrators at Rikers have ended solitary confinement for sixteen- and seventeen-year-old inmates at the facility, although at the time of writing, extending this policy to eighteen- to twenty-one-year-olds has been postponed. In early 2016 the New York City Department of Corrections also launched a pilot program to distribute tablet computers (lacking Internet access) to seventy-five young adult and adolescent inmates at Rikers as a reward for good behavior, to be used for playing movies, music, and games. We thus seem to have come full circle in the deployment of screen media to govern carceral communities; to the adolescents awaiting trial at Rikers, the tablet may serve as an object of reassurance and social connection, a talisman for clawing back some normalcy and killing time while incarcerated.

Carceral Fantasies has given us virtual entry into prison via cinema. We have come to learn about incarceration via the back door of popular culture, and though *Carceral Fantasies* tells the story of American cinema's long-standing fascination with punishment and incarceration, it also fills in the

missing story of how cinema found a home in the early twentieth-century peni-
tentiary. Cinema shaped a generation of incarcerated moviegoers through
the 1910s and 1920s, instilling in its captives the national myths of rugged
individualism, consumerism, and the American dream.

The film industry has always been obsessed with prison as a fictional set-
ting, and the loan of films to penitentiaries by the Hollywood studios was
driven by a wish to gain access to prisons for location shooting. The industry
also sought audiences everywhere, and, given that the majority of incarcer-
ated men and women would eventually be released, it made sense to inculcate
them with the habit of moviegoing. The media remain fascinated by the
way prison acts upon the human mind and senses, although press coverage
today is less about charges of coddling than about widespread and system-
atic abuse, including overcrowding, the use of excessive force by correction
officers, the grotesque over-incarceration of men and women of color, and
botched executions (the 2014 Oklahoma lethal injection fiasco was replayed
in the media in virtually identical terms to that of the Kemmler electrocution
in 1890).[38]

Inmate film viewers at the turn of the last century constituted a demo-
graphic group for which we have unusually detailed information. We know
what films they watched, how often, where they went to the movies, and how
important entertainment was to many of them. And even though incarcerated
audiences cannot stand in for civilian consumers, their experiences are none-
theless historiographically valuable. And while this research has barely
scratched the surface of the psychic meanings of popular media under the
conditions of incarceration, a comment made by Jenkins offers a heart-
wrenching window into what it means to claw back a modicum of self-worth
when you have done wrong. When asked if responding emotionally to media
helped him cope with imprisonment, he replied, "What it does, it allows me
to realize that I'm a good person and if I can watch something and incite emo-
tion in me that is heartfelt, and that someone else can watch who has never
ever done crime . . . and feel the same way that I do, then I know I am . . . not
off the totem pole. I'm right in line with what the average person is. So it al-
lows me to feel good about myself."[39] This is precisely how Sing Sing warden
Lewis E. Lawes envisaged cinema could be used to develop an inmate's range
of "normal" reactions in the 1920s. Jenkins's reflections about how he re-
acts to emotional popular culture suggest a process of reintegration into
the normative, the very opposite of the plot of the 1907 film *The Disinte-*

grated Convict (Vitagraph, 1907), a trick comedy that used object animation to represent a prisoner's body dropping to the floor in pieces, the fragments flying together, and the body becoming whole again. Though the escaped convict in *The Disintegrated Convict* fragments and recomposes in order to elude disciplinary containment, the act itself serves as a fitting metaphor for the mental (and physical) disintegration besetting a great many prisoners, not only because of their untreated (or diagnosed) mental illness, but because prisoners suffer from higher levels of depression, anxiety, and psychoses as a result of their incarceration.

One could argue that prison media continues to train the senses and morals of incarcerated citizens as it did in late nineteenth- and early twentieth-century institutions. Cinema's usefulness was defined by government regulations, civic mandates, and at times ad hoc policies, as when Sing Sing authorities introduced nightly screenings in the late 1910s to lessen prisoners' exposure to the damp conditions in the cells. Photography and cinema revealed and reified the underworld of modern society, and criminals, like native peoples in the ethnographic field, were measured, documented, and fingerprinted using Alphonse Bertillon's infamous system of human cartography. Perceived as "urban" as opposed to "ethnographic" savages, products of the metropole's grimy underbelly, criminals and the poor were surveilled in a manner similar to other subject peoples. Photography and film assisted immeasurably in the Victorian project of positivistic knowledge that divided the world, as Thomas Richards argues in *The Imperial Archive*, into "little pieces of fact," but these films also sated a public's voracious appetite for real and imagined glimpses of the incarcerated.[40]

Carceral Fantasies has constructed a parallax view of prisons and modern media, one that presupposes that in order to understand how prisoners consumed popular culture, we need a better grasp of the imaginary machinery that molds our views of inmates in the first place. It has told a uniquely American story, one involving iconic prisons such as Sing Sing and famous assassins such as Leon Czolgosz. The historical distance from many of the people, events, and films described in this book might be a catalyst for reassessing how we got to our current manifestly imperfect prison system and where we might imagine ourselves in the future. Ironically, prison might be one of the last places to escape the consequences of neoliberal globalization and the expanding, nonstop world of twenty-first-century capitalism that Jonathan Crary explores in *24/7*, an era "of indifference, against which the

fragility of human life is increasingly inadequate and in which sleep has no necessity or inevitability."[41] Tethered to our smartphones and celebrating the power nap as a macho response to the vanishing time we allow ourselves to sleep, we are prisoners of a new kind of disciplinary regime. For many men and women languishing in U.S. prisons, the contemporary media landscape of Internet, social media, and smartphone has only been experienced vicariously via prison media, and a better understanding of the role of media within incarceration might offer insights into the ways social power operates in our own 24/7-connected world.

Beyond providing a metaphor for people of color and others who are "socially disappeared,"[42] prison's scopic and regulatory regimes have been extended across society by a state that subjects its citizens to a pervasive surveillance that one hundred years ago would have been in the realm of science fiction. Ironically, the French production company Gaumont predicted this kind of surveillance society in the comedy *La police de l'an 2000* (1910), which shows gendarmes using telescopes to spy on their citizenry from the bird's-eye vantage point of a futuristic airship.[43] Witnessing burglars in the midst of committing crimes, the police lower a wire lasso to earth to ensnare and scoop them up into a holding cell on the airship. At shift's end, the airship hovers over a local police station, whereupon the criminals are thrown down a chute that leads directly into another cell. An amusing if darkly dystopian vision of policing and carcerality, *La police de l'an 2000* is a comic mix of fantasy, surveillance, and tactical policing. The punitive imaginary enacted in this film serves as a fitting end to *Carceral Fantasies*, not simply because of the film's predictive logic as a panoptic fable, but because of its figuration of technology's agency in criminal capture and incarceration. A pity that Gaumont never made a prison sequel to *La police de l'an 2000*, perhaps depicting the future penitentiary as an entirely automated space, where machines supervise prisoners and technology reprograms them for reentry into a civilian world dominated by constant surveillance from above.[44]

Notes

Acknowledgments

1. Walter Mignolo, *Local Histories/Global Designs: Colonially, Subaltern Knowledges, and Border Thinking* (Princeton, NJ: Princeton University Press, 2000).

Introduction

1. Thomas Mott Osborne, "Address Delivered at a Meeting Held Under the Auspices of the Men's Club, People's Presbyterian Church," Bridgeport, Connecticut, February 28, 1915, 149, in *Prison Reform*, The Handbook Series, ed. Corinne Bacon (New York: H. W. Wilson, 1917).

2. Feminist scholar and activist Angela Davis views prison in similarly paradoxical terms, acknowledging the fact that as an institution, the penitentiary "is present in our lives, and, at the same time . . . absent." Angela Y. Davis, *Are Prisons Obsolete?* (New York: Seven Stories, 2003), 15.

3. David Garland, *Punishment and Modern Society: A Study in Social Theory* (Chicago: University of Chicago Press, 1999), 1–2.

4. Caleb Smith, *The Prison and the American Imagination* (New Haven, CT: Yale University Press, 2009), 23.

5. Kristen Whissel, *Picturing American Modernity: Traffic, Technology, and the Silent Cinema* (Durham, NC: Duke University Press, 2008), 154.

6. Kemmler was an illiterate Buffalo fruit vendor convicted in 1890 of murdering his lover with a hatchet. His death by electrocution was covered extensively in the domestic and international press, and its legal record is still cited in challenges to capital punishment legislation. While witnesses had observed the instant death that followed from the accidental electrocution of people as a result of contact with a live wire, the effect of alternating current (AC) on humans in a more controlled environment had

not been observed before Kemmler's electrocution. For more on Kemmler, see Richard Moran, *Executioner's Current: Thomas Edison, George Westinghouse, and the Invention of the Electric Chair* (New York: Vintage, 2002), 119–57.

7. Edison was initially opposed to capital punishment, refusing to consult with the Death Penalty Commission charged with finding a replacement for hanging, which was deemed too spectacular and plagued by equipment failures and mishaps. But when the commission approached Edison a second time, he agreed, explaining that while he would "heartily join in an effort to totally abolish capital punishment," adopting the "most humane method available for the purpose of disposing of criminals under sentence of death" was a legitimate cause, given its legality in New York State. But as historians of the direct- versus alternating-current wars of the late nineteenth century have pointed out, Edison's change of heart coincided with the height of his competition with his rival, George Westinghouse. Edison's initial reluctance to become embroiled in the work of the commission faded when he realized the usefulness of associating alternating current with electrocution in the public mind in order to discourage its domestic use. Even though Edison lost the current wars, he was successful in establishing the alternating-current electric chair as the chief means of execution in the United States, until the rise of the lethal injection in the 1970s. Death Penalty Commission Report, 68–69, cited in Mark Essig, *Edison and the Electric Chair: A Story of Light and Death* (New York: Walker, 2005), 97.

8. "Remarks on a Late Execution at Shrewsbury," *Philanthropist* 2 (1812): 207–8, cited in Randall McGowen, "A Powerful Sympathy: Terror, the Prison, and Humanitarian Reform in Early Nineteenth-Century Britain," *Journal of British Studies* 25 (July 1986): 324. Also see McGowen's essay "The Body and Punishment in Eighteenth Century England," *Journal of Modern History* 59 (1987): 312–34.

9. For influential histories of the birth of the penitentiary, see Adam Hirsch, *The Rise of the Penitentiary: Prisoners and Punishment in Early America* (New Haven, CT: Yale University Press, 1992); Michael Ignatieff, *A Just Measure of Pain: The Penitentiary in the Industrial Revolution, 1750–1850* (London: Macmillan, 1978); Norval Morris and David J. Rothman, eds., *The Oxford History of the Prison: The Practice of Punishment in Western Society* (New York: Oxford University Press, 1995); Scott Christianson, *With Liberty for Some: 500 Years of Imprisonment in America* (Boston: Northeastern University Press, 1998); and Rebecca M. McLennan, *The Crisis of Imprisonment: Protest, Politics, and the Making of the Penal State, 1776–1941* (Cambridge: Cambridge University Press, 2008).

10. Yvonne Jewkes, "Creating a Stir? Prisons, Popular Media and the Power to Reform," in *Captured by the Media: Prison Discourse in Popular Culture*, ed. Paul Mason (Cullompton, UK: Willan, 2006), 150.

11. McLennan, *Crisis of Imprisonment*, 314.

12. Nicole Hahn Rafter, *Shots in the Mirror: Crime Films and Society* (New York: Oxford University Press, 2006), 122. Press interest in Sing Sing increased exponentially during prison reformer Thomas Mott Osborne's two-year stint as its warden. Denis Brian notes that there was more press coverage of penal reform during this period than at any other time in the country's history. The press relished the scandal surrounding the investigation into inappropriate conduct by Osborne, including the carnival atmosphere upon his reinstatement. Osborne retired three months after his reinstatement. *New York Times*, 1916, cited in Denis Brian, *Sing Sing: The Inside Story of a Notorious Prison* (Amherst, NY: Prometheus, 2005), 103, 109.

13. Jan Alber, "The Ideological Underpinnings of Prisons and Their Inmates from Charles Dickens' Novels to Twentieth-Century Film," in *Images of Crime III: Representations of Crime and the Criminal*, ed. Telemach Serassis, Harald Kania, and Hans-Jörg Albrecht (Berlin: Duncker and Humblot, 2009), 133.

14. Juliet Ash, *Dress Behind Bars: Prison Clothing as Criminality* (London: I. B. Tauris, 2010), 3–4.

15. McLennan, *Crisis of Imprisonment*, 226. For more on the standardization of bodily practices in schools, museums, and prisons, see Constance Classen, *The Deepest Sense* (Urbana: University of Illinois Press, 2012), 171–78.

16. Haidee Wasson, "Electric Homes! Automatic Movies! Efficient Entertainment! 16mm and Cinema's Domestication in the 1920s," *Cinema Journal* 48, no. 4 (Summer 2009): 21.

17. For a fascinating analysis of the therapeutic uses of the magic lantern, see Emily Godbey, "Picture Me Sane: Photography and the Magic Lantern in a Nineteenth-Century Asylum," *American Studies* 41, no. 1 (Spring 2000): 31–69.

18. The three central tenets of progressive prison reform were parole, probation, and the indeterminate sentence; see Estelle B. Freedman, *Maternal Justice: Miriam Van Waters and the Female Reform Tradition* (Chicago: University of Chicago Press, 1996), 112.

19. Michel Foucault, *Discipline and Punish: The Birth of the Prison*, trans. Alan Sheridan (New York: Vintage Books, 1995), 11.

20. Ann Laura Stoler, *Along the Archival Grain: Epistemic Anxieties and Colonial Common Sense* (Princeton, NJ: Princeton University Press, 2009), 32.

21. Angela Y. Davis, "Race and Criminalization: Black Americans and the Punishment Industry," in *The Angela Y. Davis Reader*, ed. Joy James (Maldon, MA: Blackwell, 1988), 70; Nancy Bentley, *Frantic Panoramas: American Literature and Mass Culture, 1870–1920* (Philadelphia: University of Pennsylvania Press, 2009), 123.

22. See Antonia Lant, *The Red Velvet Seat: Women's Writings on the Cinema in the First Fifty Years* (London: Verso, 2006); Shelley Stamp, *Movie-Struck Girls: Women and Motion Picture Culture After the Nickelodeon* (Princeton, NJ: Princeton

University Press, 2000); Vicki Callahan, ed., *Reclaiming the Archive: Feminism and Film History* (Detroit: Wayne State University Press, 2010); Jennifer M. Bean and Diane Negra, eds., *A Feminist Reader in Early Cinema* (Durham, NC: Duke University Press, 2002).

23. See, for example, "Prisoner Art for Social Justice," the inaugural exhibition at the New Gallery at John Jay College of Criminal Justice, which displayed the artwork of eleven men incarcerated in two Pennsylvania prisons. All but one of the artists are serving life sentences or on death row; http://philippetheise.journalism.cuny.edu/2012/11/26/prisoners-art-invites-reflection-at-john-jay/. Among the most noted arts organizations working with inmates is Rehabilitation Through the Arts, founded at Sing Sing in 1996 (http://www.rta-arts.org), partnering with NYU's Graduate Department of Educational Theater program (for an NPR story on a production of *West Side Story* at Sing Sing, see http://www.rta-arts.org/downloads/NPR50 yearsofWestSideStory.pdf). For more on theater, see Laurence Tocci, *The Proscenium Cage: Critical Case Studies in U.S. Prison Theatre Programs* (Amherst, NY: Cambria Press, 2007), and Thomas Fahy and Kimball King, eds., *Captive Audience: Prison and Captivity in Contemporary Theatre* (New York: Routledge, 2003); for a discussion of photography, see Steven Schoen and John Conroy, *Sing Sing: The View from Within— Photographs by the Prisoners* (New York: Winter House, 1972).

1. Tableaux Mort

1. Austin Sarat, *When the State Kills: Capital Punishment and the American Condition* (Princeton, NJ: Princeton University Press, 2001), 205.

2. When the "body as the major target of penal repression disappeared" with the banning of public executions, it was because, as Foucault argues, "it is the certainty of being punished and not the horrifying spectacle of public punishment that must discourage crime." Foucault, *Discipline and Punish*, 11.

3. Roald Dahl, *The Witches* (New York: Scholastic, 1983), 66.

4. Grace Elizabeth Hale, *Making Whiteness: The Culture of Segregation in the South, 1890–1940* (New York: Vintage, 1998), 277, cited in Bentley, *Frantic Panoramas*, 281.

5. *Clipper*, November 16, 1901, 832, cited in Charles Musser, *Before the Nickelodeon: Edwin S. Porter and the Edison Manufacturing Company* (Berkeley: University of California Press, 1991), 187.

6. The customary autopsy following electrocution defined a cultural logic of death that demanded a protective sequestering of the body; as Michael Sappol argues, "The deathbed vigil, the wake, the death shroud, burial in a coffin or tomb, embalming, served to set apart the dead person from the living, providing temporary protection

from the predations of desecration, curiosity seekers, and vermin." Michael Sappol, *A Traffic of Dead Bodies: Anatomy and Embodied Social Identity of Nineteenth-Century America* (Princeton, NJ: Princeton University Press, 2002), 18.

7. *New York World*, October 29, 1901, 3, cited in Musser, *Before the Nickelodeon*, 517n83. For psychosociological analyses of Czolgosz as a murderer, see L. Vernon Briggs, *The Manner of Man That Kills: Spencer, Czolgosz, Richeson* (Boston: Gorham Press, 1921), and Walter Channing, "The Mental Status of Czolgosz," *American Journal of Insanity* 59, no. 2 (1902). Dime museums often claimed to own body parts of famous assassins, including one in New York that advertised "The Head and Right Arm of Anton Probst, the Murderer of the Deering Family, Amputated After Execution." Essig, *Edison and the Electric Chair*, 119.

8. Sarat, *When the State Kills*, 210.

9. Craig Brandon, *The Electric Chair: An Unnatural American History* (Jefferson, NC: MacFarland, 1999), 246.

10. Detailed descriptions of executions in urban newspapers exploited the public's fascination with every aspect of the event, from the sound of mothers sobbing to snapping necks. Brandon, *Electric Chair*, 32.

11. For more on the history of the wonder show in America, see Fred Nadis, *Wonder Shows: Performing Science, Magic, and Religion in America* (New Brunswick, NJ: Rutgers University Press, 2005), 6–81. For electricity at a world's fair, see Judith A. Adams, "The Promotion of New Technology Through Fun and Spectacle: Electricity at the World's Columbia Exposition," *Journal of American Culture* 18 (1995): 44–55.

12. Foucault, *Discipline and Punish*, 8.

13. A great deal has been written about this disturbing film shot before 1,500 people in Coney Island. The elephant, Topsy, from Barnum and Bailey's circus, had attacked a cruel keeper who had put out cigarettes on her trunk. As a public corollary to *The Execution of Czolgosz*, Edison decided to shoot the public electrocution of this animal and made *Electrocuting an Elephant* in front of a large group of spectators in Coney Island; see Michael Daly, *Topsy: The Startling Story of the Crooked Tailed Elephant, P. T. Barnum, and the American Wizard, Thomas Edison* (New York: Atlantic Monthly, 2013); and Christopher Kamerbeek, "The Ghost and the Corpse: Figuring the Mind/Brain Complex at the Turn of the Twentieth Century," PhD diss., University of Minnesota, December 2010, 196–203. For press coverage, see "Coney Elephant Killed," *New York Times* [hereafter abbreviated as *NYT*], January 5, 1903.

14. Electrocution is the twentieth century's most common method of capital punishment. In the United States, over four thousand condemned inmates have died in the electric chair over the past hundred years; the most recent, Paul Werner Powell, was electrocuted in Virginia in March 2010. There are stark differences across U.S.

states: between 1910 and 1935, Southern states accounted for nearly 80 percent of all executions. Trina N. Seitz, "Electrocution and the Tar Heel State: The Advent and Demise of a Southern Sanction," *American Journal of Criminal Justice* 31, no. 1 (2006): 107.

15. Musser, *Before the Nickelodeon*, 163. For an analysis of the Biograph Company's nonfiction filmmaking, see Stephen Bottomore, "Every Phase of Present-Day Life: Biograph's Non-Fiction Production," in "The Wonders of the Biograph," special issue, *Griffithiana* 69–70 (1999–2000): 147–211.

16. James Boswell, *The Life of Samuel Johnson, LL.D Including the Journal and Diary* (London: Murray, 1835), N2.

17. Clinton Prison No. 4499, "Reformed by a Picture," *Star of Hope* [hereafter abbreviated as *SOH*] 8, no. 18 (December 14, 1901): 297–98.

18. According to Charles Musser, Mary was played by Robert Thomas, secretary and treasurer of the Kinetoscope Company. Despite the historical subject matter and its stop-camera technique, the film did not generate large sales. Charles Musser, *The Emergence of Cinema: The American Screen to 1907* (New York: Scribner, 1990), 86–87.

19. Clinton Prison No. 4499, "Reformed by a Picture," 298.

20. Louis P. Masur, *Rites of Execution: Capital Punishment and the Transformation of American Culture, 1776–1865* (New York: Oxford University Press, 1989), 26.

21. Clinton Prison No. 4499, "Reformed by a Picture," 298.

22. André Gaudreault and Timothy Barnard, *From Plato to Lumière: Narration and Monstration* (Toronto: University of Toronto Press, 2009).

23. Miriam Hansen, *Babel and Babylon: Spectatorship in Cinema* (Cambridge, MA: Harvard University Press, 1994), 31. As is the case today, African American men were executed at a disproportionately higher level than white men (see Seitz, "Electrocution and the Tar Heel State," 115).

24. American Film Institute, "An Execution by Hanging," *AFI Catalog of Feature Films*, 2015, http://www.afi.com/members/catalog/DetailView.aspx?s=1&Movie=44301.

25. Released just ten years after the passing of the Electrical Execution Act in the United States on June 4, 1888, the "by" in the title serves as a stark reminder that even though ten states would go on to abolish the death penalty between 1897 and 1917, hangings were routine enough that the method by which capital punishment was carried out needed to be specified. In 1905, cameraman F. A. Dobson reconstructed convicted murderess Mary Rogers's death by hanging in *Execution of a Murderess*, alternately titled *Execution by Hanging*, discussed in the following chapter. For more on the Rogers case, see "Mary Rogers (Murderer)," *Wikipedia*, last modified October 25, 2015, http://en.wikipedia.org/wiki/Mary_Rogers_(murderer).

26. See "Execution of Saddam Hussein," *Wikipedia*, last modified November 5, 2015, http://en.wikipedia.org/wiki/Execution_of_Saddam_Hussein. For the uncensored hanging footage shot by the mobile phone, see "Real Footage of Saddam Hussein's Execution," YouTube, July 13, 2012, http://www.youtube.com/watch?v=JmlaPQOtDbQ.

27. Whissel, *Picturing American Modernity*, 153.

28. Pieter Spierenburg, "The Body and the State: Early Modern Europe," in *The Oxford History of the Prison: The Practice of Punishment in Western Society*, ed. Norval Morris and David J. Rothman (New York: Oxford University Press, 1995), 49.

29. Henry Mayhew and John Binny, *The Criminal Prisons of London and Scenes of Prison Life* (London: Griffin, Bohn, 1862; reprint, Cambridge: Cambridge University Press, 2011), 590.

30. Kathleen Kendrick, "'The Things Down Stairs': Containing Horror in the Nineteenth-Century Wax Museum," *Nineteenth Century Studies* 12 (1998): 2–3.

31. As Vanessa Toulmin notes, the Chamber of Horrors was initially called the "Separate Room" until given the new name by *Punch* magazine in 1846; connotatively linked to both the judicial and legislative spheres and the more licentious bedroom, the word "chamber" summoned up a slew of associations. Vanessa Toulmin, "An Early Crime Film Rediscovered: Mitchell and Kenyon's *Arrest of Goudie* (1901)," *Film History* 16, no. 1 (2004): 44.

32. Kendrick, "'Things Down Stairs,'" 15. Also see Vanessa Schwartz's influential work on spectacular display in the Paris morgue and waxwork, *Spectacular Realities: Early Mass Culture in Fin-de-Siècle Paris* (Berkeley: University of California Press, 1999), 45–148.

33. George Shrady cited in Deborah W. Denno, "Is Electrocution an Unconstitutional Method of Execution? The Engineering of Death Over a Century," *William and Mary Law Review* 35, no. 2 (1994): 601n326.

34. Auerbach, *Body Shots*, 35.

35. Mary Anne Doane, *The Emergence of Cinematic Time: Modernity, Contingency, the Archive* (Cambridge, MA: Harvard University Press, 2002).

36. Kamerbeek, "Ghost and the Corpse," 202; and Auerbach, *Body Shots*, 41.

37. The courts have continued to rely upon Kemmler, 136 U.S. 436 (1890) as constitutional support for all methods of execution as well as general Eighth Amendment propositions; *Kemmler* exerted precedential force on 226 cases in the twentieth century. Denno, "Is Electrocution an Unconstitutional Method of Execution?," 559.

38. When Edison was asked by his 1910 biographers whether he had invented the electric chair, "he grew indignant and replied, 'I did not invent such an instrument.'"

See Frank Lewis Dyer and Thomas Commerford Martin, *Edison: His Life and Inventions*, 2 vols. (New York: Harper, 1910), cited in Essig, *Edison and the Electric Chair*, 287. Also see James S. Evans, "Edison Regrets Electric Chair Was Ever Invented," *New York American*, February 10, 1905, cited in Essig, *Edison and the Electric Chair*, 285.

39. Essig, *Edison and the Electric Chair*, 279. Edison was even reluctant to talk about himself or his achievement in an interview for *Moving Picture World*: see Frank Parker Hurlette, "An Interview with Thomas A. Edison," *MPW* 9, no. 1 (July 15, 1911): 104–5.

40. Iwan Rhys Morus, *Frankenstein's Children: Electricity, Exhibition, and Experiment in Early-Nineteenth-Century London* (Princeton, NJ: Princeton University Press, 1998), xi.

41. *New York World*, October 29, 1901, 3, cited in Musser, *Before the Nickelodeon*, 187. Also see "Want to See Czolgosz Die," *NYT*, September 21, 1901.

42. Masur, *Rites of Execution*, 3.

43. The first man electrocuted at Sing Sing was Harris A. Smiler on July 7, 1891. Lewis E. Lawes, *Life and Death in Sing Sing* (New York: Doubleday, 1928), 186.

44. Edison, quoted in *New York Morning Sun*, June 24, 1888, from Essig, *Edison and the Electric Chair*, 202.

45. "A Failure: The Electrical Torture of William Kemmler," *Buffalo Express*, August 8, 1890.

46. Essig, *Edison and the Electric Chair*, 235. Electrocution was legalized in New York State on June 4, 1888, when Governor David B. Hill signed a bill that authorized death to "be inflicted by causing to pass through the body of the convict a current of electricity of sufficient intensity to cause death." *New York Herald*, April 20, 1890, cited in *Edison and the Electric Chair*, 239.

47. Robert G. Elliot with Albert R. Beatty, *Agent of Death: The Memoirs of an Executioner* (New York: E. P. Ditton, 1940), 38, 92.

48. Essig, *Edison and the Electric Chair*, 226, 228.

49. Ibid., 226.

50. "Device for the Execution of Criminals," *Electrical World* 14, no. 22 (June 2, 1883): 341. Sheridan's device was an electric chair with a brass button that touched the spinal cord, two brass knobs at the end of the arms that the criminal would hold, and a footrest with a brass plate. The condemned would have to wear a collar put on in the "same manner as the noose end used in hangings." However, it is ironic that the degree of certitude evinced by Sheridan (death by electrocution occurred "instantly and without pain") is sharply undercut in "Electricity—What Is It?," which appeared on the following page. While physicists know something of the properties of electricity, "its origin and character are wrapped in a profound mystery" (342).

51. Essig, *Edison and the Electric Chair*, 189; Brandon, *Electric Chair*, 82. The Death Penalty Commission Report provided the legal framework for the substitution of hanging by electrocution, although the bulk of the document was devoted to describing, in alphabetical order, virtually every method of capital punishment known to mankind, including one called the "Illuminated Body," in which "tiny holes were bored throughout the skin, oil and tapirs [*sic*] pushed inside, and at a given moment, simultaneously lighted." Essig, *Edison and the Electric Chair*, 95.

52. "A Roasting of Human Flesh in Prison—Strong Men Sickened and Turned from the Sight," *New York World*, August 7, 1890, 1. According to Denno, the term *botched* was used to describe Kemmler's execution and from then on became the standard refrain. Denno, "Is Electrocution an Unconstitutional Method of Execution?," 565n20. Falsely declared dead after an initial seventeen-second current, Kemmler's body began to twitch, and after a mad scramble and a wait of several minutes as a result of a faulty dynamo, a second current was applied for seventy seconds, during which time his body began to burn. The *New York Times* described the stench as "unbearable." "Far Worse than Hanging," *NYT*, August 7, 1890, 1.

53. Brian, *Sing Sing*, 52–53.

54. Jesse Taferno's electrocution on May 4, 1990, eerily replicates what happened to William Kemmler one hundred years earlier: Taferno received third-degree burns to his face and head, which caused the room to fill with the smell of burning flesh. Taferno's head and chest continued to move even after the second surge of current. Chris Greer, "Delivering Death: Capital Punishment Botched Executions and the American News Media," in *Captured by the Media: Prison Discourse in Popular Culture*, ed. Paul Mason (Cullompton, UK: Willan, 2006), 89.

55. Denno, "Is Electrocution an Unconstitutional Method of Execution?," 605. For more "botched electrocutions" throughout the twentieth century, see Essig, *Edison and the Electric Chair*, 261; and Elliot and Beatty, *Agent of Death*, 57. To test that the electric chair was working, the *Buffalo Evening News* reported that a "gaunt worn-out horse" was electrocuted in it the day before Kemmler. "It Is Guess Work," *Buffalo Evening News*, August 16, 1890, 1.

56. See Daniel Allen Hearn, *Legal Executions in New York State: A Comprehensive Reference, 1639–1963* (Jefferson, NC: McFarland, 1997), 81–91. Ohio, Massachusetts, and New Jersey adopted electrocution immediately after New York; the next batch occurred in the South and included North Carolina, Kentucky, and South Carolina. Essig, *Edison and the Electric Chair*, 282.

57. Morus, *Frankenstein's Children*, 12.

58. "Dynamo-Electric Dangers," *Operator and Electrical World* 15, no. 1 (January 6, 1883): 1.

59. For more on galvanism in Britain, see Iwan Rhys Morus, *Shocking Bodies: Life, Death and Electricity in Victorian England* (Stroud, UK: History, 2011), 20–38.

60. Brandon, *Electric Chair*, 18.

61. Essig, *Edison and the Electric Chair*, 8, 41. A famous cinematic example is Boris Karloff's revival after electrocution in *The Walking Dead* (Michael Curtiz, 1936).

62. John [Giovanni] Aldini, *An Account of the Galvanic Experiments Performed . . . on the Body of a Malefactor Executed at Newgate, January 17, 1803* (London: Cutchell and Martin, 1803), 8–10, cited in Essig, *Edison and the Electric Chair*, 42. Aldini applied electricity to several executed corpses, making them "briefly breathe, twitch, grimace, and kick." Nadis, *Wonder Shows*, 33.

63. Mary Shelley, *Frankenstein; or, The Modern Prometheus* (London: Lackington, Hughes, Harding, Mavor, and Jones, 1818), 56. Dr. Frankenstein gives life to his hybridized monster by harnessing electricity's power in virtually the same way as doctors, EMS technicians, and even members of the public do when a medical emergency requires use of a cardiac resuscitation unit.

64. Essig, *Edison and the Electric Chair*, 178, 180. According to Spierenburg, live burial was classified as a "merciful" form of capital punishment, representing a "decent alternative to hanging in France until the 16th century." Spierenburg, "Body and the State," 54.

65. Laurent Mannoni, *The Great Art of Light and Shadow: Archaeology of the Cinema* (Exeter: University of Exeter Press, 2000), 141.

66. "Electrical Marionettes," *Electrical World* 12 (November 17, 1883): 192.

67. David A. Cook, *A History of Narrative Film*, 4th ed. (New York: Norton, 2004), 426.

68. Christoph Asendorf, *Batteries of Life: On the History of Things and Their Perception in Modernity*, trans. Don Reneau (Berkeley: University of California Press, 1993), 155–56.

69. Ibid., 156.

70. Steven Dimeo cited in William F. Nolan, introduction to Bradbury, *The Last Circus and The Electrocution* (Northridge, CA: Lord John, 1980), xvii. Bradbury originally published "The Electrocution" under the pseudonym William Elliott in *The Californian* (August 1946).

71. Vanessa Toulmin, "Within the Reach of All: Travelling Cinematograph Shows on British Fairgrounds, 1896–1914," in *Travelling Cinema in Europe*, ed. Martin Loiperdinger (Frankfurt: Stroemfeld/Roter Stern, 2008), 19.

72. Anonymous, "Our First Anniversary," *SOH* 2, no. 1 (April 21, 1900): 12.

73. Ralph Blumenthal, *Miracle at Sing Sing: How One Man Transformed the Lives of America's Most Dangerous Prisoners* (New York: St. Martin's, 2004), 55.

74. Essig, *Edison and the Electric Chair*, 237.

75. Anonymous, "Prison Removal Committee Urge Abandonment of Electrocution," *Democratic Register*, November 16, 1928.

76. Musser, *Before the Nickelodeon*, 187; Auerbach, *Body Shots*, 37; Whissel, *Picturing American Modernity*, 154.

77. Whissel, *Picturing American Modernity*, 154.

78. Musser, *Before the Nickelodeon*, 189.

79. Thomas Mott Osborne, quoted in Rudolph Chamberlain, *There Is No Truce: A Life of Thomas Mott Osborne* (New York: Macmillan, 1935), 235.

80. Tom Gunning, "Phantasmagoria and the Manufacturing of Illusions of Wonder: Towards a Cultural Optics of the Cinematic Apparatus," in *The Cinema: A New Technology for the 20th Century*, ed. André Gaudreault, Catherine Russell, and Pierre Véronneau (Lausanne, Switzerland: Editions Payot Lausanne, 2004), 33.

81. Cook, *History of Narrative Film*, 426.

82. Terry Castle, *The Female Thermometer: Eighteenth-Century Culture and the Invention of the Uncanny* (New York: Oxford University Press, 1995), 142, 144.

83. Ibid., 141, 151.

84. Osborne's experience as recounted by Chamberlain in *There Is No Truce*, 258.

85. Cited in Musser, *Before the Nickelodeon*, 188. Emphasis added.

86. Lewis E. Lawes, *Twenty Thousand Years in Sing Sing* (New York: A. L. Burt, 1932), 8. Emphasis added. To mitigate the stench of burning flesh at the double execution of Kenneth Hale and John Leak in 1925, the sheriff lit a cigar in the small North Carolina execution room (Seitz, "Electrocution and the Tar Heel State," 114).

87. Gunning, "Phantasmagoria and the Manufacturing of Illusions," 35.

88. "Report of the Committee of the Medico-Legal Society on the Best Method of Execution of Criminals by Electricity," *Medico-Legal Journal* 6 (1888–1889): 278, cited in Essig, *Edison and the Electric Chair*, 228.

89. Thomas Mott Osborne, *Within Prison Walls: Being a Narrative of Personal Experience During a Week of Voluntary Confinement in the State Prison at Auburn, New York* (Rome, NY: Spruce Gulch, 1914), 232; Lawes, *Life and Death in Sing Sing*, 161, 170.

90. Masur, *Rites of Execution*, 113. Some death row inmates embraced the theatricality of their own execution; there are accounts of men walking the forty-foot distance from cell to electric chair on their hands, singing loudly, cracking jokes vaudeville style (a man named George Appel announced, "Well, folks, you'll now see a baked Appel"), and requesting in advance to die not in the regulatory prison stripes but in pressed white shirts (Elliot and Beatty, *Agent of Death*, 166). See Elliot and Beatty, 168, for more examples of electric chair humor. Elliot mentions that the killer of a sheriff requested a "clean white shirt to wear to the chair" (158). Women, too,

dressed for the occasion, as evidenced by the long black satin dress, with narrow ruffles at the bottom to maintain modesty, and tight-fitting blouse worn by Mrs. Roxalana Druse of Herkimer, New York, to her execution. A bouquet of roses from her daughter was pinned to her blouse (Brandon, *Electric Chair*, 42).

91. Seitz, "Electrocution and the Tar Heel State," 104.

92. Elliot and Beatty, *Agent of Death*, 147.

93. Susan Ashbrook Harvey, *Scenting Salvation: Ancient Christianity and the Olfactory Imagination* (Berkeley: University of California Press, 2006), 7.

94. Electrocution as cinema may also be considered a progenitor of contemporary 4-D entertainment; found most often at tourist sites and zoos, the experience integrates smell, motion, and touch into the (costly) brief screening. Both the London Eye and Central Park Zoo have 4-D screenings.

95. Carlos F. MacDonald, "The Trial, Execution, Autopsy and Mental State of Leon F. Czolgosz, Alias Fred Nieman, the Assassin of President McKinley," *Philadelphia Medical Journal* 9 (January 4, 1902): 33. Emphasis added. For a record of New York State electrocutions, see Negley K. Teeters, "Electrocutions in New York State Prison by Counties: From the First at Auburn, August 6, 1890 to Probably the Last, in Sing Sing, August 15, 1963: Total 695," New York Historical Society.

96. Opponents to capital punishment were galvanized in the 1840s, flooding the public with books, pamphlets, and reports; as Louis P. Masur notes, "ministers, editors, and lecturers better known for their devotion to other moral and social causes adopted the anti-gallows movement as their own." Masur, *Rites of Execution*, 117.

97. Sing Sing Inmate No. 77681 cited in Lawes, *Life and Death in Sing Sing*, 180–81. For more on unusual, often macabre inmate behavior prior to electrocution and ironic factoids about the death house, see Lawes, *Life and Death in Sing Sing*, 176–81.

98. Andrea Stulman Dennett, *Weird and Wonderful: The Dime Museum in America* (New York: New York University Press, 1997), 58; Harold Kellock and Beatrice Houdini, *Houdini: His Life Story, from the Recollections and Documents of Beatrice Houdini* (New York: Blue Ribbon, 1931), 122.

99. Kellock and Houdini, *Houdini*, 64. For more on Houdini's magic in relation to cinema, see Matthew Solomon, *Disappearing Tricks: Silent Film, Houdini, and the New Magic of the Twentieth Century* (Urbana: University of Illinois Press, 2010).

100. I thank Matthew Solomon for this information on the *Master Mystery* serial. Houdini also made *The Grim Game* (Irvin Willat, 1919) and *Terror Island* (James Cruze, 1920), both featuring his escapology; neither film was financially successful. The *Master Mystery* series was shown at Sing Sing in March 1919, a reviewer in the prisoner-published *Star-Bulletin* praising the "ingenious professor in the art of 'escape'" for putting his performances in "perpetual form." "On the Screen at Sing Sing: The Master Mystery," *Star-Bulletin* 20, no. 9 (March 1919): 12.

101. The black leather mask worn by the condemned had an opening for the nostrils. It hid the face and held the head against the headrest. An electrode attached to a skullcap was placed on top of the head.

102. Kellock and Houdini, *Houdini*, 275, 287.

103. Solomon, *Disappearing Tricks*, 81.

104. For a fascinating discussion of the role of race in death penalty verdicts in Florida, see Ken Driggs, "A Current of Electricity Sufficient in Intensity to Cause Immediate Death: A Pre-*Furman* History of Florida's Electric Chair," *Stetson Law Review* 22, no. 1 (1993): 1169–209. Other Southern states showed similar patterns of inequity. In Virginia, for example, all but 17 of 148 people executed between 1908 and 1930 were African American. Essig, *Edison and the Electric Chair*, 281.

105. For more on Houdini's affiliation with prisons and how his body is resignified within popular discourses of masculinity, see John F. Kasson, *Houdini, Tarzan, and the Perfect Man: The White Male Body and the Challenge of Modernity in America* (New York: Hill and Wang, 2001), 8–142.

106. Kellock and Houdini, *Houdini*, 344; Blumenthal, *Miracle at Sing Sing*, 152.

107. Nadis, *Wonder Shows*, 125.

108. Paula Marantz Cohen, *Silent Film and the Triumph of the American Myth* (New York: Oxford University Press, 2001), 48. For a discussion of corporeality in relation to real and mythical men, see Kasson, *Houdini, Tarzan, and the Perfect Man*.

109. "Wizard in Gaol: Opens Cell and Is Taken for the Devil. His 61st Escape," *Daily Express* (London), February 2, 1904.

110. Guy Geltner, *The Medieval Prison: A Social History* (Princeton, NJ: Princeton University Press, 2008), 93–94.

111. The last woman to die in the electric chair before Ruth Snyder was Martha Place in 1899. Elliot and Beatty, *Agent of Death*, 184. According to Lawes, more than 2,500 men, women, and children gathered outside the prison on the night of Snyder's execution, planes circled overhead, and one might have thought it was homage to a "modern Joan of Arc," not a murderess who was facing the death chamber. Said Lawes, "If the body had been offered for exhibition, hundreds of thousands would have fought for the privilege of buying tickets." Lawes, *Life and Death*, 241. For tabloid coverage of the Snyder case and its resignification in *Double Indemnity*, see V. Penelope Pelizzon and Nancy Martha West, "Multiple Indemnities: Film Noir, James M. Cain, and Adaptations of a Tabloid Case," *Narrative* 13, no. 3 (October 2005): 211–37.

112. Efforts to prosecute Howard and the *Daily News* were unsuccessful; the photograph caused a sensation and became a rallying cry for death penalty opponents. Howard became an overnight star photographer and went on to become head of photography for the White House. See Alex Selwyn-Holmes, "An Execution at Sing Sing,"

Iconic Photos, May 13, 2009, http://iconicphotos.wordpress.com/2009/05/13/an-execu tion-at-sing-sing/.

113. See John E. Drewry, "Presidential Address: The Journalist's Inferiority Complex," *Journalism Quarterly* 8 (1931): 12–23, cited in Matthew C. Ehrlich, "Facts, Truth, and Bad Journalists in the Movies," *Journalism* 7, no. 4 (2006): 504.

114. Linda Williams, "Melodrama in Black and White: Uncle Tom and *The Green Mile*," *Film Quarterly* 55, no. 2 (Winter 2001): 17.

115. Tania Modleski, "In Hollywood, Racist Stereotypes Can Still Earn 4 Oscar Nominations," review of *The Green Mile*, *Chronicle of Higher Education*, March 3, 2000, B10; Williams, "Melodrama in Black and White," 17. According to Williams, *The Green Mile* reenacts "all the worst anti-Tom scenarios of the paranoid white racist imagination in order to disavow them . . . rescu[ing] white Americans from the guilt of putting the innocent black man to death" (20). The Christian press constitutes a third interpretive community that identified with the film's anagogic themes, viewing John Coffey as a redemptive Christlike figure and the film as an allegory of the Christian Passion. For a discussion of different readings of the film, see A. Susan Owen and Peter Ehrenhaus, "Communities of Memory, Entanglements, and Claims of the Past Upon the Present: Reading Race Trauma Through *The Green Mile*," *Critical Studies in Mass Communication* 27, no. 2 (June 2010): 131–54.

116. Christopher John Farley, "That Old Black Magic," *Time*, November 27, 2000, 14, cited in Heather J. Hicks, "Hoodoo Economics: White Men's Work and Black Men's Magic in Contemporary American Film," *Camera Obscura* 18, no. 2 (2003): 27.

117. Owen and Ehrenhaus, "Communities of Memory," 132, 136.

118. Ibid., 147.

119. Lawes, *Twenty Thousand Years in Sing Sing*, 6.

120. When a new execution wing was built at a cost of $300,000 in 1922, it was officially named the "Condemned Cells." The original death house became a registration room for new inmates, an ironic reversal of a space's use value, since this was now an inmate's first, as opposed to last, view of Sing Sing. Facing the clerk who logged them into the register, inmates stood in front of what was once the "little green door" (now painted brown) leading into the execution chamber. "What tragic tales of weakness, sin, sorrow, pain, death and despair these four walls might tell if they could speak," Lawes opined in *Life and Death*, 51.

121. "Oppenheimer Put to Death," *Los Angeles Times*, July 12, 1913.

122. For a discussion of the use of film on death row in San Quentin Prison in the 1940s, see Clinton T. Duffy, *San Quentin: The Story of a Prison, as Told to Dean Jennings* (London: Davies, 1951), 166. The films were shown weekly to the men from 1943 until at least the end of the 1940s.

123. Lawes uncredited source cited in Blumenthal, *Miracle at Sing Sing*, 99.

124. There are two additional electrocutions in *The Green Mile*. The first, while difficult to watch, has no obvious mistakes or equipment malfunctions. The second is horrific beyond words and reminiscent of the bloodcurdling fiasco that was William Kemmler's electrocution. The procedure is sabotaged by a sociopathic guard, who places a dry, instead of a wet, sponge on the condemned man's shaved head, which causes the prisoner's body to burst into flames and be charred beyond recognition.

125. Seitz, "Electrocution and the Tar Heel State," 104.

126. Essig, *Edison and the Electric Chair*, 46.

127. *New York Sun*, December 1, 1878, cited in Essig, *Edison and the Electric Chair*, 46. Emphasis added. The punishment is also referenced in the *Annual Report of the Ohio Penitentiary . . . for the Fiscal Year 1895* (Columbus, OH: Westbote, 1895), 28–29.

128. Essig, *Edison and the Electric Chair*, 3.

129. Another use of electricity to inflict punishment on inmates was the "humming bird," an electrical torture device in which a naked prisoner sat in a shallow metal tank filled with water connected with an electrode from a dynamo and was shocked repeatedly as a wet sponge passed slowly over his body by a guard wearing a rubber glove served as the second electrode; see Charles Edward Russell, "Beating Men to Make Them Good," *Hampton's Magazine* 23, no. 5 (November 1, 1909): 619.

130. Bruce Crowther, *Captured on Film: The Prison Movie* (London: Batsford, 1989), 37.

131. Lewis E. Lawes, "An Address Delivered by Warden Lawes of Sing Sing," *New School for Social Research*, April 27, 1931.

132. Blumenthal, *Miracle at Sing Sing*, 160.

133. Elliot and Beatty, *Agent of Death*, 133. The *New York Times* recently ran a story about one of the few remaining arts-in-corrections programs, the Actors' Gang theater program, which presented Molière's *Tartuffe* at the California Rehabilitation Center in Norco. See Adam Nagourney, "An Actors' Studio Behind Bars Energizes Inmates," *NYT*, July 1, 2011, A1, 11, 15.

134. Essig, *Edison and the Electric Chair*, 290. For more on the reformation of theater space and shifts in representational practices to reflect the influence of women's domesticity, see Lee Grieveson, *Policing Cinema: Movies and Censorship in Early Twentieth-Century America* (Berkeley: University of California Press, 2004), 78–120.

135. Essig, *Edison and the Electric Chair*, 290.

136. Texas and Oklahoma were the first states to change to lethal injection, quickly followed by several others. Charles Brookes Jr. was the first man to be executed by lethal injection, on December 8, 1982. Marlin Shipman, "Killing Me Softly? The Newspaper Press and the Reporting on the Search for a More Humane Execution Technology," *American Journalism* 13 (1996): 198. The Georgia Supreme Court

deemed electrocution "unconstitutionally cruel" in 2001. Essig, *Edison and the Electric Chair*, 284–85.

137. The phrase "cruel and unusual punishment" is from the Eighth Amendment, which states that "excessive bail shall not be required, nor excessive fines, nor cruel and unusual punishment." Cited in Denno, "Is Electrocution an Unconstitutional Method of Execution?," 557n24. The phrase was appropriated from the English Bill of Rights (1689), where it was intended to inhibit a return to such inhumane methods of killing as drawing and quartering and burning alive. Essig, *Edison and the Electric Chair*, 133, 181. A case brought before the U.S. Supreme Court in 2015 that argued that the three-drug cocktail currently used in lethal injection cases constitutes "cruel and unusual punishment" was overturned by a 5 to 4 majority. See Adam Liptak, "Supreme Court Allows Use of Execution Drug," *NYT*, June 30, 2015, http://www.nytimes.com/2015/06/30/us/supreme-court-execution -drug.html?_r=0.

138. Elliot and Beatty, *Agent of Death*, 230. Elliot was paid $150 per execution by New York State (101).

139. Ibid., 223.

140. Ibid., 237.

141. For more on the unpredictability of hanging, see Brandon, *Electric Chair*, 32–38.

142. *Buffalo Evening News*, May 10, 1889, cited in Essig, *Edison and the Electric Chair*, 167. In Brandon's words, Kemmler was introduced to the witnesses as if by "a master of ceremonies announcing an act." Brandon, *Electric Chair*, 26.

143. Dane A. Drobny, "Death TV: Media Access to Executions Under the First Amendment," *Washington University Law Quarterly* 70, no. 4 (1992): 1180. For an excellent analysis of why the death penalty, despite garnering an approval rating of 63 percent in 2014, is increasingly too costly, difficult, and bureaucratically unmanageable, see David Von Drehle, "Bungled Executions. Backlogged Courts. And Three More Reasons the Modern Death Penalty Is a Failed Experiment," *Time*, June 8, 2015, 26–33.

144. Brian, *Sing Sing*, 60.

145. Morus, *Frankenstein's Children*, 43–98.

146. Nolan, "Introduction," *Last Circus and The Electrocution*, xvi–xvii.

147. Ibid.

148. Toulmin, "Early Crime Film Rediscovered," 37. The *Arrest of Goudie* actually consists of two rolls of negative film, the first lasting four minutes and showing eight scenes, the second lasting about one hundred seconds and showing four scenes that lead up to Goudie's arrest (41–43), emphasis added. For more on the Mitchell and

Kenyon collection, see Vanessa Toulmin, *Electric Edwardians: The Films of Mitchell and Kenyon* (London: British Film Institute, 2008).

149. Davis, *Are Prisons Obsolete?*, 18.

150. G. W. Bitzer, *Billy Bitzer: His Story* (New York: Farrar, Straus and Giroux, 1973), cited in Bottomore, "Every Phase of Present-Day Life," 159.

151. Foucault, *Discipline and Punish*, 16.

2. Prison on Screen

1. *Kinematograph and Lantern Weekly*, July 11, 1912, 715. This clipping is from Stephen Bottomore's "Early Film Collection," to which I was kindly given access.

2. Davis, *Are Prisons Obsolete?*, 18.

3. John B. Bender, *Imagining the Penitentiary: Fiction and the Architecture of Mind in Eighteenth-Century England* (Chicago: University of Chicago Press, 1987), 202.

4. Auli Ek, *Race and Masculinity in Contemporary American Prison Narratives* (New York: Routledge, 2005), 7.

5. Russell, "Beating Men," 609.

6. Peter Caster, *Prisons, Race, and Masculinity in Twentieth-Century U.S. Literature and Film* (Columbus: Ohio State University Press, 2008), 3–4.

7. For more on how masculinity and male subjectivity play out in prison films, see Din Sabo, Terry A. Kupers, and Willie London, eds., *Prison Masculinities* (Philadelphia: Temple University Press, 2001); see Ek, *Race and Masculinity*, 17–46, for an analysis of prison masculinities in science fiction and documentary film; Caster, *Prisons, Race, and Masculinity*; and Angela Y. Davis, "Race and Criminalization: Black Americans and the Punishment Industry," in *The House That Race Built: Black Americans, U.S. Terrain*, ed. Wahneema Lubiano (New York: Pantheon, 1997), 264–79.

8. Gresham M. Sykes, *The Society of Captives: A Study of a Maximum Security Prison* (1958; reprint, Princeton, NJ: Princeton University Press, 2007), 101.

9. Nicole Hahn Rafter, *Shots in the Mirror: Crime Films and Society* (New York: Oxford University Press, 2000), 121.

10. Theodore Waters, "Out with a Moving Picture Camera," *Cosmopolitan* 40, no. 3 (January 1906): 251–59.

11. These films complicate the flattening effect of Foucault's contributions to critical prison studies, an effect Caster argues can result in a glare that "shine[s] so brightly" on the projections of the cultural meanings of prisons on page, screen, and stage as to "obscure the representations themselves." Caster, *Prisons, Race, and Masculinity*, 3–4.

12. Raymond Williams, *Marxism and Literature* (New York: Oxford University Press, 1978), 132.

13. Megan Cassidy-Welch, "Prison and Sacrament in the Cult of the Saints: Images of St. Barbara in Late Medieval Art," *Journal of Medieval History* 35, no. 4 (December 2009): 371.

14. Ibid., 372. Imprisoned by Herod, Saint Peter was "chained between two guards before being freed from his prison cell by the appearance and intervention of an angel" (373).

15. Norman Johnston with Kenneth Finkel and Jeffrey A. Cohen, *Eastern State Penitentiary: Crucible of Good Intentions* (Philadelphia: Philadelphia Museum of Art, 2010), 48–51. Eschewing Bentham's radial prison design in favor of cells arranged in a parallel fashion, Wormwood Scrubs Prison in London ensured that each cell had access to direct sunlight at some part of the day and that the cell windows of one block did not overlook the yard of another. Charles Fletcher Peck, "A Model Prison," *Pall Mall Magazine* 7, no. 31 (1895): 453.

16. Jean Dunbabin, *Captivity and Imprisonment in Medieval Europe, 1000–1300* (New York: Palgrave Macmillan, 2002), 121.

17. Geltner, *The Medieval Prison*, 4. Also see R. B. Pugh, *Imprisonment in Medieval England* (Cambridge: Cambridge University Press, 1968).

18. Russell, "Beating Men to Make Them Good," 610.

19. Everett Peterson, "Crime and Punishment as Our Forefathers Knew It," *The Outlook*, ca. 1921, Scrapbook entry, folder 46, 1926–1929, p. 283, Lewis Lawes Papers, Lloyd Sealey Library, John Jay College of Criminal Justice, City University of New York (hereafter abbreviated as LLP-JJC).

20. Addison Johnson, "Annual Report of Sing Sing," *1901 Report of the Superintendent of State Prisons, New York*, 1902, 39.

21. At first glance, the image evokes the much-later figure of the early motion picture photographer, cranking the handle of the camera to record brief slivers of life in seventy-five- to one-hundred-yard rolls of film. The image is from Mayhew and Binny, *The Criminal Prisons of London*, plate next to 398.

22. Prison directors at the time came up with all manner of contraptions to "employ" their populations in (un)productive labor, maintaining the convicts' bodies as hapless pieces of machinery, constantly tweaking the number of calories so they had just enough, but never more, to complete the pointless work. At the House of Correction, Coldbath Fields, London, men sentenced to hard labor worked on a treadmill, where they were forced to ascend 12,000 feet a day, although given the restricted calories the men received, this amount was reduced to 1,200 feet. Oakum (untwisting old ropes) or coir (outer fibers of coconut) pick-

ing were other activities, unless the men and women were required to work in separate parts of the prison. Mayhew and Binny, *Criminal Prisons of London*, 288, 282.

23. Bender, *Imagining the Penitentiary*, 23–24. Questions of space naturally evoke Jeremy Bentham's oft-cited Panopticon, a prison design in which guards in a central "inspection house" could observe prisoners located around its perimeter. Bentham was influenced by French cadets in a Parisian military school who lived in individual cells made of glass so that they could be observed (and observe) at all times. Since the cadets were allowed no bodily contact with either other cadets or staff, the visual senses and a degree of self-consciousness must have made contemporary disquiet about the flimsy partition of the office cubicle a minor inconvenience compared to a life lived behind glass. Michel Foucault, "The Eye of Power: A Conversation with Jean-Pierre Barou and Michelle Perrot," in *CTRL [SPACE]: Rhetorics of Surveillance from Bentham to Big Brother*, ed. Thomas Y. Lewin, Ursula Frohne, and Peter Weibel (Cambridge, MA: MIT Press, 2002), 95.

24. *Times*, October 13, 1853, cited in Helen Johnston, "'Buried Alive': Representations of the Separate System in Victorian England," in *Captured by the Media*, 117.

25. For an analysis of the system in the British context, especially media coverage, see Johnston, "'Buried Alive,'" 103–21. Johnston notes that both the separate and silent systems (where prisoners worked in congregate labor, during which talking was forbidden, but slept in separate cells) were premised on the idea that "first offenders or young offenders could be contaminated by more experienced criminals, and that prisoners should be silent, or separated from others, to allow reflection and repentance for their criminal behavior" (106).

26. John Haviland, "Explanation of a Design for a Penitentiary," July 2, 1821, daybook 1, p. [19], Haviland Papers, cited in Johnston, Finkel, and Cohen, *Eastern State Penitentiary*, 35.

27. Johnston, Finkel, and Cohen, *Eastern State Penitentiary*, 29. Eastern State Penitentiary's design and principle of solitary confinement were adopted by more than three hundred prisons worldwide (a version of it was instituted at the Surrey House of Correction), although it had less of an influence in the United States, where the Auburn Prison or "New York system" of congregate labor (working together in silence during the day but returning to individual cells at night) won out as the more practical, and, many argued, humane, method of incarcerating and rehabilitating criminals. Nevertheless, a debate ensued among members of the Prison Society as to whether a laboring or languishing body would help or hinder the process of reform. One side argued that activity might inhibit reflection and quash the conscience,

while the other contended that the "prohibition of labor would mean the corrective results could be achieved in a shorter period of time."

28. See Peck, "A Model Prison," 455. Emphasis added.

29. For an excellent case study on prison growth in northern New York State, see Jack Norton, "Little Siberia, Star of the North: The Political Economy of Prison Dreams in the Adirondacks," in *Historical Geographies of Prisons: Unlocking the Usable Carceral Past*, ed. Karen M. Morin and Dominique Moran (London: Routledge, 2015), 168–84. New York built thirty-nine new state prisons between 1982 and 2000.

30. This "Higher Life" logo, which was created by Inmate No. 315, who signed the lower right edge of the image, appeared in *SOH* 3, no. 1 (April 20, 1901).

31. "Study Crime at Sing Sing," *Ithaca Journal-News*, February 2, 1930.

32. Sing Sing warden Lewis E. Lawes refers to the inmate projectionist in his unpublished essay "The Great Unseen Audience," 3, supplementary collection, box 1, folder 22, LLP-JJC. When there was a break in the film or a problem with the projector, Sing Sing's audience would begin a slow clap to which the ad hoc projectionist would reply, "Quit the works. What do you expect for nothing?" (ibid.).

33. Ash, *Dress Behind Bars*, 32.

34. Robin Evans, *The Fabrication of Virtue: English Prison Architecture, 1750–1840* (Cambridge: Cambridge University Press, 1982), 189–94, cited in Ash, *Dress Behind Bars*, 33.

35. Given that inmates were employed to serve food at the warden's dinner parties and work on prison construction and were even housed with other prisoners so they could learn a trade such as shoemaking, the mask was never employed systematically and was never foolproof as a means of control. Johnston, Finkel, and Cohen, *Eastern State Penitentiary*, 48–50.

36. For more on English prison history, see Philip Priestly, *Victorian Prison Lives: English Prison Biography, 1830–1914* (London: Methuen, 1985), and Martin J. Wiener, *Reconstructing the Criminal: Culture, Law, and Policy in England, 1830–1914* (Cambridge: Cambridge University Press, 1990).

37. Mayhew and Binny, *Criminal Prisons of London*, 504.

38. "The End and the Means," *SOH* 17, no. 16 (1915): 272.

39. Jeremiah O'Donavan Rossa, *Irish Rebels in English Prisons* (New York: Sadlier, 1880), 127, cited in Ash, *Dress Behind Bars*, 50.

40. Striped uniforms were abolished at Sing Sing on October 1, 1904. Addison Johnson, "Annual Report of Sing Sing," *Report of the Superintendent of State Prisons, New York*, 1904, 41.

41. Ash, *Dress Behind Bars*, 22. Many U.S. federal prisons abolished striped uniforms in 1914. Despite being abolished in Britain in 1920, the broad arrow stripe continued to be worn into the 1930s (ibid., 60).

42. Johnson, "Annual Report of Sing Sing," 1904.

43. Cornelius V. Collins, "The Prison Stripe," *Report of the Superintendent of State Prisons, New York*, 1904, 22. Being clothed in more respectful-looking uniforms engendered respect in both wearer and perceiver. In 1905, honor emblems were introduced, red stripes worn on the left sleeve for each year of good conduct (a red star indicated five years of good behavior). Cornelius V. Collins, "Honor Emblems," *Report of the Superintendent of State Prisons, New York*, 1906, 20. Uniform reform was one small victory, however, leaving such issues as a lack of toilet facilities in the cells (save buckets), overcrowding, and poor prisoner health to be addressed. The year 1906 was something of a watershed year of reform, with hair clipping upon admission abolished; tin plates and cups replaced with crockery; a comprehensive school system introduced; lightweight, washable summer clothing provided; and the Bertillon system of identification replaced with fingerprinting (since its inauguration in 1896, the Bertillon Bureau of Identification in the Prison Department in Albany had amassed records of seventy-six thousand criminals). Cornelius V. Collins, "By the Superintendent's Order," *Report of the Superintendent of State Prisons, New York*, 1907, 14; and Cornelius V. Collins, "The Parole of Prisoners," *Report of the Superintendent of State Prisons, New York*, 1905, 27.

44. John Harvey, *The Story of Black* (London: Reaktion Books, 2013), 7.

45. Ibid., 7.

46. Sykes, *Society of Captives*, 4. Gresham's investigation of the New Jersey State Maximum Security Prison, built in 1780 near Trenton, is a classic criminological study of its time, written against the backdrop of the Cold War.

47. For more on film and the Spanish-American War, see James Castonguay, "The Spanish-American War in U.S. Media Culture," *American Quarterly* 51, no. 2 (1999): 247–49, http://chnm.gmu.edu/aq/war/index.html; and the collection "The Spanish American War in Motion Pictures," Library of Congress (2006), http://memory.loc.gov/ammem/sawhtml/sawhome.html.

48. For more on the Dreyfus affair, see Eric Cahm, *The Dreyfus Affair in French Society and Politics* (New York: Routledge, 1996). For an in-depth filmography, frame grabs, and meticulous research on how the event captured the public imagination, see Luke McKernan, "Lives in Film, No. 1: Alfred Drefus," *Bioscope* (blog), pt. 1, March 10, 2010, pt. 2, March 11, 2010, pt. 3, March 14, 2010, http://thebioscope.net/?s=Dreyfus&submit=Search.

49. Crowther, *Captured on Film,* 38.

50. See Castonguay, "Spanish-American War in U.S. Media Culture," 247–49.

51. For an introduction to the British newsreel, with contemporaneous essays and context, see Luke McKernan, ed., *Yesterday's News: The British Cinema Newsreel Reader* (London: British Universities Film and Video Council, 2002).

52. The film can be viewed at http://www.screenonline.org.uk/film/id/734361/.

53. For an analysis of the treatment of WWI prisoners, see Heather Jones, *Violence Against Prisoners of War in the First World War: Britain, France, and Germany, 1914–1920* (Cambridge: Cambridge University Press, 2011).

54. Lawes, *Twenty Thousand Years*, 100.

55. Robert Herring, "The News-Reel," in *In Letters of Red*, ed. E. Allen Osborne (London: Joseph, 1938), cited in McKernan, *Yesterday's News*, 114.

56. Calvyn Pryluck, "Ultimately We Are All Outsiders: The Ethics of Documentary Filmmaking," in *New Challenges for Documentary*, ed. Alan Rosenthall (Berkeley: University of California Press, 1988), 260. For a theoretical reading of the return gaze, see Paula Amad, "Visual Riposte: Looking Back at the Return of the Gaze as Postcolonial Theory's Gift to Film Studies," *Cinema Journal* 52, no. 3 (Spring 2013): 49–74.

57. New York State Commission of Prisons, *Annual Report* (1899), 14–15, cited in McLennan, *Crisis of Imprisonment,* 226.

58. For more on the kinds of crimes women were arrested for and their unfair treatment by the judicial system, see Lucia Zedner, "Wayward Sisters: The Prison for Women," in *The Oxford History of the Prison: The Practice of Punishment in Western Society*, ed. Norval Morris and David J. Rothman (New York: Oxford University Press, 1995). I discuss women's criminology in greater depth in chapter 5.

59. Rogers tricked her husband, Marcus Rogers, into getting his hands tied behind his back, forced him to inhale chloroform until he fell unconscious, and then tried to stage a suicide by drowning by dragging his body to the river and tacking a suicide note to a tree, along with his hat. The resolution to commute Rogers's sentence was adopted by the Vermont House but rejected by the Senate. Information on Rogers from "Mary Rogers (Murderer)," *Wikipedia*, last modified October 25, 2015, http://en.wikipedia.org/wiki/Mary_Rogers_(murderer).

60. According to Laurent Le Forestier, the Pathé catalog advertises *Le bagne des gosses*'s modular structure through detailed descriptions of the various tableaux, all of them, Forestier argues, autonomous. The film is even connected to another Pathé title featuring the same ensemble actors, *Les Apaches de Paris* [Apaches in Paris] (1905), a hugely successful film with ongoing appeal. Laurent Le Forestier, "From Craft to Industry: Series and Serial Production Discourses and Practices in France," in *A Companion to Early Cinema*, ed. André Gaudreault, Nicolas Dulac, and Santiago Hidalgo (Chichester, UK: Wiley, 2012), 196.

61. Paul Mason, "Relocating Hollywood's Prison Film Discourse," in *Captured by the Media,* 204; Sykes, *Society of Captives*, 66.

62. Devil's Island was a prison settlement comprising three islands: Iles du Diable, Royale, and St. Joseph. Conditions were so bad that the complex simply became known as Devil's Island (Ile du Diable). Crowther, *Captured on Film*, 46.

63. Richard Abel, *The Ciné Goes to Town: French Cinema, 1896–1914* (Berkeley: University of California Press, 1998), 185.

64. The Auburn system of congregant labor by day and isolation in the single cell by night is in effect in the French "maison de correction," although there is an obvious comic element to seeing eight- to fourteen-year-old boys as opposed to adult men dressed in prison stripes performing hard labor.

65. The image of children being subjected to punishments that hardly match their crimes raises the question of the potential bad taste of a film like *Le bagne des gosses*. For a discussion of Pathé's reception in the United States, and the censorship problems it ran into, see Richard Abel, *The Red Rooster Scare: Making Cinema American, 1900–1910* (Berkeley: University of California Press, 1999), 94–106.

66. Jonas Hanway, *Distributive Justice and Mercy* (London: J. Dodsey, 1781), 65, cited in Smith, *The Prison*, 96.

67. The book was on display in the 2011 exhibit "Pilgrims" at St. Catherine Convent Museum, Utrecht, Netherlands.

68. Christopher Hale, "Punishment and the Visible," in *The Prison Film*, ed. Mike Nellis and Christopher Hale (London: Radical Alternatives to Prison, 1982), 62.

69. Prison escape films not discussed here include *The Prisoner's Escape* (Gaumont, 1907), in which a prisoner jumps through a window and is pursued by guards (see review in *MPW* 1, no. 20 [July 20, 1907]: 314), and *The Jail Bird and How He Flew* (Vitagraph, 1906), in which an escaped inmate is pursued by a man with a rifle and four prison guards and evades capture by donning multiple disguises including a scarecrow, a woman pushing a stroller, and a gentleman whose back is striped from sitting on a recently painted bench is wrongfully captured as the escaped convict. Thanks to Maggie Hennefeld for alerting me to this film.

70. "Miles of Moving Pictures," *Washington Post* [first reported in the *Kansas City Star*], January 9, 1907, 6.

71. Richard Kozarski, "Introduction to Theodore Water's 'Out with a Motion Picture Camera,'" *Film History* 15, no. 4 (2003): 399, 396.

72. As Jan Olsson notes, *Escape from Sing Sing*'s long run in the market meant it was singled out among a group of sensational titles in the 1907 crusade against motion pictures in Chicago. Jan Olsson, *Los Angeles Before Hollywood: Journalism*

and American Film Culture, 1905–1915 (Stockholm: National Library of Sweden, 2009), 43. The film is a lost title.

73. Kozarski, "Introduction," 397.

74. Ibid.

75. Waters was cast as an extra, playing one of the convicts escaping from Sing Sing in the film, clad in stripes and a witness to the violent assault on the warden that led to freedom; later in the film a guard is beaten and choked into "feigned insensibility." Waters, "Out with a Moving Picture Camera," 399.

76. Ibid., 402.

77. Sarat, *When the State Kills*, 212.

78. Prison as a permeable space is an enduring concept, referencing not only the idea of questionable security, but, as Sykes argued in *Society of Captives*, "the relationship between the prison social system and the larger social system upon which it rests." Sykes, *Society of Captives*, 8.

79. Maggie Hennefeld discusses the "grammar" of bodily metamorphosis in the convict trick film in "Miniature Women, *Acrobatic Maids*, and Self-Amputating Domestics: Comediennes of the Trick Film," *Early Popular Visual Culture* 13, no. 2 (May 2015): 135.

80. Kellock and Houdini, *Houdini*, 344.

81. Ibid.; see also 13–121, 188–97.

82. See Solomon, *Disappearing Tricks*, for an analysis of cinema's relationship to magic during the early cinema period.

83. Maggie Hennefeld, "Destructive Metamorphosis: From Convicts to Comediennes in Vitagraph's Transitional Trick Films," paper presented at Society for Cinema and Media Studies Conference, Chicago, March 2013, 4. Also see the special issue of *Early Popular Visual Culture* entitled "Tricks and Effects," 13, no. 2 (May 2015).

84. Quote from unidentified prisoner study participant. Edward Zamble and Frank J. Porporino, *Coping, Behavior, and Adaptation in Prison Inmates* (New York: Springer-Verlag, 1988), 114.

85. Yvonne Jewkes, *Captive Audiences: Media, Masculinity and Power in Prisons* (Cullompton, UK: Willan, 2002), 111.

86. *American Heritage Dictionary of the English Language*, 5th ed., s.v. "impossible," http://www.thefreedictionary.com/impossible.

87. See pages 650 and 651 of folder 48 (1926–1930, primarily 1929), box 9, series 6, General Scrap Books, LLP-JJC, for press coverage of the drowning.

88. "A Convict's Sacrifice," *MPW* 5, no. 5 (July 31, 1909): 160. Gaumont released a virtual remake of the story in the form of *A Convict's Heroism* (1909); the *MPW*

called the film a "prisoner with a heart of gold narrative." "The Convict's Heroism," *MPW* 5, no. 21 (November 20, 1909): 731.

89. Tom Gunning, *D. W. Griffith and the Origins of American Narrative Films: The Early Years at Biograph* (Urbana: University of Illinois Press, 1991), 208–9.

90. The phrase "lulled into lassitude" riffs on an argument about the consequences of boredom and monotony on the prisoner population in a Canadian prison study conducted by Edward Zamble and Frank J. Porporino. See Zamble and Porporino, *Coping, Behavior, and Adaptation*, 114.

91. Lewis E. Lawes, "Capital Punishment Tends to Make More Murderers," *New York Times Book Review*, December 2, 1928, 11.

92. *MPW* ad, December 27, 1913, reproduced in Kevin Brownlow, *Behind the Mask of Innocence: Sex, Violence, Prejudice, Crime in the Silent Era* (London: Cape, 1990), 241. Emphasis added.

93. Prisons were high on the list of must-see places for dignitaries, celebrities, and Hollywood executives. D. W. Griffith visited Sing Sing in 1928. Blumenthal, *Miracle at Sing Sing*, 158.

94. For a discussion of how prison's rites of passage are liminal, see Bender, *Imagining the Penitentiary*, 26–35. Bender draws upon anthropologist Victor Turner's ideas of liminality, arguing that prison enacts a form of symbolic demise in which the neophyte prisoners are, in Turner's words, "neither living nor dead from one aspect, and both living and dead from another." Victor Turner, "Betwixt and Between: The Liminal Period in *Rites de Passage*," *Proceedings of the American Ethnological Society* (1964): 4–20, reprinted in *Reader in Comparative Religion: An Anthropological Approach*, 3rd ed., ed. William A. Lessa and Evon Z. Vorgt (New York: Harper and Row, 1972), 360, cited in Bender, *Imagining the Penitentiary*, 26.

95. Mike Nellis, "Notes on the Prison Film," in *The Prison Film*, 46. Jan Alber traces the ideological valences of twentieth-century prison films to Charles Dickens's novels, in which prisons proliferate. Dickens's novels normalized the image of incarceration for mass audiences in the nineteenth century in similar ways to motion pictures. Alber, "The Ideological Underpinnings of Prisons and Their Inmates," 133.

96. See, for example, Zamble and Porporino's study of Canadian male prisoners, *Coping, Behavior, and Adaptation*, 83.

97. According to Jamie Bennett, even in reform-minded prison films from the 1990s to the 2000s, the commercial imperative of popular entertainment makes it hard to critically engage with the idea. See Jamie Bennett, "Reel Life After Prison:

Repression and Reform in Films About Release from Prison," *Probation Journal* 55, no. 4 (2008): 364.

98. Lawes, "Great Unseen Audience," 8–9.

99. Charles Dickens, *American Notes* (1842; London: Collins, 1906), 154, cited in Johnston, "'Buried Alive,'" 108.

100. The "era-based" approach is used by Derral Cheatwood in "Prison Movies: Films About Adult, Male, Civilian Prisons: 1929–1995," in *Popular Culture, Crime, and Justice*, ed. Frankie Bailey and Donna Hale (Albany: West/Wadsworth Publishing, 1998). Prison sociologist Paul Mason rightly takes umbrage with this method, arguing that "these oversimplified taxonomies become tautologous, where historical periods narrowly defined . . . serve simply as artificial frames wedged round an ill-fitting pile of prison films which may or may not be justifiably grouped together based on their release date. This practice becomes a one-eyed decontextualizing of the prison film, the purpose of which seem to be seeking out films which prove the category works, rather than exploring what discourse(s) Hollywood constructs through its representation of prison at particular historic moments." Mason, "Relocating Hollywood's Prison Film Discourse," 196–97.

101. Jewkes, "Creating a Stir? Prisons," 140–41. Geltner traces prison as a source of multisensory stimulation to the Middle Ages, quoting from a fourteenth-century manuscript in which prisoners' "cries, their outstretched hands, even their scent, were strongly present," ASV, MSDel. 18 [Liber Spiritus], fols. 329v–330r (January 22, 1344), cited in Geltner, *Medieval Prison*, 72.

102. Claire Valier, "Looking Daggers: A Psychoanalytical Reading of the Scene of Punishment," *Punishment and Society* 2, no. 4 (2000): 380. Vincent Van Gogh's painting *La ronde des prisonniers* was based on an engraving of Gustave Doré's sketch of prisoners exercising at Newgate Prison in London, an illustration in Gustave Doré and Blanchard Jerrold, *London: A Pilgrimage* (London: Grant, 1872; reprint, Mineola, NY: Dover, 1970).

103. We are also implicated as taxpayers in the business of corrections; as Cheatwood argues, "The motion picture audience forms the constituency of the elected legislatures of the states, and the legislature is the direct source of the funding necessary for any change or improvement in the correctional system." Cheatwood, "Prison Movies," 209–10.

104. A celebrated graphic artist in his own country, Doré visited London for the first time in 1868. See the introduction and chapter 17, "Under Lock and Key," of his book cowritten with Jerrold, *London*, ix, 136.

105. Ek, *Race and Masculinity*, 7.

106. See Grieveson, *Policing Cinema*, for an adroit analysis of how issues of governance and culture played out and were shaped by modernity, immigration, gender, and social class.

107. See, for example, Cheatwood, "Prison Movies," 217–27.

108. Bender, *Imagining the Penitentiary*, 226.

109. Garland, *Punishment and Modern Society*, 1.

110. Nellis, "Notes on the Prison Film," 46; also see Mike Nellis, "The Aesthetics of Redemption: Released Prisoners in American Film and Literature," *Theoretical Criminology* 13, no. 1 (2009): 129–46.

111. Christopher Hale discusses this famous image from Hardy's memory. Hale, "Punishment and the Visible," 90. As Ralph Pite argues, this description ties in with the "persistent impression . . . that looking was for Hardy a highly erotic activity. Women are gazed at, with an eye that is almost voracious. The female body is regarded, anatomized, and appreciated—it is visually consumed." Ralph Pite, *Thomas Hardy: The Guarded Life* (New Haven, CT: Yale University Press, 2007), 238.

112. Sergei Eisenstein, "Constanza (Whither "The Battleship Potemkin") in *Selected Works*, vol. 1, *Writings, 1922–1934*, ed. and trans. Richard Taylor (Bloomington: Indiana University Press, 1988), 75. Cited in James Goodwin, *Eisenstein, Cinema, and History* (Urbana: University of Illinois Press, 1993), 60–61.

3. Screens and the Senses in Prison

1. "Christmas Movies Delight Prisoners: Local Theater Manager and Two Actors at State Prison," *Hartford Courant*, December 26, 1914, 5. Warden Ward A. Garner had recently undertaken a number of reforms at the state prison in Connecticut, including lifting the ban on talking at mealtimes.

2. For more on the representation of prisons in film, see Crowther, *Captured on Film*.

3. For more on nontheatrical film exhibition, see Gregory Waller, *Moviegoing in America: A Sourcebook in the History of Film Exhibition* (London: Blackwell, 2002); Gregory Waller, *Main Street Amusements: Movies and Commercial Entertainment in a Southern City, 1896–1930* (Washington, DC: Smithsonian Institution, 1995); Scott Curtis, *The Shape of Spectatorship: Art, Science, and Early Cinema in Germany* (New York: Columbia University Press, 2015); Alison Griffiths, *Wondrous Difference: Cinema, Anthropology, and Turn-of-the-Century Visual Culture* (New York: Columbia University Press, 2001), and *Shivers Down Your Spine: Cinema, Museums, and the Immersive View* (New York: Columbia University Press, 2008);

Charles R. Acland and Haidee Wasson, eds., *Useful Cinema* (Durham, NC: Duke University Press, 2011); Kathryn Fuller-Seeley, *At the Picture Show: Small-Town Audiences and the Creation of Movie Fan Culture* (Norfolk: University of Virginia Press, 2001); Devin Orgeron, Marsha Orgeron, and Dan Streible, eds., *Learning with the Lights Off: Educational Film in the United States* (New York: Oxford University Press, 2012); and Vinzenz Hediger and Patrick Vonderau, eds., *Films That Work: Industrial Film and the Productivity of Media* (Amsterdam: Amsterdam University Press, 2009).

4. Haidee Wasson and Charles R. Acland, "Introduction: Utility and Cinema," in Acland and Wasson, *Useful Cinema*, 3.

5. Zebulon R. Brockway, "The Reformatory System," in *The Reformatory System in the United States: Reports Prepared for the International Prison Commission*, ed. Samuel J. Barrows (Washington, DC: Government Printing Office, 1900), 42.

6. "MWL Educational Activities," *SOH* 16, no. 18 (January 30, 1915): 295. Emphasis added. Russian prisons boasted a vibrant magazine culture, with 432 printed prison papers in circulation. In Kharkov, the most popular prison paper had a circulation of seventy thousand including civilian subscribers; see Alfred Richman, "Prisons in Soviet Russia," file 29, Miscellaneous Drafts Submitted to Lawes, box 4, series 1, Personal Papers: A Correspondence, Correspondence Scrapbooks (1925–1932), LLP-JJC.

7. "Making the Old Bit Pay Dividends," *Baltimore Sun*, August 3, 1930, SM9. Prison library books were often made up of collections from wartime military camps, public donations, and gifts. Any book dealing with prison life, or even having the word *prison* in the title, was guaranteed to be in high demand. Titles such as *Condemned to Devil's Island*, *The House of the Dead*, *The Prisoner of Chillon*, *Crime and Punishment in Germany*, *Beating Back*, and *Through the Shadows with O'Henry* were all very popular. Since books crossed the threshold from the free to the captive world, they served an illicit function by transporting all manner of contraband, including illegal drugs, razor blades, even pages soaked with morphine (ibid).

8. Frank L. Christian, "'Travelogue': Sound Motion Pictures," 7, in Recreation at the Elmira Reformatory, nine-page typed document in file 26, Juvenile Delinquency Prevention and Rehabilitation, box 5, Drafts of Articles and Scripts, LLP-JJC.

9. Charles Dudley Warner, "A Study of Prison Management," in *The Reformatory System in the United States*, 49.

10. William H. Jackson quoted in "Denton Jail Reform," *Washington Post*, August 16, 1927, 6.

11. Sunday Lecture Series Flier (1930–1931), file 13, box 2, series 1, A Correspondence, LLP-JJC.

12. Russell, "Beating Men," 610. Prior to the inauguration of the MWL at Sing Sing, prisoners would be in their cells from 4:30 P.M. Saturday until 9:30 A.M. Sunday, when they left to empty buckets, eat breakfast, and attend chapel. They would be back in their cells by 10:45 A.M., where they would stay until 6:30 A.M. Monday. If Monday was a holiday, the men would be locked inside for more than sixty hours, only allowed out once for a meal on Monday. After the formation of the MWL, the men received an hour of recreation each weekday and four hours on Sundays and holidays. The 1914 *Report of the Prison Association of New York* called this system "cruel and inhuman" and Sing Sing prison "so many square feet of hell on earth." "Sing Sing and Warden Osborne," *Report of the Prison Association of New York* (1914), cited in *Prison Reform*, 110, 112; and F. M. White, "Prisons of Freedom," *World's Work* 30 (May 1915): 114–20, cited in Bacon, *Prison Reform*, 115.

13. Blumenthal, *Miracle at Sing Sing*, 95. According to Roger Panetta, solitary confinement, which grew in popularity in the 1820s as a result of its success in Eastern State Penitentiary outside of Philadelphia, was nevertheless responsible for roughly 50 percent of the deaths in Auburn Prison and numerous cases of insanity. According to Auburn's resident physician, one man in solitary lost his eye as a result of repeatedly banging his head against the cell wall. G. Powers, *A Brief Account of the Construction, Management, and Discipline Etc. of the New York State Prison at Auburn* (Auburn, 1826), 44–45, cited in Roger G. Panetta, "Up the River: A History of Sing Sing Prison in the Nineteenth Century," PhD diss., City University of New York, 1999, 101.

14. Stephen West [Rose Heylbut], "What Music in Sing Sing Prison Means to the Lives and Reclamation of Many Inmates," *The Etude*, November 1938, 713.

15. Auburn Editress 321, Women's Prison, "The Minstrel Show," *SOH* 3, no. 19 (December 28, 1901): 324.

16. "Mutual Welfare League Educational Activities," *SOH* 16, no. 18 (January 30, 1915): 295.

17. "An Excellent Concert," *SOH* 16, no. 3 (May 23, 1914): 38.

18. Sing Sing Prison No. 64791, "Open Air Concert," *SOH* 16, no. 10 (September 26, 1914): 150.

19. James Hennessey brought the company of performers to the prison. The MWL organized an amateur night for inmates on December 26, 1914, with lots of encores: "The vocal, instrumental and recitatives went off without the aid of any 'hook.'" "MWL Educational Activities," 295. Two more travelogues, one through Hawaii, the other

through England and Scotland, were scheduled for the January 1915 lectures, along with another talk on wireless on January 13, 1915 (ibid).

20. "Comments on the Christmas Entertainment" [Clinton Prison], *SOH* 2, no. 10 (January 12, 1901): 351.

21. For more on travelogue spectatorship in early cinema, see Jennifer Lynn Peterson, *Education in the School of Dreams: Travelogues and Early Nonfiction Film* (Durham, NC: Duke University Press, 2013), 207–34.

22. Christian, *Recreation at the Elmira Reformatory*, 8.

23. Ibid., 1.

24. Inmate George cited in Jewkes, *Captive Audiences*, 107.

25. Lawes, *Life and Death*, 181.

26. Henri Lefebvre, *The Production of Space*, trans. Donald Nicholson-Smith (London: Blackwell, 1991), 82–83.

27. Auburn Prison No. 25551, "Mental Visions," *SOH* 1, no. 17 (December 2, 1899): 2.

28. Brian, *Sing Sing*, 61.

29. Gaston Bachelard, *The Poetics of Space: The Classic Look at How We Experience Intimate Places*, trans. Maria Jolas (Boston: Beacon, 1958), 150.

30. Søren Kierkegaard, *Fear and Trembling*, trans. Alastair Hannay (London: Penguin, 2003), 63.

31. Burton H. Allbee, "Future of the Motion Picture," *MPW* 4, no. 9 (February 27, 1909): 234. Emphasis added.

32. Auburn Prison No. 33577, "Memory's Motion Picture Show," *SOH* 18, no. 4 (August 1916): 19.

33. Auburn Prison No. 35154, "Movie Reveries," *SOH* 18, no. 8 (December 1916): 29.

34. Jack London, *The Jacket* (London, 1915) published in the United States as *The Star Rover* (New York: Macmillan, 1915), 13, 77–78. The book inspired *The Jacket* (John Maybury, 2005), starring Adrian Brody and Keira Knightley.

35. "Powerful Book by London," *Boston Daily Globe*, October 23, 1915, 4.

36. Leon Thompson, "Stop Six: The Hole," *Doing Time: The Alcatraz Cellhouse Tour*, press script, Antenna Audio and Golden Gate National Parks Conservancy, 2006, 11.

37. Auburn Prison No. 26336, "Music," *SOH* 3, no. 3 (May 18, 1901): 57. According to the author, inmate musicians were model prisoners as well as being thoughtful, remorseful, and optimistic about a brighter future. Music drove the monotony of life away and made "less irksome the restraint under which they were placed" (ibid.).

38. "Miss Virginia Pearson Visits Sing Sing," *SOH* 19, no. 12 (May 1918).

3. Screens and the Senses in Prison 317

39. Osborne, *Within Prison Walls*, 62.

40. John M. Picker, *Victorian Soundscapes* (New York: Oxford University Press, 2003), 4.

41. Ibid., 6.

42. For reference to pipe tapping, see Randall McGowen, "The Well-Ordered Prison, England, 1780–1865," in *The Oxford History of the Prison: The Practice of Punishment in Western Society*, ed. Norval Morris and David J. Rothman (New York: Oxford University Press, 1995), 106. For more on the role of sound in the history of surveillance, see Katie Hemsworth, "Carceral Acoustemologies: Historical Geographies of Sound in a Canadian Prison," in *Historical Geographies of Prisons: Unlocking the Usable Carceral Past*, ed. Karen M. Morin and Dominique Moran (New York: Routledge, 2015), 17–33.

43. Christian, *Recreation at the Elmira Reformatory*, 9.

44. For a discussion of how inmates cope with time, see Zamble and Porporino, *Coping, Behavior, and Adaptation*, 146–52.

45. Sidereal time is a foreshortened day calculated at twenty-three hours, fifty-six minutes, 4.091 seconds that helps astronomers calculate the location of stars based on the regularity of the earth's rotation about its polar axis.

46. Chamberlain, *There Is No Truce*, 259.

47. Osborne, *Within Prison Walls*, 62.

48. Ibid., 225, 250.

49. The nation's first "good time" law rewarding inmates for good behavior was approved in New York State in 1817. "Indeterminate" sentences permitting a minimum and maximum term were passed starting in 1876, however, according to a notice in the 1905 *Report of the Superintendent of State Prisons, New York*. So few prisoners had actually been given indeterminate sentences since 1889 that the parole system did not really take effect in New York State until October 1901. Between 1901 and 1905, the Parole Board considered the applications of 2,087 prisoners and granted 1,075 paroles. Of the 1,075 paroled, 662 had been discharged, 204 were on parole in good standing, and 81 had been returned to prison for parole violations, while 128 were classified as "delinquents" (25). For a history of parole in New York State, see "History of Parole in New York State," New York State Department of Corrections and Community Supervision, accessed September 3, 2013, https://www.parole.ny.gov/introhistory.html.

50. Smith, *The Prison*, 28.

51. "Undercurrents," *SOH* 2, no. 1 (April 21, 1900): 17.

52. "Cinematography on Railroad Cars," *MPW* 4, no. 13 (March 27, 1909): 363. The article was reprinted from the *PhonoCine Gazette*. For more on cinema and the

railroad, see Lynne Kirby, *Parallel Tracks: The Railroad and Silent Cinema* (Durham, NC: Duke University Press, 1997); Wolfgang Schivelbusch, *The Railway Journey: The Industrialization and Perception of Time and Space* (Berkeley: University of California Press, 1987); and Marc Furstenau, "Hitchcock in Europe: Railways, Magic, and Political Crisis in *The Lady Vanishes*," paper presented at "Europe on Display/Exposer L'Europe" conference, McGill University, September 22–24, 2011.

53. "Another Good Suggestion: Moving Pictures in Railway Depots," *MPW* 7, no. 27 (December 31, 1910): 1525. Moving pictures were included with observation cars, libraries, and barbershops as "luxuries furnished the passengers to pass the time" (ibid.).

54. Lawes, *Twenty Thousand Years*, 271.

55. Mayhew and Binny, *The Criminal Prisons*, 117.

56. Ibid., 512.

57. Ibid., 101.

58. Several scholars have researched motion picture exhibition in chapels during the early era, including Stephen Bottomore, "Projecting for the Lord: The Work of Wilson Carlile," *Film History* 14, no. 2 (2002): 195–209; Dean R. Rapp, "A Baptist Pioneer: The Exhibition of Film to London's East End Working Classes, 1900–1918," *Baptist Quarterly* 40, no. 1 (2003): 6–21; and Terry Lindvall, "Sundays in Norfolk: Toward a Protestant Utopia Through Film Exhibition in Norfolk, Virginia, 1910–1920," in *Going to the Movies: Hollywood and the Social Experience of Cinema*, ed. Richard Maltby, Melvyn Stokes, and Robert C. Allen (Exeter: University of Exeter Press, 2007), 76–98.

59. William E. Cashin, "Office of the Chaplain," *Report of the Superintendent of State Prisons, New York*, 1914, 71.

60. An issue of concern to both prison wardens and church dignitaries was light: how to screen it out in order to view the films adequately but manage the resulting loss of control in policing the space. Inventions allowing house lights to remain on during screenings—one, by A. L. Simpson, kept the house lights up and allowed individual faces to be distinguished in the New York theater where it was in use—were for the most part deemed inadequate or annoying, so churches often showed films in annexes that did not have stained-glass windows. Issues concerning the use of "morality lighting" (pink or amber lighting) during a screening, the raising of house lights during reel changes (the norm, at least in the United Kingdom, until about 1917), and shining flashlights in the faces of miscreants, were doubly fraught in prisons. "More Light in the Theaters," *MPW* 4, no. 13 (March 27, 1909): 365. This issue of well-lighted theaters was discussed at the

1911 Chicago Child Welfare Exhibit, where "daylight curtains [screens]" and "daylight auditoriums" were deemed vital in the war against "vicious and immoral conditions." See "Chicago Child Welfare Exhibit," *MPW* 8, no. 22 (June 3, 1911): 1242.

61. According to Richard Abel, churches in Indiana and Michigan began using motion pictures in 1900. See Richard Abel, "From Peep Show to Picture Palace: The Early Exhibition of Motion Pictures," in *The Wiley-Blackwell History of American Film*, vol. 1, *Origins to 1928*, ed. Cynthia Lucia, Roy Grundmann, and Art Simon (Hoboken, NJ: Wiley-Blackwell, 2012). Also see the special issue of *Film History* on "Film and Religion," especially Bottomore, "Projecting for the Lord," 195–209. Alfred Tildsley exhibited commercially produced religious films at Poplar and Bromley Tabernacle during weekday half-hour lunchtime services, at Good Friday services, and most popularly during his Pleasant Thursday Evening series. He did not show films on Sundays, which would have been considered blasphemous. According to Rapp, the time devoted to film screenings doubled from about fifteen minutes a week in 1906 to thirty minutes in 1907, and to one hour a week in 1908. Due to their popularity, two shows were scheduled on Thursdays, one for children at 5:30 P.M. and one for adults at 7:30 P.M. See Rapp, "Baptist Pioneer," 9–10. Also see Dean R. Rapp, "The British Salvation Army, the Early Film Industry, and Urban Working-Class Adolescents, 1897–1918," *Twentieth-Century British History* 7, no. 2 (1996): 161, 165–78, 187–88.

62. "Federal Prisoners Caught in $150,000 Plot to Swindle Government by Forgery Scheme," *NYT*, July 22, 1926, 3.

63. Wrote the *Moving Picture World*, "A uniformed attendant at a moving picture house . . . symbolizes order, in that the public at large recognizes that he is the representative of the proprietor and is there to keep order." "Uniformed Attendants," *MPW* 6, no. 11 (March 19, 1910): 417.

64. "Thirty-Seven Flee Jail," *Los Angeles Times*, June 8, 1922, 11.

65. "Naval Prisoners Escape in Auto," *Hartford Courant*, July 8, 1924, 4. Two other escapes during motion picture screenings occurred at Auburn Prison in 1929: "Escaped Convicts Battle in Syracuse," *NYT*, March 4, 1929, 23; and at Wethersfield Prison, Connecticut, in January 1930: "Convicts Still at Large; State Will Probe Break," *Hartford Courant*, January 6, 1930, 1. A near escape during a motion picture screening at Sing Sing took place in 1928: "Traps 3 in Sing Sing in Plot to Escape," *NYT*, November 19, 1928, 1.

66. "Matching Wits with Convicts," *Atlanta Constitution*, December 2, 1928, 8. Based on the number of killings in the New York metropolitan area, being a prison guard was eight times more dangerous than being a police officer.

67. Anonymous, "Eight Men Dead in Prison Revolt," *Boston Daily Globe*, November 15, 1927, 1.

68. According to the *New York Times*, the disturbance at the Ohio State Penitentiary was the seventh major prison disturbance in the United States since August 1929, consisting of "spectacular gun battles, many deaths and the destruction of millions of dollars in property." See "Again Death Stalks Through a Prison," *NYT*, April 27, 1930.

69. "Ban in Ohio Urged on Pen-Riot Movie," *Baltimore Sun*, August 2, 1920, 1.

70. "Trapped Convicts Burned at Movie Show," *NYT*, July 30, 1928, 1. Also see "Convicts Die in Explosion," *Los Angeles Times*, July 30, 1928, 5, for coverage of the same event.

71. Lewis Wood, *Sing Sing from the Inside*, New York Committee on Prison pamphlet; republished in in *New York Tribune*, January 18, 1915.

72. "Moving Pictures in State Institutions," *Nickelodeon* 1, no. 1 (January 1909): 20. Thanks to Gregory Waller for sharing material on early nontheatrical exhibition sites.

73. The phrase "amusement of the shutins" is from a column called the "M. S. P. Forum" in the Charleston State Prison inmate-published magazine the *Mentor* 22, no. 22 (November 1921): 46. The column reviewed "addresses, lectures and other entertainments tendered to the entire inmate body on Sunday afternoon in the Prison Chapel" (41). Information about film donors, what was screened, and inmate reactions are amply recorded in this useful snapshot of film culture in a Southern penitentiary. The magazine was launched in 1899.

74. "The Micro-Kinetoscope," *MPW* 7, no. 15 (October 8, 1910): 797.

75. *MPW* 1, no. 25 (August 25, 1907): 391.

76. W. Stephen Bush, "Who Goes to the Moving Pictures?" *MPW* 3, no. 18 (October 30, 1908): 336.

77. Dr. Willis Cummings, untitled article from *Medical Council* (May 1908) cited in "The Moving Pictures as a Brain Rest," *MPW* 4, no. 20 (March 15, 1909): 625.

78. This point is made in the same issue of *MPW* as the "brain rest" idea in an article by Willis Cummings, "The Use of Moving Pictures as a Remedial Agent," *MPW* 4, no. 20 (May 15, 1909): 626. Cummings believed that there was in the "vibratory movement of the picture a tendency to more or less hypnotic effect due to the condition of the observer" (ibid.).

79. "Moving Pictures as a Cure for Insanity," *MPW* 6, no. 10 (March 12, 1910): 376. The screening occurred at the State Asylum for the Nebraska Insane, Norfolk, Nebraska, overseen by a Dr. Percival, who installed a "small, private machine" for the benefit of the inmates. According to Percival, "the viewing of pictures produces the

most soothing effect upon the mind where they are shown in action, and that the rapid change in the view will be much more beneficial than any regular course of treatment that could be suggested by experts" (ibid.).

80. "Says Motion Pictures Do Not Increase Crime," *Boston Daily Globe*, December 29, 1925, A2.

81. Godbey, "Picture Me Sane," 33, 38.

82. Ibid., 50.

83. "Crazy People Entertained with Moving Pictures," *MPW* 8, no. 5 (February 5, 1910): 233. The story originally appeared in the *Waynesboro Herald* (PA).

84. John Callan [Laughlin] O'Laughlin, "The Picture in the Insane Asylum," *MPW* 10, no. 9 (December 2, 1911): 710. The author did admit, however, that insane spectators constituted a different "type" of spectator, lacking in "finer emotional feelings" and purportedly with a reduced ability to "appreciate love, sorrow, [and] the affection of the family" (ibid.).

85. Dr. Henry S. Atkins cited in "Moving Pictures Cure Mental Diseases," *MPW* 6, no. 25 (June 25, 1910): 1092. Also see "Moving Pictures as a Cure for Insanity," *MPW* 7, no. 21 (November 19, 1910): 1181; "Pictures for the Afflicted," *MPW* 8, no. 1 (January 7, 1911): 20; and "Colorado Insane Asylum Adopts Motion Pictures," *MPW* 10, no. 12 (December 23, 1911): 982.

86. Stan Brakhage, *Metaphors of Vision* (New York: Anthology Film Archive, 1976), 1.

87. "Five Hundred Convicts See Outside World—'By Movies,'" *Chicago Daily Tribune*, December 4, 1912, 1.

88. "Lifer's Dean Fifty Years Behind Bars," *Los Angeles Times*, December 7, 1925, 3.

89. "Five Hundred Convicts," 1.

90. Jeremy W. Peters, "To the Editor, in an Inmate's Hand," *NYT*, January 8, 2011, B–1, B–4. Magazine editors refer to inmate letters as "jail mail"; *Maxim* receives between ten and thirty letters a week and *Rolling Stone* at least one a day.

91. "Goes Mad on Seeing Film: Eskimo in Expedition Becomes Violent at His First Movie," *NYT*, July 7, 1931.

92. "Observations by Our Man About Town," *MPW* 6, no. 7 (February 9, 1910): 250. The observer blamed the homemade sign boards and gaudy colored posters for serving as a deterrent to potential well-heeled customers.

93. The Aberdeen Visiting Committee organized the screening. Mr. Dove Paterson brought the bioscope and Mr. John Paterson operated it. The twin goals of the screening were to "make better men and better women" and to remind the prisoners that their welfare was not entirely neglected. "Picture Show in Prison," *Bioscope*,

November 18, 1909, 50. This clipping is from Stephen Bottomore's "Early Film Collection," identified hereafter as SBEFC. The *Times* of London (inaccurately) reported in November 1923 that the first British screening of films in prison occurred at Dartmouth Prison following a long discussion by the home office that finally agreed "to try the experiment of moving pictures in British convict prisons." Presented by the Associated First National Pictures company, the film was *Might Lak'a Rose*, an adaptation of Frank L. Stanton's poem. A great deal hinged on this screening, since "on the success of this film show . . . will depend whether similar exhibitions will be given at convict establishments throughout the country." "Frank L. Stanton's Poem Is Taken as the Basis of English Prison Play," *Atlanta Constitution*, November 15, 1923, 8.

94. "Christmas at State Prison a Merry One," *Hartford Courant*, December 27, 1927, 1.

95. Z. R. Brockway, "Beginnings of Prison Reform in America," *Charities* 13 (February 4, 1905), in Bacon, *Prison Reform*, 21–22. The idea of the indeterminate sentence (released on parole for good behavior) can be traced to an act of the Michigan legislature in 1869, long predating the emergence of cinema.

96. Smith, *The Prison*, 27, 47.

97. *Kinematograph and Lantern Weekly*, July 11, 1912, 715 (SBEFC).

98. The earliest account of a prison screening I have found in Europe is a 1909 press clipping about a bioscope exhibition at Craiginches Prison in Aberdeen, Scotland.

99. "Convicts Hiss Chaplain," *Washington Post*, October 14, 1907, 3.

100. Haldane George, "Convicts at Large Without Guards," *Los Angeles Times*, April 27, 1912, IM20; Great Meadow Prison No. 1602, "Happenings," *Star-Bulletin* 16, no. 16 (January 2, 1915): 260.

101. "Moving Pictures in Prison," *NYT*, December 2, 1911, 8.

102. Ibid.

103. Marching to time was an important part of a prisoner's regeneration; boys' reformatories were especially keen to impose this kind of discipline in their wards; even doing sports was framed in benefit analysis, rather than pleasure surfeit, terms: "No form of athletics is tolerated which simply gives pleasurable sensations; there must be a definite relationship between the gymnastic effort and the object desired in particular groups of pupils." At Elmira Reformatory in upstate New York, the entire prison population was enrolled in the military organization. See R. C. Bates, "Character Building at Elmira," *American Journal of Sociology* 3, no. 5 (March 1898): 582.

104. "Leavenworth Prisoners Have Show," *Nickelodeon* 5, no. 2 (January 14, 1911): 45.

105. "Pictures for Leavenworth Convicts," *Nickelodeon* 4, no. 10 (November 15, 1910): 282.

106. Ibid. Sadly, there is no mention of this discussion in Charles Richmond Henderson (commissioner for the United States on the International Prison Commission), *Report of the Proceedings of the Eighth International Prison Congress, Washington, DC, September–October 1910*, House Document Issue 52, Law Pamphlets Volume 78 (Washington, DC: Government Printing Office, 1913).

107. Pennsylvania started prison film screenings in 1917 at the county jail in Scranton. The biblical film *The Ninety and Nine* (Ralph Ince, 1916) was shown "within the walls of the grim old prison." The journalist questioned the suitability of this title for a prison audience; the man who goes astray in the film (the one out of a hundred from the title) was "rewarded by acquiring a fortune and marrying the beautiful Lucille Stewart which is *rather an incentive to stray*." "Shadows on the Screens," *New York Tribune*, January 14, 1917, C4.

108. Two notices about prisoners refusing to attend a prison screening are "Life Battle Begins for Chapman Today," *NYT*, March 29, 1926, 7, and "Pomerory Sad Over Death of a Friend," *Boston Daily Globe*, November 26, 1926, A20.

109. *Bioscope*, December 23, 1909, 51 (SBEFC).

110. "Picture Shows for Prisoners," *Motography* 6, no. 1 (July 1911): 30. A similar arrangement was made for members of the armed services to watch films while based at isolated army posts. Thomas H. Martell, director of the U.S. Motion Picture Service, announced that a circuit of thirty motion picture theaters would provide screened entertainment. "Picture Plays and People," *NYT*, November 5, 1923, X5. The U.S. Navy was the largest film distributor in the world, having 1,200 complete eight-reel programs in duplicate and 150 in triplicate and almost 4,800 reels of shorts. Navy movies were exhibited 125–140 times before completing the three-year circuit and approximately twenty-five feature pictures were acquired each month. See "Feature Comedies Favored as Movies by American Tars," *Washington Post*, February 13, 1927, S13.

111. *Motography*, September 14, 1912, 205.

112. For a discussion of the exhibition and reception of *It's a Wonderful Life* (Frank Capra, 1946) and other films at San Quentin Prison in 1947, see Eric Smoodin, "Coercive Viewings: Soldiers and Prisoners Watch Movies," in *Regarding Frank Capra: Audience, Celebrity, and American Film Studies, 1930–1960* (Durham, NC: Duke University Press, 2004), 182–202. Smoodin states that prisoners at San Quentin had not seen movies prior to Warden Clinton T. Duffy's arrival, although film screenings began as early 1913 but probably ceased prior to Duffy's tenure. For more on San Quentin during this time and the California

prison system, see the research by Shelley Bookspan, "A College of Morals: Educational Reform at San Quentin Prison, 1880–1920," *History of Education Quarterly* 40, no. 3 (Autumn 2000): 270–301; and Shelley Bookspan, *A Germ of Goodness: The California State Prison System, 1851–1944* (Lincoln: University of Nebraska Press, 1991).

113. "San Quentin to See Vaudeville Chronicle to Present Big Bill," *San Francisco Chronicle*, December 31, 1914, 3.

114. "Federal Prisoners See Splendid Film," *Atlanta Constitution*, November 25, 1921, 8.

115. "Chicken Dinner for 611 at State Prison," *Boston Daily Globe*, December 1, 1922, 9.

116. "Feature Comedies Favored," S13.

117. Public health and information films were also screened to prisoners, films that were often playing in local theaters near the prison; for example, the anti–venereal disease melodrama *Open Your Eyes* (Gilbert P. Hamilton, 1919), which had been playing to packed houses at the Shubert Theater in Boston, was shown to inmates at Massachusetts State Prison in July 1919. "M. S. P. Forum," *Mentor* 19, no. 10 (August 1919): 440.

118. "638 Convicts See 'Movies' at State Prison: Chapel Decorated with Flags—Institution's Own Band Plays," *Hartford Courant*, July 6, 1915, 13.

119. "Federal Prisoners Are Given a Treat in Universal Film," *Atlanta Constitution*, March 4, 1915, 3. For a discussion of how prisoner amusements (baseball and "up-to-date movies") improved considerably at the prison thanks to the generosity of sixty-seven-year-old California millionaire prisoner Frederick A. Hyde, see "Send Presents to Convict Pals," *Atlanta Constitution*, April 3, 1915, 8.

120. "With the Producers and Players," *NYT*, November 8, 1925, X5.

121. Kathleen Moran and Michael Rogin, "'What's the Matter with Capra?': *Sullivan's Travels* and the Popular Front," *Representations* 71 (2000): 127.

122. Davis, *Are Prisons Obsolete?*, 33.

123. See William Uricchio and Roberta Pearson, *Reframing Culture: The Case of the Quality Vitagraph Films* (Princeton, NJ: Princeton University Press, 1993); and Grieveson, *Policing Cinema*.

124. "638 Convicts See 'Movies,'" 13.

125. Miriam Hansen, "Early Cinema: Whose Public Sphere?," *New German Critique* 29 (Spring/Summer 1983): 159.

126. Jewkes, *Captive Audiences*, 154.

127. Poe also explores the nightmare of a living entombment in "The Premature Burial" (1844) and "The Fall of the House of Usher" (1839). Smith, *The Prison*, 57.

128. My thanks to Maggie Hennefeld for her valuable feedback on this idea and for suggesting interesting juxtapositions.

129. Great Meadow Prison No. 1964, "An Essay on Motion Pictures," *SOH* 18, no. 7 (November 1916): 30.

130. Ibid.

131. Ibid.

132. See Marcel Mauss, *Sociologie et anthropologie* (Paris: Presses universitaires de France, 1973), 3–137; Pierre Bourdieu, *Outline of a Theory of Practice* (Cambridge: Cambridge University Press, 1977), 78–86; and Pierre Bourdieu and Loïc J. D. Wacquant, *An Invitation to Reflexive Sociology* (Chicago: University of Chicago Press, 1992), 115–40.

133. Norval Morris, "The Contemporary Prison," in Morris and Rothman, *Oxford History of the Prison*, 230.

134. See the "Prison Information Handbooks" (different for male and female inmates) and image of the television next to a barred window at http://webarchive.nationalarchives.gov.uk/20110603043057/http://hmprisonservice.gov.uk/adviceandsupport/prison_life/.

4. *"The Great Unseen Audience"*

1. Unidentified Sing Sing prisoner quoted in "Notes Written on the Screen," *NYT*, March 14, 1915, xii.

2. Panetta, "Up the River," 121–22, 129. Construction on Sing Sing Prison began in May 1825 and finished in 1828. In the ensuing century, more than 70 percent of all men committed for felonies in New York State went to Sing Sing. Lawes, *Life and Death*, 30.

3. Lawes, *Twenty Thousand Years*, 68. The prison was originally called Mount Pleasant, and, in 1830, a year after construction, it had a population of eight hundred (74).

4. Panetta, "Up the River," 152.

5. First-run pictures were made available to Sing Sing Prison as a result of the cooperation between the Skouras Brothers distributors and Sing Sing's membership in the New York Film Board of Trade. "These Are Your New York State Correctional Institutions, 8: Sing Sing Prison," *Corrections* 14, no. 8/9 (August–September 1949): 15.

6. Football was championed within reform discourse late into the 1930s, considered by *Correctional Educational Today* to be the sport "best calculated to bring out the qualities that it is desirable to encourage in readjusting inmate personalities." See

Walter Marle Wallack, "Physical Education and Recreation," *Correctional Educational Today*, First Yearbook of the Committee on Education of the American Prison Association (New York: Prison Association, 1939), 228.

7. Baseball was hugely popular at the prison; according to Lawes, approximately 85 percent of able-bodied prisoners played the sport, the official team called the Mutual Welfare League. Once a year a team sent by the New York Giants would play against Sing Sing. Lawes, "The Great Unseen Audience," 105. See "On the Screen at Sing Sing: *The Master Mystery*," *Star-Bulletin* 20, no. 9 (March 1919): 12, for mention of Houdini's film playing.

8. Thomas Mott Osborne, "New Methods at Sing Sing," *Review of Reviews* 52 (October 1915): 133; Max Eastman, "Riot and Reform at Sing Sing," *Masses* 6 (June 1915): 126.

9. Sing Sing Correctional Facility still operates as a maximum-security prison with 1,700 men. Seventy-nine percent have been convicted of a violent crime and more than half have a minimum sentence of at least ten years. See Correctional Association of New York, "Sing Sing Correctional Facility," Prison Visiting Project, April 2009, http://www.correctionalassociation.org/wp-content/uploads/2012/05/sing-sing_4-28 -09.pdf.

10. There is reference to no guards being present at a screening in Frank Marshall White, "The University of Sing Sing," *Century Magazine* 94, no. 6 (October 1917): 846.

11. Stoler, *Along the Archival Grain*.

12. Ibid., 8, 21.

13. I examine contemporary media access and use at Sing Sing in the book's conclusion.

14. Sumner Blossom to Lewis E. Lawes, April 16, 1930, on the subject of an article Lawes was invited to submit to *American Magazine*. The idea for the piece was later dropped since "several articles will appear in other magazines before we could publish anything" in file no. 1, American Magazine 1930–1931, Series I Personal Papers, LLP-JJC.

15. Edward Wise, a professional baseball player from the Boston area, would have been the thirty-third person to be electrocuted at Sing Sing, but his sentence was commuted to life imprisonment. "Secret of Sing Sing Prison's Death House," *World*, August 19, 1900, 3, PR Materials, 1900–1923 file, box 268, Osborne Family Papers, Special Collections, Syracuse University Library [hereafter abbreviated as OFP].

16. Sing Sing Prison No. 312, "A Study in Criminology," *SOH* 1, no. 3 (May 20, 1899): 1. In 1901, Protestant services were held in Sing Sing's chapel at 8:30 A.M. on

Sundays; Catholic services at the same time in another space; and Jewish prisoners had services on the first and third Saturdays of each month. Of roughly 1,200 men imprisoned in 1903, 1,011 were Catholic, 183 Jewish, and the remainder Protestant or other religious denominations. In 1905, there were 1,083 Caucasian, 152 African American, and 7 Asian inmates in the prison. *Report of the Superintendent of State Prisons, New York*, 1905, 65. Mrs. Cortlandt de P. Field's Bible class met on the last Wednesday of every month and about a hundred men attended; according to the 1903 annual report, "the ladies also hold interviews from time to time with many of the men, persuading them to a better life." Frank Russell, "Report of the Chaplain," *Report of the Superintendent of State Prisons, New York*, 1903, 54. For a snapshot of religious services at Sing Sing, including the provisions made for different faiths, see George Sanderson, "Chaplain's Report," *Report of the Superintendent of State Prisons, New York*, 1899, 66–68.

17. J. Saunders, *Prisoners Mail*, Petition to Congress from the inmates of Arizona State Penitentiary, Board of Pardons and Paroles, Florence, Arizona, 1914, cited in Estelle B. Freedman, *Their Sisters' Keepers: Women's Prison Reform in America, 1830–1930* (Ann Arbor: University of Michigan Press, 1984), 4.

18. For an autobiographical account, see John Luckey, *Life in Sing Sing State Prison: As Seen in a Twelve Years' Chaplaincy* (New York: N. Tibbals, 1860), and Blake McKelvey, *American Prisons: A History of Good Intentions* (Chicago: University of Chicago Press, 1936), 42. According to the *New York State Commission of Prisons Annual Report 1899*, cited in McLennan, *The Crisis of Imprisonment,* 226.

19. *New York State Commission of Prisons Annual Report,* 1899, 70, cited in McLennan, *Crisis of Imprisonment*, 226. For more on bibliotherapy, especially in its historical context, see the special issue of *Library Trends* 11, no. 2 (October 1962), edited by Ruth M. Tews, notably essays by William K. Beatty, "A Historical Review of Bibliotherapy" (106–17), and Mildred T. Moody, "Bibliotherapy: Modern Concepts in General Hospitals and Other Institutions" (147–58). According to Beatty, the term *bibliotherapy* was first used in 1916 by Samuel McChord Crothers in "A Literary Clinic," *Atlantic Monthly*, August 1916, 291–301, and garnered more interest throughout the 1920s.

20. Commission W. F. Spalding cited in Isabel C. Barrows, "The Massachusetts Reformatory Prison for Women," in *The Reformatory System in the United States: Reports Prepared for the International Prison Commission*, ed. Samuel J. Barrows (Washington, DC: Government Printing Office, 1900), 113.

21. McLennan, *Crisis of Imprisonment*, 224.

22. McKelvey, *American Prisons*, 42.

23. John Luckey, "Chaplain's Report," *Twelfth Annual Report of the Inspectors of New York*, January 3, 1860, 72.

24. Lawes, *Twenty Thousand Years in Sing Sing*, 170.

25. "Can Get Library Books at Any Time," *Mutual Welfare League Bulletin* 1, no. 15 (February 1916): 7.

26. Auburn Prison, about thirty miles from Syracuse in upstate New York, kept detailed records of the types of magazines and books read by inmates that suggested that prisoners read less in the summer and preferred fiction at least ten times more than any other genre. Library visits in prisons were strictly rationed, and few prisons allowed inmates access to the stacks (book requests were made by forms).

27. Sing Sing Prison No. 65368, "The Library at Sing Sing," *SOH* 18, no. 9 (January 1917): 19.

28. New York State Department of Corrections, *Sing Sing Prison: Its History, Purpose, Makeup, and Program* (Albany, NY: Department of Corrections, 1958), cited in McLennan, *Crisis of Imprisonment*, 243.

29. Sanderson, "Chaplain's Report," 70.

30. For an excellent overview of prison libraries from the early 1930s, see "Making the Old Bit Pay Dividends," *Baltimore Sun*, August 3, 1930, SM9.

31. *New York State Commission of Prisons Annual Report*, 1899, 70, cited in McLennan, *Crisis of Imprisonment*, 226.

32. *Report of the Superintendent of State Prisons, New York*, 1899, 16. This justification of the prison school and library is virtually identical to one made thirty-five years later in Sing Sing's library handbook: "Books do more than kill the monotony of the four hours between supper and taps. They do more than keep prisoners out of trouble. They accomplish mental therapy; they relieve tension; they carry the prisoner outside the confines of his own thoughts; they keep him from turning his mind on itself. They provide recreation for men who have seldom before known what it means to enjoy anything quietly. They give indirect education to men who could never be lured into a classroom." "These Are Your New York," 14.

33. John C. S. Weills, "Chaplain's Report [Sing Sing]," *Report of the Superintendent of State Prisons, New York*, 1899, 75.

34. Rachel Aviv, "No Remorse," *New Yorker*, January 2, 2012, 64, http://www.newyorker.com/magazine/2012/01/02/no-remorse. Miller was convicted at age fourteen of murdering his girlfriend, and despite being a juvenile, was incarcerated in an adult prison. Imprisoning juveniles with adults has become increasingly common since the late 1990s, when juveniles were increasingly likely to be imprisoned

rather than placed in community-supervision or treatment programs: "Forty-six states rewrote their laws to make it easier for minors to be tried as adults," says Aviv (ibid., 57).

35. Russell, "Report of the Chaplain," 53.

36. The VPL was seventeen thousand members strong at this point, with Hope Halls in Chicago and in Flushing, New York. The VPL held meetings at Sing Sing on an ad hoc basis. *SOH* 3, no. 1 (April 20, 1901): 10. For background on Booth, see Daniel Lombardo, "Maud Billington Booth (1865–1948): Volunteer Pioneer Leaves Legacy of Service," *Corrections Today* 58, no. 7 (1996): 28.

37. Russell, "Report of the Chaplain," 53.

38. "The V.P.L. Day: Mrs. Booth Tendered an Enthusiastic Reception," *SOH* 1, no. 13 (October 7, 1899): 7.

39. *Report of the Superintendent of State Prisons, New York*, 1899, 15.

40. "You Can Get an Education," *SOH* 20, no. 3 (August 1918): 1. In 1911, 711 adult men representing twenty-nine different nationalities and speaking forty-one different languages were enrolled in Sing Sing's school, making the task of educating them "very difficult." One hundred percent of the African Americans entering the prison school were illiterate, with Northern-born blacks more likely than Southern-born ones to have received some education. *Report of the Superintendent of State Prisons, New York*, 1911, 81, 79.

41. Lawes, *Twenty Thousand Years in Sing Sing*, 171.

42. E. Anthony Rotundo, *American Manhood: Transformations in Masculinity from the Revolution to the Modern Era* (New York: Basic Books, 1993), 241.

43. "Survey of Sing Sing," sent to governor of New York State F. D. Roosevelt, August 23, 1929, item 2, p. 2, file 4, box 1A, Correspondence, LLP-JJC.

44. Sing Sing Prison No. 61550, "Boxing at Sing Sing," *SOH* 16, no. 6 (August 1, 1914): 83.

45. "Lambs Gambol for Amusement of Sing Sing," *American*, June 28, 1915, 5, F415, miscellaneous clippings, H. Estabrook Collection, Margaret Herrick Library, Academy of Motion Picture Arts and Sciences [hereafter abbreviated as MHL].

46. Ibid.

47. Lawes, "The Great Unseen Audience," 5.

48. "Happy Dust: Overheard at Sing Sing," *SOH* 18, no. 6 (October 1916): 20.

49. Thomas Mott Osborne, *Society and Prisons*, Yale Lectures (New Haven, CT: Yale University Press, 1916), 176.

50. After twenty-one years in print, the *Sing Sing Bulletin* ceased publication in 1920. The journal had started out as the *Star of Hope*; a second paper, the *Bulletin*, was launched in 1914. The two papers merged in 1915, becoming the *Star-Bulletin*. Lawes

changed its name to the *Sing Sing Bulletin* in 1920. The order to stop publication came from Charles F. Rattigan, superintendent of prisons. Three months prior to halting publication, Rattigan had cut circulation from 5,000 to 1,500. See "Chapin's Sing Sing Paper Suspended," *NYT*, August 17, 1920, 20.

51. *SOH* 3, no. 1 (April 20, 1901): 9.

52. McLennan, *Crisis of Imprisonment*, 244. The *Star of Hope* was praised for assisting in the project of prisoner mental development, especially when coupled with "all that encourages a determined step towards higher life." Sing Sing Prison No. 312, "A Study in Criminology," *SOH* 1, no. 3 (May 20, 1899): 1.

53. The *Mirror*, a weekly published by the inmates of the Minnesota State Prison in Stillwater, took the credit for being the oldest prison newspaper in the United States, commencing publication in 1886. *O. E. Library Critic* 4, no. 2 (September 9, 1914): 5.

54. "Our First Anniversary," *SOH* 2, no. 1 (April 21, 1900): 9.

55. Ibid.; S. Ernest Jones, as quoted in the *Report of the Superintendent of State Prisons, New York*, 1911, 51.

56. Cornelius V. Collins, *Report of the Superintendent of State Prisons, New York*, 1899, 16.

57. Auburn Women's Prison No. 316, "Women's Prison," *SOH* 3, no. 1 (April 20, 1901): 2.

58. "Pictures for Prisoners," *Washington Post*, March 22, 1914, SM3.

59. Clinton Prison No. 10874, "Two Hours of Fun," *SOH* 16, no. 10 (September 26, 1914): 160.

60. Tom Gunning, "Pictures of Crowd Splendor: The Mitchell and Kenyon Factory Gate Films," in *The Lost World of Mitchell and Kenyon*, ed. Vanessa Toulmin, Patrick Russell, and Simon Popple (London: British Film Institute, 2004), 49.

61. *Times* (London), July 15, 1910, n.p., cited in Audrey Field, *Picture Palace: A Social History of the Cinema* (London: Gentry, 1974), 23.

62. McLennan, *Crisis of Imprisonment*, 294.

63. "Sing Sing's Movies: Inaugurating the Golden Rule Brotherhood's New Machine," *SOH* 16, no. 12 (October 1914): 178.

64. "Weather," *NYT*, December 7, 1914, 8.

65. "Sing Sing's Movies," 178. For an extensive discussion of the emergence of the Golden Rule Brotherhood, whose seeds were sown in the basket-making workshop at Auburn Prison when Osborne went undercover as Tom Brown in 1913, see Osborne, *Society and Prisons*, 141–76.

66. "Sing Sing's Movies: Inaugurating the Golden Rule Brotherhood's New Machine," *SOH* 16, no. 12 (October 24, 1914): 178.

67. "The Lights of New York" (in Five Parts) to Be Shown at Sing Sing," *Star Bulletin* 8 (December 1916): 32.

68. D. Ireland Thomas, "Motion Picture News," *Chicago Defender*, September 13, 1924, 7.

69. Ibid.

70. Lawes, *Twenty Thousand Years in Sing Sing*, 119.

71. Editor in chief, "Entertainment: Sunday Feb. 7th 1915," *SOH* 16, no. 19 (February 13, 1915): 302. There is no extant production information on *The Blind Queen*, except reference to it having been "daintily colored by a new process" and never before exhibited in the United States (ibid.).

72. Brought in by Mr. James Hennessey, the vaudeville numbers included "The Macabees, Demons of Fire, Something New in Pyrotechnics"; "Nibold's Birds . . . Just Plain Bird Talk"; "Baby Helen . . . Songs, Imitations and Stories"; "The Rube and the Daughter-in-Law . . . The Country in a City Flat"; "An Eccentric Pair of Senegambians . . . Quagua a la South Africa"; "Miss Annette Lawler . . . Violin Melodies"; "Johnny Edge . . . Contortionist Extraordinary"; "The Aidab's Musical Sketch . . . Something New and Good"; "James Kennedy & Company in . . . The Swift." "Christmas in the Monastery," *SOH* 16, no. 18 (January 30, 1915): 295.

73. "The Movies," *SOH* 16, no. 13 (November 7, 1914): 198.

74. Sing Sing Prison No. 64943, "Instructive Pictures," *SOH* 16, no. 17 (January 16, 1915): 260. All subsequent information about films screened at Sing Sing on January 4, 1915, is from this article.

75. For more on this discourse, see Richard Abel, *Americanizing the Movies and Movie Mad Audiences, 1910–1914* (Berkeley: University of California Press, 2006); Richard Abel, Giorgio Bertellini, and Rob King, eds., *Early Cinema and the "National"* (New Barnet, UK: Libbey, 2008); and Giorgio Bertellini, *Italy in Early American Cinema: Race, Landscape, and the Picturesque* (Bloomington: Indiana University Press, 2010).

76. E. J. Meagher and Thomas P. O'Brien, "Mutual Welfare League Committee Reports: Entertainment Committee," *Star-Bulletin* 19, no. 8 (January 1918): 14.

77. "An Appreciation," *Star-Bulletin* 19, no. 9 (February 1918): 15. Professional agents, such as Joseph A. Eckl of the Knickerbocker Theatrical Enterprise, booked vaudeville artists such as Clifford B. Harmon to perform at Sing Sing in December 1918, his second time performing at the prison.

78. "Film Chief's Gift Is Told," *San Antonio Light*, April 7, 1935. State law prohibited the payment of inmates as extras; according to Blumenthal, Lawes also contributed some of his earnings from *Twenty Thousand Years at Sing Sing* to the

gymnasium construction. Blumenthal, *Miracle at Sing Sing*, 213. For more on Lawes's relationship with Warner Bros., see Blumenthal, *Miracle at Sing Sing*, 247–74.

79. Nellis, "Notes on the Prison Film," 20.

80. Earl Wingart to Lawes, March 8, 1940, file 20, box 19, LLP-JJC. Wingart, a Fox publicist, gave Lawes the option of prescreening the film before showing it to the inmates, or just showing it to the prison guards if he felt it was not suitable for inmates.

81. *Star-Bulletin* 18, no. 17 (April 11, 1917): 5. Volume 18 marks the name change from the *Star of Hope* to the *Star-Bulletin*.

82. "Pictures Seen on Sing Sing's Movie Screen," *Star-Bulletin* 19, no. 8 (January 1918): 6.

83. Charles L. Timmin (identified as "chief booker"), Philip Hodes (assistant service manager), and other Universal Film Corporation representatives joined prison officials during a May 1919 Sing Sing inspection. The MWL used the opportunity to express deep gratitude to the company for supplying films free of charge. Just over six months before Lawes's arrival, the studio cannot have anticipated how involved it would become with the prison in the years following Lawes's appointment. "Visitors to Sing Sing," *Star-Bulletin* 20, no. 11 (May 1919): 15.

84. *SOH* 16, no. 20 (February 11, 1915): 322.

85. Anonymous, "The GM Movies," *SOH* 16, no. 19 (February 13, 1915): 38.

86. The gift was preceded by a visit to the prison by Strand Theater representatives R. Alfred Jones, J. Victor Wilson, and Mr. Kruse. Ibid.

87. "Sing Sing Inmates Strive to Produce a Reel Name," *New York Tribune*, February 13, 1915, 5.

88. Williamson's equipment was also used to shoot the first underwater fiction film, Jules Verne's *Twenty Thousand Leagues Under the Sea* (1916). Six months before the Sing Sing screening, *Twenty Thousand Leagues* premiered at the American Museum of Natural History.

89. "M. W. L. Educational Activities," *SOH* 16, no. 19 (February 11, 1915): 322.

90. For more on the humors and temperaments, see Noga Arikha, *Passions and Tempers: A History of the Humours* (New York: Harper Perennial, 2008).

91. "Entertainments at Sing Sing," *SOH* 16, no. 20 (February 27, 1915): 322.

92. Ibid., 318. *Alias Jimmy Valentine* was shown on Sunday, February 14, 1915. For a review of the film's theatrical release, see "Attraction at the Theatres: Review of *Alias Jimmy Valentine*," *Boston Globe*, May 16, 1920, 66.

93. "Invites Police Officials," *Los Angeles Times*, May 6, 1921, 19. Sing Sing would go on to appear in many prison films: *The City of Silent Men* (Tom Forman,

1921) was shot on location, where its star, Thomas Meighan, was apparently mistaken for an actual prisoner by one of the guards and had to talk his way out of the situation. The film, which generated considerable buzz among prison officials on the East Coast, was written up in the *Los Angeles Times* and a special screening given at a local downtown LA theater.

94. F. Raymond Daniel, "Sing Sing's Pampering Done in Tiny, Damp Cells," *New York Evening Post*, February 26, 1927.

95. Richard Harding Davis, "The New Sing Sing," *NYT*, July 18, 1915, 6.

96. "Prison Entertainments," *NYT*, December 22, 1924.

97. "Sing Sing Cuts Movie Shows, Since Cells Are More Livable," *NYT*, August 15, 1929, 19.

98. Daniel, "Sing Sing's Pampering." Sing Sing's hospital records show that between 1910 and 1912, men were contracting syphilis after they had been admitted to the prison. See James W. White, "Facts About Sing Sing," unpublished report, ca. 1914, MS 64, box 276, Original Records, OFP, cited in McLennan, *Crisis of Imprisonment*, 285n13.

99. Lawes, *Twenty Thousand Years in Sing Sing*, 83.

100. "Convicts Are Men—Men Need Women," *New York Daily News*, September 16, 1934, 1666. On the futility of reform initiatives in the same-sex prison, the author argued, "You can't force a convict to live an abnormal life, cut off from women, for two or five or ten or twenty years, and expect to have much luck with your highly intelligent plans to make him over from a criminal to a decent citizen."

101. The Westchester County Grand Jury brought two indictments against Osborne: perjury and neglect of duty. Of the six charges contained in the latter indictment, the last alleged that he committed "various unlawful and unnatural acts with inmates at Sing Sing." Chamberlain, *There Is No Truce*, 327. For more on accusations of sexual misconduct, Osborne's legal travails, and his eventual resignation from Sing Sing, see McLennan, *Crisis of Imprisonment*, 414–16.

102. Lawes, *Twenty Thousand Years at Sing Sing*, 247.

103. Richard Enright cited in Blumenthal, *Miracle at Sing Sing*, 95.

104. Said Lawes, "The band is composed of prisoners who work at other tasks and who own their own instruments. . . . It is not provided for the entertainment of the inmates but is used just as it is in the army, because marching men can be handled more easily and quickly than a motley group." Lawes, *Life and Death in Sing Sing*, 73.

105. Charles Dudley Warner, "A Study of Prison Management," in Barrows, *Reformatory System*, 48. For an example of anticoddling, especially incredulity at the lengths to which governors and wardens were prepared to go in the name of progressivism, see

George, "Convicts at Large Without Guards," IM20. For a sense of the coddling debate from a woman's perspective, see "Convict 'Coddling' Causes Lively Debate Among Women," *Brooklyn Daily Eagle*, January 11, 1930.

106. Henry A. Higgins, quoted in "Penal Methods in Massachusetts and State Prison Administration," *Gazetta del Massachusetts*, 1921, file 46a, box 9, series 6, General Scrapbooks, LLP-JJC.

107. Henry Melville to Lewis E. Lawes, March 2, 1922, Correspondence Scrapbook, 1904–1924, box 3, LLP-JJC.

108. Lewis E. Lawes to Brice P. Disque, undated two-page transcript in response to General Disque's speech before the Merchants Association of New York City [ca. 1928], file 23, box 5, LLP-JJC.

109. Lawes quoted in Charles M. Bayer, "Writers Find No 'Coddling' at Sing Sing," unidentified newspaper clipping [most likely the *New York Times*], 1929, folder 48, 1928–1930, box 9, series 6, General Scrapbooks, LLP-JJC.

110. Ironically, the end of competitive football playing at Sing Sing, during which the public paid to watch the Black Sheep team play local rivals, and the end of prison theatricals that also charged admission to the public were not as a result of pressure from anticoddlers but an order from Commissioner of Corrections Edward P. Mulrooney, who declared it was wrong for the public to pay to watch prisoners perform either as athletes or as entertainers. See Curt Wilson, "Sound and Fury: No More Football at Sing Sing," *Danbury New Times*, October 20, 1936. The Black Sheep had been widely praised for instilling such values as good sportsmanship; see "College Athletic Officials Laud Football Games at Sing Sing," unidentified clipping, box 11, LLP-JJC.

111. Lewis E. Lawes, draft of article for the *New York Times*, November 19, 1931, file 2, box 1, LLP-JJC.

112. "Love Praises Baumes-Law; Favors Movies in Prisons," unidentified clipping, file 45, box 9, series 6, General Scrapbooks, LLP-JJC.

113. For a sample of press coverage that recuperates inmates from racist, conservative, and condemnatory discourses, see Peter Applebome, "After Graduation, Back to the Sing Sing Cellblock, with Hope," *NYT*, June 7, 2010, A16; Mary Pilon, "A Series of Poses for Fitness, Inside and Out," *NYT*, January 4, 2013, A11, A15. In February 2011, CUNY's University Faculty Senate hosted a conference on higher education in the prisons that became a film of the same name, directed by Campbell Dalglish and released in 2012. The UFS launched a campaign and task force to restore financial aid (Pell and TAP monies) to incarcerated college students. See "PFS Conference on Higher Education in the Prisons: One Year Later," *Senate Digest*, April 2012, 4. For videos, see Carnegie Hall, "Behind Bars: Music at Sing Sing,"

YouTube, 11:43, July 30, 2012, https://www.youtube.com/watch?v=TBYRMgPny-k; and Odyssey Networks, "20 to Life: Prisoners Find a Purpose at Sing Sing," YouTube, 4:55, May 16, 2012, https://www.youtube.com/watch?v=hi8aeba1L8E. The latter video documents the MA in Professional Studies based at Sing Sing in conjunction with Union Theological Seminary.

114. "Seek Fake Sing Sing Agent," *NYT*, May 2, 1921, 15.

115. "Transcript of Speech Given in Support of Parole," *Harper's Weekly*, April 1938, 4, file 27, box 5, Drafts of Articles and Scripts, LLP-JJC.

116. Blumenthal, *Miracle at Sing Sing*, 10; Osborne to Lawes, February 6, 1920, file 1, box 1, General Correspondence of the 1920s, LLP-JJC. For background reading on Lawes, see John Jay Rouse, *Firm but Fair: The Life of Sing Sing Warden Lewis Lawes* (New York: Xlibris, 2000).

117. Elmira Reformatory was founded in 1876 upon the following principles: an indeterminate sentence; a prisoner classification and accounting system including wage-earning possibilities; a trades school; traditional school and supplementary lectures; military organizations, training, and drills; physical culture and gymnasium; manual (physical) training especially to overcome physical defects; library and religious instruction. Lawes, *Twenty Thousand Years in Sing Sing*, 36.

118. Lawes was criticized by John G. Purdie, who, in a letter to the editor of the *Globe* entitled "Leniency with Criminals," attacked progressive penal policy. In letters to Charles F. Rattigan, superintendent of prisons, Purdie railed on Lawes for "craving the limelight" and behaving "as though his position were that of press agent for a burlesque show instead of prison warden." Lawes to Rattigan, July 19, 1920 (quoting the *Globe* piece), and Purdie to Rattigan, June 28, 1920, file 3, Commissioner of Corrections Misc., 1915–1941, box 1A, Correspondence, series 1, Personal Papers, LLP-JJC. It is interesting that this attack on Lawes should occur within six months of him taking up the wardenship at Sing Sing.

119. Lawes, *Twenty Thousand Years in Sing Sing*, 307.

120. For a negative review of *Chalked Out*, cowritten by Lawes with Brook Pemberton, see "Other Business," *New Yorker*, April 3, 1937.

121. Major works by Lawes, listed chronologically, include *Man's Judgment of Death: An Analysis of the Operation and Effect of Capital Punishment Based on Facts, Not on Sentiment* (New York: G. P. Putnam, 1924); *Life and Death in Sing Sing* (1928); *Twenty Thousand Years in Sing Sing* (1932); *Cell 202, Sing Sing* (New York: Farrar and Rinehart, 1935); *Invisible Stripes* (New York: Farrar and Rinehart, 1938); *Meet the Murderer!* (New York: Harper, 1940); *Stone and Steel: The Way of Life in a Penitentiary* (Evanston, IL: Row, Peterson, 1941); *The Last Mile: A Play in Three Acts* (cowritten with John Wexley) (New York: R. French, 1941).

122. For examples of solicitations from publishers and invitations to appear on radio, see file 9, Publisher's Solicitations, 1925–1942; file 10, Radio Shows, 1933–1943; and file 11, Requests for Comments (1933–1934 and 1938–1989), box 1A, Correspondence, series 1, Personal Papers, LLP-JJC.

123. Commission Pénitentiaire Internationale, "Programme of Questions to Be Discussed at the Ninth International Penitentiary Congress, London 1925" (Groningen, Netherlands: J. B. Walters, 1923). The quote is from Lawes's response to this question: "What is the best method to preserve the community especially youth from the corruptive influence of pictures and in particular from film productions which incite crime or immorality?" File 9, Publisher's Solicitations, 1925–1942, box 1A, Correspondence, series 1, Personal Papers, LLP-JJC.

124. Lewis E. Lawes, "The Price We Pay When Character Training Fails," *Bulletin of the Welfare Council of New York City*, ca. 1928, folder 47, 1926–1930, box 9, series 6, General Scrapbooks, LLP-JJC.

125. Schedule A, "Suggested Comment of Warden Lawes," Lawes Supplementary Collection I, box 1, LLP-JJC.

126. Lawes, "Price We Pay," n.p.

127. *International Review of Educational Cinematography* 1 (1929): 493.

128. Franklin Roosevelt to Lawes, March 13, 1935, box 11, LLP-JJC.

129. Jack Warner to Lawes, August 14, 1932, box 19, Contracts and Related Correspondence: 1932–1939, LLP-JJC.

130. Charles Chaplin to Lawes, April 3, 1935, box 11, General Scrapbook, LLP-JJC.

131. "Convict Wins a Film Prize: Suggests Best Name for Moving Picture Shown at Sing Sing," *NYT*, September 13, 1915, 4. It is worth adding that the industry also recruited talent from the inmate population, with the press covering it as a novelty news item: "Convict Story Writer Gets Film Magazine Job," *New York Sun*, April 17, 1931. First National Pictures also offered $100 for a Sing Sing inmate review of *The Beautiful City*, many scenes of which were shot on New York's Lower East Side. "With the Producers and Players," *NYT*, November 8, 1925, X5.

132. "'Valentine' Film at Sing Sing: Motion Pictures of Well Known Play Please Convict Audience," *New York Tribune*, February 16, 1915, 9.

133. Lawes, *Twenty Thousand Years at Sing Sing*, 115; "Sing Sing Bars Arbuckle," *NYT*, December 25, 1922, 11. According to Sing Sing historian Denis Brian, the MWL "passed liberally on the movies and plays shown to the inmates," but Lawes did censor parts of the first big annual show under his supervision at Sing Sing; said Lawes, "There's a lot goes on Broadway . . . that won't get over in Sing Sing." Brian, *Sing Sing*, 25.

134. Lawes, *Twenty Thousand Years in Sing Sing*, 119.

135. For a discussion of how crime films "reflected and refracted the widespread anxieties about urbanization, criminality, and governance that characterized the early years of the twentieth century," see Lee Grieveson, "Gangsters and Governance in the Silent Era," in *Mob Culture: Hidden Histories of the American Gangster Film*, ed. Lee Grieveson, Esther Sonnet, and Peter Stanfield (New Brunswick, NJ: Rutgers University Press, 2005), 13–40 (quote on 40).

136. George Gordon Wade, "On the Screen," *Star-Bulletin* 20, no. 1 (June 1918): 10.

137. Edward Rooney, "On the Screen in Sing Sing," review of *Idolators* (Walter Edwards, 1917), *Star-Bulletin* 19, no. 8 (January 1918): 29. Wade makes the same argument about the need for strong moral lessons in Sing Sing screened films in "On the Screen at Sing Sing: A Foreward," *Star-Bulletin* 19, no. 2 (May 1918): 18.

138. "Sing Sing Cuts Movie Shows." A total of 1,650 men moved into the new cell block, leaving 145 in the old cell building.

139. Lawes, *Life and Death in Sing Sing*, 79.

140. "These Are Your New York," 15.

141. Lawes to William N. Thayer Jr., commissioner of corrections, December 8, 1931, file 2, Correspondence, 1930–1935, LLP-JJC.

142. "Model Prison Abolishes Its Cells to House Convicts in a Spacious Dormitory with Appointments," unidentified publication, March 25, 1928, file 45 (1925–1931), box 9, series 6, General Scrapbooks, LLP-JJC.

143. Lawes to editor of *New York Telegram*, July 18, 1928, file 1, General Correspondence of the 1920s, box 1, Lawes Supplementary Collection, LLP-JJC. Sing Sing's cemetery was called the "Twenty-Five Gallery," since the highest number gallery in the cell block was twenty-four. Osborne, *Society and Prison*, 196.

144. "No Social Revolution Seen as a Result of Broadcasting," *NYT*, March 13, 1927, X20. For more on radio as a palliative against loneliness in prion cells, see George Holmes, "Man Behind the Bars Hears Distant Cities," *NYT*, April 19, 1931, 128.

145. Unidentified Lawes quote cited in Blumenthal, *Miracle in Sing Sing*, 111. Not all penitentiaries had individual listening devices in cells. Concord State Prison, a maximum-security prison for youth offenders in New Hampshire, installed a receiving set in the late 1920s after prisoners lobbied for radio, along with an amplifier strong enough to broadcast programs from stations in the Newark and Pittsburgh areas through the cell corridors. Concord State was also the setting of a Harvard University experiment led by Timothy Leary in which inmates were given the psychoactive drug psilocybin and psychotherapy to see whether it reduced levels of recidivism. The study's conclusion showed only a slight statistical improvement in recidivism levels. "Radio Installed at Concord Prison," unidentified, undated clipping, file 46b, p. 322, box 7, series 3, Sing Sing Publications, LLP-JJC.

146. Unidentified Lawes quote cited in Blumenthal, *Miracle at Sing Sing*, 111–12. Inmates at Eastern State Penitentiary in Philadelphia illegally obtained and operated eighteen radios at the prison in 1923; radios, like other contraband, permeated prison's walls. "Grand Jury Flays Prison Conditions," *Evening Bulletin* (Philadelphia), May 24, 1923, 34.

147. The first three tubes supplied 21 loudspeakers, the next three supplied 300 headphones, and the last three 680 headphones, for a total of [980] headphones. "Every Jail Must Have Radio," *Science and Instruction*, January 1920.

148. Radio was anticipated at Sing Sing by lectures on telegraphy. In January 1915, Sing Sing prisoners heard a lecture on telegraphy in which telegrapher-inmates were given an "opportunity to read the tune of the wireless in the sound-waves of the Assembly Hall. Many of the boys caught the tune and repeated the exact words of the message back to the Professor [Colby]." "Christmas in the Monastery," 295. For a sample of press coverage of radio's first appearance in prisons, see "Radio Opens Walls for 3,000 Convicts," *NYT*, May 26, 1930, 30 (about Joliet Prison), and Lewis E. Lawes, "Radio Goes to Jail," *Radio Guide*, July 7, 1934, 3.

149. Lawes mentions this in "A Talk with the Governor of Sing Sing," *London Evening News*, July 15, 1935.

150. Lawes, *Twenty Thousand Years in Sing Sing*, 334.

151. "These Are Your New York," 15.

152. For more on early radio, masculinity, and agency, see William Boddy, *New Media and Popular Imagination: Launching Radio, Television, and Digital Media in the United States* (New York: Oxford University Press, 2004); and Lynn Spigel, *Make Room for TV: Television and the Family Idea in Postwar America* (Chicago: University of Chicago Press, 1992).

153. "Radio in 1,800 New Cells for Long-Termers at Sing Sing," uncredited newspaper clipping, p. 522, folder 48, 1926–1930, General Scrapbook, LLP-JJC.

154. "A Royal Entertainment," *SOH* 16, no. 18 (January 30, 1915): 292.

155. San Quentin's radio system, the "Grey's Network," was so successful that Warden Clinton T. Duffy started a program called "Interview Time," in which he would respond to questions that the men had submitted to him on pieces of paper. Duffy, *San Quentin*, 199.

156. "Danes Hear 'Radio Trial.' 'Jury' of 100,000 Mails Verdict on Broadcast Case," file 45, 1925–1931, box 9, series 6, General Scrapbooks, LLP-JJC.

157. Robert Eichberg, "Convicts Are Radio Fans," *Broadcasting*, November 1934.

158. M. Newman to Lawes, January 27, 1930, series 1, Personal Papers A: Correspondence Scrapbooks (1925–1932), box 4, LLP-JJC.

159. Script of *The Vitalis Program*, 19, file 28, Sing Sing, box 5B, Drafts of Articles and Scripts, LLP-JJC.

160. Ibid., 22.

161. Lawes discussed the death penalty in a 1928 appearance on "Collier's Hour." He also used the opportunity to refer to what he saw as the positive and negative effects of motion pictures on criminals; he received several congratulatory letters and was praised for his comments on the deleterious effects of motion pictures. "Correspondence on 1928 'Colliers Hour' Radio Program," file 6, box 1, General Correspondence of the 1920s, LLP-JJC.

162. Lawes announced that "leading clergymen, scientists, educators, military officers and others would address the prisoners via radio during the winter." Untitled clipping from the *Sun*, December 15, 1930, file 52A, box 10, LLP-JJC.

163. "A Radio in Every Sing Sing Cell," *Lowell, Mass., Telegram*, February 25, 1934, file 56, 1933–1936, box 11, LLP-JJC.

164. According to the U.S. Bureau of Justice, 1,561,500 adults were incarcerated in U.S. federal and state prisons at the end of 2014, the highest documented incarceration rate in the world but down 1 percent from 2013. A total of 6,851,000 adults were under correctional supervision (probation, parole, jail, or prison). For statistics on incarceration rates in the United States, see http://www.bjs.gov/index.cfm?ty=tp&tid=11.

165. Lawes quoted in "News!," *Radio Stars*, November 1934.

166. Lecture announcement for talk by Professor Colby at Auburn on December 22, 1914, *SOH* 16, no. 18 (January 30, 1915): 295.

167. "Police of Many Cities Have Radio as Aid," *New York Sun*, April 30, 1931.

168. Frank L. Christian, "Recreation at the Elmira Reformatory," 3 and 5, LLP-JJC.

169. Lawes, unidentified source, file 23, Crime and Penology, box 5, Drafts of Articles and Scripts, LLP-JJC.

170. Visual instructions were written up in "On the Screen at Sing Sing," *Star-Bulletin* 20, no. 6 (November 1918): 10; advertising in "On the Screen at Sing Sing," *Star-Bulletin* 20, no. 7 (December 1918): 10.

171. Lawes, "Great Unseen Audience," 4.

172. Blumenthal, *Miracle at Sing Sing*, 2.

173. Ibid., 92.

174. Ibid., 2.

175. Lawes, "Great Unseen Audience."

176. Wallack, "Physical Education," 231.

177. Lawes, "Great Unseen Audience."

178. "Sing Sing . . . the Jail with a Human Touch," *Daily Herald*, November 29, 1937.

5. A Different Story

1. Auburn Women's Prison No. 321, "Women's Writes," *SOH* 3, no. 3 (May 18, 1901): 66. The idea of a woman ending up in prison because of a man is a refrain (and often a reality) in prison history. Henry Mayhew and John Binny were often dumbfounded as to why women stayed with criminals: "Do they love the half brutes with whom they cohabit, and from those hands they bear the blow after blow without a murmur. . . . What strange quality is it that makes them prize them beyond any other being in the world?" Mayhew and Binny, *The Criminal Prisons of London*, 467.

2. I refer to correctional facilities for women throughout this chapter interchangeably as *reformatories* and *prisons* for the simple reason that provisions for women's incarceration varied across states. While some women were held in prison farms modeled on the "cottage system" discussed later in the chapter, others were held in small female wings of male penitentiaries. Some reformatories even included custodial prisons for women who, "because of their age, offense, prior record, or history of disciplinary infractions in a reformatory, seemed beyond reform." For a discussion of the rise of reformatories in the last quarter of the nineteenth century, see Nicole Hahn Rafter, "Hard Times: Custodial Prisons for Women and the Example of the New York State Prison for Women at Auburn, 1893–1933," in *Judge, Lawyer, Victim, Thief*, ed. Nicole Hahn Rafter and Elizabeth Anne Stanko (Boston: Northeastern University Press, 1982), 238. For a European perspective on the topic, see Eugenia Cornelia Lekkerkerker, *Reformatories for Women in the United States* (The Hague: Bij J. B. Wolters' Uitgevers-Maatchappij, 1931).

3. Drawing upon a rich, virtually untapped archival record of women's experiences in prison in the late nineteenth and early twentieth centuries, I appropriate Guiliana Bruno's tactic of "mapping out the scene of microhistories," connecting the "analytical detail [of carceral life] with panoramic vision." Guiliana Bruno, *Streetwalking on a Ruined Map: Cultural Theory and the City Films of Elvira Notari* (Princeton, NJ: Princeton University Press, 1993), 3–4.

4. Cesare Lombroso and Guglielmo Ferrero, *Criminal Women, the Prostitute, and the Normal Woman*, trans. and with new introduction by Nicole Hahn Rafter and Mary Gibson (Durham, NC: Duke University Press, 2004), 8.

5. Rafter, "Introduction" to *Criminal Women*, 4, 6, 8. Criminal women were infantilized and seen as less evolved than law-abiding women and even male criminals; so-

called female crimes such as shoplifting were explained, Rafter argues, "in terms of sublimated sexuality, and in many jurisdictions girls arrested for delinquency were automatically given vaginal exams to determine their virginity" (28).

6. Davis, *Are Prisons Obsolete?*, 65.

7. For more on this network of women reformers, see Freedman, *Maternal Justice,* 111–21. Women were assuming positions of power in penal institutions internationally; for example, reformer Victoria Kent, the first woman to argue criminal cases in Madrid and one of four women admitted to the bar in Spain, was hired to run Spain's prison system in 1931, and declared that newspapers and books should be readily available in prison and that prisoners without religious beliefs should not be forced to attend services: "One may deprive men of their freedom, but not of their liberty and conscience," she said. Victoria Kent, "A Woman Runs Spain's Prisons," *Literary Digest*, June 27, 1931, 15. Women were also active in the anti–capital punishment movement, one group forming a female Anti–Capital Punishment Society in New York and another, in Philadelphia in 1847, delivering a petition with 1,777 names on it. Masur, *Rites of Execution*, 122.

8. Founded in 1870, the American Prison Association is now called the American Correctional Association (name changed in 1954), with approximately 80 percent (twenty thousand) of its members coming from state departments of corrections and youth services. Rutherford B. Hayes was elected first president of the association. For a mid-nineteenth-century perspective on the challenge of where to house female criminals and the dangers they faced by corrupt priests, see Andrew B. Cross, *Priests' Prisons for women; or, A consideration of the question, whether unmarried foreign priests ought to be permitted to erect prisons, into which, under pretense of religion, to seduce or entrap, or by force compel young women to enter, and after they have secured their property, keep them in confinement and compel them, as their slaves, to submit themselves to their will, under the penalty of flogging or the dungeon? In Twelve Letters to T. Parkin Scott* (Baltimore: Sherwood, 1854).

9. Lucia Zedner, *Women, Crime, and Custody in Victorian England* (Oxford: Clarendon, 1991), 353. According to Rafter, the women's reformatory movement launched with two important milestones: the founding of a house of shelter for women, which operated for a short time at the Detroit House of Corrections, and the opening of the first completely separate, female-run prison for women, the Reformatory for Women and Girls, in 1873. Nicole Hahn Rafter, "Chastising the Unchaste: Social Control Functions of a Women's Reformatory, 1894–1931," in *Social Control and the State*, ed. Stanley Cohen and Andrew Scull (New York: St. Martin's, 1983), 289.

10. Rafter, "Chastising the Unchaste," 289. Women were infantilized and discriminated against by the judicial process; separate women's courts (established in New York City in 1908), like juvenile courts, "dispensed with jury trials, giving the judge extraordinary powers to convict and sentence." Freedman, *Their Sisters' Keepers*, 129.

11. Nicole Hahn Rafter, *Partial Justice: Women, Prisons, and Social Control* (New Brunswick, NJ: Transaction, 2004), 29. Sherborn Reformatory looked no different from other stone-edifice, congregate-style prisons. Constructed on thirty acres of land, thirty miles east of Boston, the pastoral setting was considered a key asset in the reform process. Freedman, *Maternal Justice*, 185. It still operates, as the Massachusetts Correctional Institution (MCI Framingham). For a contemporary analysis that also contains information on the prison's history, see Cristina Rathbone, *A World Apart: Women, Prison, and Life Behind Bars* (New York: Random House, 2006).

12. http://www.prisonpublicmemory.org/hudson-prison-history#houseofrefuge. For a detailed analysis of the Western House of Refuge in Albion, New York, operational from 1894 to 1931, see Rafter, "Chastising the Unchaste," 291–306. For contemporaneous analysis of why women turned to prostitution, see George Kneeland, *Commercialized Vice in New York*, in which he interviewed prostitutes, discussed in Paul Boyer, *Urban Masses and Moral Order in America, 1820–1920* (Cambridge, MA: Harvard University Press, 1978), 202–10; and Jane Addams, *A New Conscience and an Ancient Evil* (New York: Macmillan, 1912).

13. Mayhew and Binny, *Criminal Prisons of London*, 177. For a discussion of prison-farms housing women prisoners in Britain, see Zedner, *Women, Crime, and Custody*, 239–42.

14. Zedner, *Women Crime, and Custody*, 4.

15. See Jeanne Robert, "The Case of Women in State Prisons," *Review of Reviews* 44 (July 1911): 76–84, reprinted in Bacon, *Prison Reform*, 93–101.

16. "Prison for Women Has No Lock or Bars," *New York Sun*, March 16, 1931.

17. "Prison in West Follows Line of Summer Resort," unidentified newspaper clipping, ca. 1930, file 45, 1925–1931, p. 167, box 9, series 6, LLP-JJC. The earliest reference I have come across of women working as guards in a male prison is at Sing Sing Correctional Facility in 1930. In "Sing Sing to Hire Woman," the *New York Times* reported that a female guard, who would oversee women visitors to the prison, was charged with the task of searching suspicious visitors for weapons or contraband and "checking up on women who say they are married to prisoners in order to get permission to see them" (March 16, 1930).

18. Ibid.

19. "Convicts to Live in Dormitories," *New York Sun*, September 18, 1931.

20. Freedman, *Maternal Justice*, 193.

21. *1901 Report of the Superintendent of State Prisons, New York*, 1902, 34.

22. Robert, "The Case of Women," 93. The prison opened in 1877 and was the second women's prison in the United States. Women also adorned their cells with pictures at the State Prison for Women, Auburn, and were given striped rag rugs to place on the floor (95).

23. Barrows, "The Massachusetts Reformatory," 127.

24. Auburn Women's Prison No. 321, "Women's Prison: Its History and Its Industries," *SOH* 2, no. 5 (August 25, 1900): 175.

25. The prison chapel at Sherborn was used for services and Sunday school on the weekend, and, on an "occasional week-day evening," the women would gather for an "entertainment, musical or literary, sometimes given by talent from outside the prison and sometimes prepared by the women themselves." Barrows, "Massachusetts Reformatory Prison for Women," 121.

26. Robert, "Case of Women," 77.

27. Rafter, *Partial Justice*, 27.

28. See Rafter, "Chastising the Unchaste," 288, 291. For reform materials targeting younger girls, see Annie W. Allen, "How to Save Girls Who Have Fallen," *Survey* 24, no. 19 (1910): 684–96.

29. "Bare Legs No Offense: Jury Acquits Woman on Trial as a Common Nuisance," unidentified clipping, ca. 1928, file 46b, box 9, series 6, General Scrapbooks, LLP-JJC.

30. Zedner, *Women, Crime, and Custody*, 7; J. O. Stutsman, *Curing the Criminal* (New York: Macmillan, 1926), cited in Lawes, *Life and Death*, 131.

31. Zedner, *Women, Crime, and Custody*, 7; Zedner, "Wayward Sisters," 331.

32. McLennan, *The Crisis of Imprisonment*, 273n95.

33. Dunbabin, *Captivity and Imprisonment*, 129. For a contemporaneous historical account of prison life for women in mid-nineteenth-century England, see Susan Willis Fletcher, *Twelve Months in an English Prison* (London: Lee and Shepard, 1864).

34. Gertrude Durston, wife of Auburn Prison warden Charles F. Durston (1887–1893), was described by the *New York Herald* as "a sort of Florence Nightingale in the prison" for her tours of Auburn Prison, where, accompanied by a Saint Bernard and an English mastiff, she delivered religious tracts to the prisoners. William Kemmler, the first man to die in the electric chair in the United States (see chapter 1), was her pet project, and she gave him a pictorial Bible primer and a writing slate. Essig, *Edison and the Electric Chair*, 236.

35. "Elizabeth Fry," *Wikipedia*, last modified November 20, 2015, http://en
.wikipedia.org/wiki/Elizabeth_Fry. See Elizabeth Fry, *Observations on Visiting, Su-
perintending, and Government of Female Prisons* (London: John and Arthur Arch,
1827). At the House of Correction, Holloway, London, in the mid-1850s, eight women
visitors would join the prison chaplain for prayer every Thursday morning before call-
ing on various female prisoners in their cells. For a discussion of the volunteers read-
ing to women in their cells, the prisoners' lack of education, and singing lessons from
the chaplain's wife, see Mayhew and Binny, *Criminal Prisons of London*, 527–68.

36. Zedner, *Women, Crime, and Custody*, 126.

37. Women volunteers would be assigned small groups of girls for their "special
charge," creating pseudofamilial groups. Praised for functioning as a "well governed
and well regulated family" in 1842, the Ladies Committee Report complained of a
"refractory spirit" the following year, one calling for "*mild* firmness" on the part of
the administration and, presumably, the Ladies Committee. F. H. McDowell, "Report
of the Ladies Committee," *Fifteenth Annual Report of the House of Refuge of Phila-
delphia with Appendix* (Philadelphia: Dorsey, 1843), 14–15.

38. John Sergeant, "To the Contributors to the House of Refuge," *Ninth Annual
Report of the Philadelphia House of Refuge with Appendix* (Philadelphia: Harding,
1834), 5. Religious services for various denominations were performed twice in the
chapel on Sundays (ibid.). No children of color were sent to the House of Refuge,
the administration arguing that it was hard enough to secure funding to open it for
Caucasians, let alone "make provision for Colored children." *Nineteenth Annual
Report of the Philadelphia House of Refuge with Appendix* (Philadelphia: Collins,
1847), 26. However, the 1861 *Report* refers to a "White" and a "Colored" department at
the House of Refuge, evidence that at least by this point in time African American
children were being admitted, but educated separately in their segregated gender
groups. The head teachers of the Caucasian as well as the African American girls
wrote the reports. *Thirty-Third Annual Report of the House of Refuge of Philadel-
phia with Appendix* (Philadelphia: Ashmead, 1861), 36, 51.

39. Zedner, *Women, Crime, and Custody*, 4.

40. As in all prisons across time, the image of female inmates with infants is piti-
ful, as Mayhew and Binny noted in 1862 when they came across mothers in the nurs-
ery at the House of Correction, Tothill Fields; their countenances make the visitor
"at once respect the nursery, and pity rather than loathe the degraded situation of the
poor creatures." Mayhew and Binny, *Criminal Prisons of London*, 475.

41. Auburn Women's Prison No. 321, "Women's Writes," *SOH* 3, no. 3 (May 18,
1901): 66. Rafter notes that the grade system allowed certain women to wear solid as
opposed to striped dresses; honor societies such as the Red Badge of Courage, founded

by a matron at AWP in 1903, helped induce obedience, but these systems were fairly short lived. Rafter, "Hard Times," 251.

42. Wrote Annie M. Welshe, matron, "To every inmate this change has been of material benefit. The old feeling of hatred which the stripes have caused can hardly be imagined and the removal of the cause banishes that, putting in its place gratitude toward you [warden] for your humane and thoughtful action." Annie M. Welshe, "Annual Report of the Women's Prison," *Annual Report of the Superintendent of State Prisons, New York*, 1903, 273.

43. Ash, *Dress Behind Bars*, 42–43, 28. For a fascinating description of women's ingenuity in customizing their prison dress in London prisons in the 1850s, see Mayhew and Binny, *Criminal Prisons of London*, 185.

44. More often than not, women bore responsibility for a prison's laundry, but they also performed other labor including weaving toweling, finishing blankets woven in the men's department, manufacturing prison clothing, and making mattresses and pillows. When we factor in the cooking and food preparation that women also did for the correctional officers and fellow inmates, it is clear that women were engaged in labor that was virtually identical to that which they performed on the outside. Robert, "Case of Women," 94.

45. For an analysis of prisoners of color at Auburn Women's Prison, see Leigh-Anne Francis, "Burning Down the Cage: African American Women Prison Communities in Auburn, New York, 1893–1933," PhD diss., Rutgers University, 2013. Welshe was matron of AWP for eighteen years until she resigned on August 1, 1911. She was succeeded by Miss Nettie M. Leonard, who for many years had worked at the Western House of Refuge for Women at Albion (*Report of the Superintendent of State Prisons, New York*, 1911, 14).

46. Robert, "Case of Women," 94.

47. Randall G. Sheldon, *Our Punitive Society: Race, Class, Gender and Punishment in America* (Long Grove, IL: Waveland, 2010), 134.

48. For a history of the prison written by a female Auburn inmate, see Auburn Women's Prison No. 321, "Women's Prison," 175. Auburn is the second oldest prison in New York State, after New York City's Newgate Prison, which opened in 1769 and was demolished in 1902. Auburn Correctional Facility operates as a maximum-security prison housing approximately 1,700 men (its capacity is 1,821). For a 2011 report on the prison see Correctional Association of New York, "Auburn Correctional Facility," Prison Visiting Project, June 2011, http://www.correctionalassociation.org /resource/auburn-correctional-facility-2.

49. "Women to Leave Auburn," *Telegraph*, April 5, 1932, n.p., file 50, box 10, LLP-JJC.

50. Rafter, "Hard Times," 238, 248. Rafter's argument that Auburn women prisoners "probably seemed incapable of resocialization to meet middle-class standards of womanliness" is not entirely borne out by evidence, which indicates that the prison authorities did attempt to socialize the women to bourgeois values; they were by no means lost causes (248). For an analysis of how race played out in discussions of criminal justice in New York State, see Cheryl D. Hicks, *Talk with You Like a Woman: African-American Women, Justice, and Reform in New York, 1890–1935* (Chapel Hill: University of North Carolina Press, 2010).

51. Lobbying to appropriate the space taken up by the women's prison had begun as early as 1911 when Superintendent of Prisons Joseph F. Scott argued that since the men's prison was overcrowded, the women should be moved to the State Farm for Women at Valatie. Scott, *Report of the Superintendent of State Prisons, New York*, 1911, 14. Calls to take over the space of the women's prison grew desperate in the late 1920s, when two hundred or so male Auburn prisoners were sleeping in the corridors due to overcrowding. See *Annual Report of Auburn Prison and State Prison for Women*, June 30, 1928, 1.

52. "Auburn Brevities," *SOH* 1, no. 15 (November 4, 1899): 12. This article provides a fascinating demographic snapshot of Auburn women prisoners confined in 1899, including status, education, county where convicted, native versus foreign born, preprison occupation, and sentence length.

53. Whissel, *Picturing American Modernity*, 154.

54. "Women's Writes," *SOH* 2, no. 6 (September 22, 1900): 211.

55. The women's prison population almost halved within the next six years to ninety-six at the end of 1908; almost half of the women (forty-two) were black and one-third (twenty-nine) foreign born. Seventy-one of them lived in New York, Kings, or Westchester counties. *1908 Annual Report of the Superintendent of State Prisons, New York*. A statistical snapshot from 1928 reveals that of fifty-three admitted women, twenty-seven had committed murder (fifteen second degree, twelve manslaughter), three assault, and eleven grand larceny. The median mental age of the women was ten to eleven years; thirty-one were married, nine single, and ten widowed. Of the 114, 87 were incarcerated for a first offense. "State Prison for Women Annual Report," *Annual Report of Auburn Prison and State Prison for Women*, 1928, 1.

56. Cornelius V. Collins, *Annual Report of the Superintendent of State Prisons, New York*, 1904, 30.

57. *Annual Report of the Superintendent of State Prisons, New York*, 1911, 14. A new system of classification was introduced in 1912: a two-week initial period of quarantine was followed by entry into the second grade, which could lead to promotion to first grade, with greater privileges, after a period of six months. Nettie M. Leonard,

"State Prison for Women Annual Report," *Annual Report of the Superintendent of State Prisons, New York*, 1912, 255.

58. Robert, "Case of Women," 94. The garden had previously been under the care of the male prisoners, but Matron Welshe persuaded the warden of the male prison to give it up for the women inmates (95).

59. Annie M. Welshe, "Annual Report for the Women's Prison," *Annual Report of the Superintendent of State Prisons, New York*, 1907, 281.

60. "State Prison for Women Annual Report, 1912," *Annual Report of the Superintendent of State Prisons, New York*, 1912, 253. In 1916, the National Committee on Prison Labor formed a Women's Auxiliary to the Employment Committee with the purpose of "helping women ex-cons find employment upon release." Memo of President's Report, 1916, in National Committee on Prisons and Prison Labor, 1913–1921 file, box 270, OFP.

61. Leonard, "State Prison for Women Annual Report," 253. According to Elizabeth Quirk, "agent" (read matron) of Sherborn Prison, demand outpaced the supply of domestics from the prison: families applied directly to the prison office, transforming it into an employment exchange (see Robert, "Case of Women," 78–79). Of the 3,150 imprisoned at the Western House of Refuge in Albion, New York, in its thirty-seven years of operation, 25 percent were paroled directly to live-in domestic positions; and of the admitted inmate population, 37 percent reported their previous occupation as domestic or houseworker. Rafter, "Chastising the Unchaste," 297.

62. George W. Benham, "Annual Report of Auburn Prison," *Annual Report of the Superintendent of State Prisons, New York*, 1908, 22.

63. Annie M. Welshe, "Women's Prison," *Annual Report of the Superintendent of State Prisons, New York*, 1901, 237.

64. *New York State Commission of Prisons Annual Report*, 1902, 52, cited in Rafter, *Partial Justice*, 91.

65. Reference to the spiritual work of the prison can be found in Welshe, "Annual Report of the Women's Prison," 1903, 165. Several women were paroled into the care of "Little Mother." Welshe, "Annual Report for the Women's Prison," 1907, 282.

66. Sykes, *The Society of Captives*, 76.

67. Freedman, *Maternal Justice*, 208, 198.

68. Auburn Women's Prison No. 321, "Women's Prison," 175.

69. "Women's Prison Library," *SOH* 3, no. 6 (June 29, 1901): 114. Some of the recently added titles included *The Crisis* by Winston Churchill and *The Eagle's Heart* by Hamlin Garland.

70. Ibid. Chaplain Herrick selected the books.

71. The *Annual Report of the House of Refuge of Philadelphia* includes interesting information on the prison library, bibliotherapy, and prisoner access for both the boys' and the girls' schools. See H. B. Niles, *Thirty Third Annual Report of the House of Refuge of Philadelphia with Appendix* (Philadelphia: Ashmead, 1861), 36.

72. The "Women's Writes" column appeared in issue ten of the first volume of the *Star of Hope.* Auburn Women's Prison No. 253 recounted the news of the women's invitation to contribute in the form of a poem: "Girls, you are granted permission / To write for the STAR OF HOPE / I know there will be no omission / You will all do well I hope. . . . We girls are anxious to help you [male prisoners] / In pushing the paper along / And kindly believe when we tell you / We know how to write a good song." "Women's Writes," *SOH* 1, no. 10 (August 26, 1899): 11.

73. For more on how women's writing in the late 1880s and 1890s constructs "both a modern consciousness" and exists as "an enigmatic cultural object" see Bentley, "Women and the Realism of Desire," 128.

74. Auburn Women's Prison No. 253, "Crime Causes," *SOH* 1, no. 15 (November 4, 1899): 14.

75. Auburn Women's Prison No. 25502, "Man's Inhumanity to Woman," *SOH* 1, no. 14 (October 21, 1899): 4.

76. Auburn Women's Prison No. 196, "The Star of Hope a Medium," *SOH* 3, no. 1 (April 20, 1901): 13.

77. All classes were ninety minutes long; completed materials would be mailed from the prison every Friday, after first being checked by the head teacher. See Helen P. Stone, "Remarks," *Annual Report of Auburn Prison and State Prison for Women*, June 30, 1928, 2; the author of *Female Life in Prison* (1862) viewed the teaching of women in prison to be a "hopeless task—the little progress one week is entirely forgotten the next." *Female Life in Prison*, 71, cited in Zedner, *Women, Crime, and Custody*, 193–94.

78. Helen P. Stone, "Remarks," *Annual Report of Auburn Prison and State Prison for Women*, June 30, 1925, 1.

79. E. J. Jennings, *Annual Report of Auburn Prison and State Prison for Women*, 1921, 3. For more on cinema's role within public education, see Orgeron, Orgeron, and Streible, eds., *Learning with the Lights Off*, and Peterson, *Education in the School of Dreams*, 101–36.

80. Auburn Prison No. 33828, "Thanksgiving Day: A Prisoner's Point of View," *SOH* 16, no. 16 (January 2, 1915): 251. Auburn Women's Prison No. 813 supplied the missing information about how the women were entertained at Thanksgiving four pages later: no movies were shown, but performances included musical numbers by members of the Doyle family, accompanied by piano, guitar, mandolin, and

trombone; a sketch involving four couples; and a "school boy's idea of 'Uncle Tom's Cabin.'"

81. "State Prison for Women at Auburn," *SOH* 18, no. 8 (December 1916): 25. Prison reformers Madeline Z. Doty, member of the New York Commission on Prison Reform, and Elizabeth C. Watson, investigator for the National Child Labor Committee, undertook their own Tom Brown experiment a few weeks after Osborne's. Intending to stay for a full week, the women broke down and left after four days. Chamberlain, *There Is No Truce*, 263–64. A fourteen-page report written by the women can be found in file 11–20, box 101, November 1913, OFP. Doty published her findings in *Society's Misfits* (New York: Century, 1916), available at https://archive.org/details/societysmisfits00dotyrich. Osborne wrote the introduction.

82. Auburn Women's Prison No. 876, "Evening Entertainment," *SOH* 16, no. 16 (January 1915): 255. The lantern projector was donated by friends of a Miss McCrea and weekly shows were organized for the women at the state prison.

83. "Seen and Heard on Sing Sing's Screen," *Star-Bulletin* 18, no. 16 (April 4, 1917) (starting with vol. 18, no. 10, when the name changes to *Star-Bulletin*, there are no page numbers). The film was originally called *The Girl Who Wanted to Live*. For a compendium of reviews, see Q. David Bowers, "Her Life and His," *Thanhouser Films: An Encyclopedia and History*, 1995, http://www.thanhouser.org/tcocd/Filmography_files/lq5dts.htm.

84. Arthur Copeland, "Chaplain's Report," *Annual Report of the Superintendent of State Prisons, New York*, 1912, 148. Emphasis added.

85. Arthur Copeland, writing in the 1914 annual report of the chaplain's department, endorsed the hymn singing but also asked that the music be "attractive," an initiative he hoped would help the women "make the most out of this opportunity of expression." Arthur Copeland, "Chaplain's Report," *Annual Report of the Superintendent of State Prisons, New York*, 1914, 201. Singing as a disciplinary agent has a long history in the reformatory or house of refuge movement; for example, children at the Philadelphia House of Refuge had singing lessons, which it was thought would "advance their moral and mental improvement." *Thirty-Third Annual Report of the House of Refuge of Philadelphia with Appendix* (Philadelphia: Ashmead, 1861), 38.

86. Auburn Women's Prison No. 958, *SOH* 18, no. 4 (August 1916): 17.

87. "State Prison for Women at Auburn," 25.

88. Leonard, "Auburn Report of Women's Prison," *Report of the Superintendent of State Prisons, New York*, 1911, 225.

89. Auburn Women's Prison No. 914, "A Fine Entertainment," *SOH* 16, no. 23 (April 10, 1915): 370.

90. Matron M. E. Daly, "Women's Prison Report," *Annual Report of Auburn Prison and State Prison for Women*, June 30, 1920, 3.

91. Author interview with Brian Capra, Sing Sing superintendent, May 2014. MCI Framingham was a hub for theatrical performances and clubs when Van Waters was superintendent from 1932 to 1957: the International Club, Glee Club, Merry Makers, and Drama Club were devoted to the performance arts. Inmates often worked on musicals in ethnic groups, using folk songs from Russia, Poland, and Portugal. See Freedman, *Maternal Justice*, 194–98.

92. Freedman, *Maternal Justice*, 78, 80, 90. For a discussion of how race impacted the California juvenile system, see Miroslava Chavez-Garcia, *States of Delinquency: Race and Science in the Making of California's Juvenile Justice System* (Berkeley: University of California Press, 2012).

93. Auburn Women's Prison No. 321, "The Minstrel Show," *SOH* 3, no. 19 (December 28, 1901): 324. The minstrels had performed in the women's prison several years back and were recognized by some of the women inmates. Space precludes digging deeper into the raced and gendered meanings of white men in blackface performing for an all-female audience at AWP. To be sure, minstrelsy's already complex sign system must have brought into play a slew of other meanings around the pseudoblack body.

94. Auburn Women's Prison No. 917, "Labor Day in Women's Prison," *SOH* 16, no. 10 (September 26, 1914): 151.

95. Welshe, "Annual Report for the Women's Prison," 1907, 282.

96. The Auburn Women's Christian Temperance visits in June and December continued at least into 1911, when they visited with flowers in June and brought a calendar, orange, and box of candy for each inmate in December. Leonard, "Auburn Report of Women's Prison," 1911, 225.

97. Welshe, "Annual Report for the Women's Prison," 1907, 283. Emphasis added.

98. "Report of the Board of Managers," *Twenty-First Annual Report of the New York State Reformatory for Women*, Bedford Hills, New York, June 30, 1920.

99. Freedman, *Their Sisters' Keepers*, 131.

100. Robert, "Case of Women," 98.

101. Superintendent Katherine B. Davies appealed to Rockefeller in 1910 for financial support to institute a clinic for the mental testing of women at Bedford. She was awarded a grant of $3,000. Rafter, *Partial Justice*, 69.

102. For a history of female delinquency as defined in New York State, see Ruth M. Alexander, *The "Girl Problem": Female Delinquency in New York, 1900–1930* (Ithaca, NY: Cornell University Press, 1995); Mara L. Dodge, *"Whores and Thieves of the Worse Kind": A Study of Women, Crime, and Prisons, 1835–2000* (DeKalb: Northern Illinois University Press, 2002); and Mary J. Bularzik, *Sex, Crime, and Justice:*

Women in the Criminal Justice System of Massachusetts, 1900–1950 (Ann Arbor: University Microfilms International, 1982).

103. There is a sizable bibliography on women's prisons and reformatories but little specifically on their access to media.

104. Rafter, *Partial Justice*, 72. See Rafter, *Partial Justice*, for a discussion of the disturbing "treatments" used at Bedford, which included hydrotherapy and the use of ice packs (73). By the late 1920s, discipline had been restored to Bedford (80). For an illustration of the "water cure" in a male prison, see Russell, "Beating Men," 618. The caption alone signifies the horrific nature of the torture: "First it is necessary to get the man's mouth open by making him cry out (which is usually done by frightening him) whereupon the water streams down his throat and strangles him."

105. For a write-up of the eighteen-month investigation of the psychopathic hospital connected to Bedford Hills, see Edith R. Spaulding, "The Problem of a Psychopathic Hospital Connected with a Reformatory," *Medical Record* 99, no. 20 (May 13, 1921): 815–22. The women examined in the study group were "borderline cases of mental disease . . . early cases of schizophrenic and cases of cerebrospinal lues [syphilis] that are not committable . . . cases of epilepsy, and the many that may be grouped under the general terms of constitutional inferior or psychopathic personality" (815).

106. Ibid., 820.

107. *Annual Report of the New York State Reformatory for Women*, Bedford Hills, New York, June 30, 1919, 10. The plea for a chapel was made again in the *Twenty-Second Annual Report of the New York State Reformatory for Women*, 1921.

108. "Report of the Board of Managers," *Twenty-Second Annual Report of the New York State Reformatory for Women*, 1921.

109. "Girl Prisoners Mutiny," *NYT*, January 3, 1920, 2.

110. For more on the situation at Bedford Hills during the 1910s and 1920s, see Rafter, *Partial Justice*, 71–80.

111. *Annual Report of the New York State Reformatory for Women*, 1913, 15, cited in Rafter, *Partial Justice*, 79. Shifting attitudes toward prostitution after 1917 unleashed fears toward women as a threat to society, a rejection of the idea of the fallen woman as victim, which had prevailed in the late nineteenth century; see Freedman, *Their Sisters' Keepers*, 147.

112. "Bedford Girls Say Ban on Film Caused Flight," *New York Tribune*, May 11, 1921, 8.

113. Ibid.

114. *Annual Report of the New York State Reformatory for Women*, 1922.

115. Zedner, "Wayward Sisters," 349.

116. For a contemporaneous analysis of incarcerated women, see Caroline H. Woods, *Woman in Prison* (New York: Hurd and Houghton, 1869).

117. Arthur Griffiths, uncited quotation in Zedner, "Wayward Sisters," 350.

118. Medical Report on Brixton Female Prisoners, 1854, cited in Mayhew and Binny, *Criminal Prisons of London*, 182.

119. Simon Schama, *The Embarrassment of Riches: An Interpretation of Dutch Culture in the Golden Age* (New York: Knopf, 1987), 445, cited in Angela Vanhaelen, *Comic Print and Theatre in Early Modern Amsterdam* (Farnham, UK: Ashgate, 2003), 106. Vanhaelen examines the symbolic reversals at play in catchpenny presses, especially the topos of gender reversal in which women engage in traditionally masculine activities while their husbands enact the role of the stay-at-home wife and mother (109).

120. Mayhew and Binny, *Criminal Prisons of London*, 527–58.

121. Zedner, "Wayward Sisters," 349.

122. For more on "breaking out" and examples from Millbank Prison, where, in 1854 alone, there were 154 cases, see Zedner, *Women, Crime, and Custody*, 209.

123. John Collier, "Cheap Amusements," *Charities and Commons*, April 11, 1908, 73–76, cited in Abel, *The Red Rooster Scare*, 75.

124. The phrase "crimes of morality" is from Zedner, *Women, Crime, and Custody*, 2.

125. Reference to the *Birminghman Herald* in Editorial, *MPW*, March 14, 1908, 203, cited in Abel, *Red Rooster Scare*, 67.

126. Freedman, *Their Sisters' Keepers*, 126.

127. "Observations by Our Man About Town," *MPW* 6, no. 22 (June 4, 1910).

128. "Children's Subjects for the Moving Picture: Kalem Company Inaugurates a New Policy," *MPW* 5, no. 27 (December 31, 1909): 953.

129. Ibid.

130. Stamp, *Movie-Struck Girls*, 48. For an analysis of the moral panic around women and sexual permissiveness in London between 1913 and 1919, see Alex Rock, "The 'Khaki Fever' Moral Panic: Women's Patrols and the Policing of Cinemas in London, 1913–19," *Early Popular Visual Culture* 12, no. 1 (February 2014): 57–72.

131. Stamp, *Movie-Struck Girls*, 48.

132. *The Terror* was screened under the auspices of Mrs. W. K. Vanderbilt and the Sociological Fund of the Medical Review of Reviews. Commissioner of Corrections Katherine B. Davis endorsed the film, although it came in for "expert criticism" from the dope fiends, who jeered at the unrealistic representation of cocaine use. In keeping with the "social experiment" quality of prison film exhibition discussed in chapter 3, the journalist took note of the transformation that occurred in the spectators who "lost

most of their cynical attitude and became more like the customary 'movie' patrons." "Drug Terror Film Shown in the Tombs," *Trenton Evening Times*, May 24, 1914, 22.

133. "Nickelodeon Versus Saloon," *MPW* 2, no. 20 (May 16, 1908): 433. This article was republished in the July 4, 1908, issue of *Moving Picture World*, this time credited as reproduced from the *Lawrence Tribune* (Massachusetts).

134. "The Lecturer and the Picture: A Distinguished Lady Enters the Moving Picture Field," *MPW* 7, no. 14 (October 1, 1910): 750.

135. Grieveson, *Policing Cinema*, 12.

136. *Chicago Tribune*, April 10, 1907, 8, cited in ibid., 59.

137. "Children's Subjects for the Moving Picture," 953. Richard Koszarski, *An Evening's Entertainment: The Age of the Silent Feature Picture, 1915–1928* (Berkeley: University of California Press, 1994), 50, cited in Stephen Groening, "'We Can See Ourselves as Others See Us': Women Workers and Western Union's Training Films in the 1920s," in *Useful Cinema*, 38. For more on women as early film spectators, see Kathy Peiss, *Cheap Amusements: Working Women and Leisure in Turn-of-the-Century New York* (Philadelphia: Temple University Press, 1986); Hansen, *Babel and Babylon*; and Stamp, *Movie-Struck Girls*.

138. Groening, "'We Can See Ourselves,'" 39.

139. Zedner, "Wayward Sisters," 342.

140. William Healy, *The Individual Delinquent: A Textbook of Diagnosis and Prognosis for All Concerned in the Understanding of Offenders* (New York: Little Brown, 1916), 309.

141. The term *proxy warden* is an adaptation from Groening's discussion of film as a "proxy manager." Groening, "'We Can See Ourselves,'" 35.

142. Ibid., 40.

143. Report of the Prison Commission, 1873, n.p., cited in Barrows, "The Massachusetts Reformatory," 108.

144. Emma Hall quoted in Zebulon R. Brockway, *Fifty Years of Prison Service: An Autobiography* (1912; reprint, Montclair, NJ: Patterson-Smith, 1969). Emphasis added.

145. Abel, *Red Rooster Scare*, 98, 101.

146. Grieveson, *Policing Cinema*, 18.

147. Siegfried Kracauer, "Boredom," in *The Mass Ornament: Weimar Essays*, trans. Thomas Y. Levin (Cambridge, MA: Harvard University Press, 1995), 332, cited in Bentley, *Frantic Panoramas*, 255.

148. Bentley, *Frantic Panoramas*, 111.

149. Grieveson, *Policing Cinema*, 18, 24.

150. Addams, *A New Conscience*, 111, cited in Stamp, *Movie-Struck Girls*, 48.

151. Quoted in John Joseph Phelan, *Motion Pictures as a Phase of Commercialized Amusement in Toledo, Ohio* (Toledo, OH: Little Book, 1998), 116–21, cited in Stamp, *Movie-Struck Girls*, 48.

152. Jane Addams, *MPW*, December 5, 1908, 451, cited in Grieveson, *Policing Cinema*, 86.

153. Grieveson, *Policing Cinema*, 92–93.

154. Abel, *Red Rooster Scare*, 98, 101.

155. Zedner, "Wayward Sisters," 344.

156. Rafter, "Hard Times," 239.

157. Leslie Fishbein, "The Fallen Woman as Victim in Early American Film: Soma Versus Psyche," *Film and History: An Interdisciplinary Journal of Film and Television Studies* 17, no. 3 (September 1987): 51, 59.

158. Cited in Ralph R. Atditi et al., "The Sexual Segregation of American Prisons," *Yale Law Journal* 82 (May 1973): 1245n92, 1245n94, quoted in Freedman, *Their Sisters' Keepers*, 148.

159. Freedman, *Their Sisters' Keepers*, 150. See ibid., 150–52, for a discussion of the double-edged-sword nature of reform in women's prisons.

160. Groening, "'We Can See Ourselves,'" 38.

161. Rafter, *Partial Justice*, 79.

162. As Haidee Wasson points out, operating instructions would have been standard with most portable projectors after the introduction of 16 mm in 1923, though recent theatrical releases would have been available exclusively in 35 mm in this period. Wasson, personal communication with the author, January 12, 2011. Also see Haidee Wasson, "Protocols of Portability," *Film History* 25, nos. 1/2 (2013): 236–47; and Wasson, "Electric Homes!," 1–21. As Groening notes, the cheaper and lighter film stock was pivotal to the growth of the educational film movement, allowing for installation of film equipment in "schools, churches, and corporate offices, and homes during the 1920s and 1930." Groening, "'We Can See Ourselves,'" 36.

163. According to Zedner, in smaller jails and correction houses in the United Kingdom in the mid-nineteenth century, "female prisoners were barely separated from males and could communicate and even meet with them." Women also climbed fences to reach the men, an issue discussed in the *Fifteenth Report of the Inspectors of Prison, Northern and Eastern Districts*, Pentonville Prison 1850, 567, cited in Zedner, *Women, Crime, and Custody*, 134.

164. "638 Convicts See 'Movies' at State Prison: Chapel Decorated with Flags—Institution's Own Band Plays," *Hartford Courant*, July 6, 1915, 13. Similarly, at the small East Cambridgeshire jail in Boston on Christmas Day, 1922, 223 men

and 12 women spent the morning being entertained by motion pictures and local vaudeville performers before an afternoon of recreation outdoors and a pork dinner. "Prisoners Entertained in East Cambridge Jail," *Boston Daily Globe*, December 26, 1922, 7.

165. "Christmas at State Prison a Merry One," *Hartford Courant*, December 27, 1927, 1.

166. "Movies Will Be Christmas Treat at State Prison: *Brewster's Millions* Is Film to Be Shown," *Hartford Courant*, December 23, 1914, 7.

167. George Gordon Wade, "A Step Forward," *SOH* 20, no. 2 (July 1918): 10.

168. Author interview with Andre Jenkins, May 28, 2014, Sing Sing Correctional Facility, Ossining, New York.

169. Van Waters interviewed by Lewis Lyons, *Boston Globe*, December 28, 1931, n.p., cited in Freedman, *Maternal Justice*, 188.

170. The subject of an intense investigation in 1949, Van Waters was dismissed for purportedly failing to comply with correction department rules. The politically charged investigation took place against a backdrop of antiprogressive, anticommunist rhetoric and reeked of a witch hunt in its relentless attempts to expose the lesbianism of the superintendent and certain staff and inmates. Even attending motion pictures and eating ice cream in town "now carried the taint of homosexuality." Freedman, *Maternal Justice*, 282.

171. *Annual Report of the New York State Reformatory for Women*, 1919. Emphasis added.

172. Rose Giallombardo, *Society of Women: A Study of a Women's Prison* (New York: Wiley, 1966), 7–8.

173. Waters interviewed by Lyons, 188; Miriam Van Waters to parents, March 21, 1932, cited in Freedman, *Maternal Justice*, 188. See Sykes, *Society of Captives* for a discussion of prison imitating life (35).

174. Zamble and Porporino, *Coping, Behavior, and Adaptation*, 88.

175. Rafter, *Partial Justice*, 36.

176. Seminal works on women's prisons include Russel P. Dobash, R. Emerson Dobash, and Sue Gutteridge, *The Imprisonment of Women* (London: Blackwell, 1986); Xenia Field, *Under Lock and Key: A Study of Women in Prison* (London: Parrish, 1963).

177. Helen Worthington Rogers, "A Digest of Laws Establishing Reformatories for Women in the United States," *Journal of the American Institute of Criminal Law and Criminology* 8, no. 4 (November 1917): 535.

178. Davis, *Are Prisons Obsolete?*, 13.

179. Giallombardo, *Society of Women*, 7.

6. Cinema and Prison Reform

1. Wood, *Sing Sing from the Inside*, 12. *New York Tribune* journalist Wood lived for three days and nights at Sing Sing, describing the project as "the attempted photographing by a trained observer of the 'feel' of New York State's most notorious prison under reform conditions" (ibid).

2. Acting warden A. L. Bowen quoted in "Blames Women Reformers for Joliet Prison Riot," *The Delinquent*, June 1917.

3. A. L. Bowen, "The Joliet Prison and the Riots of June 5th," *Journal of Law and Criminology* 8, no. 4 (1918): 581.

4. For a contemporaneous discussion of the seeds of prison reform and Elmira Reformatory for Boys in upstate New York, established in 1876, see Zebulon R. Brockway, "Beginnings of Prison Reform in America," *Charities* 13 (February 4, 1905): 437–44. According to Brockway, the reform movement was galvanized in the United States in the wake of the 1870 Prison Congress held in Cincinnati. Major initiatives included the building of reformatories and the establishment of parole laws, probation service, the indeterminate sentence, and the honor system (prisoner self-government). Education was hailed as the number one priority in reform discourse. Elmira's methods were copied widely in penitentiaries across the country, and the prison included a "well constructed library" in its list of fundamental requirements. As envisioned by Brockway, every single space in the reformatory would work to further the reform effort, thus, the dormitories (with separate rooms) would be those "a respectable citizen might occupy," the dining hall was modeled on a "well-regulated restaurant for work people," and the library building and public hall were suitable for "intellectual exercises of a public nature." Brockway, "The Reformatory System," 28. Also see Bacon, *Prison Reform*.

5. Grieveson, *Policing Cinema*, 30.

6. Ibid., 12.

7. Osborne's legacy lives on through the prisoner advocacy organization the Osborne Association, which offers "opportunities for individuals who have been in conflict with the law to transform their lives through innovative, effective, and replicable programs." The association offers opportunities for "reform and rehabilitation through public education, advocacy, and alternatives to incarceration that respect the dignity of people and honor their capacity to change." "Overview and History," Osborne Association website, 2012, http://www.osborneny.org/about.cfm?pageID=15.

8. Osborne quoted in "American Prison System: Severe Condemnation. British Methods Advocated," *Daily Telegraph*, December 19, 1913.

9. "Fail to Make Osborne Films," *Rochester Union*, October 3, 1913. No media access was granted, not even to photojournalists: "The picture-takers had to content

themselves with photographs already in existence of the exterior of the prison, the electric chair, the chapel and other views, which they could buy on picture postcards at various newsstands in the city" (ibid).

10. The cartoon appeared in the *Newburgh Journal*, October 1, 1913.

11. The second cartoon appeared in the *Johnson Telegram*, October 3, 1913.

12. The Auburn Prison oath appears in "Self Governing Welfare League of Prisoner," *Survey*, April 4, 1913, 4. Prisoners pledged to promote "friendly feeling, good conduct, and fair dealing among both officers and men to the end that each man after serving the briefest possible term of imprisonment may go forth with renewed strength and courage to face the world again." The first meeting of the MWL occurred at Auburn Prison on February 12, 1913; the organization's motto was "Do Good. Make Good," and members wore the group's insignia (a small green-and-white shield) on their coats. Chamberlain, *There Is No Truce*, 267.

13. "'Convict Brown,' Self-Imposed, Suffers in Jail," *New York World*, October 4, 1913.

14. Brian, *Sing Sing*, 103.

15. "Osborne's Film Story of Prison Life Will Have First Showing in Syracuse," *Syracuse Herald*, February 6, 1921.

16. "Honors System in Prison Ridiculed by T. M. Osborne," unidentified clipping, Prison Clippings Misc. 1914, box 342, OFP.

17. Editor in chief, "Entertainment: Sunday Feb. 7th 1915," *SOH* 16, no. 19 (February 13, 1915): 302.

18. Adolph Lewison to Lawes, May 5, 1932, box 4, series 1, Personal Papers: A, Correspondence Scrapbooks, 1925–1932, LLP-JJC; E. M. King, "Sing Sing Under Warden Moyer's Direction," *SOH* 19, no. 11 (April 1918): 3. Also see "These Are Your New York," 7. Alfred Coynes, an inmate who spent fifty years in Sing Sing, attested to the lax oversight at the prison following the ratification of the MWL. For Coynes, the pendulum had swung too far, from an era when convicts were brutalized to one in which "they over-ran the guards, entertained women, went out motoring, and lived on the fat of the land." Coynes chose to remain at Sing Sing upon release to serve as a tour guide for the countless visitors traipsing through. He held the record at the time for the longest continuous sentence served in New York State. See Edward Kavanaugh, "Half a Century Behind Bars by Choice," *New York Herald Tribune*, September 5, 1926, 7.

19. Lawes, *Twenty Thousand Years in Sing Sing*, 105.

20. "Convicts Carnival Welcome Osborne: Prisoners in Costume and Wild with Joy," *NYT*, July 17, 1916, 1.

21. "These Are Your New York," 7.

22. O. F. Lewis, "The Prison Exhibit," *Delinquent* 6, no. 1 (January 1916): 1. The New York Prison Association was founded in 1846.

23. Ibid., 2.

24. Mrs. E. G. Routzan is credited with spending four months completing the panels in consultation with prison reformers. Each booth where the panels were installed was devoted to a specific topic, including the treatment of "misdemeanants, tramps, women, the feebleminded" (curiously lumped together as a singular othered group), probation and parole, indeterminate sentences, reformatories, prison labor, prison administration, and the NYC Department of Correction. Ibid., 3, 5.

25. For more on the challenges of using media technology in museum exhibits in the 1920s and 1930s at the American Museum of Natural History and the role of phonographs in the hugely popular tuberculosis exhibit there in 1909, see Griffiths, *Shivers Down Your Spine*, 245, 236–37.

26. "A Remarkable Slide Feature," *MPW* 13, no. 10 (September 7, 1912): 986.

27. "Concert to Precede YMCA Meeting," *Hartford Courant*, December 6, 1914, 6. Prison reformer C. H. Roman toured the country in 1915 with a three-reel film made by the American Feature Film Company containing footage taken in Ohio Penitentiary. The cinematic tour included the modern cell houses, the Bertillon measuring system, the workshop, the prisoners at dinner, the chapel, the steel gates, the women's department, the "famous Morgan escape, the notorious prisoners, the death cage, the old gallows, the electric chair, the men who have been hanged and electrocuted and the convict's last resting place." "3,000 Feet of Film Showing Prison Life: To Be Accompanied Sunday Evening at Empire Theater by Lecture on Prison Reform," *Hartford Courant*, September 24, 1915, 5.

28. Established in 1914, the Joint Committee on Prison Reform (JCPR) amalgamated membership of the New York and New Jersey branches of the Women's Department of the National Civic Federation. The JCPR's mission focused on the educational and legislative fields of prison reform work. Mrs. Francis McNiel Bacon Jr. chaired the JCPR. Its members included Katherine Bement Davis, New York's first commissioner of correction, as well as individuals from the Prison Commission, the Prison Association, the National Committee on Prisons, the Department of Agriculture, the Department of Correction, and the Women's Prison Association. See Lewis, "Prison Exhibit," 1–6.

29. John B. Riley to wardens of Auburn, Clinton, Sing Sing, Great Meadows, State Prison for Women, Mattawan State Hospital, Dannemora State Hospital, State Farm for Women, and the Bureau of Identification, file August 21–31, 1914, box 106, OFP.

30. Alexander Cleland to Osborne, September 2, 1914, file September 1–10, 1914, box 106, OFP. Emphasis added.

31. Riley to Cleland, September 7, 1914, file September 1–10, 1914, box 106, OFP. Emphasis added.

32. Horace G. Plimpton to Cleland, October 7, 1914, file October 1–10, 1914, box 106, OFP.

33. See the Women Film Pioneers Project, ed. Jane Gaines, Radha Vatsal, and Monica Dall'Asta, Center for Digital Research and Scholarship (New York: Columbia University Libraries, 2013), https://wfpp.cdrs.columbia.edu. For more on Alice Guy Blaché, see Alison McMahan, *Alice Guy Blaché: Lost Visionary of the Cinema* (London: Bloomsbury Academic, 2014).

34. See Jane Gaines and Michelle Koerner, "Women as Camera Operators or 'Cranks,'" Women Film Pioneers Project, https://wfpp.cdrs.columbia.edu/essay/women-as-camera-operators-or-cranks/.

35. "All Ready! Now the Villain Enters! Camera!" *Photoplay*, November 1915, 91; and "Prison Moving Pictures Taken by a Girl," *NYT Sunday Magazine*, November 21, 1915, SM19. The article was reproduced with the title "New York State Prisons in Movies," *Delinquent* 5, no. 10 (October 1915): 9–11.

36. "Prison Moving Pictures," SM19.

37. Lewis, "Prison Exhibit," 3.

38. Bleecker said that the flogging volunteer was sentenced to two years for stealing a suitcase he had mistaken as his own when drunk on an Albany boat. He took great solace in the Mutual Welfare League and enjoyed privileges such as letter writing. "Prison Moving Pictures," SM19.

39. "Osborne Going into Movies: Will Act Tom Browne at Auburn Prison for Reform Committee," *NYT*, September 24, 1915, 7. Also see "Osborne Hero in Prison 'Movie': Public to See Warden Starred as Voluntary Convict in Auburn," *NYT*, November 4, 1915, 7.

40. "Prison Moving Pictures," SM19.

41. The film was re-released in 1928 with a screening at the Columbus Theater in New York and a small reminder in *Variety* that since "Thomas Mott Osborne's theories of prison reform serve as the basis of this flicker," it should be classified as "educational." The film would only pass muster in the daily changes of double bills if the accompanying film was also not too serious.

42. American Film Institute, "Sing-Sing and Great Meadows Prison," *AFI Catalog of Feature Films*, 2015, http://www.afi.com/members/catalog/DetailView.aspx?s=1&Movie=15562.

43. For a discussion of why this prison was called the "reward and promotion" prison of New York State, see "Great Meadow Prison," *Report of the New York State Commission of Prisons*, 1914, n.p., reprinted in Bacon, *Prison Reform*, 83–87.

44. Visitors were invited to sign a petition located on a huge roll of paper next to the cell urging the governor and legislature to abolish Sing Sing Prison and erect an

industrial prison farm in the country; at least twenty thousand people signed the petition. Lewis, "Prison Exhibit," 4.

45. Ibid., 5.

46. For more on the use of film within education and social causes, see Kay Sloan, *The Loud Silents: Origin of the Social Problem Film* (Champaign: University of Illinois Press, 1988); Brownlow, *Behind the Mask of Innocence*, 239–61, for a discussion of prisons; Acland and Wasson, *Useful Cinema*; Jennifer Horne, "'Neutrality-Humanity': The Humanitarian Mission and the Films of the American Red Cross," in *Beyond the Screen: Institutions, Networks, and Publics of Early Cinema*, ed. Charlie Keil, Rob King, and Paul S. Moore (New Barnet, UK: Libbey, 2012), 11–18; Orgeron, Orgeron, and Streible, *Learning with the Lights Off*; Phillip Roberts, ed., "Social Control and Early Visual Culture," special issue, *Early Popular Visual Culture* 12, no. 2 (May 2014); Marina Dalquist, "'Swat the Fly': Educational Films and Health Campaigns, 1909–1914," in *Kinoöffentlichkeit/Cinema's Public Sphere*, ed. Corinna Müller (Marburg, Germany: Schüren Verlag, 2008), 211–25. Also see Lydia Jakobs's conference review, review of "Screen Culture and the Social Question: Poverty on Screen 1880–1914," H-Soz-u-Kult, H-New Reviews, March 2012, http://www.h-net.org/reviews/showpdf.php?id=35806.

47. "Movies Used to Aid Fredericks," *Los Angeles Times*, October 20, 1914, 112.

48. Ibid.

49. Freedman, *Maternal Justice*, 303.

50. "Fox Makes Powerful Prison Film," *Motography* 16, no. 2 (November 11, 1916): 1071.

51. "Will Make Trial of Entertainments at State Prison," *Hartford Courant*, January 19, 1929, 1.

52. "Plays and Players," *Photoplay*, July 1916, 99.

53. Raoul Walsh refers to this in his autobiography, *Each Man in His Time: The Life Story of a Director* (New York: Farrar, Straus and Giroux, 1974).

54. "Plays and Players," 99.

55. André Bazin, *What Is Cinema?*, trans. Hugh Gray (Berkeley: University of California Press, 1967).

56. For a discussion of how the idea of melodrama was operationalized in film reviews of this period, what Ben Singer sees as a "cluster concept involving five constitutive elements," see Ben Singer, *Melodrama and Modernity: Early Sensational Cinema and Its Context* (New York: Columbia University Press, 2001), 1–58.

57. "*The Honor System* Interesting, but Not Significant as Propaganda," *Exhibitors Trade Review* 1, no. 12 (February 24, 1917): 835.

58. Charles R. Condon, review of *The Honor System*, *Motography* 17, no. 8 (February 24, 1917): 424.

59. "Big Preachment Made Entertaining," *Wid's*, May 3, 1917, 274–75.

60. "*The Honor System* Shown," *NYT*, February 13, 1917, 4.

61. "*The Honor System* Interesting," 424.

62. This debate reached a pinnacle in analyses of the 1950s American melodrama. See, for example, Christine Gledhill, *Home Is Where the Heart Is: Studies in Melodrama and the Woman's Film* (London: British Film Institute, 1987); Barbara Klinger, *Melodrama and Meaning: History, Culture, and the Films of Douglas Sirk* (Bloomington: Indiana University Press, 1994); and D. N. Rodowick, "Madness, Authority and Ideology in the Domestic Melodrama of the 1950s," *Velvet Light Trap* 19 (1982): 40–45. For the intersection of race and melodrama, see Linda Williams, *Playing the Race Card: Melodramas of Black and White from Uncle Tom to O. J. Simpson* (Princeton, NJ: Princeton University Press, 2002).

63. "*The Honor System* Interesting," 424.

64. Edward Weitzel, "Review of *The Honor System*," *MPW* 31, no. 9 (March 3, 1919): 1370.

65. Condon, review of *The Honor System*, 424.

66. A. H. S., review of *The Honor System*, *New York Dramatic Mirror*, February 17, 1917, 32. Despite mixed reviews, the film was held up as a yardstick for measuring other crime and underworld films. An inmate film reviewer at Sing Sing compared *Come Through* (Jack Conway, 1917), about a burglar masquerading as a society gentleman, to *The Honor System*, noting as well that the Sing Sing audience was privileged to have placed its "stamp of approval on it long before it was released for outside public gaze." "Pictures Seen on Sing Sing's Movie Screen," 6.

67. "Shadows on the Screens," *New York Tribune*, November 12, 1916, C2.

68. "Fox Makes Powerful Prison Film," 1071. For a review of *The Honor System* written by a Sing Sing inmate, see "Seen and Heard on Sing Sing's Movie Stage and Screen," *Star-Bulletin* 18, no. 10 (February 19, 1917): 8.

69. Even though the film has not survived, the shooting script is extant, along with publicity stills. Paramount Pictures Script, *Prison Without Walls* (E. Mason Hooper, 1917), Turner/MGM scripts B-1236, *The Big House* (1930) file, MHL. All quotes are from this shooting script.

70. Robert E. MacAlarney, Paramount Picture Script, New York Synopsis, "The Prison Without Walls," Master File 1426, MHL.

71. For a treatise on the role of the prison farm within a progressive vision of penology, see O. F. Lewis, "The 'Trusty' in the New Penology," *Boston Evening Transcript*, August 8, 1914, 4.

72. This idea is the plot of the classical reform film *Ann Vickers* (John Cromwell, 1933), which follows the heroine's coming of age and growing interest in the suffrage movement, social work, and prison reform. Pregnant after her first sexual encounter, she decides to have an abortion, and ends up marrying a dull man for companionship rather than following the passions of her heart. She has an affair with a controversial judge by whom she becomes pregnant and bears a son. She fulfills her passion for reform by running a modern, progressive prison for women.

73. Shelley Stamp, *Lois Weber in Early Hollywood* (Berkeley: University of California Press, 2015), 97–101. While drawing primarily from the celebrated Stielow murder case, Lois Weber's *The People vs. John Doe* (1916) is a composite of several celebrated murder cases. The film criticized capital punishment by indicting a system that sentenced a man for murder on circumstantial evidence. Mischa Appelbaum, founder of the Humanitarian Cult, delivered an address after a screening at the Broadway Theatre. See "Capital Punishment Film Play's Theme," *NYT*, December 11, 1916.

74. *Variety*, November 4, 1921, 4.

75. Marion Russell, review of *The Right Way*, *Billboard*, November 5, 1921.

76. Had the protagonists of *The Right Way* committed the same crimes in Northern Europe, they might well have not been convicted, since penalties for minor crimes were less severe in Europe. See Alexander Paterson, "Prison Problems of America Analyzed by a British Critic," *NYT*, August 2, 1931.

77. Plot detail from "Osborne Prison Film Is Playing the Allen," unidentified clipping, Prison Clippings Misc. 1914, box 342, OFP.

78. Osborne quoted in "Written and Censored by Noted Reformer, It Is True in Every Detail," n.p., unattributed article in Prison Clippings Misc. 1914, box 342, OFP.

79. Ibid.

80. "Great Moral Sermon Presented in Realistic Production," *Wid's Daily*, November 13, 1921, 9. For an analysis of the impact a film crew had on location shooting for a Universal script written by Lionel White in the 1970s, see Will Tusher, "Prison Films: The Quest for Reality Causes New Problems," *Hollywood Reporter*, April 3, 1972. According to Tusher, "The antics of a picture company planted the seeds—and left the weapons—for a riot." A catering truck brought onto prison grounds for the cast and crew reported losing all the steak knives, and the wardens of the prisons used as locations worried that the filmmakers had been too liberal with the money they gave the prisoners. Wardens were also annoyed by what they saw as the duplicity of Hollywood production companies, "in which they submit one script and shoot an entirely different scenario."

81. "The Redeemed," document, Writings, Film, *The Right Way* (1921) Publicity, box 249, OFP.

82. "Honors System in Prison Ridiculed."

83. It is possible that this film circulated with the title *Humanity in Prison*. The *Hartford Courant* noted in January 1916 that a film showing the "work to reform the criminal," the Mutual Welfare League, death chamber, and electric chair was playing at the Palace Theater in Hartford, Connecticut. "Palace Theater," *Hartford Courant*, January 12, 1916, 6.

84. In the final editing stage, the film went by the title *The Gray Brother*. See "Final Editing of *The Gray Brother* Completed," *Exhibitors Trade Review* 7, no. 6 (January 10, 1920): 607. Advertisement from the *Syracuse Herald*, February 6, 1921, n.p., Prison Clippings Misc. 1914, box 342, OFP. See the AFI catalog entry for production history. The film was also reissued in 1928 with the title *Within Prison Walls*, the same title as Osborne's best-selling account of his imprisonment as Tom Brown. American Film Institute, "The Gray Brother," *AFI Catalog of Feature Films*, 2015, http://www.afi.com/members/catalog/DetailView.aspx?s=1&Movie=15901.

85. "The Right Way Said to Carry a Moral," unidentified newspaper review for *The Right Way*, Writings, Film, *The Right Way* (1921) Publicity, box 249, OFP.

86. "Advertising Suggestions for 'The Right Way,'" Writings, Film, *The Right Way* (1921) Publicity, box 249, OFP.

87. Writings, Film, *The Right Way* (1921) Publicity, box 249, OFP.

88. Review of *The Right Way*, *Advertizer*, March 21, 1921.

89. Rush, untitled review of *The Right Way*, untitled Denver newspaper, November 4, 1921, 41, box 342, file: prison clippings misc. 1914, OFP.

90. Russell, review of *The Right Way*.

91. C. S. Sewell, review of *The Right Way*, *MPW* (November 12, 1921): 218.

92. Russell, reviewing the film for *Billboard*, was present at a private screening in New York City on October 28, 1921. Osborne spoke before the screening, "outlining his reasons for consenting to have the picture made from material furnished from his actual experiences while Warden of Sing Sing." *Billboard*, November 5, 1921.

93. Arthur James, "*The Right Way* Is a Big Picture," *MPW* (November 19, 1921): 288.

94. Laurence Reid, review of *The Right Way*, *Motion Picture News*, November 12, 1921, 2601.

95. "'The Right Way' Will Keep You Out of Jail," *Chicago Herald and Examiner*, May 17, 1922.

96. The uniforms are discussed in "Osborne's Film Story of Prison Life."

97. Russell, review of *The Right Way*.

98. "Prison Movies Show Grim Side of Convict Life," *Auburn Citizen*, September 23, 1920.

99. Similar to the Boy's Club, the Boy Scouts of America got firsthand experience in crime deterrence while visiting New York's Police Headquarters and other agencies

in July 1931 and chatting with Police Commissioner Edward Mulrooney before witnessing a lineup. See "Boy Scouts Study Crime," *NYT*, July 15, 1931. Scouting was perceived to be a strong deterrent to juvenile crime. Dr. John H. Finley, vice chairman of the State Crime Commission, boasted that only two Boy Scouts had ever been sent to Elmira Reformatory. See "Whalen to Extend Curb on Wayward," *NYT*, March 9, 1930. The *Brooklyn Daily Eagle*, citing Warden Lawes's tribute to the Boy Scouts, reported that less than 0.03 percent of Sing Sing inmates had ever been Boy Scouts; recruitment of young boys into the scouts would, the author predicted, have saved the taxpayer millions of dollars each year. Operation of boys' clubs cost an estimated $15 per capita annually, whereas funding a prisoner exceeded $400 per annum. "Schelling Cites Warden Lawes' Tribute to the Boy Scouts Movement," *Brooklyn Daily Eagle*, March 9, 1935; and Lawes, *Twenty Thousand Years in Sing Sing*, 358.

100. Lewis E. Lawes, "Radio Address Delivered by Warden Lewis E. Lawes" over station WJZ, December 2, 1928, file 23, Crime and Penology, box 5, Drafts of Articles and Scripts, LLP-JJC.

101. In response to anxieties about young people's socialization habits, the federal government created the Children's Bureau in 1912; as Grieveson argues, "moving pictures were frequently linked to anxieties about delinquency, widely seen as both causing delinquency and as antisocial spaces," what the Vice Commission for Chicago called "hang out places for delinquent boys and girls." Vice Commission of Chicago, *The Social Evil in Chicago; a Study of Existing Conditions* (Chicago: Gunthrop-Warren, 1911), 240, cited in Grieveson, *Policing Cinema*, 14–15.

102. "Mothers May Check Children at Movies Under Shopping Plan," *NYT*, February 13, 1931; and "Engelwood Club Scores Crime Films," *NYT*, February 20, 1931.

103. See, for example, "Young Gunmen Lay Crimes to Movies," *NYT*, August 4, 1931. For more on criminal youth discourse leading up to this period, see Steven Schlossman, *Love and the American Delinquent: The Theory and Practice of "Progressive" Juvenile Justice, 1825–1920* (Chicago: University of Chicago Press, 1977).

104. "Judge Condemns Gangster Pictures: Public Demands Best Type, Hays Says," *Christian Science Monitor*, March 31, 1931. New Jersey was a hub of anti–crime film protests in the tristate region in the early 1930s, some municipalities calling upon theater managers to ban gangster films and replace them with films on "subjects free from the sordidness of the underworld." "Oranges Fight Gang Films: Heads of the Four Municipalities and Mapelwood Send Plea to Theaters," *NYT*, June 3, 1931. For a snapshot of contemporaneous criticism of gangster films from 1931, see "Day of Crime Film Is Over, Hays Says," *NYT*, March 31, 1931; "Gang Film Protest Asked: Knights of Columbus Meeting May Petition Hollywood," *Herald Tribune*,

May 29, 1931; "Hit Crime Pictures and Racketeer News," *NYT*, June 11, 1931; and Dorothy Manners, "Are Movie Gangsters Being Overdone?," *Motion Picture Classics*, June 1931, 74–75, 104. For a secondary discussion, see Grieveson, "Gangsters and Governance," 13–40.

105. "Higher Education the Need," *MPW* 7, no. 21 (November 19, 1910): 1185; and "Film Pictures Stir British Boys to Crime," *San Francisco Chronicle*, May 19, 1912, 31.

106. "How the Picture Causes Juvenile Delinquency," *MPW* 10, no. 7 (November 18, 1911): 534. The *MPW* reported that one way to combat truancy purportedly caused by motion pictures was to introduce them into schools, as recommended by officials from the National League of Compulsory Education. "Moving Pictures and Truancy," *MPW* 8, no. 26 (July 1, 1911): 1503. Manufacturing more films for boys was another strategy: "A Plea for the Boys," *MPW* 8, no. 27 (July 8, 1911): 1571.

107. "Scores Film Plays: Miss Davis Traces Many Tragedies to Crime Scenes," *Washington Post*, April 21, 1913, 1. Also see Steven Schlossman with Stephanie Wallach, "The Crime of Precocious Sexuality: Female Juvenile Delinquency in the Progressive Era," *Harvard Educational Review* 48 (February 1978): 65–94.

108. Charles Dudley, *Being a Boy* (Boston, 1897), 66–67, cited in Rotundo, *American Manhood*, 33. For more on the moral panic about youth, see Roy Rozenzweig, *Eight Hours for What We Will: Workers and Leisure in an Industrial City, 1870–1920* (Cambridge: Cambridge University Press, 1985).

109. See David Macleod, *Building Character in the American Boy: The Boy Scouts, YMCA and Their Forerunners, 1870–1920* (Madison: University of Wisconsin Press, 2004). For more on the Woodcraft League of America, which began as the League of Woodcraft Indians in 1902, in relation to the American Boy Scouts, see Alison Griffiths, "*Camping Among the Indians*: Visual Education and the Sponsored Expedition Film at the American Museum of Natural History," in *Recreating First Contact: Expeditions, Anthropology, and Popular Culture*, ed. Joshua A. Bell, Alison K. Brown, and Robert J. Gordon (Washington, DC: Smithsonian Institution, 2013), 90–108.

110. Boyer, *Urban Masses*, 117. For background on the operational culture of the YMCA, an organization brought to America in 1851 by divinity student George M. Van Derlip and NYC merchant George H. Petrie, along with other charitable institutions waging a war against urban vice and moral debasement, see ibid., 108–250. For coverage of a national campaign by the Boys' Club Federation of America to lure boys off the streets and into classes where they can learn about the "useful arts of industry and trade," see "Boys' Clubs and Employment," *Christian Science Monitor*, March 31, 1931.

111. Ronald Walter Greene, "Pastoral Exhibition: The YMCA Motion Picture Bureau and the Transition to 16mm, 1928–39," in Acland and Wasson, *Useful Cinema*, 205–229.

112. Sing Sing veteran Jerry McAuley established a nondenominational mission in 1872 on Water Street in New York, preaching, singing, and providing much-needed soup, baths, and beds. Boyer, *Urban Masses*, 135. The organization of missions is indubitably linked to the charities movement that according to Boyer was imported from London with the opening of Stanton Coit's Neighborhood Guild in New York City. It was followed three years later with the College Settlement in New York and Jane Addams's Hull House in Chicago (ibid., 155). For more on the convergence of moral and political reform, see ibid., 157–260. For two contemporaneous analyses of the deleterious effects of urbanism, both written by women, see Jane Addams, *The Spirit of Youth and the City Street* (New York: Macmillan, 1909), and Mary Kingsbury Simkhovitch, *The City Worker's World in America* (New York: Macmillan, 1917).

113. Walter M. Germain, "Crime Prevention Expert Sounds Warning on Seriousness of Juvenile Delinquency," *American Police Review*, July–August 1939.

114. "Here's a Film for You Who Like Crook Heroes," *Chicago Daily Tribune*, May 13, 1923, D1.

115. Irene Thirer, review of *The Big House*, *New York News*, June 25, 1930. Several reviewers compared the film to the stage play "The Last Mile" and the film *The Criminal Code* (Howard Hawkes, 1931); see, for example, Edwin C. Stein, "The Prisoners Riot Again," *Standard Union*, June 25, 1930.

116. "Prison Drama Necessitated Unusual Sets," *Washington Post*, July 6, 1930, A2.

117. All three quotes are from "The Big House," press book, Audrey Chamberlin Scrapbook 11, MHL.

118. Frances Marion, *Off with Their Heads! A Serio-Comic Tale of Hollywood* (New York: Macmillan, 1972), 200.

119. Crowther, *Captured on Film*, 4, 7.

120. Thirer, review of *The Big House*. If women took "femaleless war pictures with good grace," whether they would be "so strong for this harsh, bloody, cruel, cold prison fare is something to be revealed by the box office receipts" (ibid).

121. Blumenthal, *Miracle at Sing Sing*, 184. The film was quickly followed by *Ladies of the Big House* (Marion Gering, 1931), which Bruce Crowther argues doubled the usual "innocent-in-jeopardy plot of having a young married couple sent down for a murder they did not commit" (*Captured on Film*, 63). Paramount employees were invited to have their pictures appear in a rogues gallery in the film by an impromptu photograph gallery at the studio entrance, and carpenters, cameramen, actors, electricians, and press agents doubled up as criminal types. "Director Gering Selects

Himself as Convict Type: Picks His Own Photograph as Best Model to Portray Man Waiting to Be Executed," *Ladies of the Big House* press book, 1931–1932, Paramount Press Sheets, MHL.

122. Telegram from William A. Orr to Lewis E. Lawes, May 31, 1930, in Personal Papers: A, Correspondence Scrapbooks, 1925–1932, LLP-JJC.

123. Stanley Kauffmann, "Jail, Jokes, and Junk," *New Republic*, July 19, 1980, 22. One contemporaneous viewer analogized the viewing of the drama to the consumption of red meat, a "photo play with guts . . . as lusty a dish as ever was set before King Movie Fan." Regina Crewe, "'The Big House' Packs Thrills and Suspense on Screen," *New York American*, June 25, 1930.

124. The Federal Census Bureau identified overcrowding in prisons and reformatories in 1927 as at 19.1 percent over capacity, an 8 percent increase from the year before; federal prisons in 1930 were 65.9 percent over capacity. Information from U.S. National Commission on Law Observance and Enforcement, *Penal Institutions, Probation, and Parole*, Report No. 9 (Washington, DC: Government Printing Office, 1931), 7, 11, 15–16, cited in "Study Guide Accompanying *The Big House*," Progressive Education Association, 1939 (no publisher identified), 20–21, MHL.

125. "Nickelodeon versus Saloon," *MPW* 2, no. 20 (May 16, 1908): 433.

126. "Suggested Questions for Discussion of *The Big House*," Progressive Education Association, 1939 (no publisher identified), 6, MHL.

127. McLennan, *The Crisis of Imprisonment*, 239.

128. Erving Goffman, *Asylums: Essays on the Social Situation of Mental Patients and Other Inmates* (New Brunswick, NJ: Aldine Transaction, 2009), 12, 14.

129. Joseph F. Scott, "The Massachusetts Reformatory," in Barrows, *Reformatory in the United States*, 84–85.

130. Review of *The Prison Without Walls*, *Variety*, April 27, 1917, 29. A related topic too broad to do full justice to in this chapter is cinema's role as an agent of religious reform. Richard Abel notes that churches in Indiana and Michigan began using motion pictures between 1901 and 1902, and Dean Rapp has traced screenings in London's East End churches to 1900. Abel, "From Peep Show to Picture Palace"; and Rapp, "A Baptist Pioneer," 6–21. The Reverend Charles E. McClellan of the Fairhill Baptist Church in Philadelphia decided in 1907 to add motion pictures to the existing lineup of vaudeville staged in the church's rooftop garden as a way of countering the effect of the saloon and cheap theater and also to raise $12,000 for the construction of a new auditorium. "Vaudeville, moving pictures, illustrated songs, vocal and instrumental music on a Saturday night, when our streets, playhouses, and saloons are crowded" would turn the church into a veritable hub of clean, sanctioned, parallel amusement. *MPW* 1, no. 15 (June 15, 1907): 233. Despite the relative ubiquity of motion pictures in churches, the trade press still treated the idea as something of a

novelty, and even though religious films such as *The Passion and Death of Jesus Christ* (Pathé Frères, 1906), *The Life of Moses* (J. Stuart Blackton, 1909), and *The Modern Prodigal* (D. W. Griffith, 1910) were logical choices for church screenings, questions remained concerning the suitability of nonreligious subjects. Whether religious films made good economic sense and whether Biblical pictures were useful were other issues pushed to the fore. For example, in a 1910 article entitled "Usefulness of Moving Pictures," American identity was conscripted into the debate, the idea that the United States was "too intensely practical to long tolerate anything that does not perform some definite object, or is not of some direct usefulness." *MPW* 6, no. 7 (February 19, 1910): 247. Also see Bottomore, "Projecting for the Lord," 195–209, and Lindvall, "Sundays in Norfolk," 76–98.

131. I borrow the term *cognitive cognition* from Rob Moore, "Cognitive Cognition: Transdisciplinarity in a Precarious World," paper presented at WC2 Summer Symposium, London, August 2015.

Conclusion

1. Mayhew and Binny, *The Criminal Prisons*, 141. Emphasis added.

2. Auburn Prison No. 33828, "Thanksgiving Day: A Prisoner's Point of View," *SOH* 16, no. 16 (January 2, 1915): 251.

3. Maxim Gorky, "The Kingdom of Shadows," *Lumière Cinematograph*, July 4, 1896, http://www.seethink.com/stray_dir/kingdom_of_shadows.html.

4. For a critique of the prison-industrial complex in America, see Smith, *The Prison*, 17; Davis, *Are Prisons Obsolete?*; Ernest Drucker, *A Plague of Prisons: The Epidemiology of Mass Incarceration* (New York: New Press, 2013).

5. A Flemish team tested this thesis in a qualitative study of thirty-three inmates entering the prison for the first time. See Jan Van den Bulck and Heidi Vandebosch, "When the Viewer Goes to Prison: Learning Fact from Watching Fiction. A Qualitative Study," *Poetics* 31, no. 2 (April 2003): 103–16. For more on our fascination with prisons within popular culture, see Eleanor Novek, "Mass Culture and the American Taste for Prison," *Peace Review: A Journal of Social Justice* 21, no. 3 (2009): 376–84.

6. Joshua Meyrowitz, "Television and Interpersonal Behavior: Codes of Perception and Response," in *Inter/Media: Interpersonal Communication in a Media World*, ed. Gary Gumpert and Robert Cathcart (New York: Oxford University Press, 1979), 75. Emphasis added.

7. "Beatings Worse than Shown on Videotape Missouri Inmates Say," Associated Press, August 27, 1997, cited in Davis, *Are Prisons Obsolete?*, 97.

8. For histories of these prisons see Michael Esslinger, *Alcatraz: A Definitive History of the Penitentiary Years* (Carmel, CA: Ocean View, 2003); Johnston, Finkel, and Cohen, *Eastern State Penitentiary*. For more on the prison museum, see Jennifer Turner and Kimberley Peters, "Doing Time-Travel: Performing Past and Present at the Prison Museum," in *Historical Geographies of Prisons: Unlocking the Usable Carceral Past*, ed. Karen M. Morin and Dominique Moran (New York: Routledge, 2015), 71–87.

9. See Ash, *Dress Behind Bars*.

10. For more on Alcatraz's representation in film, see Robert Lieber, *Alcatraz: The Ultimate Movie Book* (San Francisco: Golden Gate National Parks Conservancy, 2006).

11. Nicole Fleetwood, "Carceral Aesthetics: Art and Visuality in the Era of Mass Incarceration," lecture at the City University of New York Graduate Center, May 3, 2013.

12. "Captive America: An Interview with Alyse Emdur," *Venue*, June 2012. http://v-e-n-u-e.com/Captive-America-An-Interview-with-Alyse-Emdur. *Venue* is a joint project between BLDGBLOG and Nicole Twilley of *Edible Geography*, supported by the Nevada Museum of Art's Center for Art+Environment.

13. See the Bodmin Jail website at http://www.bodminjail.org.

14. For more on this artist initiative and proposal guidelines, see "Art Proposals—2017 Season," Eastern State Penitentiary website, http://www.easternstate.org/visit/site-rentals-special-arrangements/art-proposals. More than seventy artists have created installations for ESP's cell blocks and yards, successful ones making "connections between the complex history of this building and today's criminal justice system and corrections policies."

15. *Orange Is the New Black* (Netflix, 2013) is filmed at the Kaufman Astoria Studios in Queens, New York. For a discussion of the set, see Kevin Fallon, "My Visit to the 'Orange Is the New Black' Prison," *Daily Beast*, June 4, 2014, http://www.thedailybeast.com/articles/2014/06/04/my-visit-to-the-orange-is-the-new-black-prison.html. According to Fallon, the set was "designed with all the functionality of a real prison, which is actually quite astounding to see. Unlike the three-walled sets of Hollywood soundstages, this is made for every nook and cranny to be filmed." Fallon found the simulacral prison set discombobulating: "It's . . . hard to shake the uncomfortable, at times even suffocating, feeling of being in a prison." (Piper Kerman apparently freaked out at the verisimilitude.)

16. This portrayal of Piper Kerman's memory of watching film in prison paints a portrait of corrections-based filmgoing that few of us will ever experience. Our image of women's prisons, like that of men's, has been shaped by prison exploitation films

such as *Caged* (John Cromwell, 1950), *Caged Heat* (Jonathan Demme, 1974), and *Chained Heat* (Paul Nicholas, 1983), dramatic series such as *Orange Is the New Black*, and reality television prison shows including *Babies Behind Bars* (Witness, 1997), *Cell Block 6: Female Lock Up* (TLC, 2010), *Beyond Scared Straight* (A&E, 2011), and *Breaking Down the Bars* (OWN, 2011). For a critique of reality shows set in prisons, see Mansfield Frasier, "The Saddest Reality Stars of All: Prisoners," *Daily Beast*, May 19, 2013, http://www.thedailybeast.com/articles/2013/05/19/the-saddest-reality-stars-of-all-prisoners.html; and Robert Ito, "Reality TV: Prison Shows Break New Grounds with Female Inmates," *Los Angeles Times*, May 15, 2011, http://articles.latimes.com/2011/may/15/entertainment/la-ca-women-prison-20110515.

17. For policy on print media access in New York State prisons, see State of New York Department of Corrections and Community Supervision, Directive #4572 (Media Review). Each prison has a facility media review committee that vets questionable publications. Inmates complete an appeal form about disputed items and must hear a determination within ten days.

18. For a sociological investigation of media use and meanings in British prisons, see Jewkes, *Captive Audiences*; and Yvonne Jewkes and Helen Johnston, eds., *Prison Readings: A Critical Introduction to Prisons and Imprisonment* (Cullompton, UK: Willan, 2006).

19. My thanks to Deputy Superintendent Lesley Malin, Sing Sing Correctional Facility, for information on contemporary media use at the facility. E-mail exchange with the author, October 2013.

20. Jewkes, *Captive Audiences*, 159.

21. For a discussion of TV use as an incentive for good behavior, see Jewkes, *Captive Audiences*, 71–73; on the violation of public and private, see 64–65.

22. The seven founding members of Forgotten Voices, formed at Sing Sing in 2010, advocates for incremental changes as well as outreach, working with community leaders, legislators, clergy members, and at-risk youth. With one exception, all of the members entered prison between the ages of sixteen and eighteen and have been in prison for more than twenty years. The group's mission, in Andre Jenkins's words, is to "redefine what it is to pay your debt to society. . . . It's not just about prison time, it's about what are you doing while you're here to not only improve the quality of your life, but the quality of the life you had a hand in destroying. So we've taken that responsibility on and it's working pretty well." Author interview with Andre Jenkins, Sing Sing Correctional Facility, May 28, 2014 [hereafter AI-AJ]. All subsequent quotes from Jenkins are from this interview.

23. See the Hudson Link website at http://www.hudsonlink.org. Nyack and Mercy Colleges collaborate with Hudson Link to deliver classes at Sing Sing and other New

York State correctional facilities. Former Sing Sing inmate Sean Pica took classes via the group and is now its executive director.

24. Hudson Link sponsored a Tedx Sing Sing event on December 5, 2014. Filmed by Jonathan Demme, it was a celebration of voice, music, and higher education. Guest speakers included actor and rapper Ice-T and acquitted Central Park jogger and former inmate Yusef Salaam, returning to the prison for the first time. See Corey Kilgannon, "At Sing Sing, Inmates Who Are Pursuing an Education Take the Stage," *NYT*, December 5, 2014, http://www.nytimes.com/2014/12/06/nyregion/sing-sing-inmates -pursuing-an-education-take-the-stage.html?_r=0. For an informative and moving profile of several inmates participating in higher education programs at Sing Sing, see the documentary *The University of Sing Sing* (Tom Skousen, 2013), available at http://www.hbo.com/#/schedule/detail/The+University+of+Sing+Sing/577874. The documentary was originally titled *Zero Percent*, to reflect the lack of recidivism for graduates of the Hudson Link Mercy College program; when one person broke the record, the film had to be retitled. Still, the success is phenomenal, considering the hundred or so graduates.

25. For insight into the unique pleasures of giving back to a community and teaching inmates, see Christia Mercer, "I Teach Philosophy at Columbia. But Some of My Best Students Are Inmates," *Washington Post*, March 24, 2015, http://www .washingtonpost.com/posteverything/wp/2015/03/24/i-teach-philosophy-at-columbia -but-the-best-students-i-have-are-inmates/?hpid=z10.

26. *Oz*, short for the Oswald State Correctional Facility, focused largely on Emerald City, an experimental unit in the prison devoted to rehabilitation and responsibility. For a review of the third season, see Dinitia Smith, "Prison Seeks to Shatter Expectations," *NYT*, July 12, 1999, http://www.nytimes.com/1999/07/12/arts/prison -series-seeks-to-shatter-expectations.html.

27. For a snapshot of in-cell television access in U.S. prisons, see Steve Kilar, "Clear Televisions Help Occupy Md. Prisoners, Keep Out Contraband," *Baltimore Sun*, August 11, 2011; Kayte Rath, "TV in Prison: What Men and Women Watch in Their Cells," *BBC News*, September 14, 2012; and Paul Wright, "Prison TV: Luxury or Management Tool?," *Prison Legal News*, September 14, 1994, 14.

28. In order to become an in-cell TV facility, inmates would have to trade television access for a reduction in the size of mailed packages. This was institutionally mandated and part of a collective bargaining arrangement when Sing Sing became a "TV facility." Author interview with Superintendent Michael Capra, Sing Sing Correctional Facility, September 25, 2013 [hereafter AI-MC].

29. Jenkins reported that a friend of his had constructed a purpose-built stand for his TV that he had mounted on his cell wall. TVs would have to be placed on the small desks in the general-population cell blocks. AI-AJ.

30. Wende Correctional Facility in Alden, New York, was the first in the state to agree to the trade-off between limited packages and in-cell television; Corrections Commissioner Thomas Coughlin put the proposal to the state's twelve other facilities, but only Wende agreed. Darren Dopp, "Allowing Sets in Cells Brings Calm to Upstate N.Y. Facility: Prison Officials Gain Leverage Through TV Privileges," *Los Angeles Times*, June 5, 1988.

31. AI-MC. Despite the total absence of Internet access, Sing Sing has an open phone policy, meaning there are no restrictions on the number of calls to loved ones, and a Family Reunion program, where spouses or common law partners visit with or without family members and live with the inmate for thirty-six hours in a trailer. The trailer has a TV, DVD player, CD player, and radio. The Forgotten Voices team is lobbying for a gaming system to be installed (with the modem removed) in the trailer so that visiting children can play games. AI-AJ.

32. For policy on film use, see State of New York Department of Corrections and Community Supervision (DOCCS), Directive #4556 (Entertainment Media). No X or NC-17 movies or programs can be shown to inmates. Only film titles from contractors who have licensed the DOCCS for public showings may be shown. Movie rentals are funded through the Occupational Therapy Account. There is currently no inmate-published newsletter at Sing Sing, although the Department of Corrections does allow publication. Publications can only circulate internally and cannot be sent to other correctional facilities or to private citizens. See State of New York Department of Corrections and Community Supervision, Directive #4521 (Inmate Newspapers and Newsletters).

33. Louis Victor Eytinge cited in "Films Strong Uplift Force in the Prisons," *New York Tribune*, April 29, 1923, D4. Emphasis added.

34. AI-MC.

35. Jewkes, *Captive Audiences*, 114.

36. See Nick Anderson, "Pell Grants for Prisoners? An Experiment Will Test Reversal of a 20-Year Ban," *Washington Post*, July 30, 2015, http://www.washingtonpost.com/news/grade-point/wp/2015/07/30/pell-grants-for-prisoners-an-experiment-will-test-reversal-of-a-20-year-ban/.

37. Obama instructed Attorney General Loretta E. Lynch and the Justice Department to review overuse of solitary confinement across U.S. prisons during the summer of 2015 and then adopted the review's recommendations. The policy change will affect some ten thousand federal prisoners currently held in solitary confinement, including many juveniles and people suffering from mental illness. "Barack Obama: Why We Must Rethhink Solitary Confinement," *Washington Post*, January 25, 2016, https://www.washingtonpost.com/opinions/barack-obama-why-we-must-rethink

-solitary-confinement/2016/01/25/29a361f2-c384-11e5-8965-0607e0e265ce_story .html. Also see Juliet Eilperin, "Obama Bans Solitary Confinement for Juveniles in Federal Prisons," *Washington Post*, January 29, 2016, https://www.washingtonpost .com/politics/obama-bans-solitary-confinement-for-juveniles-in-federal-prisons /2016/01/25/056e14b2-c3a2-11e5-9693-933a4d31bcc8_story.html; and Michael D. Shear, "Obama Bans Solitary Confinement of Juveniles in Federal Prisons," *NYT*, January 25, 2016, http://www.nytimes.com/2016/01/26/us/politics/obama-bans-solitary -confinement-of-juveniles-in-federal-prisons.html?ref=topics&_r=0.

38. Erik Eckholm, "One Execution Botched, Oklahoma Delays the Next," *NYT*, April 29, 2014, http://www.nytimes.com/2014/04/30/us/oklahoma-executions.html.

39. AI-AJ.

40. Thomas Richards, *The Imperial Archive: Knowledge and Fantasy of Empire* (London: Verso, 1993), 6.

41. Jonathan Crary, *24/7* (London: Verso, 2014), 8–9.

42. Tiffany Ana Lopez, "Emotional Contraband: Prison as Metaphor and Meaning in U.S. Latina Drama," in *Captive Audience: Prison and Captivity in Contemporary Theatre*, ed. Thomas Fahy and Kimball King (New York: Routledge, 2003), 26.

43. The film was shown as part of the "Cruel and Unusual Comedy, Part 3: Selections from the Eye Film Institute, the Netherlands" series at MOMA, March 15–28, 2012. My thanks to Elif Rongen-Kayanakci for generously providing me with a copy of the film.

44. This is, of course, a vision described in Philip K. Dick's short story "The Minority Report," which became the Steven Spielberg film *Minority Report*, starring Tom Cruise (2002).

Filmography

The Execution of Mary, Queen of Scots (Edison, 1895)

Admiral Cervera and Officers of the Spanish Fleet Leaving the St. Louis (American Mutoscope and Biograph [hereafter AM&B], 1898)

An Execution by Hanging (AM&B, 1898)

Captain Dreyfus, aka *Alfred Dreyfus During His Daily Outing in the Courtyard of the Jail* (Biograph, 1899)

Female Prisoners: Detroit House of Corrections (AM&B, 1899)

The Lock-Step (AM&B, 1899)

Male Prisoners Marching to Dinner (AM&B, 1899)

Boers Bringing in British Prisoners (Edison, 1900)

A Career of Crime (AM&B, 1900)

Execution of a Spy (Biograph, 1900)

Arrest of Goudie (Mitchell and Kenyon, 1901)

The Executioner (Pathé Frères, 1901)

The Execution of Czolgosz, with Panorama of Auburn Prison (Edison, 1901)

Histoire d'un crime (Ferdinand Zecca, 1901)

A Convict's Punishment (AM&B, 1903)

Electrocuting an Elephant (Edison, 1903)

The Passion Play (Lucien Nonguet and Ferdinand Zecca, 1903)

The Escaped Convict (Percy Stow, 1904)

The Escaped Lunatic (Wallace McCutcheon, 1904)

Au bagne [Scenes of convict life] (Pathé Frères, 1905)

Le bagne des gosses [Children's reformatory] (Pathé Frères, 1905)

A Break for Freedom (AM&B, 1905)

Escape from Sing Sing (Vitagraph, 1905)

Execution by Hanging, aka *Execution of a Murderess* (AM&B, 1905)

The Impossible Convicts (Billy Bitzer, 1905)

The Life of Moses (Pathé Frères, 1905)

Reading the Death Sentence (AM&B, 1905)

A Reprieve from the Scaffold (AM&B, 1905)

In the Tombs (AM&B, 1906)

The Jail Bird and How He Flew (Vitagraph, 1906)

The Passion and Death of Jesus Christ (Pathé Frères, 1906)

The Disintegrated Convict (Vitagraph, 1907)

The Prisoner's Escape (Gaumont, 1907)

A Famous Escape (Wallace McCutcheon, 1908)

A Tricky Convict (David Aylott, 1908)

The Convict's Dream (A. E. Coleby, 1909)

A Convict's Heroism (Gaumont, 1909)

A Convict's Sacrifice (D. W. Griffith, 1909)

A Corner in Wheat (D. W. Griffith, 1909)

A Drunkard's Reformation (D. W. Griffith, 1909)

The Life of Moses (J. Stuart Blackton, 1909)

Resurrection (D. W. Griffith, 1909)

When Prison Bars and Fetters Are Useless (Pathé Frères, 1909)

Convict No. 796 (Van Dyke Brook, 1910)

The Modern Prodigal (D. W. Griffith, 1910)

La police de l'an 2000 (Gaumont, 1910)

Prison Reform (David Aylott and A. E. Coleby, 1910)

Convict Life in the Ohio Penitentiary (America's Feature Film, 1912)

Conway, the Kerry Dancer (Sidney Olcott, 1912)

Crime of Carelessness (James Oppenheim, 1912)

Never Again (Edwin R. Philips, 1912)

A Race with Time (Kenean Buel, 1912)

What the Doctor Ordered (Mack Sennett, 1912)

Workman's Lesson (Edison, 1912)

An American in the Making (Carl Gregory, 1913)

Il due machinisti (Cines, 1913)

Life in a Western Penitentiary (Citagraph, 1913)

Life in a Western Penitentiary (Citagraph, 1914)

The Man from Mexico (Thomas N. Heffron, 1914)

The Man He Might Have Been (William Humphrey, 1914)

The Toll of Mammon (Harry Handworth, 1914)

Alias Jimmy Valentine (Maurice Tourneur, 1915)

A Day in Sing Sing (Katherine Russell Bleecker, 1915)

A Prison Without Walls (Katherine Russell Bleecker, 1915)

Winning the Futurity (Walter Miller Feature Film, 1915)

Within Prison Walls (Katherine Russell Bleecker, 1915)

Austrian Prisoners in a Concentration Camp (Italy, 1916)

The Brand of Cowardice (John W. Noble, 1916)

German Prisoners Embark on a French Transport (Pathé Topical Budget, 1916)

The Girl and the Gangster (Harry Leverage, 1916)

The Light of New York (Van Dyke Brooke, 1916)

The Man Behind the Curtain (Cortland Van Deusen, 1916)

The Ninety and Nine (Ralph Ince, 1916)

The People vs. John Doe (Lois Weber, 1916)

Come Through (Jack Conway, 1917)

Her Life and His (Frederick Sullivan, 1917)

The Honor System (Raoul Walsh, 1917)

Idolators (Walter Edwards, 1917)

The Prison Without Walls (E. Mason Hopper, 1917)

The Caillaux Case (Richard Stanton, 1918)

The Grim Game (Irvin Willat, 1919)

The Master Mystery (Harry Grossman and Burton L. King, 1919)

Open Your Eyes (Gilbert P. Hamilton, 1919)

Terror Island (James Cruze, 1920)

Miss Lulu Bett (William C. de Mille, 1921)

The Right Way, aka *Making Good* (Sidney Olcott, 1921)

Boston Blackie (Scott R. Dunlap, 1923)

Body and Soul (Oscar Micheaux, 1925)

The Big House (George W. Hill, 1930)

Up the River (John Ford, 1930)

The Criminal Code (Howard Hawkes, 1931)

Ladies of the Big House (Marion Gering, 1931)

I Am a Fugitive from a Chain Gang (Mervyn LeRoy, 1932)

20,000 Years in Sing Sing (Michael Curtiz, 1932)

Anne Vickers (John Cromwell, 1933)

Picture Snatcher (Lloyd Bacon, 1933)

Top Hat (Mark Sandrich, 1935)

The Walking Dead (Michael Curtiz, 1936)

Alcatraz Island (William C. McGann, 1937)

Angels with Dirty Faces (Michael Curtiz, 1938)

Each Dawn I Die (William Keighley, 1939)

Johnny Apollo (Henry Hathaway, 1940)

Sullivan's Travels (Preston Sturges, 1941)

It's a Wonderful Life (Frank Capra, 1946)

Shoeshine (Vittorio De Sica, 1946)

Kiss of Death (Henry Hathaway, 1947)

Caged (John Cromwell, 1950)

The Tingler (William Castle, Columbia Pictures, 1959)

Thirteen Ghosts (William Castle, 1960)

Birdman of Alcatraz (John Frankenheimer, 1962)

In Cold Blood (Richard Brooks, Columbia Pictures, 1967)

Titicut Follies (Frederick Wiseman, 1967)

The Godfather (Francis Ford Coppola, 1972)

Caged Heat (Jonathan Demme, 1974)

Godfather 2 (Francis Ford Coppola, 1974)

Escape from Alcatraz (Don Siegel, 1979)

Executioner's Song (Lawrence Schiller, 1982)

Chained Heat (Paul Nicholas, 1983)

Fourteen Days in May (Paul Hamann, 1988)

The Thin Blue Line (Errol Morris, 1988)

Roger and Me (Michael Moore, 1989)

True Believer (Joseph Ruben, 1989)

Hudson Hawk (Michael Lehmann, 1991)

Schindler's List (Steven Spielberg, 1993)

The Shawshank Redemption (Frank Darabont, 1994)

Dead Man Walking (Tim Robbins, 1995)

The Rock (Michael Bay, 1996)

Babies Behind Bars (Witness, 1997)

Oz (HBO, 1997–2003)

Analyze This (Harold Ramis, 1999)

The Green Mile (Frank Darabont, 1999)

Monster's Ball (Marc Forster, 2001)

Half Past Dead (Don Michael Paul, 2002)

The Lord of the Rings: The Return of the King (Peter Jackson, 2003)

Fahrenheit 9/11 (Michael Moore, 2004)

The Trials of Darryl Hunt (Ricki Stern and Annie Sundberg, 2006)

Half Past Dead 2 (Art Comacho, 2007)

The Dark Knight (Christopher Nolan, 2008)

Cell Block 6: Female Lock Up (TLC, 2010)
Beyond Scared Straight (A&E, 2011)
Breaking Down the Bars (OWN, 2011)
Orange Is the New Black (Netflix, 2013)
12 Years a Slave (Steve McQueen, 2013)
The University of Sing Sing (Tom Skousen, 2013)

Bibliography

ANNUAL REPORTS

Annual Report of Auburn Prison and State Prison for Women. New York State
Archives.

Annual Report of the House of Refuge of Philadelphia with Appendix. Philadelphia:
William Brown, 1833–.

Annual Report of the New York State Reformatory for Women. Albany, NY: J. B. Lyon,
1902–.

Annual Report of the Ohio Penitentiary . . . for the Fiscal Year 1895. Columbus, OH:
Westbote, 1895.

Annual Report of the Superintendent of State Prisons, New York. Albany, NY: Jerome
R. Parmenter.

New York State Commission of Prisons Annual Report, 1895–. New York State
Archives.

PRIMARY SOURCES

Addams, Jane. *A New Conscience and an Ancient Evil.* New York: Macmillan, 1912.
——. *The Spirit of Youth and the City Street.* New York: Macmillan, 1909.

A. H. S. "Review of *The Honor System.*" *New York Dramatic Mirror,* February 17,
1917, 32.

Aldini, John [Giovanni]. *An Account of the Galvanic Experiments Performed . . . on
the Body of a Malefactor Executed at Newgate, January 17, 1803.* London: Cutchell
and Martin, 1803.

Allen, Annie W. "How to Save Girls Who Have Fallen." *Survey* 24, no. 19 (1910):
684–96.

Anonymous. "Again Death Stalks Through a Prison." *New York Times* [hereafter abbreviated to *NYT*], April 27, 1920.

——. "All Ready! Now the Villain Enters! Camera!" *Photoplay*, November 1915, 91.

——. "American Prison System: Severe Condemnation. British Methods Advocated." *Daily Telegraph*, December 19, 1913.

——. "Announcement of *The Electrocution of Czolgosz*." *New York Clipper*, November 16, 1901, 832.

——. "Another Good Suggestion: Moving Pictures in Railway Depots." *Moving Picture World* [hereafter abbreviated as *MPW*] 7, no. 27 (December 31, 1910): 1525.

——. "An Appreciation." *Star-Bulletin* 19, no. 9 (February 1918): 15.

——. "Attraction at the Theatres: Review of *Alias Jimmy Valentine*." *Boston Globe*, May 16, 1920, 66.

——. "Auburn Brevities." *Star of Hope* [hereafter abbreviated as *SOH*] 1, no. 15 (November 4, 1899): 12.

——. "Ban in Ohio Urged on Pen-Riot Movie." *Sun*, August 2, 1920, 1.

——. "Bedford Girls Say Ban on Film Caused Flight." *New York Tribune*, May 11, 1921, 8.

——. "Big Preachment Made Entertaining." *Wid's*, May 3, 1917, 274–75.

——. *Bioscope*, December 12, 1909, 51. Stephen Bottomore's "Early Film Collection" [hereafter SBEFC].

——. "Boys' Clubs and Employment." *Christian Science Monitor*, March 31, 1931.

——. "Boy Scouts Study Crime." *NYT*, July 15, 1931.

——. "Can Get Library Books at Any Time." *Mutual Welfare League Bulletin* 1, no. 15 (February 1916): 7.

——. "Capital Punishment Film Play's Theme." *NYT*, December 11, 1916.

——. "Chapin's Sing Sing Paper Suspended." *NYT*, August 17, 1920, 20.

——. "Chicago Child Welfare Exhibit." *MPW* 8, no. 22 (June 3, 1911): 1242.

——. "Chicken Dinner for 611 at State Prison." *Boston Daily Globe*, December 1, 1922, 9.

——. "Children's Subjects for the Moving Picture: Kalem Company Inaugurates a New Policy." *MPW* 5, no. 27 (December 31, 1909): 953.

——. "Christmas at State Prison a Merry One." *Hartford Courant*, December 27, 1927, 1.

——. "Christmas Movies Delight Prisoners: Local Theater Manager and Two Actors at State Prison." *Hartford Courant*, December 26, 1914, 5.

——. "Cinematography on Railroad Cars." *MPW* 4, no. 13 (March 27, 1909): 363.

——. "Colorado Insane Asylum Adopts Motion Pictures." *MPW* 10, no. 12 (December 23, 1911): 982.

——. "Comments on the Christmas Entertainment." *SOH* 2, no. 10 (January 12, 1901): 351.

——. "Concert to Precede YMCA Meeting." *Hartford Courant*, December 6, 1914, 6.

——. "Coney Elephant Killed." *NYT*, January 5, 1903.

——. "'Convict Brown,' Self-Imposed, Suffers in Jail." *New York World*, October 4, 1913.

——. "Convict 'Coddling' Causes Lively Debate Among Women." *Brooklyn Daily Eagle*, January 11, 1930.

——. "Convicts Are Men—Men Need Women." *New York Daily News*, September 16, 1934.

——. "Convicts Carnival Welcome Osborne: Prisoners in Costume and Wild with Joy." *NYT*, July 17, 1916, 1.

——. "Convicts Die in Explosion." *Los Angeles Times*, July 30, 1928, 5.

——. "Convicts Hiss Chaplain." *Washington Post*, October 14, 1907, 3.

——. "Convicts Still at Large; State Will Probe Break." *Hartford Courant*, January 6, 1930, 1.

——. "Convicts to Live in Dormitories." *New York Sun*, September 18, 1931.

——. "Convict Story Writer Gets Film Magazine Job." *New York Sun*, April 17, 1931.

——. "Convict Wins a Film Prize: Suggests Best Name for Moving Picture Shown at Sing Sing." *NYT*, September 13, 1915, 4.

——. "Crazy People Entertained with Moving Pictures." *MPW* 8, no. 5 (February 5, 1910): 233.

——. "Day of Crime Film Is Over, Hays Says." *NYT*, March 31, 1931.

——. "Denton Jail Reform." *Washington Post*, August 16, 1927, 6.

——. "Device for the Execution of Criminals." *Electrical World* 14, no. 22 (June 2, 1883): 341.

——. "Drug Terror Film Shown in the Tombs." *Trenton Evening Times*, May 24, 1914, 22.

——. "Dynamo-Electric Dangers." *Operator and Electrical World* 15, no. 1 (January 6, 1883): 1.

——. "Electrical Marionettes." *Electrical World* 12 (November 17, 1883): 192.

——. "Engelwood Club Scores Crime Films." *NYT*, February 20, 1931.

——. "Escaped Convicts Battle in Syracuse." *NYT*, March 4, 1929, 23.

——. "An Excellent Concert." *SOH* 16, no. 3 (May 23, 1914): 38.

——. "Fail to Make Osborne Films." *Rochester Union*, October 3, 1913.

——. "Far Worse than Hanging." *NYT*, August 7, 1890, 1.

——. "Feature Comedies Favored as Movies by American Tars." *Washington Post*, February 13, 1927, S13.

——. "Federal Prisoners Are Given a Treat in Universal Film." *Atlanta Constitution*, March 4, 1915, 3.

——. "Federal Prisoners Caught in $150,000 Plot to Swindle Government by Forgery Scheme." *NYT*, July 22, 1926, 3.

——. "Federal Prisoners See Splendid Film." *Atlanta Constitution*, November 25, 1921.

——. "Film Chief's Gift Is Told." *San Antonio Light*, April 7, 1935.

——. "Film Pictures Stir British Boys to Crime." *San Francisco Chronicle*, May 19, 1912, 31.

——. "Films Strong Uplift Force in the Prisons." *New York Tribune*, April 29, 1923, D4.

——. "Final Editing of *The Gray Brother* Completed." *Exhibitors Trade Review* 7, no. 6 (January 10, 1920): 607.

——. "Five Hundred Convicts See Outside World—'By Movies.'" *Chicago Daily Tribune*, December 4, 1912, 1.

——. "Fox Makes Powerful Prison Film." *Motography* 16, no. 2 (November 11, 1916): 1071.

——. "Frank L. Stanton's Poem Is Taken as the Basis of English Prison Play." *Atlanta Constitution*, November 15, 1923, 8.

——. "Future of the Motion Picture." *MPW* 4, no. 9 (February 27, 1909): 234.

——. "Gang Film Protest Asked: Knights of Columbus Meeting May Petition Hollywood." *Herald Tribune*, May 29, 1931.

——. "Girl Prisoners Mutiny." *NYT*, January 3, 1920, 2.

——. "Goes Mad on Seeing Film: Eskimo in Expedition Becomes Violent at His First Movie." *NYT*, July 7, 1931.

——. "Great Moral Sermon Presented in Realistic Production." *Wid's Daily*, November 13, 1921, 9.

——. "Here's a Film for You Who Like Crook Heroes." *Chicago Daily Tribune*, May 13, 1923, D1.

——. "Higher Education the Need." *MPW* 7, no. 21 (November 19, 1910): 1185.

——. "Hit Crime Pictures and Racketeer News." *NYT*, June 11, 1931.

——. "*The Honor System* Interesting, but Not Significant as Propaganda." *Exhibitors Trade Review* 1, no. 12 (February 24, 1917): 835.

——. "*The Honor System* Shown." *NYT*, February 13, 1917, 4.

——. "How the Picture Causes Juvenile Delinquency." *MPW* 10, no. 7 (November 18, 1911): 534.

——. "Invites Police Officials." *Los Angeles Times*, May 6, 1921, 19.

——. "James Kennedy & Company in . . . *The Swift*." *SOH* 16, no. 18 (January 30, 1915): 295.

——. "Judge Condemns Gangster Pictures: Public Demands Best Type, Hays Says." *Christian Science Monitor*, March 31, 1931.

——. "Leavenworth Prisoners Have Show." *Nickelodeon* 5, no. 2 (January 14, 1911): 45.

——. "The Lecturer and the Picture: A Distinguished Lady Enters the Moving Picture Field." *MPW* 7, no. 14 (October 1, 1909): 750.

——. "Life Battle Begins for Chapman Today." *NYT*, March 29, 1926, 7.

——. "Lifer's Dean Fifty Years Behind Bars." *Los Angeles Times*, December 7, 1925, 3.

——. "Making the Old Bit Pay Dividends." *Baltimore Sun*, August 3, 1930, SM9.

——. "Matching Wits with Convicts." *Atlanta Constitution*, December 2, 1928, 8.

——. "The Micro-Kinetoscope." *MPW* 7, no. 15 (October 8, 1910): 797.

——. "Miss Virginia Pearson Visits Sing Sing." *Star-Bulletin* 19, no. 12 (May 1918).

——. "More Light in the Theaters." *MPW* 4, no. 13 (March 27, 1909): 365.

——. "Mothers May Check Children at Movies Under Shopping Plan." *NYT*, February 13, 1931.

——. *Motography*, September 14, 1912, 205.

——. "The Movies." *SOH* 16, no. 13 (November 7, 1914): 198.

——. "Movies Used to Aid Fredericks." *Los Angeles Times*, October 20, 1914, 112.

——. "Movies Will Be Christmas Treat at State Prison: *Brewster's Millions* Is Film to Be Shown." *Hartford Courant*, December 23, 1914, 7.

——. "Moving Pictures and Truancy." *MPW* 8, no. 26 (July 1, 1911): 1503.

——. "The Moving Pictures as a Brain Rest." *MPW* 4, no. 20 (March 15, 1909): 625.

——. "Moving Pictures as a Cure for Insanity." *MPW* 6, no. 10 (March 12, 1910): 376.

——. "Moving Pictures Cure Mental Diseases." *MPW* 6, no. 25 (June 25, 1910): 1092.

——. "Moving Pictures in Prison." *NYT*, December 2, 1911, 8.

——. "Moving Pictures in State Institutions." *Nickelodeon* 1, no. 1 (January 1909): 20.

——. *MPW* 1, no. 25 (August 25, 1907): 391.

——. "M. S. P. Forum." *Mentor* 19, no. 10 (August 1919): 440.

——. "M. S. P. Forum." *Mentor* 22, no. 22 (November 1921): 46.

——. "MWL Educational Activities." *SOH* 16, no. 18 (January 30, 1915): 295.

——. "Naval Prisoners Escape in Auto." *Hartford Courant*, July 8, 1924, 4.

——. "Nickelodeon Versus Saloon." *MPW* 2, no. 20 (May 16, 1908): 433.

——. "Notes Written on the Screen." *NYT*, March 14, 1915, xii.

——. "Observations by Our Man About Town." *MPW* 6, no. 7 (February 9, 1910): 250.

——. "Observations by Our Man About Town." *MPW* 6, no. 22 (June 4, 1910): 680.

——. "On the Screen at Sing Sing." *Star-Bulletin* 20, no. 6 (November 1918): 10.

——. "On the Screen at Sing Sing." *Star-Bulletin* 20, no. 7 (December 1918): 10.

——. "On the Screen at Sing Sing: *The Master Mystery*." *Star-Bulletin* 20, no. 9 (March 1919): 12.

——. "Oppenheimer Put to Death." *Los Angeles Times*, July 12, 1913.

——. "Oranges Fight Gang Films: Heads of the Four Municipalities and Mapelwood Send Plea to Theaters." *NYT*, June 3, 1931.

——. "Osborne Going into Movies: Will Act Tom Browne at Auburn Prison for Reform Committee." *NYT*, September 24, 1915, 7.

——. "Osborne's Film Story of Prison Life Will Have First Showing in Syracuse." *Syracuse Herald*, February 6, 1921.

——. "Other Business." *New Yorker*, April 3, 1937.

——. "Our First Anniversary." *SOH* 2, no. 1 (April 21, 1900): 9.

——. "Picture Plays and People." *NYT*, November 5, 1923, X5.

——. "Pictures for Leavenworth Convicts." *Nickelodeon* 4, no. 10 (November 15, 1910): 282.

——. "Pictures for Prisoners." *Washington Post*, March 22, 1914, SM3.

——. "Pictures for the Afflicted." *MPW* 8, no. 1 (January 7, 1911): 20.

——. "Picture Show in Prison." *Bioscope*, November 18, 1909, 50.

——. "Picture Shows for Prisoners." *Motography* 6, no. 1 (July 1911): 30.

——. "Pictures Seen on Sing Sing's Movie Screen." *Star-Bulletin* 19, no. 8 (January 1918): 6.

——. "Plays and Players." *Photoplay*, July 1916, 99.

——. "A Plea for the Boys." *MPW* 8, no. 27 (July 8, 1911): 1571.

——. "Police of Many Cities Have Radio as Aid." *New York Sun*, April 30, 1931.

——. "Pomerory Sad Over Death of a Friend." *Boston Daily Globe*, November 26, 1926, A20.

——. "Powerful Book by London." *Boston Daily Globe*, October 23, 1915, 4.

——. "Prison Drama Necessitated Unusual Sets." *Washington Post*, July 6, 1930, A2.

——. "Prison Entertainments." *NYT*, December 22, 1924.

——. "Prisoners Entertained in East Cambridge Jail." *Boston Daily Globe*, December 26, 1922, 7.

——. "Prison for Women Has No Lock or Bars." *New York Sun*, March 16, 1931.

——. "Prison Movies Show Grim Side of Convict Life." *Auburn Citizen*, September 23, 1920.

——. "Prison Moving Pictures Taken by a Girl." *NYT Sunday Magazine*, November 21, 1915, SM19. Also appeared as "New York State Prisons in Movies." *Delinquent* 5, no. 10 (October 1915): 9–11.

——. "Prison Removal Committee Urge Abandonment of Electrocution." *Democratic Register*, November 16, 1928.

——. "A Radio in Every Sing Sing Cell." *Lowell, Mass., Telegram*, February 25, 1934.

——. "A Remarkable Slide Feature." *MPW* 13, no. 10 (September 7, 1912): 986.

——. Review of *The Prison Without Walls*. *Variety*, April 27, 1917, 29.

——. Review of *The Right Way. Advertizer*, March 21, 1921.

——. "A Roasting of Human Flesh in Prison—Strong Men Sickened and Turned from the Sight." *New York World*, August 7, 1890, 1.

——. "A Royal Entertainment." *SOH* 16, no. 18 (January 30, 1915): 292.

——. "San Quentin to See Vaudeville Chronicle to Present Big Bill." *San Francisco Chronicle*, December 31, 1914.

——. "Says Motion Pictures Do Not Increase Crime." *Boston Daily Globe*, December 29, 1925, A2.

——. "Schelling Cites Warden Lawes' Tribute to the Boy Scouts Movement." *Brooklyn Daily Eagle*, March 9, 1935.

——. "Scores Film Plays: Miss Davis Traces Many Tragedies to Crime Scenes." *Washington Post*, April 21, 1913, 1.

——. "Secret of Sing Sing Prison's Death House." *World*, August 19, 1900, 3.

——. "Seek Fake Sing Sing Agent." *NYT*, May 2, 1921, 15.

——. "Seen and Heard on Sing Sing's Movie Stage and Screen." *Star-Bulletin* 18, no. 10 (February 19, 1917): 8.

——. "Seen and Heard on Sing Sing's Screen." *Star-Bulletin* 18, no. 16 (April 4, 1917).

——. "Self Governing Welfare League of Prisoner." *Survey*, April 4, 1913, 4.

——. "Send Presents to Convict Pals." *Atlanta Constitution*, April 3, 1915, 8.

——. "Shadows on the Screens." *New York Tribune*, November 12, 1916, C2.

——. "Shadows on the Screens." *New York Tribune*, January 14, 1917, C4.

——. "Sing Sing Bars Arbuckle." *NYT*, December 25, 1922, 11.

——. "Sing Sing Cuts Movie Shows, Since Cells Are More Livable." *NYT*, August 15, 1929, 19.

——. "Sing Sing Inmates Strive to Produce a Reel Name." *New York Tribune*, February 13, 1915, 5.

——. "Sing Sing's Movies: Inaugurating the Golden Rule Brotherhood's New Machine." *SOH* 16, no. 12 (October 1914): 178.

——. "Sing Sing . . . the Jail with a Human Touch." *Daily Herald*, November 29, 1937.

——. "Sing Sing to Hire Woman." *NYT*, March 16, 1930.

——. "638 Convicts See 'Movies' at State Prison: Chapel Decorated with Flags—Institution's Own Band Plays." *Hartford Courant*, July 6, 1915, 13.

——. "State Prison for Women at Auburn." *SOH* 18, no. 8 (December 1916): 25.

——. "Study Crime at Sing Sing." *Ithaca Journal-News*, February 2, 1930.

——. "A Talk with the Governor of Sing Sing." *London Evening News*, July 15, 1935.

——. "These Are Your New York State Correctional Institutions, 8: Sing Sing Prison." *Corrections* 14, no. 8/9 (August–September 1949): 3–15.

——. "Thirty-Seven Flee Jail." *Los Angeles Times*, June 8, 1922, 11.

——. "3,000 Feet of Film Showing Prison Life: To Be Accompanied Sunday Evening at Empire Theater by Lecture on Prison Reform." *Hartford Courant*, September 24, 1915, 5.

——. "Trapped Convicts Burned at Movie Show." *NYT*, July 30, 1928, 1.

——. "Traps 3 in Sing Sing in Plot to Escape." *NYT*, November 19, 1928, 1.

——. "Undercurrents." *SOH* 2, no. 1 (April 21, 1900): 17.

——. "Uniformed Attendants." *MPW* 6, no. 11 (March 19, 1910): 417.

——. "'Valentine' Film at Sing Sing: Motion Pictures of Well Known Play Please Convict Audience." *New York Tribune*, February 16, 1915, 9.

——. "Visitors to Sing Sing." *Star-Bulletin* 20, no. 11 (May 1919): 15.

——. "The V.P.L. Day: Mrs. Booth Tendered an Enthusiastic Reception." *SOH* 1, no. 13 (October 7, 1899): 7.

——. "Want to See Czolgosz Die." *NYT*, September 21, 1901.

——. "Weather." *NYT*, December 7, 1914, 8.

——. "Whalen to Extend Curb on Wayward." *NYT*, March 9, 1930.

——. "Will Make Trial of Entertainments at State Prison." *Hartford Courant*, January 19, 1929, 1.

——. "With the Producers and Players." *NYT*, November 8, 1925, X5.

——. "Wizard in Gaol: Opens Cell and Is Taken for the Devil. His 61st Escape." *Daily Express* (London), February 2, 1904.

——. "Women's Writes." *SOH* 2, no. 6 (September 22, 1900): 211.

——. "Women to Leave Auburn." *Telegraph*, April 5, 1932.

——. "You Can Get an Education." *SOH* 20, no. 3 (August 1918): 1.

——. "Young Gunmen Lay Crimes to Movies." *NYT*, August 4, 1931.

Auburn Prison No. 25551. "Mental Visions." *SOH* 1, no. 17 (December 2, 1899): 2.

Auburn Prison No. 26336. "Music." *SOH* 3, no. 3 (May 18, 1901): 57.

Auburn Prison No. 33577. "Memory's Motion Picture Show." *Star-Bulletin* 4 (August 1916): 19.

Auburn Prison No. 33828. "Thanksgiving Day: A Prisoner's Point of View." *SOH* 16, no. 16 (January 2, 1915): 251.

Auburn Prison No. 35154. "Movie Reveries." *SOH* 18, no. 8 (December 1916): 29.

Auburn Women's Prison No. 196. "The Star of Hope a Medium." *SOH* 3, no. 1 (April 20, 1901): 13.

Auburn Women's Prison No. 253. "Crime Causes." *SOH* 1, no. 15 (November 4, 1899): 14.

Auburn Women's Prison No. 316. "Women's Prison." *SOH* 3, no. 1 (April 20, 1901): 2.

Auburn Women's Prison No. 321. "The Minstrel Show." *SOH* 3, no. 19 (December 28, 1901): 324.

——. "Women's Prison: Its History and Its Industries." *SOH* 2, no. 5 (August 25, 1900): 175.

——. "Women's Writes." *SOH* 3, no. 3 (May 18, 1901): 66.

Auburn Women's Prison No. 876. "Evening Entertainment." *SOH* 16, no. 16 (January 1915): 255.

Auburn Women's Prison No. 914. "A Fine Entertainment." *SOH* 16, no. 23 (April 10, 1915): 370.

Auburn Women's Prison No. 958. *SOH* 18, no. 4 (August 1916): 17.

Auburn Women's Prison No. 25502. "Man's Inhumanity to Woman." *SOH* 1, no. 14 (October 21, 1899): 4.

Bacon, Corinne, ed. *Prison Reform*. The Handbook Series. New York: H. W. Wilson, 1917.

Barrows, Isabel C. "The Massachusetts Reformatory Prison for Women." In Barrows, *The Reformatory System in the United States*, 101–28.

Barrows, Samuel J., ed. *The Reformatory System in the United States: Reports Prepared for the International Prison Commission*. Washington, DC: Government Printing Office, 1900.

Bates, R. C. "Character Building at Elmira." *American Journal of Sociology* 3, no. 5 (March 1898): 582.

Beatty, William K. "A Historical Review of Bibliotherapy." Special issue edited by Ruth M. Tews, *Library Trends* 11, no. 2 (October 1962): 106–17.

Boswell, James. *The Life of Samuel Johnson, LL.D Including the Journal and Diary*. London: Murray, 1835.

Bowen, A. L. "The Joliet Prison and the Riots of June 5th." *Journal of Law and Criminology* 8, no. 4 (1918): 576–85.

Briggs, L. Vernon. *The Manner of Man That Kills: Spencer, Czolgosz, Richeson*. Boston: Gorham, 1921.

Brockway, Zebulon R. "Beginnings of Prison Reform in America." *Charities* 13 (February 4, 1905): 437–44.

——. *Fifty Years of Prison Service: An Autobiography*. 1912. Reprint, Montclair, NJ: Patterson-Smith, 1969.

——. "The Reformatory System." In *The Reformatory System in the United States: Reports Prepared for the International Prison Commission*, edited by Samuel J. Barrows. Washington, DC: Government Printing Office, 1900, 17–47.

Bush, W. Stephen. "Who Goes to the Moving Pictures?" *MPW* 3, no. 18 (October 30, 1908): 336.

Chamberlain, Rudolph W. *There Is No Truce: A Life of Thomas Mott Osborne*. New York: Macmillan, 1935.

Channing, Walter. "The Mental Status of Czolgosz." *American Journal of Insanity* 59, no. 2 (1902): 1–47.

Christian, Frank L. "'Travelogue': Sound Motion Pictures." In "Recreation at the Elmira Reformatory," nine-page typed document, file 26, Juvenile Delinquency Prevention and Rehabilitation, box 5, Drafts of Articles and Scripts, Lewis Lawes Papers. Lloyd Sealey Library, John Jay College of Criminal Justice, City University of New York [hereafter LLP-JJC].

Clinton Prison No. 4499. "Reformed by a Picture." *SOH* 8, no. 18 (December 14, 1901): 297–98.

Clinton Prison No. 10874. "Two Hours of Fun." *SOH* 16, no. 10 (September 26, 1914): 160.

Collins, Cornelius V. "The Prison Stripe," *Report of the Superintendent of State Prisons, New York, 1904.*

——. *Report of the Superintendent of State Prisons, New York*, 1899.

Commission Pénitentiaire Internationale. "Programme of Questions to Be Discussed at the Ninth International Penitentiary Congress, London 1925." Groningen, Netherlands: J. B. Walters, 1923.

Condon, Charles R. Review of *The Honor System. Motography* 17, no. 8 (February 24, 1917): 424.

Crewe, Regina. "'The Big House' Packs Thrills and Suspense on Screen." *New York American*, June 25, 1930.

Cross, Andrew B. *Priests' Prisons for women; or, A consideration of the question, whether unmarried foreign priests ought to be permitted to erect prisons, into which, under pretense of religion, to seduce or entrap, or by force compel young women to enter, and after they have secured their property, keep them in confinement and compel them, as their slaves, to submit themselves to their will, under the penalty of flogging or the dungeon? In twelve letters to T. Parkin Scott.* Baltimore: Sherwood, 1854.

Crothers, Samuel McChord. "A Literary Clinic." *Atlantic Monthly*, August 1916, 291–301.

Cummings, Willis. "The Use of Moving Pictures as a Remedial Agent." *MPW* 4, no. 20 (May 15, 1909): 626.

Daniel, F. Raymond. "Sing Sing's Pampering Done in Tiny, Damp Cells." *New York Evening Post*, February 26, 1927.

Davis, Richard Harding. "The New Sing Sing." *NYT*, July 18, 1915, 6.

Dickens, Charles. *American Notes.* 1842. Reprint, London: Collins, 1906.

Doré, Gustave and Blanchard Jerrold. *London: A Pilgrimage.* London: Grant, 1872. Reprint, Mineola, NY: Dover, 1970.

Doty, Madeline Z. *Society's Misfits.* New York: Century, 1916.

Drewry, John E. "Presidential Address: The Journalist's Inferiority Complex." *Journalism Quarterly* 8 (1931): 12–23.

Dudley, Charles. *Being a Boy*. Boston, 1897.

Duffy, Clinton T. *San Quentin: The Story of a Prison, as Told to Dean Jennings*. London: Davies, 1951.

Dyer, Frank Lewis and Thomas Commerford Martin. *Edison: His Life and Inventions*. 2 vols. New York: Harper, 1910.

Eastman, Max. "Riot and Reform at Sing Sing." *Masses* 6 (June 1915): 126.

Editor in chief. "Entertainment: Sunday Feb. 7th 1915." *SOH* 16, no. 19 (February 13, 1915): 302.

Eichberg, Robert. "Convicts Are Radio Fans." *Broadcasting*, November 1934.

Eilperin, Juliet. "Obama Bans Solitary Confinement for Juveniles in Federal Prisons." *Washington Post*, January 29, 2016, https://www.washingtonpost.com/politics/obama-bans-solitary-confinement-for-juveniles-in-federal-prisons/2016/01/25/056e14b2-c3a2-11e5-9693-933a4d31bcc8_story.html.

Eisenstein, Sergei. "Constanza (Whither "The Battleship Potemkin")." In *Selected Works*, vol. 1, *Writings, 1922–1934*, edited and translated by Richard Taylor. Bloomington: Indiana University Press, 1988.

Elliot, Robert G. with Albert R. Beatty. *Agent of Death: The Memoirs of an Executioner*. New York: E. P. Ditton, 1940.

Evans, James S. "Edison Regrets Electric Chair Was Ever Invented." *New York American*, February 10, 1905.

"A Failure: The Electrical Torture of William Kemmler." *Buffalo Express*, August 8, 1890.

Fletcher, Susan Willis. *Twelve Months in an English Prison*. London: Lee and Shepard, 1864.

Fry, Elizabeth. *Observations on Visiting, Superintending, and Government of Female Prisons*. London: John and Arthur Arch, 1827.

George, Haldane. "Convicts at Large Without Guards." *Los Angeles Times*, April 27, 1912, IM20.

Gorky, Maxim. "The Kingdom of Shadows." *Lumière Cinematograph*, July 4, 1896. http://www.seethink.com/stray_dir/kingdom_of_shadows.html.

Great Meadow Prison No. 1602. "Happenings." *Star-Bulletin* 16, no. 16 (January 2, 1915): 260.

Great Meadow Prison No. 1964. "An Essay on Motion Pictures." *Star-Bulletin* 18, no. 7 (November 1916): 30.

Hanway, Jonas. *Distributive Justice and Mercy*. London: J. Dodsey, 1781.

"Happy Dust: Overheard at Sing Sing." *SOH* 18, no. 6 (October 1916): 20.

Healy, William. *The Individual Delinquent: A Textbook of Diagnosis and Prognosis for All Concerned in the Understanding of Offenders*. New York: Little Brown, 1915.

Henderson, Charles Richmond. *Report of the Proceedings of the Eighth International Prison Congress, Washington, DC, September–October 1910*. House Document Issue 52, Law Pamphlets Volume 78. Washington, DC: Government Printing Office, 1913.

Herring, Robert. "The News-Reel." In *In Letters of Red*, edited by E. Allen Osborne, 94–101. London: M. Joseph, 1938.

"History of Parole in New York State." New York State Department of Corrections and Community Supervision. Accessed September 3, 2013. https://www.parole.ny.gov/introhistory.html.

Holmes, George. "Man Behind the Bars Hears Distant Cities." *NYT*, April 19, 1931, 128.

Hurlette, Frank Parker. "An Interview with Thomas A. Edison." *MPW* 9, no. 1 (July 15, 1911): 104–5.

James, Arthur. "*The Right Way* Is a Big Picture." *MPW* (November 19, 1921): 288.

Kavanaugh, Edward. "Half a Century Behind Bars by Choice." *New York Herald Tribune*, September 5, 1926, 7.

Kellock, Harold and Beatrice Houdini. *Houdini: His Life Story, from the Recollections and Documents of Beatrice Houdini*. New York: Blue Ribbon, 1931.

Kent, Victoria. "A Woman Runs Spain's Prisons." *Literary Digest*, June 27, 1931, 15.

King, E. M. "Sing Sing Under Warden Moyer's Direction." *SOH* 19, no. 11 (April 1918): 3.

Lawes, Lewis E. "An Address Delivered by Warden Lawes of Sing Sing." *New School for Social Research*, April 27, 1931. LLP-JJC.

——. "Capital Punishment Tends to Make More Murderers." *New York Times Book Review*, December 2, 1928, 11.

——. *Cell 202, Sing Sing*. New York: Farrar and Rinehart, 1935.

——. *Invisible Stripes*. New York: Farrar and Rinehart, 1938.

——. *Life and Death in Sing Sing*. New York: Garden City, 1928.

——. *Man's Judgment of Death: An Analysis of the Operation and Effect of Capital Punishment Based on Facts, Not on Sentiment*. New York: G. P. Putnam, 1924.

——. *Meet the Murderer!* New York: Harper, 1940.

——. "Miles of Moving Pictures." *Washington Post* [first reported in the *Kansas City Star*], January 9, 1907, 6.

——. "The Price We Pay When Character Training Fails." *Bulletin of the Welfare Council of New York City*, c. 1928.

——. "Radio Goes to Jail." *Radio Guide*, July 7, 1934, 3.

——. *Stone and Steel: The Way of Life in a Penitentiary*. Evanston, IL: Row, Peterson, 1941.

——. *Twenty Thousand Years in Sing Sing*. New York: A. L. Burt, 1932.

Lawes, Lewis E. with John Wexley. *The Last Mile: A Play in Three Acts*. New York: R. French, 1941.

Lekkerkerker, Eugenia Cornelia. *Reformatories for Women in the United States.* The Hague: Bij J. B. Wolters' Uitgevers-Maatchappij, 1931.

Lewis, O. F. "The Prison Exhibit." *Delinquent* 6, no. 1 (January 1916): 1–6.

——. "The 'Trusty' in the New Penology." *Boston Evening Transcript*, August 8, 1914, 4.

London, Jack. *The Star Rover.* New York: Macmillan, 1915 [published as *The Jacket* in London].

Luckey, John. "Chaplain's Report." *Twelfth Annual Report of the Inspectors of New York*, January 3, 1860, 72.

——. *Life in Sing Sing State Prison: As Seen in a Twelve Years' Chaplaincy.* New York: N. Tibbals, 1860.

MacDonald, Carlos F. "The Trial, Execution, Autopsy and Mental State of Leon F. Czolgosz, Alias Fred Nieman, the Assassin of President McKinley." *Philadelphia Medical Journal* 9 (January 4, 1902): 33.

Manners, Dorothy. "Are Movie Gangsters Being Overdone?" *Motion Picture Classics*, June 1931, 74–75, 104.

Mayhew, Henry and John Binny. *The Criminal Prisons of London and Scenes of Prison Life.* London: Griffin, Bohn, 1862. Reprint, Cambridge: Cambridge University Press, 2011.

McDowell, F. H. "Report of the Ladies Committee." In *Fifteenth Annual Report of the House of Refuge of Philadelphia with Appendix*, 14–15. Philadelphia: Dorsey, 1843.

McKelvey, Blake. *American Prisons: A History of Good Intentions.* Chicago: University of Chicago Press, 1936.

Moody, Mildred T. "Bibliotherapy: Modern Concepts in General Hospitals and Other Institutions." Special issue edited by Ruth M. Tews, *Library Trends* 11, no. 2 (October 1962): 147–58.

New York State Department of Corrections. *Sing Sing Prison: Its History, Purpose, Makeup, and Program.* Albany: Department of Corrections, 1958.

O'Donavan Rossa, Jeremiah. *Irish Rebels in English Prisons.* New York: D. and J. Sadlier, 1880.

O'Laughlin, John Callan [Laughlin]. "The Picture in the Insane Asylum." *MPW* 10, no. 9 (December 2, 1911): 710.

Osborne, Thomas Mott. "Address Delivered at a Meeting Held Under the Auspices of the Men's Club, People's Presbyterian Church." Bridgeport, Connecticut, February 28, 1915. In Bacon, *Prison Reform*, 149.

——. "New Methods at Sing Sing." *Review of Reviews* 52 (October 1915): 133.

——. *Society and Prisons.* Yale Lectures. New Haven, CT: Yale University Press, 1916.

——. *Within Prison Walls: Being a Narrative of Personal Experience During a Week of Voluntary Confinement in the State Prison at Auburn, New York.* Rome, NY: Spruce Gulch, 1914.

Paterson, Alexander. "Prison Problems of America Analyzed by a British Critic." *NYT,* August 2, 1931.

Peterson, Everett. "Crime and Punishment as Our Forefathers Knew It." *Outlook,* c. 1921. Scrapbook entry file 46, 1926–1929, box 9, series VI, General Scrap Books, LLP-JJC.

Powers, G. *A Brief Account of the Construction, Management, and Discipline Etc. of the New York State Prison at Auburn.* Auburn, New York, 1826.

Reid, Laurence. Review of *The Right Way. Motion Picture News,* November 12, 1921, 2601.

Robert, Jeanne. "The Case of Women in State Prisons." *Review of Reviews* 44 (July 1911): 76–84. Reprinted in Bacon, *Prison Reform,* 93–101.

Rogers, Helen Worthington. "A Digest of Laws Establishing Reformatories for Women in the United States." *Journal of the American Institute of Criminal Law and Criminology* 8, no. 4 (November 1917): 535.

Russell, Charles Edward. "Beating Men to Make Them Good." *Hampton's Magazine* 23, no. 5 (November 1, 1909): 609–20.

Russell, Frank. "Report of the Chaplain." *Report of the Superintendent of State Prisons, New York,* 1903, 53–54.

Russell, Marion. Review of *The Right Way. Billboard,* November 5, 1921.

Sanderson, George. "Chaplain's Report." *Report of the Superintendent of State Prisons, New York,* 1899, 66–70.

Scott, Joseph F. "The Massachusetts Reformatory." In Barrows, *The Reformatory in the United States,* 84–85.

Sewell, C. S. Review of *The Right Way. MPW* (November 12, 1921): 218.

Shelley, Mary. *Frankenstein; or, The Modern Prometheus.* London: Lackington, Hughes, Harding, Mavor, and Jones, 1818.

Simkhovitch, Mary Kingsbury. *The City Worker's World in America.* New York: Macmillan, 1917.

Sing Sing Prison No. 312. "A Study in Criminology." *SOH* 1, no. 3 (May 20, 1899): 1.

Sing Sing Prison No. 61550. "Boxing at Sing Sing." *SOH* 16, no. 6 (August 1, 1914): 83.

Sing Sing Prison No. 64791. "Open Air Concert." *SOH* 16, no. 10 (September 26, 1914): 150.

Sing Sing Prison No. 64943. "Instructive Pictures." *SOH* 16, no. 17 (January 16, 1915): 260.

Sing Sing Prison No. 65368. "The Library at Sing Sing," *SOH* 18, no. 9 (January 1917): 19.

Spaulding, Edith R. "The Problem of a Psychopathic Hospital Connected with a Reformatory." *Medical Record* 99, no. 20 (May 13, 1921): 815–22.

Stein, Edwin C. "The Prisoners Riot Again." *Standard Union*, June 25, 1930.

Tews, Ruth M. Guest editor of *Library Trends* 11, no. 2 (October 1962).

Thirer, Irene. Review of *The Big House. New York News*, June 25, 1930.

U.S. National Commission on Law Observance and Enforcement. *Penal Institutions, Probation, and Parole*. Report No. 9. Washington, DC: U.S. Government Printing Office, 1931.

Vice Commission of Chicago. *The Social Evil in Chicago; a Study of Existing Conditions*. Chicago: Gunthrop-Warren, 1911.

Wade, George Gordon. "On the Screen at Sing Sing: The Flash of Progress." *Star-Bulletin* 20, no. 1 (June 1918): 10.

Wallack, Walter Marle. "Physical Education and Recreation." *Correctional Educational Today*. First Yearbook of the Committee on Education of the American Prison Association. New York: Prison Association, 1939.

Warner, Charles Dudley. "A Study of Prison Management." In Barrows, *The Reformatory System in the United States*, 48–58.

Waters, Theodore. "Out with a Moving Picture Camera." *Cosmopolitan* 40, no. 3 (January 1906): 251–59.

Weills, John C. S. "Chaplain's Report [Sing Sing]." *Report of the Superintendent of State Prisons, New York*, 1899, 75.

Weitzel, Edward. "Review of *The Honor System*." *MPW* 31, no. 9 (March 3, 1919): 1370.

West, Stephen [Rose Heylbut]. "What Music in Sing Sing Prison Means in the Lives and Reclamation of Many Inmates." *The Etude*, November 1938, 713–14.

White, Frank M. "The University of Sing Sing." *Century Magazine* 94, no. 6 (October 1917): 846–58.

Wilson, Curt. "Sound and Fury: No More Football at Sing Sing." *Danbury New Times*, October 20, 1936.

Wood, Lewis. *Sing Sing from the Inside*. New York Committee on Prison pamphlet. Republished in the *New York Tribune*, January 18, 1915.

Woods, Caroline H. *Woman in Prison*. New York: Hurd and Houghton, 1869.

Secondary Sources

Abel, Richard. *Americanizing the Movies and Movie Mad Audiences, 1910–1914*. Berkeley: University of California Press, 2006.

———. *The Ciné Goes to Town: French Cinema, 1896–1914.* Berkeley: University of California Press, 1998.

———. "From Peep Show to Picture Palace: The Early Exhibition of Motion Pictures." In *The Wiley-Blackwell History of American Film*, vol. 1, *Origins to 1928*, edited by Cynthia Lucia, Roy Grundmann, and Art Simon, 87–108. Hoboken, NJ: Wiley-Blackwell, 2012.

———. *The Red Rooster Scare: Making Cinema American, 1900–1910.* Berkeley: University of California Press, 1999.

Abel, Richard, Giorgio Bertellini, and Rob King, eds. *Early Cinema and the "National."* New Barnet, UK: John Libbey, 2008.

Acland, Charles R. and Haidee Wasson, eds. *Useful Cinema.* Durham, NC: Duke University Press, 2011.

Adams, Judith A. "The Promotion of New Technology Through Fun and Spectacle: Electricity at the World's Columbia Exposition." *Journal of American Culture* 18 (1995): 44–55.

Alber, Jan. "The Ideological Underpinnings of Prisons and Their Inmates from Charles Dickens' Novels to Twentieth-Century Film." In Serassis, Kania, and Albrecht, *Images of Crime III*, 133–48.

Alexander, Ruth M. *The "Girl Problem": Female Delinquency in New York, 1900–1930.* Ithaca, NY: Cornell University Press, 1995.

Amad, Paula. "Visual Riposte: Looking Back at the Return of the Gaze as Postcolonial Theory's Gift to Film Studies." *Cinema Journal* 52, no. 3 (Spring 2013): 49–74.

Anderson, Nick. "Pell Grants for Prisoners? An Experiment Will Test Reversal of a 20-Year Ban." *Washington Post*, July 30, 2015. http://www.washingtonpost.com /news/grade-point/wp/2015/07/30/pell-grants-for-prisoners-an-experiment-will -test-reversal-of-a-20-year-ban/.

Applebome, Peter. "After Graduation, Back to the Sing Sing Cellblock, with Hope." *NYT*, June 7, 2010, A16.

Arikha, Noga. *Passions and Tempers: A History of the Humours.* New York: Harper Perennial, 2008.

Asendorf, Christoph. *Batteries of Life: On the History of Things and Their Perception in Modernity.* Translated by Don Reneau. Berkeley: University of California Press, 1993.

Ash, Juliet. *Dress Behind Bars: Prison Clothing as Criminality.* London: I. B. Tauris, 2010.

Atditi, Ralph R. et al. "The Sexual Segregation of American Prisons." *Yale Law Journal* 82 (May 1973): 1269–71.

Auerbach, Jonathan. *Body Shots: Early Cinema's Incarnations.* Berkeley: University of California Press, 2007.

Aviv, Rachel. "No Remorse." *New Yorker*, January 2, 2012. http://www.newyorker.com /magazine/2012/01/02/no-remorse.

Bachelard, Gaston. *The Poetics of Space: The Classic Look at How We Experience Intimate Places*. Translated by Maria Jolas. Boston: Beacon, 1958.

Bazin, André. *What Is Cinema?* Translated by Hugh Gray. Berkeley: University of California Press, 1967.

Bean, Jennifer M. and Diane Negra, eds. *A Feminist Reader in Early Cinema*. Durham, NC: Duke University Press, 2002.

Bender, John B. *Imagining the Penitentiary: Fiction and the Architecture of Mind in Eighteenth-Century England*. Chicago: University of Chicago Press, 1987.

Bennett, Jamie. "Reel Life After Prison: Repression and Reform in Films About Release from Prison." *Probation Journal* 55, no. 4 (2008): 353–68.

Bentley, Nancy. *Frantic Panoramas: American Literature and Mass Culture, 1870–1920*. Philadelphia: University of Pennsylvania Press, 2009.

Bertellini, Giorgio. *Italy in Early American Cinema: Race, Landscape, and the Picturesque*. Bloomington: Indiana University Press, 2010.

Bitzer, G. W. *Billy Bitzer: His Story*. New York: Farrar, Straus and Giroux, 1973.

Blumenthal, Ralph. *Miracle at Sing Sing: How One Man Transformed the Lives of America's Most Dangerous Prisoners*. New York: St. Martin's, 2004.

Boddy, William. *New Media and Popular Imagination: Launching Radio, Television, and Digital Media in the United States*. New York: Oxford University Press, 2004.

Bookspan, Shelley. "A College of Morals: Educational Reform at San Quentin Prison, 1880–1920." *History of Education Quarterly* 40, no. 3 (Autumn 2000): 270–301.

——. *A Germ of Goodness: The California State Prison System, 1851–1944*. Lincoln: University of Nebraska Press, 1991.

Bottomore, Stephen. "Every Phase of Present-Day Life: Biograph's Non-Fiction Production." In "The Wonders of the Biograph," special issue, *Griffithiana* 69–70 (1999–2000): 147–211.

——. "Projecting for the Lord: The Work of Wilson Carlile." *Film History* 14, no. 2 (2002): 195–209.

Bourdieu, Pierre. *Outline of a Theory of Practice*. Cambridge: Cambridge University Press, 1977.

Bourdieu, Pierre and Loïc J. D. Wacquant. *An Invitation to Reflexive Sociology*. Chicago: University of Chicago Press, 1992.

Boyer, Paul. *Urban Masses and Moral Order in America, 1820–1920*. Cambridge, MA: Harvard University Press, 1978.

Brakhage, Stan. *Metaphors of Vision*. New York: Anthology Film Archive, 1976.

Brandon, Craig. *The Electric Chair: An Unnatural American History*. Jefferson, NC: McFarland, 1999.

Brian, Denis. *Sing Sing: The Inside Story of a Notorious Prison*. Amherst, NY: Prometheus, 2005.

Brownlow, Kevin. *Behind the Mask of Innocence: Sex, Violence, Prejudice, Crime in the Silent Era*. London: Cape, 1990.

Bruno, Guiliana. *Streetwalking on a Ruined Map: Cultural Theory and the City Films of Elvira Notari*. Princeton, NJ: Princeton University Press, 1993.

Bularzik, Mary J. *Sex, Crime, and Justice: Women in the Criminal Justice System of Massachusetts, 1900–1950*. Ann Arbor: University Microfilms International, 1982.

Bulck, Jan Van den and Heidi Vandebosch. "When the Viewer Goes to Prison: Learning Fact from Watching Fiction. A Qualitative Study." *Poetics* 31, no. 2 (April 2003): 103–16.

Cahm, Eric. *The Dreyfus Affair in French Society and Politics*. New York: Routledge, 1996.

Callahan, Vicki, ed. *Reclaiming the Archive: Feminism and Film History*. Detroit: Wayne State University Press, 2010.

Cassidy-Welch, Megan. "Prison and Sacrament in the Cult of the Saints: Images of St. Barbara in Late Medieval Art." *Journal of Medieval History* 35, no. 4 (December 2009): 371–84.

Caster, Peter. *Prisons, Race, and Masculinity in Twentieth-Century U.S. Literature and Film*. Columbus: Ohio State University Press, 2008.

Castle, Terry. *The Female Thermometer: Eighteenth-Century Culture and the Invention of the Uncanny*. New York: Oxford University Press, 1995.

Castonguay, James. "The Spanish-American War in U.S. Media Culture." *American Quarterly* 51, no. 2 (1999): 247–49.

Chavez-Garcia, Miroslava. *States of Delinquency: Race and Science in the Making of California's Juvenile Justice System*. Berkeley: University of California Press, 2012.

Cheatwood, Derral. "Prison Movies: Films About Adult, Male, Civilian Prisons: 1929–1995." In *Popular Culture, Crime, and Justice*, edited by Frankie Bailey and Donna Hale, 209–31. Albany: West/Wadsworth, 1998.

Christianson, Scott. *With Liberty for Some: 500 Years of Imprisonment in America*. Boston: Northeastern University Press, 1998.

Classen, Constance. *The Deepest Sense*. Urbana: University of Illinois Press, 2012.

Cook, David A. *A History of Narrative Film*. 4th ed. New York: Norton, 2004.

Crary, Jonathan. *24/7*. London: Verso, 2014.

Crowther, Bruce. *Captured on Film: The Prison Movie*. London: Batsford, 1989.

Curtis, Scott. *The Shape of Spectatorship: Art, Science, and Early Cinema in Germany*. New York: Columbia University Press, 2015.

Dahl, Roald. *The Witches*. New York: Scholastic, 1983.

Dalquist, Marina. "'Swat the Fly': Educational Films and Health Campaigns, 1909–1914." In *Kinoöffentlichkeit/Cinema's Public Sphere*, edited by Corinna Müller, 211–25. Marburg, Germany: Schüren Verlag, 2008.

Daly, Michael. *Topsy: The Startling Story of the Crooked Tailed Elephant, P. T. Barnum, and the American Wizard, Thomas Edison.* New York: Atlantic Monthly, 2013.

Davis, Angela Y. *Are Prisons Obsolete?* New York: Seven Stories, 2003.

——. "Race and Criminalization: Black Americans and the Punishment Industry." In *The Angela Y. Davis Reader*, edited by Joy James, 61–73. Maldon, MA: Blackwell, 1988.

Dennett, Andrea Stulman. *Weird and Wonderful: The Dime Museum in America.* New York: New York University Press, 1997.

Denno, Deborah W. "Is Electrocution an Unconstitutional Method of Execution? The Engineering of Death Over a Century." *William and Mary Law Review* 35, no. 2 (1994): 554–692.

Doane, Mary Ann. *The Emergence of Cinematic Time: Modernity, Contingency, the Archive.* Cambridge, MA: Harvard University Press, 2002.

Dobash, Russel P., R. Emerson Dobash, and Sue Gutteridge. *The Imprisonment of Women.* London: Blackwell, 1986.

Dodge, Mara L. *"Whores and Thieves of the Worse Kind": A Study of Women, Crime, and Prisons, 1835–2000.* DeKalb: Northern Illinois University Press, 2002.

Dopp, Darren. "Allowing Sets in Cells Brings Calm to Upstate N.Y. Facility: Prison Officials Gain Leverage Through TV Privileges." *Los Angeles Times*, June 5, 1988.

Driggs, Ken. "A Current of Electricity Sufficient in Intensity to Cause Immediate Death: A Pre-*Furman* History of Florida's Electric Chair." *Stetson Law Review* 22, no. 1 (1993): 1169–1209.

Drobny, Dane A. "Death TV: Media Access to Executions Under the First Amendment." *Washington University Law Quarterly* 70, no. 4 (1992): 1179–1204. http://openscholarship.wustl.edu/law_lawreview/vol70/iss4/5.

Drucker, Ernest. *A Plague of Prisons: The Epidemiology of Mass Incarceration.* New York: New Press, 2013.

Dunbabin, Jean. *Captivity and Imprisonment in Medieval Europe, 1000–1300.* New York: Palgrave Macmillan, 2002.

Ehrlich, Matthew C. "Facts, Truth, and Bad Journalists in the Movies." *Journalism* 7, no. 4 (2006): 501–19.

Ek, Auli. *Race and Masculinity in Contemporary American Prison Narratives.* New York: Routledge, 2005.

Essig, Mark. *Edison and the Electric Chair: A Story of Light and Death.* New York: Walker, 2003.

Esslinger, Michael. *Alcatraz: A Definitive History of the Penitentiary Years.* Carmel, CA: Ocean View, 2003.

Evans, Robin. *The Fabrication of Virtue: English Prison Architecture, 1750–1840.* Cambridge, UK: Cambridge University Press, 1982.

Fahy, Thomas and Kimball King, eds. *Captive Audience: Prison and Captivity in Contemporary Theatre.* New York: Routledge, 2003.

Fallon, Kevin. "My Visit to the 'Orange Is the New Black' Prison." *Daily Beast*, June 4, 2014. http://www.thedailybeast.com/articles/2014/06/04/my-visit-to-the-orange-is-the-new-black-prison.html.

Farley, Christopher John. "That Old Black Magic," *Time*, November 27, 2000, 14.

Field, Audrey. *Picture Palace: A Social History of the Cinema.* London: Gentry, 1974.

Field, Xenia. *Under Lock and Key: A Study of Women in Prison.* London: Parrish, 1963.

Fishbein, Leslie. "The Fallen Woman as Victim in Early American Film: Soma Versus Psyche." *Film and History: An Interdisciplinary Journal of Film and Television Studies* 17, no. 3 (September 1987): 50–61.

Fleetwood, Nicole. "Carceral Aesthetics: Art and Visuality in the Era of Mass Incarceration." Lecture at the City University of New York Graduate Center, May 3, 2013.

Foucault, Michel. *Discipline and Punish: The Birth of the Prison.* Translated by Alan Sheridan. New York: Vintage, 1995.

——. "The Eye of Power: A Conversation with Jean-Pierre Barou and Michelle Perrot." In *CTRL [SPACE]: Rhetorics of Surveillence from Bentham to Big Brother*, edited by Thomas Y. Levin, Ursula Frohne, and Peter Weibel, 94–101. Cambridge, MA: MIT Press, 2001.

Francis, Leigh-Anne. "Burning Down the Cage: African American Women Prison Communities in Auburn, New York, 1893–1933." PhD dissertation, Rutgers University, 2013.

Frasier, Mansfield. "The Saddest Reality Stars of All: Prisoners." *Daily Beast*, May 19, 2013. http://www.thedailybeast.com/articles/2013/05/19/the-saddest-reality-stars-of-all-prisoners.html.

Freedman, Estelle B. *Maternal Justice: Miriam Van Waters and the Female Reform Tradition.* Chicago: University of Chicago Press, 1996.

——. *Their Sisters' Keepers: Women's Prison Reform in America, 1830–1930.* Ann Arbor: University of Michigan Press, 1984.

Fuller-Seeley, Kathryn. *At the Picture Show: Small-Town Audiences and the Creation of Movie Fan Culture.* Norfolk: University of Virginia Press, 2001.

Furstenau, Marc. "Hitchcock in Europe: Railways, Magic, and Political Crisis in *The Lady Vanishes*." Paper presented at "Europe on Display/Exposer L'Europe" conference, McGill University, September 22–24, 2011.

Gaines, Jane and Michelle Koerner. "Women as Camera Operators or 'Cranks.'" Women Film Pioneers Project website, edited by Jane Gaines, Radha Vatsal, and Monica Dall'Asta. Center for Digital Research and Scholarship. New York: Columbia University Libraries, 2013. https://wfpp.cdrs.columbia.edu/essay/women-as -camera-operators-or-cranks/.

Garland, David. *Punishment and Modern Society: A Study in Social Theory.* Chicago: University of Chicago Press, 1999.

Gaudreault, André and Timothy Barnard. *From Plato to Lumière: Narration and Monstration.* Toronto: University of Toronto Press, 2009.

Gaudreault, André, Catherine Russell, and Pierre Véronneau, eds. *The Cinema: A New Technology for the 20th Century.* Lausanne, Switzerland: Editions Payot Lausanne, 2004.

Geltner, Guy. *The Medieval Prison: A Social History.* Princeton, NJ: Princeton University Press, 2008.

Giallombardo, Rose. *Society of Women: A Study of a Women's Prison.* New York: Wiley, 1966.

Gledhill, Christine. *Home Is Where the Heart Is: Studies in Melodrama and the Woman's Film.* London: British Film Institute, 1987.

Godbey, Emily. "Picture Me Sane: Photography and the Magic Lantern in a Nineteenth-Century Asylum." *American Studies* 41, no. 1 (Spring 2000): 31–69.

Goffman, Erving. *Asylums: Essays on the Social Situation of Mental Patients and Other Inmates.* New Brunswick, NJ: Aldine Transaction, 2009.

Goodwin, James. *Eisenstein, Cinema, and History.* Urbana: University of Illinois Press, 1993.

Greene, Ronald Walter. "Pastoral Exhibition: The YMCA Motion Picture Bureau and the Transition to 16mm, 1928–39." In Acland and Wasson, *Useful Cinema*, 205–29.

Greer, Chris. "Delivering Death: Capital Punishment Botched Executions and the American News Media." In *Captured by the Media: Prison Discourse in Popular Culture*, edited by Paul Mason, 89. Cullompton, UK: Willan, 2006.

Grieveson, Lee. "Gangsters and Governance in the Silent Era." In *Mob Culture: Hidden Histories of the American Gangster Film*, edited by Lee Grieveson, Esther Sonnet, and Peter Stanfield, 13–40. New Brunswick, NJ: Rutgers University Press, 2005.

——. *Policing Cinema: Movies and Censorship in Early Twentieth-Century America.* Berkeley: University of California Press, 2004.

Griffiths, Alison. "*Camping Among the Indians*: Visual Education and the Sponsored Expedition Film at the American Museum of Natural History." In *Recreating First Contact: Expeditions, Anthropology, and Popular Culture*, edited by Joshua A. Bell,

Alison K. Brown, and Robert J. Gordon, 90–108. Washington, DC: Smithsonian Institution, 2013.

——. *Shivers Down Your Spine: Cinema, Museums, and the Immersive View*. New York: Columbia University Press, 2008.

——. *Wondrous Difference: Cinema, Anthropology, and Turn-of-the-Century Visual Culture*. New York: Columbia University Press, 2001.

Groening, Stephen. "'We Can See Ourselves as Others See Us': Women Workers and Western Union's Training Films in the 1920s." In Acland and Wasson, *Useful Cinema*, 34–58.

Gunning, Tom. *D. W. Griffith and the Origins of American Narrative Films: The Early Years at Biograph*. Urbana: University of Illinois Press, 1991.

——. "Phantasmagoria and the Manufacturing of Illusions of Wonder: Towards a Cultural Optics of the Cinematic Apparatus." In Gaudreault, Russell, and Véronneau, *The Cinema*, 31–44.

——. "Pictures of Crowd Splendor: The Mitchell and Kenyon Factory Gate Films." In *The Lost World of Mitchell and Kenyon*, edited by Vanessa Toulmin, Patrick Russell, and Simon Popple, 49–58. London: British Film Institute, 2004.

Hale, Christopher. "Punishment and the Visible." In *The Prison Film*, edited by Mike Nellis and Christopher Hale, 50–64. London: Radical Alternatives to Prison, 1982.

Hansen, Miriam. *Babel and Babylon: Spectatorship in American Silent Film*. Cambridge, MA: Harvard University Press, 1994.

——. "Early Cinema: Whose Public Sphere?" *New German Critique* 29 (Spring/Summer 1983): 147–84.

Harvey, John. *The Story of Black*. London: Reaktion, 2013.

Harvey, Susan Ashbrook. *Scenting Salvation: Ancient Christianity and the Olfactory Imagination*. Berkeley: University of California Press, 2006.

Hearn, Daniel Allen. *Legal Executions in New York State: A Comprehensive Reference, 1639–1963*. Jefferson, NC: McFarland, 1997.

Hediger, Vinzenz and Patrick Vonderau, eds. *Films That Work: Industrial Film and the Productivity of Media*. Amsterdam: Amsterdam University Press, 2009.

Hemsworth, Katie. "Carceral Acoustemologies: Historical Geographies of Sound in a Canadian Prison." In *Historical Geographies of Prisons: Unlocking the Usable Carceral Past*, edited by Karen M. Morin and Dominique Moran, 17–33. New York: Routledge, 2015.

Hennefeld, Maggie. "Destructive Metamorphosis: From Convicts to Comediennes in Vitagraph's Transitional Trick Films." Paper presented at Society for Cinema and Media Studies Conference, Chicago, March 2013.

——. "Miniature Women, *Acrobatic Maids*, and Self-Amputating Domestics: Comedi-ennes of the Trick Film." *Early Popular Visual Culture* 13, no. 2 (May 2015): 134–51.

Herivel, Tara and Paul Wright, eds. *Prison Profiteers: Who Makes Money from Mass Incarceration*. New York: New Press, 2009.

Hicks, Cheryl D. *Talk with You Like a Woman: African-American Women, Justice, and Reform in New York, 1890–1935*. Chapel Hill: University of North Carolina Press, 2010.

Hicks, Heather J. "Hoodoo Economics: White Men's Work and Black Men's Magic in Contemporary American Film." *Camera Obscura* 18, no. 2 (2003): 27–55.

Hirsch, Adam. *The Rise of the Penitentiary: Prisoners and Punishment in Early Amer-ica*. New Haven, CT: Yale University Press, 1992.

Horne, Jennifer. "'Neutrality-Humanity': The Humanitarian Mission and the Films of the American Red Cross." In *Beyond the Screen: Institutions, Networks, and Pub-lics of Early Cinema*, edited by Charlie Keil, Rob King, and Paul S. Moore, 11–18. New Barnet, UK: Libbey, 2012.

Ignatieff, Michael. *A Just Measure of Pain: The Penitentiary in the Industrial Revo-lution, 1750–1850*. London: Macmillan, 1978.

Jewkes, Yvonne. *Captive Audience: Media, Masculinity and Power in Prisons*. Cullompton, UK: Willan, 2002.

——. "Creating a Stir? Prisons, Popular Media and the Power to Reform." In Mason, *Captured by the Media*, 137–53.

Jewkes, Yvonne and Helen Johnston, eds. *Prison Readings: A Critical Introduction to Prisons and Imprisonment*. Cullompton, UK: Willan, 2006.

Johnston, Helen. "'Buried Alive': Representations of the Separate System in Victo-rian England." In Mason, *Captured by the Media*, 103–21.

Johnston, Norman with Kenneth Finkel and Jeffrey A. Cohen. *Eastern State Peniten-tiary: Crucible of Good Intentions*. Philadelphia: Philadelphia Museum of Art, 2010.

Jones, Heather. *Violence Against Prisoners of War in the First World War: Britain, France, and Germany, 1914–1920*. Cambridge: Cambridge University Press, 2011.

Kamerbeek, Christopher. "The Ghost and the Corpse: Figuring the Mind/Brain Com-plex at the Turn of the Twentieth Century." PhD dissertation, University of Min-nesota, December 2010.

Kasson, John F. *Houdini, Tarzan, and the Perfect Man: The White Male Body and the Challenge of Modernity in America*. New York: Hill and Wang, 2001.

Kauffmann, Stanley. "Jail, Jokes, and Junk." *New Republic*, July 19, 1980, 22.

Kendrick, Kathleen. "'The Things Down Stairs': Containing Horror in the Nineteenth-Century Wax Museum." *Nineteenth Century Studies* 12 (1998): 1–35.

Kierkegaard, Søren. *Fear and Trembling.* Translated by Alastair Hannay. London: Penguin, 2003.

Kilar, Steve. "Clear Televisions Help Occupy Md. Prisoners, Keep Out Contraband." *Baltimore Sun*, August 11, 2011.

Kirby, Lynne. *Parallel Tracks: The Railroad and Silent Cinema.* Durham, NC: Duke University Press, 1997.

Klinger, Barbara. *Melodrama and Meaning: History, Culture, and the Films of Douglas Sirk.* Bloomington: Indiana University Press, 1994.

Koszarski, Richard. *An Evening's Entertainment: The Age of the Silent Feature Picture, 1915–1928.* Berkeley: University of California Press, 1994.

——. "Introduction to Theodore Water's 'Out with a Motion Picture Camera.'" *Film History* 15, no. 4 (2003): 396–402.

Kracauer, Siegfried. "Boredom." In *The Mass Ornament: Weimar Essays*, translated by Thomas Y. Levin, 331–34. Cambridge, MA: Harvard University Press, 2005.

Lant, Antonia. *The Red Velvet Seat: Women's Writings on the Cinema in the First Fifty Years.* London: Verso, 2006.

Lefebvre, Henri. *The Production of Space.* Translated by Donald Nicholson-Smith. London: Blackwell, 1991.

Le Forestier, Laurent. "From Craft to Industry: Series and Serial Production Discourses and Practices in France." In *A Companion to Early Cinema*, edited by André Gaudreault, Nicolas Dulac, and Santiago Hidalgo, 183–201. Chichester, UK: Wiley, 2012.

Lessa, William A. and Evon Z. Vorgt, eds. *Reader in Comparative Religion: An Anthropological Approach.* 3rd ed. New York: Harper and Row, 1972.

Lieber, Robert. *Alcatraz: The Ultimate Movie Book.* San Francisco: Golden Gate National Parks Conservancy, 2006.

Lindvall, Terry. "Sundays in Norfolk: Toward a Protestant Utopia Through Film Exhibition in Norfolk, Virginia, 1910–1920." In Maltby, Stokes, and Allen, *Going to the Movies*, 76–98.

Loiperdinger, Martin, ed. *Travelling Cinema in Europe.* Frankfurt: Stroemfeld / Roter Stern, 2008.

Lombardo, Daniel. "Maud Billington Booth (1865–1948): Volunteer Pioneer Leaves Legacy of Service." *Corrections Today* 58, no. 7 (1996): 28.

Lopez, Tiffany Ana. "Emotional Contraband: Prison as Metaphor and Meaning in U.S. Latina Drama." In Fahy and King, *Captive Audience*, 25–40.

Macleod, David. *Building Character in the American Boy: The Boy Scouts, YMCA and Their Forerunners, 1870–1920.* Madison: University of Wisconsin Press, 2004.

Maltby, Richard, Melvyn Stokes, and Robert C. Allen, eds. *Going to the Movies: Hollywood and the Social Experience of Cinema.* Exeter, UK: University of Exeter Press, 2007.

Mannoni, Laurent. *The Great Art of Light and Shadow: Archaeology of the Cinema.* Exeter, UK: University of Exeter Press, 2000.

Marion, Frances. *Off with Their Heads! A Serio-Comic Tale of Hollywood.* New York: Macmillan, 1972.

Mason, Paul, ed. *Captured by the Media: Prison Discourse in Popular Culture.* Cullompton, UK: Willan, 2006.

———. "Relocating Hollywood's Prison Film Discourse." In Mason, *Captured by the Media*, 190–209.

Masur, Louis P. *Rites of Execution: Capital Punishment and the Transformation of American Culture, 1776–1865.* New York: Oxford University Press, 1989.

Mauss, Marcel. *Sociologie et anthropologie.* Paris: Presses universitaires de France, 1973.

McGowen, Randall. "The Body and Punishment in Eighteenth Century England." *Journal of Modern History* 59 (1987): 312–34.

———. "A Powerful Sympathy: Terror, the Prison, and Humanitarian Reform in Early Nineteenth-Century Britain." *Journal of British Studies* 25 (July 1986): 324.

———. "The Well-Ordered Prison, England, 1780–1865." In Morris and Rothman, *The Oxford History of the Prison*, 71–99.

McKernan, Luke, ed. *Yesterday's News: The British Cinema Newsreel Reader.* London: British Universities Film and Video Council, 2002.

McLennan, Rebecca M. *The Crisis of Imprisonment: Protest, Politics, and the Making of the Penal State, 1776–1941.* Cambridge: Cambridge University Press, 2008.

McMahan, Alison. *Alice Guy Blaché: Lost Visionary of the Cinema.* London: Bloomsbury Academic, 2014.

Mercer, Christia. "I Teach Philosophy at Columbia. But Some of My Best Students Are Inmates." *Washington Post*, March 24, 2015. http://www.washingtonpost.com /posteverything/wp/2015/03/24/i-teach-philosophy-at-columbia-but-the-best -students-i-have-are-inmates/?hpid=z10.

Meyrowitz, Joshua. "Television and Interpersonal Behavior: Codes of Perception and Response." In *Inter/Media: Interpersonal Communication in a Media World*, edited by Gary Gumpert and Robert Cathcart, 253–72. New York: Oxford University Press, 1979.

Modleski, Tania. "In Hollywood, Racist Stereotypes Can Still Earn 4 Oscar Nominations." *Chronicle of Higher Education*, March 3, 2000.

Moore, Rob. "Cognitive Cognition: Transdisciplinarity in a Precarious World." Paper presented at WC2 Summer Symposium, London, August 2015.

Moran, Kathleen and Michael Rogin. "'What's the Matter with Capra?': *Sullivan's Travels* and the Popular Front." *Representations* 71 (2000): 106–34.

Moran, Richard. *Executioner's Current: Thomas Edison, George Westinghouse, and the Invention of the Electric Chair.* New York: Vintage, 2002.

Morin, Karen M., and Dominique Moran, eds. *Historical Geographies of Prisons: Unlocking the Usable Carceral Past.* New York: Routledge, 2015.

Morris, Norval. "The Contemporary Prison." In Morris and Rothman, *The Oxford History of the Prison,* 202–31.

Morris, Norval and David J. Rothman, eds. *The Oxford History of the Prison: The Practice of Punishment in Western Society.* New York: Oxford University Press, 1995.

Morus, Iwan Rhys. *Frankenstein's Children: Electricity, Exhibition, and Experiment in Early-Nineteenth-Century London.* Princeton, NJ: Princeton University Press, 1998.

——. *Shocking Bodies: Life, Death and Electricity in Victorian England.* Stroud, UK: History, 2011.

Musser, Charles. *Before the Nickelodeon: Edwin S. Porter and the Edison Manufacturing Company.* Berkeley: University of California Press, 1991.

——. *The Emergence of Cinema: The American Screen to 1907.* New York: Scribner, 1990.

Nadis, Fred. *Wonder Shows: Performing Science, Magic, and Religion in America.* New Brunswick, NJ: Rutgers University Press, 2005.

Nagourney, Adam. "An Actors' Studio Behind Bars Energizes Inmates." *NYT,* July 1, 2011, A1, 11, 15.

Nellis, Mike. "The Aesthetics of Redemption: Released Prisoners in American Film and Literature." *Theoretical Criminology* 13, no. 1 (2009): 129–46.

——. "Notes on the Prison Film." In *The Prison Film,* edited by Mike Nellis and Christopher Hale, 5–49. London: Radical Alternatives to Prison, 1982.

Nolan, William F. Introduction to *The Last Circus and the Electrocution,* by Raymond Bradbury, v–vi. Northridge, CA: Lord John, 1980.

Norton, Jack. "Little Siberia, Star of the North: The Political Economy of Prison Dreams in the Adirondacks." In *Historical Geographies of Prisons: Unlocking the Usable Carceral Past,* edited by Karen M. Morin and Dominique Moran, 168–84. London: Routledge, 2015.

Novek, Eleanor. "Mass Culture and the American Taste for Prison." *Peace Review: A Journal of Social Justice* 21, no. 3 (2009): 376–84.

Obama, Barack. "Why We Must Rethink Solitary Confinement." *Washington Post,* January 25, 2016. https://www.washingtonpost.com/opinions/barack-obama-why-we-must-rethink-solitary-confinement/2016/01/25/29a361f2-c384-11e5-8965-0607e0e265ce_story.html.

Olsson, Jan. *Los Angeles Before Hollywood: Journalism and American Film Culture, 1905–1915.* Stockholm: National Library of Sweden, 2009.

Orgeron, Devin, Marsha Orgeron, and Dan Streible, eds. *Learning with the Lights Off: Educational Film in the United States.* New York: Oxford University Press, 2012.

Owen, A. Susan and Peter Ehrenhaus. "Communities of Memory, Entanglements, and Claims of the Past Upon the Present: Reading Race Trauma Through *The Green Mile*." *Critical Studies in Mass Communication* 27, no. 2 (June 2010): 131–54.

Panetta, Roger G. "Up the River: A History of Sing Sing Prison in the Nineteenth Century." PhD dissertation, City University of New York, 1999.

Peiss, Kathy. *Cheap Amusements: Working Women and Leisure in Turn-of-the-Century New York*. Philadelphia: Temple University Press, 1986.

Pelizzon, V. Penelope and Nancy Martha West. "Multiple Indemnities: Film Noir, James M. Cain, and Adaptations of a Tabloid Case." *Narrative* 13, no. 3 (October 2005): 211–37.

Peters, Jeremy W. "To the Editor, in an Inmate's Hand." *NYT*, January 8, 2011, B1, B4.

Peterson, Jennifer Lynn. *Education in the School of Dreams: Travelogues and Early Nonfiction Film*. Durham, NC: Duke University Press, 2013.

"PFS Conference on Higher Education in the Prisons: One Year Later." *Senate Digest*, April 2012, 4.

Phelan, John Joseph. *Motion Pictures as a Phase of Commercialized Amusement in Toledo, Ohio*. Toledo, OH: Little Book, 1998.

Picker, John M. *Victorian Soundscapes*. New York: Oxford University Press, 2003.

Pilon, Mary. "A Series of Poses for Fitness, Inside and Out." *NYT*, January 4, 2013, A11, A15.

Pite, Ralph. *Thomas Hardy: The Guarded Life*. New Haven, CT: Yale University Press, 2007.

Priestly, Philip. *Victorian Prison Lives: English Prison Biography, 1830–1914*. London: Methuen, 1985.

"Prison Information Handbooks." https://www. gov.uk/life-in-prison.

Pryluck, Calvyn. "Ultimately We Are All Outsiders: The Ethics of Documentary Filmmaking." In *New Challenges for Documentary*, edited by Alan Rosenthall, 255–68. Berkeley: University of California Press, 1988.

Pugh, R. B. *Imprisonment in Medieval England*. Cambridge: Cambridge University Press, 1968.

Rafter, Nicole Hahn. "Chastising the Unchaste: Social Control Functions of a Women's Reformatory, 1894–1931." In *Social Control and the State*, edited by Stanley Cohen and Andrew Scull, 288–311. New York: St. Martin's, 1983.

——. "Hard Times: Custodial Prisons for Women and the Example of the New York State Prison for Women at Auburn, 1893–1933." In *Judge, Lawyer, Victim, Thief*, edited by Nicole Hahn Rafter and Elizabeth Anne Stanko, 237–38. Boston: Northeastern University Press, 1982.

——. Introduction to *Criminal Women, the Prostitute and the Normal Woman*, by Cesare Lombroso and Gugliemo Ferrero, 3–34. Translated by Nicole Hahn Rafter and Mary Gibson. Durham, NC: Duke University Press, 2004.

——. *Partial Justice: Women, Prisons, and Social Control*. New Brunswick, NJ: Transaction, 2004.

——. *Shots in the Mirror: Crime Films and Society*. New York: Oxford University Press, 2006.

Rafter, Nicole Hahn and Elizabeth Anne Stanko, eds. *Judge, Lawyer, Victim, Thief*. Boston: Northeastern University Press, 1982.

Rapp, Dean R. "A Baptist Pioneer: The Exhibition of Film to London's East End Working Classes, 1900–1918." *Baptist Quarterly* 40, no. 1 (2003): 6–21.

——. "The British Salvation Army, the Early Film Industry, and Urban Working-Class Adolescents, 1897–1918." *Twentieth-Century British History* 7, no. 2 (1996): 158–88.

Rathbone, Cristina. *A World Apart: Women, Prison, and Life Behind Bars*. New York: Random House, 2006.

Rath, Kayte. "TV in Prison: What Men and Women Watch in Their Cells." *BBC News*, September 14, 2012.

Richards, Thomas. *The Imperial Archive: Knowledge and Fantasy of Empire*. London: Verso, 1993.

Roberts, Phillip, ed. "Social Control and Early Visual Culture." Special issue, *Early Popular Visual Culture* 12, no. 2 (May 2014).

Rock, Alex. "The 'Khaki Fever' Moral Panic: Women's Patrols and the Policing of Cinemas in London, 1913–19." *Early Popular Visual Culture* 12, no. 1 (February 2014): 57–72.

Rodowick, D. N. "Madness, Authority and Ideology in the Domestic Melodrama of the 1950s." *Velvet Light Trap* 19 (1982): 40–45.

Rotundo, E. Anthony. *American Manhood: Transformations in Masculinity from the Revolution to the Modern Era*. New York: Basic Books, 1993.

Rouse, John Jay. *Firm but Fair: The Life of Sing Sing Warden Lewis Lawes*. New York: Xlibris, 2000.

Rozenzweig, Roy. *Eight Hours for What We Will: Workers and Leisure in an Industrial City, 1870–1920*. Cambridge: Cambridge University Press, 1985.

Sabo, Din, Terry A. Kupers, and Willie London, eds. *Prison Masculinities*. Philadelphia: Temple University Press, 2001.

Sappol, Michael. *A Traffic of Dead Bodies: Anatomy and Embodied Social Identity of Nineteenth-Century America*. Princeton, NJ: Princeton University Press, 2002.

Sarat, Austin. *When the State Kills: Capital Punishment and the American Condition*. Princeton, NJ: Princeton University Press, 2001.

Schama, Simon. *The Embarrassment of Riches: An Interpretation of Dutch Culture in the Golden Age*. New York: Knopf, 1987.

Schivelbusch, Wolfgang. *The Railway Journey: The Industrialization and Perception of Time and Space*. Berkeley: University of California Press, 1987.

Schlossman, Steven. *Love and the American Delinquent: The Theory and Practice of "Progressive" Juvenile Justice, 1825–1920*. Chicago: University of Chicago Press, 1977.

Schlossman, Steven with Stephanie Wallach. "The Crime of Precocious Sexuality: Female Juvenile Delinquency in the Progressive Era." *Harvard Educational Review* 48 (February 1978): 65–94.

Schoen, Steven and John Conroy. *Sing Sing: The View from Within—Photographs by the Prisoners*. New York: Winter House, 1972.

Schwartz, Vanessa. *Spectacular Realities: Early Mass Culture in Fin-de-Siècle Paris*. Berkeley: University of California Press, 1999.

Seitz, Trina N. "Electrocution and the Tar Heel State: The Advent and Demise of a Southern Sanction." *American Journal of Criminal Justice* 31, no. 1 (2006): 103–24.

Serassis, Telemach, Harald Kania, and Hans-Jörg Albrecht, eds. *Images of Crime III: Representations of Crime and the Criminal*. Berlin: Duncker and Humblot, 2009.

Shear, Michael D. "Obama Bans Solitary Confinement of Juveniles in Federal Prisons. *NYT*, January 25, 2016. http://www.nytimes.com/2016/01/26/us/politics/obama-bans-solitary-confinement-of-juveniles-in-federal-prisons.html?ref=topics&_r=0.

Sheldon, Randall G. *Our Punitive Society: Race, Class, Gender and Punishment in America*. Long Grove, IL: Waveland, 2010.

Singer, Ben. *Melodrama and Modernity: Early Sensational Cinema and Its Context*. New York: Columbia University Press, 2001.

Sloan, Kay. *The Loud Silents: Origin of the Social Problem Film*. Champaign: University of Illinois Press, 1988.

Smith, Caleb. *The Prison and the American Imagination*. New Haven, CT: Yale University Press, 2009.

Smith, Dinitia. "Prison Seeks to Shatter Expectations." *NYT*, July 12, 1999. http://www.nytimes.com/1999/07/12/arts/prison-series-seeks-to-shatter-expectations.html.

Smoodin, Eric. "Coercive Viewings: Soldiers and Prisoners Watch Movies." In *Regarding Frank Capra: Audience, Celebrity, and American Film Studies, 1930–1960*, 160–82. Durham, NC: Duke University Press, 2005.

Solomon, Matthew. *Disappearing Tricks: Silent Film, Houdini, and the New Magic of the Twentieth Century.* Urbana: University of Illinois Press, 2010.

Spierenburg, Pieter. "The Body and the State: Early Modern Europe." In Morris and Rothman, *The Oxford History of the Prison*, 44–70.

Spigel, Lynn. *Make Room for TV: Television and the Family Idea in Postwar America.* Chicago: University of Chicago Press, 1992.

Stamp, Shelley. *Lois Weber in Early Hollywood.* Berkeley: University of California Press, 2015.

——. *Movie-Struck Girls: Women and Motion Picture Culture After the Nickelodeon.* Princeton, NJ: Princeton University Press, 2000.

Stoler, Ann Laura. *Along the Archival Grain: Epistemic Anxieties and Colonial Common Sense.* Princeton, NJ: Princeton University Press, 2009.

Sykes, Gresham M. *The Society of Captives: A Study of a Maximum Security Prison.* 1958. Reprint, Princeton, NJ: Princeton University Press, 2007.

Teeters, Negley K. "Electrocutions in New York State Prison by Counties: From the First at Auburn, August 6, 1890 to Probably the Last, in Sing Sing, August 15, 1963: Total 695." Oneonte, NY: Hartwick College, 1965 (New York Historical Society library).

Thompson, Leon. "Stop Six: The Hole." *Doing Time: The Alcatraz Cellhouse Tour.* Press script. Antenna Audio and Golden Gate National Parks Conservancy, 2006, 11.

Tocci, Laurence. *The Proscenium Cage: Critical Case Studies in U.S. Prison Theatre Programs.* Amherst, NY: Cambria, 2007.

Toulmin, Vanessa. "An Early Crime Film Rediscovered: Mitchell and Kenyon's *Arrest of Goudie* (1901)." *Film History* 16, no. 1 (2004): 37–53.

——. *Electric Edwardians: The Films of Mitchell and Kenyon.* London: British Film Institute, 2008.

——. "Within the Reach of All: Travelling Cinematograph Shows on British Fairgrounds, 1896–1914." In Loiperdinger, *Travelling Cinema in Europe*, 19–33.

Turner, Jennifer and Kimberley Peters. "Doing Time-Travel: Performing Past and Present at the Prison Museum." In *Historical Geographies of Prisons: Unlocking the Usable Carceral Past*, edited by Karen M. Morin and Dominique Moran, 71–87. New York: Routledge, 2015.

Turner, Victor. "Betwixt and Between: The Liminal Period in *Rites de Passage*." *Proceedings of the American Ethnological Society* (1964): 4–20.

Tusher, Will. "Prison Films: The Quest for Reality Causes New Problems." *Hollywood Reporter*, April 3, 1972.

Uricchio, William and Roberta Pearson. *Reframing Culture: The Case of the Vitagraph Quality Films.* Princeton, NJ: Princeton University Press, 1993.

Valier, Claire. "Looking Daggers: A Psychoanalytical Reading of the Scene of Punishment." *Punishment and Society* 2, no. 4 (2000): 379–94.

Vanhaelen, Angela. *Comic Print and Theatre in Early Modern Amsterdam*. Farnham, UK: Ashgate, 2003.

Von Drehle, David. "Bungled Executions. Backlogged Courts. And Three More Reasons the Modern Death Penalty Is a Failed Experiment." *Time*, June 8, 2015, 26–33.

Waller, Gregory. *Main Street Amusements: Movies and Commercial Entertainment in a Southern City, 1896–1930*. Washington, DC: Smithsonian Institution, 1995.

——. *Moviegoing in America: A Sourcebook in the History of Film Exhibition*. London: Blackwell, 2002.

Walsh, Raoul. *Each Man in His Time: The Life Story of a Director*. New York: Farrar, Straus and Giroux, 1974.

Wasson, Haidee. "Electric Homes! Automatic Movies! Efficient Entertainment! 16mm and Cinema's Domestication in the 1920s." *Cinema Journal* 48, no. 4 (Summer 2009): 1–21.

——. "Protocols of Portability." *Film History* 25, no. 1/2 (2013): 236–47.

Whissel, Kristen. *Picturing American Modernity: Traffic, Technology, and the Silent Cinema*. Durham, NC: Duke University Press, 2008.

Wiener, Martin J. *Reconstructing the Criminal: Culture, Law, and Policy in England, 1830–1914*. Cambridge: Cambridge University Press, 1990.

Williams, Linda. "Melodrama in Black and White: Uncle Tom and *The Green Mile*." *Film Quarterly* 55, no. 2 (Winter 2001): 14–21.

——. *Playing the Race Card: Melodramas of Black and White from Uncle Tom to O. J. Simpson*. Princeton, NJ: Princeton University Press, 2002.

Williams, Raymond. *Marxism and Literature*. New York: Oxford University Press, 1978.

Wright, Paul. "Prison TV: Luxury or Management Tool?" *Prison Legal News*, September 14, 1994, 14.

Zamble, Edward and Frank J. Porporino. *Coping, Behavior, and Adaptation in Prison Inmates*. New York: Springer-Verlag, 1988.

Zedner, Lucia. "Wayward Sisters: The Prison for Women." In *The Oxford History of the Prison: The Practice of Punishment in Western Society*, edited by Norval Morris and David J. Rothman. New York: Oxford University Press, 1995.

——. *Women, Crime, and Custody in Victorian England*. Oxford: Clarendon, 1991.

Index

FILM AND CULTURE

A series of Columbia University Press

Edited by JOHN BELTON

Studios Before the System: Architecture, Technology, and the Emergence of Cinematic Space
 Brian R. Jacobson

Impersonal Enunciation, or the Place of Film
 Christian Metz

When Movies Were Theater: Architecture, Exhibition, and the Evolution of American Film
 William Paul